Henry M. Sayre

Oregon State University

The Humanities

Culture, Continuity & Change

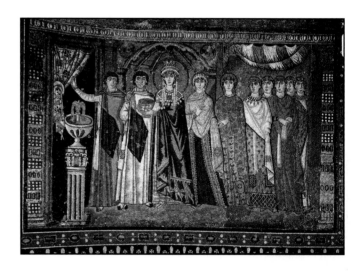

BOOK 2

MEDIEVAL EUROPE AND THE SHAPING OF WORLD CULTURES: 200 CE TO 1400

PEARSON

Prentice Hall

Upper Saddle River, New Jersey 07458

Library of Congress Cataloging-in-Publication Data

Sayre, Henry M.

The humanities : culture, continuity & change / Henry M. Sayre.

p. cm.

Includes index.

ISBN 0-205-63825-2

1. Civilization—History. 2. Humanities—History. 3. Social change—History. I. Title.

CB69.S29 2008

909—dc22 2007016065

For Bud Therien, art publisher and editor par excellence, and a good friend

Editor-in-Chief: Sarah Touborg
Senior Editor: Amber Mackey
Editor-in-Chief Development: Rochelle Diogenes
Senior Development Editor: Roberta Meyer
Development Editor: Karen Dubno
Assistant Editor: Alexandra Huggins
Editorial Assistant: Carla Worner
Media Editor: Alison Lorber
Director of Marketing: Brandy Dawson
Executive Marketing Manager: Marissa Feliberty
Senior Managing Editor: Mary Rottino
Project Manager: Harriet Tellem
Production Editor: Assunta Petrone
Production Assistant: Marlene Gassler
Senior Operations Specialists: Sherry Lewis and Brian Mackey
Senior Art Director: Nancy Wells
Interior and Cover Design: Ximena Tamvakopoulos
Layout Specialists: Gail Cocker-Bogusz and Wanda España
Line Art and Map Program Management: Gail Cocker-Bogusz
 and Mirella Signoretto
Fine Line Art: Peter Bull Art Studio
Cartographer: Peter Bull Art Studio

Line Art Studio: Precision Graphics
Pearson Imaging Center
 Site Supervisor: Joe Conti
 Project Coordinator: Corin Skidds
 Scanner Operators: Corin Skidds, Robert Uibelhoer, Ron Walko
Photo Research: Image Research Editorial Services/Francelle
 Carapetyan and Rebecca Harris
Director, Image Resource Center: Melinda Reo
Manager, Rights and Permissions: Zina Arabia
Manager, Visual Research: Beth Brenzel
Manager, Cover Visual Research and Permissions:
 Karen Sanatar
Image Permissions Coordinator: Debbie Latronica
Text Permissions: Warren Drabek, ExpressPermissions
Text Research: John Sisson
Copy Editor: Karen Verde
Proofreaders: Barbara DeVries and Nancy Stevenson
Composition: Preparé, Inc.
Cover Printer: Phoenix Color Corp.
Printer/Binder: Courier Kendallville
Cover Photo: Detail of *Empress Theodora and Her Attendants*.
 547 CE. Mosaic in San Vitale, Ravenna, Italy. Canali Photobank.

Credits and acknowledgments borrowed from other sources and reproduced, with permission, in this textbook appear on appropriate pages within text and beginning on page Credits-1.

Pearson Education LTD.
Pearson Education Singapore, Pte. Ltd.
Pearson Education, Canada, Ltd.
Pearson Education–Japan
Pearson Education, Upper Saddle River, New Jersey

Pearson Education Australia PTY, Limited
Pearson Education North Asia Ltd
Pearson Educación de Mexico, S.A. de C.V.
Pearson Education Malaysia, Pte. Ltd

10 9 8 7 6 5 4 3
ISBN 10: 0-205-63825-2
ISBN 13: 978-0-205-63825-3

Series Contents

Contents

iv

15 Siena and Florence in the Fourteenth Century
Toward a New Humanism 459

16 China, India, Japan, Africa, and the Americas before 1400 497

Dear Reader,

You might be asking yourself, why should I be interested in the Humanities? Why do I care about ancient Egypt, medieval France, or the Qing Dynasty of China?

I asked myself the same question when I was a sophomore in college. I was required to take a year long survey of the Humanities, and I soon realized that I was beginning an extraordinary journey. That course taught me where it was that I stood in the world, and why and how I had come to find myself there. My goal in this book is to help you take the same journey of discovery. Exploring the humanities will help you develop your abilities to look, listen, and read closely; and to analyze, connect, and question. In the end, this will help you navigate your world and come to a better understanding of your place in it.

What we see reflected in different cultures is something of ourselves, the objects of beauty and delight, the weapons and wars, the melodies and harmonies, the sometimes troubling but always penetrating thought from which we spring. To explore the humanities is to explore ourselves, to understand how and why we have changed over time, even as we have, in so many ways, remained the same.

About the Author

Henry M. Sayre is Distinguished Professor of Art History at Oregon State University–Cascades Campus in Bend, Oregon. He earned his Ph.D. in American Literature from the University of Washington. He is producer and creator of the 10-part television series, *A World of Art: Works in Progress*, aired on PBS in the fall of 1997; and author of seven books, including *A World of Art*, *The Visual Text of William Carlos Williams*, *The Object of Performance: The American Avant-Garde since 1970*; and an art history book for children, *Cave Paintings to Picasso*.

See Context and Make Connections...

The Humanities: Culture, Continuity, and Change shows the humanities in context and helps readers make connections—among disciplines, cultures, and time periods. Each chapter centers on a specific geographic location and time period and includes integrated coverage of all disciplines of the humanities. Using an engaging storytelling approach, author Henry Sayre clearly explains the influence of time and place upon the humanities.

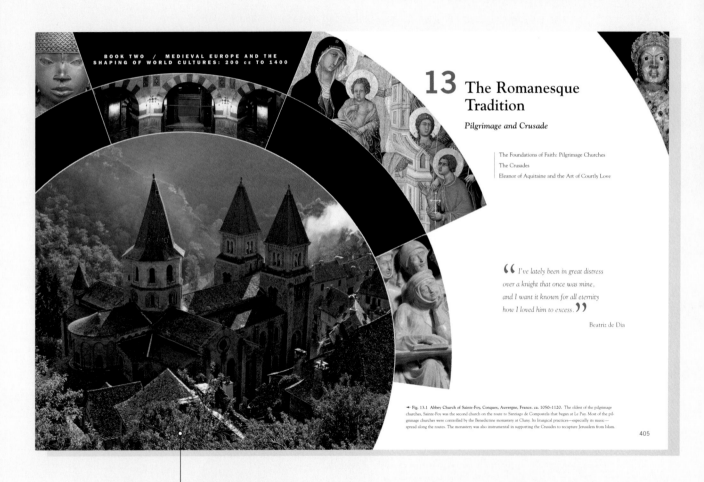

BOOK TWO / MEDIEVAL EUROPE AND THE
SHAPING OF WORLD CULTURES: 200 CE TO 1400

13 The Romanesque Tradition

Pilgrimage and Crusade

The Foundations of Faith: Pilgrimage Churches
The Crusades
Eleanor of Aquitaine and the Art of Courtly Love

" *I've lately been in great distress over a knight that once was mine, and I want it known for all eternity how I loved him to excess.* "

Beatriz de Dia

◀ Fig. 13.1 **Abbey Church of Sainte-Foy, Conques, Auvergne, France. ca. 1050–1120.** The oldest of the pilgrimage churches, Sainte-Foy was the second church on the route to Santiago de Compostela that began at Le Puy. Most of the pilgrimage churches were controlled by the Benedictine monastery at Cluny. Its liturgical practices—especially its music—spread along the routes. The monastery was also instrumental in supporting the Crusades to recapture Jerusalem from Islam.

405

CHAPTER OPENERS Each chapter begins with a compelling chapter opener that serves as a snapshot of the chapter. These visual introductions feature a central image from the location covered in the chapter. Several smaller images represent the breadth of disciplines and cultures covered throughout the book. An engaging quote drawn from one of the chapter's readings and a brief list of the chapter's major topics are also included.

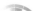

Across the Humanities

Egyptian
and Greek Sculpture

Continuity & Change

CONTINUITY & CHANGE
Full-page essays at the end of each chapter illustrate the influence of one culture upon another and show cultural changes over time.

Freestanding Greek sculpture of the Archaic period—that is, sculpture dating from about 600–480 BCE—is notable for its stylistic connections to 2,000 years of Egyptian tradition. The Late Period statue of *Mentuemhet* [men-too-em-het] (Fig. 6.18), from Thebes, dating from around 2500 BCE, differs hardly at all from Old Kingdom sculpture at Giza (see Figs. 3.8–3.9), and even though the *Anavysos* [ah-NAH-vee-sus] *Kouros* (Fig. 6.19), from a cemetery near Athens, represents a significant advance in relative naturalism over the Greek sculpture of just a few years before, it still resembles its Egyptian ancestors. Remarkably, since it follows upon the *Anavysos Kouros* by only 75 years, the *Doryphoros* [dor-IF-uh-rus] (*Spear Bearer*) (Fig. 6.20) is significantly more naturalistic. Although this is a

Roman copy of a lost fifth-century BCE bronze Greek statue, we can assume it reflects the original's naturalism, since the original's sculptor, Polyclitus [pol-ih-KLY-tus], was renowned for his ability to render the human body realistically. But this advance, characteristic of Golden Age Athens, represents more than just a cultural taste for naturalism. As we will see in the next chapter, it also represents a heightened cultural sensitivity to the worth of the individual, a belief that as much as we value what we have in common with one another—the bond that creates the city-state—our *individual* contributions are at least of equal value. By the fifth century BCE, the Greeks clearly understood that individual genius and achievement could be a matter of civic pride. ∎

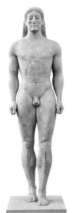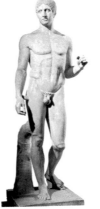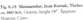

Fig. 6.18 *Mentuemhet*, from Karnak, Thebes. ca. 660 BCE. Granite, height 54". Egyptian Museum, Cairo.

Fig. 6.19 *Anavysos Kouros*, perhaps young Kroisos, from a cemetery at Anavysos [ah-NAH-vee-sus], near Athens. ca. 525 BCE. Marble with remnants of paint, height 6' 4". National Archaeological Museum, Athens; Fig. 6.20 *Doryphoros* (*Spear Bearer*), Roman copy after the original bronze by Polyclitus of ca. 450–440 BCE. Marble, height 6' 6". Museo Archeologico Nazionale, Naples.

185

Fig. 18.6 Donato Bramante, *Tempietto*. 1502. San Pietro in Montorio, Rome. This chapel was certainly modeled after a classical temple. It was commissioned by King Ferdinand and Queen Isabella of Spain, financiers of Christopher Columbus's voyages to America. It was undertaken in support of Pope Alexander VI, who was himself Spanish.

In his plan for a new Saint Peter's (Fig. 18.7a), Bramante adopted the Vitruvian square, as illustrated in Leonardo's drawing, p. 260, placing inside it a **Greek cross** (a cross in which the upright and transverse shafts are of equal length and intersect at their middles) topped by a central dome purposely reminiscent of the giant dome of the Pantheon (see Fig. 8.25). The resultant central plan is essentially a circle inscribed within a square. In Renaissance thinking, the central plan and dome symbolized the perfection of God. Construction began in 1506.

Julius II financed the project through the sale of **indulgences**, dispensations granted by the Church to shorten an individual's stay in purgatory. This was the place where, in Catholic belief, individuals temporarily reside after death as punishment for their sins. Those wanting to enter heaven faster than they otherwise might could shorten their stay in purgatory by purchasing an indulgence. The Church had been selling these documents since the twelfth century, and Julius's building campaign intensified the practice (see *Voices*, page 588). (In protest against the sale of indulgences, Martin Luther would launch the Protestant Reformation in Germany in 1517; see chapter 21.) The New Saint Peter's would be a very expensive project, but there were also very many sinners willing to help pay for it. With the deaths of both pope and architect, in 1513 and 1514 respectively, the project came to a temporary halt. Its final plan would be developed in 1546 by Michelangelo (Fig. 18.7b).

Continuity & Change

The Pantheon

CONTINUITY & CHANGE references provide a window into the past. These eye-catching icons enable students to refer to material in other chapters that is relevant to the topic at hand.

CRITICAL THINKING questions at the end of each chapter prompt readers to synthesize material from the chapter.

Critical Thinking Questions

1. What was the relationship of the Anglo-Saxon lord or chief to his followers and subjects?

2. How does the *Song of Roland* reflect feudal values? How do these values differ from those found in *Beowulf*?

3. What is the Rule of St. Benedict and how did it affect monastic life?

4. What role did music play in Charlemagne's drive to standardize the liturgy?

See Context and Make Connections...

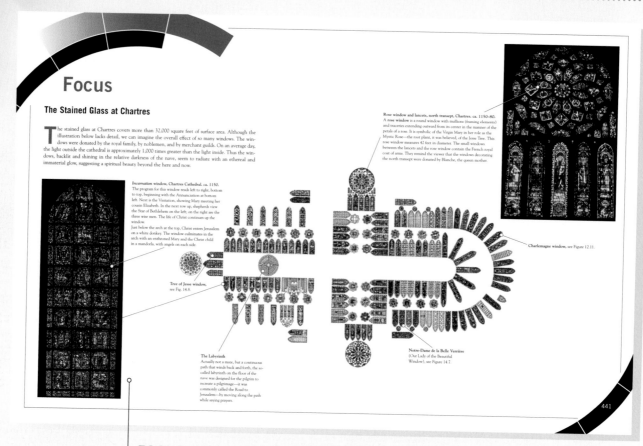

Focus

The Stained Glass at Chartres

The stained glass at Chartres covers more than 32,000 square feet of surface area. Although the illustration below lacks detail, we can imagine the overall effect of so many windows. The windows were donated by the royal family, by noblemen, and by merchant guilds. On an average day, the light outside the cathedral is approximately 1,000 times greater than the light inside. Thus the windows, backlit and shining in the relative darkness of the nave, seem to radiate with an ethereal and immaterial glow, suggesting a spiritual beauty beyond the here and now.

Incarnation window, Chartres Cathedral. ca. 1150. The program for this window reads left to right, bottom to top, beginning with the Annunciation at bottom left. Next is the Visitation, showing Mary meeting her cousin Elizabeth. In the next row up, shepherds view the Star of Bethlehem on the left, on the right are the three wise men. The life of Christ continues up the window. Just below the arch at the top, Christ enters Jerusalem on a white donkey. The window culminates in the arch with an enthroned Mary and the Christ child in a mandorla, with angels on each side.

Tree of Jesse window, see Fig. 14.8.

The Labyrinth Actually not a maze, but a continuous path that winds back and forth, the so-called labyrinth on the floor of the nave was designed for the pilgrim to recreate a pilgrimage—it was commonly called the Road to Jerusalem—by moving along the path while saying prayers.

Rose window and lancets, north transept, Chartres. ca. 1150–80. A **rose window** is a round window with mullions (framing elements) and traceries extending outward from its center in the manner of the petals of a rose. It is symbolic of the Virgin Mary in her role as the Mystic Rose—the root plant, it was believed, of the Jesse Tree. This rose window measures 42 feet in diameter. The small windows between the lancets and the rose window contain the French royal coat of arms. They remind the viewer that the windows decorating the north transept were donated by Blanche, the queen mother.

Charlemagne window, see Figure 12.11.

Notre-Dame de la Belle Verrière (Our Lady of the Beautiful Window), see Figure 14.7.

441

FOCUS Highly visual Focus features offer an in-depth look at a particular work from one of the disciplines of the humanities. These annotated discussions give students a personal tour of the work—with informative captions and labels—to help students understand its meaning.

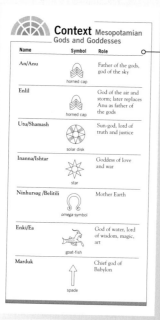

Context Mesopotamian Gods and Goddesses

Name	Symbol	Role
An/Anu	horned cap	Father of the gods, god of the sky
Enlil	horned cap	God of the air and storm; later replaces Anu as father of the gods
Utu/Shamash	solar disk	Sun-god, lord of truth and justice
Inanna/Ishtar	star	Goddess of love and war
Ninhursag /Belitili	omega symbol	Mother Earth
Enki/Ea	goat-fish	God of water, lord of wisdom, magic, art
Marduk	spade	Chief god of Babylon

CONTEXT boxes summarize important background information in an easy-to-read format.

MATERIALS AND TECHNIQUES boxes explain and illustrate the methods artists and architects use to produce their work.

Materials & Techniques
Tapestry

Tapestries are heavy textiles hand-woven on looms. The looms range in size from small, hand-held models to large, freestanding structures. They serve as frames, holding in tension supporting threads, called the **warp**, so that striking threads, called the **weft**, can be interwoven between them. Warp threads are made of strong fibers, usually wool or linen, while weft threads are brightly colored strands of silk or wool, spun gold, or spun silver. Once the warp threads are stretched on the loom, the weaver places a **cartoon**, or full-scale drawing, below or behind the loom. The weaver then works on the back side of the tapestry, pushing the weft threads under and over the warp threads, knotting alternating colors together in a single strand, to match the cartoon's design. So the front side of the tapestry reproduces the design in reverse. The design can approach painting in its compositional complexity, refinement, and the three-dimensional rendering of forms.

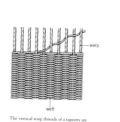

warp

weft

The vertical warp threads of a tapestry are interwoven with horizontal weft threads.

Through Special Features and Primary Sources

Each chapter of *The Humanities* includes **PRIMARY SOURCE READINGS** in two formats. Brief readings from important works are included within the body of the text. Longer readings located at the end of each chapter allow for a more in-depth study of particular works. This organization offers great flexibility in teaching the course.

END-OF-CHAPTER READINGS

BRIEF READINGS

The following appears within an example page reproduction:

READINGS

READING 17.4

from Baldassare Castiglione, *The Book of the Courtier*, Book 1 (1513–18; published 1528)

Castiglione spent his life in the service of princes, first in the courts of Mantua and Urbino, and then in Rome, where he served the papacy. His Book of the Courtier was translated into most European languages and remained popular for two centuries. It takes the form of a series of fictional conversations between the courtiers of the duke of Urbino in 1507 and included the duchess. In the excerpt below, the separate speakers have not been identified to facilitate ease of reading. The work is a celebration of the ideal character of the Renaissance humanist and the ethical behavior associated with that ideal.

[The Perfect Courtier]

Within myself I have long doubted, dearest messer Alfonso, which of two things were the harder for me: to deny you what you have often begged of me so urgently, or to do it. For while it seemed to me very hard to deny anything (and especially a thing in the highest degree laudable) to one whom I love most dearly and by whom I feel myself to be most dearly loved, yet to set about an enterprise that I am not sure of being able to finish, seemed to me ill befitting a man who esteems just censure as it ought to be esteemed. . . .

You ask me then to write what is to my thinking the form of Courtiership most befitting a gentleman who lives at the court of princes, by which he may have the ability and knowledge perfectly to serve them in every reasonable thing, winning from them favor, and praise from other men; in short, what manner of man he ought to be who may deserve to be called a perfect Courtier without flaw. . . .

So now let us make a beginning of our subject, and if possible let us form such a Courtier that any prince worthy to be served by him, although of but small estate, might still be called a very great lord.

I wish then, that this Courtier of ours should be nobly born and of gentle race; . . . for noble birth is like a bright lamp that manifests and makes visible good and evil deeds, and kindles and stimulates to virtue both by fear of shame and by hope of praise. . . . And thus it nearly always happens that both in the profession of arms and in other worthy pursuits the most famous men have been of noble birth, because nature has implanted in everything that hidden seed which gives a certain force and quality of its own essence to all things that are derived from it, and makes them like itself: as we see not only in the breeds of horses and of other animals, but also in trees, the shoots of which nearly always resemble the trunk; and if they sometimes degenerate, it arises from poor cultivation. And so it is with men, who if rightly trained are nearly always like those from whom they spring, and often

It is true that, by favor of the stars or of nature, some men are endowed at birth with such graces that they seem not to have been born, but rather as if some god had formed them with his very hands and adorned them with every excellence of mind and body. So too there are many men so foolish and rude that one cannot but think that nature brought them into the world out of contempt or mockery. Just as these can usually accomplish little even with constant diligence and good training, so with slight pains those others reach the highest summit of excellence. . . .

Besides this noble birth, then, I would have the Courtier favored in this regard also, and endowed by nature not only with talent and beauty of person and feature, but with a certain grace and (as we say) air that shall make him at first sight pleasing and agreeable to all who see him; and I would have this an ornament that should dispose and unite all his actions, and in his outward aspect give promise of whatever is worthy the society and favor of every great lord.

But to come to some details, I am of opinion that the principal and true profession of the Courtier ought to be that of arms; which I would have him follow actively above all else, and be known among others as bold and strong, and loyal to whomsoever he serves. And he will win a reputation for these good qualities by exercising them at all times and in all places, since one may never fail in this without severest censure. And just as among women, their fair fame once sullied never recovers its first lustre, so the reputation of a gentleman who bears arms, if once it be in the least tarnished with cowardice or other disgrace, remains forever infamous before the world and full of ignominy. Therefore the more our Courtier excels in this art, the more he will be worthy of praise . . .

. . . And of such sort I would have our Courtier's aspect; not so soft and effeminate as is sought by many, who not only curl their hair and pluck their brows, but gloss their faces with all those arts employed by the most wanton and unchaste women in the world; and in their walk, posture and every act, they seem so limp and languid that their limbs are like to fall apart; and they pronounce their words so mourn-

The following appears within a second example page reproduction:

The poem, in short, demonstrates that traditional chivalric virtues—those that Castiglione was outlining in *The Book of the Courtier* (see chapter 17) even as Ariosto was writing his poem—had little or no relevance to modern Italian court, just as armor, swords, and lances had been made irrelevant by the invention of gunpowder. On the subject of gunpowder, the poem makes the following lament (**Reading 19.2b**):

READING 19.2b from Ludovico Ariosto, *Orlando Furioso*, Canto XI

XXVI

How, foul and pestilent discovery,
Didst thou find place within the human heart?
Through thee is martial glory lost, through thee
The trade of arms become a worthless art:
And at such ebb are worth and chivalry,
That the base often plays the better part.
Through thee no more shall gallantry, no more
Shall valour prove their prowess as of yore.

Love is never ennobling in the poem—and rarely chivalric—but leads only to insult, rejection, madness, and death. The only way to save oneself is not to love at all. But however unsympathetic the poem is to the chivalric code, Ariosto's ability to create an exciting narrative of nonstop action that moves across the globe in large part accounts for his poem's extraordinary success. Throughout the sixteenth century, new readers discovered the poem as the printing press (see chapter 21) made it more widely available, especially to a popular audience that had little use for the conventions of chivalry.

Lucretia Marinella's *The Nobility and Excellence of Women*

Not surprisingly, Renaissance women also attacked the chivalric, or rather pseudo-chivalric, attitudes and behavior of Renaissance males. One such attack was *The Nobility and Excellence of Women and the Defects and Vices of Men* by the Venetian writer Lucretia Marinella [loo-CREE-sha mah-ree-NEL-lah] (1571–1653), published in Venice around 1600 and widely circulated. (See **Reading 19.3a**.) Marinella was one of the most prolific writers of her day. She published many works, including a pastoral drama, musical compositions, religious verse, and an epic poem celebrating Venice's role in the Fourth Crusade, but her sometimes vitriolic polemic against men is unique in the literature of the time. *The Nobility and Excellence of Women* is a response to a contemporary diatribe, *The Defects of Women*, written by her Venetian contemporary, Giuseppe Passi [PAHS-see].

It is clear enough to Marinella, who had received a humanistic education, that any man who denigrates women

is motivated by such reasons as anger and envy (see **Reading 19.3**, pages 631–632, for an extended excerpt).

READING 19.3a from Lucretia Marinella, *The Nobility and Excellence of Women*

When a man wishes to fulfill his unbridled desires and is unable to because of the temperance and continence of a woman, he immediately becomes angry and disdainful, and in his rage says every bad thing he can think of, as if the woman were something evil and hateful. . . . When a man sees that a woman is superior to him, both in virtue and in beauty, and that she is justly honored and loved even by him, he tortures himself and is consumed with envy. Not being able to give vent to his emotions in any other way, he resorts with sharp and biting tongue to false and specious vituperation and reproof. . . . But if with a subtle intelligence, men should consider their own imperfection, oh how humble and low they would become! Perhaps one day, God willing, they will perceive it.

From Marinella's point of view, Renaissance women possess the fullest measure of Castiglione's moral virtue and humanist individualism, not the courtiers themselves. The second part of the book, on the defects and vices of men, is a stunning and sometimes amusing reversal of Passi's arguments, crediting men with all the vices he attributes to women.

For Marinella, Ariosto's *Orlando Furioso*, with its many exemplary female characters, was a rich mine of opinions, episodes, and characters that suggest women's moral and intellectual eminence. She makes use of the Neoplatonic argument that beauty is a reflection of goodness, arguing that women's souls must be preeminent because of "the beauty of their bodies." But perhaps Marinella's most important distinction is her insistence that women are autonomous beings, who should not be defined only in relation to men. (See *Voices*, page 627.)

Music of the Venetian High Renaissance

Almost without exception, women of literary accomplishment in the Renaissance were musically accomplished as well. As we have seen, Isabella d'Este played both the lute and the *lira da braccio*, the precursor to the modern violin (see Fig. 18.18). Through her patronage, she and her sister-in-law Lucretia Borgia, duchess of Ferrara, competed for musicians and encouraged the cultivation of the *frottola*, (see chapter 17). Courtesans such as Veronica Franco could both sing and play. And both Isabella and Elisabetta Gon-

Included in every chapter, **VOICES** features offer vivid first person accounts of the experiences of ordinary people during the period covered in the chapter. These primary source readings offer a glimpse of what life was like in the past and help students understand the social context of a particular culture.

The following appears within a Voices feature reproduction:

))) Voices

A Young Woman's Perspective on Venetian Society

Against her will, the parents of Arcangela Tarabotti (1604–1652) sent her to a Benedictine convent near Venice for her education. Here she expresses her passionate anger at her family, the convent system, and the hierarchy of Venetian society. This excerpt is from her first work, Paternal Tyranny. Her next work was an even more searing indictment (never published) entitled Convent Hell.

Compares the plight of young girls in the convent to captured birds:

Whenever I see one of these hapless young girls, betrayed by their very own parents, I am reminded of what happens to a pretty little bird from within the tree's foliage or along riverbanks, it delights the ear with sweet chirping and charming song, soothing the hearts of its audience—when suddenly it's trapped in a treacherous net, robbed of precious liberty.

Discussing education, Tarabotti focuses on her own experiences:

So shameless are you that while reproaching women for stupidity you strive with all your power to bring

"As soon as you men catch sight of a woman with pen in hand, you start ranting and raving; you order them under penalty of death to put aside their scribbling and attend to "feminine" tasks like needlework and spinning. . . ."

them up and educate them as if they were witless and insensitive. You give them as a governess another woman, also unlettered, who can barely instruct them in the rudiments of reading, to say nothing of anything to do with philosophy, law, and theology. In short, they learn nothing but the ABC, and even that is poorly taught. (I know from experience, so I can bear witness at length.)

As soon as you catch sight of a woman with pen in hand, you start ranting and raving; you order them under penalty of death to put aside their scribbling and attend to "feminine" tasks like needlework and spinning. . . . (As if our intellects could find no more appropriate occupation than spinning!)

A **CD ICON** calls out musical selections discussed in the text that are found on the supplemental CDs available for use with *The Humanities*.

The following appears within a text reproduction at bottom:

zaga, duchess of Urbino, were well known for their ability to improvise songs. By the last decades of the sixteenth century, we know that women were composing music as well. The most famous of these was the Venetian Madalena Casulana [mah-dah-LAY-nah kah-soo-LAH-nah].

Madalena Casulana's Madrigals

Madalena Casulana was the first professional woman composer to see her own compositions in print. In 1566, her anthology entitled *The Desire* was published in Venice. Two years later, she dedicated her first book of songs to Isabella

chapter 17), the madrigal was **through-composed**—that is, each line of text is set to new music. This allows for **word painting**, where the musical elements imitate the meaning of the text in mood or action. Anguish, for example, is conveyed with an unusually low pitch, as in Casulana's *Morir non pu il mio cuore* [moh-REER nohn pwo eel MEE-oh KWOR-eh] ("My Heart Cannot Die") (**CD-Track 19.1**). The song laments a relationship gone bad, and the narrator contemplates driving a stake through her heart because it is in so much pain. When she says that her suicide might kill her beloved—*so che morreste toi* [so keh mor-EH-stay VOY] ("I know that you would die")—

See Context and Make Connections... Across Cultures

The Humanities: Culture, Continuity, and Change provides the most comprehensive coverage of various cultures including Asia, Africa, the Americas, and Europe.

Included in every chapter, **CULTURAL PARALLELS** highlight historical and artistic developments occurring in different locations during the period covered in the chapter. This feature helps students understand parallel developments in the humanities across the globe.

Detailed **MAPS** in each chapter orient the reader to the locations discussed in the chapter.

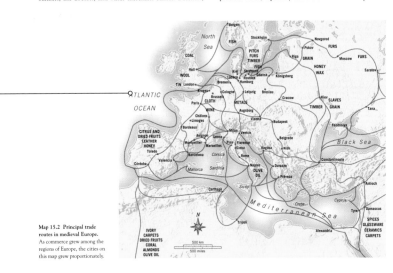

The reproduced textbook page reads:

464 ⌒ **BOOK TWO** MEDIEVAL EUROPE AND THE SHAPING OF WORLD CULTURES

CULTURAL PARALLELS

Textiles in Florence and Peru

Florence was the center of textile production in the West, but 7,000 miles farther west, the Inca culture of the Peruvian highlands also produced abundant supplies of high-quality textiles. The Inca valued these woolen products even more than gold, and weavers encoded complex symbolism into the fabric (see chapter 16).

The Guilds and Florentine Politics Only two other cities in all of Italy—Lucca and Venice—could boast that they were republics like Siena and Florence, and governing a republic was no easy task. As in Siena, in Florence the guilds controlled the commune. By the end of the twelfth century there were seven major guilds and fourteen minor ones. The most prestigious was the lawyers' guild (the Arte dei Giudici), followed closely by the wool guild (the Arte della Lana), the silk guild (the Arte di Seta), and the cloth merchants' guild (the Arte di Calimala). Also among the major guilds were the bankers, the doctors, and other merchant classes. Butchers,

bakers, carpenters, and masons composed the bulk of the minor guilds.

As in Siena, too, the merchants, especially the Arte della Lana, controlled the government. They were known as the *Popolo Grasso* (literally, "the fat people"), as opposed to *Popolo Minuto*, the ordinary workers, who comprised probably 75 percent of the population and had no voice in government. Only guild members could serve in the government. Their names were written down, the writing was placed in leather bags (*borse*) in the Church of Santa Croce, and nine names were drawn every two months in a public ceremony. (The period of service was short to reduce the chance of corruption.) Those *signori* selected were known as the *Priori*, and their government was known as the *Signoria*—hence the name of the Piazza della Signoria, the plaza in front of the Palazzo Vecchio. There were generally nine Priori—six from the major guilds, two from the minor guilds, and one standard-bearer.

The Florentine republic might have resembled a true democracy except for two details: First, the guilds were very close-knit so that, in general, selecting one or the other of their membership made little or no political difference; and second, the available names in the *borse* could be easily manipulated. However, conflict inevitably arose, and throughout the thirteenth century other tensions made the problem worse, especially feuds between the Guelphs and

Map 15.2 Principal trade routes in medieval Europe. As commerce grew among the regions of Europe, the cities on this map grew proportionately.

See Context and Make Connections...
with Teaching and Learning Resources

Title: *The Libyan Sibyl*
Artist: Michelangelo Buonarroti
Date: 1511-1512
Source/Museum: Detail of the Sistine Ceiling, Sistine Chapel, Vatican Palace, Vatican State, Italy.
Medium: Fresco
Size: n/a

THE PRENTICE HALL DIGITAL ARTS LIBRARY contains every image in *The Humanities* in the highest resolution and pixellation possible for optimal projection. Each image is available in jpeg format and as a customizable PowerPoint® slide with an instant download function. Available to instructors upon adoption of *The Humanities*, the Digital Arts Library also includes video and audio clips for use in classroom presentations.

DVD Set: 978-0-13-615298-9
CD Set: 978-0-13-615299-6

myhumanitieslab

MYHUMANITIESLAB is a dynamic online resource that provides opportunities for practice, assessment, and instruction—including digital flashcards of every image in the text. Easy to use and easy to integrate into the classroom, it engages students as it builds confidence and enhances students' learning experience.

Visit **www.myhumanitieslab.com** to begin.

Instructor's Manual and Test Item File
978-0-113-18272-5

Test Generator
978-0-13-182730-1
www.prenhall.com/irc

Companion Website
www.prenhall.com/sayre

Student Study Guide
Volume I: 978-0-13-615316-0
Volume II: 978-0-13-615317-7

VangoNotes Audio Study Guides
www.vangonotes.com

Music CDs
Music CD to Accompany Volume I: 978-0-13-601736-3
Music CD to Accompany Volume II: 978-0-13-601737-0

The Prentice Hall Atlas of the Humanities
978-0-13-238628-9

Package Penguin titles at a significant discount
Visit **www.prenhall.com/art** for information.

Developing *The Humanities*

The Humanities: Culture, Continuity, and Change is the result of an extensive development process involving the contributions of over one hundred instructors and their students. We are grateful to all who participated in shaping the content, clarity, and design of this text. Manuscript reviewers and focus group participants include:

Kathryn S. Amerson, *Craven Community College*
Helen Barnes, *Butler County Community College*
Bryan H. Barrows III, *North Harris College*
Amanda Bell, *University of North Carolina, Asheville*
Sherry R. Blum, *Austin Community College*
Edward T. Bonahue, *Santa Fe Community College*
James Boswell Jr., *Harrisburg Area Community College–Wildwood*
Diane Boze, *Northeastern State University*
Robert E. Brill, *Santa Fe Community College*
Daniel J. Brooks, *Aquinas College*
Farrel R. Broslawsky, *Los Angeles Valley College*
Benjamin Brotemarkle, *Brevard Community College–Titusville*
Peggy A. Brown, *Collin County Community College*
Robert W. Brown, *University of North Carolina –Pembroke*
David J. Califf, *The Academy of Notre Dame*
Gricelle E. Cano, *Houston Community College–Southeast*
Martha Carreon, *Rio Hondo College*
Charles E. Carroll, *Lake City Community College*
Margaret Carroll, *Albany College of Pharmacy of Union University*
Beverly H. Carter, *Grove City College*
Michael Channing, *Saddleback Community College*
Patricia J. Chauvin, *St. Petersburg College*
Cyndia Clegg, *Pepperdine University*
Jennie Congleton, *College Misericordia*
Ron L. Cooper, *Central Florida Community College*
Similih M. Cordor, *Florida Community College*
Laurel Corona, *San Diego City College*
Michael W. Coste, *Front Range Community College–Westminster*
Harry S. Coverston, *University of Central Florida*
David H. Darst, *Florida State University*
Gareth Davies-Morris, *Grossmont College*
James Doan, *Nova Southeastern University*
Jeffery R. W. Donley, *Valencia Community College*
William G. Doty, *University of Alabama*
Scott Douglass, *Chattanooga State Technical Community College*
May Du Bois, *West Los Angeles College*
Tiffany Engel, *Tulsa Community College*
Walter Evans, *Augusta State University*
Douglas K. Evans, *University of Central Florida*
Arthur Feinsod, *Indiana State University*
Kimberly Felos, *St. Petersburg College–Tarpon Springs*
Jane Fiske, *Fitchburg College*
Brian Fitzpatrick, *Endicott College*
Lindy Forrester, *Southern New Hampshire University*
Barbara Gallardo, *Los Angeles Harbor College*
Cynthia D. Gobatie, *Riverside Community College*
Blue Greenberg, *Meredith College*
Richard Grego, *Daytona Beach Community College–Daytona*
Linda Hasley, *Redlands Community College*

Dawn Marie Hayes, *Montclair State University*
Arlene C. Hilfer, *Ursuline College*
Clayton G. Holloway, *Hampton University*
Marion S. Jacobson, *Albany College of Pharmacy of Union University*
Bruce Janz, *University of Central Florida*
Steve Jones, *Bethune-Cookman College*
Charlene Kalinoski, *Roanoke College*
Robert S. Katz, *Tulsa Community College*
Alice Kingsnorth, *American River College*
Connie LaMarca-Frankel, *Pasco-Hernando Community College*
Leslie A. Lambert, *Santa Fe Community College*
Sandi Landis, *St. Johns River Community College–Orange Park*
Vonya Lewis, *Sinclair Community College*
David Luther, *Edison Community College, Collier*
Michael Mackey, *Community College of Denver*
Janet Madden, *El Camino College*
Ann Marie Malloy, *Tulsa Community College–Southeast*
James Massey, *Polk Community College*
John Mathews, *Central Florida Community College*
Susan McClung, *Hillsborough Community College–Ybor City*
Joseph McDade, *Houston Community College, Northeast*
Brian E. Michaels, *St. Johns River Community College*
Maureen Moore, *Cosumnes River College*
Nan Morelli-White, *St. Petersburg College–Clearwater*
Jenny W. Ohayon, *Florida Community College*
Beth Ann O'Rourke, *University of Central Florida*
Elizabeth Pennington, *St. Petersburg College–Gibbs*
Nathan M. Poage, *Houston Community College–Central*
Norman Prinsky, *Augusta State University*
Jay D. Raskin, *University of Central Florida*
Sharon Rooks, *Edison Community College*
Douglas B. Rosentrater, *Bucks County Community College*
Grant Shafer, *Washtenaw Community College*
Mary Beth Schillaci, *Houston Community College–Southeast*
Tom Shields, *Bucks County Community College*
Frederick Smith, *Lake City Community College*
Sonia Sorrell, *Pepperdine University*
Jonathan Steele, *St. Petersburg Junior College*
Elisabeth Stein, *Tallahassee Community College*
Lisa Odham Stokes, *Seminole Community College*
Alice Taylor, *West Los Angeles College*
Trent Tomengo, *Seminole Community College*
Cordell M. Waldron, *University of Northern Iowa*
Robin Wallace, *Baylor University*
Daniel R. White, *Florida Atlantic University*
Naomi Yavneh, *University of South Florida*
John M. Yozzo, *East Central University*
James Zaharek, *Rio Hondo College*
Kenneth Zimmerman, *Tallahassee Community College*

Acknowledgments

No project of this scope could ever come into being without the hard work and perseverance of many more people than its author. In fact, this author has been humbled by a team at Pearson Prentice Hall that never wavered in its confidence in my ability to finish this enormous undertaking (or if they did, they had the good sense not to let me know); never hesitated to cajole, prod, and massage me to complete the project in something close to on time; and always gave me the freedom to explore new approaches to the materials at hand. At the down-and-dirty level, I am especially grateful to fact checker, George Kosar; to historian Frank Karpiel, who helped develop the timelines, the Cultural Parallels, and the Voices features of the book; to Mary Ellen Wilson for the pronunciation guides; as well as the more specialized pronunciations offered by David Atwill (Chinese and Japanese); Jonathan Reynolds (African); Nayla Muntasser (Greek and Latin); and Mark Watson (Native American); to John Sisson for tracking down the readings; to Laurel Corona for her extraordinary help with Africa; to Arnold Bradford for help with critical thinking questions; and to Francelle Carapetyan and her assistant Rebecca Harris for their remarkable photo research. The maps and some of the line art are the work of cartographer and artist, Peter Bull, with Precision Graphic drafting a large portion of the line art for the book. I find both in every way extraordinary.

In fact, I couldn't be more pleased with the look of the book, which is the work of Leslie Osher, associate director of design, Nancy Wells, senior art director, and Ximena Tamvakopoulos, designer. The artistic layout of the book was created by Gail Cocker-Bogusz and Wanda España. Gail Cocker-Bogusz coordinated the map and line art program with the help of Mirella Signoretto. The production of the book was coordinated by Barbara Kittle, director of operations; Lisa Iarkowski, associate director of team-based project management; Mary Rottino, senior managing editor; and by Harriet Tellem, project manager; who oversaw with good humor and patience the day-to-day, hour-to-hour crises that arose. Sherry Lewis, operations manager, ensured that this project progressed smoothly through its production route.

The marketing and editorial teams at Prentice Hall are beyond compare. On the marketing side, Brandy Dawson, director of marketing; Marissa Feliberty, executive marketing manager; and Irene Fraga, marketing assistant; helped us all to understand just what students want and need. On the editorial side, my thanks to Yolanda de Rooy, president of the Humanities and Social Science division; to Sarah Touborg, editor-in-chief; Amber Mackey, senior editor; Bud Therien, special projects manager; Alex Huggins, assistant editor; and Carla Worner, editorial assistant. The combined human hours that this group has put into this project are staggering. Deserving of special mention is my development team, Rochelle Diogenes, editor-in-chief of development; Roberta Meyer, senior development editor; Karen Dubno; and Elaine Silverstein. Roberta may be the best in the business, and I feel extremely fortunate to have worked with her.

Finally, I want to thank, with all my love, my beautiful wife, Sandy Brooke, who has supported this project in every way. She continued to teach, paint, and write, while urging me on, listening to my struggles, humoring me when I didn't deserve it, and being a far better wife than I was the husband. I was often oblivious, and might at any moment disappear into the massive pile of books beside my desk that she never made me pick up. To say the least, I promise to pick up.

BOOK TWO

Following the last three hundred years of the Roman Empire, from 200 to about 500 CE, the Middle Ages span a period of about a thousand years of European history, from the collapse of the Empire to the beginning of the fifteenth century. Its opening centuries, until about 800 CE, were once commonly referred to as the "Dark Ages." During this time, the great cultural achievements of the Greeks and Romans were forgotten, so-called barbarian tribes from the north overran the continent, and ignorance reigned. But this era was followed by an age of remarkable innovation and achievement, marked by the ascendancy of three great religions—Christianity, Buddhism, and newborn Islam. Because of the way these three religions dominated their respective cultures, the centuries covered in Book 2 might be best thought of as the Age of Faith.

This was the age of the monastery, the religious pilgrimage, the cathedral, the mosque, and the spread of Buddhism across Asia. By the sixth century, a new Christian mode of representation, reflecting a new ideal of beauty, had asserted itself in Byzantium, the eastern half of the Roman Empire. Unlike the Romans and Greeks, Byzantine artists showed little interest in depicting the visual appearance of the material

Detail of Simone Martini, *Maestà*, Council Chamber, Palazzo Pubblico, Siena. ca. 1311–1317, repaired 1321. Fresco, 25′ × 31′ 9″. (See Fig. 15.11.)
(right) Last Judgment tympanum, Sainte-Foy, Conques, ca. 1065. (See Fig. 13.7.)

Medieval Europe and the Shaping of World Cultures: 200 CE to 1400

world. They abandoned perspectival depth and rendered figures as highly stylized, almost geometric configurations. In other words, they depicted a spiritual rather than physical ideal.

In the first half of the seventh century, after the death of the prophet Muhammad, Islam began its rapid spread from Arabia across the Middle East to North Africa and into Spain. The role of image-making in Muslim art was hotly debated. Iconoclasts, or "image breakers," believed that making figurative images encouraged the worship of false idols, which was expressly forbidden by Islamic scripture. The practical solution to the problem was to decorate without figurative images and instead emphasize complex geometric and curvilinear patterns and beautiful writing. Islam was, after all, a religion of the book. Influenced by this Muslim position, a sect of Christian iconoclasts systematically destroyed religious imagery in Byzantium during the eighth century.

In northern Europe, Christianity had almost disappeared after the departure of the Romans in 406 CE. A few remote monasteries carried on Christian traditions, but in most areas non-Christian Germanic and Scandinavian feudal lords held sway. They demanded absolute loyalty from their followers, who, in turn, demanded the same from those below them, a hierarchical system that was a hallmark of the medieval period. In feudal society, personal valor and heroism, especially in the service of one's lord, were of supreme value.

Over the centuries, Christian and feudal traditions gradually merged. By the time Charlemagne was crowned emperor by Pope Leo III in the year 800, fidelity to one's chief could be understood as analogous to fidelity to one's God. By the late twelfth century, this brand of loyalty had found its way into the social habits of court life, where it took the form known as courtly love. In the love songs of the troubadour poets, the loyalty that a knight or nobleman had once conferred upon his lord was now transferred to a lady.

Charlemagne's passionate interest in education and the arts was broadcast across Europe through the development first of monastic schools and later of universities, which were themselves made possible by a resurgence of economic activity and trade. The Christian Crusades to recapture the Holy Land, principally Jerusalem, from Muslim control contributed to this economic revitalization, as did the practice of pilgrimage journeys to the Holy Land and to churches that housed sacred relics. The art of creating monumental stone sculpture was revived to decorate these churches, which grew ever larger to accommodate the throngs that visited them. The culmination of this trend was the Gothic cathedral, adorned with stained glass and rising to formerly unobtainable heights. The sacred music of the liturgy became more complex and ornate as well, reflecting the architecture of the buildings in which it was played. To appeal to the masses of worshipers, the sculpture and painting that decorated these churches became increasingly naturalistic. Similarly, poetry and prose were more frequently written in the vernacular—the everyday language of the people—and less often in Latin. In both literature and art, the depiction of universal types, or generalized characters, gave way to the depiction of real characters and actual personalities.

We can begin to account for this shift by recognizing that, by the late Middle Ages, the center of intellectual life had shifted from the monastery to the town. From the great metropolis of Hangzhou, China, that Marco Polo visited in 1271, to the cities of Teotihuacan and Palenque in Mesoamerica, urban life was the center of culture. In Asia and the Americas, these centers reflected the aspirations and power of the ruling nobility. But in Europe, towns like Florence and Siena flourished as a result of ever-enlarging trade networks. Now, suddenly, merchants and bankers began to assert themselves with as much or more power than either pope or king, ruling local governments and commissioning civic and religious works of architecture and art.

Timeline Book Two: 200 CE to 1400

	100 BCE–300 CE	300–600	600–900
HISTORY AND CULTURE	**250 BCE–900 CE:** Classic era of Mesoamerican civilization, with Zapotec, Teotihuacan, and Mayan civilizations flourishing **98 BCE–211 CE:** rule of Roman emperors: Trajan, Hadrian, Marcus Auerelius, Septimus Severus **66–70 CE:** Jewish revolt; Romans destroy Temple of Jerusalem **74 CE:** Jewish last stand against Romans at Masada **220 CE:** fall of Han dynasty, China	**306–337:** reign of Roman emperor Constantine, makes Byzantium (Constantinople) new imperial capital **402:** Ravenna becomes capital of Western Roman Empire **406:** Romans withdraw from Britain **410:** Visigoths sack Rome **455:** Vandals sack Rome **526:** Western Roman Empire collapses **500–600:** feudal system begins to develop in England **527–565:** reign of Justinian, Byzantine/Roman emperor *Constantine the Great*	**618–907:** Tang dynasty, China **632:** Caliphs begin rule over Islamic territories **632–710:** Islamic armies conquer Damascus, Persia, Jerusalem, Egypt, North Africa, and Spain **700–732:** Muslim expansion in Europe, attack on France **732:** Charles Martel defeats Muslims at Battle of Poitiers **750–900:** Muslim expansion in Africa, beginning of Abbasid caliphate, Islamic capital shifts to Baghdad **800:** Pope Leo III crowns Charlemagne emperor **794–1185:** Heian period, Japan **843:** Holy Roman Empire dissolved **867–1056:** Macedonian dynasty, initiated by Basil I, Byzantium
RELIGIONS AND PHILOSOPHY	**587 BCE–70 CE:** Jewish religion becomes increasingly messianic; Herod (r. 37–4 BCE) promotes religious toleration throughout Judea **4 BCE–30 CE:** lifetime of Jesus of Nazareth **35–100 CE:** beginnings of Christian religion **193–337 CE:** Romans adopt mystery cults from Egypt and Persia **260 CE:** Chinese monk Zhu Shixing travels to India to bring back Buddhist scriptures **284–305 CE:** reign of Roman emperor Diocletian persecutes Christians **300 CE:** 5 million Christians live in Roman Empire	**313:** Emperor Constantine, grants religious freedom to all **325:** Constantine convenes Council of Nicea, unifying Church behind Orthodox dogma **379–395:** reign of Theodosius, all pagan temples closed throughout empire, Christianity named official religion **496:** conversion of Clovis, founder of France's Merovingian dynasty **593–622:** reign of Prince Shotoku, Japan, sponsors Buddhism, builds temples	**ca. 570–632:** lifetime of Muhammad **599–602:** lifetime of Chinese monk Xuanzang, returns from India with Buddhist texts **Late 630s:** Anglo-Saxon ship burial at Sutton Hoo, England **610:** beginnings of Islamic religion **622:** Muhammad flees Mecca (the hijra) **700–843:** iconoclastic controversy—split between Roman Catholic and Eastern Orthodox churches
TECHNOLOGY AND SCIENCE			**618–907:** Tang dynasty builds Grand Canal on Yellow River; uses iron and steel casting to build large pagodas
ART AND ARCHITECTURE	**135 CE:** Romans rebuild Jerusalem **193–217 CE:** Roman emperor Septimus Severus and son Caracalla construct enormous bath complex in Rome **300 CE:** massive sculptures of Buddha carved at Bamiyan, Silk Road **ca. 600 CE:** first shrine complex of Ise, Japan built to house Amateratsu, Shinto Sun goddess	**313:** Mesoamerican city of Teotihuacan includes monumental pyramids, temples **306–337:** Constantine builds forums, baths, palaces in Constantinople; his son builds Hagia Sophia Basilica **320–350:** Saint Peter's Basilica in Rome **402–750:** church construction in Ravenna, elaborate mosaics **525–537:** Justinian and wife Theodora rebuild Constantinople, construct new Hagia Sophia	**612:** Monastery of St. Gall, Switzerland, founded, later a model for Charlemagne **Late 700s:** Charlemagne builds palace and religious complex at Aachen, designed by Odo of Metz *Palentine Chapel of Charlemagne, Interior (Aachen, Germany)*
LITERATURE AND MUSIC	**35 CE:** Saint Paul's epistles comprise 14 books Christian scriptures **ca. 80 CE:** Jewish historian Josephus writes *Jewish War* outlining Jewish history **70–90 CE:** gospels written by Matthew, Mark, and Luke	**339–397:** lifetime of Ambrose of Milan, writes hymns to accompany Catholic liturgy **342–420:** lifetime of Saint Jerome who translates Hebrew scriptures, Greek New Testament into Latin, producing first Bible of Catholic Church **354–430:** lifetime of Saint Augustine, author of *The City of God* **680–700:** *Kojiki*, chronicles ancient events in Japanese mythology	**610–632:** one of the first books written in Arabic, the *Qur'an*, central religious text of Islam compiled **700–1000:** epic English poem *Beowulf* compiled from Anglo-Saxon myths **701–762:** lifetime of Confucian poet Li Po **731:** Venerable Bede writes *History of the English Church and People* **735–804:** lifetime of Alcuin, leader of Charlemagne's court school **800–110:** epic poem *Song of Roland* depicts Christian hero's battle with Muslims

900–1100	1100–1400	
900–1000: Vikings invade, conquer, terrorize Europe **900–1521:** Post-classic era of Mesoamerican civilization; Toltec culture flourishes **900–1400:** Islamic culture develops in Persia and Spain **960–1279:** Song dynasty, China **987:** Hugh Capet founds Capetian dynasty, France **1000–1200:** ongoing competition between Byzantium and Venice **1000–1200:** Muslim invaders enter India **1100–1200:** growth of large African kingdoms—Ife, Benin, Zagwe, Swahili states, Zimbabwe Great Mosque of Córdoba, (Spain)	**1148:** first university founded, Bologna, Italy **ca. 1185–1392:** Kamakura period, Japan; weakened central government, civil war **1200–1300:** rivalry between Florence and Siena, Italy **1200:** University of Paris founded **1202–1204:** Fourth Crusade; looting of Christian cathedral of Hagia Sophia **1204:** Venice conquers and loots Constantinople **1215:** *Magna Carta*, England; limits the power of the king **1230–1255:** lifetime of Sunjata, founder of the Malian empire **1279:** Kublai Khan conquers China **1279–1368:** Yuan dynasty **1280s:** Papal transfer of banking privileges to Florence **1300–1537:** Inca culture, South America, flourishes **1312–1337:** Mansa Moussa leads Mali **1325–1519:** Aztec culture flourishes, Mesoamerica **1346–1400:** Black Death devastates Europe **1368–1644:** Ming dynasty, China	HISTORY AND CULTURE
910: Abbey of Cluny, Cluniac order founded in France **1095:** Pope Urban II initiates First Crusade against Muslims **1096:** thousands of European Jews murdered by Crusaders **1099:** Crusaders retake Jerusalem **1187:** Muslim Saladin conquers Jerusalem **1170:** Benin, Africa develops hereditary lineage of kings **1000–1200:** Swahili culture mixes Arabic and African customs, language	**1138–1204:** lifetime of Moses Maimonides, writes *Guide to the Perplexed* **ca. 1181–1226:** lifetime of Saint Francis of Assisi, founder of Franciscan order **1198–1216:** papacy of Pope Innocent III, author of *On the Misery of the Human Condition* **1216:** Dominican order founded to study theology	RELIGION AND PHILOSOPHY
960–1279: Song dynasty, Chinese lead world in iron production, invent movable type **1100:** Ife culture, Africa, develops brass sculptures Head of an Oni (King), Ife culture		TECHNOLOGY AND SCIENCE
1066–1080: Norman invasion, England depicted in *Bayeux Tapestry*, France **ca. 1150:** Cambodian temple complex Angkor Wat built **1120:** Abbey Church of Sainte-Foy, France, built as first pilgrimage church using Romanesque architecture **1120–1270:** Rock churches built in Ethiopia by Zagwe dynasty	**1100–1200:** beginnings of Gothic architecture, Île-de-France, Paris **1150:** first phase of Chartres Cathedral completed **1200–1300:** Gothic style cathedrals built across northern France **1200–1400:** Great Zimbabwe walled African city built **1296–1400:** New Florence cathedral (Duomo) built **1297–1310:** Florence and Siena city halls replicate medieval fortresses **1300–1450:** Incas use granite blocks to construct Cuzco, Machu Picchu **1308–1311:** Duccio paints *Virgin and Child in Majesty* **1338:** *Allegory of Good Government*, Ambrogio Lorenzetti **1338–1390:** Alhambra palace, Islamic fortress complex built in Granada, Spain	ART AND ARCHITECTURE
973–1014: lifetime of Mirasaki Shikabu, author of *Tale of Genji*, the world's first novel **1079–1144:** lifetime of Peter Abelard, author of *Sic et Non* **1086:** *Domesday Book* survey of England completed **1098–1179:** lifetime of Hildegard of Bingen, mystic and composer of hundreds of compositions **ca. 1150:** *Guide to Santiago de Compostela* illustrates town and monuments on pilgrimage routes	**1170:** Marie de France, composer of over 100 fables, writes *Lancelot* **1225–1274:** lifetime of Thomas Aquinas, author of *Summa Theologica* **1230–1546:** epic poem *Sunjata* passed down through generations of griots **1304–1374:** lifetime of Francesco Petrarca (Petrarch), author of *Canzoniere* (1349) **1313–1375:** Boccaccio's lifetime, author of *Decameron* **1332–1406:** lifetime of Islamic historian Ibn Khaldun, writes a universal history **1342–1400:** lifetime of Geoffrey Chaucer, writes *The Canterbury Tales* **1348:** *Book of the Hours* by Jean Le Noir focuses on death **1364–1430:** lifetime of Christine de Pizan, author of *Book of the City of Ladies*; *Tale of Joan of Arc* **1375:** *Catalan Atlas* depicts Mali King Mansa Moussa crowned in gold	LITERATURE AND MUSIC

9 The Late Roman Empire, Judaism, and the Rise of Christianity

Power and Faith

> *The two cities were created by two kinds of love: the earthly city by a love of self even to the point of contempt for God, the heavenly city by a love of God carried even to the point of contempt for self.*
>
> Augustine, *The City of God*

◄ **Fig. 9.1 Colonnaded street in Thamugadi, North Africa. View toward the Arch of Trajan. Late 2nd century CE.**
Thamugadi was established in about 100 CE as a colony for retired soldiers of the Roman Third Legion. It represents the deep imprint Rome left upon its entire empire. By the 4th century CE, Thamugadi had become the center of North African Christian dissent from Roman authority. It represents, then, the crisis that Christianity, in its emphasis on the rule of faith, represented to the Roman rule of law.

277

T HAMUGADI, MODERN TIMGAD, ALGERIA, IS ONE OF THE FEW

totally excavated towns in the Roman Empire, and its ruins tell us as much or

more about Roman civilization as Pompeii. It was founded during the reign of

Trajan in about 100 CE as a colony for retired soldiers of the Roman legions who had

served the Empire as it constantly expanded its borders in Africa. Whereas Rome had grown haphazardly over hundreds of years and many rulers, Thamugadi [tham-uh-GAY-dee] was an entirely new city and a model, if not of Rome itself, then of the Roman sense of order. It was based on the rigid grid of a Roman military camp and was divided into four quarters defined by east–west and north–south arteries, broad avenues lined with columns (Fig. **9.1**), with a forum at their crossing. The town had 111 *insulae* blocks, and all the amenities of Roman life were available: 14 public baths, a library, a theater, and several markets, including one that sold only clothes (Fig. **9.2**).

Thamugadi is the product of the conscious Roman decision to "Romanize" the world. Julius Caesar's conquest of the Celtic tribes of Gaul, Titus's defeat of the Jews in Jerusalem, and Trajan's victory over the Dacians [DAY-shunz], immortalized on his column in Rome, were not just military campaigns. They were examples of Romanization itself. The Roman military campaigns led to the building of cities, amphitheaters, temples, arches, roads, fortresses, aqueducts, bridges, and monuments of every description, all across the Empire, all modeled on the profusion of public monuments that dominated Rome by the fourth century CE (Map **9.1**). Local aristocrats took up Roman customs. Roman law governed the state. Rome remained the center of culture all others at the periphery imitated. Nevertheless, within Roman culture profound changes began to arise that would challenge Roman authority, producing significant and enduring consequences that continue to shape the modern world.

This chapter examines the conflict between imperial Rome and the beliefs and moral forces associated with Christianity, as the religion gradually came to be known in the first four centuries CE. At first understood as one of many competing sects of Judaism, then as one of the religious cults that captured the imaginations of citizens throughout the Empire, Christianity defined itself as a universalist faith: It accepted any believer, male or female, of any nationality or race. Its universalist nature was especially evident in the second and third centuries CE, when women served as priests, spreading the Christian message throughout the Empire. This universalist tendency would change as the religion became increasingly codified. The artistic practices associated with the religion changed as well, so that while Hellenistic forms of representation continued to be evident in its sculpture and art, naturalism gradually faded away. An emphasis on the visible world gave way to a more symbolic art designed to reflect the spiritual life of Christian believers.

As the religion gained popularity, it inevitably came into conflict with Rome: both Rome and the Church demanded the absolute allegiance and loyalty of the citizen/believer. Until the Emperor Constantine granted religious freedom to all Romans in 313 CE, the power of the state was at odds with the power of Christian faith. Finally, as pagan tribes from the north successfully invaded the empire and the power of the state waned, Christian philosophers would argue that Rome's fall was a direct consequence of its dedication to material, rather than spiritual, well-being. The City of God, Augustine argued, could offer the believer much more than the city of Rome.

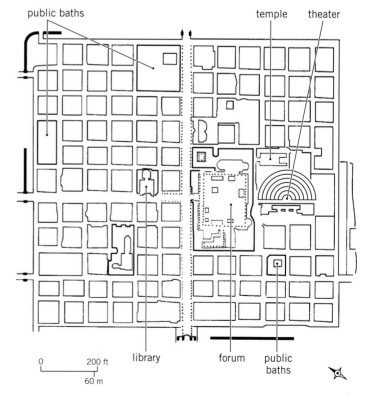

Fig. 9.2 City plan of Thamugadi. ca. 200 CE. The layout of Thamugadi is a symbol of Roman reason and planning—efficient and highly organized.

278

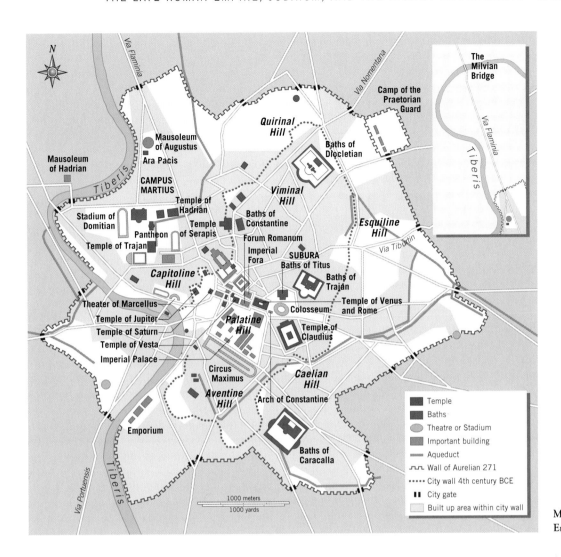

Map 9.1 Rome in the late Empire, with all its monuments.

The Late Roman Empire: Moral Decline

Most of the late emperors were themselves "Romanized" provincials. Both Trajan and Hadrian were born on the Iberian peninsula, near present-day Seville, and during his reign Hadrian had the city redesigned with colonnaded streets and an amphitheater. Septimius Severus [sep-TIM-ee-us suh-VIR-us] (r. 193–211 CE) was African, and two of his successors were Syrian. Septimius Severus lavished an elaborate public works project on his hometown of Leptis Magna, on the coast just east of Tripoli in present-day Libya, giving the city a new harbor, a colonnaded forum, and an aisled **basilica**, the Roman meeting hall that would develop into the earliest architectural form of the Christian church.

In the third century CE, during the Severan [suh-VIR-un] Dynasty (193–235 CE), Rome's every amenity was imitated at its outposts, especially its baths. Septimius Severus began construction of enormous baths, dedicated in 217 by his son and successor, Caracalla [kar-uh-KAL-uh] (Fig. **9.3**). The baths

were set within a 50-acre walled park on the south side of the city and were fed by an aqueduct dedicated exclusively to this purpose. Although no ceilings survive, the vaulted central hall appears to have been 140 feet high. There were three bathing halls with a combined capacity of 1,600 bathers: the *frigidarium* [free-gee-DAR-ee-um] (cold bath), the *tepidarium* [te-pee-DAR-ee-um] (lukewarm bath), and the *caldarium* [cal-DAR-ee-um] (hot bath). There were two *gymnasia* (exercise rooms) on either side of the pools, as well a barbershop and a hair salon, sauna-like moist- and dry-heat chambers, and outdoor areas for sunbathing or exercising in the nude. Other amenities of the baths included libraries, a painting gallery, auditoriums, and, possibly, a stadium. Early in the fourth century, the emperor Diocletian [dy-uh-KLEE-shun] would build even more enormous and sumptuous baths at the northern end of the city. Although dedicated to public health and hygiene, the baths came to signal a general decline in the values that had defined Rome. Writing as early as the mid-first century CE, in his *Moral Letters*, Seneca complained that no one in his day could bathe in the simple ways of the great

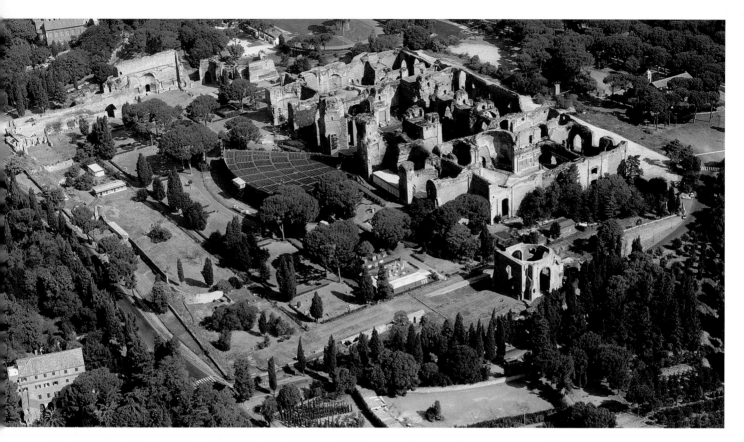

Fig. 9.3 Baths of Caracalla, Rome. 211–217 CE. Rome's baths and public waterworks required enormous amounts of water. The city's 14 aqueducts brought 220 million gallons of pure spring water per day from the Apennines, the mountain chain that extends the length of the Italian peninsula. This water supplied 11 public baths, 856 private smaller baths, and 1,352 fountains and cisterns.

Republican general Scipio Africanus [SIP-ee-oh af-ruh-CAN-us], who had defeated Hannibal in 202 BCE (**Reading 9.1**):

READING 9.1 **Seneca, *Moral Epistles*, Epistle 86**

Who today could bear to bathe in such a fashion? We think ourselves poor and mean if our walls are not resplendent with large and costly mirrors; if our marbles from Alexandria are not set off by mosaics of Numidian [noo-MID-ee-un] stone, if their borders are not faced over on all sides with difficult patterns, arranged in many colors like paintings; if our vaulted ceilings are not buried in glass; if our swimming pools are not lined with Thasian [THAY-zhun] marble, once a rare and wonderful sight in any temple. . . . What a vast number of statues, of columns that support nothing, but are built for decoration, merely in order to spend money! And what masses of water that fall crashing from level to level! We have become so luxurious that we will have nothing but precious stones to walk upon.

To many citizens at the time, such material excess signaled an atmosphere of moral depravity, inevitably associated with the public nudity practiced at the baths. A surviving floor mosaic from Thamugadi, for instance, represents a black bath attendant carrying a fire shovel (to heat the baths) in one hand and gripping an enormous phallus, from which he either ejaculates or urinates, with the other. The image invokes a culture comfortable in its exploitation—racial, sexual, and political—of others, a sense of cultural superiority that deeply informs Rome's relations with the developing Christian faithful in the Empire. Not far from Thamugadi, in Carthage, the Christian writer Tertullian [tur-TUL-yun] (ca. 160–ca. 240 CE) had argued against the worldly pleasures of secular culture, as early as 197 CE, going so far as to propose the "rule of faith" over the rule of Roman law. By the early fourth century CE, Christians across the Empire forbade visitation to the baths, arguing that bathing might be practiced for cleanliness but not for pleasure. Thus would the Empire find itself defined in moral opposition to a growing religious community throughout its territories. With its moral authority challenged, its political power would inevitably be threatened as well.

The Development of Judaism

From the Babylonian Captivity of 587–520 BCE to the rise, beginning around 70 CE, of rabbinic Judaism (the Judaism of the rabbis, the scholars and teachers of the Jewish faith), the Jewish religion became increasingly **messianic**—that is, it prophesied that the world would end in **apocalypse**, the coming of God on the day of judgment, and that the post-apocalyptic world would be led by a **Messiah**, or Anointed One, in ever-lasting peace. These feelings were fueled in 168 BCE, when the Seleucid [suh-LOO-sid] king Antiochus [an-TY-uh-kus] IV tried to impose worship of the Greek gods on the Jews, placing a statue of Zeus in the Second Temple of Jerusalem and allowing pigs to be sacrificed there. The Jews were outraged. From their point of view, the Greek conquerors had not merely transformed the sacred temple into a pagan shrine, but had replaced the Ark with a "graven image." The slaughter of pigs rendered the Temple impure. Still worse, Antiochus made observance of the Hebrew law punishable by death. Led by Judas Maccabeus [JOO-dus mak-uh-BEE-us], a priest of the Maccabean family, the Jews revolted, defeating Antiochus, purifying the temple, and reestablishing Jewish control of the region for the period 142–63 BCE. In 63 BCE the Romans, led by their great general Pompey, conquered Judea (modern Israel).

Sectarianism and Revolt

It was a deeply unsettled time and place. In the early first century CE, large numbers of people claiming to be the Messiah and larger numbers of apocalyptic preachers roamed Judea. This situation was complicated by the growing sectarianism of Judaism itself. Much of what we know about this time comes from the writings of Josephus [joe-SEE-fus], a Jewish historian (ca. 37–ca. 100 CE). Josephus's *Jewish War*, completed in the early 80s CE, outlines Jewish history from the rise of the Maccabees to the destruction of the temple in 70 CE and the fall of Masada [muh-SAHD-uh] in 74 CE. "There are three philosophical sects among the Jews," Josephus writes, "The followers of the first of which are the Pharisees [FAIR-uh-sees], a scribal group associated with the masses; of the second, the Sadducees [SAD-juh-seez] priests and high priests associated with the aristocracy; and the third sect, which pretends to a severer discipline, are called Essenes [ESS-eenz]." (For Josephus's extended description of these sects, see **Reading 9.2**, pages 304–305.)

A **sect** is a small, organized group that separates itself from the larger religious movement because it asserts that it alone understands God's will and therefore it alone embodies the ideals of the religion. As a result, a sect generally creates strongly enforced social boundaries between its members and all others. Finally, members of a sect view themselves as good and all others as evil. Of the three sects Josephus described, the Essenes were the most conservative, going so far as to ban women from their community so that they might live in celibacy and purity. The Essenes are generally identified with

CULTURAL PARALLELS

New Religions in Rome and China

After the first century CE, as more Romans converted to Christianity, China's citizens also departed from their traditional spiritual path toward an imported religion. Instead of Confucianism, which was based on social and civic duty, the Chinese began to adopt Buddhist beliefs that focused on liberating the individual's soul.

the group of Jews who lived at Qumran [kum-RAHN], on the Dead Sea southeast of Jerusalem, where in 1947 a Bedouin [BED-uh-wun] shepherd discovered the oldest extant version of the Hebrew Scriptures, dating from around the time of Jesus—the so-called Dead Sea Scrolls. These documents are the richest source of our knowledge of Jewish sectarianism, for they include the Hebrew Scriptures—the *Torah* [TOH-ruh] (the five books of Moses), *Nevi'im* [neh-fee-EEM] (the Prophets), and *Ketubim* [kuh-tuh-BEEM] (the Writings), what Christians call the "Old Testament"—as well as other works originating in sectarian circles within and outside the Qumran community.

The Jews of Qumran abandoned their coreligionists to seek salvation on their own. Unlike the Pharisees and Sadducees, they never engaged in the Jewish political struggle with the Romans or with the other sects. The Pharisees and Sadducees argued, sometimes violently, over questions of philosophy, the temple, and purity. Philosophically, the Sadducees denied the resurrection of the dead, while the Pharisees affirmed it.

The purity laws were a point of special contention with far-reaching implications for the temple. According to Leviticus [luh-VIT-ih-kus] and Numbers (two books of the Hebrew Bible), the house of God (the temple) must be pure, and that which is impure must be expelled. In practice, the laws of purity prevented normal social relations between those who observed them and those who did not, to the point that even routine physical contact (a handshake, for instance) with a non-observer was forbidden. Since all the sects developed their own purity laws, they were in essence forbidding contact with one another. The Qumran Essenes withdrew completely from Jewish society. Furthermore, the sectarian communities, especially the Pharisees, considered the Jerusalem Temple, the traditional center of Jewish worship, to be polluted, its priests—particularly the Sadducees, corrupt, and its rituals debased. The Pharisees, and perhaps the Sadducees as well, considered the house of God to be the larger state of Judea rather than just the temple in Jerusalem, and they felt compelled to expel the "impure" Romans from their midst.

The Romans had been careful not to make the same mistake as Antiochus IV. They installed a client king, Herod

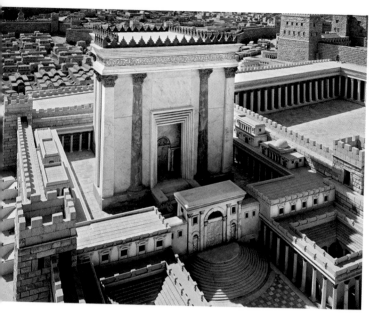

Fig. 9.4 Model of the Second Temple of Jerusalem, ca. 20 BCE. Only the Western Wall of Herod's temple survives today, and for Jews it remains the most sacred site in Jerusalem. It functions as an open-air synagogue where daily prayers are recited and other Jewish rituals are performed. On Tisha B'Av, the ninth day of the month of Av, which occurs either in July or August, a fast is held commemorating the destruction of the successive temples on this site, and people sit on the ground before the wall reciting the Book of Lamentations. As a result of the sense of loss associated with the site and the lamentations it provokes, for centuries it has been known as the Wailing Wall.

(the Great), who claimed to be Jewish but was not according to Jewish law. Herod tried to reconcile Jews and Romans, primarily through religious tolerance and a massive building program. During his reign (37–4 BCE), he rebuilt the city of Jerusalem, constructing a large palace and enlarging the Second Temple (Fig. 9.4). We can see the Hellenistic influence in its tall, engaged Corinthian columns and its decorative frieze, and its Roman roots in its triple-arched gateway. Herod also engaged in other massive building programs, including a port at Caesarea and a mountain fortress above the Dead Sea at Masada. Though Herod's three sons ruled briefly after their father's death, Rome became less and less tolerant of the Jewish faith—the laws of Rome often coming into conflict with the Law of the Book—and direct Roman rule was soon imposed.

Finally, in 66 CE, the Jews revolted. In 68 CE, the Romans destroyed Qumran. In 70 CE, they sacked the temple in Jerusalem, as depicted on the Arch of Titus in Rome (see Fig. 8.21). At Masada, a band of zealots held out until 73 CE. The Roman general Flavius Silva surrounded the mountain with a wall and eight encampments, then built a huge earthen ramp up the mountainside. Rather than submit to the Romans, the Jews inside the fortress committed mass suicide, each man responsible for killing his own family and then himself. The Romans renamed the land Palestine, "land of the Philistines" [FIL-ih-steenz], instead of Judea, "land of the Jews." Finally, in 135 CE, after yet another Jewish revolt, the Emperor Hadrian rebuilt Jerusalem as a Roman city, which Jews were forbidden to enter. Hundreds of thousands of Jews were killed or sold into slavery, their land and property was confiscated, and the survivors fled throughout the Mediterranean and Middle East. The diaspora that had begun with the Assyrian invasion of Israel in 722 BCE was now complete. Not until 1948, when the state of Israel was established by the United Nations, would Jews control their homeland again.

The Rabbis and the Mishnah

With the destruction of the temple in 70 CE and the subsequent diaspora, the center and focal point of Jewish faith evaporated. From then on, Judaism developed as a religion in a manner anticipated by the sectarianism of the second temple period. The sects, after all, had viewed the temple and temple rituals with deep skepticism and had practiced their religion outside the temple, in localized **synagogues**, or "houses of assembly," engaging in daily prayer, studying Torah, and observing the laws of purity more or less independently of priests. Yet despite growing sectarianism, a community of scholars known as Sanhedrin, who had met for centuries to discuss and interpret the Torah, continued to provide a strong intellectual center for the Jews. In the town of Yavneh, where the group had moved after the destruction of the temple, ongoing study of the Torah and other traditional teachings known as the Oral Torah had been sufficient to maintain continuity about what it meant to live and think properly as Jews. After the diaspora of the second century CE, however, it seemed likely that the Jews would be living for generations in many different places under widely varying circumstances, and without an institution such as the Sanhedrin, maintaining a strong, collective Jewish identity was unlikely.

The solution to this problem came from the rabbis, to whom, in the second to the sixth centuries CE, Jewish communities throughout the Mediterranean world turned for guidance and instruction. The rabbis, who were scholars functioning as both teachers and scribes, realized the importance of writing down the Oral Torah, a massive body of explanations and interpretations of the covenant, as well as traditional stories told to each new generation. In the early years of the third century CE, under the leadership of Rabbi Judah haNasi (ca. 165–220 CE), the Oral Torah was recorded in a work called the Mishnah [MISH-nuh].

Almost immediately, the work was viewed as inadequate. The Oral Torah was part of a dynamic intellectual tradition of applying what was perceived as the perfect and unchanging word of God to the circumstances and demands of the changing times. The Mishnah seemed too permanent, too dry, too incomplete. To capture some of the stimulating discussion characteristic of the Sanhedrin, as well as its traditional respect

for well-reasoned but differing points of view, a commentary known as the Gemara began to surround the text of each passage of the Mishnah. The Gemara was a record of what had been debated, preserving disagreements as well as consensus. Commentaries on the commentaries continued to be added by successive generations of rabbis, and the Gemara did not take its final shape until around 700 CE. The combined Mishnah and Gemara came to be known as the Talmud.

Judaism and the Rise of Christianity

The development of Christianity, the religion that would have such a profound effect upon the history of the Western world, can only be understood in the context of Jewish history. It developed as one among many other minor sects of Judaism, at first so inconsequential that Josephus does not even mention it. Later theological writings, as opposed to actual historical accounts written at the time, tell us that in Judea's sectarian climate, Jesus of Nazareth was born to Mary and Joseph of Judea in about 4 BCE. At about the age of 30, Jesus began to lead the life of an itinerant rabbi. He preached repentance, compassion for the poor and meek, love of God and neighbor, and the immanence of the apocalypse, which he called the coming of the kingdom of God.

Although his teachings were steeped in the wisdom of the Jewish tradition, they antagonized both Jewish and Roman leaders. Jesus, in the spirit of reform, had challenged the commercialization of the Jewish Temple in Jerusalem, especially the practice of money-changing within its sacred precincts, alienating the Sadducee sect that managed it. After his followers identified him as the Messiah, or Savior—he did not make the claim for himself—both conservative Jewish leaders and Roman rulers were threatened. The proclamation by his followers that he was the son of God amounted to a crime against the Roman state, since the emperor was considered to be the only divine human on earth. In fact, since Jews were monotheistic and refused to worship other gods, including the emperor, their beliefs were a political threat to the Romans. The Christian sect's belief in the divinity of Jesus posed a special problem.

An enemy of the state, denounced by the other Jews that he had antagonized, betrayed by his disciple Judas (a betrayal now called into question with the publication of the Gospel of Judas), Jesus was crucified in about 30 CE, a degrading fate reserved for criminals and non-Roman citizens. Christian tradition has it—we possess no actual historical account—that the crucifixion occurred outside the city walls on a hillside known as Golgotha, now the site of the Church of the Holy Sepulchre (Fig. 9.5), and that Jesus was buried in a rock tomb just behind the site. Three days later, his followers reported that he rose from the dead and reappeared among them. The promise of resurrection, already a fundamental tenet of the Pharisee and Essene sects, became the foundation of Christian faith.

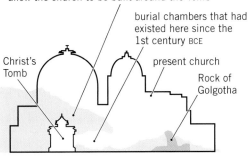

Fig. 9.5 Cutaway drawing of the Church of the Holy Sepulchre, Jerusalem, showing site of Christ's Tomb. This site was originally a small rocky hill, Golgotha, upon which Jesus was crucified, and an unused stone quarry in which tombs had been cut. The first basilica on the site was built by the Emperor Constantine between 326 and 335 CE.

The Evangelists

Upon his death, Jesus's reputation grew as his **evangelists** spread the word of his life and resurrection (the word "evangelist" comes from the Greek *evangelos* [eh-van-GEH-los], meaning "bearer of good"—and note the root *angel* in the word as well). Preeminent among these was Paul, who had persecuted Jews in Judea before converting to the new faith in Damascus (in modern Syria) in 35 CE. Paul's epistles, or letters, are the earliest writings of the new Christian faith. In letters written to churches he founded or visited in Asia Minor, Greece, Macedonia, and Rome, which comprise 14 books of the Christian Scriptures, he argues the nature of religious truth and interprets the life of Christ—his preferred name for Jesus, one that he coined. "Christ" means, literally, "the Anointed One." It refers to the Jewish tradition of anointing priests, kings, and prophets with oil, and the fact that by Jesus's time Jews had come to expect a savior who embodied all the qualities of priest, king, and prophet. In true sectarian tradition, for Paul the only correct expression of Judaism included faith in Christ. Paul conflated Jewish tradition, then, with his belief that Jesus's crucifixion was the act of his salvation of humankind. He argued that Christ was blameless and suffered on the cross to pay for the sins of humanity. Resurrection, he believed, was at the heart of the Christian faith, but redemption was by no means automatic—sinners had to show their faith in Christ and his salvation. Faith, he argues in his Epistle to the Church in Rome, ensures salvation (**Reading 9.3**):

READING 9.3 **from the Bible, Romans 5:1–11**

[1]Therefore, since we are justified by faith, we have peace with God through our Lord Jesus Christ, [2]through whom we have obtained access to this grace

in which we stand; and we boast in our hope of shar-
ing the glory of God. [3]And not only that, but we also
boast in our sufferings, knowing that suffering pro-
duces endurance, [4]and endurance produces character,
and character produces hope, [5]and hope does not dis-
appoint us, because God's love has been poured into
our hearts through the Holy Spirit that has been
given to us.

[6]For while we were still weak, at the right time
Christ died for the ungodly. . . [8]But God proves his love
for us in that while we still were sinners Christ died for
us. [9]Much more surely then, now that we have been
justified by his blood, will we be saved through him
from the wrath of God. [10]For if while we were enemies,
we were reconciled to God through the death of his
Son, much more surely, having been reconciled, will
we be saved by his life. [11]But more than that, we even
boast in God through our Lord Jesus Christ, through
whom we have now received reconciliation.

Fifteen centuries after Paul wrote these words, the Church
would find itself divided between those who believed that sal-
vation was determined by faith alone, as Paul argues, and those
who believed in the necessity of good works to gain entry to
Heaven, a tradition that survives in the Epistle of James—
"What use is it, my brethren, if a man says he has faith, but he
has no works?" (2:14). Other aspects of Paul's writings would
also have lasting significance, particularly his emphasis, like
that of the Essene sect, on sexual chastity. Although it was bet-
ter to marry than engage in sexual activity out of marriage, it
was better still to live chastely. In later years, the celibate lives
of priests, monks, and nuns, as well as the Church's teaching
that sexuality was sinful except for the purposes of procreation,
were directly inspired by Paul's position.

Not long after Paul's death, as the religion spread rapidly
through Asia Minor and Greece, other evangelists began to
write gospels, or "good news," specifically narrating the story
of Jesus's life. What would become the first three books of the
Christian New Testament, the gospels of Matthew, Mark, and
Luke, are believed by scholars to have been written between
70 and 90 CE. Each emphasizes slightly different aspects of
Jesus's life, though all focus particularly on his last days. It is
important to recognize that many early Christian documents
do not describe a virgin birth or a resurrection, a difference
from Paul that reflects sectarian differences already present in
the Jewish community. Evidence suggests that both the vir-
gin birth and the resurrection were Matthew and Luke's addi-
tions to Mark's gospel. Luke also wrote the Acts of the
Apostles, narrating the activities of Jesus's apostles, literally
"those who have been sent" by God as his witness, immedi-
ately after the resurrection. The apostles were originally those
who had seen or lived with Jesus, and the book contains
descriptions of miraculous events, signs from God that vali-
date the apostles' teachings.

The Gnostic Gospels Many New Testament scholars say that
the actions and sayings attributed to Jesus in the Gospels cannot
be factually traced to him, and that since they were written
many decades after his death, they are composites of hearsay, leg-
ends, and theological interpolations, reflecting the hopes and
beliefs of the early Christian community. There are, further-
more, other versions of Jesus's life than those contained in the
Bible, especially among the 52 texts dating from the fourth cen-
tury buried in a jar discovered by an Arab peasant in 1945 in Naj
Hammadi [nazh ham-MAH-dee], Upper Egypt. These texts are
Gnostic [NOS-tik] (from the Greek *gnosis*, "knowledge" in the
sense of "insight"), written by Christians who claimed special,
even secret, knowledge of Jesus's life.

The Gospel of Thomas claims that Jesus had a twin. Other
relationships are suggested in these books as well; among the
most controversial was the implication in the Gospel of
Philip that Christ had a sexual relationship with Mary Mag-
dalene [MAG-duh-lun]. At other points in the Gnostic texts,
common Christian beliefs, such as the virgin birth and the
bodily resurrection, are criticized as naïve misunderstandings.
In the late 1970s, another batch of Gnostic gospels was dis-
covered near El Minya in Egypt. These contained the Gospel
of Judas, in which, unlike the accounts in the canonical
Gospels of Matthew, Mark, Luke, and John where Judas is
portrayed as a reviled traitor, Judas is described as acting at
Jesus's request in handing him over to the authorities.

As the Church developed, it banned the Gnostic books
(and other texts like them) as **heresy**, opinion or doctrine at
odds with what would become normative belief. Although
extremely diverse in their beliefs, with opinions at least as
various as the Jewish sects, Gnostics tended to believe that a
transcendent and impersonal God rules the heavens, while
Christianity, as it developed, came to believe that God
resided in Jesus, in the human realm. John's insistence that
"Jesus Christ has come in the flesh is of God" (1 John 4:2)
suggests that his gospel is aimed directly at refuting Gnostic
gospels. Gnostics believed that the material world in which
humankind finds itself is evil and ruled by darkness, while the
heavenly world is good and ruled by light.

In contrast, Christianity as it developed would come to
argue that humankind is inherently good, and although fallen
in sin, is capable of repentance. Normative Christians would
argue that salvation is acquired through faith, not knowledge,
but Gnostics would cite the example of Jesus himself, who, they
believed, was sent to earth to open humanity's eyes, offering
them enlightenment or *gnosis* [NO-sis]. Finally, the Gnostics
believed that only those with great intellectual strength might,
through the acquisition of *gnosis*, regain the spiritual condition
lost in the material world. The normative Christian position
was that salvation was available to all believers.

It seems possible, perhaps even likely, that the Gnostics
were influenced by Indian philosophy. Gnostic doctrine is
decidedly Eastern in spirit (see chapter 4). Alexander the
Great had introduced the teachings of the Brahmins [BRAH-
mins] and the Christian bishop Hippolytus [hih-POL-ih-tus],

writing in approximately 225 CE in Rome, directly attributed Gnostic belief to Indian thought:

> There is . . . among the Indians a heresy of those who philosophize among the Brahmins, who live a self-sufficient life, abstaining from (eating) living creatures and all cooked food. . . . They say that God is light, not like the light one sees, nor like the sun nor fire, but to them God is discourse, not that which finds expression in articulate sounds, but that of knowledge (*gnosis*) through which the secret mysteries of nature are perceived by the wise.

Brahmins and Gnostics share one important trait—their common belief that spiritual ascendancy is acquired through knowledge, not mere faith. Gnosticism was eventually rejected as sectarian and nonauthoritative as the Church developed.

The Gospels of Matthew, Mark, and Luke Particularly important to the normative view of Jesus's life is the recording in the Gospel of Matthew of the so-called Sermon on the Mount (see **Reading 9.4**, pages 305–307). The Gospel was probably written in the last decades of the first century CE. So many of the principles of Jesus's message are included in this sermon that some scholars believe it is more an anthology of many sermons than a single address. In fact, it incorporates many traditional Jewish teachings, and Jesus's primary source is his Judaism. The sermon contains Jesus's most famous sayings, and his most famous metaphors. It includes the famous Lord's Prayer—itself a kind of collage of passages from the Hebrew Scriptures—and it differentiates, particularly, between accepted wisdom ("You have heard that it was said, 'You shall love your neighbor and hate your enemy . . .'") and the compassionate wisdom of the new faith ("But I say to you, Love your enemies and pray for those who persecute you, so that you may be children of your Father in heaven"). It is, furthermore, a masterpiece of rhetorical persuasion.

Consider the famous "lilies of the field" section (6:25–34). Jesus employs the natural metaphor of lilies clothing the landscape more richly than even Solomon in all his glory to convince his listeners that God will provide for them, thus creating an analogy between what they cannot know for sure and what they can see for themselves with certainty. This is one of 36 times in his gospel that Matthew refers to the "kingdom of God," which, it is important to understand, is not "heaven" but a spiritual kingdom on earth that people willingly enter through belief, spiritual rebirth, and carrying out the will of God. Thus, Matthew argues that God's promise is available to all through the agency of faith.

The gospels of Matthew, Mark, and Luke are known as the **synoptic gospels** [sih-NOP-tik]—literally, "seeing together." That is, they tell the same stories, in the same sequence, often using the same words, although they differ in their details. Sometime between 90 and 100 CE, the apostle John gave a different picture of Jesus. John's gospel omits materials found in the first three books, including the temptation of Jesus and the story of the Last Supper, and provides new material, including Jesus's early ministry in Galilee, his several visits to Jerusalem prior to the final one (the only one mentioned in the first three books), and the raising of Lazarus [LAZ-uh-rus].

One of its most notable features is its prologue, which consciously echoes the opening motif of the Hebrew Scriptures in Genesis: "In the beginning," John begins, "was the Word, and the Word was with God, and the Word was God" (John 1:1). Where Genesis 1 focuses on God's creation, John 1 focuses on the Word of God (*logos* in Greek) and its significance in the already created world. The term *logos* was widely used by the Greek Stoics, who in turn had adopted it from the sixth century BCE writings of Heraclitus. They believed that the universe is pervaded by *logos*, or ultimate rationality, which permeates and directs all things. Thus, John begins his gospel by appealing directly to a Greek audience in terms that would be familiar to them.

Women in the Early Christian Church

In the early Christian Church, women were considered inferior to men, as they were throughout the patriarchal Roman west, although they were at first allowed to participate on at least some equal footing. In his first letter to the Corinthians in the New Testament, Paul makes the subjugation of women clear in a discussion of whether men and women should cover their heads in church (**Reading 9.5**):

READING 9.5 **from the Bible, Corinthians I: 11:3–15**

3 But I want you to understand that Christ is the head of every man, and the husband is the head of his wife, and God is the head of Christ. 4 Any man who prays or prophesies with something on his head disgraces his head, 5 but any woman who prays or prophesies with her head unveiled disgraces her head. . . . 7 For a man ought not to have his head veiled, since he is the image and reflection of God; but woman is the reflection of man. 9 Neither was man created for the sake of woman, but woman for the sake of man. . . . 14 Does not nature itself teach you that if a man wears long hair, it is degrading to him, 15 but if a woman has long hair, it is her glory? For her hair is given to her for a covering.

What is interesting here is that even as Paul insists on woman's subservience to man, he admits that she can pray and, especially, prophesy. Paul often speaks of women in his letters as fellow evangelists, and many interpreters of the New Testament believe that his injunctions against women's participation were added by later authors as part of a trend to remove women from positions of authority within the Church. As the Church developed in the first four centuries

CE, women's role was diminished as a male hierarchy of clergy asserted its authority, based in part on the Pauline letters. The same Tertullian who in Carthage had argued against the worldly pleasures of secular culture, condemned women working in the Church as "heretical": "They teach, they baptize, they preach, they do all kinds of things they shouldn't do. It's horrible, in short." Mary Magdalene herself would be transformed in Western Church tradition from a disciple to a repentant prostitute, no doubt a strategy designed to undermine both her influence and the more general appeal of women for roles of leadership in the Church. At any rate, by late in the first century CE, pressures to minimize women's roles likely came from the predominantly patriarchal structure of both Roman and conservative Jewish society, or from men's historical proclivity to dominate. There is strong evidence, however, that especially in the eastern Mediterranean, women continued to serve as deacons (the secular clerical order just below that of priest) well into the ninth century CE. After that, and as much as six centuries earlier in the Roman west, women were prohibited from holding any position of authority in the Church.

Symbols and Iconography in Christian Thinking and Art

The new Christian faith did not immediately abandon its traditions as a Jewish sect. Jesus, for instance, never thought of himself as anything other than a Jew. All of his associates and disciples were Jews. He regularly worshiped in Jewish communal worship and he preached from the Torah, the authority of which he never denied. The major distinction was that Christian Jews believed in Jesus's resurrection and status as Messiah, while non-Christian Jews did not. Christian Jews regarded the failure of the larger Jewish community to recognize the importance of Jesus as reason to separate themselves from that community to pursue what they believed to be the true will of God. Not until sometime in the early second century CE did Christianity cease to be a Jewish sect. By then, Christians had abandoned Jewish rituals, including circumcision, but even as it slowly distinguished itself from its Jewish roots, Christianity had to come to terms with those roots. In doing so, it found a distinctive way to accept the Hebrew Scriptures.

Christians believed the stories in the Hebrew Scriptures prefigured the life of Jesus. For example, Adam and Eve's fall from grace in the Garden of Eden—the original sin that was believed to doom all of humanity—was seen as anticipating the necessity of God's sacrifice of his son, Jesus, to atone for the sins of humankind. As Paul put it in his Epistle to the Church in Rome (Romans 5:12–14):

> 12 Therefore, just as sin came into the world through one man, and death came through sin, and so death spread to all because all have sinned—13 sin was indeed in the world before the law, but sin is not reckoned when there is no law. 14 Yet death exercised dominion from Adam to Moses, even over those whose sins were not like the transgression of Adam, who is a type of the one who was to come . . .

Similarly, Christians interpreted Abraham's willingness to sacrifice his son, Isaac, as prefiguring God's sacrifice of his son. This view of history is called **typology**, from the Greek *tupos* [TOO-pus], meaning "example" or "figure." Thus Solomon, in his wisdom, is a *type* for Christ.

Very little early Christian art survives, and most of what we have dates from the third and fourth centuries. In paintings decorating catacombs, underground cemeteries, and a few sculptures, certain themes and elements are so prevalent that we can assume they reflect relatively long-standing representational traditions. In almost all of these works it is not so much the literal meaning of the image that matters, but rather its symbolic significance. Likewise, the aesthetic dimension of the work is clearly less important than its message.

One of the most popular of these symbolic representations is the story of Jonah [JOE-nuh] and the whale from the Hebrew Bible (Jonah 1–2). Jonah was viewed as a type for Christ, his regurgitation from the whale prefiguring the death and resurrection of Christ. A set of small marble sculptures, probably made in the third century in Asia Minor, depicts the Jonah story (Fig. **9.6**), showing him swallowed in one, and cast up in the other. Another very common image is that of Christ as the Good Shepherd, which derives from Jesus's promise, "I am the good shepherd. A good shepherd lays down his life for the sheep" (John 10:11). The overwhelming message of this symbolism involves the desire of the departed to join Jesus's flock in heaven, to be miraculously reborn like Jonah. As the Lamb of God, a reference to the age-old role of the lamb in sacrificial offerings, Jesus is, of course, both shepherd and sheep—guardian of his flock and God the Father's sacrificial lamb. In fact, it is unclear whether images such as the free-standing representation of *The Good Shepherd* (Fig. **9.7**) represent Christ or symbolize a more general concept of God caring for his flock, perhaps even capturing a sheep for sacrifice. The naturalism of the sculpture echoes Classical and Hellenistic traditions. We see this too in monumental

Continuity & Change
p. 194

Doryphoros

funerary sculpture, such as the *Sarcophagus of Junius Bassus* (see *Focus*, pages 288–289). The shepherd adopts a contrapposto pose, reminiscent of Polyclitus's *Doryphoros* (see Fig. 7.4). His body is confidently modeled beneath the drapery of his clothing. He turns as if engaged with some other person or object outside the scope of the sculpture itself, animating the space around him. And the sheep he carries on his back seems to struggle to set itself free.

These examples make clear the importance of symbolism to Christian thinking. Over the course of the first 200 years of Christianity, before freedom of worship was legalized, Christians developed many symbols that served to identify them to each other and to mark the articles of their faith. Their symbols allowed them to represent their faith in full view of a general populace that largely rejected it.

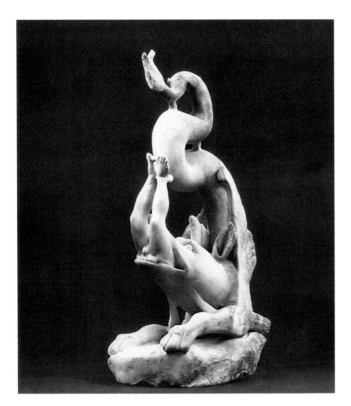

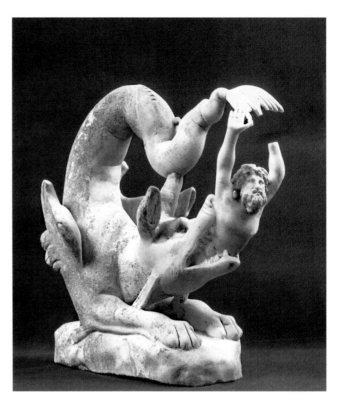

Fig. 9.6 *Jonah Swallowed* and *Jonah Cast Up*, two statuettes of a group from the eastern Mediterranean, probably Asia Minor, probably third century. Marble, heights 20$\frac{5}{16}$″ and 16″. The Cleveland Museum of Art. The function of the figures is unknown.

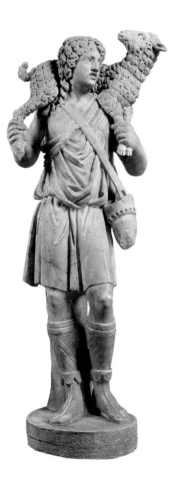

Fig. 9.7 *The Good Shepherd*, ca. 300 CE. Marble, height 3′. Vatican Museums, Rome. The legs of this figure have been restored. Free-standing sculptures such as this one are rare in the early Christian period. Much more common are wall paintings.

They adopted the symbol of the fish, for instance, because the Greek word for fish, *ichthys* [IK-tis], is a form of acronym, a combination of the first letters of the Greek words for "Jesus Christ, Son of God, Savior." The first and last letters of the Greek alphabet, *alpha* and *omega* [oh-MEG-uh], symbolize Christ's presence from the beginning to the end of time. The *alpha* and *omega* often flank the initials *I* and *X*, the first letters of Jesus and Christ in Greek, and the initials *XP* were the first two letters of the word *Christos* [KRIH-stohs] (Fig. **9.8**).

alpha omega

alpha and *omega*
I and *X*

chi rho

Fig. 9.8 Traditional Christian symbols.

Focus

The *Sarcophagus of Junius Bassus*

The stone coffin known as the *Sarcophagus of Junius Bassus* is one of the most extraordinary pieces of sculpture of the late Roman Empire. It consists of ten individual scenes on two tiers, each separated from the next by a column (in fact, the two top right-hand scenes are one, representing Christ's confrontation with Pontius Pilate). The columns framing the central two scenes are decorated with *putti* [POO-tee], plump, naked boys who in Classical art are usually cupids and in Christian art are called *cherubs*. They can be seen here harvesting grapes, symbolic of the blood of Christ and his sacrifice. This element underscores the importance of these two central panels, which depict Christ in his glory. The bottom panel represents Christ's triumphal entry into Jerusalem on Palm Sunday, the top his presentation of the Christian law to Peter and Paul after his resurrection. Note, in the top panel, how Christ's feet rest on what is generally taken to be a symbolic representation of the world as a whole, but the figure is unmistakably the Roman god Neptune (the Greek Poseidon) and represents Christ's triumph over the Roman gods as well.

Across the top of the sarcophagus these words are written: "Junius Bassus, a man of highest rank, who lived 42 years, 2 months, in his own prefecture of the city, went to God, the 8th day from the Kalends of September, Eusebius [yoo-SEE-bee-us] and Hypatius [hie-PAY-shus] being consuls [25 August 359]." Thus, the sarcophagus collapses the "present" time of Junius Bassus's death into historical time. Four scenes from the Old Testament prophesy the story of Christ, itself represented in four panels, as well as the arrest and persecution of two Roman martyrs, Paul and Daniel, who represent the fate of all Roman Christians up until the Edict of Milan, which Constantine endorsed just four years before Junius Bassus's birth. In his sarcophagus, Bassius assumes his place in Christian history.

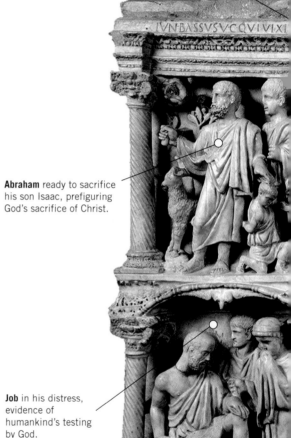

The arrest of **St. Peter**, who would be crucified in Rome in imitation of Christ. At his own insistence, Peter was crucified upside down, to emphasize his status as lesser than his Savior's.

Abraham ready to sacrifice his son Isaac, prefiguring God's sacrifice of Christ.

Job in his distress, evidence of humankind's testing by God.

Adam and Eve in the Garden of Eden, at the moment when they succumbed to the Temptation of Satan, who is shown wrapped around the Tree of the Knowledge of Good and Evil in his guise as a serpent.

Sarcophagus of Junius Bassus. 359 CE. Marble, Museo Storico del Tesoro della Basilica di San Pietro, Vatican City.

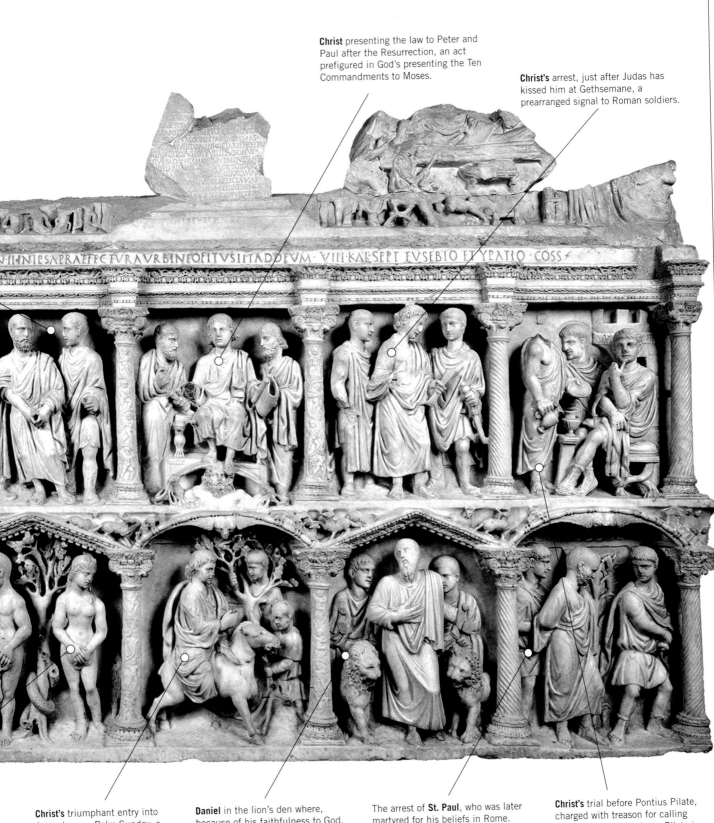

Christ presenting the law to Peter and Paul after the Resurrection, an act prefigured in God's presenting the Ten Commandments to Moses.

Christ's arrest, just after Judas has kissed him at Gethsemane, a prearranged signal to Roman soldiers.

Christ's triumphant entry into Jerusalem on Palm Sunday, a week before the Crucifixion.

Daniel in the lion's den where, because of his faithfulness to God, he was spared.

The arrest of **St. Paul**, who was later martyred for his beliefs in Rome.

Christ's trial before Pontius Pilate, charged with treason for calling himself King of the Jews. Pilate is shown here about to wash his hands, symbolizing his denial of responsibility for Jesus's death.

Over the years, Christians developed a consistent **iconography**—the subject matter of a work, both literal (factual) and figurative (symbolic)—in their art and literature. A story or person might be a type for some other story or person. A figure might symbolize something else, as particular figures symbolized each of the four evangelists—an angel for Matthew; a lion for Mark; an ox for Luke; an eagle for John. And the stories surrounding Jesus's life coalesced into distinct story "cycles," each part in some sense signifying the whole, and all of them becoming standard themes in the arts throughout the history of the West.

Christian Rome

Throughout its history, the Roman Empire had been a polytheistic state in which literally dozens of religions were tolerated. But as Christianity became a more and more dominant force in the Empire, it threatened the political and cultural identity of the Roman citizen. No longer was a Roman Christian first and foremost Roman. Increasingly, that citizen was first and foremost Christian.

In reaction to this threat to imperial authority, during the chaotic years after the fall of the Severan emperors in 235 CE, Christians were blamed, as their religion spread across the Empire (see Map **9.2**), for most of Rome's troubles. By the end of the third century, there were about 5 million Christians in the Roman Empire, nearly a tenth of the population. Rome had a particularly large Christian congregation with considerable influence, since its leadership was believed to have descended from Jesus's original disciples, Peter and Paul. In 303, the emperor Diocletian [di-o-CLEE-shun] (r. 284–305 CE) unleashed a furious persecution of Christians that lasted for eight years. Diocletian had risen to power after a long period of virtual anarchy in the Roman Empire by implementing a scheme of government known as the **tetrarchy** (Fig. **9.9**), a four-part monarchy. Diocletian ruled from Solana, a city on the Adriatic near modern-day Split, Croatia, and controlled the East, with the other regions of the Empire governed by monarchs in Milan, the Balkans, and Gaul. In the sculpture representing the four, they are almost indistinguishable from one another, except that the two senior tetrarchs are bearded and their juniors clean-shaven. They hold identical bird-headed swords and wear flat caps from Pannonia. This Roman province was bordered on the north and east by the Danube River in present-day Central Europe, which is the meeting place of the Eastern and Western empires. Their sameness symbolizes their equality, just as their embrace symbolizes their solidarity. Even the sculpture's material is symbolic: Porphyry is a deep purple Egyptian stone traditionally reserved for imperial portraits.

This shift of the Empire's administration from Rome to its provincial capitals had dramatic implications for Rome itself. Perhaps most important was Diocletian's removal to Asia Minor (modern Turkey). There, he almost completely deified the role of the emperor, presenting himself more as the divine manifestation of the gods than as a leader of a citizen-state.

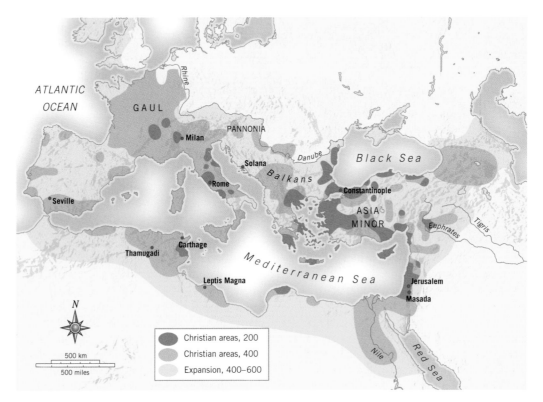

Map 9.2 The spread of Christianity by 600 CE.

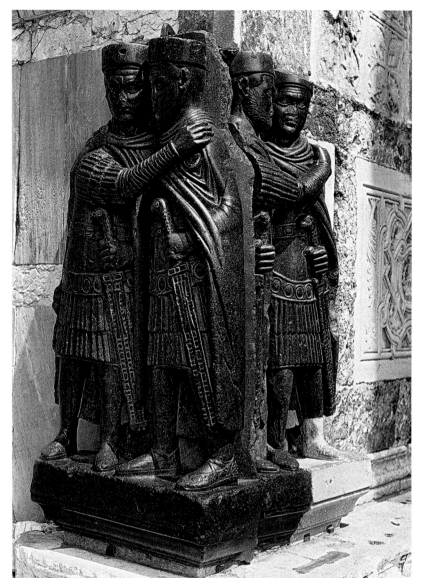

Fig. 9.9 Portrait group of the Tetrarchs. ca. 305 CE. Porphyry, height 51″. Basilica of San Marco, Venice. Originally decorating a crossroads square in Constantinople known as the Philadelphion, this sculpture was probably the base of a porphyry column. It was removed to Venice after 1204.

had all bishops arrested. Under penalty of death, Christians were compelled to make sacrifices to the emperor, whom non-Christian Romans considered divine. Thousands refused, and the martyrdom they thus achieved fueled rather than diminished the Church's strength.

Constantine, the Church, and Change

In 305, Diocletian retired due to bad health, ushering in a period of instability, as the other members of the tetrarchy competed for control of the Empire. Finally, Constantine I, known as "Constantine the Great" (r. 306–337), won a decisive battle against Maxentius (son of one of the tetrarchy monarchs), at the Milvian [MIL-vee-un] Bridge, at the entrance to Rome, on October 28, 312. Under the tetrarchy, Constantine had ruled Gaul, the Iberian Peninsula, and Britannia. Two years earlier, as Constantine was advancing on Rome from Gaul, the story had circulated that he had seen a vision of the sun god Apollo accompanied by Victory (Nike) and the Roman numeral XXX symbolizing the 30 years he would reign. By the end of his life he claimed to have seen, instead, above the sun, a single cross, by then an increasingly common symbol of Christ, together with the legend, "In this sign you shall conquer." At any rate, it seems certain that at the Battle of the Milvian Bridge, Constantine ordered that his troops decorate their shield with crosses, and perhaps the Greek letters *chi* [ky] and *rho* [roh] as well. As we have seen, these letters stood for *Christos*, although *chi* and *rho* had long meant *chrestos* [KREH-stohs], "auspicious," and Constantine probably meant only this and not Jesus Christ. While Constantine himself reasserted his devotion to the Roman state religion, within a year, in 313, he issued the Edict of Milan, which granted religious freedom to all, ending religious persecution in the Empire.

The Abandonment of Classicism in Art Constantine's victory was celebrated in the usual Roman way with the construction of an impressive triple arch (Fig. **9.10**), for which Constantine raided the artworks of other Roman monuments. Comparing the reliefs made for Constantine's arch, particularly the horizontal panel that shows *Constantine Speaking to the People*, with the circular **roundels** (round reliefs) above it, provides insight into the profound changes in the art and culture of this period that the Christian faith inspired. The roundels come from a monument to Hadrian made almost 200 years earlier

He dressed in robes of blue- and gold-threaded silk, glittering with jewels, to symbolize sky and sun. He had his fingernails gilded and gold dust sprinkled in his hair to create the sense of a halo or nimbus encircling his head. When he entered the throne room, servants sprinkled perfume behind him and fan-bearers spread the scent through the room. All kneeled in his presence. He was addressed as *dominus* [DOM-ih-nus], "lord," and his right to rule, he claimed, was derived not from the people but from God.

Diocletian saw the Roman Church as a direct threat to his own authority, recognizing that it had achieved an almost monarchical control over the other dioceses, or Church territories, in the Empire. He forbade Christian worship, ordered churches destroyed, burned books, and

Voices

A Pagan in Christian Constantinople

Zozimus was a late-fifth-century Roman writer who chronicled the decline of the Empire. A pagan during an era of Christian dominance, here he offers a glimpse into the battle between Church authorities such as John, the bishop of Constantinople, and the strong-willed Empress Eudoxia, as well as the staying power of the pagan gods.

"This circumstance inspired all persons above the ordinary rank with more favourable hopes for the city, as if these deities resolved to afford it their continual protection. . . ."

As if these circumstances did not sufficiently heighten the public misery, another inconceivable disaster fell on Constantinople. (Bishop) John, as I have related, having returned from his banishment, and instigating the populace against the empress in his usual sermons, finding himself expelled both from his Episcopal see [church position] and from the city . . . left the city. Those who had espoused his party, endeavouring to prevent any person from succeeding to his bishopric . . . set fire to a church in the night, and left the city at break of day, in order to avoid detection. As soon as it was day, the people discovered the extreme danger in which the city stood. Not only was the church burnt to the ground, but the adjacent houses were likewise consumed. . . . Besides these, the fire extended to the senate-house, which stood before the palace, and was a most beautiful and magnificent edifice.

At that time occurred a miracle. . . . Before the doors of the temple of the senate were the statues of Jupiter and Minerva, standing on two pedestals, as they still continue. . . . When the fire consumed the temple, the lead on its roof melted and ran down on the statues, and all the stones which could not resist the force of the fire likewise fell upon them, until at length the beauty of the building was converted into a heap of rubbish, and it was supposed that these two statues were also reduced to ashes. But when the ruins were removed, the statues of these two deities alone appeared to have escaped the general destruction. This circumstance inspired all persons above the ordinary rank with more favourable hopes for the city, as if these deities resolved to afford it their continual protection. . . .

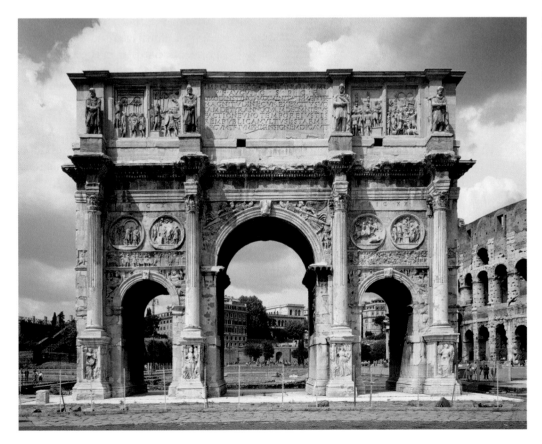

Fig. 9.10 Arch of Constantine (south side), Rome. 312–315 CE. Constantine built the arch to celebrate his victory over Maximian.

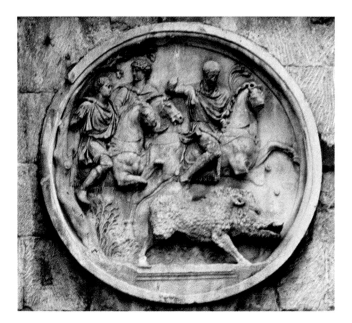

Fig. 9.11 *Hadrian Sacrificing to Apollo*, **roundel imported from a monument to Hadrian (ca. 130–138 CE) and reused over the left arch on the Arch of Constantine.** Diameter of roundel 40″. Constantine recycled many works from other monuments for his own use. In addition to the round reliefs, known as roundels, there are other reliefs taken from a monument celebrating Marcus Aurelius's victory over the Germans in 174 CE, at the top of the arch on each side of the inscription. At the top of the columns stand sculptures, originally made for Trajan, of captured Dacian prisoners.

CULTURAL PARALLELS

King Ezana of Aksum Converts to Christianity

In the fourth century CE, the Aksumite Empire (located in modern-day Ethiopia) was one of four great regional powers of the time, along with Egypt, Rome, and Persia. The city of Aksum controlled much of the Indian Ocean trade to the east. When the Aksumite king, Ezana, converted to Christianity during the fourth century, he established the only Christian kingdom outside Europe and began the tradition of Ethiopian Christianity that continues today.

(Fig. **9.11**). In the roundel on the right, Hadrian and two companions stand before the statue of a deity. The space is illusionistic, rendered realistically so that the figures seem to stand well in front of the sculpture. The horse on the right emerges from behind its master on a diagonal that emphasizes a logical progression from background to foreground. The draperies on the figures fall naturalistically.

The relief depicting *Constantine Addressing the People* is quite different (Fig. **9.12**). No real sense of illusionistic space exists. Constantine stands in the middle (his

head has not survived), surrounded by a linear arrangement of mostly frontally posed attendants whose clothing is rendered merely by lines cut into the flat surface of the stone—they are not really sculpted at all. All of the figures are the same height, their heads abutting on a line dividing the upper piece of marble from the bottom. But the real difference between the two pieces becomes apparent when we realize that the two seated figures on either side of the podium are themselves sculptures—statues of Hadrian and Marcus Aurelius. These statues signal Constantine's dedication to them and his identification with their imperial majesty. Unlike the statue of the deity in the Hadrian roundel, they are undistinguishable from the other figures. This comparison indicates that by the fourth-century CE, naturalism is no longer an important aim of art, and the classical heritage of the Greek and Roman tradition has been abandoned. The symbolic function of art has supplanted its illusionistic purposes: The spiritual has replaced the physical. Additionally, the standards of beauty that defined Classical art, specifically those defining the beauty of the human body, have been replaced by a more abstract standard of

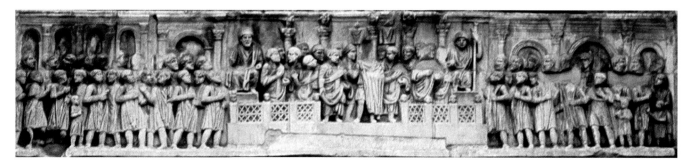

Fig. **9.12** *Constantine Addressing the People*, **Arch of Constantine. ca. 130–138 CE.** Marble, height of panel approx. 40″. Compared to Fig. 9.11, the lack of spatial complexity in this relief is striking.

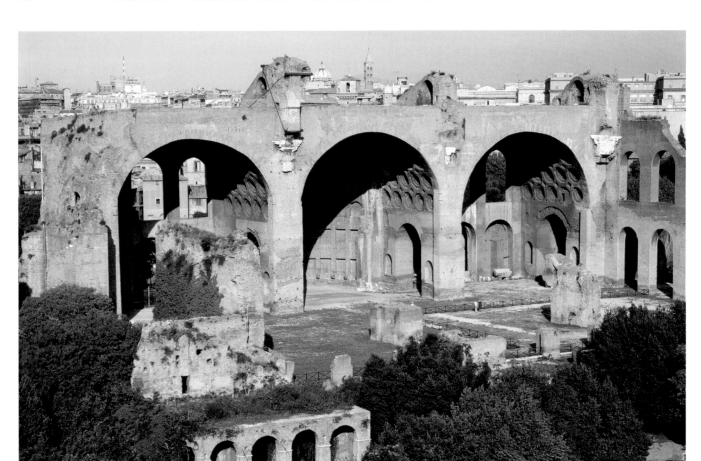

Figs. 9.13 and 9.14 The Basilica of Maxentius and Constantine, also known as the Basilica Nuova, and plan (below), Rome. 306–313 CE. Constantine added an imposing entrance on the southwest side of Maxentius's basilica and another apse across from it, perhaps to accommodate crowds. The basilica plan, with the apse as its focal point, would exert considerable influence on later Christian churches. These later churches would transform the massive interiors from administrative purposes to religious sanctuaries, whose vast interior spaces elicited religious awe.

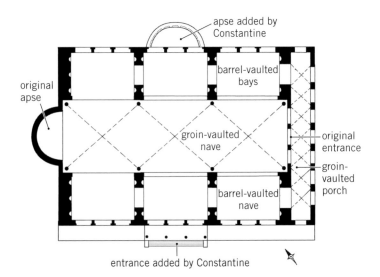

beauty. The new standard still depends on visual balance and order, but it has little or no interest in the body, since it is in the symbolism of an image that true beauty is believed to lie.

Constantine also left his imprint on a basilica at the southern end of the line of Imperial Forums (see *Focus*, chapter 8, pages 258–259). Originally built by Maxentius, it was the last of the great imperial buildings erected in Rome (Figs. **9.13**, **9.14**). Like all Roman basilicas, the Basilica of Maxentius and Constantine (also known as the Basilica Nuova [noo-OH-vuh]) was a large rectangular building with a rounded extension, called an **apse**, at one or both ends and easy access in and out. It was, similarly, an administrative center—courthouse, council chamber, and meeting hall—and its high vaulted ceilings were purposefully constructed on the model of the Baths of Caracalla (see chapter 8). Its **nave**, the large central area, rose to an elevation of 114 feet. One entered through a triple portico at the south-

east end and looked down the nave some 300 feet to the original semicircular apse at the other end of the building, which acted as a focal point.

After construction of the basilica was underway, Constantine made several changes, including erecting a giant sculpture of himself (Fig. **9.15**). The head alone is $8\frac{1}{2}$ feet high, composed entirely of marble, and the entire seated figure was approximately 30 feet in height. The emperor's hair is composed of repeated geometric arcs. His eyes are disproportionately large, symbolizing contact with the divine. He looks both serene and imposing, appearing to gaze into the far distance, as if symbolically contemplating spiritual things beyond the material world itself. Even if the jutting chin and hawklike nose reflect his actual appearance, the totality has been transformed into a godlike presence, more an abstract image of imperial majesty and power than a realistic representation of the human emperor.

The Nicene Creed Constantine recognized that Diocletian's scheme for controlling the Empire was, in most respects, sound. Particularly important was an imperial presence near the eastern and Danubian frontiers of the Empire. To provide this imperial presence in the East, in 324 CE Constantine founded the city of Constantinople, modern Istanbul, on the site of the Greek city of Byzantium [bih-ZAN-tee-um]. The city was dedicated with both pagan rites and Christian ceremonies on May 11, 330. Constantine's own Christianity became more and more pronounced in his new eastern capital. Though he did not persecute pagans, he officially rejected pagan practices, openly favored Christians as officials, and admitted Church clergy to his court. Perhaps his most important act was to convene the first **ecumenical**, or worldwide, **council** of Church leaders in 325 CE at Nicaea [nye-SEE-uh] (modern Iznik), a site just southeast of Constantinople. The council produced a document, the Nicene [NYE-seen] Creed, that unified the Church behind a prescribed doctrine, or **dogma**, creating, in effect, an orthodox faith. Church leaders believed that by memorizing the Creed, laypeople would be able to easily identify deviations from orthodox Christianity.

The Creed was revised and extended in 381 by a Second Ecumenical Council in Constantinople, quoted here (**Reading 9.6**):

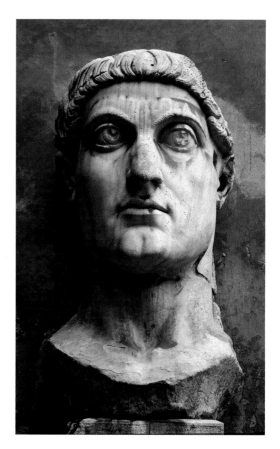

Fig. 9.15 Fragment of *Constantine the Great*, from the Basilica of Maxentius and Constantine, Rome. ca. 315–330 CE. Marble, height of bust approx. $8\frac{1}{2}'$. Palazzo dei Conservatori, Rome. The flesh of Constantine's body, wherever revealed beneath its bronze armor, was sculpted in marble. Fragments of the right hand, the upper right arm, the lower left leg, and both feet survive.

READING 9.6 **The Nicene Creed**

We believe in one God the Father All-Sovereign, maker of heaven and earth, and of all things visible and invisible;

And in one Lord Jesus Christ, the only-begotten Son of God, Begotten of the Father before all the ages, Light of Light, true God of true God, begotten not made, of one essence with the Father, through whom all things were made; who for us men and for our salvation came down from the heavens, and was made flesh of the Holy Spirit and the Virgin Mary, and became man, and was crucified for us under Pontius Pilate [PON-chus PYE-lut], and suffered and was buried, and rose again on the third day according to the Scriptures, and ascended into the heavens, and sitteth on the right hand of the Father, and cometh again with glory to judge living and dead, of whose kingdom there shall be no end;

And [we believe] in the Holy Spirit, the Lord and the Life-giver, that proceedeth from the Father, who with Father and Son is worshiped together and glorified together, who spake through the prophets;

In one holy catholic and apostolic Church: We acknowledge one baptism unto remission of sins. We look for a resurrection of the dead, and the life of the age to come.

The Creed is an article of mystical faith, not a doctrine of rational or empirical observation. In its very first line, it states its belief in the invisible. It argues for the virgin birth of Jesus, for a holy "spirit," for the resurrection of the dead. It imagines what cannot be rationally known: Jesus in heaven at the right hand of God (perhaps not coincidentally an image evocative of Diocletian modeling himself as *dominus*, "lord," ruling at the will of and beside God). Nothing could be further from the Aristotelian drive to describe the knowable world and to represent it in naturalistic terms. (See chapter 7.)

But perhaps most important, the Nicene Creed establishes "the one holy catholic and apostolic Church," that is, a united church that is universal ("catholic") and based on the teachings of the apostles ("apostolic"). The Church was organized around the administrative divisions of the Roman state—archbishops oversaw the provinces, bishops the dioceses, and priests the parishes—an organization that provided Constantine with the means to impose the Creed throughout the Empire, eliminate rivalries within the Empire, rule over both church and state. Finally, the Church's **liturgy**, the rites prescribed for public worship, was established. In Rome, Saint Jerome (ca. 342–420) translated the Hebrew Bible and the Greek books of the New Testament into Latin. The resulting **Vulgate**, meaning "common" or "popular," became the official Bible of the Roman Catholic Church. As the version of the Bible known by the faithful for over a thousand years, from about 400 CE to 1530, it would exert an influence over Western culture, which came to consider it virtually infallible.

Music in the Liturgy The Roman prelate Ambrose (339–397), bishop of Milan, wrote hymns to be sung by the congregation, an important part of the new liturgy. Recognizing that common people, with no musical training, were to sing along with the clergy, Ambrose composed simple, melodic songs or psalms, generally characterized by one syllable for each note of the hymn. "The psalm is our armor by night," he wrote, "our instructor by day. The dawn of the day resounds with the psalm, and with the psalm re-echoes at sunset." St. Augustine, whose writings are discussed later in this chapter, tells us in his *Confessions* that "the practice and singing of hymns and psalms . . . was established so that the people [of Milan] would not become weak as a result of boredom or sorrow. It has been retained from that day to this; many, in fact, nearly all of God's flocks now do likewise throughout the rest of the world." These hymns and songs, Augustine says, represented a "kind of consolation and exhortation, in which the voice and the hearts of the brethren joined in zealous harmony."

Ambrose's authorship is certain for only four hymns, all attributed to him by Augustine. The melodies survive only in tenth- and eleventh-century versions, and their authenticity is disputed Ambrose, *Deus Creator Omnium* (*God Creator of All Things*). Each hymn is composed of eight four-line stanzas, each written in a strict **iambic tetrameter** (short-long, short-long, short-long, short-long). Ambrose also seems to have introduced an **antiphonal** method of chanting, where one side of the choir responds to the other.

Roman and Greek Influences on Christian Churches and Rituals

The community that developed around the new liturgy required a physical church, and Constantine obliged with a building that became a model for many subsequent churches: Saint Peter's Basilica, begun in 320 on the site of Peter's crucifixion and tomb in Rome (Figs. **9.16, 9.17**). Its original dimensions are difficult to fathom, but an eighteenth-century print of a nearly contemporary church in Rome, Saint Paul's Outside the Walls, gives us a fair idea (Fig. **9.18**). The church was as long, as high, and as wide as the Roman basilicas upon which it was modeled (see Figs. 9.13, 9.14). It was approached up a set of stairs to a podium, reminiscent of the Roman Temple of Fortuna Virilis (see Fig. 8.7). Entering through a triple-arched gateway (again reminiscent of Roman triumphal arches), visitors found themselves in a colonnaded atrium with a fountain in the center (reminiscent of the Roman *domus*, Fig. 8.28—perhaps suggesting the "House of God").

Continuity & Change
p. 238

Temple of
Fortuna Virilis

The church proper consisted of a **narthex**, or entrance hall, and a **nave**, with two aisles on each side. At the eastern end was an apse, housing the altar framed by a giant triumphal arch, where the sacrament of Holy Communion was performed. A transverse aisle, or **transept**, crossed between the nave and the apse; in other church plans it could be extended north and south to form a **Latin cross** (a long arm, the nave, with three shorter arms—the apse and the arms of the transept). The nave was two stories high, the aisles one story, allowing for a **clerestory**, a zone with windows that lit the length of the church. Open timber-work tresses supported the roof (making the structure particularly susceptible to fire).

All in all, the basilica church was far more than an assembly hall. It was a richly decorated spiritual performance space, designed to elicit awe and wonder in its worshipers. As the liturgy was performed, as the congregation—consisting of literally thousands—raised their voices together in song and then fell silent in prayer, the effect would have been stunning. No one, it was hoped, could leave without their faith re-energized.

A second type of Christian church also first developed in Rome, although it was initially conceived as a mausoleum for the daughter of Constantine, a devout Christian who died in 354. Santa Costanza [koh-STAN-zuh] is a **central plan church**, so called because of its circular structure,

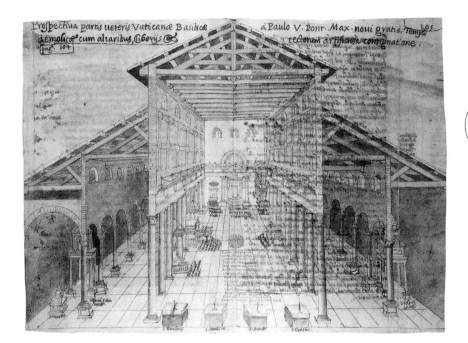

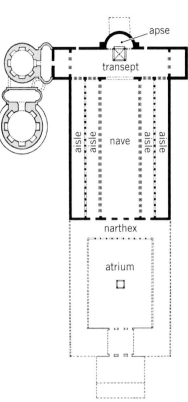

Figs. 9.16 and 9.17 Reconstruction drawing and plan of Old St. Peter's, Rome. ca. 320–327, atrium added in the later 4th century. Vatican Museums, Rome, Italy. What we know of Old St. Peter's (a "new" St. Peter's replaced it in the 16th century) comes from modern archeological finds from written descriptions, drawings made both before and during its destruction, and the surviving churches it inspired.

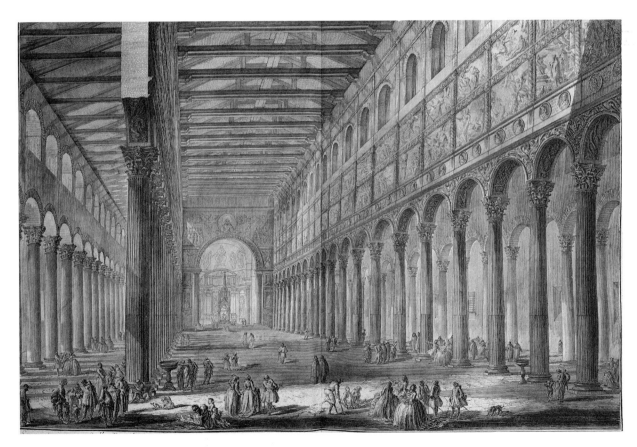

Fig. 9.18 Interior of Saint Paul's Outside the Walls, Rome. Begun 386 CE. Etching by Gianbattista Piranesi, 1749. Note the wooden tresses of the ceiling and the spaciousness of the interior, reminiscent of the Roman baths.

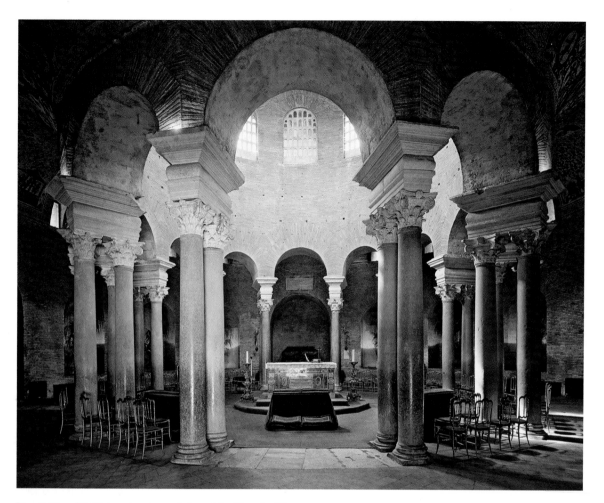

Figs. 9.19 and 9.20 Interior view and plan of the Church of Santa Costanza, Rome. ca. 350 CE. The view above is from the ambulatory into the central space. This is the earliest surviving central plan building in the world. Originally the central plan was used for mausoleums or shrines. Another central plan church very much like this one originally covered Christ's tomb in Jerusalem, but it was later incorporated into the basilica. The Church of Santa Costanza was originally attached to the now destroyed basilica of Saint Agnes Outside the Walls.

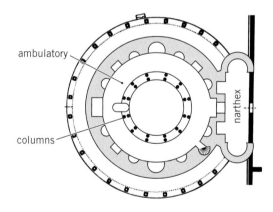

topped by a dome (Figs. **9.19, 9.20**). This type of church has an architectural legacy that includes the high domed structures created to house the Roman baths and the great domed space of the Pantheon (see Figs. 9.3, 8.25, 8.26).

A double ring of paired columns separates the circular central space from the barrel-vaulted **ambulatory**, the walkway or passage around the outside. (Later Christian churches would adapt this ambulatory to encircle the apse.) This ambulatory is elaborately decorated with mosaics (Fig. **9.21**), consisting of an overall vine pattern interspersed with small scenes, such as laborers picking grapes and putting them into carts, transporting them to a press, and then crushing them underfoot.

One of the Christian references here is to the use of wine in the Eucharist, symbolizing the blood of Christ. But the Dionysian implications of the scene, with its unruly swirls of undulating line—the very opposite of the Roman (and Classical) sense of order and proportion—are unmistakable. Used to decorate a church, these lines imply the very nature of faith—that is, the abandonment by faith of reason and logic, the very principles of Classical balance and proportion.

Greek and Roman Myths in Christianity

The design makes clear, in fact, the ways in which Christianity incorporated into itself many Greek and Roman mythic traditions—a practice known as **syncretism** [SIN-kruh-tiz-um], the reconciliation of different rites and practices into a single philosophy or religion. This occurred not only in the design of Christian churches but also in the symbolism of its art and literature—and it makes perfect sense. How better to convert pagan peoples than to present your religious program in their own terms? After all, the Greek wine god Dionysus had, like Christ, promised human immortality in the manner of the grapevine itself, which appears to die each autumn only to be reborn in the spring. Just as Christians had found prefigurings of Christ in the Hebrew Bible, it was possible to argue that Dionysus was a pagan type of Christ.

CULTURAL PARALLELS

Two Capital Cities

In the fourth century CE, Constantinople was the capital of the eastern Roman Empire, supplanting Rome both politically and culturally. Some 7,000 miles away, in what is now Mexico, the city of Teotihuacan also served as a cultural and political center for rapidly expanding Mesoamerican culture, with monumental pyramids, temples, and markets that rivaled its Old World counterparts.

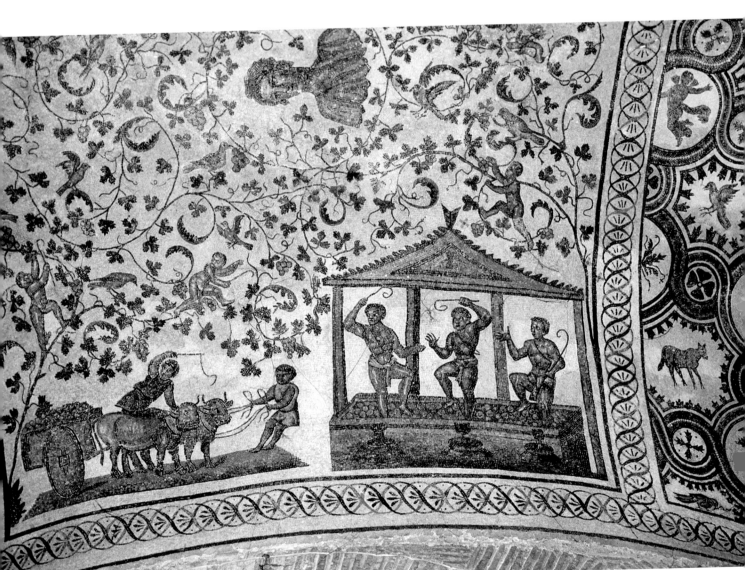

Fig. 9.21 Ambulatory vault mosaic, Church of Santa Costanza, Rome. ca. 350 CE. The figure at the top of this reproduction (which is actually positioned in the center of the volute motif) is probably Constantine's daughter Constantia herself.

The cult of Bacchus, as the Romans referred to Dionysus, was extremely popular in Rome. So high-spirited were the drunken orgies engaged in by the cult of Dionysus that the Roman Senate had restricted its activities in 186 BCE. Other cults, known as **mystery cults** because their initiation rites were secret, were also popular among the Romans, and Christianity borrowed freely from these as well. In fact, the evidence suggests a remarkable process of cross-fertilization, each cult adapting elements from the others that were attractive or popular as they competed for followers. By the second century CE, in Rome, the *taurobolium* [toh-roh-BOH-lee-um], or sacrifice of a bull, usually associated with the Great Mother of the Gods, was performed annually on March 24. The bull's blood would run over a person beneath the sacrificial altar, who received the blood on his face, tongue, and palate, and who was said to be "reborn for eternity," as a consequence of the ceremony. Note that the *taurobolium's* date is near the beginning of the Christian Easter season, which celebrates rebirth and resurrection. And it resonates as well with the practice of the Eucharist, or Communion, the part of the liturgy when Christians, in taking bread and wine, are believed to partake of the body and blood of Christ.

The cult of Isis in Rome had originated in Egypt and was based on the ebb and flow of the Nile. Each summer, Isis would see Egypt's arid desert landscape and she would be moved to tears of compassion for the Egyptian people. Her tears, in turn, would cause the Nile to flood, bringing the land back to life—regarded by the Isis cult as an act of resurrection, not unlike the return of the vines in the Dionysian cult. In Egypt, in the late fourth and early fifth centuries, a new representation of Isis suckling the baby Horus began to appear (Fig. **9.22**). (Remember, too, Horus is the son of Osiris, just as, in Christian tradition, Jesus is the son of God.) In a Christian context an image of a mother with a child at her breast could easily be mistaken for Mary and Jesus, and it is entirely possible that the Isis cult was the inspiration for the Virgin and Child theme in Christian art.

Finally, the secret cult of Mithras [MITH-rus], which originated in Persia perhaps as far back as Neolithic times, became very popular among the Roman troops stationed in Palestine at the time of Christ. In the second through fourth centuries it spread across the Empire, and examples of its iconography can be found in Mithraic temples from Syria to Britain. Almost no texts explaining

Fig. 9.22 *Isis Lactans*, Isis giving the breast to the infant Horus, from Antinoe, Egypt, late fourth or early fifth century. Limestone, height 35″. Staatliche Museen, Berlin. This is one example of a Greco-Egyptian motif that was popular in the first four or five centuries CE.

the cult survive, its rites and traditions were likely passed down orally among initiates. What we know of it comes from wall paintings and relief sculptures in its sanctuaries. It appears to have derived from a Persian religion, based on the teachings of Zoroaster [ZOR-oh-as-tur] (born between 1000 BCE and the early seventh century BCE). The Avesta, the Zoroastrian sacred book, teaches that life is a battlefield between the forces of good and evil, truth and deceit. Free to choose between these forces, humans await a Last Judgment consigning those who choose evil to eternal darkness, and those who choose good to a place of eternal luxury and light—the Persian *pairidaeza* [pie-ree-DEE-zah], the origin of the English word "paradise." In Zoroastrian tradition, Mithras appears as a judge at the Last Judgment.

In the most widespread of his representations, Mithras is depicted killing a bull by stabbing him in the neck, as a snake and dog lap up the bull's blood and a scorpion clutches the bull's testicles (Fig. **9.23**). The end of the bull's tail is metamorphosed into an ear of wheat. At the top left and right are busts of the sun and moon. Zoroastrian sources suggest that Mithras was sent to earth by a divine bull, and all living things sprang from the bull's blood. The story can be read as a reverse version of God's sacrifice of Jesus. Mithras sacrifices his "father"—or, at least, his divine ruler, the bull—in order to create life itself. The cult had seven stages of initiation, one of which was baptism. We also know that the birthday of Mithras was celebrated each year on December 25. When this date was adopted in about 350 CE as the traditional birth date of Jesus, the choice was most likely an attempt to appropriate the rites of Mithraic cults, then still active throughout the Roman Empire, to Christianity.

Mithraism shares many ritual practices with Christianity—baptism, periods of fasting, a communal meal of bread and wine representing the flesh and blood of the bull, reminiscent of the Christian Eucharist (in which bread and wine are believed to be transformed into the flesh and blood of Christ)—as well as many themes, especially sacrifice for the good of humanity. And it was Christianity's chief rival among the Roman people through the first four centuries CE. Christianity's ability to supplant the various mystery cults probably had several related causes. The new religion's advocates labeled the cults "pagan" and "heretical," at the same time they codified and promoted their own rituals, beliefs, and sacred texts.

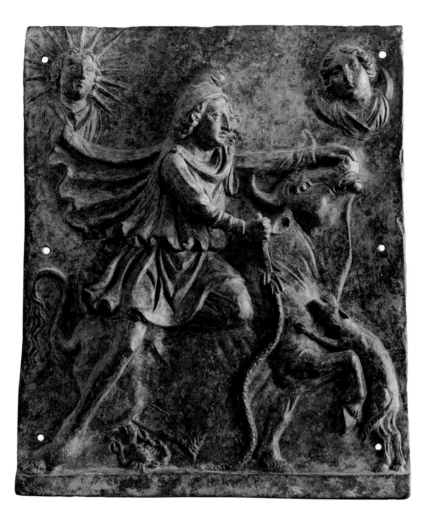

Fig. 9.23 **Mithraic relief, early 3rd century.** The Metropolitan Museum of Art, Gift of Mr. and Mrs. Klaus G. Peris, 1997 (1997.145.3). Image © The Metropolitan Museum of Art. Similar versions of this image have been found throughout the Roman Empire.

Early Christian Philosophy: Augustine and Boethius

There is one other aspect of Mithras's cult that we also know—he was the god of truth and light. How much the Mithras cult influenced the Church Fathers is unclear, but light played an important role in their writing, and images of light appear often in the writings of early Christians. The Roman prelate Ambrose's "Ancient Morning Hymn," for instance, refers to God as the "Light of light, light's living spring." Perhaps the most important of the early Church Fathers, Augustine of Hippo (modern Annaba, Algeria), describes the moment of his conversion to Christianity as one in which he was infused with "the light of full certainty."

Augustine of Hippo: *Confessions* and *The City of God*

Augustine, who lived from 354 to 430 CE, was in his forties and had recently been made bishop of Hippo when he felt the need to come to terms with his past. He did this in the form of a prose work, the *Confessions*, the first Western autobiography. Though addressed to God, it was intended to be read by fellow Christians. Augustine had enjoyed an apparently wild adolescence. He describes it as a kind of "overcast" and "shadowy" atmosphere in which he gave up the "bright path" of friendship for carnal pleasure (**Reading 9.7a**):

READING 9.7a **from Augustine, *Confessions***

As I became a youth, I longed to be satisfied with worldly things, and I dared to grow wild in a succession of various and shadowy loves. . . . But what was it that delighted me save to love and to be loved? Still I did not keep the moderate way of the love of mind to mind—the bright path of friendship. Instead, the mists of passion steamed up out of the puddly concupiscence of the flesh, and the hot imagination of puberty, and they so obscured and overcast my heart that I was unable to distinguish pure affection from unholy desire. Both boiled confusedly within me, and dragged my unstable youth down over the cliffs of unchaste desires and plunged me into a gulf of infamy.

Such thinking about the dangers of sexuality has exercised enormous influence over Western thought. For Augustine, sexuality is not so much an act, but an interior state of mind, and all sensual pleasure represents a triumph of the carnal will over the spiritual. Sex is the means of transmission of original sin, and sexual desire is evidence of humanity's inability to resist it. The exercise of the carnal will inevitably lead, in his mind, to the famous episode of "The Pear Tree" in Book 2, where he describes his darkest moment: his theft of a neighbor's pears when he was 16. Later, in Book 8, still leading a dissolute life as a student but despairing of his lifestyle, he describes his conversion to Christianity in a garden near Carthage (see **Reading 9.7**, page 308, for both episodes).

Augustine's storytelling is so compelling that the *Confessions* became one of the most influential books of the Middle Ages. The frankness of Augustine's autobiographical self-assessment—for instance, he is not proud of the follies of his youth though he is clearly still fascinated by them—would also make it influential later, in the context of the general rediscovery of the self that defines the great awakening to awareness of the human body known as the Renaissance.

But the *Confessions* is also a profoundly religious treatise that became influential on the merits of its religious arguments as well as its narrative power. For Augustine, humankind is capable of understanding true ideas only when they are illuminated by the soul of God. He adds to the Platonic emphasis on pure ideas a Christian belief in the sacred word of God, in which God's "light" is understood to shine. In the *Confessions*, too, Augustine codified the idea of typological readings of the Bible, proposing, for example, Eve, the biological mother of humanity, as a type for Mary, the spiritual mother. Similarly, he saw the deliverance of the Israelites from Egypt as a prefiguration of the redemption of Jesus.

Augustine was a prolific writer and thinker and a renowned teacher. One of his most important works is *The City of God*, written between 413 and 425 (**Reading 9.8**). It is a reinterpretation of history from a theological point of view. In many ways, the book was a response to the sack of Rome by the Visigoths in 410. What had happened to the once powerful empire that had controlled the world, in a common phrase, "to its very edge"? How had such a disaster come to pass? Augustine attempts to answer these questions.

Many Romans blamed the Christians for the city's downfall, but Augustine argued, to the contrary, that pagan religion and philosophy, and particularly the hubris, or arrogance, of the emperors in assuming to be divine had doomed Rome from the beginning. Even more to the point, Augustine argued that the fall of Rome was inevitable, since the city was a product of humankind, and thus corrupt and mortal. Even a Christian Rome was inevitably doomed. History was a forward movement—at least in a spiritual sense—to the Day of Judgment, a movement from the earthly city, with its secular ways, to the heavenly city, untouched by worldly concerns:

READING 9.8 from Augustine, *The City of God*

The two cities were created by two kinds of love: the earthly city by a love of self even to the point of contempt for God, the heavenly city by a love of God carried even to the point of contempt for self. Consequently, the earthly city glories in itself while the heavenly city glories in the Lord. . . . In the one, the lust for dominion has dominion over its princes as well as over the nations it subdues; in the other, both those put in charge and those placed under them serve one another in love, the former by their counsel, the latter by their obedience. . . .

Thus, in the earthly city . . . if any of [its wise men] were able to know God, "they did not honor him as God, or give thanks to him, but they became futile in their thinking and their senseless minds were darkened . . . [and] they became fools, and exchanged the glory of the immortal God for images resembling mortal man or birds or beasts or reptiles," for in adoration of idols of this sort they were either leaders or followers of the populace, "and worshiped and served the creature rather than the creator, who is blessed forever."

The quotations at the end of this excerpt from *The City of God* are from Romans 1:21–25, Paul's first epistle to the Romans. The Romans are portrayed here as Stoics, "futile in their thinking," and worshipers of pagan images, but they are not necessarily lost souls. Paul, after all, is preaching to them. For Augustine, as for Paul, evil is a deficiency of good, the result of incorrect choices, as prefigured by Adam and Eve's choice to eat the forbidden fruit in the Garden of Eden, not something that exists in its own right. The Romans can be saved, then, but only if they give up the earthly city and accept the City of God. And if history was the progress of humankind from the earthly city to the heavenly one, then the church was "the mediator between God and men," between one city and the other.

Augustine's worldview is essentially dualistic, composed of two parts. In his writings the movement of history (and of life itself) follows a linear progression from darkness to light, from body to soul, from evil to goodness, from doubt to faith, and from blindness to understanding. His own life story, as described in *Confessions*, revealed him as the sinner saved. He saw himself, in fact, as a *type* for all Christians, whose ultimate place, he believed, would one day be the City of God.

Boethius's *Consolation of Philosophy*

One of Augustine's most important early followers was a leading Roman nobleman, Boethius [boh-EE-the-us] (ca. 480–ca. 524), who was implicated in a senatorial conspiracy, imprisoned, and executed. While awaiting death in prison, he composed *Consolation of Philosophy*, a dialogue between himself and Lady Philosophy. In the work, Boethius is languishing in prison (as he really was), awaiting execution and wondering why God permits evil and chaos in the world. Lady Philosophy appears to him and offers to show him the order of the universe. He sees that from a human perspective, events are the result of fortune, or chance. The "good fortune" humans enjoy—riches, honorable positions, political power, fame, noble birth—actually leads them away from what is their true good. But from a divine perspective, Lady Philosophy argues, events are the result of **Providence**, or God's plan for the world.

Understanding the nature of Providence leads Boethius to a second question: If God knows the future, does that mean that the future is predestined and that human beings have essentially no role in determining their lives? He learns that Providence does not mean "predetermination" or "predestination." Something can be known without the knowledge being the cause of it.

Consolation of Philosophy would become one of the most influential books of the Middle Ages, summing up an entire philosophical tradition from Plato and Aristotle through the Stoics and Augustine. Philosophy's final admonition to Boethius provides a sort of moral direction for the era to come (**Reading 9.9**):

READING 9.9 **Boethius, *Consolation of Philosophy***

Thus, therefore, mortal humans have their freedom of judgment intact. And since their wills are freed from all binding necessity, laws do not set rewards or punishments unjustly. God is ever the constant foreknowing overseer, and the ever-present eternity of His sight moves in harmony with the future nature of our actions, as it dispenses rewards to the good, and punishments to the bad. Hopes are not vainly put in God, nor prayers in vain offered: if these are right, they cannot but be answered. Turn therefore from vice: ensue virtue: raise your soul to upright hopes: send up on high your prayers from this earth. If you would be honest, great is the necessity enjoined upon your goodness, since all you do is done before the eyes of an all-seeing Judge.

Boethius's consolation rests in this. His life, even as he awaits his execution, is not the product of chance or blind fate or an uncaring God. Lady Philosophy convinces him that human life has purpose and meaning.

READINGS

Josephus, *The Jewish War*, Book 2, "The Three Sects"

At the beginning of The Jewish War, *its author introduces himself as "Joseph, son of Matthias, an ethnic Hebrew, a priest from Jerusalem." He had fought the Romans in the First Jewish-Roman War beginning in 66* CE, *as a commander in Galilee [GAL-uh-lee], but after the destruction of the temple in 70* CE, *he apparently joined Titus's entourage when it returned to Rome with all its spoils. Despite living rather comfortably under the patronage of the Flavian emperors, he remained, in his own eyes at least, a loyal and observant Jew, intent on advocating for the Jewish people in the hostile atmosphere of the Roman Empire.*

Josephus wrote all his works, including The Jewish War, *in Rome. His is the most thorough account we have of Roman-Jewish relations in the first century* CE. *It also provides much information about Jewish sectarian thought, since he blamed the Jewish War on "unrepresentative and over-zealous fanatics" among the Jews—sects, that is, other than the aristocratic Pharisees to which he belonged. The passage from* The Jewish War *excerpted here concentrates on one of the "overzealous" sects, the Essenes.*

2 For there are three philosophical sects among the Jews. The followers of the first of which are the Pharisees; of the second, the Sadducees; and the third sect, which pretends to a severer discipline, are called Essenes. These last are Jews by birth, and seem to have a greater affection for one another than the other sects have. These Essenes reject pleasures as an evil, but esteem continence, and the conquest over our passions, to be virtue. They neglect wedlock, but choose out other person's children, while they are pliable, and fit for learning, and esteem them to be of their kindred, and form them according to their own manners. They do not absolutely deny the fitness of marriage, and the succession of mankind thereby continued; but they guard against the lascivious behavior of women, and are persuaded that none of them preserve their fidelity to one man.

3 These men are despisers of riches, and so very communicative as raises our admiration. Nor is there any one to be found among them who hath more than another; for it is a law among them, that those who come to them must let what they have be common to the whole order—insomuch that among them all there is no appearance of poverty, or excess of riches, but every one's possessions are intermingled with every other's possessions; and so there is, as it were, one patrimony among all the brethren. They think that oil is a defilement; and if any one of them be anointed without his own approbation, it is wiped off his body; for they think to be sweaty is a good thing, as they do also to be clothed in white garments. They also have stewards appointed to take care of their common affairs, who every one of them have no separate business for any, but what is for the uses of them all. . . .

5 And as for their piety towards God, it is very extraordinary; for before sun-rising they speak not a word about profane matters, but put up certain prayers which they

have received from their forefathers, as if they made a supplication for its rising. After this every one of them are sent away by their curators, to exercise some of those arts wherein they are skilled, in which they labor with great diligence till the fifth hour. After which they assemble themselves together again into one place; and when they have clothed themselves in white veils, they then bathe their bodies in cold water. And after this purification is over, they every one meet together in an apartment of their own, into which it is not permitted to any of another sect to enter; while they go, after a pure manner, into the dining-room, as into a certain holy temple, and quietly set themselves down; upon which the baker lays them loaves in order; the cook also brings a single plate of one sort of food, and sets it before every one of them; but a priest says grace before meat; and it is unlawful for any one to taste of the food before grace be said. The same priest, when he hath dined, says grace again after meat; and when they begin, and when they end, they praise God, as he that bestows their food upon them; after which they lay aside their [white] garments, and betake themselves to their labors again till the evening; then they return home to supper, after the same manner; and if there be any strangers there, they sit down with them. Nor is there ever any clamor or disturbance to pollute their house, but they give every one leave to speak in their turn; which silence thus kept in their house appears to foreigners like some tremendous mystery; the cause of which is that perpetual sobriety they exercise, and the same settled measure of meat and drink that is allotted them, and that such as is abundantly sufficient for them. . . .

11 For their doctrine is this: That bodies are corruptible, and that the matter they are made of is not permanent; but that the souls are immortal, and continue for ever; and that they come out of the most subtle air, and are united to their bodies as to prisons, into which they are drawn by

a certain natural enticement; but that when they are set free from the bonds of the flesh, they then, as released from a long bondage, rejoice and mount upward. And this is like the opinions of the Greeks, that good souls have their habitations beyond the ocean, in a region that is neither oppressed with storms of rain or snow, or with intense heat, but that this place is such as is refreshed by the gentle breathing of a west wind, that is perpetually blowing from the ocean; while they allot to bad souls a dark and tempestuous den, full of neverceasing punishments. . . . [80]

14 But then as to the two other orders at first mentioned, the Pharisees are those who are esteemed most skillful in the exact explication of their laws, and introduce the first sect. These ascribe all to fate [or providence], and to God, and yet allow, that to act what is right, or the contrary, is principally in the power of men, although fate does cooperate in every action. They say that all souls are incorruptible, but that the souls of good men only are removed into other bodies—but that the souls of bad men are subject to eternal punishment. But the Sadducees are those that compose the second order, and take away fate entirely, and suppose that God is not concerned in our doing or not doing what is evil; and they say, that to act what is [90]

good, or what is evil, is at men's own choice, and that the one or the other belongs so to every one, that they may act as they please. They also take away the belief of the immortal duration of the soul, and the punishments and rewards in Hades. Moreover, the Pharisees are friendly to one another, and are for the exercise of concord, and [100] regard for the public; but the behavior of the Sadducees one towards another is in some degree wild, and their conversation with those that are of their own party is as barbarous as if they were strangers to them. And this is what I had to say concerning the philosophic sects among the Jews. ■

Reading Questions

Is there any correspondence between the doctrines of the Essene sect and Christianity, which was also developing as a sect of Judaism in Josephus's time? In terms of their relations with others, both Jewish and non-Jewish, Essenes and Christians differed dramatically. How do they differ, and what do you think are the consequences of those differences?

READING 9.4

The Gospel of Matthew, "The Sermon on the Mount"

The Gospel of Matthew was probably written in Syria in the years after the destruction of the temple in Jerusalem, although the date and place of its composition are much debated. It relies heavily on the other two synoptic gospels, Mark and Luke. Matthew and Luke, in turn, are believed by many scholars to have been influenced by a hypothetical "Q document," a text (or oral verse) that contained many of Jesus's sayings. The "Q document" would have circulated in the Middle East before Matthew or Luke was written, and would have borne a strong resemblance to the apocryphal Gospel of Thomas, itself a non-narrative collection of Jesus's sayings. In fact, of its 1,071 verses, only 370 are unique to Matthew, without parallel in the other gospels. Many of these unique verses are to be found in the Sermon on the Mount, delivered by Jesus in about 30 CE to his disciples and a large crowd. It outlines Christian ethics and its spiritual premises, often by contrasting traditional Jewish teachings with the new Christian version of the same teachings. But it does not reject its Jewish heritage. Rather, it sees itself as fulfilling the promise of Jewish law, not unlike the way in which the summer fruit of a tree fulfills the promise of the springtime's bud.

The Sermon on the Mount

And seeing the multitudes, he went up into a mountain: and when he was set, his disciples came unto him: and he opened his mouth, and taught them, saying,[1]

Blessed are the poor in spirit: for theirs is the kingdom of heaven.

Blessed are they that mourn: for they shall be comforted.

Blessed are the meek: for they shall inherit the earth.

Blessed are they which do hunger and thirst after righteousness: for they shall be filled.

Blessed are the merciful: for they shall obtain mercy. [10]

Blessed are the pure in heart: for they shall see God.

Blessed are the peacemakers: for they shall be called the children of God.

Blessed are they which are persecuted for righteousness' sake: for theirs is the kingdom of heaven.

Blessed are ye, when men shall revile you, and persecute you, and shall say all manner of evil against you falsely, for my

[1]The Sermon on the Mount is often regarded as the quintessence of Christian ethical teaching. That it is given from a hill (or "mountain") underlines a basic theme in what follows: the relationship of the new teaching to the law of Moses, also delivered from a mountain (Sinai).

sake. Rejoice, and be exceeding glad: for great is your reward in heaven: for so persecuted they the prophets which were before you. (5:1–12) 20

Ye are the salt of the earth: but if the salt have lost his savor, wherewith shall it be salted? it is thenceforth good for nothing, but to be cast out, and to be trodden under foot of men. Ye are the light of the world. A city that is set on an hill cannot be hid. Neither do men light a candle, and put it under a bushel,[2] but on a candlestick; and it giveth light unto all that are in the house. Let your light so shine before men, that they may see your good works, and glorify your Father which is in heaven. (5:13–16)

Think not that I am come to destroy the law, or the 30 prophets: I am not come to destroy, but to fulfill. For verily I say unto you, Till heaven and earth pass, one jot or one tittle shall in no wise pass from the law, till all be fulfilled. Whosoever therefore shall break one of these least commandments, and shall teach men so, he shall be called the least in the kingdom of heaven: but whosoever shall do and teach them, the same shall be called great in the kingdom of heaven. For I say unto you, That except your righteousness shall exceed the righteousness of the scribes and Pharisees, ye shall in no case enter into the kingdom of heaven. (5:17–20) 40

Ye have heard that it was said by them of old time, 'Thou shalt not kill'; and 'whosoever shall kill shall be in danger of the judgment':[3] but I say unto you, That whosoever is angry with his brother without a cause shall be in danger of the judgment: and whosoever shall say to his brother, 'Raca,'[4] shall be in danger of the council:[5] but whosoever shall say, 'Thou fool,' shall be in danger of hell fire. Therefore if thou bring thy gift to the altar, and there rememberest that thy brother hath ought against thee; leave there thy gift before the altar, and go thy way; first be reconciled to thy brother, 50 and then come and offer thy gift. Agree with thine adversary quickly, whiles thou art in the way with him;[6] lest at any time the adversary deliver thee to the judge, and the judge deliver thee to the officer, and thou be cast into prison. Verily I say unto thee, Thou shalt by no means come out thence, till thou hast paid the uttermost farthing.[7] (5:21–26)

Ye have heard that it was said by them of old time, 'Thou shalt not commit adultery': but I say unto you, That whosoever looketh on a woman to lust after her hath committed adultery with her already in his heart. And if thy right eye 60 offend thee, pluck it out, and cast it from thee: for it is profitable for thee that one of thy members should perish, and not that thy whole body should be cast into hell. And if thy right hand offend thee, cut it off, and cast it from thee: for it is profitable for thee that one of thy members should perish, and not that thy whole body should be cast into hell. It hath

been said, 'Whosoever shall put away his wife, let him give her a writing of divorcement': but I say unto you, That whosoever shall put away his wife, saving for the cause of fornication, causeth her to commit adultery: and whosoever 70 shall marry her that is divorced committeth adultery. (5:27–32)

Again, ye have heard that it hath been said by them of old time, 'Thou shalt not forswear thyself, but shalt perform unto the Lord thine oaths': but I say unto you, Swear not at all; neither by heaven; for it is God's throne: nor by the earth; for it is his footstool: neither by Jerusalem; for it is the city of the great King. Neither shalt thou swear by thy head,[8] because thou canst not make one hair white or black. But let your communication be, 'Yea, yea'; 'Nay, nay': for whatsoever is 80 more than these cometh of evil. (5:33–37)

Ye have heard that it hath been said, 'An eye for an eye, and a tooth for a tooth': but I say unto you, That ye resist not evil: but whosoever shall smite thee on thy right cheek, turn to him the other also. And if any man will sue thee at the law, and take away thy coat, let him have thy cloak also. And whosoever shall compel thee to go a mile, go with him twain.[9] Give to him that asketh thee, and from him that would borrow of thee turn not thou away. (5:38–42)

Ye have heard that it hath been said, 'Thou shalt love thy 90 neighbor, and hate thine enemy.[10] But I say unto you, Love your enemies, bless them that curse you, do good to them that hate you, and pray for them which despitefully use you, and persecute you; that ye may be the children of your Father which is in heaven: for he maketh his sun to rise on the evil and on the good, and sendeth rain on the just and on the unjust. For if ye love them which love you, what reward have ye? do not even the publicans[11] the same? And if ye salute your brethren only, what do ye more than others? do not even the publicans so? Be ye therefore perfect, even as your Father 100 which is in heaven is perfect. (5:43–48)

Take heed that ye do not your alms before men, to be seen of them: otherwise ye have no reward of your Father which is in heaven. Therefore when thou doest thine alms, do not sound a trumpet before thee, as the hypocrites do in the synagogues and in the streets, that they may have glory of men. Verily I say unto you, They have their reward. But when thou doest alms, let not thy left hand know what thy right hand doeth: that thine alms may be in secret: and thy Father which seeth in secret himself shall reward thee openly. (6:1–4) 110

And when thou prayest, thou shalt not be as the hypocrites are: for they love to pray standing in the synagogues and in the corners of the streets, that they may be seen of men. Verily I say unto you, They have their reward. But thou, when thou prayest, enter into thy closet,[12] and when thou

[2]A measuring tub for meal.

[3]Prosecutable in court. Jesus goes on to say that even anger should be similarly prosecutable, like actual murder.
[4]Blockhead or idiot.
[5]The Sanhedrin, the highest Jewish law court.
[6]On the way to court.
[7]The last penny of the money owed for which one is being sued.

[8]By one's self.
[9]Two.
[10]The Old Testament enjoins love of one's neighbor but not explicitly hatred of enemies. That was, however, a popular inference from the former.
[11]Tax collectors, a generally despised group; elsewhere in the Gospels they are usually mentioned more sympathetically.
[12]Private room. Jesus is not condemning, however, congregational prayer in the temple or synagogue.

hast shut thy door, pray to thy Father which is in secret; and thy Father which seeth in secret shall reward thee openly. But when ye pray, use not vain repetitions, as the heathen do: for they think that they shall be heard for their much speaking. Be not ye therefore like unto them: for your Father knoweth[120] what things ye have need of, before ye ask him. After this manner therefore pray ye:

Our Father which art in heaven,
Hallowed be thy name.
Thy kingdom come.
Thy will be done
 in earth as it is in heaven.
Give us this day our daily bread.
And forgive us our debts,
 as we forgive our debtors.[13] [130]
And lead us not into temptation,
 but deliver us from evil:[14]
For thine is the kingdom, and the power, and the glory, for
 ever. Amen.

For if ye forgive men their trespasses, your heavenly Father will also forgive you: but if ye forgive not men their trespasses, neither will your Father forgive your trespasses. (6:5–15)

Moreover when ye fast, be not, as the hypocrites, of a sad[140] countenance: for they disfigure their faces, that they may appear unto men to fast. Verily I say unto you, They have their reward. But thou, when thou fastest, anoint thine head, and wash thy face;[15] that thou appear not unto men to fast, but unto thy Father which is in secret: and thy Father, which seeth in secret, shall reward thee openly. (6:16–18)

Lay not up for yourselves treasures upon earth, where moth and rust doth corrupt, and where thieves break through and steal: but lay up for yourselves treasures in heaven, where neither moth nor rust doth corrupt, and where thieves do not break through nor steal: for where your treasure is, there will your heart be also. The light of the body is the eye: if there-[150] fore thine eye be single,[16] thy whole body shall be full of light. But if thine eye be evil, thy whole body shall be full of darkness. If therefore the light that is in thee be darkness, how great is that darkness! (6:19–23). . . .

Judge not, that ye be not judged. For with what judgment ye judge, ye shall be judged: and with what measure ye mete, it shall be measured to you again. And why beholdest thou the mote[17] that is in thy brother's eye, but considerest not the beam that is in thine own eye? Or how wilt thou say to thy brother, 'Let me pull out the mote out of thine eye'; and,[160] behold, a beam is in thine own eye? Thou hypocrite, first cast out the beam out of thine own eye; and then shalt thou see clearly to cast out the mote out of thy brother's eye. (7:1–5)

Give not that which is holy unto the dogs, neither cast ye your pearls before swine, lest they trample them under their feet, and turn again and rend you. (7:6)

Ask, and it shall be given you; seek, and ye shall find; knock, and it shall be opened unto you: for every one that asketh receiveth; and he that seeketh findeth; and to him that knocketh it shall be opened. Or what man is there of[170] you, whom if his son ask bread, will he give him a stone? Or if he ask a fish, will he give him a serpent? If ye then, being evil, know how to give good gifts unto your children, how much more shall your Father which is in heaven give good things to them that ask him? (7:7–11)

Therefore all things whatsoever ye would that men should do to you, do ye even so to them: for this is the law and the prophets. (7:12)

Enter ye in at the strait gate: for wide is the gate, and broad is the way, that leadeth to destruction, and many there[180] be which go in thereat: because strait is the gate, and narrow is the way, which leadeth unto life, and few there be that find it. (7:13–14)

Beware of false prophets,[18] which come to you in sheep's clothing, but inwardly they are ravening wolves. Ye shall know them by their fruits. Do men gather grapes of thorns, or figs of thistles? Even so every good tree bringeth forth good fruit; but a corrupt tree bringeth forth evil fruit. A good tree cannot bring forth evil fruit, neither can a corrupt tree bring forth good fruit. Every tree that bringeth not forth good fruit[190] is hewn down and cast into the fire. Wherefore by their fruits ye shall know them. (7:15–20). . . . ■

Reading Question

In many ways, the Sermon on the Mount is a reiteration, in the terms of Jesus's own day, of the Ten Commandments, similarly delivered by God on a mountain, Mount Sinai. How does this fact underscore the sectarian nature of early Christianity?

[13]The words *debts* and *debtors* can be rendered as, respectively, the wrongs we have committed and those that have been committed against us.
[14]In most of the earliest manuscripts, the Lord's Prayer ends here.
[15]Anointing and washing were part of preparing for a banquet.
[16]Healthy, as opposed to the "evil" (diseased) eye.

[17]A tiny speck of wood, as contrasted with a "beam," or large board.
[18]The caution against false prophets and that in the following passage against those who say "Lord, Lord" are less applicable to Jesus's own time than to the problems the early Church faced a half-century later (when Matthew was written).

READING 9.7

from Augustine's *Confessions*

Of all the Latin Church fathers, Augustine of Hippo was the most influential. His Confessions are unique in the history of early Christianity because they represent the personal struggle of an individual to overcome his love of worldly pleasures and come, instead, to love God. The distinction he draws between the rewards of the physical appetites as opposed to those of spiritual knowledge, between the demands of the body and those of the soul, are fundamental to the development of Christian doctrine. In the first of the two passages excerpted below, the famous episode of "The Pear Tree" in Book 2, he describes what can only be called his darkest moment, when, in his sixteenth year, his stole a neighbor's pears. Later, in Book 8, still leading a dissolute life as a student but despairing of his lifestyle, he describes his conversion to Christianity in a garden near Carthage at the age of 33.

from Book 2:

There was a pear tree close to our own vineyard, heavily laden with fruit, which was not tempting either for its color or for its flavor. Late one night—having prolonged our games in the streets until then, as our bad habit was—a group of young scoundrels, and I among them, went to shake and rob this tree. We carried off a huge load of pears, not to eat ourselves, but to dump out to the hogs, after barely tasting some of them ourselves. Doing this pleased us all the more because it was forbidden. Such was my heart, O God, such was my heart—which thou didst pity even in that bottomless pit. Behold, now let my heart confess to thee what it was seeking there, when I was being gratuitously wanton, having no inducement to evil but the evil itself. It was foul, and I loved it. I loved my own undoing. I loved my error—not that for which I erred but the error itself. A depraved soul, falling away from security in thee to destruction in itself, seeking nothing from the shameful deed but shame itself. 10

from Book 8:

The streams of my eyes gushed out. . . . And, not indeed in these words, but to this effect, I cried to thee: "And thou, O Lord, how long? How long, O Lord? Wilt thou be angry forever? . . . How long, how long? Tomorrow and tomorrow? Why not now? Why not this very hour make an end to my uncleanness?" 20

I was saying these things and weeping in the most bitter contrition of my heart, when suddenly I heard the voice of a boy or a girl I know not which—coming from the neighboring house, chanting over and over again, "Pick it up, read it; pick it up, read it." Immediately I ceased weeping and began most earnestly to think whether it was usual for 30 children in some kind of game to sing such a song, but I could not remember ever having heard the like. So, damming the torrent of my tears, I got to my feet, for I could not but think that this was a divine command to open the Bible and read the first passage I should light upon. So I quickly returned to the bench where . . . I had put down the apostle's book when I had left there. I snatched it up, opened it, and in silence read the paragraph on which my eyes first fell: "Not in rioting and drunkenness, not in chambering and wantonness, not in 40 strife and envying, but put on the Lord Jesus Christ, and make no provision for the flesh to fulfill the lusts thereof" [Romans 13:13]. I wanted to read no further, nor did I need to. For instantly, as the sentence ended, there was infused in my heart something like the light of full certainty and all the gloom of doubt vanished away. ■

Reading Question

What do you believe motivated Augustine to write his *Confessions*?

Summary

■ **Constructing the Empire** The North African imperial town of Thamugadi exemplifies how even the Empire's remotest outposts modeled themselves on Rome. Even here, the baths were the focus of social life, the symbol of Roman material well-being, but they gradually came to represent the moral depravity of the Empire to Christians, who banned them.

■ **The Rise of Christianity** Christianity developed as a sect of Judaism. By the first century CE, Judaism had become increasingly sectarian in nature, each sect believing that it possessed the one true understanding of God's will. It had also become increasingly messianic and apocalyptic. Preaching his own sectarian doctrine based on his understanding of the Hebrew Scriptures, Jesus was essentially an itinerant Jewish rabbi. His life and teachings, as described in the Gospels, written 40 to 80 years after his death, are the foundation of Christian faith. The religion was spread by evangelists, chief among them Paul, whose epistles comprise 14 books of the New Testament. Other evangelists wrote the gospels, which narrate the story of Jesus's life. Many of these, the so-called Gnostic gospels, which were perhaps inspired by Eastern religion, are not included in the Bible because the Church fathers came to see them as heresy. Among the orthodox gospels, the Gospel of Matthew is particularly important. It includes the Sermon on the Mount, which contains many of Jesus's most important teachings.

Although women were at first treated as equals in the Church—according to the Gnostic Gospel of Mary, Mary Magdalene was a disciple and evangelist—gradually their role was reduced and they were prohibited from holding positions of authority in the Church. To incorporate its Jewish heritage, early Christianity viewed its history as a typology, seeing the stories and figures of the Hebrew Scriptures as prefiguring the life of Jesus. Early Christian art is clearly indebted to Classical and Hellenistic precedents, but it includes many symbols designed to indicate the Christian content of the image. These symbols developed into a consistent iconography.

■ **Christian Rome** Christians were consistently blamed for the troubles that beset Rome after the fall of the Severan Dynasty. Diocletian unleashed a furious persecution in 303 and divided the Empire into four areas of rule—the tetrarchy.

Diocletian ruled in Asia Minor, where he presented himself as the divine manifestation of the Roman gods on Earth. Thus Christians, who were monotheistic and worshiped their own god, were a direct threat to his own authority. When Diocletian retired in 305, various rulers vied for power. In 312, Constantine I ("Constantine the Great") assumed total authority. Giving at least some credit for his victory to Christian symbols on his soldiers' shields, he granted religious freedom in the Edict of Milan of 313. Constantine became increasingly supportive of Christianity, convening the first ecumenical council of Church leaders in 325 at Nicea, near his new capital at Constantinople. The resulting Nicene Creed established a uniform liturgy. Soon the Bible was translated into Latin by Saint Jerome, and Ambrose, bishop of Milan, wrote some of the earliest hymns to accompany the liturgy.

Like so many Roman emperors before him, the victorious Constantine celebrated with a campaign of public works. The Classical and naturalistic style of these works contrasts dramatically with the style of the relief, *Constantine Addressing the People*, which conveys no real sense of illusionistic space. The standards of beauty that defined Classical art have been replaced by a more abstract standard of beauty that has little or no interest in the body.

Constantine erected the last great imperial building in Rome, the Basilica Nuova, whose architectural features anticipate the first great Christian church, St. Peter's Basilica. A second type of Christian church was built as a mausoleum for Constantine's daughter, Constantia. Santa Costanza is a central plan church, decorated with mosaics of a vine pattern. Although fully Christian in their symbolism, these mosaics suggest the ways that Christianity incorporated Greek and Roman mythic traditions, including the mystery cults of Dionysius, Isis, and Mithras.

■ **Augustine and Boethius** Augustine's *Confessions* are the first Western autobiography, describing his conversion to Christianity. His *City of God* argues that the demise of the Roman Empire was caused by the arrogance of its emperors and the worldly concerns of the citizens of the earthly city. Romans, he argues, might be saved if they turn their attention to the heavenly city of God. Augustine's Roman follower, Boethius, authored the *Consolation of Philosophy*. One of the most influential books of the later Middle Ages, it is a meditation on the role that free choice plays in Christian thought.

Glossary

ambulatory The walkway around the outside of the circular central space of a **central plan church**.

antiphonal Musical form of chanting in which one side of the choir responds to the other.

apocalypse The coming of God on the day of judgment.

apse The semicircular niche at the end of the nave of a Christian basilica containing the altar.

basilica An early Christian church having a central nave, side aisles, and an apse at one or both ends.

central plan church A circular structure topped by a dome with an **ambulatory** around the central space.

clerestory The topmost zone of the wall of a basilica containing windows.

dogma Prescribed Church doctrine.

ecumenical council Worldwide council of Church leaders.

evangelist One who spreads the word of Jesus's life and resurrection.

Gnostic gospels Written by those who profess secret knowledge of Jesus's life.

heresy Opinion or doctrine at odds with orthodox belief.

iambic tetrameter The three-beat rhythm of Ambrose's hymns, consisting of three iambs (short-long).

iconography The literal (factual) and figurative (symbolic) significance of an image.

Latin cross The design of a Christian basilica with a long arm (the nave) and three shorter arms—the **apse** and the arms of the **transept**.

liturgy The rites prescribed for public worship.

Messiah Anointed One.

messianic Prophesied that the world will end in **apocalypse**.

mystery cult Religious group with secret initiation rituals.

narthex The entrance hall of a Christian basilica.

nave The central space of a Christian basilica, usually flanked by aisles.

Providence God's plan for the world.

roundel A round relief.

sect A small, organized group that separates itself from the larger religious movement.

syncretism The reconciliation of different rites and practices into a single philosophy or religion.

synoptic gospels Gospels that tell the same stories, in the same sequence, often using the same words.

synagogues Jewish houses of worship.

tetrarchy The four-part monarchy begun by Diocletian that divided the Empire into two areas ruled by an Eastern and Western emperor, each with a designated successor.

transept The arm of the Latin cross church perpendicular to the nave.

type A prefigurative symbol.

typology The doctrine of prefigurative symbols, or types, in scriptural literature.

Vulgate The Latin Bible.

Critical Thinking Questions

1. What are the chief differences between Christian and Gnostic belief?

2. What led the Romans to persecute Christians?

3. What is typology and how does it affect the Christian reading of the Old Testament?

4. What was the significance of the Nicene Creed?

Turning Away from Naturalism

A remarkable shift away from naturalistic representation occurred after the fall of the Roman Empire and the Christianization of the Western world. By 300 CE, when *The Good Shepherd* (see Fig. 9.7) was carved, Christians lived throughout the Roman Empire. However, the sculpture is itself fully classical in style. The shepherd stands in a contrapposto pose, his clothing falling across his limbs to reveal his anatomy. The sheep he carries twists with almost Hellenistic dynamism. Within 30 years, however, naturalism was abandoned. Christians saw little purpose in depicting the earthly body, and large, freestanding sculpture like *The Good Shepherd* would completely disappear until the twelfth century.

Sculpture became a largely decorative medium, used primarily in relief on sarcophagi, in metalwork, and on commemorative plaques. One such plaque, *Christ Blessing Emperor Otto II and Theophona* [the-YOH-foh-nah] (Fig. **9.24**), was carved in 982–983 for the coronation of the Emperor Otto II, whose wife Theophona was a member of the Byzantine royal family. In

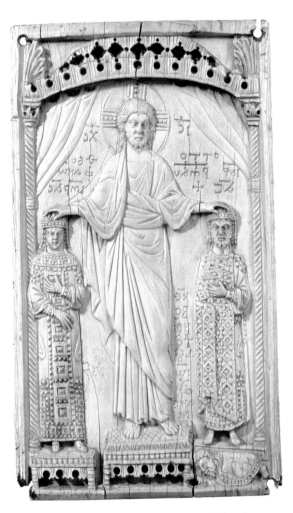

Fig. 9.24 *Christ Blessing Emperor Otto II and Theophona.* **982–983.** Ivory, $7\frac{1}{4}'' \times 4\frac{1}{4}''$. Musée National de Moyen Age de Cluny, Paris.

this miniature, and in the art of the Byzantine Empire generally, the figures are flattened to the point of becoming almost bodiless beneath their robes. The figure of Christ is static and unanimated. The emperor and his wife are also lifeless and almost two-dimensional. And though they are distinguished by the decorative pattern of their dress, their size is diminished in hierarchical and respectful submission to Christ. The celebration of human potential and accomplishment that was embodied in the philosophy and art of the Greeks and Romans had been replaced by an art that celebrates, not human life, but the otherworldly values of religious faith. This transformation would be visible throughout the Middle Ages.

For at least a thousand years, throughout the Middle Ages, naturalism and the humanist philosophical traditions that inspired it remained far removed from the concerns of art and artists. The visible things of this world seemed unimportant, even at odds with the invisible, divine things of the Christian heaven. The Church was sculpture's sole patron. Artists might create images of Christ, the Virgin, and saints. Representations of nudes were limited to Adam and Eve and St. Sebastian, his body shot through with arrows. Not until the fourteenth century would naturalism begin to reemerge in Western art. ■

10 Byzantium

Constantinople and the Byzantine Empire

Constantine's New City

Ravenna and the Western Empire

The Later Byzantine Empire

> **❝** *So the church has been made a spectacle of great beauty, stupendous to those who see it and altogether incredible to those who hear of it.* **❞**
>
> Procopius, *On Justinian's Buildings*

◄ **Fig. 10.1 Hagia Sophia, Istanbul (formerly Constantinople). 532–37.** Originally dedicated to Christ as the personification of Holy (*hagia*) Wisdom (*sophia*), the cathedral was commissioned in the 6th century by the emperor Justinian. Today, it serves as a museum, although it remains one of the oldest religious sanctuaries in the world. The artistic traditions of the Byzantine Church would remain almost unchanged for nearly a millennium—that is, throughout the Middle Ages—even as Constantinople asserted itself as the center of culture in the eastern Mediterranean.

B

YZANTIUM WAS A RELATIVELY UNIMPORTANT HARBOR CITY before the arrival of Constantine, the first Christian ruler of the Roman Empire. Located on the shore of the Bosporus, the straits linking the Black Sea with the Aegean, its site was strategic. In 325, the emperor decided to remake

Byzantium as his new imperial capital, and he renamed it after himself, Constantinople, the *polis* of Constantine. The city's main attraction for Constantine was its defensible peninsular site (Map **10.1**). Constantine's move of the imperial capital to Byzantium has often been represented as a purposeful break with the pagan Roman past—an attempt to create a new Christian capital—but in fact it was primarily a military decision motivated by the threat of Germanic invaders from the Balkans to the north (modern Serbia, Croatia, and Romania). Except that he built churches instead of temples, Constantine constructed his new city very much in the image of the old, pagan Rome. It was the Second Rome, not Rome's denial.

Constantine's empire was also a second empire. In the eighteenth century scholars named it the Byzantine [BIZ-un-teen] Empire, after the original city of Byzantium. It lasted until 1453, when the Ottoman Turks conquered Constantinople. Although the Empire's power was focused in the eastern Mediterranean, in modern-day Turkey, Israel, Lebanon, and Syria, its influence extended as far west as Spain, across northern Africa, and included large parts of Italy and all of Greece. As capital of the Empire, Constantinople boasted magnificent forums and elaborate baths. Great basilicas (Fig. **10.1**) signaled its role as the center of Christian culture in the early Middle Ages. The city's two roles, center of the Empire and center of the Church, can be traced to two historical factors. First, in 286 CE the Roman emperor Diocletian divided the Empire into two halves— the Eastern Greek empire and the Western Latin empire, ruled by the tetrarchs (see chapter 9). Second, the western half of the Empire was susceptible to invading Germanic forces, resulting in its collapse in 476 and the relocation of the Church to the eastern capital.

This chapter surveys the consequences of that relocation. First and foremost, it resulted in a division of belief and doctrine between the Western (Catholic) Church and the Eastern (Orthodox) Church. As a result of this division there developed a new Byzantine standard of beauty, which replaced the physical ideal of Classical art with the representation of spiritual power, and which led many to question the validity of representing the physical body. As a result, Byzantine art abandoned the naturalism of Classical

art. As the Empire regained control of territories in the west that had earlier succumbed to Germanic invasion, the Byzantine style spread into the rest of Europe as well. The style would endure for over 1,000 years.

Constantine's New City

In Constantinople, Constantine built forums, baths, and palaces that were in every way reminiscent of those in Rome. Every province in the Empire was ordered to send him statuary and art to adorn the new city. Works in the manner of the Greek sculptors Phidias and Praxiteles, whose sculptures the emperor collected, soon stood in his palaces. At the hippodrome, the giant entertainment complex for horse and chariot races he built to match the Circus Maximus in Rome, Constantine installed, among other great works, the bronze horses that today are housed in Venice (Fig. **10.2**). His palace, overlooking the Marmara Sea, was directly attached to his own box seat at the hippodrome. Next door, at the Baths of Zeuxippos, a statuary group of 29 figures represented the fall of Troy. A giant forum, described by a contemporary chronicler as circular, "with porticoes two stories high, and two very large arches of Prokonnesos marble facing one another," was the focal point of the new city, dominating the top of a street that led up from the palace. In its center was a massive column, on the top of which stood a bronze sculpture of the emperor. Rays of the sun radiated from his head, creating an image completely pagan in its attributes: the emperor as Sun God looking over the world, which was represented by the circular shape of the forum below.

Roman Baths and Christian Basilicas

Defying expectation, at the heart of his new city the emperor erected not a temple but a Christian basilica. We know very little about this church today, except that it was named Hagia Eirene, "Holy Peace." It stood across the main square from the emperor's palace. Also facing this square, known as the Augustaeum [aw-GUS-tee-um], in honor of Constantine's mother, Helena Augusta, stood the senate and the baths—all the elements of civic life centered around a single spot. Soon after Constantine's death, his son, Constantius II, erected a second Christian basilica next to the first one, naming it

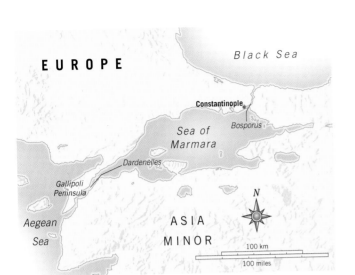

Map 10.1 From the Aegean to the Black Sea: The Dardenelles to the Bosporus.

Hagia Sophia [HA-jee-uh so-FEE-uh], "Holy Wisdom," thus affirming the centrality of Christianity to Byzantine life.

In Constantine's Constantinople, Christian basilicas stood next to Roman baths, across from a Roman palace and senate, the former connected to a Roman hippodrome, all but the basilicas elaborately decorated with pagan art and sculpture gathered from across the Empire. Christians soon developed an important new understanding of these pagan works: They could

ignore their pagan elements and think of them simply as *art*. This was the argument of Basil the Great (ca. 329–79), the major theologian of the day. In his twenties he had studied the classics of Greek literature in Athens and had fallen in love with them. He believed it was possible to understand them as literature, not theology, as great works of art, not as arguments for the existence of pagan gods.

Nonetheless, Roman pagan ways soon gave way to Christian doctrine. Constantine himself outlawed pagan sacrifices, and though the emperor Julian the Apostate (r. 361–63) briefly attempted to reinstate paganism, by the time of Theodosius [the-uh-DOE-she-us] I's rule (379–95), all pagan temples were closed throughout the Empire, and Christianity was the official religion. However, Roman law, not Biblical law, remained the norm in Byzantine culture, schools taught classical Greek texts, especially Homer's *Iliad*, and important writers still modeled their work on classical precedents. Nevertheless, by the middle of the sixth century, the emperor Justinian had closed the Academy of Athens, the last pagan school of philosophy in the Empire, and over 100 churches and monasteries stood in Constantinople alone.

This latter statistic is in some ways a reflection of the city's astonishing growth. One need only compare its size in Constantine's time, as evidenced by the boundary wall he erected to fortify the peninsula, to its size under Theodosius II (r. 408–50) in 412 (Map **10.2**). The double wall and moat that Theodosius II erected—the moat was created by connecting the Golden Horn to the Marmara Sea—more than

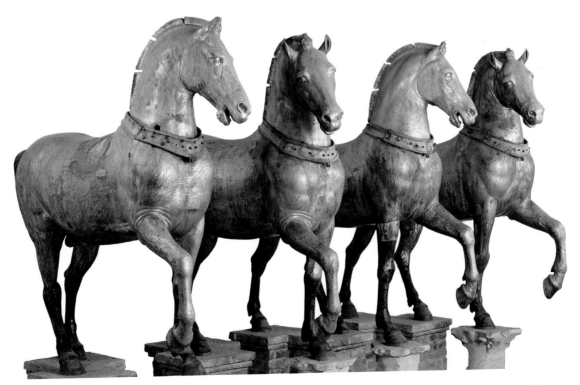

Fig. 10.2 Horses of San Marco. Greek or Roman, 2nd–3rd centuries. Gilt-bronze, life-size. Museo di San Marco, Venice. When Christian crusaders captured Constantinople in 1204, they confiscated these horses and brought them back to Venice to decorate their own great Byzantine-style cathedral.

doubled the size of the fortified city (Fig. **10.3**).

Constantinople under Justinian and Theodora

Virtually impregnable defenses protected Constantinople from the fate of the rest of the Empire. In 410, Visigoths ("Western Goths") sacked Rome (perhaps inspiring Theodosius II to build the new wall at Constantinople). Vandals, another Germanic tribe, followed suit in 455, seizing not only Rome but its grain supply in North Africa and most of Spain as well. Successive waves of Saxons, Angles, and Jutes attacked and occupied Britain. Burgundians took over Roman France. In 476, Odoacer, a Germanic leader, named himself king of Italy (r. 476–93), which he governed from the northern Italian city of Ravenna. Finally, the Ostrogothic ("Eastern Gothic") king Theodoric the Great overthrew Odoacer in 493 and ruled Italy until 526.

The Byzantine emperors tolerated Theodoric's rule in Italy largely because he was Christian and had been raised in the imperial palace in Constantinople. But after a new

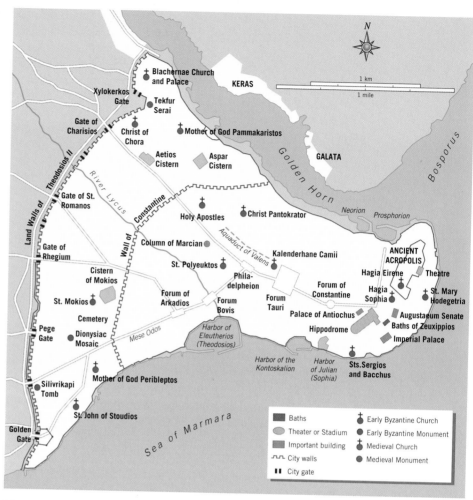

Map 10.2 Early Byzantine and Medieval Constantinople.

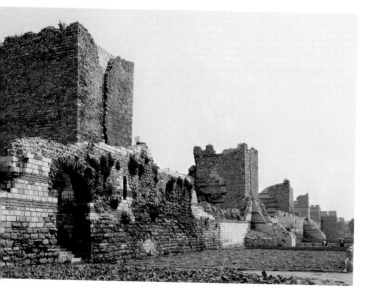

Fig. 10.3 Land walls of Constantinople, with moat in front. 412–13.
These walls, built by Theodosios II, proved to be impregnable. They protected the city against enemy attack until the Turks invaded in the 15th century, aided by the use of modern cannons.

young emperor, Justinian (r. 527–65), assumed the Byzantine throne, things quickly changed (Map **10.3**). Justinian launched a massive campaign to rebuild Constantinople, including the construction of a giant new Hagia Sophia (see Fig. 10.1) at the site of the old one when the latter was burned to the ground in 532 by rioting civic "clubs"—that probably were more like modern "gangs." The riots briefly caused Justinian to consider abandoning Constantinople, but his queen, Theodora [the-oh-DOR-uh], persuaded him to stay: "If you wish to save yourself, O Emperor," she is reported to have counseled, "that is easy. For we have much money, there is the sea, here are the boats. But think whether after you have been saved you may not come to feel that you would have preferred to die." Justinian may well have begun construction of the new Hagia Sophia to divert attention from the domestic turmoil stirred up by the warring gangs. And he may have conceived his imperial adventuring to serve the same end. In 535, he retook North Africa from the Visigoths, and a year later he launched a campaign, headed by his general Belisarius, to retake Italy from the successors of Theodoric. But through his massive building program, especially, Justinian aimed to assert not only his political leadership but his spiritual authority as well. His rule was divine, as his divine works underscored.

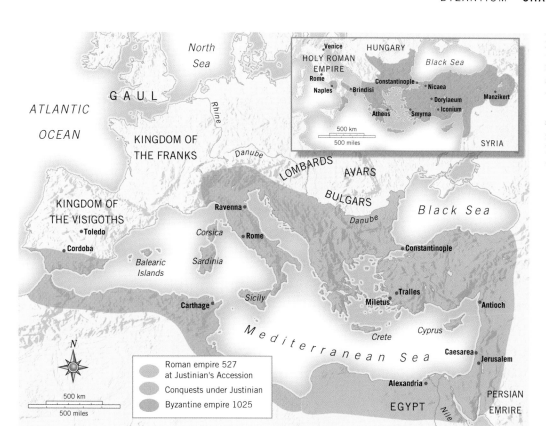

Map 10.3 The Byzantine Empire at the death of Justinian in 565 and in 1025. The insert shows the Empire nearly 500 years after Justinian's reign, in 1025. Although it had shrunk in size, the Byzantine Empire remained a powerful force in the Eastern Mediterranean throughout the Middle Ages.

Procopius's *Secret History* The empress's words were recorded by Procopius [pruh-KOH-pee-us] of Caesarea (ca. 490–ca. 560), Justinian's official court historian, in his *Anekdota*, or *Secret History*. This work was a scathing, deceitful, and almost surely apocryphal account of Justinian and Theodora's rule that was not intended for publication in the author's lifetime—hence its "secret" status. Procopius evidently harbored much ill will toward his employers. He attacks the emperor and empress on moral grounds, particularly citing the lowness of their origins and the baseness of their behavior, and he quite evidently sees himself as their superior (**Reading 10.1**):

READING 10.1 **from Procopius, *Secret History* (ca. 550)**

This Emperor, then, was deceitful, devious, false, hypocritical, two-faced, cruel, skilled in dissembling his thought, never moved to tears by either joy or pain, though he could summon them artfully at will when the occasion demanded, a liar always, not only offhand, but in writing, and when he swore sacred oaths to his subjects in their very hearing. Then he would immediately break his agreements and pledges, like the vilest of slaves, whom indeed only the fear of torture drives to confess their perjury. A faithless friend, he was a treacherous enemy, insane for murder and plunder, quarrelsome and revolutionary, easily led to anything evil, but never willing to listen to good counsel, quick to plan mischief and carry it out, but finding even the hearing of anything good distasteful to his ears.

He took a wife . . . Theodora [had been] a courtesan, and such as the ancient Greeks used to call a common one, at that: for she was not a flute or harp player, nor was she even trained to dance, but only gave her youth to anyone she met, in utter abandonment. Her general favors included, of course, the actors in the theater; and in their productions she took part in the low comedy scenes. For she was very funny and a good mimic, and immediately became popular in this art. There was no shame in the girl, and no one ever saw her dismayed: no role was too scandalous for her to accept without a blush. . . . On the field of pleasure she was never defeated. . . . Often, even in the theater, in the sight of all the people, she removed her costume and stood nude in their midst, except for a girdle about the groin: not that she was abashed at revealing that, too, to the audience, but because there was a law against appearing altogether naked on the stage, without at least this much of a fig-leaf. . . .

Justinian comes off as little better than a common thief, Theodora as a nymphomaniac (the reader will have to imagine some of Procopius's more offensive descriptions of Theodora's

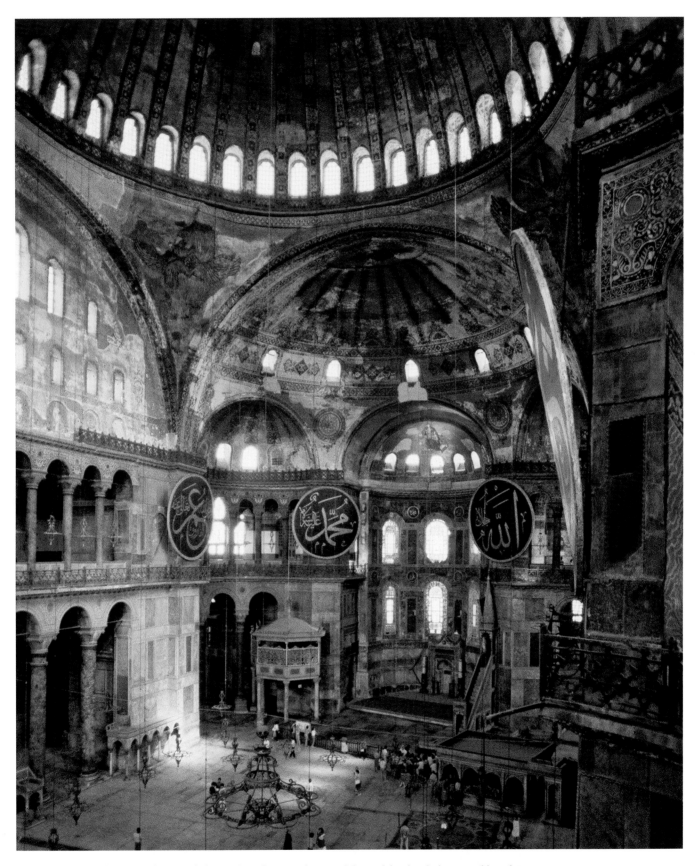

Fig. 10.4 Interior of Hagia Sophia, Istanbul. 532–537. So vast is the central dome of the church that it was likened, in its own time, to the dome of heaven. It was said that to look up at the dome from below was akin to experiencing the divine order of the cosmos.

behavior, which are simply too outrageous to include here). But Procopius does not come off particularly well himself. His account of the couple seems to have been provoked by the fact that the two enjoyed a union of mutual respect and apparently equal status. Theodora represented a nexus of power—not simply female but evidently more ruthless and far less easy-going than her husband—that did not fit a conventional understanding of women's place in society, a place Theodora sought constantly to improve. She shut down brothels in the capital, intervened on behalf of wronged women, and influenced the passage of many laws to improve the status of women in the Empire. As court historian, Procopius was well aware of the empress's good works, so the duplicity and deceit of his sexist attack on the empress are immediately evident, his delight in scandal and rumor-mongering clear, and his tabloid sensationalism everywhere apparent. In his ranting we can recognize the level of invective that many public figures have endured throughout Western history. Procopius was far more than simply a scandal monger. He also served as the official historian of Justinian's military, modeling his eight-volume *History of the Wars of Justinian* on the classical example of Thucydides. (See *Voices*, page 320.)

Hagia Sophia At the emperor's request Procopius wrote a treatise, *On Justinian's Buildings*. Book I is dedicated to the new Hagia Sophia (Fig. **10.4**) that Justinian erected on the site of the one that had burned down. As a result of Procopius's writings, we know a great deal about the building itself, including the identity of its architects, two mathematicians named Isidorus of Miletus and Anthemius of Tralles. Isidorus had edited the works of Archimedes, the third-century BCE geometrician who established the theory of the lever in mechanics, and both he and Anthemius had made studies of parabolas and curved surfaces. Their deep understanding of mathematics and physics is evident in their plan for Hagia Sophia.

Their completely original design (Fig. **10.5**) consisted of a giant dome on a square base, the thrust of the dome carried on four giant arches that make up each side of the square. Between these arches are triangular curving vault sections, called **pendentives**, that spring from the corners of the base. The dome that rises from these pendentives has around its base 40 windows, creating a circle of light that makes the dome appear to float above the naos, underscoring its symbolic function as the dome of heaven. The sheer height of the dome adds to this effect—it is 184 feet high (41 feet higher than the Pantheon), and 112 feet in diameter. In his treatise *Justinian's Buildings*, Procopius describes the central domed section of the church (**Reading 10.2**):

Fig. 10.5 Anthemius of Tralles and Isidorus of Miletus. Plan and section of Hagia Sophia, Istanbul. 532–537.

READING 10.2 **from Procopius, *On Justinian's Buildings* (ca. 537)**

So the church has been made a spectacle of great beauty, stupendous to those who see it and altogether incredible to those who hear of it. ... It abounds exceedingly in gleaming sunlight. You might say that the [interior] space is not illuminated by the sun from the outside, but that the radiance is generated within, so great an abundance of light bathes this shrine all round. In the middle of the church there rise four man-made eminences which are called piers, two on the north and two on the south, each pair having between them exactly four columns. The eminences are built to a great height. As you see them, you could suppose them to be precipitous mountain peaks. Upon these are placed four arches so as to form a square, their ends coming together in pairs and made fast at the summit of those piers, while the rest of them rise to an immense height. Two of the arches, namely those facing the rising and setting sun, are suspended over empty air, while the others have beneath them some kind of structure and rather tall columns. Above the arches the construction rises in a circle. Rising above this circle is an enormous spherical dome which makes the building exceptionally beautiful. It seems not to be founded on solid masonry, but to be suspended from heaven by that golden chain and so covers the space.

Voices

Bubonic Plague Arrives in Byzantium

As court historian for Justinian in the sixth century, Procopius wrote the multi-volume History of the Wars, *chronicling the military campaigns of the era. However,* The Wars *also contains descriptive details about Byzantium, including the first recorded instance of Bubonic plagues to reach Europe in 542 CE.*

"Apparitions of supernatural beings in human guise of every description were seen by many persons . . . and immediately upon seeing this apparition they were seized also by the disease."

During these times there was a pestilence, by which the whole human race came near to being annihilated. . . .

In the second year it reached Byzantium in the middle of spring, where it happened that I was staying at that time. And it came as follows. Apparitions of supernatural beings in human guise of every description were seen by many persons, and those who encountered them thought that they were struck by the man they had met in this or that part of the body, and immediately upon seeing this apparition they were seized also by the disease.

Now at first those who met these creatures tried to turn them aside by uttering the holiest of names and exorcising them in other ways as well as each one could, but they accomplished absolutely nothing, for even in the sanctuaries where most of them fled for refuge they were dying constantly. . . .

But with the majority it came about that they were seized by the disease without becoming aware of what was coming either through a waking vision or a dream. They were taken in the following manner. They had a sudden fever, some when just roused from sleep, others while walking about . . . the body showed no change from its previous color, nor was it hot as might be expected . . . nor indeed did any inflammation set in . . . It was natural, therefore, that not one of those who had contracted the disease expected to die from it. But on the same day in some cases, in others on the following day, and in the rest not many days later, a bubonic swelling developed; and this took place not only in the particular part of the body which is called *boubon*, that is, "below the abdomen," but also

inside the armpit, and in some cases also beside the ears, and at different points on the thighs. For there ensued with some a deep coma, with others a violent delirium . . .

Now some of the physicians who were at a loss because the symptoms were not understood, supposing that the disease centred in the bubonic swellings, decided to investigate the bodies . . . And upon opening some of the swellings, they found a strange sort of carbuncle that had grown inside them. Death came in some cases immediately, in others after many days; and with some the body broke out with black pustules about as large as a lentil and these did not survive even one day. . . . With many also a vomiting of blood ensued without visible cause and straightway brought death.

Now the disease in Byzantium ran a course of four months. . . . And at first the deaths were a little more than the normal, then the mortality rose still higher, and afterwards the tale of dead reached five thousand each day, then ten thousand. . . . Now in the beginning each man attended to the burial of the dead of his own house, and these they threw even into the tombs of others, either escaping detection or using violence; but afterwards confusion and disorder everywhere became complete. For slaves remained destitute of masters, and men who in former times were very prosperous were deprived of the service of their domestics who were either sick or dead, and many houses became completely destitute of human inhabitants.

Procopius does not mention that to the east and west, beneath the arches, are conch domes, or half domes, semicircular structures that spread out from a central dome, extending the space, and that these in turn are punctuated by yet smaller conch domes. Thus, a succession of curving spaces draw the visitor's eyes both upward to the symbolically heavenly space of the dome and forward to the sanctuary apse, seat of the altar and the liturgy. The intricate and lacy carving on the lower levels lends the stonework an almost immaterial lightness. The domes above are believed to have been covered with mosaics, probably consisting in the sixth century of plain gold grounds ornamented with crosses. Light from the windows around the

base of the dome and conch domes would have ricocheted around the gold-covered interior, creating the magical, even celestial light that Procopius describes.

The original dome collapsed in an earthquake in 558 and was subsequently rebuilt from a design by Isidorus's nephew. That dome collapsed as well, just five years later. There were additional partial collapses in 989, and finally a chain was added to help hold it together. After the Turkish conquest of Constantinople in 1453, the church became a mosque. The Turks added four minarets, towers from which a *muezzin*, a person chosen especially for the task, called the Muslim faithful to prayer. The Turks also plastered over many of the church's orig-

inal Christian mosaics, but apparently recognizing the artistic value of the original decoration, they periodically removed the plaster, restored the mosaics, and then replastered them. After the building was secularized and converted into a museum in 1935, some of these mosaics were uncovered.

St. Catherine's Monastery Justinian was not content merely to rebuild Constantinople. Bridges, roads, aqueducts, monuments, churches, and monasteries sprang up around the Empire. Not the least important of these sixth-century works was the fortress and monastery known as St. Catherine's (Fig. **10.6**), at the foot of Mount Sinai [SY-nye], in the desert near the tip of the Sinai Peninsula, in modern Egypt. It was at Mount Sinai that, according to the Old Testament, God gave Moses the Ten Commandments. The monastery was sited on the spot of the burning bush, where tradition held that God had first addressed Moses and instructed him to go to Egypt and lead the Jews to the Promised Land. Thus, the monastery had great symbolic significance.

Justinian decorated the monastery church with marble imported from quarries on an island in the Sea of Marmara, approximately 112 miles southwest of Constantinople. On

CULTURAL PARALLELS

Christianity and Paganism

Emperor Theodosius and his successors closed pagan temples and schools, making Christianity the sole religion in Constantinople from 300 CE onward. At the same time, paganism was growing at the opposite end of the fading Roman Empire. In the Roman province of Britain, the Germanic and Norse tribes began to practice their pagan rituals openly while they forged a new Anglo-Saxon culture.

the east end of the monastery, above these marble panels, in the conch dome of the apse, artisans created an extraordinary mosaic of the *Transfiguration of Christ* (Fig. **10.7**). The scene depicts the moment described in Matthew 17:1–6 when Jesus becomes a dazzling vision on Mount Tabor and a heavenly voice proclaims him to be God's son. In the center of the mosaic, Jesus appears within a **mandorla** [MAN-dor-luh], the

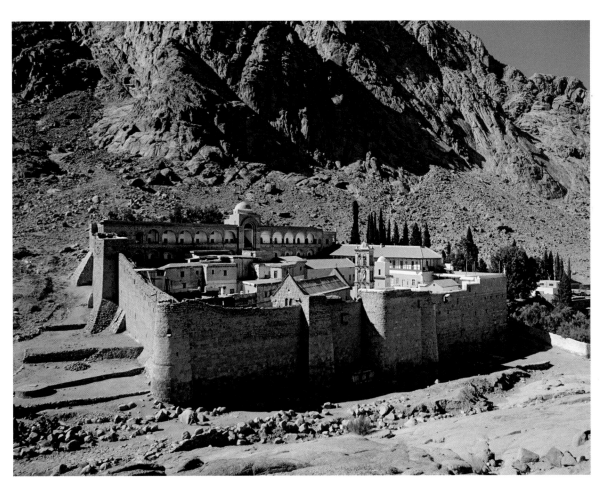

Fig. 10.6 St. Catherine's Monastery, Sinai. ca. 548–65. The fortress around the monastery was built to protect pilgrims and monks from marauding "Saracens" (i.e., Arabs).

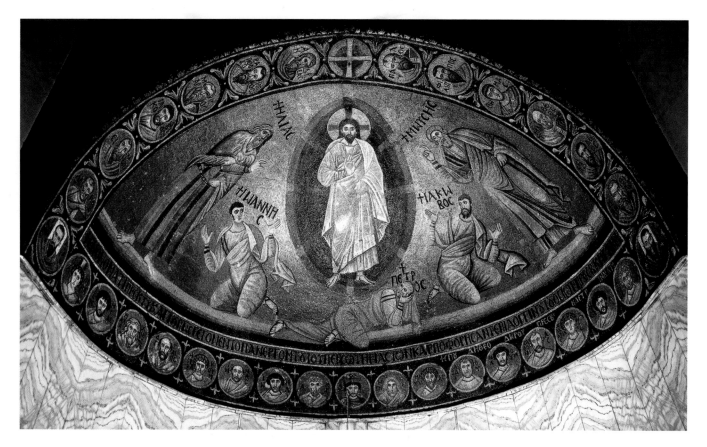

Fig. 10.7 *Transfiguration of Christ*, Church of the Virgin, St. Catherine's Monastery, Sinai. ca. 548–65. Mosaic. The marble panels, below the mosaic, must have been brought to the relatively remote site at great expense. The creators of the mosaic were probably also from elsewhere, though an inscription attributes the work to "the zeal" of Theodoros the Priest. He may have cultivated Justinian's patronage of the monastery.

light encircling or emanating from the entire figure of a sacred person, here an almond-shaped halo that signifies his glory. At his sides are the Old Testament prophets Elijah and Moses, and the disciples John, Peter, and James cower beneath his feet in amazement. Mount Tabor seems to be represented by the rainbow band of colors at the bottom of the image—each of the figures except Christ seems to stand, kneel, or lie on it—but there is no real sense of space here. Rather, the entire scene is bathed in the celestial gold light that emanates in rays from Christ's white tunic. This effect is heightened by the way light reflects off the irregular surface of the *tesserae*, the small pieces of stone or glass, that make up the mosaic (see *Materials and Techniques*, page 323).

The Abandonment of Naturalism The naturalism that dominates Greek and Roman classical art is not apparent in the St. Catherine mosaics. The artists evidently had no interest in depicting the visual appearance of the material world; instead, they turned their attention to the supernatural event of the transformation. There is no perspectival depth—as if the vision of Christ's transformation obliterates the possibility of even thinking in terms of real space. Although the event depicted is

Continuity & Change
p. 217

Dying Gaul

highly dramatic, the participants' gestures are stiff, lacking the natural drama of Hellenistic sculpture (compare with Fig. 7.27, the *Dying Gaul*). The figures are highly stylized and realized in a uniform geometric configuration. Notice the repeated use of a lozenge shape to depict the thighs of the disciples. And despite being bathed in light, these figures cast no shadows. The robes of both John, on the left, and James, on the right, blow backward in identical but improbable folds. The feet of the two prophets and Christ not only look alike but are similarly positioned. The sandaled feet of the three disciples could be transferred one to the other without a problem.

The artists, in other words, employed a standardized shorthand to depict the events. It is as if their artistic vocabulary consisted of a limited repertoire of feet, hands, robes, and faces, all of which could be used over and over again in any context, the most important figure being the largest. We call this style, which is at once formally abstract and priestly, **hieratic**. In retrospect, we can see the abstraction developing in earlier Chris-

Materials & Techniques Byzantine Mural Mosaics

Byzantine mural mosaics were made by embedding into a soft cement or plaster more or less regular squares of naturally colored stone, together with squares of opaque glass, which offered an even greater variety of color. These squares are called *tesserae* (sing. *tessera*), from the Greek word meaning "squares" or "groupings of four." Gold tesserae could be made by sandwiching gold leaf between two layers of glass, a practice widely used in Byzantine mosaics. Artists first outlined the image on the wall, then covered suc-

cessive areas with cement or plaster, filling in the tesserae as they went. Each tessera was set at a slight angle to the one adjacent to it, so that as light struck the squares, the changing angle of refraction would create a shimmering, almost heavenly radiance, both mystical and spiritual. In contrast, Greek, Roman, and earlier floor mosaics were usually laid with flat tesserae in a perfectly even surface so as not to impede walking. And the tesserae were usually limited to pebble, stone, and shell.

Continuity & Change
p. 292

Arch of
Constantine

tian art, in the reliefs, for instance, on Constantine's triumphal arch in Rome (see Fig. 9.10). But whereas the figures on Constantine's relief are squat and blocky, now, 300 years later, they are tall, thin, and elegant. These priestly figures float weightlessly in an ethereal space, as if, in witnessing the supernatural mystery of the Transfiguration, they have been transfigured themselves. But the differences between these figures and earlier ones are not just stylistic—they extend to meaning as well. Constantine had built and decorated his triumphant arch to celebrate his temporal power, but the mosaic at St. Catherine's celebrates a power that is otherworldly, just as Christ stands wholly disconnected from the ground.

Ravenna and the Western Empire

The most extensive examples of Byzantine art survive in Ravenna [ruh-VEN-uh], a relatively small city in northern Italy near the Adriatic [ay-dree-AT-ik] Sea. (In the Eastern Empire, conquering Muslims were not nearly so interested in preserving Christian art and architecture as their Christian counterparts in the West.) Ravenna's art was the result of over 250 years of Byzantine rule, beginning in 402 when Honorius, son of Theodosius I, made it the capital of the Western Empire. Surrounded by marshes and easily defended from the waves of Germanic invasion that struck at Rome, by the fifth and sixth centuries Ravenna was the most prosperous city in the West, the economic, political, and religious center of Western culture. Its art reflected its stature.

Honorius was succeeded by the first of several women to rise to positions of power in the Byzantine world, the empress Galla Placidia [GAL-uh pluh-SID-ee-uh], whose name means "the gentle, or mild, woman of Gaul." Galla Placidia

was Honorius's half-sister. The Goths captured her in Rome in 410 where she became the wife of the Goth ruler. By 416, her Goth husband dead, she returned to Ravenna and married the consul Constantius, who apparently tried to usurp the throne. Ultimately, she ruled as Galla Placidia Augusta until 450.

In Ravenna, Galla Placidia built a large basilica dedicated to Saint John the Evangelist. (Only the columns, capitals, and bases of the original church survive in the present San Giovanni Evangelista.) The story goes that on her return to Ravenna, while caught in a severe storm at sea, she prayed to Saint John for deliverance, promising to build him a church if she survived. She also built a second, large cross-shaped church, Santa Croce [KROH-chay], which reputedly contained a relic of the True Cross, the one upon which Christ had been sacrificed.

Church Building under Theodoric

A period of turmoil followed Galla Placidia's death and the murder of her son and successor. It culminated in the capture of Ravenna by the Germanic leader Odoacer in 476 and Theodoric's defeat of Odoacer in 493. Like Galla Placidia, Theodoric soon constructed his own basilica, now called Sant'Apollinare Nuovo [sant uh-POL-ih-NAHR-eh noo-OH-voh] (see *Focus*, pages 324–325). Theodoric's Ravenna was not only the center of both civic and Church authority in the West, it was also a thriving trade center, connected to the nearby port of Classis, on the Adriatic, by canal. The luxurious decoration of the port's many churches—as many as 60 churches may have been built in the city between 400 and 750—is the result of its trade with the Eastern Empire and the importance the Eastern emperors attached to the city as their seat of power in the West. The emperor Justinian's decision to send Belisarius to seize Ravenna in 540 is at least partly attributable to the city's wealth and reputation.

Focus

Sant'Apollinare Nuovo

The Ostrogothic ruler Theodoric's basilica in Ravenna, today known as Sant' Apollinare Nuovo, is one of the best-preserved sixth-century Byzantine churches. Its elaborate mosaic decoration testifies to a conflict of religious ideas going on at the time. The Ostrogoths followed the theological position of Bishop Arius of Alexandria. The Arians denied that Christ and God could be of the same essence, nature, or substance. Christ is therefore not like God, not equal in dignity with God, nor even co-eternal with God. In contrast, Orthodox Christians argued that God and his Son were one and the same. Thus, Justinian's overthrow of Arian Ravenna in 540 can be understood, at least partly, as an Orthodox overthrow of heretical Christianity. Theodoric's basilica was rededicated to Saint Martin, a fighter against heretics, and parts of its mosaic decoration was redesigned.

On both sides of the nave there are three tiers of mosaic decoration. At the top, in the clerestory, 26 scenes depict the life of Christ, 13 on each side. Below these rather small scenes, between the clerestory windows, are 16 figures on each side, possibly representing the prophets of the Hebrew Bible on one side and the apostles and evangelists of the New Testament on the other. But the bottom tier of mosaic, a section of which is illustrated here, has been radically altered. The Three Magi bearing gifts approach the Virgin and Child at the head of a procession of male saints. The procession was added under Justinian to transform the Arian church into an Orthodox one.

We can only guess what the original mosaics looked like. It is quite clear though that the depiction of Ravenna in these mosaics, represented by its palace, or *Palatium* (the word is inscribed above the central door), has been altered. Theodoric may have sat enthroned beneath the central arch of his palace. Other figures undoubtedly stood beneath the arches where draperies now hang—a hand and part of a forearm survive between the second and third arch to the left.

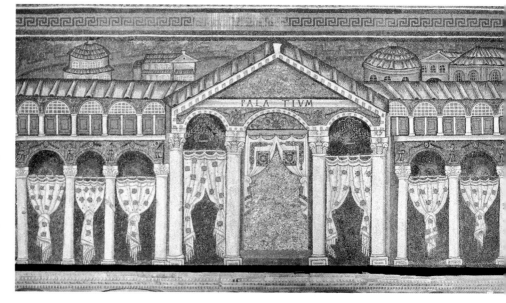

Detail of Theodoric's original mosaic of the Ravenna *Palatium*, Sant'Apollinare Nuovo. ca. 500, redesigned ca. 561 by Bishop Angellus. Note the depiction of Ravenna itself behind the roofline of the *Palatium*.

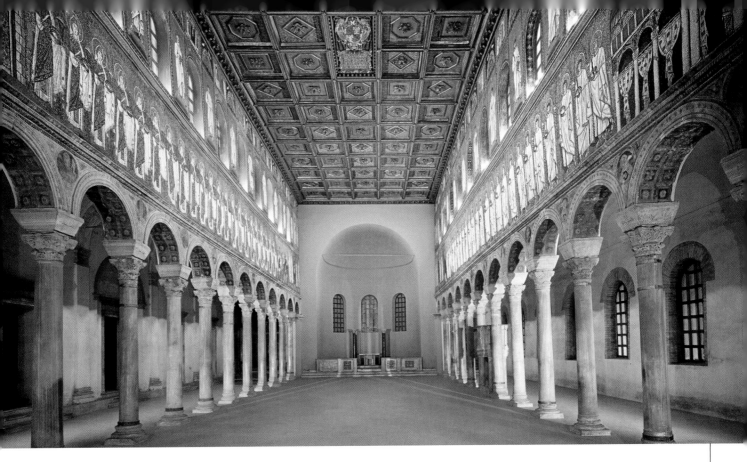

Nave of Sant'Apollinare Nuovo, looking east, Ravenna. ca. 500 and later. The rising water table in Ravenna has caused the floor of the church to be raised four feet since the 6th century. In the process, a fourth tier of mosaics, which ran between the processions and the colonnaded arcade, has been lost, cut out of the wall to accommodate the higher floor. It is not clear what was represented in this tier of mosaic, nor do we know what originally decorated the apse, which was also destroyed.

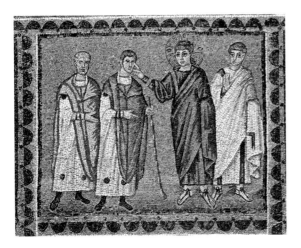

The Three Magi Approaching the Virgin and Child, north wall, Sant'Apollinare Nuovo. ca. 561. The surviving mosaics from Theodoric's decoration (see *The Healing of the Blind*, for example) are very different in character from Bishop Angellus's replacements. This becomes especially clear when comparing the elaborate, Oriental clothing of the three magi to the severe Roman togas of the Gospel scenes. The names of the magi are inscribed across the top of the mosaic—Saints Balthasar, Melchior, and Caspar.

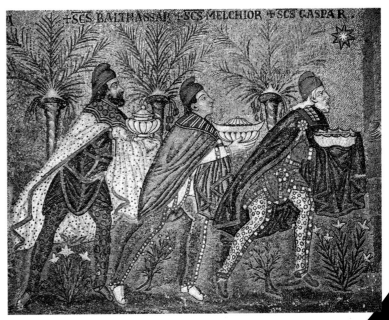

The Healing of the Blind, wall mosaic, Sant'Apollinare Nuovo, Ravenna. ca. 500. This is one of the 26 scenes that depict the life of Christ at the top of the nave mosaics above the clerestory windows. The series as a whole is the earliest surviving example of such a complete iconography. It has survived unaltered from Theodoric's time. The Crucifixion, which is not included, may have decorated at least part of the original apse, which has been destroyed.

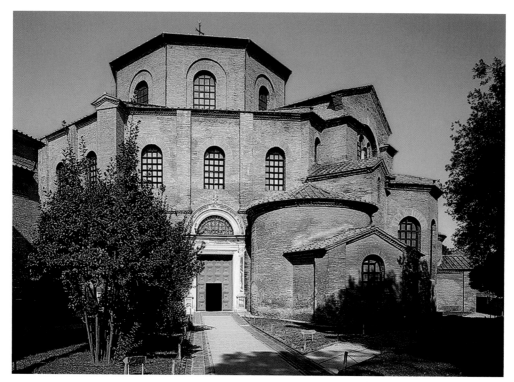

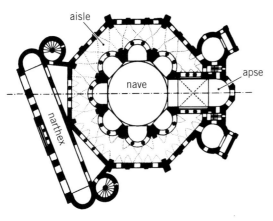

Figs. 10.8 and 10.9 Exterior and plan of San Vitale, Ravenna. Dedicated 547. Like most Byzantine churches, San Vitale is a study in contrasts. The exterior is exceedingly plain. (The decorated doorway is a later addition.) But inside, the elaborate decoration symbolizes the richness of the spiritual world.

San Vitale

In Ravenna, Justinian's new Orthodox clergy oversaw the construction of the church of San Vitale [ve-TAHL-eh], a unique central plan building, similar to Santa Costanza [koh-STAHN-zuh] in Rome (see Figs. 9.19, 9.20), but octagonal in design rather than circular (Figs. **10.8, 10.9**). On seven of its eight sides, the central space opens out into semicircular bays or niches called **exedrae** [EK-suh-dree], which themselves open, through a triple arcade, to the ambulatory. On the eighth side, the bay extends into a rectangular sanctuary and apse. The narthex (entrance hall), which has long since disappeared, was a lozenge-shaped space set at an angle to the church itself. Entering from the double doors, the visitor has two options. One is to look either directly across into the exedrae spaces, seeing a complex pattern of curves, niches,

columns, and mosaics. The other is to glance directly across the central space to the sanctuary and apse, which rose two stories to a gorgeously decorated conch dome, decorated with intricately interwoven vines and animals in a predominantly gold and green mosaic.

On the side walls of the apse, level with the windows, are two mosaics, one featuring the emperor Justinian (Fig. **10.10**) and the other the empress Theodora (Fig. **10.11**). Perhaps inspired by the as yet unaltered processions in Sant'Apollinare Nuovo, which as we have seen probably featured Theodoric and his court, the artist has the emperor and empress lead retinues of courtiers toward the back of the apse. Possibly they proceeded toward reunion with Christ in paradise, as depicted in the conch-dome mosaic of the apse. A haloed Justinian carries a paten, the plate on which the bread is placed in the celebration of the Eucharist [YOO-kuh-rist]. On the other side of the apse, the empress holds a chalice of wine for the Eucharist, and on the bottom of her robe are the Three Magi, who like her come bearing gifts to the Virgin and Child. These mosaics possess a distinct political agenda, serving as propaganda to remind the faithful of the emperor's divine authority—the union of the political and spiritual spheres.

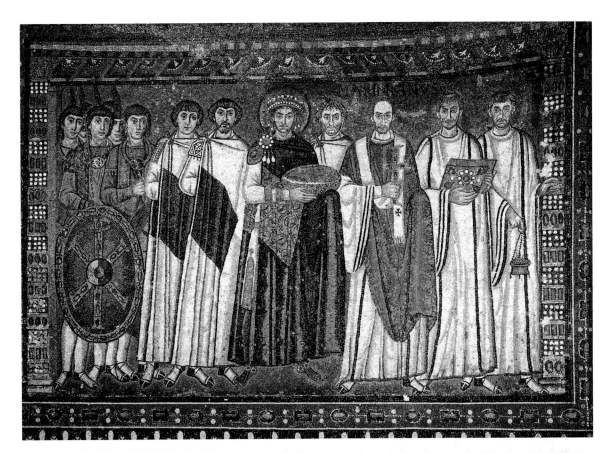

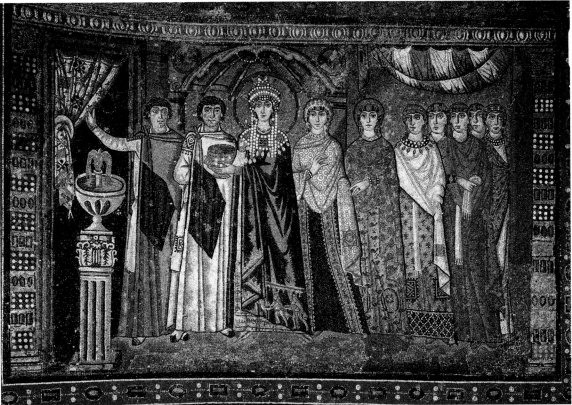

Figs. 10.10 and 10.11 (top) *Emperor Justinian with Maximian, Clergy, Courtiers, and Soldiers;* and (bottom) *Empress Theodora with Courtiers and Ladies of Her Court;* both wall mosaics, San Vitale, Ravenna. ca. 547. Standing between and behind Justinian and Maximian is Julianus Argentarius, the benefactor of the church.

The most intriguing aspect of the two mosaics, however, is their composition. Even though Theodora, for instance, stands before a scalloped half-dome niche and the attendant to her right pulls back a curtain as if to reveal the space beyond, these mosaics do not represent a view into a natural world extending back toward a distant horizon (compare Fig. 8.31). Rather, Byzantine artists conceived of space as extending forward from the picture plane, with parallel lines converging on the eye of the beholder. This technique, known as **reverse perspective**, makes objects appear to tip upward—note the top of the fountain to Theodora's right—and elongates and heightens figures. Human eyesight, Byzantine artists believed, is imperfect and untrustworthy, a fact demonstrated by the apparent decrease in the size of objects as they recede in the distance. By depicting objects in reverse perspective and in shallow space, Byzantine artists rejected earthly illusion, privileging the sacred space of the image over the mundane space of the viewer.

Music in Ravenna

We know about the music of the Church in Ravenna almost exclusively at a theoretical level. Music was considered a branch of mathematics and studied as such, and no medieval manuscripts of musical notation have survived from before the late ninth century. Yet as early as the fifth century, in Augustine of Hippo's *Confessions*, the role of music in the Church liturgy was a topic of much discussion. Augustine was himself ambivalent about it:

> I realize that when they are sung . . . sacred words stir my mind to greater religious fervor and kindle in me a more ardent flame of piety than they would if they were not sung. . . . But I ought not to allow my mind to be paralyzed by the gratification of my senses, which often leads it astray. . . . Sometimes, too, from over-anxiety to avoid this particular trap I make the mistake of being too strict. When this happens, I have no wish but to exclude from my ears, and from the ears of the Church as well, all the melody of those lovely chants to which the Psalms of David are habitually sung. . . . But I remember the tears that I shed on hearing the songs of the Church in the early days, soon after I had recovered my faith . . . so I waver between the danger that lies in gratifying the senses and the benefits which, as I know from experience, can accrue from singing.

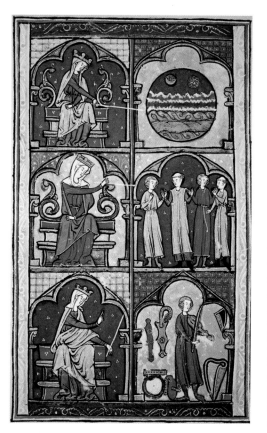

Fig. 10.12 *The Three Varieties of Music,* frontispiece to *Magnus liber organi* F. ca. 1245–55, probably in Paris. Ms. Laur. Plut. 29.1, c. 1v. Firenze, Biblioteca Medicea Laurenziana ms. Laur. Plut. 29.1, c. 1v. Su Concessione del Ministero per i Beni e le Attività Culturali. È vietata ogni ulteriore riproduzione con qualsiasi mezzo. There are four surviving manuscripts of the *Magnus liber organi.* This one is referred to as "F" because it is housed in Florence, Italy. It is the largest and the oldest of the four.

Thus we know that as early as the late fourth century, not long after Augustine's revelation in the garden (see chapter 9), "lovely chants" based on the Psalms of David were habitually sung in Christian churches. Just what they sounded like is another question entirely, although Ambrose's surviving hymns (see chapter 9) give us some clue.

Among the ministers who served Theodoric in Ravenna was Boethius [boh-EE-the-us], author of *De institutione musica* (The Fundamentals of Music), which, like his more famous treatise *The Consolation of Philosophy* (see chapter 9), would remain in obscurity until the late ninth century. There are, Boethius argues, three classes of music: *musica mundana, musica humana,* and *musica instrumentalis.* These are illustrated in the twelfth-century frontispiece to one of the earliest compilations of medieval music for the liturgy, the *Magnus liber organi,* or *Great Book of Polyphony* (Fig. **10.12**), showing Boethius's continuing influence throughout the medieval period. In the top register of the frontispiece the allegorical figure of Musica points her baton at a sphere containing the four elements—earth, water, air, and fire (represented by the stars). This is *musica mundana,* the highest form of music, created by planetary motion, the classical "harmony of the spheres." Below, in the second register, she lifts her baton for *musica humana,* the music humans create through the harmonious attunement of mind and body, reason and spirit. Finally, at the bottom, she shakes her finger, somewhat disapprovingly, at *musica instrumentalis,* the music of sound, the only one of the three that can be heard by mortals. Likewise, for Boethius, there were three classes of musician—those who play instruments, those who sing, and those who judge performance and song. These last, persons grounded in reason and thought, are the most musical, he argues, once again demonstrating the medieval emphasis on music as a form of philosophical thought.

The Later Byzantine Empire

Strange as it may seem, Justinian and Theodora never actually set foot in Ravenna, let alone San Vitale, and their depiction on its walls is probably best understood as a symbol of the relations between Church and State in the Byzantine Empire. Intimately interrelated and mutually dependent, the

two balanced one another. Thus, while Maximian, the bishop of Ravenna, stands a little forward of Justinian in the San Vitale mosaic, Justinian's arm and the paten it holds lie (somewhat improbably) in front of Maximian. It is easy to understand, then, how the century and a half of military and political setbacks that followed Justinian's rule were interpreted in Byzantium as church related. Germanic tribes overran Italy and the Balkans. Persian forces sacked Jerusalem in 614. But even more important was the rise of Islam after the death of Muhammad [moh-HAM-ud] in 632 (see chapter 11). Although the Byzantine emperor Heraclius [her-uh-KLY-us] (r. 610–41) recaptured Jerusalem in 620, the Muslim Arabs took it in 638. Within two years, the Muslim Arabs had conquered Syria, Palestine, and Iraq. In 642, the Byzantine army abandoned Alexandria, and Islam in effect controlled all of what once had been Byzantine Asia Minor. Constantinople itself did not fall, but it was besieged twice, from 674 to 678 and from 717 to 718. Only its invincible walls held the Muslim invaders at bay.

The Iconoclast Controversy

The sudden rise of Islam as a powerful military force had a chilling effect on Byzantine art. The Byzantine emperor Leo III (r. 717–41), who came to power during the second Muslim siege of Constantinople, began to formulate a position opposing the use of holy images. He understood that the Muslims, who were still regarded as Christian heretics, had barred images from their mosques and, so the logic went, their military successes against the Byzantine Empire were a sign both of God's approval of their religious practice and disapproval of Byzantium's. Like the Muslims, Leo argued that God had prohibited religious images in the Ten Commandments—"Thou shalt not make any graven image, or any likeness of any thing that is in heaven above, or that is in the earth beneath, or that is in the water under the earth: Thou shalt not bow down thyself to them nor serve them" (Exodus 20:4–5). Therefore, anyone worshiping such images was an idolater and was offending God. The solution was to ban images.

Thus was inaugurated a program of **iconoclasm**, from the Greek *eikon* ("icon" or "image") and *klao* (to "break" or "destroy"), the practice of destroying religious images. By the eighth century, the icon had a rich history in Byzantium. Mosaic icons decorated all churches, and most homes had an icon stand at the front door which visitors greeted even before greeting their host. Among the earliest examples of icons are a set of paintings on wooden panels from St. Catherine's Monastery, Mount Sinai, among them a *Theotokos* [the-OT-uh-kus] *and Child* (Fig. **10.13**). *Theotokos* means "God-bearing," an epithet defining Mary as the Mother of God, an official Byzantine Church view after 431. If Mary is the mother of Jesus, the Church argued, and if Jesus

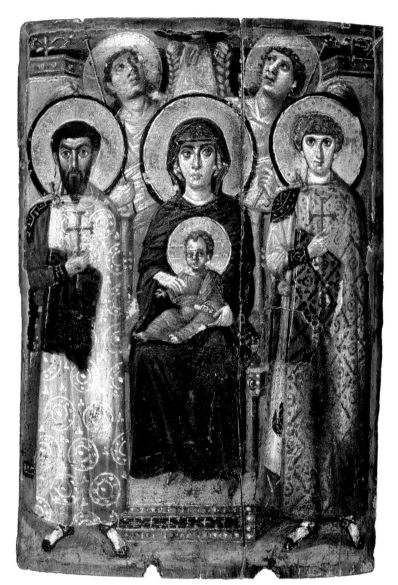

Fig. 10.13 *Theotokos and Child with Saint Theodore and Saint George.* **6th century.** Encaustic on board, 27″ × 19³⁄₄″. Monastery of St. Catherine, Mount Sinai. Byzantine culture rarely, if ever, referred to Mary as "the Virgin." Instead she was rather the *Theotokos*, the "Mother of God."

is God, then Mary is the Mother of God. Such images, and the doctrine associated with them, were expected to stir the viewer to prayer. Mary's eyes are averted from the viewer's, but the Christ Child, like the two military saints, Theodore (left) and George, who flank the central pair, looks straight out. The two angels behind raise their eyes to the sky, down from which God's hand descends in blessing. The words of the sixth-century Byzantine poet Agathias (ca. 536–82) are useful here: "The mortal man who beholds the image directs his mind to a higher contemplation. . . . The eyes encourage deep thoughts, and art is able by means of colors to ferry over the prayer of the mind." Thus the icon was in some sense a vessel of prayer directed to the saint, and, given her military escort, must have offered the viewer her protection.

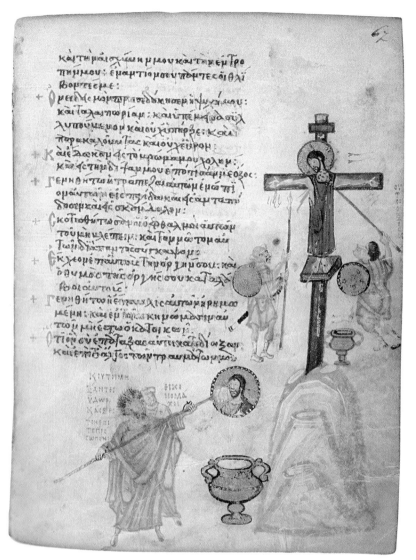

Fig. 10.14 *The Crucifixion and Iconoclasts,* folio 67r, Chludov Psalter. ca. 850–75. 7³⁄₄″ × 6″. State Historical Museum, Moscow. The psalter gets its name from its 19th century Russian owner.

Damascus (ca. 675–749) led the Orthodox defense of icons. He argued that the Incarnation itself justified the icon: "When he who is bodiless and without form, immeasurable in the boundlessness of his own nature, existing in the form of God, empties himself and is found in a body of flesh, then you may draw his image and show it to anyone willing to gaze upon it." The iconophiles furthermore argued that the honor that worshipers bestow upon an image passes on to whomever the image represents.

A page from a Russian Psalter (Book of Psalms) showing *The Crucifixion and Iconoclasts* sums up the iconophile position toward iconoclasts (Fig. **10.14**). The passage quoted on this page is from Psalm 21, which is interpreted as a prophecy of the Crucifixion: "They gave me also gall for my meat; and in my thirst they gave me vinegar to drink." On the right, a soldier offers Jesus a drink from a vinegar-soaked sponge, stuck on the end of a long stick. At the bottom of the page, two iconoclasts raise a sponge, just dipped in a vase of lime whitewash, to an icon of Christ and begin to paint it over. The image suggests that to destroy an image of Christ is tantamount to crucifying Jesus.

It took some time for the iconophile position to prevail. In 754, Leo III's son and successor, Constantine V (r. 741–75), called a Church Council at Hiereia, a palace outside Constantinople. The council declared iconoclasm an official doctrine of Church faith, and for the next 30 years many icons were destroyed. Wall paintings were whitewashed over, the leaves of books containing icons were cut out and burned together with paintings on panels, many mosaics were disassembled and reconstituted as crosses, and sculptures were smashed or defaced. Anyone who defended an image was subject to persecution. But in 787, the widow of Constantine V's son and successor, the empress Irene (r. 780–802), called a Council at Nicaea [nye-SEE-uh] that reversed the iconoclast position, declaring: "The making of icons is not an invention of painters, but an institution and tradition of the Catholic Church. Whatever is ancient is worthy of respect, said Saint Basil, and we have as testimony the antiquity of the institution and the teaching of our inspired Fathers, namely that when they saw icons in holy churches they were gratified, and when they themselves built holy churches they set up images in them." Irene ordered the image of Christ once

Leo would have none of this. In 726, he removed the image of Christ above the Chalke (Bronze) Gate of the Imperial Palace, resulting in a pitched battle between his soldiers and iconophiles ("lovers of icons") in which several soldiers died. In 730 he issued an edict requiring the removal of all religious images from all churches. The righteousness of his position was established, Leo believed, by a quick succession of military victories over the Muslims and cemented by the length of his reign—25 years, longer than the reigns of his five predecessors combined.

As the incident at the Chalke Gate suggests, not everyone was happy with the iconoclast position. John of

again placed above the Chalke Gate. But 26 years later, the emperor Leo V (r. 813–20) had it removed once more, and a new era of iconoclasm followed, lasting until yet another empress intervened in 843. This time the empress Theodora (810–62—Justinian's Theodora was her namesake), officially restored the decree of the Council at Nicaea. The veneration of images was once again blessed, and Christ was restored to his place above the Chalke Gate.

The importance of the iconoclast controversy to the history of Western art cannot be overstated. Iconoclasm would reappear several hundred years later during the Renaissance, but more important, the controversy affirmed the centrality of visual imagery to Western culture. In the debate over the function of the image—ranging from the artist's motives for creating it to the viewer's understanding of it to the patron's support of it—attention focused on the role of the visual not only in religion but also in communication, learning, and understanding. The iconoclast controversy could be said to have instigated the very notion of "visual literacy"—the idea that understanding certain images is central to cultural literacy. It also contributed to the radical division, or schism, between the Roman Catholic and Eastern Orthodox churches that developed especially in the last half of the first millennium. The two churches disputed papal authority—from the Eastern point of view the pope's rule of the Eastern Church was merely nominal. There were huge cultural differences as well, for few in the West spoke Greek, few in the East Latin. Doctrinal issues having to do with the Catholic position that the Holy Spirit proceeded from both the Father *and* the Son, an idea wholly unknown in the East, also played a part.

In terms of iconography, most Roman Catholics believed that images of God the Father, Christ, and the Virgin served to inspire reverence and piety, while, as we have seen, a very large segment of the Eastern Church did not. Once the iconoclast controversy in the East was settled in favor of imagery, the theological conservatism of the Eastern Orthodox Church discouraged innovation to the point that its art remained remarkably consistent right down to modern times. In contrast, the Church in the West was consistently open to artistic innovation, especially after the twelfth and thirteenth centuries. Any visitor to a Greek or Russian Orthodox church today would be struck by the similarity of its art to that of early medieval Constantinople. When Russia accepted Christianity in 988, Byzantine artists were dispatched to Kiev and other artistic centers in order to pass on the traditions of icon painting to Russian monks. While an individual painter might interpret tradition in an individual way—in the manner, for instance, that a musician might interpret a score—tradition dominates the art of Eastern Orthodoxy.

CULTURAL PARALLELS

Images in Christianity and Buddhism

While the Byzantine emperor Leo III opposed the use of images in Christian churches, Buddhists were increasingly using representations of the Buddha. Finely detailed sculptures and portraits of the Buddha portrayed specific attributes and teachings of Siddhartha Gautama. Visual representation was very useful, as a majority of the people were illiterate.

Tradition and Innovation: The Icon in the Second Golden Age

When the Macedonian [mas-uh-DOE-nee-un] dynasty (867–1056) initiated by Basil I came to power, the Empire enjoyed a cultural rebirth of art and architecture, often referred to as the Second Golden Age. Although the Empire's reach was somewhat reduced, its wealthy autocracy could claim control of present-day Turkey and other areas around the Black Sea, the Balkan peninsula including Greece, and southern Italy, including Sicily. It also exerted influence over Russia, Ukraine, and Venice, its major trading partner in the Adriatic.

The artists of the Macedonian era turned to both classical and Justinian models for their church decoration, lending the traditional icon a more naturalistic air and an almost Hellenistic emotional appeal. While images of Christ on the cross had occasionally appeared in earlier centuries, after the iconoclast controversy they appeared with greater frequency. A particularly fine example survives at Daphni [DAF-nee], near Athens, Greece, in the Church of the Dormition [dor-MISH-un] (from the Latin word for "sleep" and referring to the assumption into heaven of the Virgin Mary at the moment of her death) (Fig. **10.15**). The image remains completely traditional in its reverse perspective (noticeable particularly on the platform at Christ's feet) and in its refusal to create a realistic spatial setting, opting instead for the spiritual space of its golden background. But the nudity of Christ and the graceful gestures of the Virgin and Saint John, the draperies of their clothing falling almost softly in comparison to the stiff folds of the Justinian and Theodora mosaics at San Vitale, are clearly inspired by classical antecedents. Even more classical is the pure human emotion that the figures convey. Where early Christian art had emphasized the Savior's power, wisdom, and personal strength, this image hints at his vulnerability, the human pathos of his sacrifice. The arc of blood and water springing from his side, referring to both the Eucharist and the Baptism, connects his "passion" to our own.

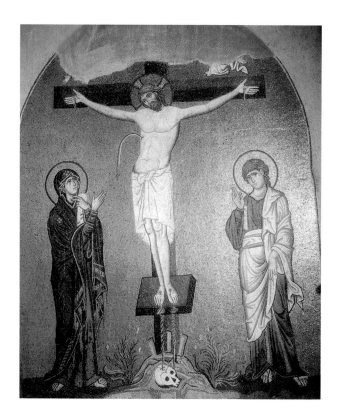

Another of the chief innovations of the era was the icon of Christ the Pantocrator painted throughout the Second Golden Age in the domes of its central plan churches. Like the remarkable *Crucifixion*, an important example survives, although much restored, at the Church of the Dormition in Daphni (Fig. **10.16**). *Pantocrator* literally means "Lord (or master) of Everything (the universe)." It is often translated as "Almighty," combining father and son, judge and savior. Although a bearded Christ had appeared earlier in Byzantine art (see Fig. 10.7), the inspiration of this figure is the bearded Zeus of classical art, especially given the enormous size and relative naturalism of the face. Positioned in the heavenly reaches of the Byzantine vault, he is a completely traditional icon, framed in gold, looking sternly down on the beholder who stands in humble smallness on the ground below.

Fig. 10.15 *Crucifixion*, mosaic in the north arm of the east wall, Church of the Dormition, Daphni, Greece. **Late 11th century.** The skull at the foot of the cross symbolizes Golgotha, the "place of the skull," a hill outside Jerusalem. Many believed it was the site of Adam's burial and of the Crucifixion.

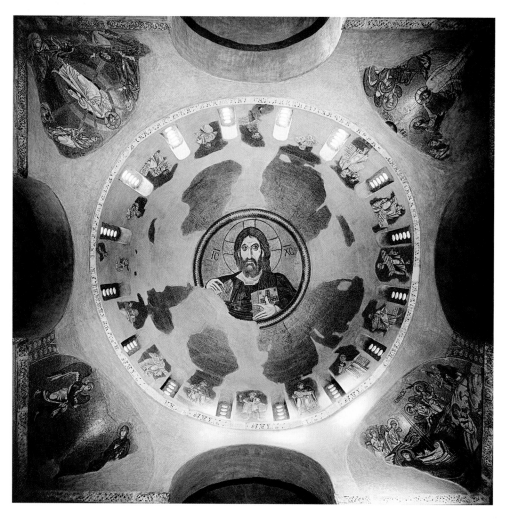

Fig. 10.16 *Christ Pantocrator,* mosaic in the central dome, Church of the Dormition, Daphni, Greece. ca. 1080–1100. In Byzantine churches of this era, the central dome represented the heavens, while the rising vaults and arches supporting the dome signified the Holy Land.

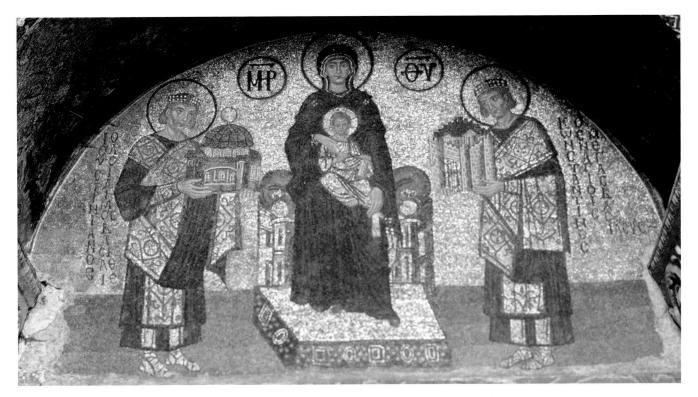

Fig. 10.17 *Theotokos and Child with Justinian and Constantine,* vestibule mosaic, Hagia Sophia, Istanbul. Early 10th century. Constantine and Justinian are beardless, which distinguished them from contemporary emperors, all of whom wore beards and had long hair. Note the reverse perspective, so typical of Byzantine art, of the throne upon which the Theotokos Mary sits.

Many scholars believe that a Christ Pantocrator lies beneath the Islamic calligraphy that today decorates the dome of Hagia Sophia. Seeking to maintain a balance between the building's Christian and Islamic heritage, restorers have hesitated to remove the Islamic inscriptions. But many of the icons decorating Hagia Sophia had been restored or redone, so it is impossible to say whether the earlier decorative scheme was repeated or a new one created. A giant *Theotokos and Child,* flanked by two archangels, decorated the apse.

No single image underscores the role of the Theotokos as protectress more than the tenth-century mosaic *Theotokos and Child with Justinian and Constantine* that decorates the vestibule to Hagia Sophia (Fig. **10.17**). To the right of the Theotokos and Child at the center stands "Justinian the Glorious King," as his inscription calls him, holding an architectural model of Hagia Sophia. To their left is "Constantine the Great, numbered among the saints," holding a model of the walled city of Constantinople. The city, the mosaic suggests, has been under the protection of the Mother of God since its inception. The implication is that such protection will continue, as indeed it would, until the year 1453, when Constantinople would finally fall to the Turks.

Summary

■ **Constantine's New City** When in 325 the emperor Constantine began to build his new capital at Byzantium, he modeled it on Rome. It was decorated with art from throughout the Empire, but instead of temples dedicated to the Roman gods, he erected Christian basilicas. By the sixth century, when the emperor Justinian closed the last pagan school of philosophy in the Empire, there were over 100 churches and monasteries in the city.

Under Justinian and his empress, Theodora, Constantinople retook North Africa from the Visigoths and launched a campaign to regain control of Italy. Although they were the objects of ridicule and scandal (as revealed in Procopius's *Secret History*), the two exercised great power. Justinian ordered the mammoth new church Hagia Sophia to be built and oversaw construction of bridges, roads, aqueducts, monuments, churches, and monasteries all around the Empire, including St. Catherine's monastery on the Sinai peninsula with its extraordinary mosaic of *The Transfiguration of Christ*. Gone was the naturalism that dominates classical Greek and Roman art. Linear perspective gave way to reverse perspective. The artists evidently had no interest in depicting the visual appearance of the material world because they focused their attention on the supernatural event of the transformation itself.

■ **Ravenna and the Western Empire** Ravenna was the most prosperous city in the West in the fifth and sixth centuries, a thriving trade center. The capital of the western half of the Roman Empire, it had been ruled, early in the fifth century, by the first of several women to rise to positions of power in the Byzantine world, the Empress Galla Placidia. The elaborate mosaic decorations of Sant'Apollinare Nuovo, built by the Ostrogothic king Theodoric, reflect the conflict between the Eastern Orthodox church and the Western Arian church. The Orthodox clergy installed in Ravenna by Justinian constructed a new central plan church, San Vitale, decorated with two mosaics featuring Justinian and Theodora. Music played a role in the liturgy, and, although we have little surviving music from the period, we do have an important treatise on the topic, Boethius's *The Fundamentals of Music*.

■ **The Later Byzantine Empire** Threatened by Muslim armies, whose successes he attributed to their having barred images from their mosques, and reading the Ten Commandments' admonition that "Thou shalt not make an idol" as forbidding all imagery, the emperor Leo III inaugurated a program of iconoclasm in 726 requiring the removal of all religious images from all churches. Not everyone agreed with him, and religious controversy raged throughout the eighth and early ninth centuries. It led to a radical division between the Roman Catholic and Eastern Orthodox churches. The later Macedonian emperors brought about a cultural revival, a Second Golden Age of Byzantine art, in which artists reinvigorated the traditional icon through their study of classical precedents.

Glossary

exedrae A semicircular bay or niche.

hieratic style A style in which the importance of figures is indicated by size, so that the most important figure is largest.

iconoclasm The idea, practice, or doctrine of an iconoclast to destroy or ban religious images and their veneration.

mandorla The light encircling or emanating from the figure of a sacred person.

pendentive A triangular curving vault section that supports a dome over a square space.

reverse perspective A technique for conceiving of space as extending forward from the picture plane, with parallel lines converging on the eye of the beholder.

Critical Thinking Questions

1. What are the characteristics of the new Byzantine style of art? Why did Byzantine artists abandon the naturalism of classical Greek and Roman art?

2. What are the three forms of music as outlined by Boethius? What is their relationship to Byzantine beliefs about art?

3. What is the iconoclast controversy? How did it affect the arts, especially with regard to the differing attitudes toward the arts in the Eastern Orthodox and Roman Catholic churches?

Byzantine Influences

Located at the crossroads of Europe and Asia and serving as the focal point of a vast trade network that stretched as far east as China, Constantinople was the economic center of, first the Roman Empire, and then the entire Mediterranean for nearly a thousand years. Only Venice would ever rival it as a center of trade, and Venice would finally conquer Constantinople during the Fourth Crusade in 1204 in order to draw the city into its own sphere of influence. Venetian mercenaries looted the city in the process, taking back to Italy art and artifacts representing over 900 years of accumulated wealth and artistic tradition. In the early years of the twelfth century, Venetian artists copied more than 110 scenes for the atrium of St. Mark's Cathedral from Byzantine originals. And St. Mark's itself was directly inspired by Byzantine architecture and decoration (Fig. **10.18**).

The wealth of Constantinople in artifacts would spread to the north as well. In 1238, Venetian merchants purchased from Byzantine officials one of the most precious relics of Western Christendom [KRIS-en-dum], the Crown of Thorns, supposedly worn by Jesus during the Crucifixion. The same year, King Louis [LOO-ee] IX of France paid the Venetians 13,304 gold coins to take the crown to Paris and place it in his newly dedicated Gothic church, Sainte-Chappelle [SANT-sha-PELL].

Throughout its history, Byzantine Constantinople was constantly under attack, not only by the rest of Christendom but also by Islam, the new religion that had originated to the south, which is the subject of chapter 11. Many in Constantinople attributed the Muslims' success to their refusal to allow images in their mosques, and this belief fed the iconoclast controversy in Byzantine political and religious life, as we have seen. The Christian West, in turn, would come to see the Muslim world not merely as barbarian, but as a direct threat to Christian dominance—political, economic, and

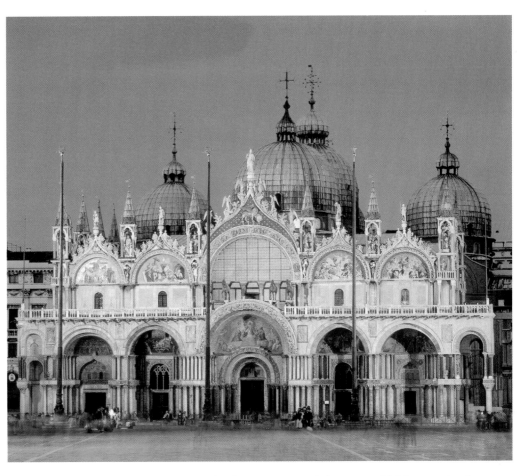

Fig. 10.18 St. Mark's Cathedral, Venice, west facade. 1063–1094, with decorations added for centuries after.
The original brick front of the cathedral is inlaid with marble slabs and carvings, much of it looted from Constantinople in 1204.

religious—of the Mediterranean world. Increasingly the region's two competing empires, east and west, would cease to be Byzantine and Catholic, but instead would become Muslim and Christian. The traditions of Byzantine art lived on, however, especially in Greece and Russia, where in the thirteenth through sixteenth centuries especially, Byzantine art continued to flourish. ■

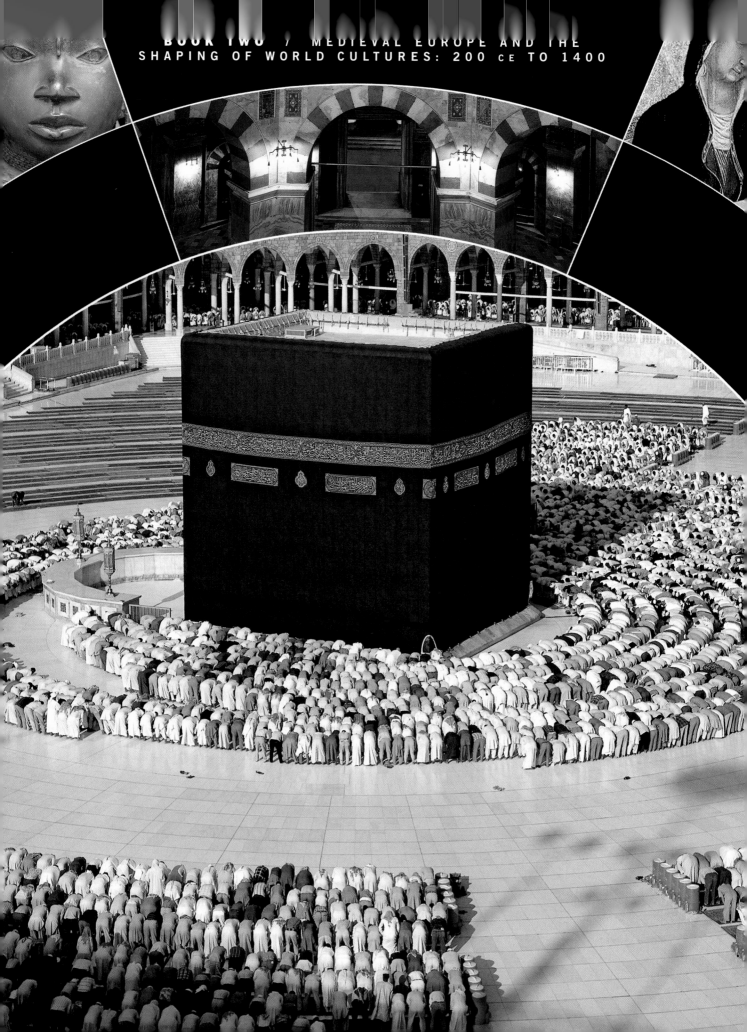

11 The Rise and Spread of Islam

A New Religion

The Prophet Muhammad

The Spread of Islam

Islam in Africa and Spain

The Arts of the Islamic World

> ❝ *Everyone starts his day and is a vendor of his soul,*
> *either freeing it or bringing about its ruin.* ❞
>
> from the *Hadith*

◄ **Fig. 11.1 The *Kaaba*, center of the Haram Mosque, Mecca.** Traditionally, all Muslims must make a pilgrimage to Mecca, in Syria, at least once in their lives. Once there, they must walk around the Kaaba seven times.

M ECCA, THE HOLIEST CITY OF ISLAM, IS LOCATED ABOUT 50 miles inland from the Red Sea on the Arabian peninsula in modern Saudi Arabia. Its natural spring originally made it an important stopping point for nomadic Arabs, known as Bedouins, who traded along caravan routes across

the arid peninsula. Until the seventh century CE, they worshiped more than one god. They stored images of those gods in a square black structure in the center of the city that came to be known as the *Kaaba* [KAAH-buh], literally "cube" (Fig. **11.1**). Scholars believe that the original Kaaba was linked to the astronomical year, containing an array of 360 idols, each associated with sea-sonal rituals and the passing of the days and months. Built with a bluish grey stone from the hills surrounding Mecca, it is now usually covered with a black curtain. The Kaaba also held a sacred Black Stone, probably a meteorite, which reportedly "fell from heaven." Legend has it that when work-ers who had been rebuilding the Kaaba were ready to place the sacred stone inside, a quarrel broke out among the prin-cipal Arab tribes regarding who would have the privilege of laying the stone. Everyone agreed that the first passerby would do the honor. That passerby turned out to be the Mus-lim prophet Muhammad (ca. 570–632), who placed the stone on his cloak and then gave a corner of the cloak to the head of each tribe to carry into the building (Fig. **11.2**). The story establishes Muhammad as a political as well as spiritual leader, and, perhaps more important, as a prophet capable of uniting the diverse elements of Arab culture.

Today, practitioners of the Muslim faith from all over the world face toward the Kaaba when they pray. They believe it is their place of origin, the site of the first "house of God," built at God's command by the biblical Abraham and his son Ishmael, the ancestors of all Muslims, on the spot where, in Muslim tradition, Abraham prepared to sacrifice Ishmael (not Isaac, as in Christian tradition). Thus, walk-ing around the Kaaba is a key ritual in the Muslim pilgrim-age to Mecca, for the cube represents the physical center of the planet and the universe. It is the physical center of Mus-lim life, around which all things turn and to which all things in the universe are connected, symbolic of the cos-mos itself. The Islamic transformation of Middle Eastern and Western culture, which began in Mecca in the seventh century and spread outward from that city, is the subject of this chapter.

Just as Muslims physically turn toward Mecca when they pray, they turn their thoughts toward the teachings of their prophet Muhammad. Wherever Muslims found themselves— and Islam rapidly spread across the Middle East, North Africa, and even into Spain—they built places of worship

modeled on Muhammad's home in Medina, the city on the Arabian peninsula where Muham-mad moved when he was driven from Mecca (Map **11.1**). And, as individuals, they submit-ted themselves to the authority of their faith, so much so that the Muslim religion quickly became synonymous with the Islamic state itself. Because Arabic, as the language of divine revelation, was believed to have a sacred nature, writing too was revered, and calligraphy developed into the preeminent form of visual art in Islam, creating an almost wholly abstract standard of beauty devoid of figurative elements. As a faith that considered sensory sat-isfaction, love, luxury, sensuality, and enjoyment to be mani-festations of divine grace, the Muslim religion enveloped Islamic culture, its art, music, and literature, in the pursuit of beauty.

The Prophet Muhammad

Born in Mecca in about 570 to a prominent family that traced its ancestry back to Ishmael, son of Abraham, Muhammad was orphaned at age six and received little formal education. He worked in the desert caravan trade, first as a camel driver for his uncle, and then, after marrying a wealthy widow 15 years his senior, as head of his wife's flourishing caravan firm. At the age of 40, in 610, he heard a voice in Arabic—the Archangel Gabriel's, as the story goes—urging him, "Recite!" He respond-ed "What shall I recite?" And for the next 22 years, he claimed to receive messages, or "recitations," from God through the agency of Gabriel. These he memorized and dictated to scribes, who collected them to form the scriptures of Islam, the **Qur'an** [kuh-RAN] (or Koran), which means "recitations." Muham-mad also claimed that Gabriel commanded him to declare himself the "Seal of the Prophets," that is, the messenger of the one and only Allah (the Arab word for God) and the final prophet in a series of prophets extending from Abraham and Moses to Jesus.

At the core of Muhammad's revelations is the concept of submission to God—the word *Islam*, in fact, means "submis-sion" or "surrender." God, or Allah, is all—all-powerful, all-seeing, all-merciful. Because the universe is his creation, it is necessarily good and beautiful, and the natural world reflects Allah's own goodness and beauty. To immerse oneself in

nature is thus to be at one with God. But the most beautiful creation of Allah is humankind, which God made in his own image. Like Christians, Muslims believe that human beings possess immortal souls and that they can live eternally in heaven if they surrender to Allah and accept him as the one and only God.

Muslims, or practitioners of Islam, dedicate themselves to the "five pillars" of the religion:

1. **Shahadah:** The repetition of the *shahadah* [sha-HAH-dah], or "creed," which consists of a single sentence, "There is no God but Allah; Muhammad is the messenger of Allah."
2. **Prayer:** The practice of daily prayer, recited facing Mecca, five times each day, at dawn, midday, mid-afternoon, sunset, and nightfall, and the additional requirement for all men to gather for a noon prayer and sermon on Fridays.
3. **Alms:** The habit of giving alms to the poor and needy, consisting of at least one-fortieth of a Muslim's assets and income.
4. **Fasting:** During the lunar month of Ramadan (which, over a 33-year period, will occur in every season of the year), the ritual obligation to fast by abstaining from food, drink, medicine, tobacco, and sexual intercourse from sunrise to sundown each day.
5. **Hajj:** At least once in every Muslim's life, in the twelfth month of the Muslim calendar, the undertaking of a pilgrimage (called the **hajj**) to Mecca.

The five pillars are supported by the teachings of the Qur'an, which, slightly shorter than the New Testament, consists of 114 *surahs* [SOO-rahs], or chapters, each numbered but more commonly referred to by their titles. Each begins, as do most Muslim texts, with the **bismillah** [bees-MEEL-lah], a sacred invocation that can be translated "In the name of Allah, the Beneficent, Ever-Merciful" (see *Focus*, pages 340–341).

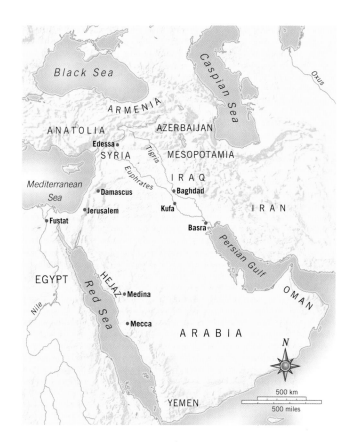

Map 11.1 The Muslim world, ca. 700 CE.

When, after Muhammad's death in 632, the Qur'an's text was established in its definitive form, the 114 *surahs* were arranged from the longest to the shortest. Thus, the first *surah* contains 287 *ayas* [ay-YAS], or verses, while the last consists of only three. The mandatory ritual prayer (*salat*) [sah-LAAT] that is performed five times a day consists of verses from *surahs* 2, 4, and 17.

Fig. 11.2 *Muhammad Placing the Black Stone on his Cloak*, from Rashid al-Din's *Jami al-Tawarikh* (Universal History), copied and illustrated at Tabriz, Iran. 1315. 5⅛" × 10¼". University Library, Edinburgh. Notice that the figures in back of the central section are lifting a veil that covers the *Kaaba*. Today the veil, the meaning of which is obscure, is black, with quotations from the Qur'an woven across it in gold thread.

Focus

The *Bismillah* and the Art of Calligraphy

The *bismillah* consists of the phrase "In the name of Allah, the Beneficent, Ever-Merciful." Every pious Muslim begins any statement or activity with it, and it inaugurates each chapter of the Qur'an. For Arab calligraphers, to write the *bismillah* in as beautiful a form as possible brings the scribe forgiveness for sins, and the phrase appears in the Islamic world in many different forms—even in the shape of a parrot. From the time that Abd al-Malik took control of the Umayyad family in 692, it became an important part of architectural practice as well. It first appears in written form on a band of mosaic script around the interior walls and above the entrance of Dome of the Rock in Jerusalem, a monument completed by Abd al-Malik in 691.

The Dome of the Rock stands atop the Temple Mount in Jerusalem, on the site where Abraham prepared to sacrifice his son Isaac. The Jewish Temple of Solomon originally stood here, and the site is further associated—by Jews, Christians, and Muslims alike—with the creation of Adam. The Dome's ambulatory encloses a projecting rock that lies directly beneath the golden dome. By the sixteenth century, believers claimed that the Prophet Muhammad ascended to heaven from this spot, on a winged horse named Buraq, but there is no evidence that this story was in circulation when the Dome was built in the 680s. Others thought that it represents the ascendancy of Islam over Christianity in the Holy Land. Still others believed the rock is the center of the world, or that it could refer to the Temple of Solomon, the importance of which is fully acknowledged by Muslims. All of this suggests that the Dome—and the *bismallah* itself—which is ubiquitous in Muslim culture—is meant to proselytize, or convert, people to the Muslim faith.

Ahmed Karahisari. Calligraphic Qur'an frontispiece, from Istanbul. ca. 1550. Ink, gold, and color on paper, $19\frac{2}{3}'' \times 13\frac{3}{4}''$. Museum of Turkish and Islamic Art, Istanbul. Karahisari (1469–1560) was the most famous calligrapher of his day. He placed the *bismillah* in black script between two square scripts. On top, the words "Praise God" are repeated four times. The bottom block contains the entire text of *surah* 112 of the Qur'an: "Say: 'He is Allah, the only one [that is, indivisible]. Allah, the eternally Besought of all! He begetteth not nor was begotten. And there is none comparable to Him.'"

The importance of writing in spreading the new faith suggests one reason that Muslim calligraphers were held in such high esteem. Most Westerners think of handwriting as a form of self-expression. But the Muslim calligrapher's style has a much more important role to play: to attract the attention of the reader, eliciting admiration for the beauty of the script, and in turn reflecting the beauty of the Muslim faith. The Muslim calligrapher is considered the medium through which Allah expresses himself. The more beautiful the calligraphic script, the more fully Allah's beauty is realized.

Bismillah in the form of a parrot, from Iran. 1834–35. Ink on paper under wax coating. Cincinnati Art Museum, Franny Bryce Lehmer Fund. 1977.65. The parrot reads right to left, beginning over the large dot beneath its tail. The word *Allah* appears at the back of its head. The parrot is to humankind as humankind is to Allah. That is, it mimics human language without understanding it, just as humans recite the words of Allah without fully understanding them.

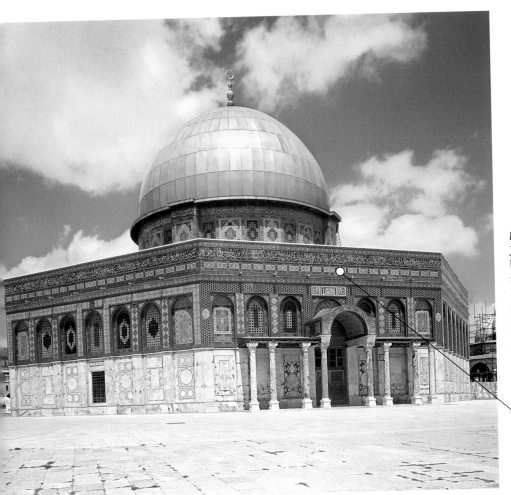

The Dome of the Rock, Jerusalem. Late 680s–691. The golden dome of the building, one of the earliest Muslim constructions, rises above a projecting rock that is surrounded by an ambulatory. The building's function remains unclear. It is not a mosque, although it is certainly some kind of religious memorial. Inscriptions from the Qur'an decorate its interior. These are the oldest excerpts from the text to have survived.

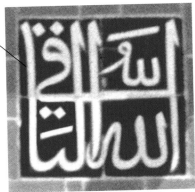

Bismillah tiles from the Dome of the Rock, Jerusalem. 20th century. This four-tile block with the sacred invocation "In the name of Allah, the Beneficent, Ever Merciful" is just above the main entrance to the Dome. The outside of the Dome was originally mosaic but was replaced by tile in the sixteenth century and again in the twentieth.

Mastering the art of calligraphy was, in this sense, a form of prayer, and it was practiced with total dedication. A famous story about an incident that happened in the city of Tabriz, in northern Iran, during the great earthquake of 1776–77, illustrates this. The quake struck in the middle of the night and buried many in the rubble. Survivors stumbled through the debris looking for signs of life. In the basement of a ruined house, rescuers discovered a man sitting on the floor absolutely absorbed in his work. He didn't respond to their yells for him to hurry out before an aftershock buried him. Finally, he looked up and complained that they were disturbing him. They told him that thousands had been killed in an earthquake, and if he didn't hurry up, he would be next. "What is all that to me?" he replied. "After many thousands of attempts I have finally made a perfect 'waw' [meaning 'and']." He showed them the letter, indeed a very difficult letter to make. "Such a perfect letter," he exclaimed, "is worth more than the whole city!"

The Qur'an

The Qur'an is a work of poetry, and in pre-Islamic Arabia, poetry was the highest form of art. Poets recited their own works, or professional reciters performed the works of others. The beauty of the poetry inspired the creation of many beautiful editions of the work (Fig. **11.3**) and, as we shall see, the art of calligraphy. But unfortunately, the beautiful, melodic qualities of the Arabic language are completely lost in translation, a fact that has helped to inspire generations of non–Arabic-speaking Muslims to learn the language. Almost all Muslims regularly read the Qur'an in Arabic, and many have memorized it completely. Translations of the Qur'an are problematic on another, more important level. Since the Qur'an is believed to be the direct word of God, it cannot be modified, let alone translated—a translation of the Qur'an is no longer the Qur'an. Nevertheless, something of the power of the poem's imagery can be understood in translation. Consider a passage describing paradise from the seventy-sixth *surah*, known as "Time" (**Reading 11.1a**):

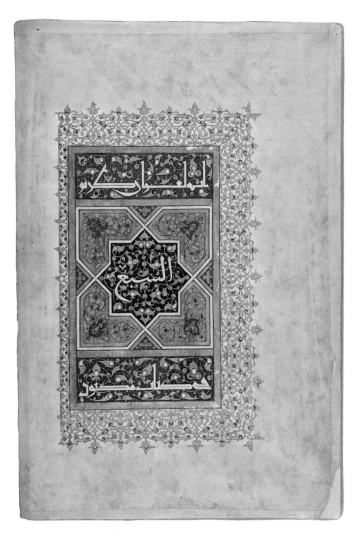

Fig. 11.3 Left page of double frontispiece to volume VII of the Qur'an of Baybars Jashnagir, from Egypt. 1304–06. Illuminated manuscript, 18½″ × 12½″. British Library, London. The most elaborate Qur'ans, such as this one, were financed by endowments created by wealthy individuals in support of a mosque and attendant buildings.

READING 11.1a　　**from the Qur'an,** *Surah 76*

76.11　Therefore Allah will guard them from the evil of that day and cause them to meet with ease and happiness;

76.12　And reward them, because they were patient, with garden and silk,

76.13　Reclining therein on raised couches, they shall find therein neither (the severe heat of) the sun nor intense cold.

76.14　And close down upon them (shall be) its shadows, and its fruits shall be made near (to them), being easy to reach.

76.15　And there shall be made to go round about them vessels of silver and goblets which are of glass,

76.16　(Transparent as) glass, made of silver; they have measured them according to a measure.

76.17　And they shall be made to drink therein a cup the admixture of which shall be ginger,

76.18　(Of) a fountain therein which is named Salsabil [sal-sa-BEEL].

76.19　And round about them shall go youths never altering in age; when you see them you will think them to be scattered pearls.

76.20　And when you see there, you shall see blessings and a great kingdom.

76.21　Upon them shall be garments of fine green silk and thick silk interwoven with gold, and they shall be adorned with bracelets of silver, and their Lord shall make them drink a pure drink.

76.22　Surely this is a reward for you, and your striving shall be recompensed.

This vision of paradise addresses all the senses—touch, taste, and smell (the fruit so "easy to reach," the drink of ginger), sight ("when you see there, you shall see blessings"), and sound (in the very melody of the verse itself). All is transformed into riches. Even the young people in attendance will appear to be "scattered pearls."

The promise of heaven, so richly described here, is balanced by a moral dimension reminiscent of both the Old and

New Testaments of the Christian Bible. Note particularly the call for believers to "let not hatred of a people incite you not to act equitably." Other parts of the Qur'an explicitly appeal to Jews and Christians to accept the teachings of Islam (Reading 11.1b):

READING 11.1b **from the Qur'an, *Surah* 5**

5.8 O you who believe! Be upright for Allah, bearers of witness with justice, and let not hatred of a people incite you not to act equitably; act equitably, that is nearer to piety, and be careful of (your duty to) Allah; surely Allah is Aware of what you do.

5.9 Allah has promised to those who believe and do good deeds (that) they shall have forgiveness and a mighty reward. . . .

5.68 Say: O followers of the Book! . . .

5.69 Surely those who believe and those who are Jews and the Sabians and the Christians whoever believes in Allah and the last day and does good—they shall have no fear nor shall they grieve. . . .

5.75 The Messiah,[1] son of Marium, is but an apostle; apostles before him have indeed passed away; and his mother was a truthful woman; they both used to eat food. See how we make the communications clear to them, then behold, how they are turned away.

[1] **Messiah:** Jesus.

In the context of the present-day political climate in the Middle East, it is worth remembering that such moral positioning—and apparent tolerance—is fundamental to the Islamic tradition. However, like both Christianity and Judaism, the Qur'an also contains less tolerant messages. In the *surah* "Muhammad," the Prophet calls for his followers to "smite the necks" of those "who disbelieve" (for excerpts from the *surah*, see **Reading 11.1**, page 364). In other words, as is the case with the Bible, what one takes from the Qur'an depends on what one chooses to emphasize.

The *Hadith*

In addition to the Qur'an, another important source of Islamic tradition is the **hadith** [ha-DEET], meaning "narrative" or "report," which consists of sayings of Muhammad and anecdotes about his life. The story of Muhammad and the Black Rock of the Kaaba comes from the hadith (**Reading 11.2**).

The *hadith* literature was handed down orally, as was common in Arab society until about 100 years after Muhammad's death, when followers began to write the sayings down.

READING 11.2 **from the *Hadith***

"Actions are but by intention and every man shall have but that which he intended."

"None of you [truly] believes until he wishes for his brother what he wishes for himself."

"Get to know Allah in prosperity and He will know you in adversity. Know that what has passed you by was not going to befall you; and that what has befallen you was not going to pass you by. And know that victory comes with patience, relief with affliction, and ease with hardship."

"If you feel no shame, then do as you wish."

"Everyone starts his day and is a vendor of his soul, either freeing it or bringing about its ruin."

"O My servants, it is but your deeds that I reckon up for you and then recompense you for, so let him who finds good [i.e., in the hereafter] praise Allah, and let him who finds other than that blame no one but himself."

"Renounce the world and Allah will love you, and renounce what people possess and people will love you."

The *Hijra* and Muslim Practice

In 622, Muhammad was forced to flee Mecca when its polytheistic leadership became irritated at his insistence on the worship of only one God. In a journey known as the **hijra** [HIJ-rah] (or *hegira*, "emigration"), he and his followers fled to the oasis of Yathrib [YA-trub], 200 miles north, which they renamed al-Medina, meaning "the city of the Prophet." Here Muhammad created a community based not on kinship, the traditional basis of Arab society, but on common submission to the will of God. Such submission did not need to be entirely voluntary. Muslims were obligated to pursue the spread of their religion, and they did so by means of the **jihad** [jee-HAAD], the impassioned religious struggle that could take either of two forms: a lesser form, holy war; or a greater form, self-control over the baser human appetites. In order to enforce submission, Muhammad raised an army of some 10,000 men and returned to Mecca, conquering the city and destroying the idols in the Kaaba, with the exception of the Black Stone. Confronted by a Muslim army defined by both piety and zealotry, soon the entire western region of Arabia came under Muslim sway, and by the time of Muhammad's death even Mecca had submitted.

Muhammad's new community, known as the *Umma* [OOM-mah], was such a departure from tradition that its creation required a new calendar. Based on lunar cycles, the Muslim year is about 11 days shorter than the Christian year, resulting in a difference of about three years per century. The calendar began in 622 CE. Thus, in the year 2007, the Muslims celebrated the start of their year 1428.

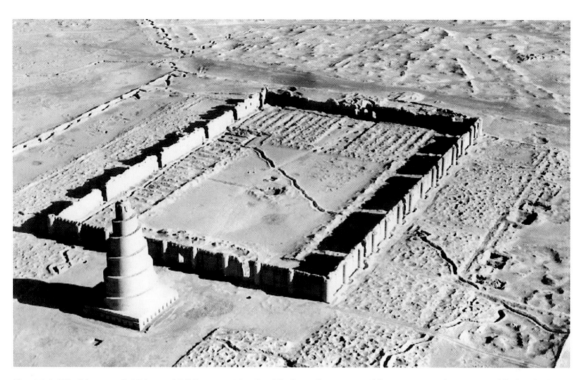

Fig. 11.4 The Mosque of al-Mutawakkil Samarra 848–52. The huge dimensions of the mosque can be accounted for by the fact that all worshipers must face the same direction—that is, toward Mecca—arranging themselves in parallel lines to kneel prostrate. Thus, each worshiper requires a good deal of individual space. As early as 670, many mosques were large enough to accommodate as many as 3,000 worshipers.

The Mosque At Medina, Muhammad built a house that surrounded a large, open courtyard, which served as a community gathering place, on the model of the Roman forum. There the men of the community would gather on Fridays to pray and listen to a sermon delivered by Muhammad. It thus became known as the *masjid* [mahs-JEED], the Arabic word for **mosque**, or "place of prostration." On the north and south ends of the courtyard, covered porches supported by palm tree trunks and roofed by thatched palm fronds protected the community from the hot Arabian sun. This many-columned covered area, known as a **hypostyle** space (from the Greek *hupostulos* [hye-pos-TOO-lus], "resting upon pillars"), would later become a required feature of all Muslim mosques. Another required feature was the *qibla* [KIB-lah], a wall that indicated the direction of Mecca. On this wall were both the *minbar* [MIN-bur], or stepped pulpit for the preacher, and the *mihrab* [meeh-RAAB], a niche commemorating the spot at Medina where Muhammad planted his lance to indicate the direction in which people should pray.

The Prophet's Mosque in Medina has been rebuilt so many times that its original character has long since been lost. But, at Samarra, some 60 miles north of Baghdad on the Tigris River in modern Iraq, the remnants of the Mosque of al-Mutawakkil [al moo-ta-WAK-kul], built in the mid-ninth century, give a fair idea of the original plan of the Prophet's Mosque, albeit on a far grander scale (Fig. **11.4**). Built between 848 and 852, the mosque measures 800 by 500 feet, an area of over 10 acres. For centuries it was the largest mosque in the world. It demonstrates the extraordinary popularity of the Muslim religion, since its central courtyard and hypostyle spaces would have been filled with many thousands of worshipers each Friday. About half the site was covered with a wooden roof on 464 supports, under which worshipers could pray. Although in a state of ruin today, the walls of the mosque were originally richly decorated with glass mosaic and marble panels.

The most remarkable feature of the surviving mosque at Samarra is the spiral tower opposite the *mihrab*, unique in Muslim architecture. Some speculate that this tower, originally 165 feet tall, is a minaret, the tower from which the *muezzin* [moo-WAD-un] (crier) calls the faithful to prayer. But none of the earliest mosques had minarets, and although the call to prayer has become standard Muslim practice, even the earliest minarets may have been modeled on lighthouses (the root of *minaret* is *nur* [NOOR], meaning "light"), serving as sentinels to guide the faithful across the desert to the mosque. Others theorize that the tower was inspired by the ziggurats of ancient Mesopotamia (see Fig. 2.1).

Women in Islam Although Muslim practice today varies widely, in Muhammad's time women were welcome in the mosque. In the Qur'an, Muhammad teaches that women and men are equal partners: "The faithful men and the faithful women are protecting friends for each other" (*Surah* 9:7).

The husband's honor becomes an integral part of his wife's honor, and vice versa. They share equally in each other's prosperity and adversity. But Muhammad further allowed for Muslim men to have up to four wives, provided that they treated all justly and gave each equal attention. (Polygamy was widely practiced in the Arab world at the time, and marrying the widow of a deceased comrade, for instance, was understood to be an act of protective charity.) Muhammad himself—and subsequently other prophets as well—was exempt from the four-wife limitation. Although he had only one wife for 28 years, after she died when he was 53, he married at least 10 other women. The Qur'an describes the wives of Muhammad—and by extension, the wives of all Muslim men—as "Mothers of the Faithful" whose duty was the education of the *umma's* children. They helped them along their spiritual path, transmitting and explaining the teaching of Muhammad in all spheres of life.

One of the most discussed and most controversial aspects of Muslim faith (even among Muslims) is the **hajib** [hih-JUHB], literally "curtain," the requirement that women be covered or veiled. Its origins can be traced to Islam's Jewish heritage and the principle of *tzenuit* [dzen-WEET], which in Hebrew means "modesty" in both dress and behavior and which requires, among other strictures, that all married women cover their hair whenever non–family members are present. Islamic covering ranges from a simple scarf covering the hair to the **chador** [sha-DOHR], which covers the wearer from head to toe, leaving only her hands and her face (or part of her face) exposed. This full covering is currently popular, especially in Iran. Interestingly, the Qur'an is not explicit about the covering. Women are advised to dress in a way that enables them to avoid harassment by not drawing attention to their beauty, or *zinat* [ZEE-nat], a word that means both physical beauty and material adornment in Arabic. The basic message and instruction expressed in the Qur'an is for Muslims to act modestly and dress modestly, a rule that applies to men and women.

Both men and women are entitled to equal treatment before the law, and justice is considered to be genderless. Both have the right to have disputes settled by an arbiter of *shari'a* [sha-REE-ah], the divine law. In the manuscript page showing a husband complaining about his wife before a state-appointed judge, or *qadi* (Fig. **11.5**) [QAH-dee], the wife, accompanied by two other women who serve as witnesses, points an accusing finger at her husband. In such disputes, the first duty of the *qadi* is to reconcile the couple and avoid divorce, which, though legal in Islam, is discouraged. But all in all, the *shari'a* regulated gender relations in ways that favored males. It defined marriage as a reciprocal relationship in which a man owed his wife material support, and a wife owed her husband unwavering obedience. It asserted the male right of polygamy and outlined the terms in which males were to treat their multiple wives equally. A man could unilaterally repudiate a wife, but a woman could only bargain with her husband to end a marriage. And the *shari'a* affirmed

the patrilineal structure of Muslim society by granting mothers only temporary custody of their children after the termination of a marriage, giving ultimate custody to the father or father's family.

Many modern scholars see the *shari'a* as a social revolution providing new rights and security for women in the cultures of the Middle East. But others regard the rules and regulations of the *shari'a* as a stifling suppression of the marriage practices of pre-Islamic Arab society, which was far less patriarchal. Traditional Arab society provided, among other things, for unilateral divorce by women and a woman's right to remain in her own clan and keep her children after divorce. It seems clear as well, that as Islam spread across the Middle East in the eighth and ninth centuries, the *shari'a* was adapted to and modified by local customs and practices. A clear example is the *shari'a's* stated punishment for adultery. The Qur'an ordains that adulterers be given 100 lashes. But the standard punishment outlined in the *shari'a's* by the early ninth century is death by stoning, justified by a *hadith* attributed to the prophet but probably originating in pre-Islamic tribal practices.

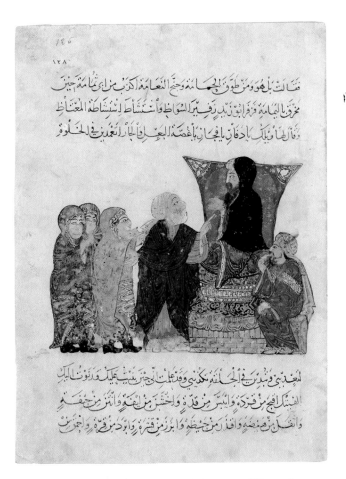

Fig. 11.5 A Qadi Sits in Judgment, Bagdad. 1327. 14½″ × 11″.
Illuminated manuscript. Bibliothèque Nationale, Paris. The women wear the *hajib,* in this instance, a full-length scarf.

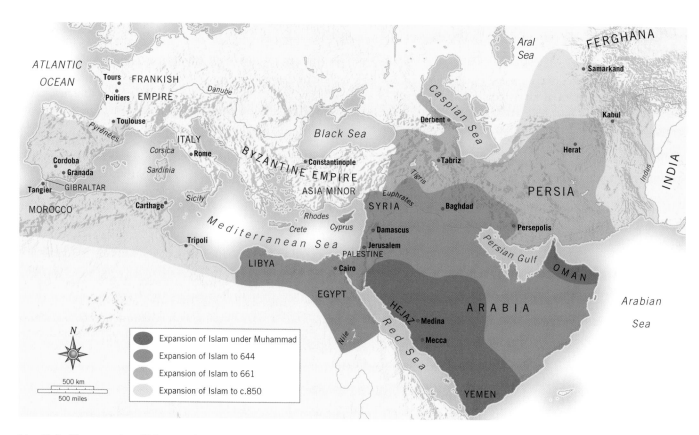

Map 11.2 The expansion of Islam to 850.

The Spread of Islam

Following the death of the Prophet in 632, the **caliphs** [KAY-lifs], or successors to Muhammad, assumed political and religious authority, and Islam spread with a rapidity that is almost unimaginable (Map **11.2**). Damascus fell to the caliphs [KAY-lifs] in 634, Persia in 636, Jerusalem in 638, and Egypt in 640. By 710, all of North Africa and Spain were under Muslim rule.

The speed of the conquest can be partially accounted for by the fact that the Byzantine and Persian empires were exhausted by a long war. Soon after the Byzantine emperor Heraclius [heh-RAK-lius] (r. 610–40) captured Egypt, Palestine, Syria, and Asia Minor from the Persians, Muslim armies struck, driving the Byzantine armies out of their newly acquired territories and overrunning most of the Persian Empire as well. Most of the peoples in these territories, although Christian, were of the same linguistic and ethnic background as their new Muslim conquerors. Furthermore, the brand of Greek Orthodox Christianity that the Byzantine rulers had imposed on them was far too conservative for many. From Persia to Egypt, many peoples accepted their Muslim conquerors as preferable to the Byzantine rulers who had preceded them.

The successes of Islam must also be attributed to its appeal both as a religion and as a form of social organization. It denied neither Judaism nor Christianity, but merely superseded them. As opposed to the Jewish faith, which was founded on a common ethnic identity, Islam opened its arms to any and all comers—a feature it shared with Christianity. But unlike Christianity, it did not draw any special distinction between the clergy and the laity. It brought people together in the mosque, which served as a community meetinghouse, courthouse, council chamber, military complex, and administrative center. Traders naturally migrated to it, as did poets, artists, and scholars. In fact, the mosque was closer in function to the classical agora than to the Christian tabernacle. The sense of community that the mosque inspired played a central role in the spread of Islam.

By the eleventh century, *madrasas* [MAD-ra-sas], or teaching colleges, were attached to the mosques, and mosques became centers of learning as well. Here students studied the Qur'an, the *hadith*, and Islamic law, as well as mathematics, poetry, and astronomy. The *madrasas* eventually contributed to the rise of an intellectual elite, the *ulama* [OO-la-mah] (people possessing "correct knowledge"), a group that functioned more or less in the manner of Christian priests or Jewish rabbis. Yet any man of great religious learning could serve as an *alim* [AA-lum] (the singular form of *ulama*), and *ulama* had the singular role of overseeing the rulers of Islam, guaranteeing that they followed the letter of the law as stated in the Qur'an. (See *Voices*, page 348.)

Works of the Umayyad Caliphs: The Great Mosque of Damascus

If, in the Muslim world, Mecca was the center of culture, the mosque was the umbilical cord that linked the faithful to their cultural center and spiritual home. Mosques sprang up everywhere as Islam extended its reach. One of the earliest was in Damascus (Fig. **11.6**). Originally, the Muslim community in Damascus shared the site with the Christian community, who worshiped in a Byzantine church enclosed inside a walled compound. But by 705, the Muslim community had grown so large that radical steps had to be taken to accommodate it. The Byzantine church was torn down, leaving a large courtyard, and the compound walls were transformed into the walls of the mosque. A large prayer hall was constructed against the *qibla* wall and decorated with an elaborate facade that faced into the courtyard, while the street side of the mosque was left relatively plain.

The Great Mosque of Damascus was the work of the Umayyad [oo-MAH-yahd] caliphs, a Meccan family who were relatives of the Prophet. The first of the Umayyad family to come to power was Ali, the Prophet's cousin, son-in-law, and first convert to Islam. In 661, a rival faction that opposed Ali's rise to power based solely on his familial connections assassinated him. The leader of the *Umma*, they argued, should simply be the best Muslim, whomever that might be. (This division exists to this day. Those who believe that only descendants of Ali should rule are known as Shiites, and they live largely in Iran and Iraq. A more moderate group, known as Sunnis, who today represent the vast majority of Muslims, believe that religious leaders should be chosen by the faithful. These two groups continue to vie for power in modern-day Islam, especially in Iraq. A more conservative group, the Kharijites [KHA-ree-jytes], who originally supported the assassination of Ali on grounds of his moral weakness, still survives in Oman and North Africa.)

After Ali's assassination, the Umayyad family briefly fell from power until Abd al-Malik [ubd al MAH-luk] (r. 685–705) subdued the family's adversaries in 692. His son, al-Walid [al wah-LEED] (r. 705–715), was responsible for the construction and decoration of the Great Mosque in

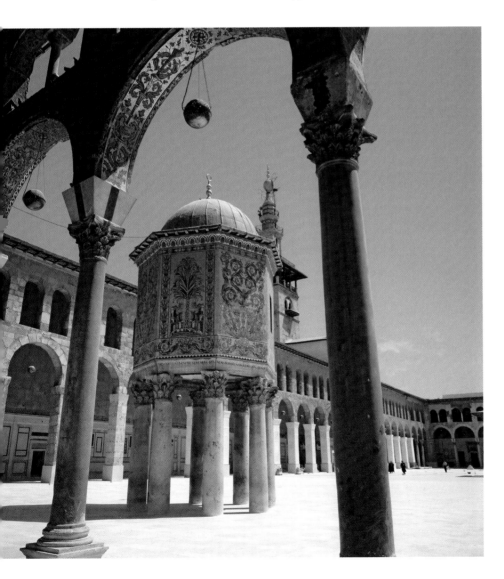

Figs. 11.6 Courtyard of the Great Mosque of Damascus. 706–15. Muslim builders may have considered the site of this mosque to possess mystical powers. The Byzantine church that had stood here was dedicated to John the Baptist. It had supplanted a Roman temple of Jupiter, which had earlier supplanted a temple dedicated to Haddad, the ancient Ammonite storm god.

Voices

A Rabbi in a Muslim World

A century before Marco Polo embarked on his adventures, Benjamin of Tudela, a Spanish rabbi, traveled in the Middle East from 1160 to 1173. In his writings, he described the atmosphere of tolerance that pervaded the capital city of the Islamic caliphate, Bagdad.

...It is two days to Bagdad, the great city and the royal residence of the Caliph Emir al Muminin al Abbasi. He is at the head of the Mohammedan religion, and all the kings of Islam obey him; he occupies a similar position to that held by the Pope over the Christian. He has a palace in Bagdad three miles in extent, wherein is a great park with all varieties of trees, fruit-bearing and otherwise, and all manner of animals.... There the great king holds his court, and many belonging to the people of Israel are his attendants; he knows all languages, and is well versed in the law of Israel. He reads and writes the holy language (Hebrew). He will not partake of anything unless he has earned it by the work of his own hands.... He is truthful and trusty, speaking peace to all men.

...Within the domains of the palace of the Caliph there are great buildings of marble and columns of silver and gold, and carvings upon rare stones are fixed in the walls. In the Caliph's palace are great riches and towers filled with gold, silken garments, and all precious stones. He does not move from his palace save once in the year, at the feast which the Mohammedans call El-id-bed Ramazan [Ramadan], and they come from distant lands that day to see him.

He built, on the other side of the river, on the banks of an arm of the Euphrates River which there borders the city, a hospital consisting of blocks of houses and hospices

> **"In Bagdad there are about 40,000 Jews and they dwell in security, prosperity, and honour under the great Caliph, and amongst them are great sages, the heads of Academies engaged in the study of the law."**

for the sick poor who come to be healed. Here there are about sixty physicians' stores which are provided from the Caliph's house with drugs and whatever else may be required. Every sick man who comes is maintained at the Caliph's expense and is medically treated ...

In Bagdad there are about 40,000 Jews and they dwell in security, prosperity, and honour under the great Caliph, and amongst them are great sages, the heads of Academies engaged in the study of the law ...

In Bagdad there are twenty-eight Jewish Synagogues, situated either in the city itself or in Al-Karkh on the other side of the Tigris; for the river divides the metropolis into two parts. The great synagogue ... has columns of marble of various colours overlaid with silver and gold, and on these columns are sentences of the Psalms in golden letters. The city of Bagdad is twenty miles in circumference, situated in a land of palms, gardens, and plantations, the like of which is not to be found in the whole land of Shinar. People come thither with merchandise from all lands. Wise men live there, philosophers who know all manner of wisdom, and magicians expert in all manner of witchcraft.

Damascus. One large section of the original interior decoration survives—a glass mosaic landscape showing small houses beside a flowing river (Fig. **11.7**). The mosaics were probably the work of Christian Byzantine artisans brought to Damascus by al-Walid. Rising in improbable scale above them is an expanse of colonnaded pavilions, towering trees, and arched bridges. In all likelihood this is the Paradise promised by the Prophet in *surah* 76:14 of the Qur'an (see Reading 11.1a, page 342).

Images in Muslim Art

Human figures are notably absent in the Great Mosque's decoration. Neither are there any animals. In fact, Muslim religious architecture is so notably free of figurative decoration that many people, even some Muslims, assume that representations of "living beings" are forbidden in Islam. As we saw in

chapter 10, the Byzantine emperor Leo III attributed the successes of the Muslim armies to their ban on human figures in their mosques. The following admonition from the Qur'an (5:92) is often cited by Muslims who worry about the role of image-making in Muslim art and decoration: "O believers, wine and arrow-shuffling idols and divining arrows are an abomination,/some of Satan's work; then avoid it." But, it can be argued, "idols" here refers to pagan idols of the kind the Prophet eliminated from the Kaaba in Mecca. Also, at the time, Muhammad had allowed a painting of Mary and the infant Jesus to remain in the building. The *hadiths,* however, also supported those who opposed image-making. There the Prophet is reported to have warned, "An angel will not enter a house where there is a dog or a painting." Likewise, the Prophet claimed that "those who make these pictures will be punished on the Day of Judgment by being told: Make alive what you have created."

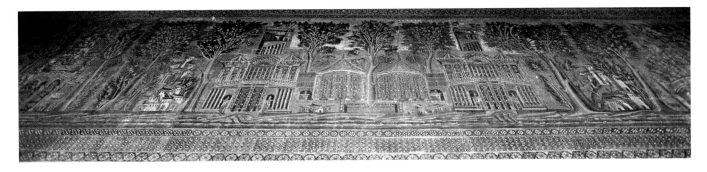

Fig. 11.7 Mosaic decoration, Great Mosque of Damascus. 715. The decorative scheme of such panels reflects Byzantine influence, as well as the Roman love of landscape mosaic.

Some religious scholars believed that the ban on representation applied only to "living" things. Thus, the depiction of Paradise, as on the walls of the Great Mosque of Damascus, was acceptable, because Paradise is "beyond the living." Such thinking would also lead the Muslim owner of a Persian miniature representing a prince feasting in the countryside to erase the heads of all those depicted (Fig. **11.8**). Such an act is closely related to Byzantine iconoclasm, as no one could presume to think that figures without heads could possibly be "alive." In fact, as we will see, Muslim artists in Persia took great delight in illustrating literary texts, creating scene after scene depicting people in various forms of action, including lovemaking. Their freedom to do so is partly explained by their distance from more conservative brands of Arabian Islam, but also by their belief that they were not illustrating "living beings" so much as fictive characters.

Whatever an individual Muslim's feelings about image-making might be, all Muslims recognized that it posed a problem. The practical solution to the problem was to decorate without images, and this was especially true for the decoration of both the Qur'an and religious architecture. At the heart of Islamic culture was the word, in the form of the recitations that make up the Qur'an. In fact, those who transcribed the Qur'an enjoyed a status higher than that of artists and architects and at least equal to that of poets, whose largely oral works had, from pre-Islamic times, been considered the highest form of art. It is also important to remember that the Qur'an is itself a work of oral poetry.

The Art of Calligraphy

The Arabic language has 28 distinctive sounds, but only 18 letterforms. As a result, the same letter has to be used to represent a variety of sounds—for instance, the same letterform is used to represent the sounds *ba, ta, tha, nun,* and *ya* [baa, taa, thaa, noon, and yaa]. And the letterforms themselves are variable, changing according to whether they stand alone or occur at the beginning, middle, or end of a word. This can cause confusion for readers, who must decide what is being said from context. Confusion is not acceptable for the word of God as transmitted in the Qur'an. Thus, when

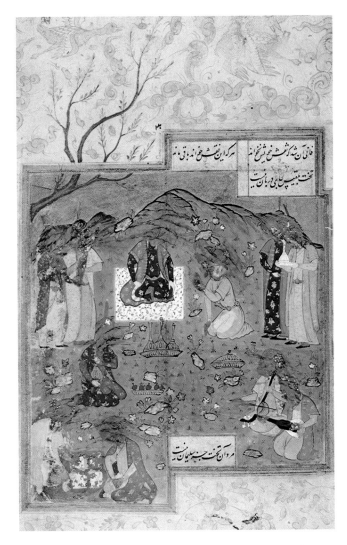

Fig. 11.8 Page from a copy of Nezami's *Khamseh* (the "Quintet"), illustrating a princely country feast, from Persia (modern Iran). 1574–75. Illuminated manuscript, 9 3/4″ × 6″. India Office, London. Nezami's poem, written in the twelfth century, consists of five romantic epics in 30,000 couplets. It became one of the most widely illustrated poems in Persian literature.

the Umayyad caliph Abd al-Malik took control of the Islamic world, he introduced a series of marks to help distinguish between the different sounds that share the same letterform. For instance, *ba* consisted of the letterform with two lines above it, *ya* by two strokes under it, and so on. (Over time, these strokes would become shortened into dots.)

Written from right to left, like Hebrew, Arabic script is entirely cursive—that is, "flowing," often with the strokes of successive characters joined and the angles rounded. As a result, it is highly susceptible to artful treatment. As previously discussed in connection with Chinese writing (see chapter 4), the art of producing artistic, stylized writing is called **calligraphy**. The beauty of Islamic calligraphy depends on how the letters are shaped and connected and on the unity of the composition as a whole. Unlike most Western art, which presumes a single focal point, every part of a work of Islamic calligraphy should have equal value. The decoration should harmonize with the text. Consider the page showing the heading for chapter 18 of the Qur'an, "The Cave" (Fig. **11.9**). The chapter heading is written in richly bordered gold, beginning with a fanciful leaf form that extends into the margin. The first lines of the chapter follow in black. The distinction between chapter heading and text indicates that the former is not part of the "received" message of God, but a conventional name for the verse. The flow of the calligraphy, the rhythmic pattern of horizontal and vertical elements, creates a sense of abstract design that is independent of the meaning of the words.

Because Arabic, as the language of divine revelation, was believed to have a sacred nature, writing, too, was thought to have a divinely inspired power. Thus, in Islamic culture, writing—especially calligraphy—developed into the preeminent form of visual art. It is a form that required knowledge of different scripts and took years of training, with instruction passing from master to student through the practice of imitating the work of the master.

Calligraphy was incorporated into Islamic architecture from the beginning. It covered the walls of palaces and mosques, and throughout the centuries the decoration became more and more elaborate. The application of calligraphy to mosques and other edifices marked them as sacred spaces.

Islam in Africa and Spain

Scholars once believed that the rapid expansion of Islam was entirely due to the determination of the faithful to convert new followers to the faith, but overpopulation of the Arabic peninsula probably also played a role. If faith offered the excuse, the practical result of Islamic expansion was the acquisition of new territories and the wealth they brought with them.

After gaining control of virtually all of the Middle East, the Arabic Muslim armies moved into North Africa in 639. After gaining control of the port of Alexandria, they launched a navy that seized Cyprus and Rhodes and began attacking Italy and Sicily. They moved across North Africa and took Carthage in 698, defeating the native Berber tribes. In 711, Muslim armies, under the command of a freed Berber slave, Tariq [TAH-ruk], crossed into Spain at the Strait of Gibraltar (*Gibraltar* is a corruption of the Arabic words meaning "Rock of Tariq") and moved quickly northward, deep into France. They were finally defeated in 732 at the Battle of Poitiers, also known as the Battle of Tours, by the king of the Franks, Charles Martel, and pushed back south of the Pyrenees. In the succeeding centuries, most of Europe became increasingly united in its opposition to Islam. This resulted in a series of military crusades to free the Holy Land, and Jerusalem in particular, of Muslim influence (discussed in chapter 13). However, the Arabs maintained a dominant presence in Spain, particularly in the southern region of Andalusia [an-duh-LOO-zhee-uh] (*al-Andalus* [al AN-da-loos], in Arabic). There Muslim culture flourished until Christian armies finally expelled the Muslims in 1492, the same year that Columbus set sail for America.

Islamic Africa

The Muslim impact on the culture of North Africa cannot be overstated. Beginning in about 750, not long after Muslim armies had conquered most of North Africa, Muslim traders, following the trade routes created by the Saharan Berber peoples, began trading for salt, copper, dates, and especially gold with the sub-Saharan peoples of the Niger [NY-jur] River drainage. Gradually they came to dominate the trans-Saharan trade routes (Map **11.3**), and Islam became the dominant faith of

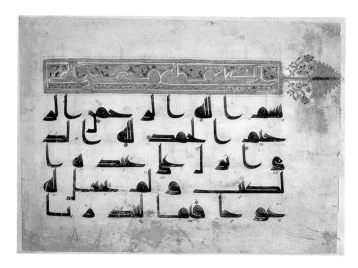

Fig. 11.9 Page from the Qur'an, with six lines of text showing heading from *Surah* 18, *Surat al-Kahf* **("The Cave"), from Syria. Ninth or tenth century.** Ink and gold on parchment, 7¼" × 10¼". © The Trustees of the Chester Beatty Library, Dublin. Parchment manuscripts of the Qur'an were sometimes bound together in leather covers or stored as loose leaves in boxes.

THE RISE AND SPREAD OF ISLAM

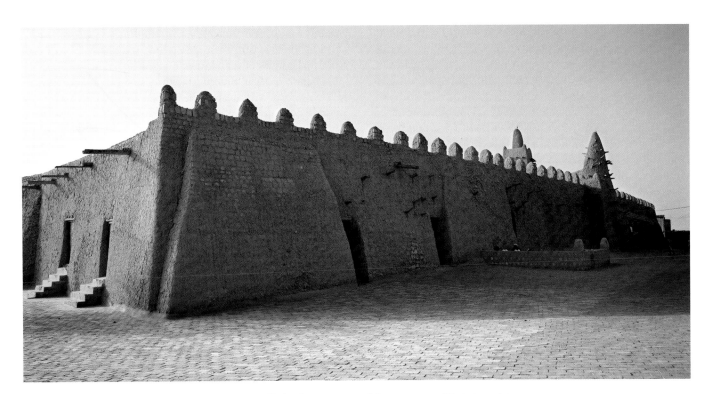

Fig. 11.10 Djingareyber Mosque, Timbuktu. ca. 1312. Today the mosque—and the entire city of Timbuktu—is in danger of becoming a desert, as the sands from the Sahara overtake what once was the Mali savanna.

West Africa. By the ninth century, a number of African states existed in the broad savanna south of the Sahara Desert known as the Sudan [soo-DAN] (which literally means "land of the blacks"). These states seemed to have formed in response to the prospects of trade with the Muslim and Arab world. Ghana [GAHN-uh], which means "war chief," is an early example, and its name suggests that a single chieftain, and later his family, exerted control over the material goods of the region, including gold, salt, ivory, iron, and particularly slaves. Muhammad, who considered slaves the just spoils of war, explicitly authorized slavery. Between the ninth and twelfth centuries the slave trade grew from 300,000 to over a million, and it was so lucrative that the peoples of the Sudan, all eager to enslave each other for profit, fought each other. (There is some reason to believe that many African converts to Islam were initially attracted to the religion as a way to avoid becoming slaves, since the faithful were exempt from servitude.) Finally, the empire of the Mali [MAH-lee] people subsumed Ghana under the leadership of the warrior-king Sunjata [soon-JAH-tuh] (r. 1230–55), and gained control of the great trade routes north out of the savanna, through Timbuktu, the leading trading center of the era.

In 1312, Mansa Moussa [MAHN-sah MOO-sah] (*mansa* is the equivalent of the term "emperor") came to the Malian throne. A devout Muslim, he built magnificent mosques throughout his empire, including the Djingareyber [jin-gah-REY-bur] Mosque in Timbuktu [tim-BUK-too] (Fig. **11.10**).

Still standing today and made of burnt brick and mud, it dominates the city. Under Moussa's patronage, Timbuktu grew in wealth and prestige and became a cultural focal point for the finest poets, scholars, and artists of Africa and the Middle East. To draw further attention to Timbuktu, and to attract more scholars and poets to it, Mansa Moussa

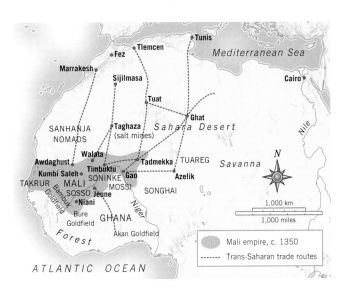

Map 11.3 The Trans-Saharan trade routes, ca. 1350. The shaded portion indicates the empire of Mali in the fourteenth century. The dashed lines trace the main trans-Saharan routes of the period.

embarked on a pilgrimage to Mecca in 1334. He arrived in Cairo at the head of a huge caravan of 60,000 people, including 12,000 servants, with 80 camels carrying more than two tons of gold to be distributed among the poor. Five hundred of the servants carried staffs of pure gold. In fact, Moussa distributed so much gold in Egypt that the value of the precious metal fell dramatically and did not recover for a number of years. When Moussa returned from the holy cities of Mecca and Medina, he built mosques, libraries, and *madrasas* throughout his kingdom. He convinced the Arab poet and architect Abu-Ishaq Ibrahim-es-Saheli [aboo iss-HAAK eeb-rah-HEEM es-SAA-heh-lee] to return with him, and it was Ibrahim-es-Saheli who devised the burnt brick and much of the construction techniques for the Djingareyber Mosque.

Such was Mansa Moussa's fame that the Jewish mapmaker Abraham Cresques [AY-bru-hum KREK] prominently represented him in his *Catalan Atlas*, made in 1375 for Charles V of France (Figs. **11.11**, **11.12**). Crowned in gold and enthroned above his capital of Timbuktu, Mansa Moussa holds a golden orb in one hand and a golden scepter in the other. Cresques depicts a river of gold flowing out of Mali east-ward to Cairo and Alexandria. The caption to the king's right reads, "So abundant is the gold which is found in his country that he is the richest and most noble king in the land."

Mansa Moussa's pilgrimage, or *hajj*, was not unique, except perhaps for its extravagance. All over the Islamic world, the requirement that all Muslims make a pilgrimage to Mecca in their lifetime meant that travel routes were always heavily populated with Muslims. Far to the north of the Mali Empire, in today's Morocco, just one year after Mansa Moussa's *hajj* another pilgrim set out on a pilgrimage that would make him equally renowned. His name was Ibn Battuta. Ibn Battuta became so enthusiastic about travel that he did not come home for three decades, traveling across lands that today constitute more than 40 countries, reaching deep into central Asia and China as well as far down both the east and west coasts of Africa. His memoirs, *The Rihla*, are in some cases the only contemporaneous account we have of many of the places he visited.

Islamic traditions meanwhile continued to exist alongside indigenous African art and music. For instance, the military exploits of the first Malian mansa, Sunjata, still survive in an

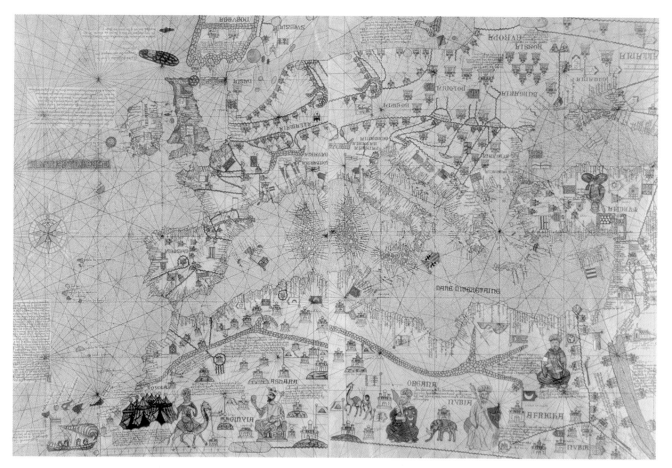

Fig. 11.11 Abraham Cresques. Map of North Africa, *The Catalan Atlas*, from Majorca, Spain. 1375. Index, Bibliothèque Nationale, Paris, France. The map features the Atlas Mountains, Mansa Moussa of Mali, the king of Organa, the king of Nubia, the king of Babylon, and the Red Sea. Note the "River of Gold" that flows across North Africa to Egypt. The mapmaker, Cresques, lived on the Catalan island of Majorca, where a school of nautical mapmakers thrived, their work based on the experience of Mediterranean sailors.

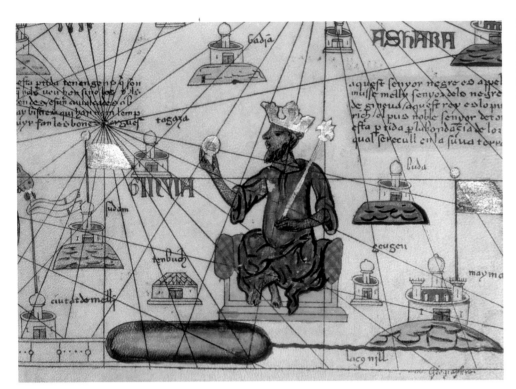

Fig. 11.12 Abraham Cresques. Detail of the Map of North Africa, *The Catalan Atlas*, from Majorca, Spain. 1375. The gold used to represent Mansa Moussa is actual gold leaf.

epic poem, the *Sunjata*. The poem was passed down through the generations, much in the way that the Homeric epics must have been passed down in prehistoric Greece. Its transmitters were Malian **griots** [gree-YOH], professional poet/storytellers who chant or sing traditional narratives from memory, generally accompanying themselves on a harp, either a three- or four-stringed **bolon** [boh-LON], or a 21-stringed *kora* [KOH-rah]. The *Sunjata* was not transcribed until the twentieth century. The poem opens with the griot identifying himself (**Reading 11.3a**):

READING 11.3a **from the *Sunjata*, 12th century**

I am a griot.... We are vessels of speech, we are the repositories which harbor secrets many centuries old. The art of eloquence has no secrets for us; without us the names of kings would vanish into oblivion, we are the memory of mankind; by the spoken word we bring to life the deeds and exploits of kings for younger generations.... Listen to my word, you who want to know; by my mouth you will learn the history of Mali.

Later in the poem, Sunjata oversees a festival in celebration of his military exploits, a description that creates a vivid picture of Malian tradition (**Reading 11.3b**):

READING 11.3b **from the *Sunjata*, 12th century**

The festival began. The musicians of all the countries were there. Each people in turn came forward to the dais under Sunjata's impassive gaze. Then the war dances began. The sofas [soldiers] of all the countries had lined themselves up in six ranks amid a great clatter of bows and spears knocking together. The war chiefs were on horseback. The warriors faced the enormous dais and at a signal from Balla Fasséké [BA-la fah-SEH-keh] [Sunjata's griot], the musicians, massed on the right of the dais, struck up. The heavy war drums thundered, the bolons gave off muted notes while the griot's voice gave the throng the pitch for the "Hymn to the Bow." The spearmen, advancing like hyenas in the night, held their spears above their heads; the archers of Wagadou [wah-gah-DOO] and Tabon [tah-BOHN], walking with a noiseless tread, seemed to be lying in ambush behind bushes. They rose suddenly to their feet and let fly their arrows at imaginary enemies. In front of the great dais the Kéké-Tigui [keh-keh TEE-ghee], or war chiefs, made their horse perform dance steps under the eyes of the Mansa. The horses whinnied and reared, then, overmastered by the spurs, knelt, got up and cut little capers, or else scraped ground with their hooves.

The rapturous people shouted the "Hymn to the Bow" and clapped their hands. The sweating bodies of the warriors glistened in the sun while the exhausting rhythm of the tam-tams [large circular gongs] wrenched from them shrill cries.

Fig. 11.13 Great Mosque of Córdoba. Begun 785, extensions 852, 950, 961–76, and 987. The caliphs of Spain intended their mosque to rival those in Jerusalem, Damascus, and Iraq. The forestlike expanse of the interior is a result of these aspirations. Even though only 80 of the original 1,200 columns survive, the space appears infinite, like some giant hall of mirrors.

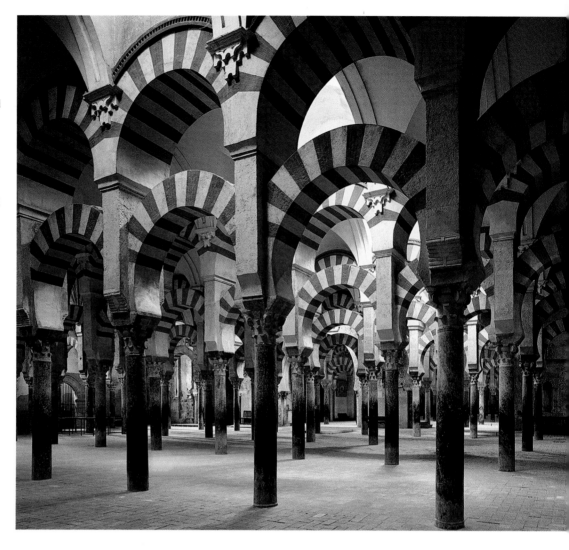

To this day, griots in West Africa perform the *Sunjata* (**CD-Track 11.1**). The performance features many of the characteristics common to West African music. These include polyrhythmic percussion, featuring as many as five to ten different rhythms simultaneously played on a variety of instruments (such as drums, rattles, and, here, bows and spears knocking together), communal performance, responsive chants, and what in another context might be considered "noise"—shrill cries, for instance—adding to the tonal richness of the whole.

Islamic Spain

Like Islamic Africa, Islamic Spain maintained its own indigenous traditions while it absorbed Muslim ones, thus creating a distinctive cultural and political life. In 750, the Abbasids [AB-ass-eed], a large family that claimed descent from Abbas [AB-bass], an uncle of Muhammad, overthrew the Umayyad caliphs. The Abbasids shifted the center of Islamic power from Mecca to a magnificent new capital in Iraq popularly known as Baghdad. In the middle of the ninth century they

moved again, to the complex at Samarra (see Fig. 11.4), 60 miles farther up the Tigris, probably in an attempt to seek more space to build palaces and mosques. Meanwhile Spain remained under Umayyad control, initially under the leadership of Abd ar-Rahman (r. 756–88) [abd ur rahh-MAN], who had escaped the Abbasid massacre of Umayyads in Syria in 750 by fleeing to Córdoba [KOR-doh-buh]. The Spain he encountered had been controlled by a Germanic tribe from the north, the Visigoths, for over three centuries, but gradually he solidified Muslim control of the region, first in Córdoba, then in Seville, Toledo (the former Visigothic capital), and Granada.

The Great Mosque of Córdoba In the last years of his reign, secure in his position, Abd ar-Rahman built a magnificent new mosque in Córdoba, converting an existing Visigothic church into an Islamic institution, for which the Christian church was handsomely reimbursed. Abd ar-Rahman's original design included a double-tiered system of columns and arches topped by a wooden roof (Fig. **11.13**).

The double arches have a practical function. The Visigoths tended to build with relatively short, stubby columns. To create the loftier space required by the mosque, the architects superimposed another set of columns on top, creating two tiers of arches, using a distinctive alternation of stone and red brick voussoirs, the wedge-shaped stones used to build an arch (see *Materials and Techniques*, page 255). The use of two different materials is functional as well, combining the flexibility of brick with the strength of stone. The hypostyle plan of the mosque was infinitely expandable, and subsequent Umayyad caliphs enlarged the mosque in 852, 950, 961–76, and 987, until it was more than four times the size of the Abd ar-Rahman's original and incorporated 1,200 columns.

Under the Umayyad caliphs, Muslim Spain thrived intellectually. Religious tolerance was extended to all. (It is worth noting that Muslims were exempt from taxes, while Christians and Jews were not—a practice that encouraged conversion.) Spanish Jews, who had been persecuted under the Visigoths, welcomed the Muslim invasion and served as scientists, scholars, and even administrators in the caliphate [KAY-lih-fate]. Classical Greek literature and philosophy had already been translated into Arabic in Abbasid Baghdad. The new School of Translation established by the Umayyads in Toledo [toh-LEH-doh] soon was responsible for spreading the nearly forgotten texts throughout the West. Muslim mathematicians in Spain invented algebra and introduced the concept of zero to the West, and soon their Arabic numerals replaced the unwieldy Roman system. By the time of Abd ar-Rahman III (r. 912–61), Córdoba was renowned for its medicine, science, literature, and commercial wealth, and it became the most important center of learning in Europe. The elegance of Abd ar-Rahman III's court was unmatched, and his tolerance and benevolence extended to all, as Muslim students from across the Mediterranean soon found their way to the mosque-affiliated *madrasa* that he founded—the earliest example of an institution of higher learning in the Western world.

In Córdoba, Abd ar-Rahman III built a huge palace complex to honor his wife. (Its extensive remains are still being excavated.) Its staff included 13,750 male servants along with another 3,500 pages, slaves, and eunuchs. Its roof required the support of 4,300 columns, and elaborate gardens surrounded the site. As many as 1,200 loaves of bread were required daily just to feed the fish in the garden ponds.

The city of Córdoba reflected the splendor of its palace. Writers at the time, visiting the caliphate, testify that its population was about 500,000 (compared to 40,000 in Paris at about the same time). There were 1,600 mosques, 900 public baths, and more than 80,000 shops. About half the population had running water and lavatories in their homes. And the main city streets were lighted by torchlight at night.

Jews in Muslim Spain Jews had settled in Spain as early as 586 BCE, when Nebuchadnezzar [neh-boo-kad-NEZ-zur] II conquered Jerusalem and destroyed the First Temple in Jerusalem. The Hebrew word for Spain was *Sepharad* [SEF-ar-

CULTURAL PARALLELS

Epic Heroes East and West

As griots performed and taught the epic poem *Sunjata* from generation to generation after 1200, an epic poem about another culture's hero was also handed down as oral narrative. Like the hero of *Beowulf,* Sunjata fights and defeats enemies endowed with supernatural powers.

ud], and the Spanish Jews were thus known as *Sephardim* [suh-FAR-deem]. Under Umayyad rule, the Jewish population flourished to such an extent that some scholars refer to the period as the Golden Age of Jewish Culture. Jews served at the highest levels of government and participated in the social and intellectual fervor that marked the Umayyad court. They dedicated themselves to the study of science and medicine. In fact, Abd-ar-Rahman III's court physician was the Jewish Hasdai ibn Shaprut [huz-DAH-ee ubun shap-ROOT] (ca. 915–ca. 990). Jewish scholars also devoted themselves, under Hasdai ibn Shaprut's patronage, to the art of poetry and the study of Hebrew grammar. He was also instrumental in making Córdoba the new center of Jewish theological studies.

The Umayyad caliphate in Spain ultimately collapsed in the eleventh century, when Muslim Berbers from North Africa assumed power. The Berbers were far less tolerant of Judaism than the Umayyads, and persecutions began. The first one was on December 30, 1066, when the Berbers expelled Jews from Granada and killed 1,500 families who refused to leave. Nevertheless, Jewish culture still thrived, especially in Toledo and Córdoba. It was in Córdoba that Moses Maimonides (1138–1204), one of the greatest Jewish scholars, was born, although he and his family were driven out of the country by Berbers in 1148. Maimonides is renowned for being the first person to write a systematic summary of Jewish law, the *Mishneh Torah*. He also produced one of the great philosophical works of Judaism, *Guide to the Perplexed*, a work about the nature of God in general that would influence later Christian thinkers such as Thomas Aquinas (see chapter 14).

One of the great Jewish poets of the era is Judah Halevi [YOO-dah hah-LEH-fee] (ca. 1075–1141). In Córdoba, he wrote one of the best-known books of the era, *The Book of Argument and Proof in Defence of the Despised Faith*, later known as *The Book of the Kuzari*. This dialogue between a Jewish scholar and the pagan king of the Khazars [khah-ZARS], a seminomadic Turkish people, is considered by many to be one of the most important works of Jewish philosophy. The book argues, among other things, that the Hebrew language is itself divine, that the Torah is supernatural—not just a "gift from God" but the very "presence of God"—and that the special function of the Jewish people in God's plan is to bring about the redemption of the world.

Halevi was a poet of both secular and religious verse, including love songs, drinking songs, and autobiographical lyric poems concerning his faith. One of the most moving of the latter is "My Heart Is in the East." It embodies feelings shared by all Jews of the diaspora (**Reading 11.4**):

READING 11.4 Judah Halevi, "My Heart Is in the East"

My heart is in the East, and I live at the edge of the West.
I eat. I taste nothing. How can I enjoy it?
How can I fulfill my word to leave
While Zion is locked up in red Edom [EH-dum][1]
and I stand in the ropes of Arabia?
Easily I could give up
all the good wonders of Spain.
Glory would be to see the dust of the Temple,
our ravaged shrine.

[1] **Edom:** a Hebrew word meaning "red" but referring to Esau in the Hebrew Scriptures as well as to the nation tracing its ancestry to him.

Before the end of his life, Halevi did leave his native Spain for Zion, perhaps driven out by the Berbers. He reached Alexandria, where he continued to write, but died six months later.

The Alhambra The collapse of the Umayyad caliphate and the subsequent rise and fall of the various Islamic dynasties was the inspiration for a pioneering work of sociology, the *Muqaddimah* [moo-QAD-dee-ma] (literally "Introduction") of Ibn Khaldun [ubun khal-DOON] (1332–1406), the first volume of a universal history that comprises six books. Originally conceived by its Tunisian-born author as a history of the Berbers, the work is based on Ibn Khaldun's central concept of *asabiyah* [ah-sa-BEE-ah], or "group feeling." Asabiyah is the source of cohesion within a community, and although it occurs almost naturally in small groups, such as families or tribes, religion can greatly expand its effects. Khaldun analyzes how *asabiyah* can carry groups to power, but he also demonstrates how, over time, the power of *asabiyah* dissipates in a group, causing its downfall and its eventual replacement by a new group with a more vital or contemporary sense of itself as a coherent power.

The Berbers in Spain represented this new, stronger power, and their architecture embodied their sense of *asabiyah*. On a hill above Granada they erected a magnificent palace and fortress, which, particularly under the rule of the Nasrid [NUSS-reed] dynasty (r. 1230–1492), flourished as a center for the arts. Named the Alhambra [al-HUM-brah]—from the Arabic word for "red citadel"—after the reddish tone of its walls, it gives us some sense of what the Abd ar-Rahman III's palace complex in Córdoba must have been like.

Within the walls of the Alhambra are palaces, mosques, gardens, quarters for artisans, baths, and tombs. The Palace of

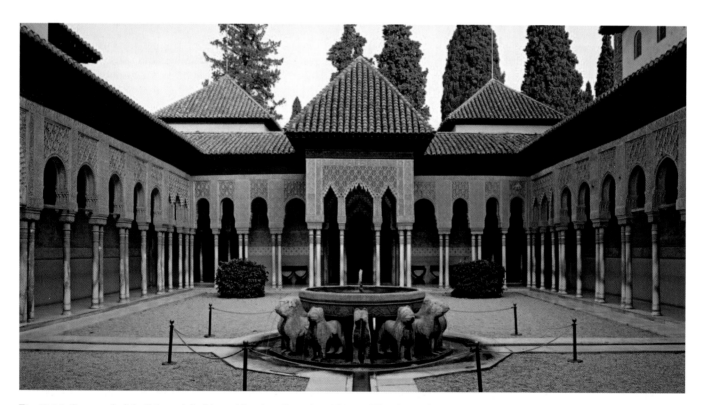

Fig. 11.14 Courtyard of the Palace of the Lions, Alhambra, Granada. 1354–91. The 12 stone lions supporting the fountain were salvaged from an earlier complex that stood on the Alhambra hill overlooking Granada.

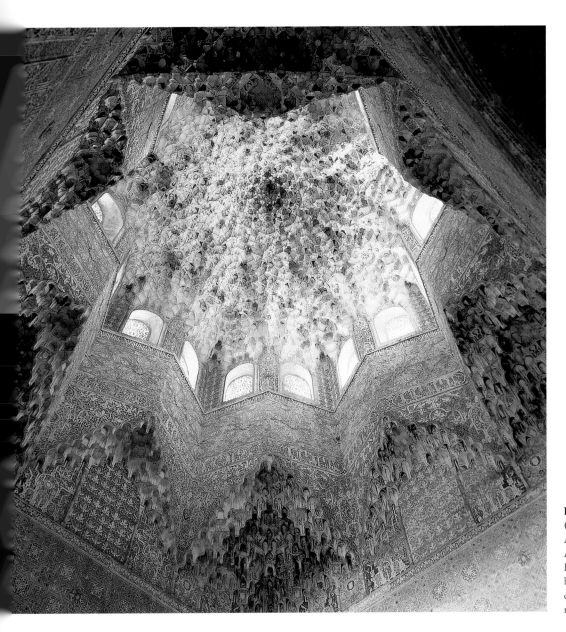

Fig. 11.15 *Muqarnas* dome (plaster ceiling), Hall of the Abencerrajes, Palace of the Lions, Alhambra, Granada. 1354–91. The Hall of the Abencerrajes may have been used as a music room, the elaborate ceiling contributing to its nearly perfect acoustics.

the Myrtles served as the official chambers for receiving and hosting visitors. Named after the shrubs planted in its courtyard, it was based on the plan of an urban dwelling in the Arab heartland, where life centered around a sheltered outdoor patio surrounded by doorways leading to the bedrooms, sitting rooms, and storage areas. The Palace of the Lions, named after the fountain in its courtyard surrounded by 12 stone lions, served as a private residence (Fig. **11.14**). The various rooms of the palaces opened into their central courtyards. Poetic texts adorn the palaces, carved into the capitals of their colonnades and inscribed on their walls and **miradors** [MEE-rah-dohrs], projecting rooms with windows on three sides. On a mirador overlooking the gardens of one palace are the words "I am a garden adorned with beauty. Gaze upon my loveliness and you will know this to be true." On another is the poignant phrase "I believe that the full moon has its home here." On the walls beneath the decorated ceilings of the Palace of the Lions, the fourteenth-century court poet

Ibn Zamrak [ubun ZAM-rak] outlined the spiritual essence of the architectural traceries and grilles of the palace's arches and domes:

> And how many arches rise up in its vault supported by columns which at night are embellished by light!
>
> You would think that they are heavenly spheres whose orbits revolve, overshadowing the pillar of dawn when it barely begins to appear after having passed through the night.

The play of light and shadow, and the airy lightness of the stone- and plasterwork that adorn the Alhambra, symbolize the celestial heavens. The ceiling of the Hall of the Abencerrajes [ah-ven-ser-RAKH-ess] is decorated with **muqarnas** [moo-QARR-nass], small nichelike components unique to Islamic architecture that are combined in successive layers to enclose a space and produce surfaces rich in three-dimensional geometric compositions (Fig. **11.15**).

Here they are used to catch the changing light as it moves from window to window across the top of the dome drum. The inescapable conclusion is that the Alhambra was meant to be something akin to heaven on earth, or paradise (from the Persian word for an enclosed park, *faradis* [faa-raa-DEES]), the literal embodiment of what, in the Great Mosque of Damascus, could only be imaged in mosaic (see Fig. 11.7).

The visitor to the Alhambra is struck by one other inescapable reality—there is water everywhere, in gardens, courtyards, and patios. Inscribed on the wall of one courtyard are the words, "The water in the basin in my center is like the soul of a believer who rests in the remembrance of God." But the water in the Alhambra is not merely passive. It flows, gurgles, and bubbles. Everywhere there is the *sound* of water, the essential *melody* of nature.

The Arts of the Islamic World

Between the eighth and thirteenth centuries the Islamic world, from Baghdad in the east to Córdoba in the west, developed artistic traditions and practices compared to which the arts in Western Europe simply paled. With the same technical virtuosity that the architects at the Alhambra employed, Islam's musicians, bookmakers, illustrators, and poets crafted beautiful works of complex abstract design.

Music in the Islamic World

Music was central to Islamic culture. Though Muhammad and his followers initially viewed music with some skepticism, believing that it distracted the faithful from their true purpose, within a century of his death, Muslim worship had become a highly musical event. In the call to prayer, each of the call's seven phrases is sung, with a long pause between each phrase and each phrase becoming more melodic than the last. In the daily prayer service and on holy days, verses from the Qur'an are chanted and special songs are sung.

Traditional Arabic music is based on intonations and rhythms closely related to the inflections of words. It utilizes many more pitch intervals than Western music, breaking what we think of as a given pitch into fractions of semitones and microtones. In addition, Arabic song is "voiced" through the nose as well as the mouth, resulting in a range of distinctly nasal pitches, as in the Andalusian song from the "Nuba 'al'istihlal'" [na-ba' aal-iss-teehh-LAAL], "Songs to be sung after sunset" (**CD-Track 11.2**). These songs were often accompanied, at least outside the mosque, by a range of instruments, including drums, tambourine, flute, oboe, and lute—or *oud* [ood], from the Arabic for "wood"—a bent-necked, pear-shaped string instrument. As Islam spread, the *oud* became known, throughout North Africa, as the *qitara* [qee-TAH-rah]—the guitar—which achieved its modern form in Islamic Spain. Like Arabic music in general, the *qitara* was believed to be closely connected to nature. Its four strings variously represented the four seasons, the four phases of the moon, the four alchemical elements (hotness, coldness, dryness, and moistness), or the four bodily humors (in the medieval world, the four elemental fluids of the body—blood, phlegm, choler or yellow bile, and melancholy or black bile).

During the Abbasid era (750–1258), only an accomplished musician could be considered a truly educated person. With the translation into Arabic of the works of Greek writers such as Pythagoras, who had championed the idea of the harmony of the spheres, scholarship in the musical arts thrived. Al-Kindi [al-KIN-dee] (790–874) studied the effects of music on people's feelings and behavior and, like the Greeks before him, developed a system of **modes**, or scales, corresponding to the emotions that the music was meant to evoke. By the ninth century, the renowned musician Ziryab [zeer-YAB] (789–857) arrived in Córdoba from Baghdad and founded the first conservatory of music in Spain. Here, musicians began to experiment with ensemble compositions divided into five or more movements performed by string, wind, and percussion instruments and often accompanied by a vocal chorus. New instruments were invented—trumpets, viols, and kettledrums. In essence, the elements of the Western orchestra were now in place.

The Art of the Book

Sometime in the eighth century the art of papermaking was introduced into the Arabic world from China. The process involved extracting cellulose pulp from any of a number of plants, suspending the pulp in water, catching it on a fine screen, and then drying it into sheets. By the first years of the ninth century, most official documents in Baghdad were executed on paper, and soon afterward books, which were more affordable than parchment manuscripts, began to increase in number. Calligraphers and artists created not only scholarly treatises but also romances, epics, and lyric poetry, and most Abbasid cities soon boasted special booksellers' markets. As Jonathan M. Bloom notes in his history of papermaking in the Islamic world, *Paper Before Print*, "Paper . . . became the prime medium of memory." Bloom suggests that although scholars have long recognized "the major achievements of intellectual life under the Abbasids . . . these achievements were not accidental. Rather, they were tied to the introduction of paper: they were a product of both increased intellectual curiosity—itself fostered by the growth of learning made possible by the explosion of books—and attempts to exploit the potential applications of paper." It is likely that the West did not produce paper in any sufficient quantity for another 500 years—until the invention of the printing press—because of its comparative lack of interest in the written word. The richest library in the West by the mid-fourteenth century, for instance, was the college library of the Sorbonne in Paris, which boasted some 2,000 volumes. By contrast, a single tenth-century Andalusian scholar, Ibn Hani al-Andalusi [ubun HAA-nee al an-DA-loo-see], reputedly owned a private library of some 400,000 volumes. Muslim culture, in turn, was slow to adopt the printing press because it so valued the art of calligraphy.

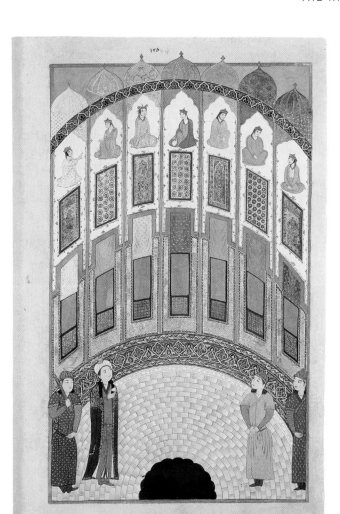

Fig. 11.16 *Prince Bahram Gur Introduced into the Hall of Seven Images*, from a copy of Nezami's poem *Haft Paykar* ("Seven Pavilions"), from *Nezami's Khamseh*, in the *Anthology of Iskandar Sultan*. From Shiraz, Iran, 1410. Illuminated manuscript, 9½" × 5⅞". Calouste Gulbenkian Foundation Museum, Lisbon. Another illustration of Nezami's poem is reproduced in Fig. 11.8, but defaced by its owner.

As a result of its book production, Abbasid Baghdad at the height of its influence, from the ninth to the twelfth centuries, was the center of world culture. Trade flourished as silk and porcelain from China, horses from Arabia, cotton from Egypt, and minerals from throughout Europe overflowed its markets. As one late ninth-century visitor remarked, "Goods are brought from India, Sind [i.e., Pakistan], China, Tibet, the lands of the Turks . . . the Ethiopians, and others to such an extent that [the goods] are more plentiful in Baghdad than in the countries from which they come. They can be procured so readily and so certainly that it is as if all the good things of the world are sent there, all the treasures of the earth assembled there, and all the blessings of creation perfected there." There are, he commented further, "none more learned than their scholars, better informed than their traditionists, more cogent than their theologians . . . more literate than their scribes, more lucid than their logicians . . . more eloquent than their preachers, more poetic than their poets." The book made this cultural eloquence manifest and transportable. Islamic learning—and with it, Islamic faith—spread throughout the world.

Nezami's *Haft Paykar* One of the most widely illustrated poems of the Middle Ages is the *Haft Paykar* [pay-KAR] (Seven Beauties). It is one of five romantic epics in 30,000 couplets that make up *Khamseh* [KHAM-sa] (Quintet) by the Persian poet considered to be the master of the genre, Nezami [nee-ZAH-mee] (ca. 1141–1203 or 1217), whose full name is Elyas Yusof Nezami Ganjavi [eel-YAS YOO-suf nee-ZAH-mee gan-YAH-vee]. A **romantic epic** is a poem that celebrates love between a man and woman as a cosmic force for harmony and justice. Thus, the love stories that form the epic's core narrative are also vehicles for treating broader philosophical issues such as just rule, human perfection, and spiritual growth. The *Haft Paykar*, Nezami's masterpiece, narrates how, one day, the legendary Persian prince Bahram Gur [BAH-ram GOOR] discovers a mysterious pavilion with portraits of seven beautiful princesses decorating its walls (Fig. **11.16**). He falls in love with all of them, marries them, sets up each princess in a separate pavilion of her own, and visits them one by one. Each princess tells him a story—each of about 1,000 **couplets**, two-line rhymed stanzas—that is meant to instruct him in the art of love and the love of beauty. **Reading 11.5** includes the first 29 couplets of "The Tale of the Black Princess."

READING 11.5 **from Nezami, *Haft Paykar*, "The Tale of the Black Princess," 1197**

When Bahram pleasure sought, he set
his eyes on those seven fair portraits;
On Saturday, from Shammasi [SHA-ma-see] temple[1] went
in Abbasid black[2] to pitch his tent,
Entered the musk-hued dome, and gave
his greetings to the Indian maid.
Til night he there made merry sport,
Burnt aloes-wood,[3] and scattered scent.
When Night in kingly fashion spilled
black grains of musk on whitest silk,
The king from that Kashmiri spring[4]
sought perfume like the dawn breeze brings:
That she might loose some women's words,
sweet stories from her store of pearls,
Those tales for which all hearers long,
and soothe to sleep the drunken man.
That Turk-eyed, Hindu-born gazelle
loosed fragrant musk, her tale to tell.
She said, "May the king's fanfare play
above the moon's high throne; and may
He live as long as turns the world;
may all heads at his threshold bow.

CULTURAL PARALLELS

Music in Muslim and Christian Worship

Music was central to the experience of Muslim worship by 1000. During this time in Germany, Christian mystic Hildegard of Bingen (Germany) composed music designed to illuminate spiritual truths during the Catholic liturgy.

May he gain all his wishes; may,
his fortune never flag." This prayer
Concluded, she bowed low, and loosed
from sugared lips sweet aloes-wood.
She told (her eyes cast down in shame)
a tale unmatched by anyone. . . .

[1] **Shammasi temple:** the temple of fire, served by white-robed priests.
[2] **Abbasid black:** the color of the Abbasid caliphs.
[3] **aloes-wood:** incense made of aloe.
[4] **Kashmiri spring:** a reference to the "black princess," who is from India.

The story of Bahram and his seven wives is a narrative device known as a **framing tale**. This form allows the poet to unite different tales—in this case seven—under an overarching narrative umbrella. The Western reader is probably most familiar with the framing tale in *The Thousand and One Nights*, also known as *The Arabian Nights*.

The Thousand and One Nights *The Thousand and One Nights* is a compilation of prose tales from various sources—Persian, Arabic, and Indian—that were united into a single narrative between the eighth and tenth centuries in Baghdad. It is likely that Nezami knew it well. The framing tale derives from the Indian story of Scheherazade [SHAHH-raa-zaad] (Shahrasad [SHAHH-raa-zaad] in Persian), who chooses to marry King Shahryar [shahh-ra-YAHR], who so fears the prospect of female infidelity that he kills each new wife on the morning after their wedding night. In a conscious defense of womankind, Scheherazade knows that if she can tell a story each night and carefully construct it so as to reach its climax just after dawn, the king must let her live until the next evening in order to hear the tale's ending. After a thousand nights—and some 250 tales—the king comes to appreciate Scheherazade's beauty, wit, and civilizing power, and so spares her the fate of all his previous wives.

Both the *Haft Paykar* and *The Thousand and One Nights* show the centrality of love and sexuality in Islamic culture. In Islam, erotic sensory satisfaction, love, luxury, sensuality, and enjoyment were manifestations of divine grace. And although both framing tales portray women in almost total subservience to the ruler/husband, the women in each tale assert a certain real authority. In the *Haft Paykar*, women bring the prince Braham Gur to a state of wisdom and spiritual wholeness. In *The Thousand and One Nights*, women's intelligence, wit, and reason at least equal and sometimes surpass that of their male counterparts.

The Thousand and One Nights was extremely popular in the West from the eighteenth century onward, and it exercised a considerable influence on the development of the novel in Western literature. It contains a wealth of stories popular to the present day—the adventures of Sinbad the Sailor, Ali Baba, and Aladdin, to name just a few—but its eroticism and ribald humor have often been sanitized in Western retellings. The stories wind in and out of one another in a seemingly endless pattern of repetition. The famous "Tale of the Fisherman and the Genie" (see **Reading 11.6**, pages 364–366) is a sequence of stories within stories that mirrors the framing technique of the whole, the fisherman telling tales to outwit an angry genie just as Scheherazade tells her tales to outwit the king. The sequence is repeatedly interrupted as dawn approaches and Scheherazade's stories must end for the night.

The Thousand and One Nights embodies a tension that pervades Islamic culture to this day and, it is fair to say, Western culture as a whole. That tension is between the exercise of authoritarian power over women in patriarchal society and the need for women to free themselves of that power—in Scheherazade's case, in order to survive. Related to this is the tendency of patriarchal society to reduce women to sexual objects even as it recognizes their great intellectual capacity. Scheherazade's tales must be understood in this context: They allow her to resist the king whom she entertains nightly, a man who is empowered by the *shari'a* (shah-REE-'a) or a like set of laws, who feels no compunction about executing wife after wife, day after day.

The Sufi Tradition

After the 1258 fall of Baghdad to Mongol invaders—the conquering Mongols would themselves become Muslim—the art of bookmaking shifted to Iran, where a thriving literary culture, exemplified by the poetry of Nezami, already existed. Particularly at the provincial capitals of Shiraz and Herat, home to a number of important Persian poets and painters, the art of the book became associated with the mystical practices of the Sufi [SOO-fee] orders. Sufism (from the Arabic word for "wool," *suf*, a reference to the coarse woolen garments worn by Sufi practitioners) embraces a wide range of mystical practices. All of them share a belief in attaining visionary experience and divine inspiration by means of trances achieved in the intense experience of music, poetry, and dance. Thus, the ecstasy of the wild, whirling dervish dance (the Persian word for a Sufi or Muslim mystic is *darvish*) represents the path of the soul as it moves closer to God (Fig. **11.17**). The great Sufi poets—Sa'di [SAA-adi]

(ca. 1213–92), Rumi [ROO-mee] (ca. 1207–73), and Jami [JAH-mee] (1414–92) among them—emphasize the pursuit of the beautiful, often in the form of a beautiful woman or, in the case of Rumi, a beautiful man. However, such a pursuit is an allegory for, or figurative representation of, the pursuit of the beauty that is God.

For instance, Jami's version of the "Seduction of Yusuf [YOO-suf] and Zulaykha [zoo-LAY-kuh]" (**Readings 11.7a and b**), a story celebrated by several Sufi writers, retells, in elaborate fashion, the story of Joseph and the wife of Potiphar [POT-uh-fur], Zuleika [zoo-LAY-kuh], which appears in both the Bible and Qur'an. Yusuf protests that his love is not sexual but divinely inspired:

READING 11.7a **from Jami, "Seduction of Yusuf and Zulaykha," 1483**

I would not passion's victim be,
And turned from sin—but not from thee.
My love was pure, no plant of earth
From my rapt being sprung to birth:
I loved as angels might adore. . . .

His pure adoration leads Yusuf to understand "the great lesson"—"That vice and bliss are wide apart." His love for his lady leads him to the love of God.

Fig. 11.17 *Dervishes Dancing,* from a copy of *Sessions of the Lovers,* from **Turkey. Sixteenth century.** Illuminated manuscript, approx. 9″ × 6″. Bodleian Library, Oxford. The Sufi's goal was to achieve direct contact with God through mystical trance, and the ecstatic whirling dance could, the Sufis believed, induce such a trance. In this miniature, the dervishes dance to the accompaniment of flutes and tambourines.

Fig. 11.18 Bihzad. *The Seduction of Yusuf,* from a copy of Sadi's *Bustan* ("Orchard"), prepared for Sultan Husayn
Mirza at Herat, Persia (modern Afghanistan). **1488.** Ink and color on paper, 11⁷⁄₈″ × 8²⁄₃″. National Library, Cairo.
Bihzad is one of the most renowned illustrators of the fifteenth century. In illustrating this manuscript, he worked together
with Sultan-Ali Mashhadi, who was himself the greatest calligrapher of the day. The text of Sadi's version of the Yusuf story
is in the cream-colored panels in the top, middle, and bottom of the page.

In Jami's poem, Zulaykha builds a palace with seven rooms, each decorated with an erotic painting of herself and Yusuf, in order to seduce the beautiful youth. As she leads the unsuspecting Yusuf from room to room, she locks each door behind her. When they reach the last room, she throws herself on Yusuf, who flees as each of the seven doors miraculously opens before him. In Jami's poem, the palace and its decorations stand for the temptations of the material world with its seven climes, the habitable climatic regions of the earth (Fig. **11.18**). Yusuf's beauty, which Zulaykha mistakenly sees as physical rather than spiritual, is comparable to the beauty of God, and his faith in the all-seeing God unlocks the doors to allow his escape. Recalling Yusuf's power over her, Zulaykha then bemoans her loss:

READING 11.7b **from Jami, "Seduction of Yusuf and Zulaykha" (before 1492)**

Let me look back to that dark hour
That bound my spirit to thy power—
Thy grateful words, thy glance recall,
My hopes, my love—and curse them all;
Let me thy tender looks retrace,
The glories of thy heavenly face;
Thy brow, where Aden's[1] splendor lies,
And the mild luster of thine eyes:
Yet let my heart no weakness prove,
But hate thee as I once could love.
What fearful eloquence was thine,
What awful anger—just—divine!
Shuddering, I saw my heart displayed
And knew all this I should have said!
'Twas mine to shrink, withstand, in time,
For, while I sinned, I knew my crime.

O wretched, wavering heart!—as vain
Thy wild resentment as thy pain:
One thought alone expels the rest,
One sole regret distracts my breast,
O'ermastering and subduing all—
More than my crime, more than my fall:
Are not shame, fear, remorse, forgot,
In that one thought—he loves me not?

[1] **Aden:** the Garden of Eden.

As we will see in the following chapters, Zulaykha's point of view, and, more powerfully, Yusuf's understanding of love itself, would soon make its way to Europe, particularly in the tradition of "courtly love" championed by the troubadour poets.

Rumi's poetry, especially the *Mathnavi* [MAT-nuh-vee] (Rhymed Discourses), an epic-length verse collection of mystical stories composed of some 27,000 verse couplets, is considered the masterwork of the Sufi tradition—"the Qur'an in Persian," Jami called it. The stories, which invariably end happily, illustrate God's limitless mercy toward humankind, and Rumi invokes the Qur'an's message of hope repeatedly. Indeed, for him hope is virtually synonymous with faith. The stories continually cite the Qur'an and interpret it in terms of human potential for mystical union with God, a potential hinted at in physical union with a lover. This hinted potential is the subject of Rumi's collection of about 30,000 verses entitled *The Divan of Shams of Tabriz*. Rumi thought of Shams (meaning "Sun") of Tabriz [tah-BREEZ] as the "Divine Beloved," the physical incarnation of spiritual love. Rumi met him in 1244, and when Shams disappeared 15 months later, Rumi wrote poems describing the loss of his lover in terms of abandonment by God. Poems like "Love's Body," "Caring for My Lover," and "The Clear Bead at the Center" (see **Reading 11.8**, page 366) are at once carnal and spiritual, erotic and mystical, and they speak of the rebirth of the human spirit through love.

READINGS

READING 11.1

from the Qur'an, *Surah* 47

The Qur'an consists of the revelations said to have been made to Muhammad and preserved in oral traditions by his followers, who used them in ritual prayers. The core of Islamic faith, they were written down and gathered into a single book in 651–52 at the order of Uthman [oot-MAN], the third caliph, or successor to the Prophet. Divided into 114 chapters, or surahs ("units of revelation"), the Qur'an is, very often, a book of remarkable beauty, but in the surah reproduced here, it reveals itself to be less than tolerant of those who do not accept the Muslim faith.

Surah 47 Muhammad

In the name of Allah, most benevolent, ever-merciful.
1. (As for) those who disbelieve and turn away from Allah's way. He shall render their works ineffective.
2. And (as for) those who believe and do good, and believe in what has been revealed to Muhammad, and it is the very truth from their Lord, He will remove their evil from them and improve their condition.
3. That is because those who disbelieve follow falsehood, and those who believe follow the truth from their Lord; thus does Allah set forth to men their examples. 10
4. So when you meet in battle those who disbelieve, then smite the necks until when you have overcome them, then make (them) prisoners, and afterwards either set them free as a favor or let them ransom (themselves) until the war terminates. That (shall be so); and if Allah had been pleased He would certainly have exacted what is due from them, but that He may try some of you by means of others; and (as for) those who are slain in the way of Allah, He will by no means allow their deeds to perish.
5. He will guide them and improve their condition. 20

6. And cause them to enter the garden which He has made known to them.
7. O you who believe if you help (the cause of) Allah, He will help you and make firm your feet.
8. And (as for) those who disbelieve, for them is destruction, and He has made their deeds ineffective.
9. That is because they hated what Allah revealed, so He rendered their deeds null.
10. Have they not then journeyed in the land and seen how was the end of those before them: Allah brought down destruction upon them, and the unbelievers shall have the like of it. 30
11. That is because Allah is the Protector of those who believe, and because the unbelievers shall have no protector for them. ■

Reading Question

Despite their apparent intolerance for non-Muslims, this *surah* also contains many passages that could be called compassionate and caring. How are the two opposing sentiments reconciled?

READING 11.6

"Tale of the Fisherman and the Genie" from *The Thousand and One Nights* (ca. 800–1300)

The Thousand and One Nights was assembled sometime between the eighth and tenth centuries from stories of Persian, Arabic, and Indian origin that had circulated orally for hundreds of years. The work itself, consisting of some 250 tales, exists in many versions—often sanitized in English translation, reducing this adult masterpiece to a collection of children's stories. It is a framed tale in which Scheherazade, a woman of great wit and beauty, tells a story each night to her king and husband. He is a man so obsessed with the possibility of female adultery that, until he marries Scheherazade, he has killed each of his new brides the morning after their wedding night. To forestall her own death Scheherazade cleverly stops her stories each morning before they reach their conclusion. "The Tale of the Fisherman and the Genie," the opening of which is excerpted here, is itself a sequence of tales within a tale, mirroring the structure of the whole, as the fisherman tells his stories in order to forestall the anger of a Genie.

I have heard, Oh worthy King, that there was once a poor, old Fisherman who had a wife and three children to support. Each day, it was his custom to cast his fishing-net into the ocean exactly four times, and no more. One day, at about noon, he went towards the seashore, where he set his basket down in the sand. Tucking up his shirt and plunging into the water, he cast his net and waited until it settled to the bottom of the sea. Then, he gathered the cords of the net together, and tried to haul it away. But its heaviness overpowered him, and no matter how hard he tried, he could not pull it up. So he carried the ends of the cords to the shore, drove a stake into the sand, and bound the cords tightly to the stake. Then he stripped his clothes from his body and dove into the water, working hard until he finally raised the net from the sea.

Rejoicing, he put his clothes back on and went to examine the net and found a dead jackass inside of it, which had torn all the net's meshes. As he saw this, the Fisherman sadly exclaimed, "There is no majesty, and there is no might except Allah the glorious, the great! But, well, this is a strange sort of daily bread." He paused, considering, and then murmured to himself, "Well, up and at it! I'll finish my fishing now, for I'm very sure of Allah's goodness."

So the Fisherman gazed at the dead ass for a moment, and then pulled it free from the netting. He wrung out the net, and spread it over the sand. Calling out "In Allah's name!" he plunged back into the sea. He cast the net a second time. . . .

[*He casts his net three times, pulling a large earthen pitcher out of the sea the second time, and shards of pottery and glass the third, blessing Allah each time although he catches no fish. On the fourth cast he pulls out. . .*] a cucumber-shaped copper jar, brimming with something mysterious. The mouth of the jar was sealed with lead, and stamped with the seal of our Lord Solomon, David's son, Allah praise them! Seeing this the Fisherman rejoiced and said, "If I sell this in the brass bazaar, I could get ten golden dinars for it!" He shook the jar, and finding it heavy, murmured, "I wish I knew what was in it. I feel as if I must find out—so I'll open it and look inside, and then I'll store it in my bag, to sell at the brass market. Taking out a knife, he pried the lead until he had loosened it from the jar. He set the seal on the ground, and turned the vase upside-down, shaking it and trying to pour out whatever could be inside. Surprisingly, nothing emerged, and the fisherman stood in wonder.

But suddenly, a spiral of smoke burst from the jar, rising toward the heavens. The fisherman marvelled as it was drawn into the air, ascending far above him. As it reached its full height, the thick, vaporous smoke condensed and formed a Genie, so huge that his head brushed the sky, and his feet touched the ground. The Genie's head curved as large as a dome; his hands dangled, big as pitchforks. His legs were long as masts, his mouth as wide as a cave, his teeth like large stones, and his nostril flared like pitchers' spouts. His eyes shone like two lamps, and his face proved fierce and threatening.

Now, when the Fisherman saw the Genie, his muscles quivered, his teeth chattered, and his throat grew too dry to swallow. Paralyzed, clenched with fear, he could do nothing.

The Genie looked at him and cried, "There is no god but *the* God, and Solomon is the prophet of God." He added, "Oh Apostle of Allah, do not slay me. Never again will I oppose you or sin against you."

The Fisherman replied, "Oh Genie, did you say, 'Solomon the Apostle of Allah.' Solomon has been dead for nearly eighteen hundred years, and now we're in the last days of the world! Where have you come from? What's happened to you? Why have you been in that jar?"

When the Evil Spirit heard the Fisherman's words, he answered, "There is no god but *the* God. Be happy, Fisherman!"

"Why should I be happy?" asked the Fisherman.

"Because," replied the Genie, "you must die a terrible death this very hour."

"You deserve heaven's abandonment for your good tidings!" cried the Fisherman. "For what reason should you kill me? What have I done to deserve death? I, who freed you from the jar, dragged you from the depths of the sea, and brought you up to dry land?"

"Ask me only in which way you will die, how I will slaughter you," said the Genie.

"What's my crime?" the Fisherman persisted. "Why such retribution?"

"Hear my story, Oh Fisherman!" cried the Genie.

The Fisherman swiftly answered, "Tell it, but tell it briefly. My heart is in my mouth."

And so, the Genie began his tale. "I am one of the heretical Genie," he explained. "I, along with the famous Sakhr al Jinni, sinned against Solomon, David's son. After this, the Prophet Solomon sent his minister, Asaf son of Barkhiya, to seize me. This minister bound me and took me against my will, bringing me to stand before the Prophet Solomon like a supplicant. When Solomon saw me, he appealed to Allah, and demanded that I embrace the True Faith and obey Allah's commands. I refused; and so he sent for this jar and imprisoned me in it, sealing it with lead and stamping it with the Most High Name. He ordered another spirit to carry me off, and cast me into the center of the ocean. I lived there for a hundred years, and during this time I said in my heart, 'I'll forever reward whoever releases me with the greatest of riches.' But an entire century passed, and when no one set me free, I began the second century saying, 'I'll reveal the secret treasures of the earth to whoever will release me.' Still, no one set me free, and soon four hundred years passed. Then I said, 'I'll grant three wishes to whoever will release me.' Yet again, no one set me free. Then I became angry, so furious, I said to myself, 'From now on, I'll kill whoever releases me, and I'll let him choose what type of death he will die.' And now, as you're the one who's released me, I give you the choice of your death."

The Fisherman, hearing the words of the Genie; exclaimed, "Oh Allah! How could it be that I didn't come to free him before this? Spare my life, Genie, and Allah will spare yours; don't kill me, and Allah will never send anyone to kill you!"

"There is no help for you. You must die," the Genie obstinately explained. . . .

As the Genie spoke, the Fisherman said to himself, "This is a Genie, but I'm a man to whom Allah has given a cunning wit. So now, as he uses his malice to destroy me, I'll use my intelligence and cunning to stop *him*." He turned to the Genie and said, "Have you really resolved to kill me?"

"Of course."

"Even so," exclaimed the Fisherman, "if I ask you a question about a certain matter, will you swear by the Most Great Name, engraved on the seal-ring of Solomon, Son of David, that you'll answer it truthfully?"

The Genie trembled as he heard the Fisherman mention the Most Great Name. "Yes," he promised the Fisherman, though his mind grew troubled. "Yes, ask, but be brief." 120

The Fisherman said, "How did you fit into this bottle, which doesn't even look big enough to hold your hand, or even your foot? How could it have been big enough to contain all of you?"

"What!" replied the Genie. "You don't believe my whole body was in there?"

"No!" cried the Fisherman. "I'll never believe it until I see all of you inside of it, with my own eyes."

And then Scheherazade saw that dawn crept over the edge of the horizon, and so she stopped telling her story. But the next day, when the fourth night came, her sister said to her, "Please finish the story. None of us are sleepy." And so, Scheherazade resumed her storytelling. . . . ■

Reading Question

In what way does the Genie mirror the king in both action and attitude?

READING 11.8

from Rumi, *The Divan of Shams of Tabriz* (ca. 1250)

Jalal ad-Din Rumi [jaa-LAAL udd-een ROO-mee] was born in the Persian province of Khorasan [KHOR-uh-sahn] in 1207. After the Mongol invasion of central and western Asia, he settled in Anatolia, a region of Asia Minor known as Rum (Rome in Turkish). Jalal ad-Din means, literally, "Glory of Religion." His entire name means, then, "Roman Glory of Religion." Rumi became a leader of the Sufi community, named sheik, or elder, and received the title "Mevlana," [meh-woo-LAH-nuh] meaning "our master." He is still known by that name throughout the Middle East and India. The four poems below are from a collection of lyrics entitled The Divan of Shams of Tabriz, *which contains about 30,000 verses celebrating the poet's physical love for Shams ad-din [SHAM-ss add-EEN] of Tabriz, who represented for him the physical incarnation on earth of the spiritual love of God.*

Love's Body

The moon and a batallion of stars came
and the sun, a lonely horseman, dissolved.
The moon lives beyond the night, beyond the day.
What eye can see him?
The sightless eye is a minaret.
How can it make out the bird on the minaret?
Sometimes the cloud in our heart is tight
because we love the moon.
Sometimes it falls away.
When you began to love your passion died 10
and though you had a thousand things to do,
you did nothing,
but since one day granite becomes a ruby,
it isn't lazy.
If in the market of love you see decapitated heads
hanging from butcher hooks,
don't run off. Come in. Look closely.
The dead are alive again.

Caring for My Lover

Friends, last night I carefully watched my love
sleeping by a spring circled with eglantine.[1]

The houris[2] of paradise stood around him,
 their hands cupped together
between a tulip field and jasmines.
Wind tugged softly in his hair.
His curls smelled of musk and ambergris.[3]
Wind turned mad and tore the hair right off
 his face
like a flaming oil lamp in a gale. 10
From the beginning of this dream I told myself
 go slowly, wait
for the break into consciousness. Don't breathe.

The Clear Bead at the Center

The clear bead at the center changes everything.
There are no edges to my loving now.
I've heard it said there's a window that opens
from one mind to another,
but if there's no wall, there's no need
for fitting the window, or the latch. ■

Reading Question

Explain, in your own words, the argument of "The Clear Bead at the Center."

[1]**eglantine:** sweetbrier, a fragrant pink climbing rose.
[2]**houris:** beautiful virgins provided in paradise to faithful Muslims.

[3]**musk and ambergris:** perfumes.

Summary

■ **The Prophet Muhammad** According to tradition, beginning in 610 the Muslim prophet Muhammad began to recite messages from God, which he dictated to scribes who collected them to form the scriptures of Islam, the Qur'an. At the core of the Qur'an is the concept of "submission" or "surrender" to Allah, the all-merciful, all-seeing, all-powerful God. Muhammad's sayings and anecdotes about his life are collected in the *hadith*, handed down orally until about 100 years after the Prophet's death. An event central to Muhammad's career is the *Hijra*, or emigration of the Prophet from Mecca to al-Medina in 622. There, Muhammad created a community based on common submission to the will of God rather than on kinship, the traditional basis of Arab society. Such submission did not need to be entirely voluntary. Muslims were obligated to pursue the spread of their religion, and they did so by means of the *jihad*, the impassioned religious struggle that could take a "lesser" form as holy war, and a "greater" form as self-control over the baser human appetites.

Muhammad's armies conquered Mecca, and by 710, the *caliphs*, or successors to Muhammad, had assumed political and religious authority over virtually all the Middle East, North Africa, and Spain. Wherever Muslim authority extended, mosques were built and modeled on the courtyard space of Muhammad's home in Medina. The mosque was the umbilical cord that linked the faithful to their spiritual home in Mecca. In Muhammad's time women were welcome in the mosque, and in the Qur'an, Mohammad teaches that women and men are equal partners. The *shari'a*, or law, dictated relations between men and women.

■ **The Spread of Islam** The rapid spread of Islam can be attributed to its appeal as both a religion and form of social organization. The mosque served as courthouse, council chamber, military complex, and administrative center. By the eleventh century, *madrasas*, or teaching colleges, were built at mosques. Among the largest was the Great Mosque of Damascus, built by the Umayyad caliphs in the early eighth century and decorated with a large glass mosaic probably depicting Paradise. Such figurative imagery is rare in Islamic decorative art, since many faithful believed that Muhammad had opposed image-making in the *hadith*. As a result, the art of calligraphy assumed a central place in Islamic visual culture, especially the *bismallah*, consisting of the phrase "In the name of Allah, the Beneficent, Ever-Merciful," with which every pious Muslim begins any statement or activity.

■ **Islam in Africa and Spain** In the eighth and ninth centuries, Muslims came to dominate the trans-Saharan trade routes, and Islam became the dominant faith of North and West Africa. Muslims especially traded in salt, gold, and slaves (Muhammad had expressly authorized the practice of enslaving conquered peoples). By 1312, the Malian ruler Mansa Moussa, a devout Muslim, had built the Djingareyber Mosque in Timbuktu and led a pilgrimage to Mecca. Traditional indigenous art and music continued alongside Islamic practice, and the epic of *Sunjata*, detailing the exploits of the first Malian king, is still sung by Malian *griots*, or professional poets, to this day.

In Spain, the Umayyad caliph Abd ar-Rahman built a magnificent new mosque in Córdoba, and by the middle of the tenth century, under the leadership of Abd ar-Rahman III, Córdoba was the most important center of learning in Europe. Sephardic or Spanish Jews were important contributors to this vital Spanish culture. Something of the luxuriousness of Abd ar-Rahman III's court can still be gleaned from the magnificent ruins of the palace in Córdoba, as well as from the Alhambra in Granada, built by the Muslim Berbers who overthrew the Umayyad caliphate.

■ **The Arts of the Islamic World** Music was central to Islamic culture. Traditional Arabic music is based on intonations and rhythms closely related to the inflections of words, and it utilizes many more pitch intervals than Western music. Its songs were accompanied by a range of instruments, including drums, tambourine, flute, oboe, lute, and the guitar. In Spain, musicians began to experiment with ensemble compositions divided into five or more movements performed by string, wind, and percussion instruments and often accompanied by a vocal chorus. New instruments were invented—trumpets, viols, and kettledrums. In essence, the Western orchestra was born.

The art of papermaking transformed Islamic culture, as the book became the prime medium of memory and Baghdad became a major publishing center. One of the most widely illustrated poems of the Middle Ages is Nezami's *Haft Paykar* (Seven Beauties), a romantic epic. One of the primary narrative devices that it employs is the framing tale, a device that is also central to *The Thousand and One Nights*, a prose compilation of Persian, Arabic, and Indian stories told by Scheherazade. After the fall of Baghdad to invading Mongols in 1258, book publishing moved to Iran. There, in the mystical poetry of Sufi poets such as Jami and Rumi, the pursuit of the beautiful became a central theme in Islamic literature, as sexual love was increasingly interpreted as the primary manifestation of divine love in the physical world.

 Glossary

bismillah A sacred invocation of the name of Allah.

bolon A three- or four-stringed harp.

caliph A successor of Muhammad.

calligraphy The art of producing artistic, stylized handwriting.

chador A covering worn by Muslim women that covers the wearer from head to toe and most or all of the face.

couplet A two-line rhymed stanza.

framing tale A narrative device that allows a writer to unite different tales under an overarching narrative umbrella.

griot A West African poet/storyteller who chants or sings traditional narratives from memory, generally accompanied by a harp.

hadith The collection of the sayings of Muhammad and anecdotes about his life, accepted as a source of Islamic doctrine.

hajib The Islamic practice of dressing modestly; specifically the requirement that women be covered or veiled.

hajj A pilgrimage to Mecca made as a religious duty for Muslims.

hijra The flight of Muhammad from Mecca in 622.

hypostyle A vast space filled with columns supporting a roof.

jihad The impassioned religious struggle undertaken by Muslims as a religious duty. The *jihad* may take one of two forms: the lesser is a holy war; the greater is self-control over the baser human appetites.

mirador A projecting room with windows on three sides.

mode A series of different scales.

mosque A building used for worship by Muslims.

muqarna A small, nichelike component unique to Islamic architecture and used in multiple rows to enclose a space.

Qur'an The sacred text of Islam composed of the revelations of Allah to Muhammad.

romantic epic A poem that celebrates love between a man and woman as a cosmic force for harmony and justice.

Critical Thinking Questions

1. What is the historical relation between Islam, Judaism, and Christianity?

2. How do you account for the fact that calligraphy is held in such high esteem in Islamic culture?

3. Describe hypostyle architecture and explain why it is so prevalent in Islamic mosque construction.

4. A great deal of the literature produced in the medieval Islamic world is highly erotic. How do these works reconcile this erotic content with Islamic faith?

The Islamic Heritage

Islam is often considered outside the Western tradition, but it is a fundamental part of the Western heritage. As we have seen, Western music—indeed, the Western orchestra—originates in Muslim musical traditions. The spiritual depth of the love poem, as it comes to fruition in the work of the medieval troubadour poets and the poets of the Renaissance, is first developed in the Muslim world. Many of the decorative effects achieved in medieval architecture and design reflect the interlace and arabesques that inform Islamic architecture. See for example, the column decoration at Poitiers Cathedral in France (Fig. **11.19**).

But in its insistence that Jesus was a "mere" prophet and not the son of God, and in its belief that the Qur'an superseded both the Hebrew and Christian Scriptures, Islam inevitably came into conflict with the Christian West. By the time that Pope Urban II (pope 1088–99) launched the First Crusade in 1095, gathering over 100,000 people to march on

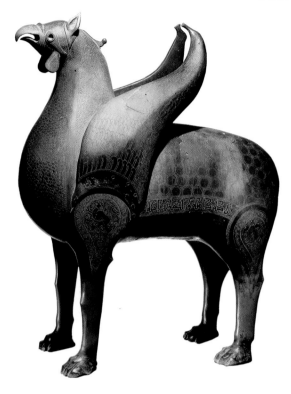

Fig. 11.20 **Griffin, from the Islamic Mediterranean, probably Fatimid Egypt. 11th century.** Bronze, height 3′ 6⅛″. Museo dell'Opera del Duomo, Pisa. The griffin was moved into the museum in 1828 to protect it from the elements.

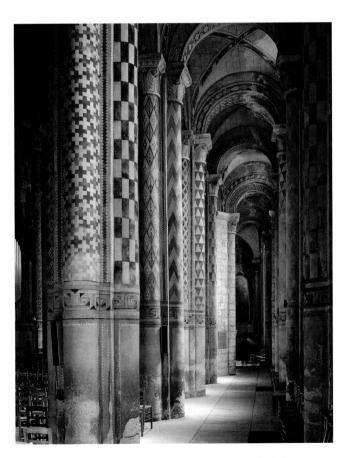

Fig. 11.19 **Columns in south aisle of nave, Poitiers Cathedral. ca. 1162–80.** Charles Martel stopped the Arab invasion of France at Poitiers in 792, but decorative work such as this underscores the lasting Islamic influence in Europe (see chapter 13).

Jerusalem, Islam represented the forces of darkness to European Christians. Their determination to liberate the Holy Land from Muslim domination became a key factor in the history of the late Middle Ages.

A notable symbol of this determination is an Islamic bronze griffin that, from 1100 to 1828, sat atop Pisa Cathedral, itself built to celebrate the victory in 1063 of this Italian city-state over Muslim forces in the western Mediterranean (Fig. **11.20**). Decorated with incised feathers, its back designed to suggest silk drapery, the griffin symbolized to Muslims eaglelike vigilance, lionlike courage, and, perhaps most of all, the rich history of Mesopotamia and Persia. But the Catholic Church appropriated this bronze griffon to different ends and transformed its meaning. From its perch atop Pisa Cathedral it symbolized the dual nature of Christ, his divinity (the eagle) and his humanity (the lion). The composite creature was, in the Church's mind, the image of the Christian victory over Islam. ■

12 Fiefdom and Monastery

The Merging of Germanic and Roman Cultures

> *They sang then and played to please the hero,*
> *words and music for their warrior prince,*
> *harp tunes and tales of adventure:*
> *there were high times on the hall benches*
> *and the king's poet performed his part.*
>
> *Beowulf*

◄ **Fig. 12.1 Sutton Hoo burial site, Suffolk, England, during excavation in 1939.**
Although the timbers of the 7th century ship had long since rotted away, the iron rivets that
fastened the ship's overlapping timbers survived in place. Perhaps even more remarkably, stains
in the sand indicated where the timbers had originally lain. Soon after this burial, pagan and
Christian traditions would merge, a process that continued from the Carolingian culture of
Charlemagne down to the Norman Conquest of Britain in 1066.

SUTTON HOO LIES NEAR THE MODERN CITY OF IPSWICH, ENGLAND,

in the county of Suffolk, East Anglia (Map **12.1**). There, a burial mound contains the remains of a wealthy and powerful Anglo-Saxon man, probably a seventh-century king (Fig. **12.1**). (Coins found at the site date to the late 630s.)

The burial mound concealed a ship, 90 feet long and 14 feet wide, that had been dragged up a 100-foot hill—or "hoo"—above the river Deben and laid in a trench. Midway between the ship's bow and stern, a house had been constructed. Inside the house was the coffin, accompanied by a treasure horde of richly decorative ornaments and armor, gold coins from France, silver spoons and bowls from the Eastern Mediterranean, and a wooden harp. The trench was filled in and a mound was raised over it. For 1,300 years it remained untouched, high above the Deben estuary, as if the dead warrior were standing perpetual guard over East Anglia, looking eternally out to sea.

First excavated in 1939, only two objects discovered at the site show any evidence of Christian culture—two silver spoons inscribed with the names Saulos and Paulos in Greek lettering. The names might refer to the biblical King Saul of the Hebrew Bible and St. Paul of the New Testament. Christianity had, in fact, almost completely disappeared in England shortly after the Romans left in 406. Over the next 200 years, Germanic and Norse tribes—Angles, Saxons, Jutes, and Frisians—invited in as mercenaries by Romanized British leaders, began to operate on their own. Their Anglo-Saxon culture, steeped in Germanic and Norse values and traditions, soon came to dominate cultural life in Britain. Nevertheless, at the time of the Sutton Hoo burial, the late 630s, Christianity had begun to reassert itself in England. There is some speculation that the elaborate Sutton Hoo burial ceremony, which included cremation—forbidden by Christianity—and apparent human and animal sacrifice, represented an open defiance of Christian practices.

Remote even at the time of its seventh-century burials, Sutton Hoo is no center of culture. However, no other archeological site has revealed more about the art and culture of Anglo-Saxon England. Whoever was buried there was a lord or chief to whom his followers owed absolute loyalty, the basis of the feudal societies that would later dominate European life in the Middle Ages. **Feudalism** is related to the Roman custom of patronage (see chapter 8), under which a patron, usually a lord or nobleman, provided protection to a person working his land in exchange for his loyalty. In the Middle Ages, this relationship developed into an economic system, based on the landholder's rights to the land, as deter-

mined by his lord, and the relationship between the tenant and the landholder. In exchange for use of a piece of land—called a **fief** [feef]—and the protection of the lord or noble who owned the fief, the tenant was obligated to serve the nobleman (often militarily) and pay him with goods or produce.

The rudiments of this system were in place in sixth-century England. The Anglo-Saxons comprised only about one-tenth of a total population of roughly 1 million; the remainder were Britons. The Anglo-Saxons controlled the land while the Britons largely worked it, and the wealth the Anglo-Saxons extracted from this relationship is everywhere apparent in the treasures discovered at Sutton Hoo. The nobles in control of their various fiefdoms in turn owed allegiance to their king, who was overlord of all the fiefdoms in his kingdom. In return for their loyalty, the king rewarded his nobles with gold, weaponry, and elaborately decorated items of personal adornment, like the artifacts buried at Sutton Hoo.

When Christianity was reintroduced to Anglo-Saxon England, the Church adapted the principles of feudalism. Instead of the tenant owing allegiance to his nobleman and the nobleman to his king, all owed allegiance to the Christian God. Briton and Anglo-Saxon alike might make gifts to the Church, and in return the Church offered them not protection, but salvation. As a result, the Church quickly became wealthy. To decorate its sanctuaries, the Church promoted the same refined and elaborate handiwork as the feudal lords had commissioned for their personal use, incorporating Christian themes and imagery into the animal and interlace styles of Germanic and Norse culture. And it acquired large parcels of property overseen by a clergy who were feudal lords themselves. These properties soon developed into large working monasteries, where like-minded individuals gathered in the pursuit of religious perfection. The monasteries in turn became great centers of learning.

This chapter outlines the rise to power of these feudal societies and the adaptation of feudal practices by the medieval kings and emperors and by the Christian Church. Perhaps the most important ruler to codify and adopt these practices was Charlemagne [SHAR-luh-mane], who dreamed not only of unifying Europe under his rule, but also of unifying church and state in a single administrative and political bureaucracy. Although Charlemagne's empire dissolved with his death in

Iona

BERNICIA Lindisfarne

NORTHUMBRIA

Jarrow
Whitby

DEIRA

York

Kells

MERCIA EAST
ANGLIA

Sutton Hoo

ESSEX

Canterbury

KENT

WESSEX SUSSEX

Tintagel

NORMANDY

ATLANTIC
OCEAN

North
Sea

N

100 km
100 miles

Anglo-Saxon England
Celtic Ireland

Map 12.1 Anglo-Saxon England and Celtic Ireland.

843, subsequent rulers, such as the Ottonian kings in Germany, followed his example by building a tightly knit political bureaucracy and championing the arts.

Anglo-Saxon Artistic Style and Culture

A purse cover from the Sutton Hoo site (Fig. **12.2**) is a fine example of the artistic style of this non-Christian Germanic culture. It is a work of **cloisonné** [kloy-zun-AY], a technique in which strips of gold are set on edge to form small cells. The cells are then filled with a colored enamel glass paste and fitted with thin slices of semiprecious stones (in this case, garnet). At the top of the purse cover shown here, two hexagons flank a central motif of **animal interlace**. In this design two pairs of animals and birds, facing each other, are elongated into serpentine ribbons of decoration, a common Scandinavian motif. Below this, two Swedish hawks with curved beaks attack a pair of ducks. On each side of this design, a male figure stands between two animals. This **animal style** was used in jewelry design throughout the Germanic and Scandinavian world in the era before Christianity. Notice its symmetrical design, its combination of interlaced organic and geometric shapes, and, of course, its animal motifs. Throughout the early Middle Ages this style was imitated in manuscripts, stone sculpture, church masonry, and wood sculpture.

In many ways, the English language was shaped by Anglo-Saxon traditions. Our days of the week are derived from the names of Saxon gods: Tuesday and Wednesday are named after two Saxon gods of war, Tiw and Woden. Thursday is named after Thor, the god of thunder, and Friday after Frigg, Woden's wife. Similarly, most English placenames have Saxon origins. *Bury* means fort, and Canterbury means the fort of the Cantii tribe. *Ings* means tribe or family; Hastings is where the family of chief Haesta lived. *Strat* refers to a Roman road; Stratford-on-Avon designates the place where

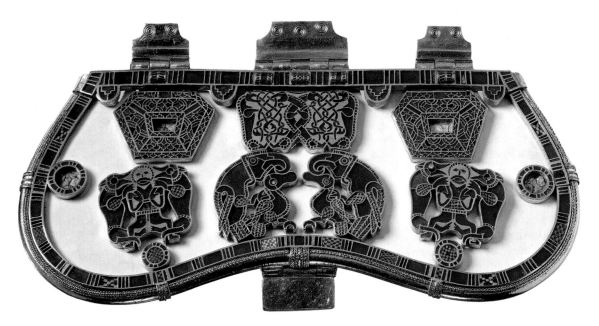

Fig. 12.2 Purse cover, from Sutton Hoo burial ship. ca. 625. Gold with Indian garnets and cloisonné enamels, originally on an ivory or bone background (now lost), length 8″. © The Trustees of the British Museum, London. This elaborate purse lid would have been attached to the owner's belt by hinges. In the Sutton Hoo burial mound, the purse contained gold coins and ingots.

Fig. 12.3 Farmers using a moulboard plow and harnessed oxen, from the Luttrell Psalter. ca. 1325–1340. British Library, London. Add. MS 42130. The Luttrell Psalter is a decorated (illuminated) manuscript from the Middle Ages. It was written and illuminated from about 1325 for a landowner and knight, Sir Geoffrey Luttrell of Irnham in Lincolnshire (England).

the Roman road fords the river Avon. *Chester* means Roman camp, as in Dorchester; *minster* means monastery, as in Westminster; and *ham* means home, as in Nottingham.

Society, Law, and Family Life

The survival of Anglo-Saxon names in modern English suggests the degree to which this culture dominated even medieval English life. Earlier Anglo-Saxon culture revolved around the king and his thanes (lords). The king possessed his own large estate, as did each of his thanes, and the king and his retinue moved continually among the estates of the thanes, who owed hospitality and loyalty to the throne. Aside from these few powerful persons, feudal society was composed of peasants. Some were *ceorls*, or churls, free men who owned farms of 90–100 acres. Others rented land from the thanes, usually in lots of 20 acres. They paid their lords in goods—sheep or grain—and worked his fields two or three days per week. All employed serfs (day laborers) and thralls (slaves), often captives of wars. (Evidence suggests that by the eighth century, the Anglo-Saxons were routinely marketing slaves abroad, in France and Rome particularly.) Runaway slaves were punished by death, as were those convicted of disloyalty to their thanes.

Anglo-Saxon law was based on the idea of the *wergeld*, or "life-price" of an individual. A thane's value was roughly six times that of a churl, and a thrall had no value at all. If a thane were killed (or injured), his family (or in the case of injury, he himself) was entitled to be compensated at the highest fixed rate. But a thane could kill or injure a thrall with no *wergeld* due at all. The *wergeld* for men and women was identical, although a pregnant woman was worth as much as three times the usual rate, and a woman's potential as a bearer of children could raise her value even if she were not pregnant.

The medieval fief averaged from 3,000 to 5,000 acres and included one or more manor houses occupied by the lord.

The manor house was surrounded by a small village that included as many as 50 families, a common mill, wine press, oven, and church. Surrounding the village were fields and pasture. Oats, corn, barley, wheat, and rye were the largest crops, and over time, serfs developed the heavy-wheeled plow for cultivating sandy soil and the Moulboard plow for plowing clay soils. The tandem, four-oxen harness helped them in their work (Fig. **12.3**). They also learned to offset soil depletion by crop rotation, allowing one-third of their fields to lie fallow each year to recover their fertility. They made beer from barley and kept pigs, cattle, goats, and sheep.

Anglo-Saxon law provided women with considerable legal status, including the right to own property and the right to sell it or even give it away without male consent. They could act in their own defense in a court of law and testify to another person's truthfulness, male or female. Women could not marry against their will, nor could they be sold for money. Most of these rights would be lost after the 1066 invasion of England by the Normans, who believed that in marrying a woman they acquired her property as well. Under the Normans, women themselves became property; their function was to serve their husbands.

Family life in Anglo-Saxon England consisted largely of work, though there seems to have been a clear division of labor between men and women. In Anglo-Saxon wills, the male line was referred to as the *wœpnedhealf*, "weapon half" or *sperehealf*, "spear half," and the female line the *wifhealf*, "wife half" or *spinelhealf*, "spindle half." Whether this division of labor between warrior and housekeeper extended into the peasant classes is debatable. It seems likely that among the lower classes, all household members worked in the fields, although food preparation and cloth-making remained women's work as well (Fig. **12.4**). In fact, the Anglo-Saxon *lorg*, or weaver's beam, later known as the distaff, became the universal symbol of women's side of the family.

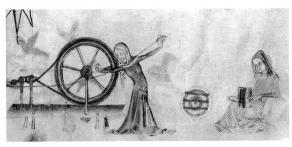

Fig. 12.4 A fourteenth-century English manuscript, the Luttrell Psalter, ca. 1325–40. British Library, London. These illustrations show women at their daily tasks: carrying jugs of milk from the sheep pen, feeding the chickens, carding and spinning wool.

Beowulf, the Oldest English Epic Poem

This rigidly hierarchical society is celebrated in the oldest English epic poem, *Beowulf*. In the poem, a young hero, Beowulf [BAY-uh-wolf], comes from afar to rid a community of monsters that have been ravaging it. A treasure very much like that found in the Sutton Hoo ship burial is described just 26 lines into the poem, when the death of Danish king Shield Sheafson is described (**Reading 12.1a**).

<hr />

READING 12.1a ***Beowulf,* trans. Seamus Heaney**

Shield was still thriving when his time came
and he crossed over into the Lord's keeping.
His warrior band did what he bade them
when he laid down the law among the Danes:
they shouldered him out to the sea's flood,
the chief they revered who had long ruled them.
A ring-whorled prow rode in the harbour,

ice-clad, outbound, a craft for a prince.
They stretched their beloved lord in his boat,
laid out by the mast, amidships,
the great ring-giver. Far-fetched treasures
were piled upon him, and precious gear.
I never heard before of a ship so well furbished
with battle tackle, bladed weapons
and coats of mail. The massed treasure
was loaded on top of him: it would travel far
on out into the ocean's sway.
They decked his body no less bountifully
with offerings than those first ones did
who cast him away when he was a child
and launched him alone out over the waves.
And they set a gold standard up
high above his head and let him drift
to wind and tide, bewailing him
and mourning their loss. No man can tell,
no wise man in hall or weathered veteran
knows for certain who salvaged that load.

<hr />

The ship described here probably looked very much like the one excavated in 1904 from Oseburg, just outside Oslo, Norway (Fig. **12.5**). Its prow rises to a spiral that corresponds to the "ring-whorled prow" described in line 32. A thick layer of blue clay, nearly impenetrable by water or air and topped with turf, preserved the ship and the other objects of wood, leather, and textiles discovered in it. As *Beowulf* suggests ("No man can tell . . . for certain who salvaged that load"), it seems likely that burial mounds were commonly looted and that the Oseberg mound was plundered in ancient times. No jewelry, gold, or silver was found in the grave.

The findings at Sutton Hoo and Oseberg suggest that *Beowulf* accurately reflects many aspects of life in the northern climates of Europe in the Middle Ages. The poem was composed in Anglo-Saxon, or Old English, sometime between 700 and 1000 CE, handed down first as an oral narrative and later transcribed. Its 3,000 lines represent a language that predates the merging of French and English tongues after 1066, when William the Conqueror, a Norman duke, invaded England. The poem survived in a unique tenth-century manuscript, copied from an earlier manuscript and itself badly damaged by fire in the eighteenth century. It owes its current reputation largely to J.R.R. Tolkien, author of *The Lord of the Rings*, who in the 1930s argued for the poem's literary value. The source of Tolkien's attraction to the poem will be obvious to anyone who knows his own great trilogy.

Beowulf is an English poem, but the events it describes take place in Scandinavia. One of its most notable literary features, common to Old English literature, is its reliance on compound phrases, or **kennings**, substituted for the usual name of a person or thing. Consider, for instance, the following line:

Hwæt we Gar-Dena in gear-dagum
So. The Spear-Danes in days gone by

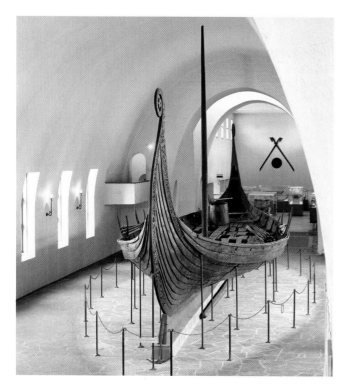

Fig. 12.5 Burial ship, from Oseberg, Norway. ca. 800. Wood, length 75′ 6″. Vikingskiphuset, Universitets Oldsaksamling, Oslo, Norway. This ship served as a burial chamber for two women. They were laid out on separate beds in a cabin containing wooden chests (empty, but probably once filled with precious objects) and several wooden, animal-head posts.

in the Shieldings' country. I come to proffer
my wholehearted help and counsel.
I can show the wise Hrothgar a way
to defeat his enemy and find respite—
if any respite is to reach him, ever.
I can calm the turmoil and terror in his mind.
Otherwise, he must endure woes
and live with grief for as long as his hall
stands on the horizon, on its high ground."
Undaunted, sitting astride his horse,
the coast-guard answered, "Anyone with gumption
and a sharp mind will take the measure
of two things: what's said and what's done.
I believe what you have told me: that you are a troop
loyal to our king. So come ahead
with your arms and your gear, and I will guide you. . . ."
So they went on their way. The ship rode the water,
broad-beamed, bound by its hawser
and anchored fast. Boar-shapes flashed
above their cheek guards, the brightly forged
work of goldsmiths, watching over
those stern-faced men. They marched in step,
hurrying on till the timbered hall
rose before them, radiant with gold.
Nobody on earth knew of another
building like it. Majesty lodged there,
its lights shone on many lands.

Instead of saying "the past," the poem says *gear-dagum,* which literally means "year-days." Instead of "the Danes," it says *Spear-Danes,* implying their warrior attributes. The poet calls the sea the *fifelstréam,* literally the "sea-monster stream," or "whale-path," and the king, the "ring-giver." A particularly poetic example is *beado-leoma,* "battle-light," referring to a flashing sword. In a sense, then, these compound phrases are metaphoric riddles that context helps to explain. *Beowulf* contains many such compounds that occur only once in all Anglo-Saxon literature—*hapax legomena,* as they are called, literally, "said or counted once"—and context is our only clue to their meaning.

The poem opens with Beowulf's arrival among the Danes to rid them of the monster Grendel [GREN-dl]. The monsters in the poem, it becomes clear, are in some sense metaphors for fate and the destructive forces of nature. When Beowulf and his troops meet a Dane guarding the coast, they are undaunted by the prospect of confronting these forces (**Reading 12.1b**):

The Danish king Hrothgar [ROTH-gar] is described elsewhere in *Beowulf* as "the best of earthly kings . . . the best of those who bestowed gold." Like all Anglo-Saxon rulers, he relied on his wealth to guarantee the loyalty of his followers—and, interestingly, a gold boar-shaped helmet crest such as the one described here has been unearthed in England. (Fig. **12.6**).

Beowulf keeps his word and kills Grendel. Subsequently, Grendel's mother attacks in an even more fearsome battle, which again Beowulf wins. But Hrothgar reminds him of life's fragility (**Reading 12.1c**):

READING 12.1b ***Beowulf,* trans. Seamus Heaney**

"So tell us if what we have heard is true
about this threat, whatever it is,
this danger abroad in the dark nights [Grendel],
this corpse-maker mongering death

READING 12.1c ***Beowulf,* trans. Seamus Heaney**

O flower of warriors, beware. . .
Choose, dear Beowulf, the better part,
eternal rewards. Do not give way to pride.
For a brief while your strength is in bloom
but it fades quickly; and soon there will follow
illness or the sword to lay you low,
or a sudden fire or surge of water
or jabbing blade or javelin from the air
or repellent age. Your piercing eye
will dim and darken; and death will arrive,
dear warrior, to sweep you away.

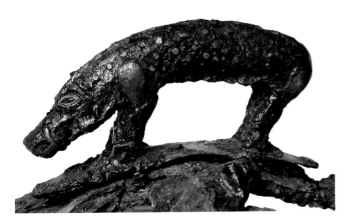

Fig. 12.6 Crest of the Benty Grange Helmet, Derbyshire, late 7th century. Hollow bronze, approx. 3½". Courtesy of Sheffield Galleries & Museums Trust. Boar-crested helmets such as this are described in *Beowulf*, lines 303–304. The boar evidently symbolized both ferocity and courage.

With these words in mind, Beowulf returns home to Sweden with his men and rules well, but 50 years later, he meets the dragon, or "hoard-guard," who teaches him Hrothgar's lesson. Resigned to the fact that only he of all warriors can defeat the dragon that is menacing his loyal people, he exhibits the courage and loyalty to his vassals that define the warrior's world in the Middle Ages (**Reading 12.1d**).

READING 12.1d *Beowulf*, trans. Seamus Heaney

"I would rather not
use a weapon if I knew another way
to grapple with the dragon and make good
　　my boast
as I did against Grendel in days gone by.
But I shall be meeting molten venom
in the fire he breathes, so I go forth
in mail-shirt and shield. I won't shift a foot
when I meet the cave-guard: what occurs on the wall
between the two of us will turn out as fate,
overseer of men, decides. I am resolved.
I scorn further words against this sky-borne foe. . . ."
Then he drew himself up beside his shield.
The fabled warrior in his warshirt and helmet
trusted in his own strength entirely
and went under the crag. No coward path.
Hard by the rock-face that hale veteran,
a good man who had gone repeatedly
into combat and danger and come through,
saw a stone arch and a gushing stream
that burst from the barrow blazing and wafting
a deadly heat. It would be hard to survive
unscathed near the hoard, to hold firm
against the dragon in those flaming depths.

Then he gave a shout. The lord of the Geats
unburdened his breast and broke out
in a storm of anger. Under grey stone
his voice challenged and resounded clearly.
Hate was ignited. The hoard-guard recognized
a human voice, the time was over
for peace and parlaying. Pouring forth
in a hot battle-fume, the breath of the monster
burst from the rock. There was a rumble under ground.
Down there in the barrow, Beowulf the warrior
lifted his shield: the outlandish thing
writhed and convulsed and viciously
turned on the king, whose keen-edged sword,
an heirloom inherited by ancient right,
was already in his hand. Roused to a fury,
each antagonist struck terror in the other. . . .
That final day was the first time
when Beowulf fought and fate denied him
glory in battle. . . . Beowulf was foiled
of a glorious victory. The glittering sword,
infallible before that day,
failed when he unsheathed it, as it never should have.
　　. . . so every man must yield
the leasehold of his days.

Some have interpreted Hrothgar's admonition to Beowulf to value "eternal rewards" over earthly glory as evidence that the poem is a Christian allegory. And although Beowulf does indeed give "thanks to Almighty God," and admit that his victory over Grendel would not have been possible "if God had not protected me," there is nothing in the poem to suggest that this is the Christian God. There are no overtly Christian references in the work. At Beowulf's tragic end, he passes "into the Lord's keeping," but "No man can tell . . . for certain" where death will carry him. The poem teaches its audience that power, strength, fame, and life itself are fleeting—a theme consonant with Christian values, but by no means necessarily Christian. And although Beowulf, in his arguably foolhardy courage at the end of the poem, displays a Christ like willingness to sacrifice himself for the greater good, the honor and courage he exhibits are fully in keeping with the values of feudal warrior culture.

The Merging of Pagan and Christian Styles

Whatever *Beowulf*'s relation to Christian tradition, it is easy to see how the poem might have been read, even in its own time, in Christian terms. Other clearly Christian poems survive from the era, among them *The Dream of the Rood*, in which a poet recounts his dream of a conversation with the wooden cross (the *rood*) upon which Jesus was crucified. Jesus is portrayed as if he were a Germanic king willing to die, like Beowulf, for the greater good. Another is the short poem known as *Caedmon's Hymn*, written by the Anglo-Saxon

monk, Caedmon [KAD-mun], probably in the 670s or 680s (Reading 12.2). It is the only surviving text of what was reportedly a large body of vernacular religious poetry by Caedmon. Tradition holds that the monk was unable to sing, but one night he heard himself singing his poem in a dream, and he miraculously awoke with the ability to sing it. So that you can see how remote the Anglo-Saxon is from the English translation, here is the original text following the translation.

READING 12.2 from *Caedmon's Hymn*

Now we must praise heaven-kingdom's guardian,
the Measurer's might and his mind-plans,
the work of the Glory-father, when he of wonders of every one,
eternal Lord, the beginning established.
He first created for men's sons
heaven as a roof, holy Creator;
then middle-earth, mankind's Guardian,
eternal Lord, afterwards made
for men earth, Master almighty.

Nu scylun hergan hefaenricaes uard
metudæs maecti end his modgidanc
uerc uuldurfadur sue he uundra gihuaes
eci dryctin or astelidæ
he aerist scop aelda barnum
heben til hrofe haleg scepen
tha middungeard moncynnæs uard
teci dryctin æfter tiadæ
firum foldu frea allmectig

The poem makes traditional use of kennings—*modgidanc*, "mind-plans," for instance, means wisdom. But perhaps what is most notable is that Caedmon's word for "Lord," *dryctin*, is the West Saxon version of the secular and military Germanic word, *truhtin*, "warlord." In Caedmon's use of this word we see the merging of Christian and pagan traditions.

Caedmon's *Hymn* is the product of a gradual re-Christianization of the British Isles that had begun in the fifth century. After the Romans withdrew from Britain in 406, Christianity had survived only in the westernmost reaches of the British Isles—in Cornwall, in Wales, and in Ireland, where St. Patrick had converted the population between his arrival in 432 and his death in 461. Around 563, an Irish monk, Columba, founded a monastery on the Scottish island of Iona. He traveled widely through Scotland and converted many northern Picts, a Scottish tribe, to Christianity. In about 635, almost simultaneous with the pagan burial at Sutton Hoo, in which only a few if any Christian artifacts were discovered, a monk from Iona built another monastery at Lindisfarne [LIN-dis-farn], an island off the coast of Northumbria [north-UM-bree-uh] in northeast England. The "re-Christianization" of Britain was under way.

The Celtic [KELL-tik] Christian Church differed from Roman Christianity in several important ways. It celebrated Easter on the Vernal equinox and believed that Mary, mother of Jesus, was exempt from original sin. It invented private confession. The office of bishop was a ceremonial position, and authority rested instead with abbots and abbesses, giving women an important role in the Church. And the Celtic cross is itself unique, symmetrical and superimposed upon a circle.

These differences would later cause considerable difficulty, but meanwhile, in 597, Pope Gregory I (pope 590–604) sent a mission to England of 40 monks, headed by the Benedictine [ben-uh-DIK-teen] prior Augustine (d. 604)—not the same Augustine who had written *The Confessions* and *The City of God*—to convert the pagan Anglo-Saxons. Augustine met with the Anglo-Saxon king, Aethelberht [ETH-el-bert] (r. 560–616), on the island of Thanet, in Kent. The encounter is described by the eighth-century historian Bede [beed] (ca. 672–735), in his *History of the English Church and People*, written in 731:

> After some days, the king came to the island and, sitting down in the open air, summoned Augustine and his companions to an audience. But he took precautions that they should not approach him in a house; for he held an ancient superstition that, if they were practicers of magic, they might have opportunity to deceive and master him. But the monks were endowed with power from God, not from the devil, and approached the king carrying a silver cross as their standard and the likeness of our Lord and Savior painted on a board.

The story narrates the confrontation, in other words, of two distinct styles of thought and art—the animal style, with which Aethelberht was at home, and the Christian icon (see chapter 10); pagan superstition and Christian faith; an oral, illiterate culture and a text-based one. Although Aethelberht was slow to convert, he allowed Augustine to build a cathedral at Canterbury on the site of an old Roman church and, soon after, a church in London dedicated to St. Paul.

Manuscript Illustration: Blending of Anglo-Saxon and Christian Traditions

In 601, Gregory sent Augustine a letter urging him not to eliminate pagan traditions overnight, but to incorporate them into Christian practice: "For it is certainly impossible to eradicate all errors from obstinate minds at one stroke, and whoever wishes to climb a mountain top climbs gradually step by step, and not in one leap." This is one reason that the basic elements of the animal style, evident in the purse cover from Sutton Hoo (see Fig. 12.2), appear in a manuscript page from the *Lindisfarne Gospels*, designed by Bishop Eadfrith of Lindisfarne in 698 (Fig. **12.7**). Notice particularly how the geometric grids in the border decoration of the purse cover are elaborated in the central circle of the Lindisfarne **carpet page** (a descriptive term, not used in the Middle Ages, that refers to the resemblance between such pages and Turkish or Islamic carpets). The animal interlace of the purse cover reappears in the corner designs that frame the central circle of the carpet page, where two birds face outward and two inward. And

the beasts that turn to face one another in the middle of the cover are echoed in the border figures of the carpet page, top and bottom, left and right. The pre-Christian decorative vocabulary of the Sutton Hoo treasure, created to honor a pagan king, has been transformed to honor the Christian conception of God.

This carpet page is an example of a Celtic cross. Legend has it that while preaching to a group of the soon-to-be converted, St. Patrick had been shown an ancient standing stone monument with a circle carved onto it, symbolic, he was told, of the moon goddess. Patrick reportedly made the mark of a Latin cross through the circle and blessed the stone, thereby making the first Celtic cross. The story is probably only a legend—the circle with a cross through it antedates Patrick's arrival in Ireland, where it probably symbolized, in pagan culture, the sun and moon, male and female, unity and balance in all things— but the legend speaks to the *syncretism* [SIN-krih-tiz-um] (the combining of different practices and principles) of the age.

The syncretic [sin-KRET-ik] style of art that flourished in England and Ireland during the early Middle Ages is called *Hiberno-Saxon* (*Hibernia* [hy-BUR-nee-uh] is the Latin name

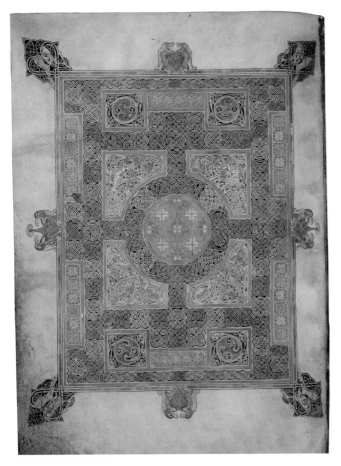

Fig. 12.7 **Bishop Eadfrith, Carpet page, from the *Lindisfarne Gospels* from Northumbria, England. ca. 698.** Tempera on vellum, 13 1/2″ × 9 3/4″. British Library, London. An inscription on the manuscript identifies Eadfrith as its scribe and decorator, Ethelwald as its binder, Billfrith as the monk who adorned it with gems, and Aldred as its translator into Anglo-Saxon: "Thou living God be mindful of Eadfrith, Ethelwald, Billfrith, and Alfred a sinner; these four have, with God's help, been engaged upon this book."

for Ireland). Hiberno-Saxon manuscript illustration is notable particularly for its unification of Anglo-Saxon visual culture with the textual tradition of Christianity. In the monastic *scriptoria* (sing. **scriptorium**)—the halls in which monks worked to copy and decorate biblical texts—artists soon began to decorate the letterforms themselves, creating elaborate capitals at the beginning of important sections of a document. One of the most beautiful capitals is a page from the *Book of Kells*, made at Iona in the late eighth century (Fig. **12.8**). The basis of the design consists of the Greek letters *chi* [ky], *rho* [roe], and *iota* [eye-OH-tuh] (X, P, and I, or *chri*), an abbreviation of *Christi*. In this instance, the text begins *Christi autem generatio*, "Now this is how the birth of Jesus Christ came about," quoting Matthew 1:18. The dominant letterform is *chi*, a giant unbalanced X much larger on the left than on the right. Below the right side of the *chi* is *rho*, which curves around and ends with the head of a red-haired youth, possibly a depiction of Christ, which also dots the *I*. Not long after Ionan monks completed this manuscript, Vikings began to threaten the Scottish coast, and the monks retreated to Kells in the interior of Ireland. So great was the renown of the book they had created that in 1006 it was referred to as "the chief relic of the Western world."

The task of Christian missionaries in England was to transfer the allegiance of the people from their king, or thane, to God. They could not offer gold, or material wealth, but only salvation, or spiritual fulfillment. They had to substitute for the great treasure at Sutton Hoo the more subtle treasures of faith and hope. The missionaries' tactic was simple—they bathed the spiritual in material splendor. They illuminated their manuscripts with a rich decorative vocabulary. They adorned Christianity in gold and silver, jewels and enamel, and placed it within an architecture of the most magnificent kind. And they transplanted pagan celebrations to the context of the Christian worship service.

A manuscript page probably created at Canterbury in the first half of the eighth century is revealing on this last point (Fig. **12.9**). It depicts an enthroned David, author of the Psalms, surrounded by court musicians. The scene could as easily illustrate an episode in *Beowulf* when a great celebration takes place in Hrothgar's hall after Beowulf defeats the monster Grendel:

> They sang then and played to please the hero,
> words and music for their warrior prince,
> harp tunes and tales of adventure:
> there were high times on the hall benches
> and the king's poet performed his part. . . .

Beowulf, ll. 1062–66

David, indeed, is a Judeo-Christian version of "the king's poet," only his king is the Christian God. More to the point, the harp that David plays in the manuscript illustration is very like the six-stringed wooden harp discovered at Sutton Hoo. As the animal-style frames and borders of the scene suggest, this is a celebration any Anglo-Saxon noble would have recognized. In the centuries to come, Christianity would create its own treasure trove, its own celebratory music, its own great

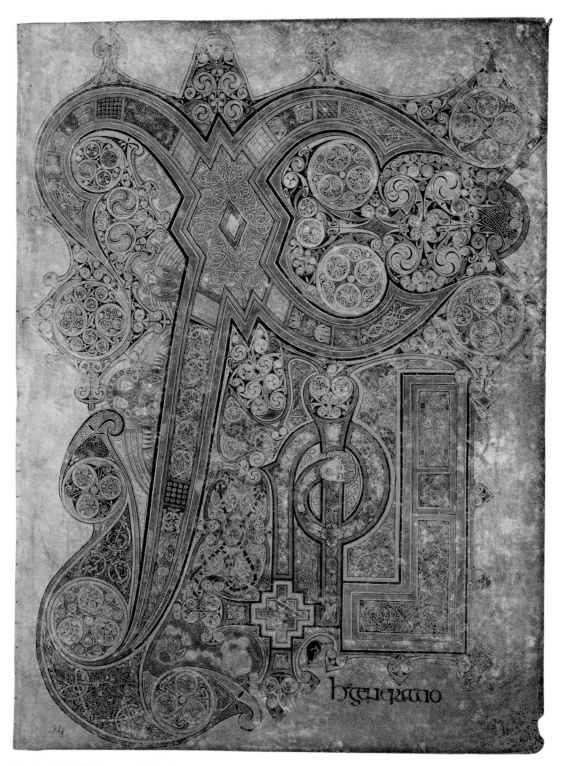

Fig. 12.8 *Chi Rho Iota* **page,** *Book of Matthew,* *Book of Kells,* **probably made at Iona, Scotland, late 8th or early 9th century.** Tempera on vellum, 13″ × 9¹⁄₂″. The Board of Trinity College, Dublin, MS 58 (A.1.6.), fol. 34v. While the abbreviation for *Christi*—*XPI* or *Chri*—dominates the page, the remainder of the verse from Matthew is at the bottom right. *Autem* appears as an abbreviation resembling the letter *h*, followed by *generatio*, which is fully written out. So common were abbreviations in manuscript illumination, saving both time and space, that the scribes were often given the title of official court "abbreviator."

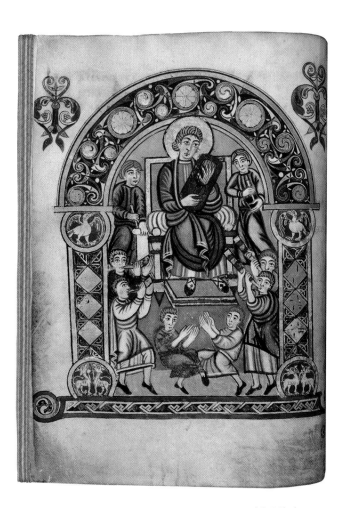

Fig. 12.9 Page with *David and Court Musicians*, now fol. 30b, but likely once the frontispiece of the *Vespasian Psalter*, Canterbury, England, first half of 8th century. British Library, MS Cotton Vespasian A.i. A psalter is a book of psalms. One of the most interesting aspects of this illustration is that it suggests that instrumental music may have played a role in Christian liturgy long before the twelfth century, when instrumentation is usually thought to have been introduced.

halls (the cathedrals), its own armored warriors fighting their own heroic battles (the Crusades). Beowulf's Grendel would become the infidel Muslim, and his king, his Lord God.

Carolingian Culture

Although England was slow to Christianize, the European continent was not. Christianity was firmly established in 732, at Poitiers [PWAH-tee-ay], France, just south of Tours [toor] in the Loire Valley. There Charles Martel [sharl MAR-tel], king of the Franks, defeated the advancing Muslim army, which had entered Spain in 711 and had been pushing northward ever since. The Arabs retreated south, beyond the Pyrenees, and settled into Spain. The Franks were one of many Germanic tribes—like the Angles and Saxons in England—that had moved westward beginning in the fourth century CE. Most of these tribes adopted most of the Christian beliefs of the Roman culture they conquered, most notably the Ostrogoths in Italy, the Visigoths in southern Gaul (France) and

Spain, the Vandals in North Africa, and the Franks, who controlled most of modern France. Unlike the other Germanic tribes, the Franks were Orthodox, or Catholic, Christians, the result of the conversion in 496 of Clovis (ca. 466–511). Clovis was the founder of the first Frankish dynasty, the Merovingians [MER-uh-VIN-gee-uns]. Within a hundred years the Franks would come to control most of Western Europe.

During the Merovingian era, the Franks attempted to establish order across a broad area that included three major regions: Neustria (western France), Austrasia (roughly comparable to central Germany), and Burgundy (Map **12.2**). They did this by making pacts with the local noble landowners and creating a new royal office, the count. Frankish kings gave land to the counts in return for their loyalty. But by the seventh century, counts and noblemen alike ruled their small territories like petty tyrants, paying little or no heed to the king. Real power rested with the head of each of the three regions, who held the office of mayor of the palace.

With the rise of Pepin I (d. 639) to the position of mayor of the palace in Austrasia, the family which would come to be known as the Carolingians [kar-oh-LIN-gee-un] gradually assumed complete power. Pepin II's son, Charles Martel (r. 714–41), not only defeated the Muslim army at Poitiers, but also bestowed more property on already landed gentry. These parcels of land, or fiefdoms, were confiscated from the Church, which depended on the Franks for protection and so had little choice in the matter. (See *Voices*, page 385).

In 751, with the pope's blessing, the Carolingian nobility elected Martel's son, Pepin the Short, as their king. Three years later, a new pope traveled to Saint-Denis [san duh-NEE], near Paris, where he anointed Pepin protector of the Church and the Carolingians "kings by the grace of God." In return, Pepin led an army south into Italy and crushed the Lombards [LOM-bards], a Germanic people who had invaded Italy nearly 200 years earlier and established a kingdom in the Po valley. Pepin turned the territory over to the pope; the land became known as the Papal States.

Pepin the Short's son, Charlemagne, "Charles the Great" (r. 768–814), had even greater imperial ambitions than his father (Fig. **12.10**). (It is for him that historians have labeled this the Carolingian era, from *Carolus*, Latin for Charles.) Charlemagne brought one after another pagan tribe to submission, forcing them to give up their brand of Christianity and submit to Rome's Nicene Creed. Charlemagne's kingdom grew to include all of modern-day France, Holland, Belgium, Switzerland, almost all of Germany, Northern Italy and Corsica, and Navarre, in Northern Spain. Even larger areas paid him tribute. In return for his Christianization of this vast area, Pope Leo III crowned him emperor on Christmas Day, 800, creating what would later be known as the Holy Roman Empire.

The *Song of Roland*: Feudal and Chivalric Values

Charlemagne's military might was the stuff of legend. For centuries after his rule, tales of his exploits circulated throughout Europe in cycles of poems sung by ***jongleurs***

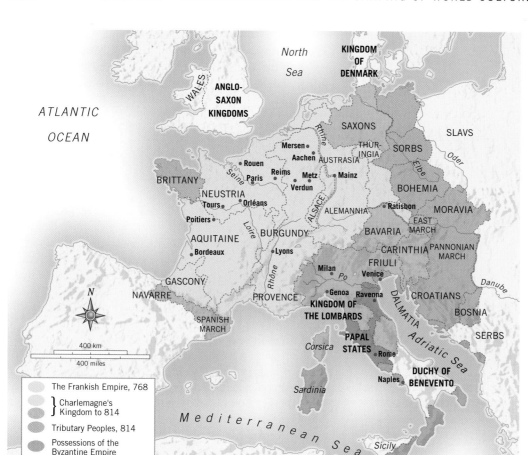

Map 12.2 The Empire of Charlemagne to 814.

[zhohn-GLER], professional entertainers or minstrels who moved from court to court and performed *chansons de geste* [shahn-SOHN deh zhest] ("songs of deeds"). The oldest of these, and the most famous, is the *Song of Roland*, a poem built around a kernel of historical truth transformed into legend and eventually embellished into an epic. Four thousand lines long, composed of ten-syllable lines grouped in stanzas, it was transmitted orally for three centuries and finally written down in about 1100, by which time the story of a military defeat of little consequence had become an epic drama of ideological importance. The *jongleurs* sang the poem accompanied by a lyre. The only surviving musical notations to the poem are the letters *AOI* that end some verses. The exact meaning of this phrase is unclear, but it probably indicates a musical refrain, repeated throughout the performance. Most likely, the poem was sung in a **syllabic** setting, one note per syllable, in the manner of most folk songs even today. Its melody was probably also **strophic**—that is, the same music repeated for each stanza of the poem.

The *Song of Roland* tells the story of an event that occurred in 778, when Charlemagne's rear guard, led by his nephew Roland, Roland's friend Oliver, and other peers, was ambushed by Muslim forces as Charlemagne's army returned from his invasion of Spain. (In fact, it was Basque [bask] Christians who ambushed Charlemagne, and he had actually been invited into Spain by Muslim Saracens [SAR-uh-senz]

to help them fight other Muslims. However, over time, the story's villains were transformed from Basque Christians into Muslims for political and propagandistic purposes, as armies were organized to fight in the Middle East for the liberation of Jerusalem from Islam.)

The story is a simple one: The heroic Roland's army is betrayed by Ganelon, who tells the Saracen Muslim army of Roland's route through Roncevaux [ROHNS-voh], where his 20,000 soldiers are attacked by 400,000 Muslims. Roland sounds his ivory horn, alerting Charlemagne to the Saracen presence, but by then the Frankish guard has been defeated. Discovering Roland and his army dead, Charlemagne executes the treacherous Ganelon, and an epic battle between Charlemagne and the Muslims ensues. Charlemagne is victorious—but not without divine intervention. Charlemagne's prayer keeps the sun from setting, allowing his army time to defeat the Saracens.

Roland as the Ideal Feudal Hero The poem embodies the values of feudalism, celebrating courage and loyalty to one's ruler above all else, in this case Roland's loyalty to Charlemagne. Although the feudal obligation of the vassal to his lord had long been established in Germanic culture—among the Anglo-Saxons, for instance—its purest form was probably Carolingian. Roland is an ideal feudal hero, courageous and loyal, but he possesses—or is possessed by—a sense of pride

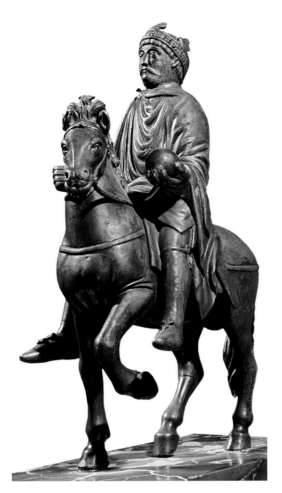

Fig. 12.10 Equestrian statue of Charlemagne, early 9th century. Bronze with traces of gilt, height 9 1/2". Musée du Louvre, Paris. Charlemagne stood 6' 3 1/2" tall, remarkably tall for the time.

that inevitably leads to his demise, just as Beowulf's self-confidence leads to his. In the following reading (**Reading 12.3**), Roland's companion, Oliver, counsels Roland that the Muslim (Saracen) army is so great that he ought to use his horn, Oliphant, to call Charlemagne to help him, but Roland's pride prevails.

READING 12.3 *Song of Roland*

81 Count Oliver has climbed up on a hill;
From there he sees the Spanish lands below,
And Saracens assembled in great force.
Their helmets gleam with gold and precious stones,
Their shields are shining, their hauberks[1] burnished gold,
Their long sharp spears with battle flags unfurled.
He tries to see how many men there are:
Even battalions are more than he can count.
And in his heart Oliver is dismayed;

Quick as he can, he comes down from the height,
And tells the Franks what they will have to fight.

82 Oliver says, "Here come the Saracens—
A greater number no man has ever seen!
The first host carries a hundred thousand shields,
Their helms are laced, their hauberks shining white,
From straight wood handles rise ranks of burnished spears.
You'll have a battle like none on earth before!
Frenchmen, my lords, now God give you the strength
To stand your ground, and keep us from defeat."
They say, "God's curse on those who quit the field!
We're yours till death—not one of us will yield." AOI

83 Oliver says, "The pagan might is great—
It seems to me, our Franks are very few!
Roland, my friend, it's time to sound your horn;
King Charles will hear, and bring his army back."
Roland replies, "You must think I've gone mad!
In all sweet France I'd forfeit my good name!
No! I will strike great blows with Durendal,[2]
Crimson the blade up to the gilt of gold.
To those foul pagans I promise bitter woe—
They are all doomed to die at Roncevaux. AOI

84 Roland, my friend, let the Oliphant[3] sound!
King Charles will hear it, his host will all turn back,
His valiant barons will help us in this fight."
Roland replies, "Almighty God forbid
That I bring shame upon my family,
And cause sweet France to fall into disgrace!
I'll strike that horde with my good Durendal;
My sword is ready, girdled here at my side,
And soon you'll see its keen blade dripping blood.
The Saracens will curse the evil day
They challenged us, for we will make them pay." AOI

85 "Roland, my friend, I pray you, sound your horn!
King Charlemagne, crossing the mountain pass,
Won't fail, I swear it, to bring back all his Franks."
"May God forbid!" Count Roland answers then.
"No man on earth shall have the right to say
That I for pagans sounded the Oliphant!
I will not bring my family to shame.
I'll fight this battle; my Durendal shall strike
A thousand blows and seven hundred more.
You'll see bright blood flow from the blade's keen steel,
We have good men; their prowess will prevail,
And not one Saracen shall live to tell the tale."

86 Oliver says, "Never would you be blamed;
I've seen the pagans, the Saracens of Spain.
They fill the valleys, cover the mountain peaks;
On every hill, and every wide spread plain,
Vast hosts assemble from that alien race;
Our company numbers but a few."

Roland replies, "The better, then, we'll fight!
If it please God and His angelic host,
I won't betray the glory of sweet France!
Better to die than learn to live with shame—
Charles loves us more as our keen swords win fame."

87 Roland is brave, and Oliver is wise;
Both are so brave men marvel at their deeds.
When they mount chargers, take up their swords and shields,
Not death itself could drive them from the field.
They are good men; their words are fierce and proud.

¹ **hauberks:** long coats of chain mail.
² **Durendal:** Roland's sword.
³ **Oliphant:** Roland's horn, made of elephant tusk.

The loyalty of the Franks—and of Roland and Oliver in particular—to Charlemagne is expressed in these words, uttered by Roland a moment later:

"In his lord's service, a man must suffer pain,
Bitterest cold and burning heat endure;
He must be willing to lose his flesh and blood. . . .
And if I die, whoever takes my sword
Can say its master has nobly served his lord."

It is out of a sense of duty that Roland turns to face the Saracens—duty to Charlemagne, his lord, and by extension, duty to the Christian God in the battle against Islam. Roland's insistence that he "will strike great blows with Durendal" (his sword is itself a gift from Charlemagne) expresses the Christian nature of the combat. Durendal's golden hilt conceals four relics (venerated objects associated with saints or martyrs), including hairs of St. Denis, the patron saint of France whose name the Franks shout as a battle cry. Thus, each blow is a blow for Christendom. The reward for such dutiful combat is, as he says, the love of his king. But it is also the love of the whole Christian world, demonstrated by the many visual retellings of episodes from the epic in church art and in manuscripts (Fig. **12.11**). Indeed, Roland ultimately sacrifices all for his king and his God. Mortally wounded in combat, he "knows that death is very near / His ears give way, he feels his brain gush out." Explicit and vivid language heightens the intensity of the moment, and the directness lends credence to characters who are otherwise reduced to stereotypes ("Roland is brave, and Oliver is wise"). But, finally, in his slow and painful death— "Count Roland feels the very grip of death / Which from his head is reaching for his heart"—he becomes a type for Jesus, sacrificing himself for all of Christendom.

The Chivalric Code The *Song of Roland* is one of the earliest expressions of feudalism's **chivalric code**. The term *chivalry* (from the French *chevalier* [shuh-VAHL-ee-ay], "horseman") expressed the qualities of an ideal knight, and

may in fact more nearly reflect the values of the eleventh century (when the poem was written down) than the eighth-century practices of Charlemagne's day. Nevertheless, something very like this set of values already exists in *Beowulf*. The chevalier was a **knight** (from the German *knecht*, "young soldier"), and he was guided by a strict, though unwritten, code of conduct: courage in battle, loyalty to his lord and peers, and a courtesy verging on reverence toward women. Although in practice these values often broke down, feudalism and chivalry were powerful mechanisms for maintaining social order and political harmony throughout medieval Europe.

Aachen and Charlemagne's Building Program

In keeping with his stature as head of the largest empire since Roman times, Charlemagne created a magnificent new capital in Aachen [AHK-un] (modern Aix-la-Chapelle [ex-lah-shah-PELL]), conceived as the new center of culture for his empire.

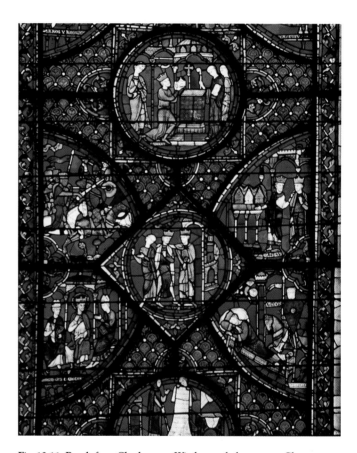

Fig. 12.11 Panels from Charlemagne Window, ambulatory apse, Chartres Cathedral. ca. 1220–25. Stained glass. So famous and important was the *Song of Roland* that, more than 400 years after its first recitations, scenes from it were included in Chartres Cathedral's stained glass scheme. Use of this secular narrative in an otherwise religious context suggests that by the 13th century the story was understood as a religious allegory, the victory of Christianity over Islam. At the top left, the battle rages. On the bottom right, Charlemagne (identified in the glass as "Carolus") arrives too late to find Roland alive.

Voices

Keeping Track of the King's Domains

The lord of the Carolingian manor received all kinds of goods and services from the workers who lived on his lands. Nothing was left to chance. The following excerpt is from The Capitulary De Villis, *which provided exact instructions for administering the king's private domains.*

That each steward shall make an annual statement of all our income: an account of our lands cultivated by the oxen which our ploughmen drive and of our lands which the tenants of farms ought to plough, an account of the pigs, of the rents, of the obligations and fines; of the game taken in our forests without our permission; ... of the mills, of the forest, of the fields, of the bridges, and ships: of the free-men and the hundreds who are under obligations to our treasury; of markets, vineyards, and those who owe wine to us; of the hay, firewood, torches, planks, and other kinds of lumber; ... of the vegetables, millet, panic; of the wool, flax, and hemp; of the fruits of the trees, of the nut trees; ... of the gardens; of the turnips; of the fishponds; of the hides, skins, and horns; of the honey, wax; of the fat, tallow and soap; of the mulberry wine, cooked wine, mead, vinegar, beer, wine new and old; ... of the geese; the number of fishermen, smiths [workers in metal], swordmakers, and shoemakers; of the bins and boxes; of the turners and saddlers; of the forges and mines, ... of the colts and fillies; they shall make all these known to us, set forth separately and in order, at Christmas, in order that we may know what and how much of each thing we have.

In each of our estates our stewards are to have as many cow-houses, piggeries, sheep-folds, stables for goats, as possible, and they ought never to be without these.

They must provide with the greatest care that whatever is prepared or made with the hands, that is, lard,

> **"That each steward on each of our domains shall always have, for the sake of ornament, swans, peacocks, pheasants, ducks, pigeons, partridges, turtle-doves."**

smoked meat, ... wine, vinegar, ... mustard, cheese, butter, malt beer, mead, honey, wax, flour, all should be ... made with the greatest cleanliness.

That each steward on each of our domains shall always have, for the sake of ornament, swans, peacocks, pheasants, ducks, pigeons, partridges, turtle-doves.

That in each of our estates, the chambers shall be provided with counterpanes, cushions, pillows, bed-clothes, coverings for the tables and benches; vessels of brass, lead, iron and wood; andirons, chains, pothooks, adzes, axes, augers, cutlasses and all other kinds of tools, so that it shall never be necessary to go elsewhere for them, or to borrow them. And the weapons, which are carried against the enemy, shall be well cared for, so as to keep them in good condition.

For our women's work they are to give at the proper time, as has been ordered, the materials, that is the linen, wool, woad, vermilion, madder, wool-combs, teasels, soap grease, vessels and the other objects which are necessary.

Of the food-products other than meat, two-thirds shall be sent each year for our own use, that is of the vegetables, fish, cheese, butter, honey, mustard, vinegar, millet, panic, dried and green herbs, radishes, and in addition of the wax, soap and other small products. . . .

The chapel and palace complex (Fig. **12.12**) were designed by Odo of Metz, the first architect of Northern origin whose name we know. The palace complex included homes for the emperor's administrative staff, workshops to supply the needs of the whole, and a judgment hall where Charlemagne would hold audiences. The Palatine [PAL-uh-teen] Chapel (*palatine* means "palace") is modeled on San Vitale in Ravenna (see Figs. 10.8, 10.9), which Charlemagne visited in 789. The outer wall of the chapel has 16 sides, and its central core is an octagon. Two

Continuity & Change
p. 326

San Vitale

stairways in twin towers lead to a gallery from which the emperor observed Mass. Relics were housed on the third, clerestory level.

Charlemagne may have modeled his Palatine Chapel on San Vitale to assert symbolically his authority over the Byzantine Empire, but his favorite building, according to his biographer, was St. Peter's in Rome (see Figs. 9.16, 9.17). Charlemagne's architects adopted St. Peter's basilica plan for many churches, but not without some northern innovations. At the Abbey Church of Saint-Riquier [san-re-kee-AY] at the Monastery of Centula [sen-TOO-lah] in northern France, which we know through surviving drawings

p. 326

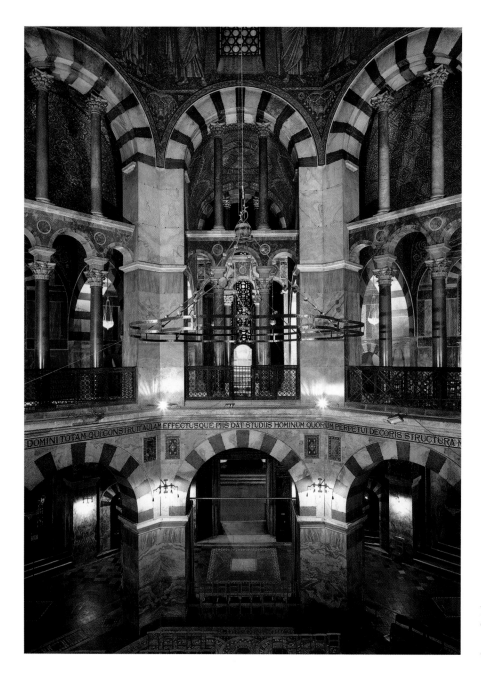

Fig. 12.12 Odo of Metz, interior of Palatine Chapel of Charlemagne, Aachen, Germany. 792–805. The chapel is the only surviving example of Carolingian architecture.

(Figs. **12.13**, **12.14**), two tall towers flank a multistoried narthex. This feature, known as the **westwork** (from the fact that the entrance to churches traditionally faces west), creates an imposing, even monumental entrance. Another Carolingian innovation is the separation of the apse from the transept crossing. The resulting square compartment, called the **choir**, would become a standard feature in church architecture.

Promoting Literacy

Across Europe, the Church had traditionally served as the chief guardian of culture. In its monastic centers, the Roman love of learning had been maintained, especially in the man-uscripts transcribed by monastic copyists. But literacy was anything but widespread. Charlemagne sought to remedy this situation at his court at Aachen, which soon attracted leading scholars and artists, whose efforts Charlemagne rewarded handsomely. Chief among these was an Englishman, perhaps even of Anglo-Saxon origin, Alcuin [AL-kwin] of York (735–804), who in 782 became head of Charlemagne's court school. One of the foremost grammarians and theologians of the period, Alcuin served as Charlemagne's personal tutor. Another of Charlemagne's resident scholars, Einhard of Gaul, describes Charlemagne's education in his biography, the *Vita Caroli* (Life of Charles) (**Reading 12.4**):

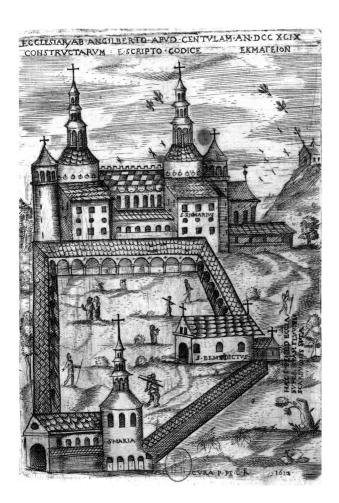

Figs. 12.13 and 12.14 View and plan of Abbey Church of Saint-Riquier, Monastery of Centula, France, dedicated 799. Engraving by Petau dated 1612, after an 11th-century manuscript illumination. With special authorization of the city of Bayeux, Musée de la Tapisserie, Bayeux, France/The Bridgeman Art Library. The church's tall towers, its most striking feature, prefigured the two-tower facades of later medieval church architecture, both Romanesque and Gothic.

Alcuin's main purpose in Aachen was to create a curriculum to promote literacy that could be disseminated throughout the Carolingian Empire. Schools designed to teach children basic skills in reading and writing and some further study in the liberal arts and theology were established in Lyon [lee-OH], Orléans [or-lay-AH], Mainz [mynts], Tours, Laon [lan], and Metz [mes], which was a center for singing and liturgy (see Map 12.2). By 798, a decree from Aachen ordered prelates and country clergy throughout the empire to start schools for children. The emphasis was on educating males. The work of the state bureaucracy would fall to them, and by receiving a Christian education, they would lead in accordance with Church principles. But there is evidence that girls, especially those of noble birth, were also admitted to the local schools created by Alcuin.

There was also a religious purpose in educating the people. Charlemagne believed that to spread the gospel, people should be able to read aloud and sing in church, to say nothing of grasping the fundamental truth believed to be revealed in the Bible. Education thus furthered the traditional role of the Church. It provided a means for the Church—and Charlemagne's state as agent of the Church—to insert itself into the lives of every individual. Alcuin published a book of Old and New Testament passages to be read during Mass, as well as a book of prayers and rites that was made obligatory for all churches in the empire in 785. The last eight years of Alcuin's life were dedicated to producing a corrected version of the Latin Vulgate Bible that would become the standard text throughout the Middle Ages.

A New Style of Writing All of this was made possible by one of the less heralded but most important accomplishments of Charlemagne's court—a standardized, legible style of writing. Until this time, manuscripts had employed a Roman script made up entirely of capital letters with no space between the words, a style still evident in the famous *Utrecht Psalter*, made in Reims [reemz] during Carolingian times (Fig. **12.15**). But Charlemagne, who demanded written documentation of his holdings by his vassals, required a more uniform and legible writing style, and Alcuin helped him develop it. The new style, known as *Carolingian miniscule*, was characterized by clearly formed lowercase letters, linked into individual words, with clearly delineated spaces between each word, and capital

READING 12.4 **Einhard of Gaul, *Vita Caroli* (Life of Charles)**

[Charlemagne] paid greatest attention to the liberal arts. . . .When he was learning the rules of grammar he received tuition [from] Peter the Deacon of Pisa, who, by then, was an old man. For all other subjects he was taught by Alcuin. . . a man of the Saxon race who came from Britain and was the most learned man anywhere to be found. Under him, the emperor spent much time and effort in studying rhetoric, dialectic, and especially astrology. He applied himself to mathematics and traced the course of the stars with great attention and care. He also tried to learn to write. With this end in view he used to keep writing tablets and notebooks under the pillows of his bed, so that he could try his hand at forming letters during his leisure moments; but, although he tried very hard, he had begun late in life and he made very little progress.

CULTURAL PARALLELS

Emperors and Education

As Charlemagne worked to increase literacy across his realm by funding schools and scholars, in the late eighth century, 5,000 miles away in China, Tang emperors also placed a supreme value on education. The imperial college at Chang'an trained civil servants with a curriculum based on Confucian and Taoist classics.

Fig. 12.16 Page in Carolingian miniscule with Psalm 111, from the *Harley Psalter*, written in Christ Church, Canterbury. 1010–1030. Ink on vellum, 15″ × 12¼″. 73 fols. Harley MS 603, fol 57b. © The British Library. In the late 10th century, the *Utrecht Psalter* (see Fig. 12.15) made its way to Canterbury, where scribes copied it in the new writing style developed at Charlemagne's court.

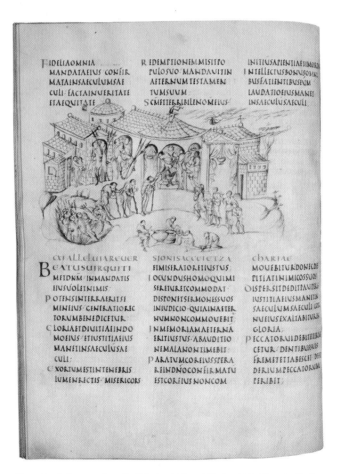

Fig. 12.15 Page with end of Psalm 111 and Psalm 112, *Utrecht Psalter*, from Benedictine Abbey at Hautvilliers, France. ca. 825–50. Ink on vellum or parchment, 13″ × 9⅛″. Bibliotheek der Rijksuniversiteit, Utrecht, the Netherlands, MS. 32 if. 65 v.

letters beginning each sentence. The page from the *Harley Psalter* (Fig. **12.16**) is an example of Carolingian miniscule, and except for the writing style, it is a direct copy of the text from the *Utrecht Psalter* shown in figure 12.15.

The importance of this script to our cultural history cannot be overstated: It is the ancestor of the modern alphabet.

All subsequent writing and type fonts derive from this model, and it made written material accessible not only to generations of learned scholars and teachers, but eventually, in the print era, to laypeople throughout Europe.

The Medieval Monastery

The monastery was a central part of Carolingian culture, arguably its most important institution. Before the Carolingian era, monastic life varied widely across Europe. In Italy, the rule of solitude (the Greek word *monos*, from which *monasticism* derives, means "alone") was barely enforced, and life in a monastery could be positively entertaining. If, in Ireland, more austere conditions prevailed, still the lively intellectual climate of the monastery attracted men and women seeking a vocation. Even from monastery to monastery, different conditions and rules prevailed.

Charlemagne imposed on all monasteries in the Frankish kingdom the rule of Benedict of Nursia [NOOR-she-uh], an Italian monk who had lived two centuries earlier (ca. 480–547). The Rule of St. Benedict defined monastic life as a community of like-minded individuals, all seeking religious perfection, under the direction of an abbot elected by the

monks. Monks were to live a family life in the pursuit of religious perfection. They were to possess nothing of their own, accepting worldly poverty. They were to live in one place and not wander, guaranteeing the community's stability. And they were never to marry, acknowledging their chastity. Each day was divided into eight parts, the *horarium* [hor-AR-ee-um] (from the Latin *hora*, "hour"). The *horarium* is the daily prayer schedule of liturgical praise called the **Divine Office** (the word "Office" comes from the Latin *officium*, meaning "duty"), marked by recitations of the psalms and the chanting of hymns and prayers at eight specific times of the day, from early morning until bedtime. Between services, the monks studied, worked, and ate a light breakfast and heartier dinner. They lived by the motto of their order: "Pray and work."

The Ideal Monastery: St. Gall The Swiss monastery of St. Gall, near Lake Constance, was Charlemagne's ideal monastery (Figs. **12.17**, **12.18**); its functional, orderly plan was used in many Benedictine monasteries. As medieval historian Walter Horn pointed out in the 1970s, the original plan was laid out in modules, or standard units, of $2\frac{1}{2}$ feet,

and the entire complex was composed of multiples or parts of this standard unit. The nave and the transept of the church, each 40 feet wide, are composed of 16 modules. The area where they cross is a perfect square with 16 modules on a side. Each arm of the transept is equal to the crossing square—that is, 16 modules square. The area between the transept and the apse is also one crossing square. And the nave is $4\frac{1}{2}$ crossing squares long—or 56 modules. The rest of the monastery is built on this rational and orderly plan. The length of each monk's bed was to be $2\frac{1}{2}$ modules, the width of each garden path $1\frac{1}{4}$ modules, and so on. This systematic arrangement reflects an increasing tendency in medieval thinking to regard Christianity as a logical and rational philosophy of life, based on carefully constructed arguments and precise definition of parts as orderly as the "rule" of the day in the *horarium*.

Adjacent to the church, with its imposing westwork, is a **cloister**, or rectangular courtyard, typically arcaded and dedicated to contemplation and reflection. Beside it, on the east side, are the monks' dormitories, latrines, and baths, and on the west, storage cellars. To the south of the cloister is the **refectory**, or dining hall. Farther to the south, and to the west

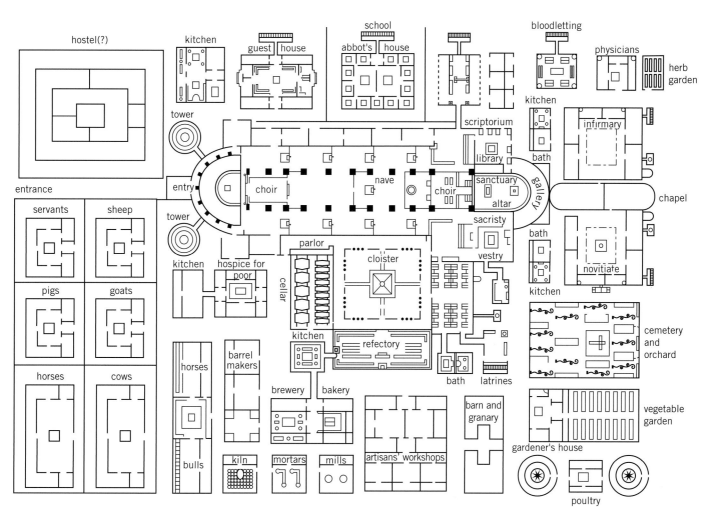

Fig. 12.17 Plan for a monastery at St. Gall, Switzerland. ca. 820. Redrawn from an original in red ink on parchment (inscriptions translated into English from Latin). 28″ × 44⅛″. Stiftsbibliothek, St. Gall, Switzerland.

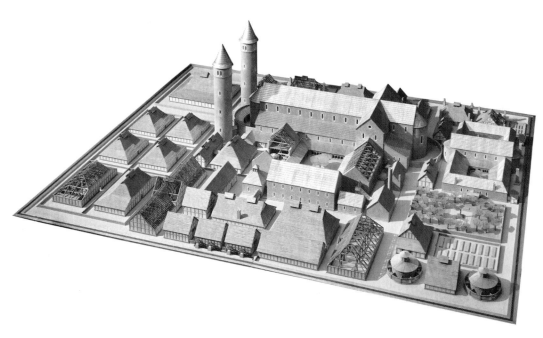

Fig. 12.18 Reconstruction model of the monastery of St. Gall, after the plan, by Walter Horn. 1965. The monastery builders did not follow this plan exactly; nevertheless, the plan was widely influential. Many of the surviving cathedrals of Europe discussed in the next chapters were originally surrounded by monasteries constructed on this model.

and east, behind and adjacent to the refectory are outbuildings housing all the facilities necessary to support a community of approximately 100 monks—a kitchen, a brewery, a bakery, a mill, workshops for artisans, barns for various animals, a vegetable garden (with its own gardener), and an orchard that doubles as a cemetery. Surrounding the entire complex were fields in which the brothers worked. This side of the monastery was reserved for the members of the community.

The general public could enter the north side of the monastery. Here, beside the entrance to the church, we find a hostel, or inn, for housing less-well-to-do visitors, as well as a guesthouse for nobility, and between them a special kitchen (St. Benedict had directed that monasteries extend hospitality to all visitors). Directly to the north of the church is the monastery school, dedicated, by imperial decree, to educating the youth of local nobility. Another school, the novitiate, to the east of the church, was dedicated to the education and housing of young novices—those hoping to take vows and become brothers. In the northeast corner of the monastery was a public hospital, including an herb garden for remedies, the physician's quarters, and a facility for bloodletting—in the Middle Ages and until the nineteenth century the most common means of curing severe illness.

Women in Monastic Life Although the religious life offered women an alternative to life as housewife or worker, life in the convent or nunnery was generally available only to the daughters of aristocrats. Within the monastic system, women could achieve significant prestige. St. Benedict himself had a sister, Scholastica (d. ca. 543), who headed a monastery not far from his own. Hilda, abbess of Whitby (614–80), ran one of the most prominent Anglo-Saxon monasteries, a commu-

nity of both monks and nuns. One of her most important acts was to host a Council at Whitby in an attempt to reconcile Celtic and Latin factions of the Church in England. It was to Hilda that the poet Caedmon first sang his *Hymn* (see Reading 12.2). She is one of the first women who rose to a prominent position within the largely male medieval Church.

Roswitha [ros-VEE-tah] of Gandersheim [GAHN-durshime] (ca. 935–75) never achieved Hilda's political prominence, but she was one of the notable playwrights of her day. Forgotten until the late fifteenth century, her plays concentrate on women heroines whose personal strength and sense of self-worth allow them to persevere in the face of adversity and challenges to their modesty and chastity.

One of the foremost women of the age was Hildegard [HIL-duh-garth] of Bingen [BING-un] (1098–1179), who ran the monastery at Bingen, near Frankfurt, Germany. She entered the convent at the age of eight and eventually became its abbess. Extraordinarily accomplished—she wrote tracts on natural science, medicine, and the treatment of disease, an allegorical dialogue between the vices and virtues, as well as a significant body of devotional songs (see the next section on Monastic Music)—she is best known as the first in a long line of female Christian visionaries and mystics, a role anticipated in Western culture by the Delphic priestesses (see chapter 6). Her visions are recorded in the *Scivias*, a work whose title derives from the Latin *Scite vias domini*, "Know the ways of the Lord" (**Reading 12.5a**). The *Scivias* was officially designated by the pope as divinely inspired. A zealous advocate for Church reform, she understood that this recognition lent her the authority to criticize her secular and Church superiors, including the pope himself, and she did not hesitate to do so.

Hildegard of Bingen, *Scite vias domini*

I n the year 1141 of the incarnation of Jesus Christ the Son of God, when I was forty-two years and seven months of age, a fiery light, flashing intensely, came from the open vault of heaven and poured through my whole brain. . . . And suddenly I could understand what such books as the psalter, the gospel and the other catholic volumes of the Old and New Testament actually set forth.

Indeed, from the age of girlhood, from the time that I was fifteen until the present, I had perceived in myself, just as until this moment, a power of mysterious, secret, and marvelous visions of a miraculous sort. . . . I have not perceived these visions in dreams, or asleep, or in a delirium, or with my bodily eyes, or with my external mortal ears, or in secreted places, but I received them awake and looking attentively about me with an unclouded mind, in open places, according to God's will.

The page from the *Scivias* reproduced here (Fig. **12.19**) illustrates this passage. Hildegard is shown recording her divine revelation, as her copyist waits to transcribe her words. Such images were directly supervised by Hildegard herself.

Later in the *Scivias*, Hildegard has a vision of the devil (**Reading 12.5** on pages 399–400), embodied as a monstrous worm who oversees a marketplace full of material goods. After describing her vision, she interprets some of the key images. Hildegard's impulse to interpret her own words is typical of religious literature in the Middle Ages: Its primary purpose was to teach and instruct. But, more than that, Hildegard's *Scivias* shares with other visionary and mystical writing of the period an impulse to make the unknowable vividly present in the mind's eye of her audience. Like the Delphic priestess, she directly encounters the divine through revelation and vision.

Monastic Music Hildegard is responsible for more surviving compositions than any other musician, male or female, who worked before the early fourteenth century. Her *Ordo virtutum* (Play of the Virtues) is a composition of texts and 82 melodies that dramatizes the conflict between good and evil. In it the devil, who never sings but shouts all his lines, confronts a personification of each of the 16 Virtues. Hildegard collected all of her liturgical works in a *Symphonia armonie electium revelationum* (Symphony of the Harmony of Celestial Revelations). Like her *Scivias*, Hildegard's music is designed to illuminate spiritual truths. She believed that in singing and playing music, the mind, heart, and body become one, that discord among celebrants is healed, and the harmony of the heavens is realized on earth.

By the time that Hildegard was composing, the liturgy, and particularly its music, had become remarkably unified. This had been accomplished at Charlemagne's insistence. Although we have no written melodies from Charlemagne's time, most scholars agree that he adopted a form that later became known as **Gregorian chant**—named after Pope Gregory the Great, the same pope who sent Augustine to England in 597. Called *cantus planus*, plainsong or **plainchant**, it consisted of **monophonic** songs (that is, songs for one or many voices singing a single melodic line with no harmony. The style of Gregorian chant probably originated in the way that ancient Jews sang the Psalms. In its simplest form, the chant is sung **a capella** (that is, without musical accompaniment) and performed in a syllabic style (a single note for each syllable). Often the final word of each phrase is emphasized by the addition of one or two other notes:

1. Di-xit Dóminus Dómino mé- o : *Séde a déxtris mé- is.

Dixit dominus from Psalm 109

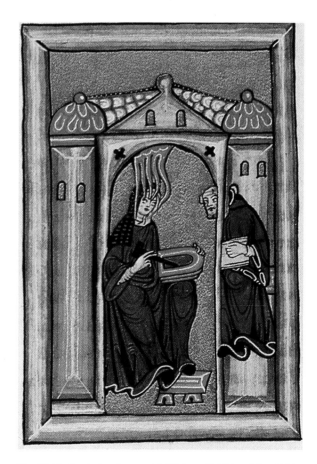

Fig. 12.19 Facsimile of page with *Hildegard's Vision, Liber Scivias*. ca. 1150–1200. Hildegard wrote 33 visionary tracts, collected in *Liber Scivias*, which were acknowledged by the Church as divine. The original manuscript was lost during World War II.

This is the opening line of Psalm 109 ("The Lord said to my Lord: sit on my right hand"). Its four-line staff would become the traditional Gregorian notation, with each note, or **neume** [noom], indicated by a small square. Neumatic chan derives its name from these notes. In **neumatic** [noo-MAT-ik] chant, the syllabic style gives way to a form in which each syllable is sung to two or three notes **(CD-Track 12.1)**. In later medieval chant, a single syllable may be sung to many notes, a practice known as **melismatic** [mel-uz-MAT-ik] chant **(CD-Track 12.2)**:

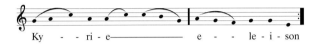

Kyrie Eleison from opening of mass

The Mass Since the earliest times, the celebration of the mass was a central rite of the Christian Church. It is a celebration of the Eucharist, the fulfillment of Jesus's instruction (recorded in 1 Corinthians 11:24–25) to do in memory of him what he did for his disciples at the Last Supper—that is, Jesus gave his disciples bread, saying, "This is my body," and wine, saying "This is my blood." Christians generally recognized, in its celebration, the presence of Christ. In the medieval Mass, the *Kyrie* [KIR-ee-ay], which is either the first or second element in every Mass, consists of three phrases: *Kyrie eleison* [ih-LAY-ih-son] ("Lord, have mercy") is sung three times, followed by *Christe* [KRIS-tay] *eleison* ("Christ, have mercy"), likewise sung three times, and then another *Kyrie eleison*, set to different music, repeated three times again. The repetition of three phrases three times each is deeply symbolic, the number three referring to the Trinity, and the three squared (three times three) signifying absolute perfection.

The plainchant composed by Hildegard of Bingen is unique in the range of musical effects it employs. In contrast to the rather narrow scope of most chants of her day, she uses extremes of register to create "soaring arches" which, she believed, brought heaven and earth together. Although traditional plainchant rarely employed intervals greater than a second or third (one or two notes apart on a keyboard), Hildegard regularly used wider intervals such as fourths and fifths, again to create a sense of moving between the divine and mundane. Her melodies ascend rapidly upward as if toward the heavens. She combines neumatic and melismatic passages: The former seem grounded in the everyday, while the latter suggest the joy of salvation. Her unique style can be more readily appreciated by comparing **CD-Track 12.3** to the more traditional approaches to plainchant represented in CD tracks 12.1 and 12.2.

The most important single element in determining the nature of a given plainchant melody is its function in the liturgy, which remained consistent from the time of Charle-magne through the sixteenth century. Certain chants, focusing on the Psalms, were composed specifically for the eight *horarium* (hours) of the Divine Office and sung exclusively by cloistered monks and nuns. The Rule of St. Benedict required that the entire 150 Psalms be recited each week.

The Mass had its own repertoire of plainchant. It was celebrated once each day, between 6 AM and 9 AM in every church, convent, and monastery, and was open to any baptized member of the community or congregation. Some elements were performed at every Mass, including the Credo, a musical setting of the Nicene Creed (see chapter 9), while others were sung only on special Sundays or feast days of the liturgical year. The liturgical year revolves around two major feast days, Christmas and Easter; each is preceded by a season of penitence.

Charlemagne standardized the liturgy by creating several singing schools, including one at St. Gall, where plainchant was taught to choirmasters from throughout the empire. "In every bishop's see," he ordered in the Law of 789, "instruction shall be given in the psalms, musical notation, chant, the computation of the years and seasons, and grammar."

The Ottonian Empire

Charlemagne's empire dissolved in 843 when his son Louis the Pious (r. 814–40) divided the kingdom among his own feuding sons, Lothar [LOH-tar], the eldest of the three; Louis the German; and their half-brother, Charles the Bald. To the east, Louis the German ruled most of what is today modern Germany and Austria. To the west, Charles the Bald ruled

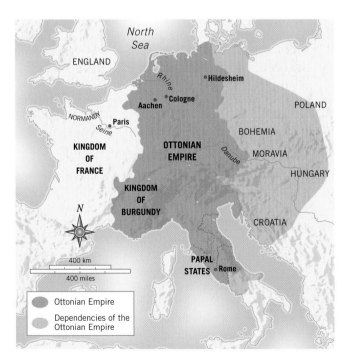

Map 12.3 The Ottonian Empire.

most of what is now modern France. And between the two was Lothar, whose kingdom extended in a narrow band from the North Sea to Italy. When Lothar died in 855, his kingdom was partitioned among his three sons. With this middle territory thus weakened, Charles the Bald to the west and Louis the German to the east began to fight over it, a contest between the German and French Frankish kingdoms. By the end of the tenth century, two powerful kingdoms—one German, the other French—had emerged.

The German kingdom was led by Duke Otto I (r. 936–73). Otto came to the rescue of Pope John XII in 961, and in return, the pope crowned Otto emperor on February 2, 962. Nevertheless, the pope lost control of the Church, as Otto made it clear that the Church depended on his military support. When John refused to accept the situation, Otto deposed him and proclaimed that the pope ruled at the pleasure of the emperor. Although the Ottonian Empire (Map **12.3**) was a conscious reinvention of the Carolingian dream, unifying church and state in a single administrative and political bureaucracy, it was built on the exercise of power, not consensus, and it collapsed in the eleventh century, as the Church retaliated against secular power.

Ottonian Art

The art created under the five Ottonian rulers (936–1024) is distinguished by its spiritual expressiveness. The so-called *Gero Crucifix*—the oldest surviving large-scale crucifix in carved wood—was commissioned by Archbishop Gero of Cologne [kuh-LONE], in 970 (Fig. **12.20**). It is intensely emotional, focusing on Christ's suffering, not his triumph. The tendons in his chest are drawn tight, and his abdomen protrudes as the

Continuity & Change
p. 322

Transfiguration of Christ

weight of his body sags downward in death. That the *Gero Crucifix* is slightly larger than life size adds to its expressive force. It seems less sculpture than real flesh, an object designed to inspire pity and awe in the viewer. Sagging, emaciated, and bloodied, it seems the very opposite of the triumphant Christ of the resurrection (compare, for instance, Fig. 10.7). It announces a new, powerful expressiveness that would be passed on to the artists of the Romanesque period (see chapter 13).

Similarly powerful because of their huge size are the bronze *Doors of Bishop Bernward* (Fig. **12.21**), commissioned by Bishop Bernward in 1015 for the south portal of the Abbey Church of St. Michael at Hildesheim. It is generally believed that Bishop Bernward created the iconographic program for the doors, and he may have played a role in their actual execution as well; according to his biographer, he was an accomplished goldsmith and bronze-caster. On a visit to Rome in 1001, he became acquainted with monuments like

the Column of Trajan (see Fig. 8.23), which may have inspired a large, column-like candlestick that he erected in St. Michael's. Similarly, the heavy wooden doors of the early Christian church of Santa Sabina in Rome may have inspired his bronze doors. Cast in a single piece, the doors rise to a height nearly three times that of the average viewer.

The iconography consists of 16 separate scenes linked typologically. Each scene from the Hebrew Bible on the left

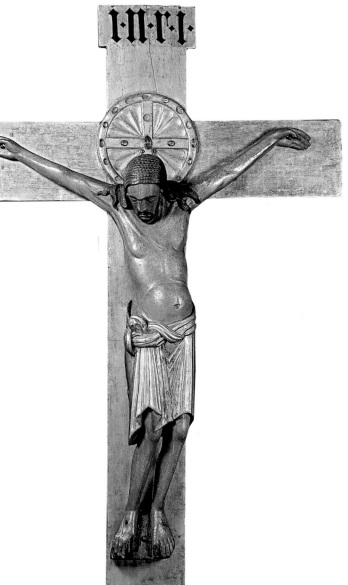

Fig. 12.20 *Gero Crucifix*, Cologne Cathedral, Germany. ca. 970. Painted and gilded oak, height of figure, 6′ 2″. This is one of the few surviving pieces of wooden sculpture from the period and certainly one of the largest. It is the most powerful representation of Christ as a tortured martyr in the early Middle Ages. A cavity in the back of the head was made to hold a piece of communion bread, the Host. Thus, the crucifix not only represents the body of the dying Jesus, but contains within it the body of Christ obtained through the sacrament of the Eucharist.

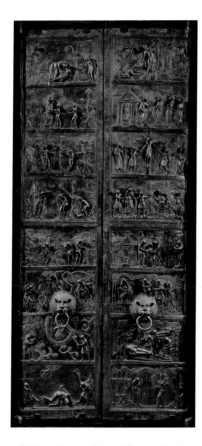

Fig. 12.21 **Doors of Bishop Bernward, detail showing God reproaching Adam and Eve, Hildesheim Cathedral (Abbey Church of St. Michael), Hildesheim, Germany. 1015.** Bronze, height of doors 16′ 6″. Individual image 23″ × 43″. The doors were originally intended for the interior of the monastery of St. Michael, but were moved to the westwerk of the larger Abbey Church, Hildesheim Cathedral, where a much larger public was able to view them.

door is matched by its New Testament counterpart on the right, which, in Christian doctrine, it prefigures. For instance, on the third panel down on the left door is the Temptation of Adam and Eve in the Garden (see Fig. 12.21). It represents the Fall of Man, the reputed origin of human sin, suffering, and death. This scene is balanced on the right door by the Crucifixion, in which Christ, by his suffering and death, atones for Adam and Eve's Original Sin. In the scene showing Adam and Eve being reproached by an angry God for their disobedience in eating the fruit of the Tree of Knowledge of Good and Evil, Adam and Eve cringe in embarrassment, hiding their nakedness (Fig. **12.22**). God jabs his figure dramatically in the direction of Adam and Eve, Adam blames Eve, Eve points to the serpent at her feet, and Satan, as serpent, hisses back at her. Vegetation curls around them in a manner much like animal interlace (see Fig. 12.2), especially at the left, a device suggesting that their Fall, the result of their disobedience, is connected to and in some sense responsible for pagan culture. Bishop Bernward's doors were the most ambitious and complex bronze-casting project since antiquity. Their monumentality suggests the Ottonian aspiration, following the example of Charlemagne, to create an empire rivaling that of Rome.

Fig. 12.22 *Accusation and Judgment of Adam and Eve,* from the Doors of Bishop Bernward. **Hildesheim, Germany. 1015.** Bronze, approx. 23″ × 43″. The Latin inscription, in inlaid silver, below the scene reads: "In the year of Our Lord 1015 Bernward the bishop of blessed memory cast these doors."

Capetian France and the Norman Conquest

To the west of the Ottonian Empire, the Frankish territory formerly controlled by Charles the Bald was invaded in the middle of the ninth century by Normans—that is, "Northmen"—Viking warriors from Scandinavia. The Viking onslaught was devastating, as they plundered and looted across the north European seas, targeting especially isolated but wealthy monasteries such as Lindisfarne, which they attacked even earlier, in 793. The Viking invasions fragmented the former empire and caused nobility, commoners, and peasants alike to attach themselves to anyone who might provide military protection—thus cementing the feudal system. By the tenth century, they had raided, explored, and settled territories from North America, which the explorer Leif [leef] Eriksson reached about the year 1000, to Iceland, Greenland, the British Isles, and France. In France, they besieged Paris in 845 and gained control of the lower Seine [sen] valley. In 915, the Frankish king Charles III (r. 893–923) was forced to grant the Norse leader Rolf, or Rollo, permanent control of the region. Rollo became the first duke of Normandy.

The rest of the western Carolingian Empire, now called France, remained fragmented, with various counts and dukes competing for power. Finally, in 987, Hugh Capet [KAY-pit], lord of the Ile de France [eel deh-frahns], a relatively small domain stretching from Paris and its environs south to Orléans in the Loire [lwahr] Valley, was selected to serve as king. Hugh began a dynasty of Capetian [kuh-PEE-shun] kings that ruled for the next 350 years. From the beginning, the Capetians concentrated their energies on building a tightly knit administrative bureaucracy. Their most contentious relationship was with the dukes of Normandy, who were fiercely independent, going so far as to claim England for themselves, independent of Capetian influence.

The Normans invaded England in 1066, a story narrated in the famous *Bayeux* [BY-yuh] *Tapestry* (see *Focus* on pages 396–397). England and northern France thus became one country, with one king, William I, the Conqueror, and a small group of barons who owned estates on both sides of the English Channel. To both pacify and defend themselves against the Saxons, the Normans constructed **motte and bailey** castles (Fig. **12.23**). A motte is a raised earth mound, and a bailey is the enclosed courtyard at its base. Archeologists estimate that the Normans built about 500 of them between 1066 and 1086, or one every two weeks. Such fortifications could be built in as little as eight days. In time, elaborate stone castles would replace these fire-prone wooden fortifications. (See *Focus* on pages 418–419, chapter 13.)

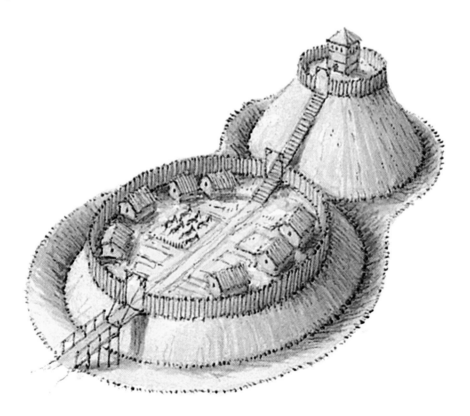

Fig. 12.23 Motte and bailey castle. When Normans first landed in England they constructed mounds, called mottes, upon which they built a square wooden tower called a keep. First used as a lookout tower and elevated fighting point, the keep later became an accommodation for the lord of the castle. At the foot of the motte was a flat area called a bailey, surrounded by a wooden stockade. Domestic buildings, including stables, kitchens, and servants' quarters, were located in the bailey. A moat, or trench filled with water, often surrounded the castle—a natural result of digging dirt for the motte.

Focus

The Bayeux Tapestry

The *Bayeux Tapestry*—actually a 231-foot embroidery—was sewn between 1070 and 1080, almost certainly by women at the School of Embroidery at Canterbury, in Kent, England—one of the few surviving works by women we have from the period. The embroiderers of the *Bayeux Tapestry* worked with twisted wool, dyed in eight colors, and used only two basic stitches. It was commissioned by Bishop Odo of Bayeux, half-brother of William, duke of Normandy, whose conquest of England in 1066 it narrates in both pictures and words (in Latin). Like the Column of Trajan (see fig. 8.23), its story is both historical and biased. The tapestry was designed to be hung around the choir of Odo's Bayeux Cathedral—an unabashed act of self-promoting propaganda on the part of the Normans.

When the English king Edward the Confessor died on January 5, 1066, without an heir, William, duke of Normandy, claimed the throne, swearing that Edward had promised William the English throne when Edward died. But on his deathbed, Edward named Harold of Wessex king, while two other contenders, Harold Hardrada of Norway and Tostig, earl of Northumbria, also laid their claims. Battle was inevitable.

William was particularly unhappy with Harold of Wessex's claim to the throne. Harold had visited Normandy, sometime between 1064 and the end of 1065, at the insistence of King Edward. In fact, the *Bayeux Tapestry* begins at this point. The tapestry narrates the Norman point of view, so its reliability is uncertain, but according to both the tapestry and other Norman sources, during his stay, Harold recognized William as Edward's heir. Whether Harold did so willingly is debatable—even the tapestry shows Harold being taken prisoner by a vassal of William.

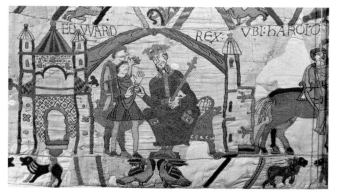

The *Bayeux Tapestry*. 1070–80. Embroidered wool on linen, height 20″. Entire length of fabric, 231′. With special authorization of the city of Bayeux, Musée de la Tapisserie, Bayeux, France/The Bridgeman Art Library. This, the first section of the tapestry, depicts King Edward the Confessor talking to Harold, earl of Wessex, his wife's brother. He is sending Harold on a mission to France, ostensibly to tell William, duke of Normandy, that he will be Edward's successor.

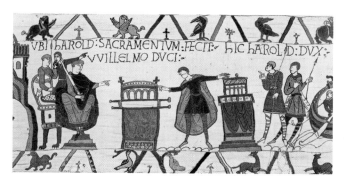

The *Bayeux Tapestry*. 1070–80. With special authorization of the city of Bayeux, Musée de la Tapisserie, Bayeux, France/The Bridgeman Art Library. Harold swears allegiance to William, his right hand on the altar between them, and his left on a chest presumably housing sacred objects from the Cathedral at Bayeux.

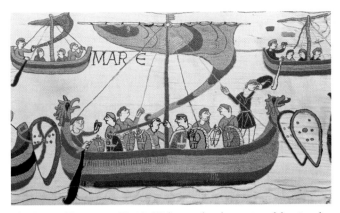

The *Bayeux Tapestry*. 1070–80. With special authorization of the city of Bayeux, Musée de la Tapisserie, Bayeux, France/The Bridgeman Art Library. The Normans sail for England. Note the animal-head prow of the ship, which underscores the Norse origins of the Normans.

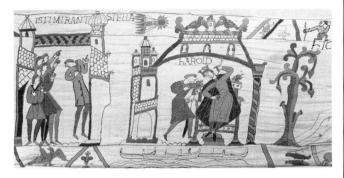

The *Bayeux Tapestry*. 1070–80. With special authorization of the city of Bayeux, Musée de la Tapisserie, Bayeux, France/The Bridgeman Art Library. Having returned to England just before Edward's death and having assumed the throne, Harold is disturbed by the arrival of a comet with a fiery tail, visible in the top border.

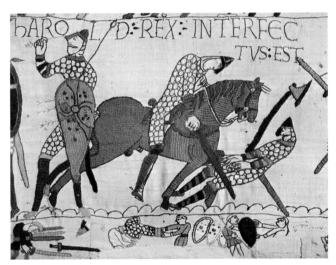

The *Bayeux Tapestry*. 1070–80. With special authorization of the city of Bayeux, Musée de la Tapisserie, Bayeux, France/The Bridgeman Art Library. Harold, with the green shield, receives an arrow to the eye at the Battle of Hastings. Immediately to the right, a Norman soldier slays him. Note the soldiers stripping armor from the dead in the bottom border.

Harold was back in England before Edward died on January 5, 1066, and he became king, abrogating whatever oath he may have sworn to William. The tapestry shows him in February with Halley's Comet in the sky—interpreted by the Anglo-Saxons as a portent of disaster and resulting, the tapestry implies, from his having broken his oath. Ghost ships, perhaps from a dream, decorate the border below the troubled king, foreshadowing the invasion to come.

As William prepared to invade England from the south, Harold Hardrada and the Norwegians prepared to press their own claims from the north. The weather determined the course of battle. Strong northerly winds kept William docked in Normandy, but the same winds favored the Norwegians, who soon landed on the north coast. Harold met them at Stamford Bridge, near York, on September 25, 1066, and defeated them. By then, the winds had changed, and William sailed from the south, landing in Sussex. Harold turned his troops southward, but exhausted from both battle and the hurried march, they were defeated by William's army at Hastings on October 14, 1066. Harold died in the battle. The embroidery ends with a simple statement—"and the English turned and fled"—as if there is nothing more to say.

For seven centuries, the tapestry was cared for at Bayeux Cathedral, where it was hung round the nave on feast days and special occasions. It escaped destruction in the French Revolution in 1789, and was taken to Paris in the early eighteenth century when Napoleon exhibited it in his own propaganda campaign as he prepared to invade England.

Fig. 12.24 **Two pages from** *The Anglo-Saxon Calendar.* **11th century.** By permission of The British Library. Cotton Tiberius B. V, Part 1. f.3v (left) and f.4v (right). On the left is the calendar page for February showing peasants pruning vines. On the right is the Calendar page for April, showing Anglo-Saxon noblemen at leisure. The two images sum up the relations between rich and poor upon which the *Domesday Book* was based.

Fearing an invasion from Denmark, William I ordered a complete survey of the country so that he could more accurately determine how much tax he could raise to provide a new army. Known as the *Domesday* [DOOMZ-day] (or "Judgment") *Book*, it measured the population of England at about 1 million, with fully three-quarters of the country's wealth resting in the hands of the king and 300 landowners. Two hundred of these were French nobles, and only two were English. The other hundred were archbishops, bishops, and the heads of monasteries. The rest of the land was in the hands of small farmers, and 90 percent of the population worked on the land. Some were freemen, but most owed at least partial allegiance to a local lord. Ten percent of the people were serfs, who owned no land at all. The *Domesday Book* gives us a remarkable view of medieval society and of the great gulf between rich and poor upon which it was based (Fig. **12.24**).

READINGS

READING 12.5

Hildegard of Bingen, *Scivias*

Hildegaard of Bingen's remarkable Scivias *("Know the Ways of the Lord") is a compilation of her visions and her analyses of them. The following is her vision of the devil. After describing her vision, she analyzes it line by line, and in so doing creates a vision of Hell sufficient to frighten any soul into accepting a Christian calling. Such visions of the devil would become commonplace in the art of her time (see the next chapter), but hers is one of the earliest and most powerful presentations.*

Then I saw a burning light, as large and as high as a mountain, divided at its summit as if into many tongues. And there stood in the presence of this light a multitude of white-clad people, before whom what seemed like a screen of translucent crystal had been placed, reaching from their breasts to their feet. And before that multitude, as if in a road, there lay on its back a monster shaped like a worm, wondrously large and long, which aroused an indescribable sense of horror and rage. On its left stood a kind of market-place, which displayed human wealth and worldly delights and various sorts of merchandise; and some people were running through it very fast and not buying anything, while others were walking slowly and stopping both to sell and to buy. Now that worm was black and bristly, covered with ulcers and pustules, and it was divided into five regions from the head down through the belly to its feet, like stripes. One was green, one white, one red, one yellow and one black; and they were full of deadly poison. But its head had been so crushed that the left side of its jawbone was dislocated. Its eyes were bloody on the surface and burning within; its ears were round and bristly: its nose and mouth were those of a viper, its hands human, its feet a viper's feet, and its tail short and horrible.

And around its neck a chain was riveted, which also bound its hands and feet and this chain was firmly fastened to a rock in the abyss, confining it so that it could not move about as its wicked will desired. Many flames came forth from its mouth, dividing into four parts: One part ascended to the clouds, another breathed forth among secular people, another among spiritual people, and the last descended into the abyss. And the flame that sought the clouds was opposing the people who wanted to get to Heaven. And I saw three groups of these. One was close to the clouds, one in the middle space between the clouds and the earth, and one moved along near the earth; and all were shouting repeatedly, "Let us get to Heaven!" But they were whirled hither and thither by that flame; some did not waver, some barely kept their balance and some fell to the earth but then rose again and started toward Heaven. The flame that breathed forth among secular people burned some of them so that they were hideously blackened and others it transfixed so that it could move them

anywhere it wanted. Some escaped from the flame and moved toward those who sought Heaven, reiterating shouts of "O you faithful, give us help!" But others remained transfixed. Meanwhile, the flame that breathed forth among spiritual people concealed them in obscurity; but I saw them in six categories. For some of them were cruelly injured by the flame's fury; but when it could not injure one of them, it burningly breathed on them the deadly poison that flowed from the worm's head to its feet, either green or white or red or yellow or black. But the flame that sought the abyss contained in itself diverse torments for those who had worshiped Satan in place of God, not washed by the font of baptism or knowing the light of truth and faith. And I saw sharp arrows whistling loudly from its mouth, and black smoke exhaling from its breast, and a burning fluid boiling up from its loins, and a hot whirlwind blowing from its navel, and the uncleanness of frogs issuing from its bowels; all of which affected human beings with grave disquiet. And the hideous and foul-smelling vapor that came out of it infected many people with its own perversity. But behold, a great multitude of people came, shining brightly; they forcefully trod the worm underfoot and severely tormented it, but could not be injured by its flames or its poison. And I heard again the voice from Heaven, saying to me . . . :

3. The deceptions of the Devil lie in the path humans take in this world

And before that multitude, as if in a road, there lies on its back a monster shaped like a worm, wondrously large and long. This means that the ancient serpent is well-known to humanity in the course of the pilgrimage of the good and the bad through the world, not in that visible form but in its inner meaning. Its mouth is gaping upward in order to pull down by deception those who are tending toward the celestial regions; but it is lying down, because the Son of God destroyed so much of its strength that it cannot stand up. **And it arouses an indescribable sense of horror and rage**; for the mental capacity of mortal humans is insufficient to understand the manifold variations of its poisonous fury and malicious exertions.

4. The Devil offers fraudulent riches and delights, and some buy them

On its left stands a kind of marketplace, which displays human wealth and worldly delights and various sorts of merchandise. For the left hand of the destroyer signifies death, and there is seen a marketplace composed of Death's evil works: pride and vainglory in corruptible riches, licentiousness and lust for transitory pleasures, and trafficking in all kinds of earthly desires. Thus those who would be terrified by the horror of the Devil if they met it openly are deceived by these things; they are lightly offered persuasions to vice as a merchant displays his diverse wares to people, and delighted by the display so that they buy what is offered. So the Devil offers humanity his lying arts; and those who desire them buy them. How? They throw away a good conscience as if selling it, and they collect deadly wounds in their souls as if buying them. . . .

6. The Devil labors to deceive the five senses of humanity

But you see that **that worm is black and gristly, covered with ulcers and pustules**. This shows that the ancient serpent is full of the darkness of black betrayal, and the bristles of concealed deception, and the ulcers of impure pollution, and the pustules of repressed fury. **And it is divided into five sections from the head down through the belly to its feet, like stripes;** for from the time of his first deception when he tried to put himself forward until the final time when his madness will end, he does not cease to inspire the five human senses with the desire for vices. Simulating a deceitful rectitude he draws people to the downward slopes of his unclean arts. One is green, one white, one red, one yellow, and one black and they are full of deadly poison. The green indicates world-ly melancholy; the white, improper irreverence; the red, deceptive glory; the yellow, biting envy; and the black, shameful deceit, with all other perversities that bring death to the souls of those who consent to them. . . .

8. What the eyes and ears and nostrils of the serpent signify

Its eyes are bloody on the surface and burning within; because his wicked intent outwardly inflicts harm on human bodies and inwardly drives a fiery dart into their souls. **Its ears are round and bristly**; for the bristles of his arts pierce a person all around, so that if he finds anything that is his in that person, he may quickly throw him down. **Its nose and mouth are those of a viper**; for he shows people unbridled and vile behavior, through which transfixing them with many vices, he may cruelly slay them.

9. Its hands and feet and tail and what they signify

Its hands are human, for he practices his arts in human deeds; its feet a viper's feet, because he ceaselessly ambushes people when they are journeying and inflicts devilish lacerations on them; **and its tail short and horrible**, for it signifies his power in the short but most evil time of the son of perdition, whose desire to run wild exceeds his power to do it. ■

Reading Questions

In her third point of analysis, Hildegard says that "the mental capacity of mortal humans is insufficient to understand the manifold variations of its poisonous fury and malicious exertions." What is her rhetorical strategy here? In other words, why does she say this, and what effect does she think it will have on the reader?

Summary

■ **Sutton Hoo and Anglo-Saxon Culture** The burial mound at Sutton Hoo has revealed more about the art and culture of Anglo-Saxon England than any other archeological site. Buried in the mound was a lord or chief to whom his followers owed absolute loyalty. The Anglo-Saxon ruler exchanged a tenant's use of a fief for his protection and payment in goods or produce. The wealth extracted from such arrangements accounts for the treasures discovered in the Sutton Hoo burial mound, with their distinctive animal style designs. The epic poem *Beowulf*, written in Old English, also helps us to understand Anglo-Saxon culture. An English poem set in Scandinavia, its hero, Beowulf, is the consummate leader, exhibiting the courage and loyalty to his vassals that define the warrior's world in the Middle Ages. The poem teaches its audience that power, strength, fame, and life itself are transitory—a theme consonant with Christian values, but by no means necessarily Christian.

■ **The Merging of Pagan and Christian Styles** Christianity survived the end of Roman control over Britain only in the farthest reaches of the British islands—in Cornwall, Wales, and Ireland. But in 597, Pope Gregory I sent a mission to England, headed by the Benedictine prior Augustine, to convert the pagan Anglo-Saxons. The pope urged Augustine not to try to eliminate pagan traditions but to incorporate them into Christian practice. Thus, in the Christian manuscripts produced in the region's monasteries, the visual tradition of Anglo-Saxon animal style merged with the Christian textual tradition.

■ **Carolingian Culture** Charlemagne converted even those who were Arian to Roman Catholicism as he gained control of most of the continent, creating what would later be known as the Holy Roman Empire. Charlemagne's exploits were celebrated in many poems, chief among them the *Song of Roland*, which embodies the values of feudalism, celebrating courage and loyalty to one's ruler above all else.

The poem is one of the earliest manifestations of feudalism's chivalric code.

In keeping with his stature as head of the largest feudal empire since Roman times, Charlemagne also created a magnificent new capital in Aachen. The scholars there, chief among them Alcuin of York, were charged with creating a curriculum that would promote literacy throughout the empire, an idea made possible by the creation of Carolingian miniscule, a form of writing characterized by clearly formed letters and delineated spaces between words. But arguably the most important institution of the Carolingian era was the monastery. Charlemagne imposed the Rule of St. Benedict on all monasteries and created what he believed to be the ideal monastery at St. Gall. Music played an important role in monastic life, where plainsong or plainchant, later known as Gregorian chant, was sung daily in the Mass. Women had a significant role in monastic life. Foremost among them was Hildegard of Bingen, a theologian, philosopher, medical authority, painter, poet, playwright, and musician.

■ **The Ottonian Empire** Although the Ottonian Empire was a conscious reinvention of the Carolingian dream, unifying church and state in a single administrative and political bureaucracy, it was built on the exercise of power, not consensus, and it eventually collapsed in the eleventh century. The art created under the five Ottonian rulers is intensely emotional and expressive.

■ **Capetian France and the Norman Conquest** The Frankish territory to the west of the Ottonian Empire was invaded by the Normans, Viking warriors from Scandinavia, in the tenth century. As illustrated in the famous Bayeux Tapestry, the Normans subsequently also invaded England from their stronghold in northern France, defeating the English at the Battle of Hastings on October 14, 1066. England and northern France thus became one country, with one king, William I, the Conqueror.

Glossary

a capella Without instrumental accompaniment.

animal interlace A type of decorative motif featuring elongated animals interlaced into serpentine ribbons.

animal style A style of decoration featuring symmetrical design, interlaced organic and geometric shapes, and animal motifs.

carpet page A descriptive term that refers to the resemblance between highly decorated pages of medieval manuscripts and Turkish or Islamic carpets.

chanson de geste A type of French medieval epic poem; literally "song of heroic deeds."

chivalric code The code of conduct for a knight: courage in battle, loyalty to his lord and peers, and courtesy toward women.

choir The part of a church formed by the separation of the apse from the transept crossing.

cloisonné A style of decoration in which strips of gold are set on edge to form small cells, which are filled with colored enamel glass paste and fitted with thin slices of semiprecious stones.

cloister A rectangular courtyard, typically arcaded and dedicated to contemplation and reflection.

Divine Office The duty of daily prayer recited by priests and other religious orders.

feudalism The economic system that prevailed in medieval Europe; it was related to the Roman custom of patronage and was based on land tenure and the relationship between the tenant and the landowner.

fief A piece of land.

Gregorian chant A type of liturgical chant popularized during the time of Charlemagne and still widely used until the twentieth century.

jongleur A professional entertainer or minstrel who performed from court to court.

kenning A compound phrase used in poetry to substitute for the name of a person or thing.

knight A chevalier guided by a strict unwritten code of conduct; see *chivalric code*.

melismatic In later medieval chant, the practice of singing a single syllable to many notes.

monophonic A song in which one or many voices sing a single melodic line with no harmony.

motte and bailey A type of castle consisting of a raised earth mound (motte) and the enclosed courtyard at its base (bailey).

neume A note in traditional Gregorian notation, usually indicated by a small square.

neumatic A simple chant form in which each syllable is sung to two or three notes.

plainchant Plainsong; a liturgical chant.

refectory A dining hall.

scriptorium The hall in which monks worked to copy and decorate biblical texts.

strophic The same music repeated for each stanza of a poem.

syllabic One note per syllable.

westwork An imposing, sometimes monumental entrance of a church made up of two tall towers flanking a multistoried narthex.

Critical Thinking Questions

1. What was the relationship of the Anglo-Saxon lord or chief to his followers and subjects?

2. How does the *Song of Roland* reflect feudal values? How do these values differ from those found in *Beowulf*?

3. What is the Rule of St. Benedict and how did it affect monastic life?

4. What role did music play in Charlemagne's drive to standardize the liturgy?

One of the distinctive features of the monastery at St. Gall (see Figs. 12.17, 12.18) is the side open to the public. As we have noted, in the sixth century Benedict of Nursia had ruled that monasteries should extend hospitality to all visitors, so St. Gall included a hostel, or inn, for housing poorer visitors, as well as a guesthouse for nobility.

Taking this particular edict from the Rule of St. Benedict as its cue, in the early tenth century the Benedictine Abbey at Cluny [KLOO-nee] (Fig. 12.25) in central France began to promote pilgrimage routes to the shrine of St. James at Compostela [kom-puh-STEL-uh] in northwestern Spain. Churches and monasteries under Cluny's control served as hostels for the pilgrims making the journey. Although the pilgrims' ultimate goal was Compostela, where the body of St. James the Greater, one of Christ's 12 apostles, lay at rest, other sacred relics relating to Christian saints were housed in the churches along the way. Pilgrims would visit these sites, worship at them, and, in less spiritual terms, pay for the privilege by leaving donations to the individual monasteries and churches. Cluny's was, in short, the first great foray of European culture into the tourist industry.

Cluny also promoted pilgrimages to Jerusalem, and it played a major role in the Crusades of the late twelfth and early thirteenth centuries. The route to Santiago de Compostela skirted Islamic Spain, and the pilgrimages to the Middle East served to integrate Islamic and Christian traditions as Western artists, poets, and musicians assimilated Islamic models.

Perhaps the most important role of the Clunaic [kloo-NAY-ik] order was its sense of culture as wider than local traditions. Its monks preserved and translated classical texts. They rediscovered, particularly, Latin and Roman antecedents. The plan of their church mimicked Old St. Peter's in Rome. They were lovers of knowledge and of beauty (both considered chief attributes of the Almighty), and of classical means of representation. The naturalism we associate with Greek and Roman art gradually began to find favor once again.

Because of their sense of mission to the larger public, the Clunaic monks began to share the knowledge obtained in their isolated studies with the populace. Monasteries directly inspired by the Clunaic orders would soon found universities across Europe, and a general level of learning unheard of since antiquity would quickly follow. Cluny was dismantled for building materials during the French Revolution in 1789, when the French people turned against the monarchy and the clergy. All that remains of the church are the south arm of the main transept with the stair turret and tower, and a few fragments of transept chapels. ■

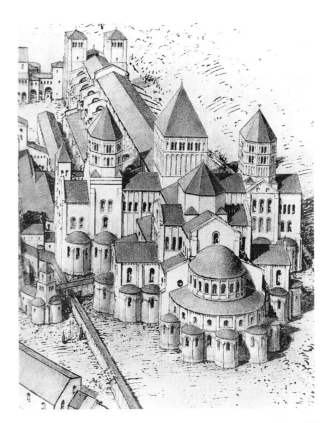

Fig. 12.25 Reconstruction drawing of the Abbey Church (Cluny III), Cluny, Burgundy, France. 1088–1130. View from the east (after Conant). By the middle of the 10th century, under the leadership of Abbot Odo (926–46), the monastery at Cluny exerted influence over 1,500 cloisters in Europe. By 1088, when Abbot Hugh de Semur began building his new church, Cluny III, even the Pope embraced its leadership.

13 The Romanesque Tradition

Pilgrimage and Crusade

❝ *I've lately been in great distress over a knight that once was mine, and I want it known for all eternity how I loved him to excess.* ❞

Beatriz de Dia

◄ **Fig. 13.1 Abbey Church of Sainte-Foy, Conques, Auvergne, France. ca. 1050–1120.** The oldest of the pilgrimage churches, Sainte-Foy was the second church on the route to Santiago de Compostela that began at Le Puy. Most of the pilgrimage churches were controlled by the Benedictine monastery at Cluny. Its liturgical practices—especially its music— spread along the routes. The monastery was also instrumental in supporting the Crusades to recapture Jerusalem from Islam.

THE ABBEY CHURCH OF SAINTE-FOY [SANT FWAH] AT

Conques [cohnk], France (Fig. **13.1**) is the oldest of the so-called pilgrimage churches that arose in France and Spain from 1050 to 1200. Its architecture and decoration define a period that art historians came to call the **Romanesque**

[roh-mun-ESK], "in the manner of the Romans," because it incorporated elements of Roman architectural tradition. The basilica tradition that extends back to the Roman Basilica Nuova (see Figs. 9.13, 9.14) became the model for the Romanesque church floor plan, although the wooden ceilings of churches like Old

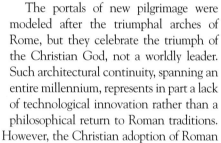

Saint Peter's (see Figs. 9.16, 9.17) were replaced by much more fire-resistant barrel vaults (see chapter 8 and below).

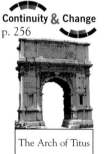

Continuity & Change
p. 256

The Arch of Titus

The portals of new pilgrimage were modeled after the triumphal arches of Rome, but they celebrate the triumph of the Christian God, not a worldly leader. Such architectural continuity, spanning an entire millennium, represents in part a lack of technological innovation rather than a philosophical return to Roman traditions. However, the Christian adoption of Roman architectural styles also suggests the Christian rejection of its Judaic heritage—the Temple and the synagogue—as well as a growing identification with the Greco-Roman West. As this identification took hold, religious fervor came to define the age.

Throughout the Middle Ages, it was customary for Christians to do penance by going on a religious pilgrimage. Part of the reason seems to have been the increasing urbanization of Europe, and with it, worsening hygienic conditions that spread disease. Believing that disease was related to sinfulness, pilgrims sought to atone for their sins, saving themselves from sickness and contagion on earth and perpetual damnation in the afterlife.

The pilgrimage sites were quick to capitalize on the sometimes massive visitations. In essence, they advertised the miraculous benefits that pilgrims might realize by visiting their towns, and reaped the economic rewards. Political and religious motives also played a role. The pilgrimage to Mecca had played an important role in Islamic tradition, and the economic benefits realized by that relatively remote city on the Arabian peninsula were not lost on Rome. But more important, the religious value of a Christian pilgrimage to Jerusalem—the most difficult and hence potentially most rewarding of Christian pilgrimages—demanded that the Western church eliminate Muslim control of the region, a prospect the Church frankly relished. By 1100, thousands of pilgrims annually were making their way to Jerusalem, which

Christian forces retook in 1099 in the First Crusade; to Rome, where the remains of Saints Peter and Paul were housed; and to Santiago de Compostela [san-tee-AH-go day kom-poh-STEL-uh], in the northwest corner of modern Spain, where the body of the apostle Saint James the Greater lay at rest (Map **13.1**). Perhaps because Santiago de Compostela was closer to Northern Europeans than the other two and had also developed a reputation for repeated miracles, it became the most popular destination. By the mid-twelfth century, a *Pilgrim's Guide to Santiago de Compostela* had appeared. A widely circulated manuscript probably written in Latin by monks in southern France, it describes and illustrates the towns and monuments on the major pilgrimage routes through France and Spain.

Fig. 13.2 Reliquary effigy of Sainte-Foy, made in the Auvergne region, France, for the Abbey Church of Sainte-Foy, Conques, mostly 983–1013 with later additions. Gold and silver over a wooden core, studded with precious stones and cameos, height 34″. Church Treasury, Conques. This jewel encrusted reliquary survived because monks hid it in the wall of the church when Protestants burned the abbey in 1568. It was not discovered until restoration of the church in the 1860s.

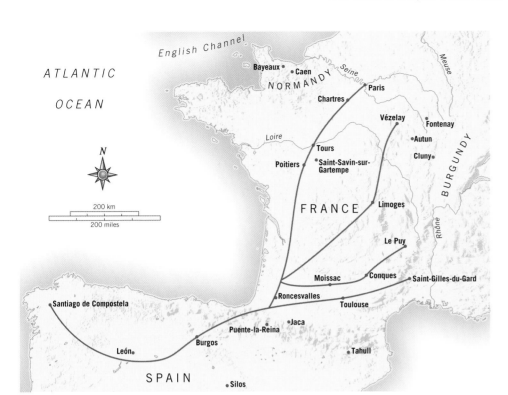

Map 13.1 The Pilgrimage Routes.

Specific routes soon developed that allowed pilgrims to visit other sacred sites along the way. These sites housed the **relics**—bones, clothing, or other possessions—of Christian saints and martyrs. Relics arrived, virtually by the boatload, from the Middle East, where Crusaders, fighting the Muslims for control of Jerusalem and other sites sacred to Christianity, purchased them for resale in the West. The resale of these artifacts, whose authenticity was often questionable, helped to finance the Crusades. What was reputed to be the tunic that the Virgin Mary wore when she gave birth to Christ was housed at Chartres [shart]. At Vézelay [VAYZ-lay], the starting point of one of the three routes to Santiago de Compostela (see Map 13.1), pilgrims could pray to what were asserted to be the bones of Mary Magdalene. Pilgrims believed that the saints would perform miracles and cure diseases.

The proliferation of pilgrimage destinations suggests that people in the Middle Ages came to understand that culture might be centered in multiple places, each competing with the others for attention. This chapter outlines how decoration of the pilgrimage churches became an increasingly important priority of the monastic orders that controlled them. These decorative programs were accompanied by increasingly elaborate liturgy that included choral music designed to move the faithful to an ever-greater piety—and perhaps generosity. Religious zeal defined the era, highlighted by the call to recapture Jerusalem from Muslim control and the military Crusades to the Middle East that followed.

The Crusades' success depended upon the feudal values of courage, heroism, and self-sacrifice. But the Crusaders' actions were sometimes anything but noble, as they resorted to unbridled brutality and greed. As we will see, this tension between religious and feudal idealism on the one hand, and the sometimes base realities of real human actions on the

other, deeply informs the literature of the era. In the literature of courtly love, the spiritual side of love, though often invoked, was often realized in purely physical terms, and a knight's loyalty to his lord was challenged by his desire to commit adultery with his lord's wife. It was an age of both deeply felt spiritual yearnings and deeply held secular habits.

The Foundations of Faith: Pilgrimage Churches

The Abbey Church housed the relics of Saint Foy ("Saint Faith" in English), a child who was martyred in 303 for refusing to worship pagan gods. Her skull was contained in an elaborate jeweled **reliquary** (Fig. 13.2), a container used to protect and display sacred relics. It stood in the choir of the church, where pilgrims could view it from the ambulatory (Fig. 13.3). The head of the reliquary, which is disproportionately large, was salvaged from a late Roman wooden mask covered with gold foil. Many of the precious stones that decorate the reliquary were gifts from pilgrims. The actual skull of the saint was housed in a recess carved into the back of the reliquary, and below it, on the back of her throne, was an engraving of the Crucifixion, indicating the connection between Saint Foy's martyrdom and Christ's.

Like other pilgrimage churches, Sainte-Foy was constructed to accommodate large numbers of visitors. Its west portal was large and opened directly into the nave (Fig. 13.4). Wide aisles skirted the nave and continued around the transept, choir, and apse, creating the ambulatory. A second-story gallery was built over the side aisles; it both accommodated still more people and served structurally to support the extra weight of the arched stone ceilings.

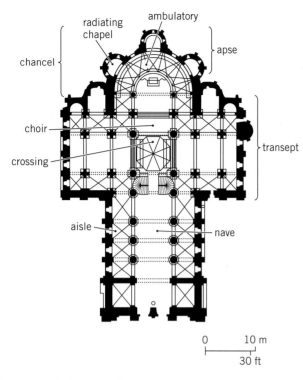

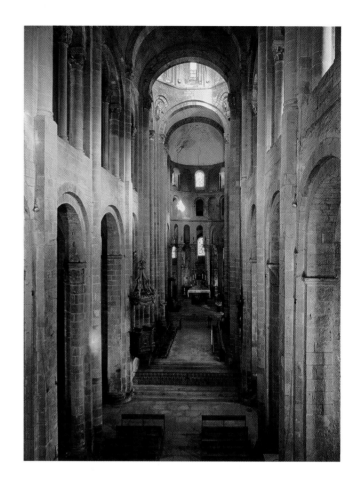

Figs. 13.3 and 13.4 Floor plan and interior of the nave, Sainte-Foy, Conques. ca. 1050–1120. Some of the innovations of the Romanesque cathedral can be explained, at least in part, by the need to allow pilgrims to pass through the church without disturbing the monks as they attended to their affairs at the main altar in the choir. Thus, an ambulatory extended around the transept and the apse where pilgrims could walk.

The **barrel vault** that rises above the nave of Sainte-Foy is one of the distinctive features of Romanesque architecture. As we saw in Chapter 8, barrel vaults are elongated arched masonry structures spanning an interior space and shaped like a half cylinder. (See *Materials and Techniques*, page 255, chapter 8.) In Romanesque churches, the space created by such vaults was designed to raise the worshiping pilgrims' eyes and thus direct their thoughts to heaven. An especially interesting example of this effect can be seen in the barrel vault of the Romanesque church of Sainte-Madeleine [sant-mad-LEN] at Vézelay (Fig. **13.5**). As at Sainte-Foy, the nave is divided into sections, called **bays**, by the round arches of the vault. But at Vézelay, these arches are constructed of alternating pink and gray stone voussoirs [voo-SWAR], the wedge-shaped stones that form the arch, quarried locally. The effect is similar to the interior of the Great Mosque at Córdoba [KORD-uh-buh] (see Fig. 11.13), built 300 years earlier. This suggests that Romanesque architects borrowed routinely from Islam, and, in fact, evidence of Islamic influence can be seen throughout southwest and central France. The effect of the alternating voussoirs at Vézeley, as at Córdoba, is to lighten the visual impact of the arches, giving them an almost airy height.

Pilgrimage churches were designed to appeal to visitors' emotions. The pilgrimage churches evidently competed with

Continuity & Change
p. 354

Great Mosque of Córdoba

one another in decorating their basilicas. Writing in the eleventh century, the French Benedictine monk Raoul Glaber [rah-ool glay-bur] noted, "throughout the world, especially in Italy and Gaul, a rebuilding of church basilicas [is occurring], . . . each Christian people striving against the others to erect nobler ones." The portals to the churches were of special importance. Not only was the portal the first thing the visitor would see; it also marked the boundary between secular and sacred space. The space created under the portal arch, called the **tympanum** [TIM-puh-num], was filled with sculptural relief. At Vézelay, where the tympanum over the main portal is not on the facade but in the narthex, Christ sits enthroned on the central axis of the tympanum relief, and rays of spiritual illumination from the Holy Spirit flow from his hands to the heads of the 12 apostles (his left hand has been broken off). Each apostle holds a book of Gospels, and Christ's blessing would be interpreted by viewers as giving the apostles the power to preach, heal the sick, drive out devils, and spread the Gospel.

All of the elements of Romanesque portals were equally subject to decorative relief (see diagram, Fig. **13.6**): the lintel, **jambs** (the vertical elements on both sides of door supporting the lintel or arch), **trumeau** [troo-MOH] (the column or post in the middle of a large door supporting the lintel), and the **archivolt** [AR-ki-volt] (the curved molding formed by the voussoirs making up the arch). The tympanum of Sainte-Foy at Conques depicts *The Last Judgment* (Figs. **13.7**, **13.8**). At the center of the tympanum, Christ raises his right arm to welcome those who are saved. His lowered left hand points to hell, the

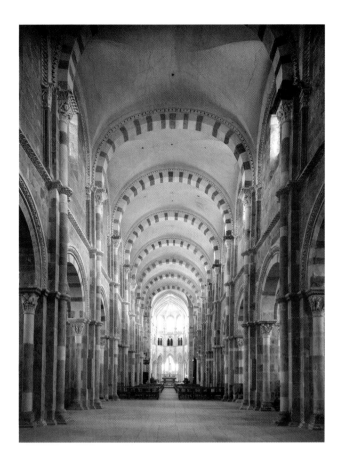

Fig. 13.5 Interior of the nave, Church of Sainte-Madeleine, Vézelay, France. ca. 1089–1206. The nave of this church is extremely long, nearly 200 feet, giving pilgrims a sense of ever-increasing majesty as they moved from the portal at the western, "dark" end of the church toward the choir and reliquary at the eastern end, toward the light of salvation. Vézeley was extensively restored in the nineteenth century.

who cheats by pressing his forefinger onto the pan, nevertheless failing to overcome the goodness of the soul in question.

The lintel is divided into two parts: on the left, heaven, and on the right, hell. The two are divided by a partition: An angel welcomes the saved, while on the other side, a demon armed with a bludgeon shoves the damned into hell's monstrous jaws. Situated frontally under the arches of heaven, the saved give the appearance of order and serenity, while all is confusion and chaos on hell's side. Satan stands in the center of the right lintel, presiding over an astonishing array of

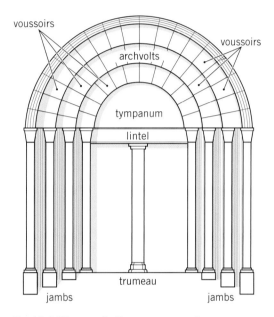

Fig. 13.6 Diagram of a Romanesque portal.

destination of the damned. He sits enthroned in a **mandorla**, an almond-shaped oval of light signifying divinity, a motif imported to the Western world from the Far East, through Byzantium (see Fig. 10.7), and one widely used by Romanesque artists. Below Christ's feet, the weighing of souls is depicted as a contest between the archangel Michael and a desperate demon

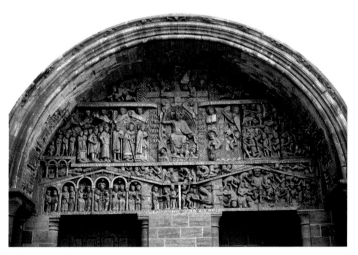

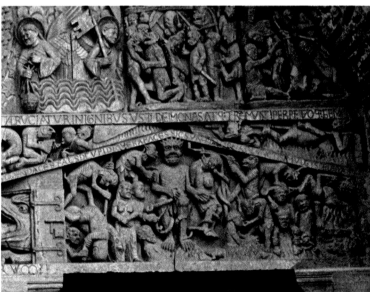

Figs. 13.7 and 13.8 *Last Judgment*, tympanum and detail of west portal, Sainte-Foy, Conques. ca. 1065. This depiction of the Last Judgment uses composition subtly and effectively to distinguish the saved from the damned. To Christ's left, the action is chaotic—figures twist and turn in often unpredictable directions. To his right, on the other hand, everyone stands upright under orderly arrangements of arches.

tortures. On Satan's left, a figure symbolizing Pride is thrown from his high horse, stabbed through with a pitchfork. Next to them, a bare-breasted adulteress and her lover await Satan's wrath. A figure symbolizing Greed is hung from on high with his purse round the neck and a toad at his feet. A demon tears the tongue out of Slander. In the small triangular space at the right above Satan, two fiendish-looking rabbits roast a poacher on a spit. In the corresponding triangular space to the left, a devil devours the brain of a damned soul who commits suicide by plunging a knife into his throat. Close by, another hunchbacked devil has just grabbed the harp of a damned soul and tears his tongue with a hook. Such images were designed to move the pilgrim to the right hand of Christ, not the left.

These themes are the focus of perhaps the most famous sermon of the Middle Ages, *On the Misery of the Human Condition*. Pope Innocent III (pope 1198–1216) wrote this tract before his ascension to the papacy; on his election, the Church cardinals unanimously approved it as official Church doctrine. In the sermon, Innocent rails at length on the wretchedness and worthlessness of human beings, their weaknesses, folly, selfishness, vileness, their crimes, and their sins. He describes the human body as putrid in both life and death: "In life, [man] produced dung and vomit; in death he produces rottenness and stench." But perhaps most dramatically, he catalogues the fate that awaits them in hell (**Reading 13.1**):

READING 13.1 **from Pope Innocent III,**
On the Misery of the Human Condition

There shall be weeping and gnashing of teeth, there shall be groaning, wailing, shrieking and flailing of arms and screaming, screeching, and shouting; there shall be fear and trembling, toil and trouble, holocaust and dreadful stench, and everywhere darkness and anguish; there shall be asperity, cruelty, calamity, poverty, distress, and utter wretchedness; they will feel an oblivion of loneliness and namelessness; there shall be twistings and piercings, bitterness, terror, hunger and thirst, cold and hot, brimstone and fire burning, forever and ever world without end. . . .

Such imagery is meant to strike terror into the soul of listeners by serving as a ***memento mori*** [mi-MENT-oh MORE-ee], a "reminder of death." Faced with such prospects, pilgrims were willing to endure the physical hardship and considerable danger their journeys entailed. Some brought great sums of money with them—gold, silver, jewelry, at least enough money to pay for their lodging and meals. If they inaugurated a new economy of hospitality in their travels, they also invited larceny, even murder, and bandits plagued the pilgrimage routes.

Cluny and the Monastic Tradition

Most of the Romanesque pilgrimage churches were controlled by the Abbey of Cluny. Like Charlemagne's Saint-Gall (see Figs. 12.17, 12.18), Cluny, founded in about 910, was a reformed Benedictine monastery. The Cluniac order enjoyed a special status in the Church hierarchy, reporting directly to the pope and bypassing all feudal or ecclesiastic control. No secular ruler could exercise any control over the monastery (the origin of our modern insistence on the separation of Church and State). Furthermore, the Cluniac order insisted on the celibacy of its monks and nuns—the Church was to be their only lord and spouse. Celibacy was not the rule elsewhere, and was not officially imposed on Catholic priests until 1139. Even then, Cluny's abbot was among the most powerful men in Europe; Abbot Hugh de Semur, who ruled the abbey from 1049 to 1109, was the most influential of these. In 1088, Hugh began work on a new church for the abbey, supported financially by King Alfonso VI of León [lay-OHN] and Castile [kah-STEEL], in northern Spain. Known as Cluny III (Fig. **13.9**, and see Fig. 12.25) because it was the third church built on the site, it was described by a contemporary as "shining on the earth like a second sun." Today only a portion of its south transept and tower remain—the rest was destroyed in the late eighteenth century by French revolutionaries.

The entire arrangement reflects the ideal Carolingian monastery at Saint-Gall. Originally, the barrel-vaulted ceiling of Cluny III soared to a height of nearly 100 feet. It had a five-aisled nave and a double transept. From the portal to the end of the apse, the interior space stretched 415 feet—twice as long as Vézelay's impressive nave. The interior of the church was richly decorated. The floor was paved with mosaic, and an elaborate sculpture scheme, most of which was painted in brilliant colors, lined the walls. Over 1,200 carved capitals topped the interior columns. Of these, some of the most interesting crowned a semicircular group surrounding the high altar, among them a pair that depicts the eight tones of the sacred psalmody (Fig. **13.10**). They indicate the importance of the liturgy to the Cluniac order and the centrality of music to that liturgy. The rich decoration, the soaring space of the stone architecture (which naturally enhanced the sound of the monks' chants), and music itself showed the faithful, according to the monk Theophilus, writing in the first decades of the twelfth century, "something of the likeness of the paradise of God."

Choral Music Benedictine monks at Cluny introduced choral music into the liturgy sometime in the first half of the tenth century. Odo of Cluny (879–942), the

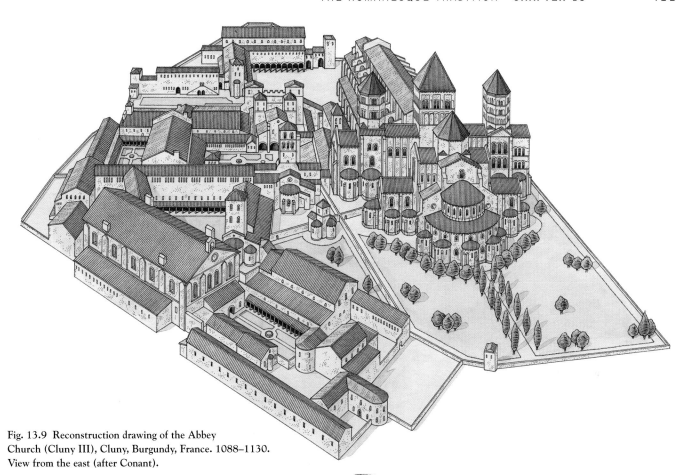

Fig. 13.9 Reconstruction drawing of the Abbey Church (Cluny III), Cluny, Burgundy, France. 1088–1130. View from the east (after Conant).

monastery's second abbot, was an important musical theorist. He is often credited with developing one of the first effective systems of musical notation, used to teach choral music to other monasteries in the Cluniac fold. The method used the letters A through G to name the seven notes of the Western scale. Working from Odo's example, 100 years later Guido [GWEE-doh] of Arezzo [ah-RET-soh] (ca. 990–ca. 1050) introduced the idea of depicting notes on a staff of lines so that the same note always appears on the same line. With this innovation, modern musical notation was born.

Choral music introduces the possibility of **polyphony** [puh-LIF-uh-nee]—two or more lines of melody—as opposed to the monophonic quality of Gregorian chant (see chapter 12). The earliest form of this new polyphonic music was called **organum**. It simply consists of voices singing note-to-note in parallel. Probably the first instance of this would

Fig. 13.10 *The Third Tone of the Sacred Psalmody*, ambulatory capital from the Abbey Church (Cluny III), Cluny, Burgundy, France. 1088–1130. Fariner Museum of the Abbey at Cluny. The inscription reads: "The third [tone] strikes, and represents the resurrection of Christ." The lyre, with its strings stretching upward to the horizontal frame, was thought to resemble the cross.

have been adult monks singing a monophonic chant in parallel with boys' voices singing the same melody at a higher pitch. Soon the second voice began to move in contrary motion to the bass chant (**free organun**), or to add numerous notes to individual syllables above the bass chant (**melismatic organum**). An excellent example of melismatic organum is the "Alleluia, dies sanctificatus" by the composer Léonin, who worked from 1163 to 1190 at Notre-Dame [noh-truh-dahm] Cathedral in Paris (**CD-Track 13.1**). The movement of the two voices could be diagrammed as shown in Figure **13.11**. The lower voices hold unusually long notes, while the upper voices move faster and more freely, creating two independent musical lines. One can only imagine how music like this, performed by as many as 100 voices, might have sounded in Cluny III, which was famous for its acoustics.

Fig. 13.11 Diagram of melismatic organum from Léonin's "Halleluia, dies sanctificatus."

The Cistercian Challenge

Not everyone supported the richness of the Cluniac liturgy and its accompanying music, art, and architecture. From the point of view of Bernard, abbot of Clairvaux [clair-VOH], such artistic excess—in other words, beauty—was an affront to the monastic mission. Chief spokesperson for a new order of Cistercian [sis-TUR-shun] monks, Bernard of Clairvaux (1091–1153) advocated a rigorous application of the rule of Saint Benedict. Cistercians were to be self-sufficient, living off their own cultivation of the land (this proved impossible in practice). They were to live a simple life of self-imposed poverty symbolized by the undyed wool of their habits. And their plain, undecorated churches, perhaps best epitomized by the Abbey Church of Notre-Dame at Fontenay [FOHNT-nay], built 1139–47 (Fig. 13.12), stand in stark contrast to the grandeur and opulence of the rest of Romanesque architecture. Can it be, Bernard asks in his *Apologia for Abbot William*, that the riches of such large and sumptuous churches as Cluny and others are meant to stimulate financial donations to the Church? Is it really true, he asks, that if "their eyes are feasted with relics... their purse strings are loosed"? Bernard is denouncing not beauty itself, but the use of beauty for monetary profit. He also objects to the fact that it distracts attention from prayer (see *Voices*, page 413). The Cistercians belong to a long tradition of thought that challenges the role of art in religion, extending back to the early years of Islam and the iconoclasts in Byzantium (see chapter 10).

The Crusades

On November 25, 1095, at the Council of Clermont [KLER-mohn] (modern Clermont-Ferrand [fuh-RAHND]), Pope Urban II (pope 1088–1099) preached the First Crusade. The pope had received his training as a monk at Cluny, under the direct tutelage of Hugh de Semur. What motivated the First Crusade is difficult to say. We know that throughout Christendom there was a widespread desire to regain free access to Jerusalem, which had been captured by the Arabs in 638. In part, however, the

aim was to bring peace to Europe. Because of the feudal **primogeniture** system, by which the eldest son in a family inherited all of its property, large numbers of aristocratic younger brothers were disinherited and left to their own devices. They had taken to feuding with one another (and with their elder brothers) and raiding other people's land. The Crusades organized these disenfranchised men with the promise of reward, both monetary and spiritual: "Jerusalem," Urban preached, "is the navel of the world; the land is fruitful above all others, like another paradise of delights. . . . Undertake the

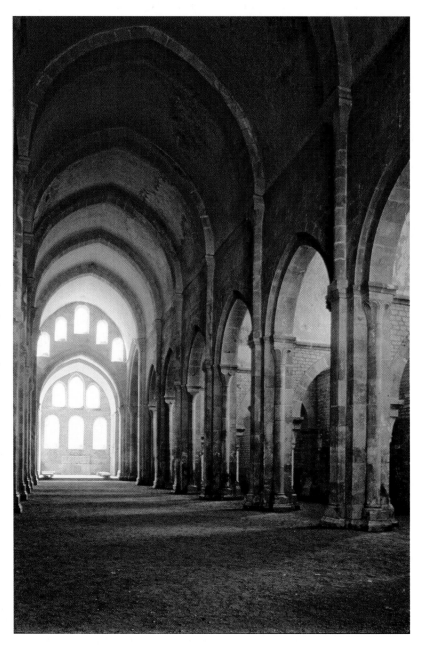

Fig. 13.12 Interior of the nave of the Abbey Church of Notre-Dame, Fontenay, Burgundy, France. 1039–47. Cistercian architecture often employs pointed arches—more stable than round ones and able to sustain greater heights—possibly derived from Islamic models. But the arch is used here to support a squat, single-story nave that speaks tellingly of Cistercian austerity.

journey [also] for the remission of your sins, with the assurance of the imperishable glory of the kingdom of heaven." The pope also presented the Crusades as a Holy War.

> A race from the kingdom of the Persians, an accursed race, a race utterly alienated from God . . . has invaded the lands of the Christians and has depopulated them by the sword, pillage and fire. . . . They destroy the altars, after having defiled them with their uncleanness. . . . When they wish to torture people by a base death, they perforate their navels, and dragging forth the extremity of the intestines, bind it to a stake; then with flogging they lead the victim around until the viscera having gushed forth the victim falls prostrate upon the ground. . . . What shall I say of the abominable rape of the women? . . . On whom therefore is the labor of avenging these wrongs and of recovering this territory, if not upon you?

It was convincing rhetoric. Nearly 100,000 young men signed on.

The First Crusade was thus motivated by several forces: religious zeal, the desire to reduce conflict at home by sending off Europe's feuding aristocrats, defending Christendom from barbarity, the promise of monetary reward otherwise unavailable to the disenfranchised young nobility, and, not least of all, that nobility's own hot blood and sense of adventure. The First Crusade (Fig. **13.13**) was a low point in Christian culture. Late in the year 1098, having destroyed the city of Antioch [AN-tee-ok], the Frankish army (called the *Franj* by the Muslims)

attacked the city of Ma'arra (modern Ma'arrat an Nu'man in Syria). "For three days they put people to the sword," the Arab historian Ibn al-Athïr wrote, "killing more than a hundred thousand people and taking many prisoners." This is undoubtedly an exaggeration, since the city's population was then something under 10,000, but the horror of what happened next somewhat justifies Ibn al-Athïr's numbers. As reported by Frankish chronicler Radulph of Caen, "In Ma'arra our troops boiled pagan adults in cooking pots; they impaled children on spits and devoured them grilled." In an official letter to the pope, the commanders explained: "A terrible famine racked the army in Ma'arra, and placed it in the cruel necessity of feeding itself upon the bodies of the Saracens." An anonymous poet of Ma'arra lamented: "I know not whether my native land be a grazing ground for wild beasts or yet my home!" Descriptions of the slaughter of the citizens of Jerusalem, when the Crusaders finally took that city on July 15, 1099, are no less gruesome. One important account of the First Crusade is the *Deeds of the Franks*, a history written anonymously about 1100–1101 (**Reading 13.2**, page 425).

The Muslim peoples of the Middle East were not the only victims of the Crusades. During the early days of the First Crusade in 1096, Count Emicho of Leiningen, in present-day Germany, making his way down the Rhine to embark for Jerusalem, robbed and murdered all the Jews he could find, killing 800 in Worms and wiping out the entire Jewish population of both Mainz and Cologne. Emicho seems to have been motivated by the need for funds to

Voices

The Silence of the Monastery

The following description of the monastery of Clairvaux (in northeastern France) about 1143 was written by the theologian and mystic, William of Saint-Thierry.

At the first glance as you entered Clairvaux by descending the hill you could see that it was a temple of God; and the still, silent valley bespoke, in the modest simplicity of its buildings. . . . Moreover, in this valley full of men, where no one was permitted to be idle, where one and all were occupied with their allotted tasks, a silence deep as that of night prevailed. The sounds of labor, or the chants of the brethren in the choral service, were the only exceptions. The orderliness of this silence, and the report that went forth concerning it struck such a reverence even into secular persons that they dreaded breaking it. . . . The solitude, also, of the place—between dense forests in a narrow gorge of neighboring hills—in a certain sense recalled the cave of our father St. Benedict, so that while they strove to imitate his life, they also had some similarity to him in their habitation and loneliness. . . .

> "[I]n this valley full of men, where no one was permitted to be idle, where one and all were occupied with their allotted tasks, a silence deep as that of night prevailed."

As regards their manual labor, so patiently and placidly, with such quiet countenances, in such sweet and holy order, do they perform all things, that although they exercise themselves at many works, they never seem moved or burdened in anything, whatever the labor may be. . . . I see them in the garden with hoes, in the meadows with forks or rakes, in the fields with scythes, in the forest with axes. To judge from their outward appearance, their tools, their bad and disordered clothes, they appear a race of fools, without speech or sense. But a true thought in my mind tells me that their life in Christ is hidden in the heavens.

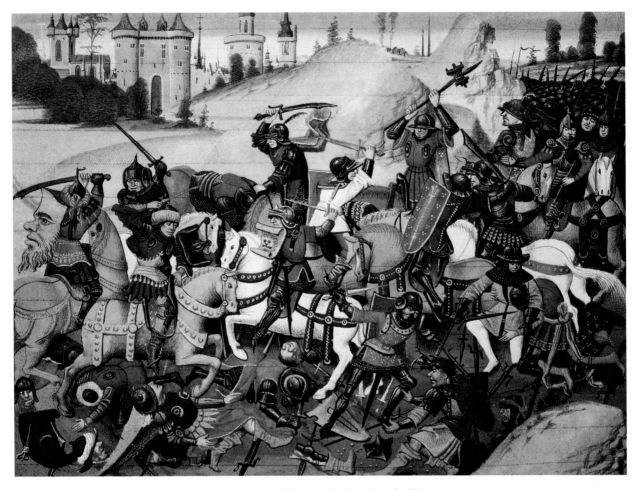

Fig. 13.13 Manuscript Illumination of the *Conquest of Antioch During the First Crusade*. This miniature painting is from a manuscript titled *History of the Emperors*.

support his army, but his was a religious war as well. In his eyes, the Jews, like the Muslims, were the enemies of Christ. Local bishops, to their credit, attempted to stop the carnage, and Bernard of Clairvaux would later preach against the persecution of Jews, but in the Middle East, once Jerusalem was taken, Jews were burned alive or sold into slavery. The small number who survived did so by converting to Christianity.

Saint-Gilles-du-Gard and the Knights Templars

The First Crusade was successful. But by the middle of the eleventh century Islamic armies had recaptured much of the Middle East. So Bernard of Clairvaux, the Cistercian reformer, preached the Second Crusade, which lasted from 1147 to 1149 and ended in defeat for the Church. In 1187, Saladin [SAHL-uh-din], king of Egypt and Syria, recaptured Jerusalem, so a Third Crusade was inaugurated in 1189 (see Map 13.2). Politically and religiously, the first three Crusades were failures. Rather than freeing the Holy Land from Muslim influence, they cemented it more firmly than ever. But they did succeed in stimulating Western

trade with the East. Merchants from Venice, Genoa, and Pisa followed the Crusaders into the region, and soon new wealth, generated by these new markets, flowed into Europe.

Some sense of the wealth that the Crusades brought to Europe is apparent in a twelfth-century townhouse (Fig. **13.14**) that still stands next to the pilgrimage church of Saint-Gilles-du-Gard [san-jeel-dew-gahr], in the delta of the Rhone [rohn] River just west of the ancient Roman city of Arles [arl], the principal embarkation point for the First Crusade and those that were to follow. The townhouse is three stories high, comparable to the church. It is made of the same stone as the church and is decorated with sculptural design elements, including columns separating its windows. It is undoubtedly the house of a merchant who made his fortune from the Crusade by importing goods from the newly conquered Jerusalem and exporting European goods to knights who remained in the Middle East, in castle enclaves such as that at the Krak des Chevaliers (see *Focus*, pages 416–417). The size of the house, rivaling that of the church, suggests the enormous wealth the Crusades brought to Europe.

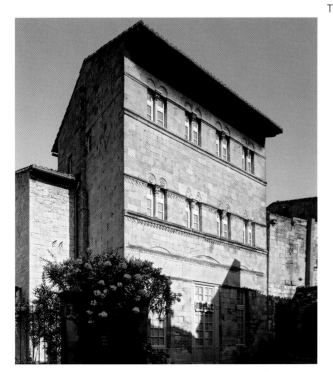

CULTURAL PARALLELS

Pilgrimages, Crusades, and Economic Impacts

From the eleventh through the thirteenth centuries, pilgrimages and crusades strengthened the economy of Western Europe, as valuable merchandise (everything from saints' relics to luxury goods) flowed from Asia Minor to the West. At the same time, wealth flowed into the Muslim world, as pilgrims such as Mansa Moussa of Mali and other African leaders brought large quantities of gold to Cairo, Mecca, and other destinations.

Fig. 13.14 Townhouse at Saint-Gilles-du-Gard, Provence, France, 12th century. In many aspects, this house is comparable to *palazzi*—or palaces—of Renaissance Florence built 300 years later.

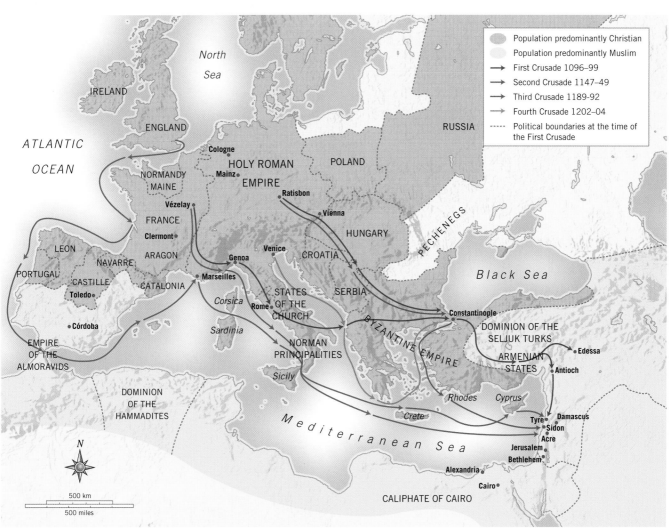

Map 13.2 The Crusades, 1096–1204. The First Crusade was predominantly over land, but the subsequent efforts were all by sea.

Focus

The Medieval Castle and Krak des Chevaliers

O f all the medieval castles of Europe and the Middle East, none survives that is as impressive as Krak des Chevaliers [krahk day shuh-VAHL-yay] in northern Syria. It was first occupied by Crusaders in 1109, and, beginning in 1142, it was occupied by the Knights Hospitaller, whose mission was to care for the sick and wounded. During the Crusades, it was besieged 12 times, finally falling to Berber invaders in 1271.

Krak des Chevaliers was modeled on the castle-fortresses built by the Normans in England and northern France. As we saw in chapter 12, when the Normans arrived in England in the twelfth century, they needed defenses against the Saxons. To provide protection, they built mounds, or mottes, topped with a wooden tower, or keep. At the bottom of the mound was a flat area called the bailey. There, domestic buildings, including kitchens, stables, and servants' quarters, were surrounded by a wooden stockade, and the entire motte and bailey castle was encircled by a trench filled with water, known as the moat.

Beginning with the so-called White Tower in London in 1078, stone castles gradually replaced these wooden fortifications. The sheer weight of the stone keep required that it be built on solid ground. So, unless a natural hill presented itself, the motte (the mound on which the older wooden towers had been built) was eliminated. Now the keep served as the main residence of the lord and included a main hall,

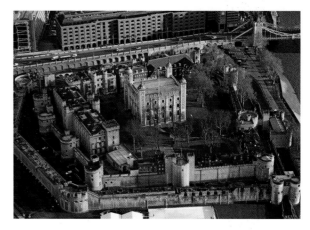

The Tower of London. Construction of the so-called White Tower, or main keep, began in 1078, more to protect William the Conqueror and his royal entourage from Londoners than to fortify London itself. It was the first stone castle in England, made with stone imported from France. When it was finished, in about 1097, it was 90 feet high, the tallest building in London. Richard the Lion-Hearted diverted the River Thames to fill the surrounding moat, which is now grass.

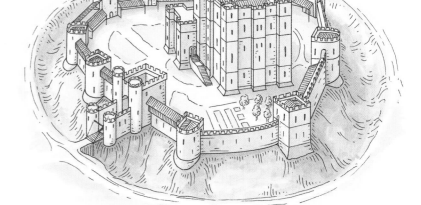

Stone castle. Surrounded by a moat, a trench filled with water, the stone castles that replaced motte and bailey castles were eminently defensible, comparatively immune from fire, and rising as high as 100 feet, imposing symbols of Norman power.

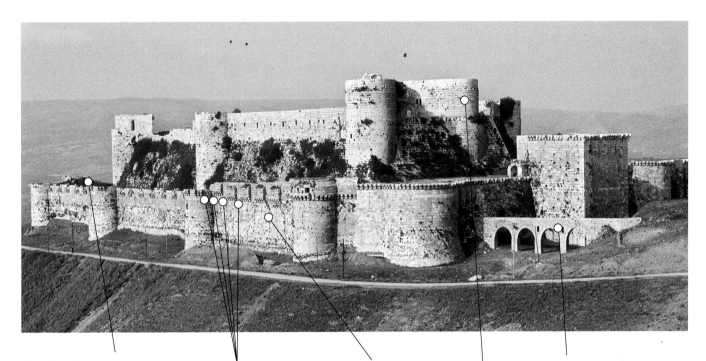

Two lines of defense made the castle virtually impenetrable.

Slotted openings and **crenellations**, or **battlements**, in the sides of the walls are narrow on the wall side, thus limiting the ability of an attacker to penetrate the defense, but they spread wide on the inside, giving archers a good view of enemy forces.

The cantilevered projections at the top of the lower wall are called **machicolation.** They support, protected chambers from which defenders could drop stones through openings in the floor on any attacker attempting to scale the walls.

An aqueduct brought water to the castle. Water was stored in huge cisterns beneath the outer ward. If during siege, the water supply was cut off, the knights could hold out for several months. Similarly, a windmill (now missing) at the top of the highest tower supplied power for grinding corn. Huge storehouses were constructed below the upper towers.

The **upper ward**, was defended by the upper towers and buttresses. Here were the meeting hall, the dormitories, a chapel, and relatively luxurious apartments for the highest-ranking knights.

a chapel, and a dungeon. Workshops, kitchens, and storehouses surrounded the bailey. Crenellations such as those at Krak des Chevaliers became a standard design feature. Most stone castles, including the Tower of London, had a well for fresh water in case of siege, a great advantage over the aqueduct supplying Krak des Chevaliers.

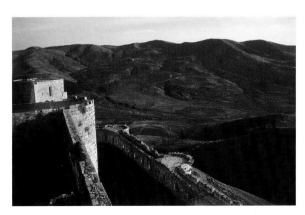

Krak des Chevaliers ("Castle of the Knights"), northern Syria, above the Orantes Valley, defending the Homs Pass (near the border of modern Lebanon). 1109–ca. 1220. This is the best preserved of all the Crusader castles in the Middle East.

To a merchant from Saint-Gilles, the most important of the knightly orders were the Knights Templars, members of a religious military order founded in Jerusalem in the early twelfth century to protect pilgrims and the Church of the Holy Sepulchre [SEP-ul-kur]. Their European headquarters were in Saint-Gilles, while in Jerusalem they occupied a building that adjoined the Dome of the Rock, itself built on the site of the ancient Jewish Temple. They believed that Jerusalem was the center of the universe—a conception that would be reflected in maps of the known world well into the fourteenth century (Fig. **13.15**). It was not long before the Templars became prominent moneylenders and bankers, ensuring the monetary as well as physical well-being of pilgrims. Much of the wealth they accumulated passed back to Saint-Gilles, and the Knights Templars became important patrons of late medieval art and architecture, including a redesign of the Church of the Holy Sepulchre (see Fig. 9.5) and Temple Church in London, built in 1160.

By the time of the Fourth Crusade in 1202, the original religious purpose of the Crusades had been abandoned in all but name. Even the Third Crusade had finally degenerated into political squabbling. Three great kings, Holy Roman Emperor Frederick Barbarossa [bar-buh-ROH-suh] (r. 1152–90), King Richard the Lion-Hearted of England (r. 1189–99), and Philip Augustus, king of France (r. 1179–1223), led the Third Crusade. Barbarossa drowned while fording a small stream in Asia Minor. Richard and Philip reached the edge of Jerusalem but fell to bickering between themselves and failed to take the city. Philip returned to France and attacked Richard's continental territories. Richard was kidnapped and held for ransom by Emperor Henry VI, Barbarossa's successor, forcing the English to raise taxes in order to rescue their king. Popular resentment of these taxes was so great that they helped fuel the revolt against the English monarchy that, in the Magna Carta of 1215, would lead to royal recognition of the citizenry's basic freedoms.

This royal political farce became more intense when Pope Innocent III, who exercised authority over the European monarchs as no pope had since the era of Charlemagne, declared a Fourth Crusade. With Egypt as their destination, some 30,000 Crusaders descended on Venice, but the Venetians were unwilling to transport the vast army without compensation. An agreement was negotiated in which the Crusaders would capture the port of Zara [ZAHR-uh], a Venetian rival on the Adriatic, in return for their passage. That accomplished, they turned on Constantinople, which they proceeded to sack. Venice had manipulated the Crusade to its own advantage. As a result, it became the most powerful city-state in the eastern Mediterranean, a position it would maintain well into the sixteenth century.

The mercenary character of the Crusaders is nowhere more evident than in a contemporary Byzantine description of their sacking of Hagia Sophia (see Fig. 10.1):

The sacred altar [of Saint Sophia], formed of all kinds of precious metals and admired by the whole world, was broken into bits and distributed among the soldiers, as was all the other sacred wealth of so great and infinite splendor. When the sacred vases and utensils of unsurpassable art and grace and rare material, and the fine silver, wrought with gold, which encircled the screen of the tribunal and ambo, of admirable workmanship, and the door and many other ornaments, were to be borne away as booty, mules and saddled horses were led to the very sanctuary of the temple. . . . All places everywhere were filled full of all kinds of crime. Oh, immortal God . . . how great the distress!

In 1204 Constantinople was not an Islamic city, but a Christian one, and the Crusaders were looting and destroying Christian imagery. Even today, much of the art of Byzantium that has survived rests in Venice (see Fig. 10.2). The Fourth Crusade finally revealed, in full force, the economic and political motivation of the entire enterprise.

Eleanor of Aquitaine and the Art of Courtly Love

In the Second Crusade, Eleanor of Aquitaine [ak-wuh-TAIN] (ca. 1122–1204) accompanied her husband, King Louis [LOO-ee] VII, into battle in the Middle East, along with 300 ladies of similar mind, all dressed in armor and carrying lances. Her intent was to help the sick and wounded. The women, most of whom eventually returned safely to Europe, never engaged in battle, but theirs was an act of uncommon personal and social bravery. They were widely chided by contemporary commentators, but their actions underscore the changing role of women in medieval society.

Eleanor was, by all accounts, fiercely independent. She was one of the greatest beauties in Europe and undoubtedly the greatest heiress, being duchess of Aquitaine and Countess of Poitiers [pwah-tee-AY] in her own right. In March 1152, Louis had his marriage to her annulled, technically on grounds that they were related by blood, but in reality because he suspected her of adultery. Eleanor lost no time in reestablishing her position—just eight weeks after the annulment, she married Henry of Anjou [ahn-ZHOO], soon to be King Henry II of England (r. 1154–89). Together they had eight children, including the future English kings Richard the Lion-Hearted and John, but Eleanor's relationship with Henry was a difficult one. Henry cheated on her and treated her abusively, until she finally abandoned England for France in 1170. From Poitiers, in 1173, she encouraged her three surviving sons, Richard, John, and Geoffrey, to rebel against their father. Henry responded by bringing her back to England in 1179 and keeping her under house arrest until his death in 1189.

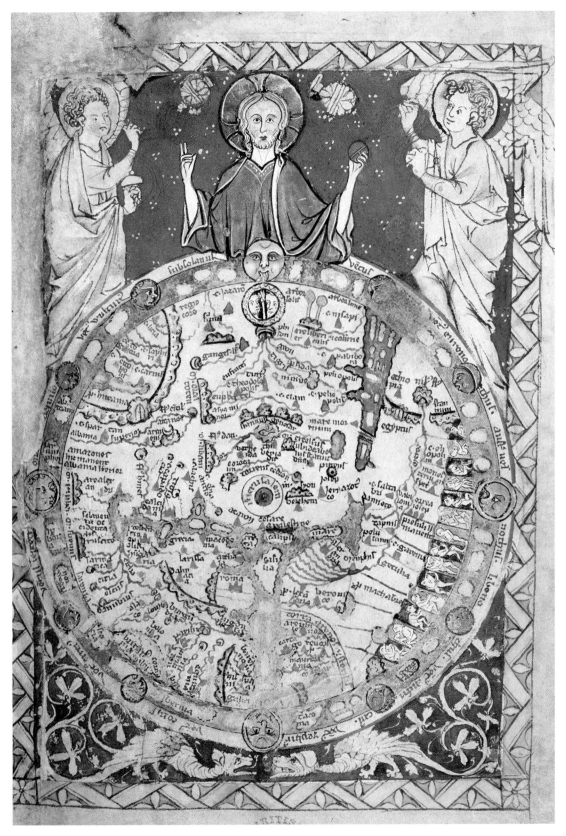

Fig. 13.15 Page with *Map of the World*, from a psalter. ca. 1260. Illumination on parchment, $6\frac{3}{4}'' \times 4\frac{7}{8}''$. British Library, London. In this map the entire world circulates around Jerusalem, with the Dome of the Rock at its center. The top of the map is oriented toward the east, the direction in which the sun rises as Christ, "the Son," rises above the map itself. The bottom is the west, a darkness inhabited by dragons. Europe is at the lower left. The Mediterranean is the green sea extending like a tree through the bottom middle of the map.

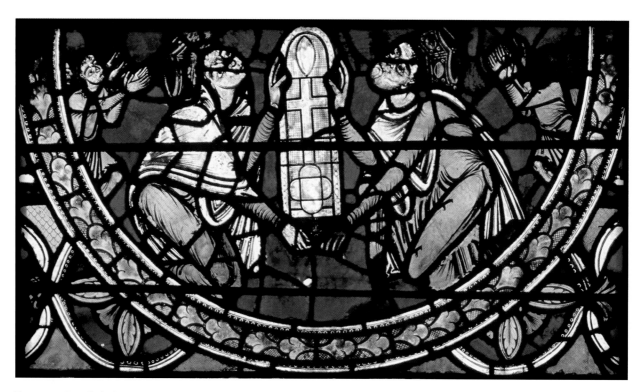

Fig. 13.16 Detail of *The Crucifixion window,* Notre-Dame-la-Grande, Poitiers. ca. 1265–70. Stained glass. At the base of a 31-foot-high window that dates from the later Gothic period and rises over the west portal of the cathedral, Eleanor of Aquitaine and Henry II of England are shown presenting a model of the cathedral to the Virgin Mary above, establishing their status as chief patrons of the church.

In the midst of this stormy relationship, Henry and Eleanor became the two major patrons of the Poitiers Cathedral, Notre-Dame-la-Grande [NOH-truh-dahm-lah-grahnd] (see Fig. 11.19), and their generosity was memorialized a century later at the base of the giant stained-glass window that rises above the central portal door of the church (Fig. **13.16**). Eleanor was also patron of Fontevrault Abbey, north of Poitiers, which became a favorite sanctuary for herself and other noblewomen of the court. She buried both Henry and their son Richard the Lion-Hearted there. Both are interred in sarcophagi bearing their likenesses, as is Eleanor herself (Fig. **13.17**), who probably commissioned her tomb before her death in 1204.

Such **tomb effigies,** or sculptural portraits of the deceased, became extremely popular in the twelfth century. In general, the purpose of the effigy was to speed the deceased's soul on its journey to heaven, since the sculptural likeness was designed to evoke the prayers of those visiting the tomb. But the tomb effigy of the king presents a special case. As medieval scholar Ernst Kantorowicz demonstrated in his classic study *The King's Two Bodies,* that to the medieval mind the king, like everyone else, was possessed of a mortal body. He was a living, breathing human, capable of good judgments and bad. But he was also possessed of a second body, the body politic, symbolized in his office, his *majesty.* This second body is most strikingly illustrated in the French saying *Le roi est mort.* [luh rwah eh

mor] *Vive* [veev] *le roi*—"The king is dead. Long live the king." Whatever happened to the mortal body of the king, the monarchy endured. Thus the royal tomb effigy symbolizes, in a manner startlingly like Egyptian imperial *ka* sculpture (see chapter 3), not only the resurrection of the king (and in Eleanor's case, an almost equally powerful queen), but the continuity and symbolic immortality of the state.

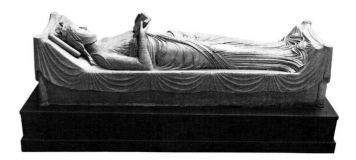

Fig. 13.17 **Effigy tomb of Eleanor of Aquitaine, Fontevrault Abbey, France. ca. 1204.** No image better captures the shift in European culture underway in Eleanor's time from a dependence on oral tradition to a focus on writing and the book.

Troubadour Poetry

On her sarcophagus, Eleanor of Aquitane is depicted, notably, reading a book, and the image underscores two important trends: the increasing number of literate women, especially women of noble birth, in medieval society, and the increasingly "textual" as opposed to "oral" emphasis of the age. This was the time in which the great oral poems of the first millennium—poems like *Beowulf* and *Song of Roland*—were first written down. Furthermore, over 2,600 poems survive as texts composed by the **troubadour** poets of Eleanor's own day. In the decade that she lived at Poitiers, from 1170 to 1179, Eleanor and her daughter by Louis VII, Marie, countess of Champagne, established that city as the center of a secular culture and literary movement that celebrated the art of courtly love.

The troubadour poets, most of them men, though a few were women, usually accompanied themselves on a lyre or lute, and in their poems they can be said to have "invented" romantic love as we know it today—not the feelings and emotions associated with love, but the conventions and vocabulary that we use to describe it. The primary feeling is one of longing, of a knight or nobleman for a woman (usually unattainable because married or of a higher status), or, when the troubadour was a woman—a **trobairitz**—the reverse. Thus, to love is to suffer, to wander aimlessly, unable to concentrate on anything but the mental image of the beloved, to lose one's appetite, to lie sleepless at night—in short, to give up life for a dream. There was, in addition, a quasi-religious aspect to courtly love. Recognizing that he is beset by earthly desires, the lover sees his ability to resist these temptations and rise above his own base humanity as evidence of his spiritual purity. Finally, in the courtly love tradition, the smitten knight or nobleman must be willing to perform any deed to win his lady's favor. In fact, the loyalty that he once conferred upon his lord in the feudal system is, in courtly love, transferred to his lady (who is often, in fact, his lord's wife), as the scenes on a jeweled twelfth-century casket make clear (Fig. **13.18**). If the courtly love tradition reduced women to little more than objects of male desire, in some measure it also allowed them to share in the power enjoyed by their husbands.

The thirteenth-century poet Guiraut Requier [GEAR-oh Reh-KEY-ay] wrote that four ranks of musicians existed. The lowest was the *jongleurs*, musicians who not only sang but also engaged in acrobatics, animal tricks, and other like entertainments. *Minstrels* were next on the ladder, full-time musicians of lesser station than troubadours because they did not write their own material. The *troubadours* composed their own music and lyrics and performed their own songs, most often at court. The highest rank of musician was *doctores de trobar* (*trobar* means "to invent" and is the root of *troubadour*), the most outstanding composers of the day.

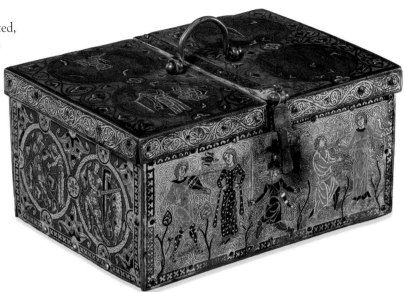

Fig. 13.18 Casket with scenes of courtly love, from Limoges. ca. 1180. Champlevé enamel, $3\frac{5}{8} \times 8\frac{1}{2} \times 6\frac{3}{8}''$. © The Trustees of the British Museum/Art Resource, NY. At the left, a lady listens, rather sternly, as a troubadour poet expresses his love for her. In the center is a knight, sword in one hand and key to the lady's heart in the other. On the right, the knight kneels before the lady, his hands shaped in a heart; a rope around his neck, held by the lady, signifies his fidelity to her.

Bernard de Ventadour One of these *doctores de trobar* was Bernard de Ventadour [VON-tuh-door] (d. 1195?). His poems, composed in honor of Eleanor, became staples of court society. Bernard apparently first met Eleanor at Anjou and accompanied her to England after she became queen. Thus, it is likely that his music influenced English song as well as French. Bernard's work is remarkable in that 41of his surviving songs are musically notated, so that they can be performed today more or less as they were originally. "The Skylark" is typical (**CD-Track 13.2**, Reading 13.3).

READING 13.3 **Bernard de Ventadour, "The Skylark," verses 1–4 and 7**

Now when I see the skylark lift
His wings for joy in dawn's first ray
Then let himself, oblivious, drift
For all his heart is glad and gay,
Ay! such great envies seize my thought
To see the rapture others find,
I marvel that desire does not
Consume away this heart of mine.

CULTURAL PARALLELS

Courtly Love in France and a Heian Court Memoir

While Eleanor of Aquitaine inspired mostly male troubadours to express the romantic nature of courtly love in the twelfth century, 5,000 miles east in Japan, ladies of the Heian court expressed their own perspective in early novels and memoirs such as *The Tale of Genji*.

Alas, I thought I'd grown so wise;
In love I had so much to learn:
I can't control this heart that flies
To her who pays love no return.
Ay! now she steals, through love's sweet theft,
My heart, my self, my world entire;
She steals herself and I am left
Only this longing and desire.

Losing control, I've lost all right
To rule my life; my life's her prize
Since first she showed me true delight
In those bright mirrors, her two eyes.
Ay! once I'd caught myself inside
Her glances, I've been drowned in sighs,
Dying as fair Narcissus died
In streams that mirror captive skies.

Deep in despair, I'll place no trust
In women though I did before;
I've been their champion so it's just
That I renounce them evermore;
When none will lift me from my fall
When she has cast me down in shame,
Now I distrust them, one and all,
I've learned too well they're all the same.

Since she, my Lady, shows no care
To earn my thanks, nor pays Love's rights
Since she'll not hear my constant prayer
And my love yields her no delights,
I say no more; I silent go;
She gives me death; let death reply.
My Lady won't embrace me so
I leave, exiled to pain for aye.

Beatriz de Dia We know of 12 or so *trobairitz*, or woman troubadour poets. Of these, one of the best is Beatriz de Dia, wife of William, count of Poitiers. While married, Beatriz fell in love with a knight and, according to a contemporary chronicler, wrote "many good songs" dedicated to him. Of the four of these late twelfth or early thirteenth century songs that survive, only one, "A chantar" ("Song"), still has its music (**CD-Track 13.3**). Each line of the poem has its

own musical phrase, and, as is true for most secular song, the music is **strophic**—the same music repeats in each stanza.

Beatriz's "Cruel Are the Pains I've Suffered" is an example of the remarkable freedom of expression that a *trobairitz* could enjoy. She clearly regrets her choice to remain true to her husband, and in fact the poem reads as a frank invitation to adultery (**Reading 13.4**):

READING 13.4 **Comtessa de Dia's "Cruel Are the Pains I've Suffered," from *Lark in the Morning: The Verses of the Troubadours***

Cruel are the pains I've suffered
For a certain cavalier
Whom I have had. I declare
I love him—let it be known forever.
But now I see that I was deceived:
When I'm dressed or when I languish
In bed, I suffer a great anguish—
I should have given him my love.

One night I'd like to take my swain
To bed and hug him, wearing no clothes—
I'd give him reason to suppose
He was in heaven, if I deigned
To be his pillow! For I've been more
In love with him than Floris was
With Blanchefleur: my mind, my eyes
I give to him; my life, *mon cor*.*

When will I have you in my power,
Dearest friend, charming and good?
Lying with you one night I would
Kiss you so you could feel my ardor.
I want to have you in my husband's
Place, of that you can rest assured—
Provided you give your solemn word
That you'll obey my every command.

* *Mon cor* means "my heart" and alludes to a popular French romance, *Floris et Blanchefleur*.

That poems such as this survived, let alone that they became well known, underscores the remarkable personal freedom of court women of the age. In fact, we know that aristocratic women, particularly in France, gained many rights during the period, among them the right to hold property, administer estates, and create wills—all at least partially attributable to the need for women to manage their husbands' estates while the men were fighting in the Crusades or other wars. That they also felt free to confess to loving men other than their husbands suggests that Eleanor's notorious relationship with Henry II was hardly unique.

The Romance: Chrétien de Troyes's *Lancelot*

Because the poetry of the courtly love tradition was written in the vernacular—the common language of everyday life—and not in the Latin of the highly educated, a broader audience was able to enjoy it. And longer forms, like the *Song of Roland*, also began to circulate widely, some of them in prose. A remarkable example is the work of Marie de France. Though born in France, she wrote in the English court, and in the late twelfth century she published a collection of over 100 *Fables*, many of which were her own. Marie also published another collection of 12 *Lais* [lay], folktales that deal, in a variety of forms and lengths, with matters of love. A *lai* is technically a short romance that combined supernatural elements and the courtly love tradition; typically they were sung by minstrels, accompanied by a harp or lyre. In *Bisclavret* (see **Reading 13.5,** pages 426–428), she tells the story of a werewolf who is unjustly betrayed by his "loving" wife but ultimately saved by a more loving king.

One of the most popular works of the day, Chrétien de Troyes's [kray-tee-EN duh trwah] *Lancelot*, appeared around 1170. Centered on the adventures of Lancelot, a knight in the court of the legendary King Arthur of Britain, and focusing particularly on his courtly-love-inspired relationship with Guinevere, Arthur's wife, the poem is an example of the **medieval romance**. The term "romance" derives from the Old French term *romans*, which referred to the vernacular, everyday language of the people as opposed to Latin. The medieval romance was designed to entertain a broad audience with stories of adventure and love, while it pretended to be an actual historical account of Charlemagne, King Arthur, or Roman legend.

Lancelot, subtitled *The Knight of the Cart*, opens with a challenge offered to King Arthur and his court on Ascension Day by a knight named Sir Meleagant of Gorre. Sir Meleagant claims to hold many of Arthur's knights in prison, but offers to free them if any knight dares to escort the beautiful Queen Guinevere [GWEN-uh-veer] into the forest and defend her against him. Arthur's brother Kay asks to take on the mission, and Arthur agrees. Knowing Kay to be a poor knight, Sir Gawain [guh-WAIN] and the other knights of the Round Table quickly chase after him into the forest. Too late, they come upon Kay's riderless horse, all that remains of a scene of recent combat. Lancelot takes one of Gawain's horses and charges off after Meleagant, who has abducted Guinevere. Gawain catches up to Lancelot, finds the horse he has lent him dead, the victim of a fierce battle, and then discovers Lancelot on foot, having overtaken a cart of the kind used to take criminals to their execution. The cart is driven by a dwarf, who has told Lancelot that if he boards the cart, he will soon know Guinevere's fate. To board such a cart is a great dishonor, but Lancelot reluctantly agrees, and the next day, Lancelot and Gawain learn the way to Meleagant's kingdom of Gorre from a damsel standing at a fork in the road.

Both forks lead to Gorre, one by way of the perilous Underwater Bridge, the other by the even more perilous Sword Bridge. Gawain takes the first, Lancelot the second. Lancelot faces many challenges and temptations but finally arrives at the Sword Bridge, which he crosses by virtue of his love for Guinevere (Fig. **13.19**). He subsequently defeats Meleagant but spares his life at Guinevere's behest. Guinevere, to his dismay, behaves coldly toward him, offended at his earlier hesitation to enter the cart. He should not have put his own honor before love, she explains. After reuniting with Gawain, who was preparing to take on Meleagant himself in Lancelot's absence, Lancelot overcomes Meleagant once and for all, and he and Guinevere are reconciled. Guinevere agrees to meet Lancelot in Meleagant's castle secretly at night. There he kneels before her, "holding her more dear than the relic of any saint," a scene in which the "religion of love"—so marvelous in its physical joy that the narrator cannot tell of it,

Fig. 13.19 Page with *Lancelot Crossing the Sword Bridge and Guinevere in the Tower*, from *Romance of Lancelot*. ca. 1300. 13 1/2″ × 10″. © The J. Pierpont Morgan Library, New York, 1990. MS 806 f. 166. Art Resource, NY. In this trial, Lancelot crosses a raging stream, cutting himself on a long, sharpened sword, but "even his suffering is sweet to him" with Guinevere in sight.

Continuity & Change
p. 360

Sufi poetry

"for in a story it has no place"—is confounded with spiritual ecstasy. This feature is surely indebted to Islamic notions of physical love as a metaphor for the love of God, as found in Sufi poetry (see chapter 11) and in the love songs popular in the Islamic Spanish courts, where the bilingual minstrels who inaugurated the troubadour tradition first flourished.

The love of woman celebrated in medieval romance and troubadour poetry was equated in the Christian mind with love for the Virgin Mary. As Mother of Heaven and of Christ, as the all-compassionate mediator between the Judgment seat and the horrors of hell, Mary was increasingly recognized as the spiritual equivalent of the lady of chivalry, crowned the Queen of Heaven, overseeing her heavenly court. Songs were sung to her, cathedrals built in her honor (all cathedrals named Notre Dame, "Our Lady," are dedicated to her), and a Cult of the Virgin developed around her.

Lancelot was written at the request of Eleanor of Aquitaine's daughter, Marie—herself named after the Virgin—as its laudatory prologue, a standard feature of the form, attests (**Reading 13.6**):

READING 13.6 from Chrétien de Troyes, *Lancelot*

Since my lady of Champagne wishes me to undertake to write a romance, I shall very gladly do so, being so devoted to her service as to do anything in the world for her, without any intention of flattery. But if one were to introduce any flattery upon such an occasion, he might say, and I would subscribe to it, that this lady surpasses all others who are alive, just as the south wind which blows in May or April is more lovely than any other wind. But upon my word, I am not one to wish to flatter my lady. I will simply say: "The Countess is worth as many queens as a gem is worth of pearls and sards." Nay I shall make no comparison, and yet it is true in spite of me; I will say, however, that her command has more to do with this work than any thought or pains that I may expend upon it. Here Chrétien begins his book. . . . The material and the treatment of it are given and furnished to him by the Countess, and he is simply trying to carry out her concern and intention.

Chrétien presents himself as the servant of Marie who devotes his writer's skill to doing her bidding, just as the knight Lancelot serves Queen Guinevere with his knightly skill, and as the Christian serves the Virgin Mary. Similarly, Chrétien's story transforms the heroism of the *Song of Roland*, which is motivated by feudal loyalty to king and country, to a form of chivalry based on the allegiance of the knight to his lady. In a medieval romance, the knight is driven to heroic action not so much by the lure of greater glory as by his own desire for his lady. To the knight, the lady is a prize to be won, an object to be possessed. Beyond the drama of his exploits and his lady's distress, the conflict between the sexual desires of both knight and lady and the hypothetical purity of their "spiritual" love gives the story its narrative power. In a medieval romance, as well as in the troubadour poem, perhaps the greatest test the lovers face is their own sexuality—an almost sure-fire guarantor of the form's popularity.

READINGS

READING 13.2

from "The Fall of Jerusalem" from the *Gesta Francorum* (Deeds of the Franks)

The Gesta Francorum is an anonymous account of the First Crusade (1096–99). It is an extraordinary account not only of military matters—tactical operations, supply and provision operations, and so on—but also of the psychological mood of the Crusaders. The knight who wrote it was, apparently, an average soldier, and he gives us something of the unprejudiced point of view of the army as a whole.

At length, our leaders decided to beleaguer the city with siege machines, so that we might enter and worship the Saviour at the Holy Sepulchre.[1] They constructed wooden towers and many other siege machines. Duke Godfrey made a wooden tower and other siege devices, and Count Raymond did the same, although it was necessary to bring wood from a considerable distance. However, when the Saracens saw our men engaged in this work, they greatly strengthened the fortifications of the city and increased the height of the turrets at night. On a certain Sabbath night, the leaders, after having decided which parts of the wall were weakest, dragged the tower and the machines to the eastern side of the city. Moreover, we set up the tower at earliest dawn and equipped and covered it on the first, second, and third days of the week. The Count of St. Gilles erected his tower on the plain to the south of the city.

While all this was going on, our water supply was so limited that no one could buy enough water for one *denarius*[2] to satisfy or quench his thirst. . . . Early on the sixth day of the week we again attacked the city on all sides, but as the assault was unsuccessful, we were all astounded and fearful. However, when the hour approached on which our Lord Jesus Christ deigned to suffer on the Cross for us, our knights began to fight bravely in one of the towers—namely, the party with Duke Godfrey and his brother, Count Eustace. One of our knights, named Lethold, clambered up the wall of the city, and no sooner had he ascended than the defenders fled from the walls and through the city. Our men followed, killing and slaying even to the Temple of Solomon, where the slaughter was so great that our men waded in blood up to their ankles. . . .

[Finally] the pilgrims entered the city, pursuing and killing the Saracens up to the Temple of Solomon, where the enemy gathered in force. The battle raged throughout the day, so that the Temple was covered with their blood. When the pagans had been overcome, our men seized great numbers, both men and women, either killing them or keeping them captive, as they wished. . . . Afterward, the army scattered throughout the city and took possession of the gold and silver, the horses and mules, and the houses filled with goods of all kinds.

Rejoicing and weeping for joy, our people came to the Sepulchre of Jesus our Saviour to worship and pay their debt [i.e., fulfill crusading vows by worshiping at the Sepulchre]. At dawn our men cautiously went up to the roof of the Temple and attacked Saracen men and women, beheading them with naked swords. Some of the Saracens, however, leaped from the Temple roof. . . .

Then our leaders in council decided that each one should offer alms with prayers, that the Lord might choose for Himself whom He wanted to reign over the others and rule the city. They also ordered all the Saracen dead to be cast outside because of the great stench, since the whole city was filled with their corpses; and so the living Saracens dragged the dead before the exits of the gates and arranged them in heaps, as if they were houses. No one ever saw or heard of such slaughter of pagan people, for funeral pyres were formed from them like pyramids, and no one knows their number except God alone. ■

Reading Question

This account of the fall of Jerusalem amounts to a description of what might be called, from a contemporary point of view, a war crime. Why does the writer not see it in those terms?

[1] **Holy Sepulchre** The church built at the site where Jesus was believed to be buried and where he rose from the dead.

[2] ***Denarius*** A silver coin of the Roman Empire.

READING 13.5

from Marie de France, *Bisclavret*
(*The Werewolf*)

We actually know almost nothing about Marie de France, except that she was a marvelous storyteller. At the end of her collection of Fables, she tells us, "I'll give my name, for memory: / I am from France, my name's Marie"—and that about sums up what we know of her. Some speculate that she worked in Henry II's court, and that she was Henry II's half-sister, since Henry's father had an illegitimate daughter named Marie who subsequently became abbess of Shaftesbury about 1180.

The following lai represents one of the darker of the 12 she wrote. Combining the stuff of medieval folk superstition and the chivalric tradition, it is a perfect example of the growing popular appeal of literary works in the Romanesque world.

Since I am undertaking to compose *lais*,
I don't want to forget Bisclavret;
In Breton, the *lai*'s name is *Bisclavret*—
the Normans call it *Garwaf [The Werewolf]*.
In the old days, people used to say—
and it often actually happened—
that some men turned into werewolves
and lived in the woods.
A werewolf is a savage beast;
while his fury is on him 10
he eats men, does much harm,
goes deep in the forest to live.
But that's enough of this for now:
I want to tell you about the Bisclavret.
In Brittany there lived a nobleman
whom I've heard marvelously praised;
a fine, handsome knight
who behaved nobly.
He was close to his lord,
and loved by all his neighbors. 20
He had an estimable wife,
one of lovely appearance;
he loved her and she him,
but one thing was very vexing to her:
during the week he would be missing
for three whole days, and she didn't know
what happened to him or where he went.
Nor did any of his men know anything about it.
One day he returned home
happy and delighted; 30
she asked him about it.
"My lord," she said, "and dear love,
I'd very much like to ask you one thing—
if I dared;
but I'm so afraid of your anger
that nothing frightens me more."
When he heard that, he embraced her,
drew her to him and kissed her.
"My lady," he said, "go ahead and ask!

There's nothing you could want to know, 40
that, if I knew the answer, I wouldn't tell you."
"By God," she replied, "now I'm cured!
My lord, on the days when you go away from me
I'm in such a state—
so sad at heart,
so afraid I'll lose you—
that if I don't get quick relief
I could die of this very soon.
Please, tell me where you go,
where you have been staying. 50
I think you must have a lover,
and if that's so, you're doing wrong."
"My dear," he said, "have mercy on me, for God's sake!
Harm will come to me if I tell you about this,
because I'd lose your love
and even my very self."
When the lady heard this
she didn't take it lightly;
she kept asking him,
coaxed and flattered him so much, 60
that he finally told her what happened to him—
he hid nothing from her.
"My dear, I become a werewolf:
I go off into the great forest,
in the thickest part of the woods,
and I live on the prey I hunt down."
When he had told her everything,
she asked further
whether he undressed or kept his clothes on [when he
became a werewolf]. 70
"Wife," he replied, "I go stark naked."
"Tell me, then, for God's sake, where your clothes are."
"That I won't tell you;
for if I were to lose them,
and then be discovered,
I'd stay a werewolf forever.
I'd be helpless
until I got them back.
That's why I don't want their hiding place to be known."

"My lord," the lady answered, 80
"I love you more than all the world;
you mustn't hide anything from me
or fear me in any way:
that doesn't seem like love to me.
What wrong have I done? For what sin of mine
do you mistrust me about anything?
Do the right thing and tell me!"
She harassed and bedeviled him so,
that he had no choice but to tell her.
"Lady," he said, "near the woods, 90
beside the road that I use to get there,
there's an old chapel
that has often done me good service;
under a bush there is a big stone,
hollowed out inside;
I hide my clothes right there
until I'm ready to come home."
The lady heard this wonder
and turned scarlet from fear;
she was terrified of the whole adventure. 100
Over and over she considered
how she might get rid of him;
she never wanted to sleep with him again . . .
[The lady asks a knight who has always loved her to find
Bisclavret and kill him, but they never find him, and the
two marry. But one day some hunters find him.]
[T]he hunters and the dogs
chased him all day,
until they were just about to take him
and tear him apart, 110
at which point he saw the king
and ran to him, pleading for mercy.
He took hold of the king's stirrup,
kissed his leg and his foot.
The king saw this and was terrified;
he called his companions.
"My lords," he said, "come quickly!
Look at this marvel—
this beast is humbling itself to me.
It has the mind of a man, and it's begging me for mercy! 120
Chase the dogs away,
and make sure no one strikes it.
This beast is rational—he has a mind.
Hurry up: let's get out of here.
I'll extend my peace to the creature;
indeed, I'll hunt no more today!"
Thereupon the king turned away.
Bisclavret followed him;
he stayed close to the king, and wouldn't go away;
he'd no intention of leaving him. 130
The king led him to his castle;
he was delighted with this turn of events,
for he'd never seen anything like it.
He considered the beast a great wonder

and held him very dear.
He commanded all his followers,
for the sake of their love for him, to guard Bisclavret well,
and under no circumstances to do him harm;
none of them should strike him;
rather, he should be well fed and watered. 140
They willingly guarded the creature;
every day he went to sleep
among the knights, near the king.
Everyone was fond of him;
he was so noble and well behaved
that he never wished to do anything wrong.
Regardless of where the king might go,
Bisclavret never wanted to be separated from him;
he always accompanied the king.
The king became very much aware that the creature 150
loved him.
Now listen to what happened next.
The king held a court;
to help him celebrate his feast
and to serve him as handsomely as possible,
he summoned all the barons
who held fiefs from him.
Among the knights who went,
and all dressed up in his best attire,
was the one who had married Bisclavret's wife. 160
He neither knew nor suspected
that he would find Bisclavret so close by.
As soon as he came to the palace
Bisclavret saw him,
ran toward him at full speed,
sank his teeth into him, and started to drag him down.
He would have done him great damage
if the king hadn't called him off,
and threatened him with a stick.
Twice that day he tried to bite the knight. 170
Everyone was extremely surprised,
since the beast had never acted that way
toward any other man he had seen.
All over the palace people said
that he wouldn't act that way without a reason:
that somehow or other, the knight had mistreated
Bisclavret,
and now he wanted his revenge.
And so the matter rested
until the feast was over 180
and until the barons took their leave of the king
and started home.
The very first to leave,
to the best of my knowledge,
was the knight whom Bisclavret had attacked.
It's no wonder the creature hated him.
Not long afterward,
as the story leads me to believe,
the king, who was so wise and noble,

went back to the forest 190
where he had found Bisclavret,
and the creature went with him.
That night, when he finished hunting,
he sought lodging out in the countryside.
The wife of Bisclavret heard about it,
dressed herself elegantly,
and went the next day to speak with the king,
bringing rich presents for him.
When Bisclavret saw her coming,
no one could hold him back; 200
he ran toward her in a rage.
Now listen to how well he avenged himself!
He tore the nose off her face.
What worse thing could he have done to her?
Now men closed in on him from all sides;
they were about to tear him apart,
when a wise man said to the king,
"My lord, listen to me!
This beast has stayed with you,
and there's not one of us 210
who hasn't watched him closely,
hasn't traveled with him often.
He's never touched anyone,
or shown any wickedness,
except to this woman.
By the faith that I owe you,
he has some grudge against her,
and against her husband as well.
This is the wife of the knight
whom you used to like so much, 220
and who's been missing for so long—
we don't know what became of him.
Why not put this woman to torture
and see if she'll tell you
why the beast hates her?
Make her tell what she knows!
We've seen many strange things
happen in Brittany!"
The king took his advice;
he detained the knight. 230
At the same time he took the wife
and subjected her to torture;
out of fear and pain
she told all about her husband:
how she had betrayed him
and taken away his clothes;
the story he had told her
about what happened to him and where he went;
and how after she had taken his clothes
he'd never been seen in his land again. 240

She was quite certain
that this beast was Bisclavret.
The king demanded the clothes;
whether she wanted to or not
she sent home for them,
and had them brought to Bisclavret.
When they were put down in front of him
he didn't even seem to notice them;
the king's wise man—
the one who had advised him earlier— 260
said to him, "My lord, you're not doing it right.
This beast wouldn't, under any circumstances,
in order to get rid of his animal form,
put on his clothes in front of you;
you don't understand what this means:
he's just too ashamed to do it here.
Have him led to your chambers
and bring the clothes with him;
then we'll leave him alone for a while.
If he turns into a man, we'll know about it." 270
The king himself led the way
and closed all the doors on him.
After a while he went back,
taking two barons with him;
all three entered the king's chamber.
On the king's royal bed
they found the knight asleep.
The king ran to embrace him.
He hugged and kissed him again and again.
As soon as he had the chance, 280
the king gave him back all his lands;
he gave him more than I can tell.
He banished his wife,
chased her out of the country.
She went into exile with the knight
with whom she had betrayed her lord.
She had several children
who were widely known
for their appearance:
several women of the family 290
were actually born without noses,
and lived out their lives noseless.
The adventure that you have heard
really happened, no doubt about it.
The *lai* of Bisclavret[3] was made
so it would be remembered forever. ▪

Reading Questions

How does Marie's story suggest the conflict between bestiality and civilization in human behavior? What values does it most uphold?

[3]Until this point, "Bisclavret" is a common noun; hereafter it is used as the werewolf's name.

Summary

■ The Foundations of Faith: Pilgrimage Churches

Churches such as the Abbey Church of Sainte-Foy in Conques, France, became the focus of Western culture in the Middle Ages as Christians began to do penance for their sins by undertaking pilgrimages to churches housing the relics of venerated saints. The churches were Romanesque—that is, certain elements of Roman architectural tradition were incorporated into their design, particularly the basilica tradition and the barrel vaults that arched above the church naves. Artists decorated the pilgrimage churches to make them attractive to travelers, and their portals were especially susceptible to sculptural reliefs.

■ Cluny and the Monastic Tradition

Most of the pilgrimage churches were controlled by the Abbey of Cluny. Cluny's abbot was among the most powerful men in Europe, and the church at Cluny was a model for all pilgrimage churches. Music was central to the Cluniac liturgy. The choral music sung there was polyphonic, and increasingly complex varieties of organum developed. Not everyone supported the richness of the Cluniac liturgy and its accompanying music, art, and architecture. From the point of view of Bernard, abbot of Clairvaux, a Cistercian monastery where the monks lived a life of poverty, such artistic excess—in other words, beauty—was an affront to the monastic mission.

■ Saint-Gilles-du-Gard and the Crusades

On November 25, 1095, Pope Urban II, who had been trained at Cluny, preached the First Crusade, pleading with Christians to retake Jerusalem from the Muslims. Nearly 100,000 young men signed on. The Crusaders were not above torturing their Muslim foes, and on one occasion, at Ma'arra, resorted to cannibalism. In the Middle East the Crusaders built giant fortresses like the Krak des Chevaliers, modeled on the fortresses built by the Normans in England. The principal embarkation point for the First Crusade and those that were to follow was Saint-Gilles-du-Gard, which became European headquarters of the Knights Templar. Although the First Crusade was successful in recapturing Jerusalem, Muslim armies retook the city, requiring three subsequent Crusades. These became increasingly mercenary in character and resulted, finally, in the sack of Constantinople and Hagia Sophia.

■ Eleanor of Aquitaine and the Culture of the Court

Eleanor of Aquitaine accompanied her husband, King Louis VII of France, on the Second Crusade. At Poitiers, Eleanor and her daughter, Marie de Champagne, championed a literary movement that celebrated the art of courtly love. Based on traditional chivalry, the loyalty that the poet had once conferred upon his lord in the feudal system is, in courtly love, transferred to his lady. There was also a quasi-religious aspect to courtly love. Recognizing that he is beset by earthly desires, the lover sees his ability to resist these temptations and rise above his own base humanity as evidence of spiritual purity. Among the most prominent troubadour poets were Bernard de Ventadour and Beatriz de Dia. Dedicated to Marie de Champagne is the long medieval romance, *Lancelot*, by Chrétien de Troyes.

 ## Glossary

archivolt A curved molding formed by the voussoirs making up the arch.

barrel vault An elongated arched masonry structure spanning an interior space and shaped like a half cylinder.

bay A main section of a nave formed by the round arches of a vault.

crenellation A battlement; see *battlement*.

free organum A type of polyphony in which the second voice moves in contrary motion to the bass chant.

jamb The vertical elements on both sides of a door that support the lintel or arch.

lai A short romance fusing, supernatural elements and the courtly love tradition, sung by minstrels and accompanied by a harp or lyre.

mandorla An almond-shaped oval of light signifying divinity.

medieval romance A story of adventure and love that pretended to be a true historical account of Charlemagne, King Arthur, or Roman legend.

melismatic organum A type of polyphony in which the second voice moves in contrary motion to the bass chant or adds numerous notes to individual syllables above the bass chant.

memento mori A reminder of death.

organum A type of polyphonic music consisting of voices singing note-to-note in parallel.

polyphony Music with two or more lines of melody.

primogeniture In the feudal system, the right of the eldest son to inherit all property.

relic An object (bones, clothing, or other possessions) venerated because of its association with a Christian saint or martyr.

reliquary A container used to protect and display relics.

Romanesque An art historical period so-called because the architecture incorporated elements of Roman architectural tradition.

strophic The same music repeated for each stanza of a poem.

tomb effigy A sculptural portrait of the deceased.

trobairitz A woman troubadour.

troubadour A class of poets that flourished in the 11th through 13th centuries in southern France and northern Italy.

trumeau The column or post in the middle of a large door supporting the lintel.

tympanum The space created under the portal arch, often filled with sculptural relief.

 ## Critical Thinking Questions

1. What are the defining features of a Romanesque church?

2. What are some of the motivating factors contributing to the popularity of pilgrimages?

3. What are the varieties of organum and how do they differ from one another?

4. How do you account for the popularity of troubadour poetry and medieval romances such as Chrétien de Troyes's *Lancelot*?

Toward a New Urban Style: The Gothic

Continuity & Change

Romanesque art and architecture thrived, especially along the pilgrimage routes in the south of France, from roughly 1050 to 1200. But in the 1140s a new style began to emerge in the north that today we call Gothic. New cathedrals—at Saint-Denis, just outside Paris, and at Chartres—were dominated by soaring spires and stained-glass windows. Decorative sculpture proliferated. Pointed arches, as opposed to the rounded arches of the Romanesque barrel vault, lifted interior spaces to new heights. All of these new elements were anticipated in the Romanesque, in the magnificent stained glass at Poitiers, in the sculpture of the pilgrimage route church portals, and in the pointed arches of Fontenay Abbey. And like their Romanesque forebears, most of the new Gothic cathedrals were built to house precious relics and to accommodate large crowds of pilgrims.

The Romanesque style was a product of rural monastic life, separated from worldly events and interactions, but the Gothic style was a creation of the emerging city—of the craft guilds and artisans, merchants, lawyers, and bankers who gathered there. It represents the first step in a gradual shift in the West from a spiritually centered culture to one with a more secular focus. No longer was religion—worshiping at a

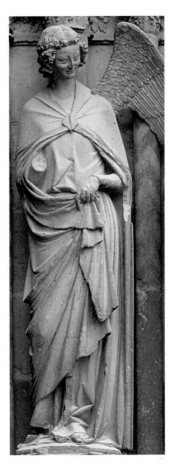

Fig. 13.21 *The Angel of the Annunciation,* west front portal, Reims Cathedral, Reims, France. ca. 1245–55 (detail of Fig. 14.17).

pilgrimage church or fighting a Crusade—the dominant motive for travel. Instead, trade was. Merchants and bankers grew in importance. Craftsmen flourished. Secular rulers became more ambitious. In fact, personal ambition and success would increasingly be defined in worldly, rather than spiritual, terms.

The Gothic does not give up its interest in the spiritual. Although the architecture was intended to invoke intensely spiritual feelings, we also see the beginning of a renewed interest in worldly things. This shift is evident in two images of angels. The flattened, distorted features of the angel on the Romanesque capital from Vézelay (Fig. **13.20**) contrast dramatically with the heightened naturalism of the angel from the portal at Reims (Fig. **13.21**). Freed from the stone backdrop of relief sculpture, the Gothic angel steps forward with an amazingly lifelike gesture. So lifelike is the Reims sculpture that it seems to have been modeled on a real person—nothing of the formulaic vocabulary of Romanesque sculpture remains. Its winsome smile and delicate figure are, finally, more worldly than angelic. ∎

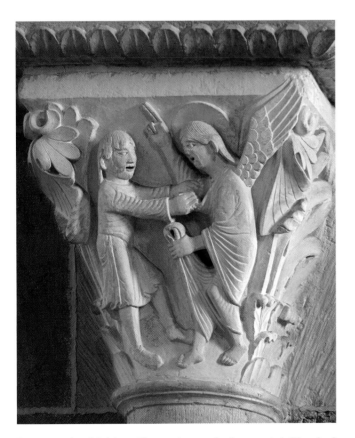

Fig. 13.20 *Angel Subduing Demon,* decorated column capital, Church of Sainte-Madeleine, Vézelay, France. ca. 1089–1206.

14 The Gothic Style

Faith and Knowledge in an Age of Inquiry

Saint-Denis and Chartres Cathedrals

The Rise of the University

The Radiant Style and the Court of Louis IX

> " *Marvel not at the gold and the expense but at the craftsmanship of the work.*
>
> *Bright is the noble work; but being nobly bright, the work should brighten the minds, so that they may travel,*
>
> *Through the true lights, to the True Light where Christ is the True Door.* "

Abbot Suger, *On What Was Done During His Administration*

◄ **Fig. 14.1 Chartres Cathedral, the Cathedral of Notre-Dame, Chartres, France. ca. 1140–1220.** Chartres Cathedral rises majestically, a crown atop the town surrounding it. Such cathedrals were the cultural centers of their communities, the source of the community's pride and prestige.

ON JUNE 11, 1144, KING LOUIS VII, HIS QUEEN, ELEANOR

of Aquitaine, and a host of dignitaries traveled a few miles north of Paris to the royal Abbey of Saint-Denis, where they dedicated a new choir for the royal church. It would be the crowning achievement of the king's personal domain,

the Île-de-France [eel duh frahns] (see Map **14.1**). Designed by Abbot Suger [soo-ZHER] of Saint-Denis, the choir would quickly inspire a new style of architecture and decoration that came to be known as **Gothic**.

"Gothic" was originally a derogatory term, adopted in sixteenth-century Italy to describe the art of northern Europe, where, it was believed, classical traditions had been destroyed by Germanic invaders—that is, by the Goths. In its own time, this style was known as *opus modernum* (modern work) or *opus francigenum* (French work). These terms highlight the style's decidedly new and contemporary flavor as well as its place of origin.

By the end of the twelfth century and the beginning of the thirteenth, town after town across northern France would imitate Suger's design at Saint-Denis. At Chartres, just to the west of the Île-de-France on the Eure [ur] River (Fig. **14.1**), to the north at Rouen [roo-ON], Amiens [ah-mee-EN], and Beauvais [boh-VAY], to the east at Laon and Reims, to the south at Bourges [boorzh], and in Paris itself, Gothic cathedrals sprang up with amazing rapidity. Much of the rest of Europe would soon follow suit.

With the rise of this new Gothic style came a new standard of beauty in Western architecture and decoration. A new masonry architecture developed, eventually resulting in intricate stonework that was almost skeletal in its lightness and soaring ever higher to create lofty interior spaces. Gothic architecture matched the decorative richness of stained glass with sculptural programs that were increasingly inspired by classical models of naturalistic representation. A new, richer liturgy developed as well, and with it, polyphonic music that by the thirteenth century was accompanied by a new instrument—the organ. The Île-de-France was the center of all these developments. It was there, as well, at the University of Paris, founded in 1200, that a young Dominican monk named Thomas Aquinas initiated the most important theological debates of the age, inaugurating a style of intellectual inquiry that we associate with higher learning to this day.

Saint-Denis and Chartres Cathedrals

Even as a pupil at the monastery school, Abbot Suger had dreamed of transforming the Abbey of Saint-Denis into the most beautiful church in France. The dream was partly

inspired by his desire to lay claim to the larger territories surrounding the Île-de-France. Suger's design placed the royal domain at the center of French culture, defined by an architecture surpassing all others in beauty and grandeur.

After careful planning, Suger began work on the Abbey in 1137, painting the walls, already almost 300 years old, with gold and precious colors. Then he added a new facade with twin towers and a triple portal. Around the back of the ambulatory he added a circular string of chapels (Figs. **14.2**, **14.3**), all lit with large stained-glass windows (Fig. **14.4**), "by virtue of which," Suger wrote, "the whole would shine with the miraculous and uninterrupted light."

This light proclaimed the new Gothic style. In preparing his plans, Suger had read what he believed to be the writings of the original Saint Denis. (We now know that he was reading the mystical tracts of a first-century Athenian follower of Saint Paul.) According to these writings, light is the physical and material manifestation of the Divine Spirit. Suger would later survey the accomplishments of his administration and explain his religious rationale for the beautification of Saint-Denis:

> Marvel not at the gold and the expense but at the craftsmanship of the work.
> Bright is the noble work; but being nobly bright, the work
> Should brighten the minds, so that they may travel, through the true lights,
> To the True Light where Christ is the true door.

The church's beauty, therefore, was designed to elevate the soul to the realm of God.

When Louis VII and Eleanor left France for the Second Crusade in 1147 (see chapter 13), just three years after Suger's dedication of his choir, they also left the abbot without the funds necessary to finish his church. It was finally completed a century after he died in 1151. Much of its original sculptural and stained-glass decoration was destroyed in the late eighteenth century during the French Revolution. Although partially restored in the nineteenth and twentieth centuries, only five of its original stained-glass windows remain, and we must turn to other churches modeled on its design to comprehend its full

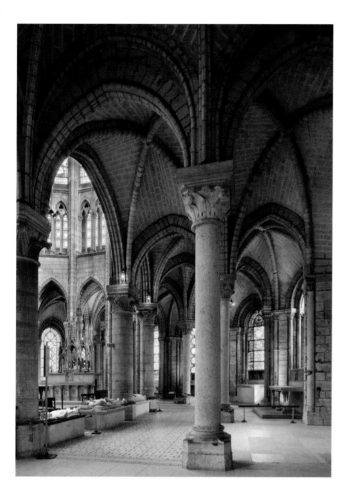

Fig. 14.2 **Ambulatory choir, Abbey Church of Saint-Denis, Saint-Denis, France. 1140–44.** In Abbot Suger's design, the ambulatory and radiating chapels around the apse were combined, so that the stained-glass windows—two in each chapel—fill the entire choir with light.

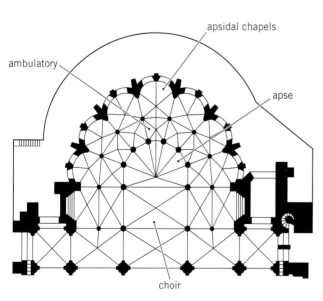

Fig. 14.3 **Plan of the ambulatory choir, Abbey Church of Saint-Denis, Saint-Denis, France. 1140–44.** By supporting the arches over the choir with columns instead of walls, Suger created a unified space reminiscent of the hypostyle space of the Mosque of Córdoba.

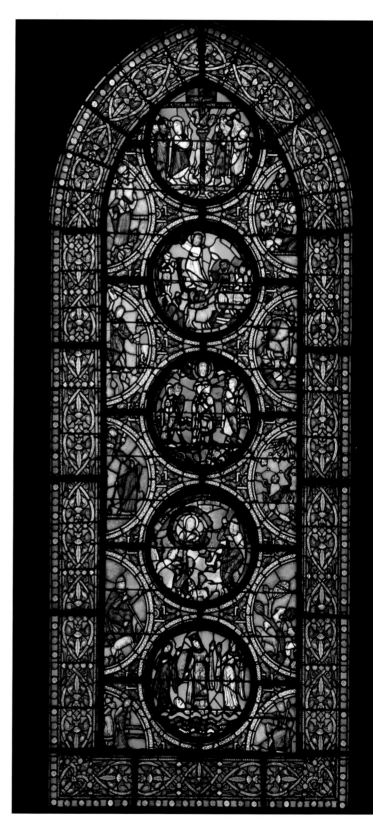

Fig. 14.4 **Moses window, Abbey Church of Saint-Denis, Saint-Denis, France. 1140–44.** This is the best preserved of the original stained-glass windows at Saint-Denis. Scholars have speculated that Moses was a prominent theme at the royal Abbey of Saint-Denis because his leadership of the Israelites was the model for the French King's leadership of his people.

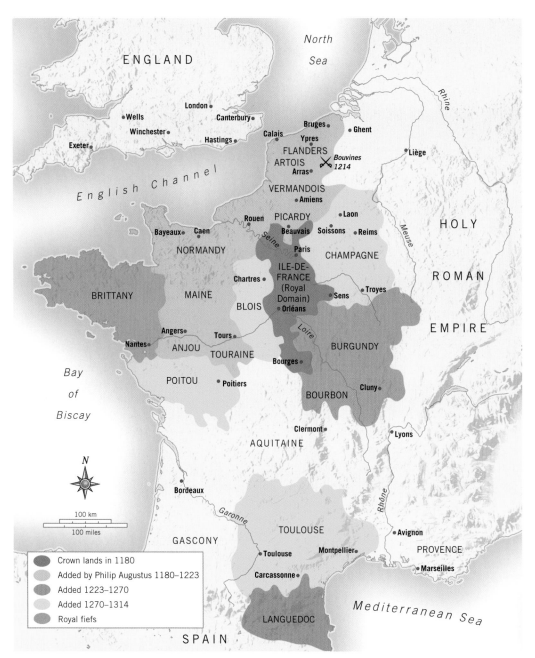

Map 14.1 The Growth of the Kingdom of France 1180–1314. As France grew during the Gothic era, the Gothic style spread with it.

Crown lands in 1180
Added by Philip Augustus 1180–1223
Added 1223–1270
Added 1270–1314
Royal fiefs

effect. Chief among these is the Cathedral of Notre-Dame [noh-truh dahm] at Chartres, [SHAR-truh] which, like the other Gothic cathedrals both in the Île-de-France and its surrounding territories, drew its inspiration from Paris.

The cathedral's spires can be seen for miles in every direction, lording over town and countryside as if it were the very center of its world (Fig. **14.5**). Chartres was, in fact, located in the heart of France's grain belt, and its economy thrived as France exported grain throughout the Mediterranean basin. But more important, Chartres was the spiritual center of the cult of the Virgin, which throughout the twelfth and thirteenth centuries assumed an increasingly important role in the religious life of Western Europe. The popularity of this cult contributed, per-

haps more than any other factor, to the ever-increasing size of the era's churches. Christians worshiped the Virgin as the Bride of Christ, Personification of the Church, Queen of Heaven, and prime Intercessor with God for the salvation of humankind. This last role was especially important, for in it the Virgin could intervene to save sinners from eternal damnation. The cult of the Virgin manifested itself especially in the French cathedrals, which are often dedicated to *Notre Dame*, "Our Lady."

Soon after the first building phase was completed at Chartres, between about 1140 and 1150, pilgrims thronged to the cathedral to pay homage to what the Church claimed was the Virgin's tunic, worn at Jesus's birth. This relic was housed in the cathedral and was believed to possess extraordinary healing

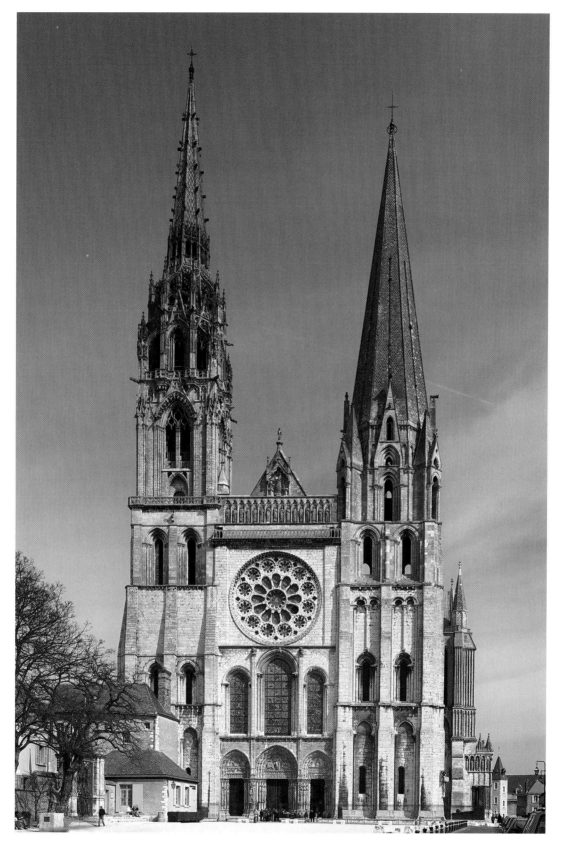

Fig. 14.5 West facade, Chartres Cathedral. ca. 1134–1220; south spire ca. 1160; north spire, 1507–13. The different designs of the two towers reflect the Gothic dismissal of Romanesque absolute balance and symmetry as well as the growing refinements of the Gothic style. The later, north tower (left) was much more elaborately decorated and, in the more open framework of its stonework, more technically advanced.

Fig. 14.6 *Sculptors and Masons at Work* window, Chartres Cathedral. ca. 1220. This window is one of many at Chartres that show local craftspeople donating their work to building the church. At the left, masons cut stones and build walls. At the right, sculptors are at work on statues to decorate the portal jambs.

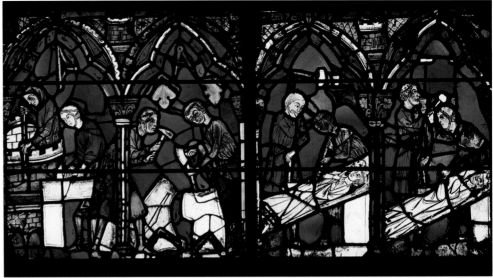

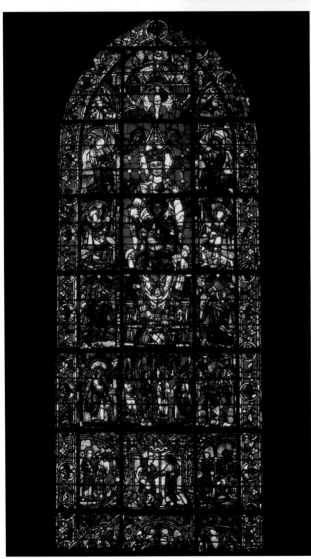

Fig. 14.7 *Notre-Dame de la Belle Verrière (Our Lady of the Beautiful Window)* window, Chartres Cathedral. Central portion, 12th century, surrounding angels, 13th century. This window is renowned for its stunning combination of red and blue stained glass.

powers. But in 1194, the original structure was destroyed by fire, except for the west facade, a few stained-glass windows, including one of the most beautiful, known as *Notre-Dame de la Belle Verrière* [noh-truh dahm duh la bel vair-ee-AIR] ("Our Lady of the Beautiful Window"), and the tunic of the Virgin. The survival of the window and the tunic was taken as a sign of divine providence, and a massive reconstruction project was begun in gratitude. Royalty and local nobility contributed their financial support, and the local guilds gave both money and work. The efforts of the guilds are celebrated in many of the windows (Fig. **14.6**). (Relations between the tradespeople and Church authorities were not always harmonious. See *Voices*, page 439.)

Behind the more or less Romanesque west facade, with its round-arch windows, rose what many consider the most magnificent of all Gothic cathedrals, its stained glass unrivaled in Europe.

Stained Glass

The stained-glass program at Chartres is immensely complex. The innovative engineering that marks Gothic architecture (to be discussed later in this chapter) freed the walls of the need to bear the weight of the structure. It also freed the walls to contain glass (see *Materials and Techniques*, page 440, and *Focus*, pages 442–443).

The purpose of the stained-glass programs in all Gothic cathedrals was to tell the stories of the Bible in a compelling way to an audience that was largely illiterate. The art allowed them to read the scriptural stories for themselves. At Chartres, 175 glass panels, containing more than 4,000 figures, are carefully designed, in Abbot Suger's words, "to show simple folk . . . what they ought to believe." Two windows are notable for their role in the cult of the Virgin. *Notre-Dame de la Belle Verrière* (Fig. **14.7**), whose central panel survived the fire of 1194, embodies the shift in style that occurred in the twelfth century as the Gothic supplanted the Romanesque. The Virgin and

Voices

A Riot at Chartres

The building of the great Gothic cathedrals was not always a peaceful process. Partway through the rebuilding of Chartres Cathedral in 1210, disputes between local tradesmen, peasants and the Church officials led to a riot. The bishop and the Cathedral Chapter (the clerics responsible for assisting the bishop) retaliated by denying the community access to the church. The following account describes the episode from the perspective of church authorities.

The terrible fury of the ancient enemy [the devil] never ceases to incite the hatred of the laity against the clergy . . . And thus impelled . . . it happened that in the city of Chartres, in the 1210th year from the incarnation of our Lord, in the month of October, on a certain Sunday after lunch, a great segment of the population dared to violently rise against the Dean [the head of the Cathedral chapter] and to violate his house. . . . And when the officials . . . namely the Marshal and the Provost, were asked by the Dean . . . either to drive back the raging multitude of the commoners from the Chapter, or to restrain their fury through the power that had been entrusted in them, they [the officials] declined to do so; rather, they attempted to incite the populous more than drive them back, and to augment its rage more than restrain it, and they even sent a messenger through the streets and squares of the town urging everyone to invade the [cathedral chapter house] with arms and to plunder it. Whence it happened that, with the crowd rushing in, some tried to overwhelm the windows of the house with stones and others tried to chop down the door, doorposts, and lintel with axes . . . [after a lengthy riot in which the

"Whence it happened that, with the crowd rushing in, some tried to overwhelm the windows of the house with stones and others tried to chop down the door, doorposts, and lintel with axes. . ."

chapter house was looted and wrecked, the rioters dispersed late in the evening].

The clergy was extremely troubled and saddened by this incident: since those who were usually laymen of sound mind and women of piety were not usually connected to such sacrilegious crimes. And therefore services ceased wholly . . . in the churches and monasteries of the region around Chartres [I]t was permitted to parish priests alone to occasionally celebrate masses—behind closed doors, with the laity excluded . . . All other sacraments were refused, except the baptism of infants, which was allowed to occur, but only outside the church or at the church porch, not within the church itself. The altar of Notre-Dame was stripped, and the holiest reliquary [of the Virgin's tunic] was taken down from the altar. . . And the Chapter ordered that each day the priests of this church should ascend the pulpit and pronounce orally the sentence of excommunication, with its horrendous curse . . . against the aforesaid blasphemers; this should be done with candles lit and with bells tolling, not only in this church [i.e., Notre-Dame] but in the other churches as well.

Continuity & Change
p. 327

Emperor Justinian

Child in the middle are almost Byzantine in their stiffness, their feet pointed downward, their pose fully frontal, the drapery of their clothing almost flat (see Figure 10.10, Emperor Justinian). But the angels on the side, which are thirteenth-century additions, are both less stiff and more animated. The swirls and folds of their gowns flow across their limbs, revealing the anatomy beneath them.

The second window depicts the so-called Tree of Jesse (Fig. **14.8**). Jesse trees are a common motif in twelfth- and thirteenth-century manuscripts, murals, sculpture, and stained glass, and their associated traditions are still

celebrated by Christians during the season of Advent. They were thought to represent the genealogy of Christ, since they depict the Virgin Mary as descended from Jesse, the father of King David, thus fulfilling a prophecy in the book of Isaiah (11:1): "And there shall come forth a rod out of the stem of Jesse and a Branch shall grow out of his roots." Most Jesse trees have at their base a recumbent Jesse with a tree growing from his side or navel. On higher branches of the tree are various kings and prophets of Judah. At the top are Christ and Mary. Sometimes the Virgin holds the infant Jesus, but here, as in a similar window at Saint-Denis, Mary appears in the register below Jesus. Since Jesse trees portray Mary as descending from royal lineage, they played an important role in the cult of the Virgin.

Focus

The Stained Glass at Chartres

The stained glass at Chartres covers more than 32,000 square feet of surface area. Although the illustration below lacks detail, we can imagine the overall effect of so many windows. The windows were donated by the royal family, by noblemen, and by merchant guilds. On an average day, the light outside the cathedral is approximately 1,000 times greater than the light inside. Thus the windows, backlit and shining in the relative darkness of the nave, seem to radiate with an ethereal and immaterial glow, suggesting a spiritual beauty beyond the here and now.

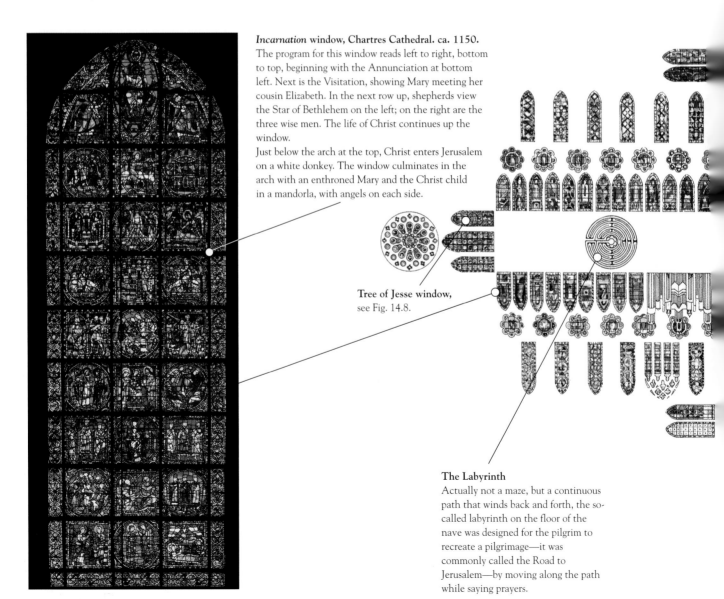

Incarnation window, Chartres Cathedral. ca. 1150.
The program for this window reads left to right, bottom to top, beginning with the Annunciation at bottom left. Next is the Visitation, showing Mary meeting her cousin Elizabeth. In the next row up, shepherds view the Star of Bethlehem on the left; on the right are the three wise men. The life of Christ continues up the window.
Just below the arch at the top, Christ enters Jerusalem on a white donkey. The window culminates in the arch with an enthroned Mary and the Christ child in a mandorla, with angels on each side.

Tree of Jesse window,
see Fig. 14.8.

The Labyrinth
Actually not a maze, but a continuous path that winds back and forth, the so-called labyrinth on the floor of the nave was designed for the pilgrim to recreate a pilgrimage—it was commonly called the Road to Jerusalem—by moving along the path while saying prayers.

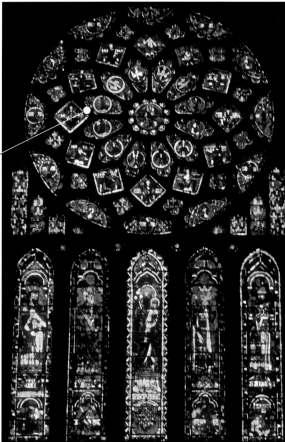

Rose window and lancets, north transept, Chartres. ca. 1150–80.
A **rose window** is a round window with mullions (framing elements) and traceries extending outward from its center in the manner of the petals of a rose. It is symbolic of the Virgin Mary in her role as the Mystic Rose—the root plant, it was believed, of the Jesse Tree. This rose window measures 42 feet in diameter. The small windows between the lancets and the rose window contain the French royal coat of arms. They remind the viewer that the windows decorating the north transept were donated by Blanche, the queen mother.

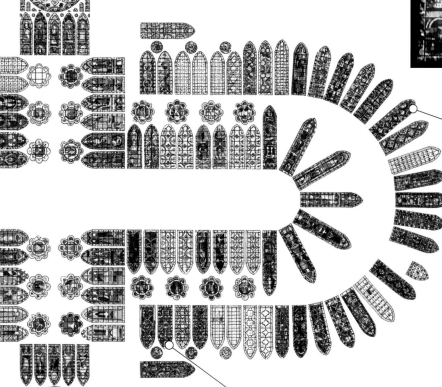

Charlemagne window, see Figure 12.11.

Notre-Dame de la Belle Verrière
(Our Lady of the Beautiful
Window), see Figure 14.7.

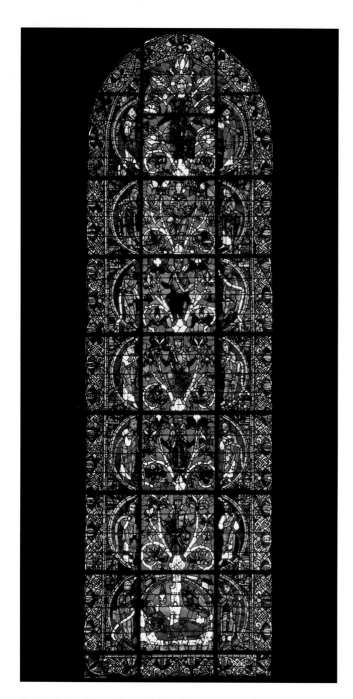

Materials & Techniques
Stained Glass

A variety of different colored glass was blown by artisans and rolled out into square pieces. These pieces were broken or cut into smaller fragments and assembled over a drawing marked out in chalk dust. Features of people were painted on in dark pigments, and the fragments were joined by strips of lead. The whole piece was then strengthened with an armature of iron bands, at first stretching over windows in a grid, but later shaped to follow the outlines of the design itself.

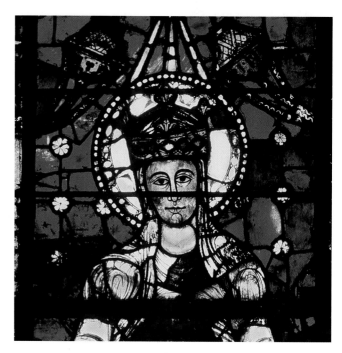

Detail from *Notre-Dame de la Belle Verrière*, Cathedral of Notre-Dame. ca. 1170.

Fig. 14.8 *The Tree of Jesse* window, Chartres. ca. 1150–70. Jesse was the father of King David, who, according to the Gospels, was an ancestor of Mary. At the base of the window lies the body of Jesse, a tree growing out of him. The tree branches into the four kings of Judea, one on each row. Mary is just below Christ. Seven doves, representing the seven gifts of the Holy Spirit, encircle Christ. In half-moons flanking each section of the tree stand the fourteen prophets.

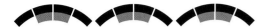

Materials & Techniques Rib Vaulting

Rib vaults are a form of groin vault (see *Materials and Techniques*, chapter 8, page 255). They are based on the pointed arch, which can reach to a greater height than a rounded arch. At the groins, structural moldings called ribs channel the vault's thrust outward and downward. These ribs were constructed first and supported the scaffolding upon which masonry webbing was built. These ribs were essentially a "skeleton" filled with a lightweight masonry "skin." Throughout the late Middle Ages, more and more intricate and complex versions of this scheme were developed.

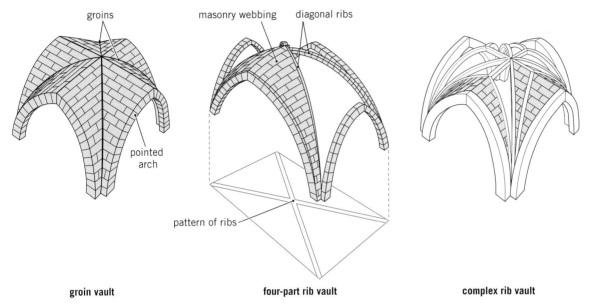

groin vault **four-part rib vault** **complex rib vault**

Gothic Architecture

As the Gothic style developed, important architectural innovations contributed to the goal of elevating the soul of worshipers to the spiritual realm. Key among these innovations was rib vaulting. The principles of rib vaulting were known to Romanesque architects, but Gothic architects used these techniques with increasing sophistication (see *Materials and Techniques*, above). Rib vaulting allowed for the massive stonework of the Romanesque style to be replaced, inside and out, by an almost lacy play of thin columns and patterns of ribs and windows, all pointing upward in a gravity-defying crescendo that carries the viewer's gaze toward the heavens. The facade of Reims Cathedral is typical (Fig. **14.9**). Extremely high naves—Chartres's nave is 120 feet high, Reims's nave is 125, and the highest of all, Beauvais's, is 157, the equivalent of a 15-story building—add to this emphasis on verticality, contributing a sense of elevation that is both physical and spiritual.

Fig. 14.9 West facade, Reims Cathedral, Reims, France. Begun 1211. The portals are built outward from the facade, and their typanums are filled with glass rather than stone. The arches are tall and thin.

The preponderance of pointed rather than rounded arches (Fig. **14.10**) creates a similar feeling. The pointed arch, in fact, possesses structural properties that contribute significantly to the Gothic style—the flatter or rounder an arch is, the greater outward thrust or pressure it puts on the supporting walls. By reducing outward thrust, the pointed arch allows for larger windows and lighter **buttresses**, pillars traditionally built against exterior walls to brace them and strengthen the vault. **Flying buttresses** (Figs. **14.11**, **14.12**) allow for even lighter buttressing and more windows. They extend away from the wall, employing an arch to focus the strength of the buttress's support at the top of the wall, the section most prone to collapse from the outward pressure of the vaulted ceiling. As the magnificent flying buttresses at Notre-Dame Cathedral in Paris demonstrate, they also create a stunning visual spectacle, arching winglike from the building's side as if defying gravity.

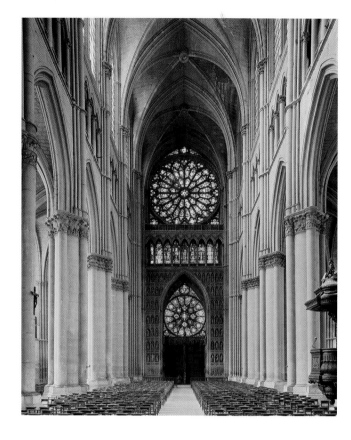

Fig. 14.10 Nave of Reims Cathedral, Cathedral of Notre-Dame, Reims, France. 1211–1290. The nave is almost three times higher than it is wide, creating a dramatic vertical space. This view looks west toward the central portal.

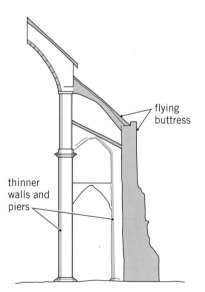

flying buttress

thinner walls and piers

Figs. 14.11 and 14.12 Flying buttresses, Cathedral of Notre-Dame, Paris. 1211–90. Romanesque architects used buttressing, but concealed it under the aisle roofs. Moving the buttresses to the outside of the structure created a sense of light bridgework that contributed to the aesthetic appeal of the building as much as to its structural integrity. A flying buttress is basically a huge stone prop that pushes in against the walls with the same force that the vaults push out. The thrust of the vaulted ceilings still come down the piers and walls, but also move down the arms of the flying buttresses, down the buttresses themselves, and into the ground. The flying buttresses help spread the weight of the vaults over more supporting stone, allowing the walls to be thinner while still supporting as much weight as earlier, thicker walls.

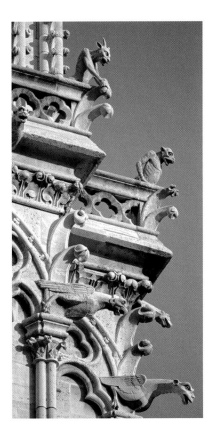

Fig. 14.13 **Gargoyles and chimeras, Notre-Dame de Paris. 1211–90.** These figures are probably related to the grotesque creatures in Romanesque depictions of the Last Judgment (compare Fig. 13.8).

During the thirteenth century, architects began to adorn the exteriors of their cathedrals with increasingly elaborate decoration. Stone **crockets**, leaflike forms that curve outward, their edges curling up, were added to the pinnacles, spires, and gables of the cathedrals. These were topped by **finials**, knoblike architectural forms also found on furniture. The textural richness of these forms is evident in the comparison of Chartres (see Fig. 14.5), where they are relatively absent, and Reims, where they are abundant (see Fig. 14.9). At the upper portions of buildings, grotesque creatures—sometimes appearing as mutant humans, other times as hybrid beasts—spouted from the walls (Fig. **14.13**). When they function as waterspouts, as many do, they are called **gargoyles**, from the Old French *gargouille* [gahr-GOO-ee], meaning "throat." Though the others are often called gargoyles as well, they are technically **chimeras** [ky-MIR-uh], simply grotesque monsters. Both were thought to ward off evil.

The Gothic style spread rapidly across Europe. It was especially well received in England, which, after all, was dominated by French Normans, and in Germany, where a fragmented conglomeration of independent cities, principalities, and bishoprics all sought to imitate what they conceived as the style of the French court. Wells Cathedral is one of the finest Gothic cathedrals built in England in the thirteenth century (Fig. **14.14**).

Fig. 14.14 **West facade, Wells Cathedral, Wells, England. 1230–50.** This cathedral exemplifies the preference for pattern and decoration in English Gothic architecture. The portal has become less important, and the rhythmic structure of the wide facade takes precedence. Life-size sculptures occupy each of the niches—originally 384 of them—representing the Last Judgment.

Stained Glass and Song Landscape Paintings

Stained-glass windows, so central to the Gothic style of architecture, illustrated biblical stories and Christian doctrine. In Song Dynasty China during the same era, a different sort of visual representation illuminated the spiritual truths of Daoism or "the way." Paintings of vast landscapes embodied the unifying principles of the natural world.

Gothic Sculpture

If we look at developments in architectural sculpture from the time of the decoration of the west portal of Chartres Cathedral (1145–70) to the time of the sculptural plan of the south transept portal (1215–20), and, finally, to the sculptures decorating the west front of Reims Cathedral (1225–55), we can see that, in a little over 100 years, Gothic sculptors had begun to reintroduce classical principles of sculptural composition into Western art.

Although they seem almost Byzantine in their long, narrow verticality, feet pointing downward, the jamb sculptures on the west portal of Chartres mark a distinct advance in the sculptural realization of the human body (Fig. **14.15**). These, and five more sets, flank the three doorways of the cathedral's Royal Portal. The center tympanum of the Portal depicts

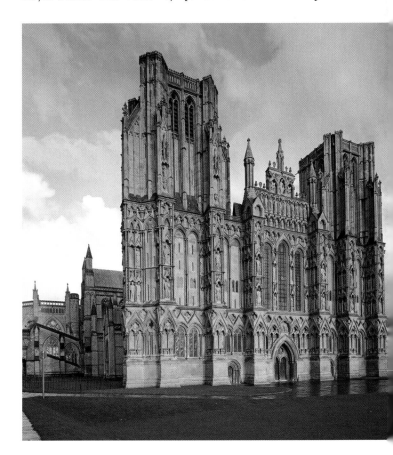

Fig. 14.15 Jamb statues, west portal, Chartres Cathedral. 1145–70.
The decorative patterns at the bottom of these jamb columns are, interestingly, reminiscent of Islamic designs in Spain.

Continuity & Change
p. 194

Doryphoros

Saint Theodore, to the left of the column, is particularly remarkable. For the first time since antiquity, the figure is posed at ease, his hip thrusts slightly to the right, his weight falling on his right foot. He stands, in other words, in a *contrapposto* position. (Recall the Greek sculptures of the fifth century BCE, carved in that posture, such as the *Doryphoros* [*The Spear Bearer*], Figure 7.4.) The weight of his sword belt seems to have pulled his cloak off to the right. Then, below the belt, the cloak falls back to the left. The strict verticality of the west portal is a thing of the past.

The sculptures at Reims break even further from Romanesque tradition. They are freed of their backdrop (Fig. **14.17**). The Angel of the Annunciation tells Mary (the figure next to the angel on the right) that she is with child. The next two figures, to the right, represent the Visitation, when Mary tells her cousin Elizabeth that she is with child and Elizabeth in turn announces the divinity of the baby in Mary's

Fig. 14.16 Jamb statues, south transept portal, Chartres Cathedral. ca. 1215–20. The statue of Saint Theodore, on the left, is meant to evoke the spirit of the Crusades.

Christ Enthroned in Royal Majesty, the north tympanum the Ascension of Christ, and the south the Virgin and Child Enthroned. The jamb sculptures represent figures from the Hebrew Bible considered to be precursors of Christ. These works have little in common with Romanesque relief sculpture, typified by the *Last Judgment* tympanum on the Cathedral of Sainte-Foy in Conques (see Fig. 13.7). While the Chartres figures remain contained by the form of the colonnade behind them, they are fully rounded and occupy a space in front of the column itself.

When Chartres was rebuilt after the fire of 1195, a new sculptural plan was realized for the transept doors. The figures stand before a colonnade, as do the jamb figures on the west portal, but their form is hardly determined by it (Fig. **14.16**). Now they stand flat-footed. Their faces seem animated, as if they see us. The monk just to the right of the dividing column seems quite concerned for us. The portrait of the knight

Fig. 14.17 *Annunciation* and *Visitation*, central portal, west facade, Reims Cathedral. Angel of the Annunciation, ca. 1245–55; Virgin of the Annunciation, 1245; Visitation group, ca. 1230–33. If these sculptures seem more naturalistic than any for nearly a thousand years, it is partly because they engage one another. It is as if, looking at them, we can overhear their conversation. Note that the most naturalistic sculpture, the Angel of the Annunciation, dates from 15 or 20 years after the Visitation group, suggesting an extraordinary advance, and preference for, naturalism in a very short span of years.

womb. Note how the drapery adorning the pair on the left, with its simple, soft folds, differs profoundly from the drapery of the pair on the right, whose robes are Roman in their complexity. The earlier Mary bears little, if any, resemblance to the other Mary, the first probably carved by a sculptor trained in Romanesque traditions, the latter by one acquainted with Classical models.

The two pairs are as different, in fact, as the two towers of Chartres Cathedral (see Fig. 14.5), which reflect both a weakening of the Romanesque insistence on balance and symmetry as well as the fact that both were done at different times. And yet the two pairs of sculptures share a certain emotional attitude—the good-humored smile of the angel, the stern but wise concern of Elizabeth. Even the relative ages of the persons depicted are apparent, where age would have been of no con-

cern to a sculptor working in the Romanesque tradition. These are, in short, the most fully human, most natural sculptures since Roman times. During the Gothic period artists developed a new visual language. The traditional narratives of biblical tradition could no longer speak through abstracted and symbolic types, but instead required believable, individual bodies to tell their stories. This new language invests the figures of Jesus, Mary, the saints, and even the Angel of the Annunciation with personality.

Music in the Gothic Cathedral: Growing Complexity

With its vast spaces and stone walls, the Gothic cathedral could be as animated by its acoustics as by its light, or, as at Reims, the liveliness of its sculpture. Ecclesiastical leaders were quick to take advantage of this quality in constructing their liturgy. At the School of Notre-Dame, in Paris, the first collection of music in two parts, the *Magnus Liber Organi* [MAG-nus LEE-bur or-GAN-ee] (The Great Book of Polyphony), was widely distributed in manuscript by about 1160. Among its many anonymous composers was Léonin [lay-OH-nen] (see CD–Track 13.1). The *Magnus Liber Organi* was arranged in song cycles to provide music for all the feast days of the Church calendar. The *Magnus Liber* was created at a time when most polyphony was produced and transmitted only orally. What makes it so significant is that it represents the beginning of the modern sense of "composition"—that is, works attributable to a single composer.

At the end of the century, Léonin's successor, Pérotin [pay-roh-TEN], revised and renotated the *Magnus Liber*. One of his most famous works is *Viderunt Omnes* (All Have Seen), a four-part polyphonic composition based on the traditional plainchant of the same name, meant to be sung in the middle of the Christmas Mass at Notre-Dame Cathedral in Paris (**CD-Track 14.1**). Throughout the piece, the choir sings a smooth monophonic plainchant, while three soloists sing the second, third, and fourth melodic lines in **counterpoint**, that is, in opposition, to the plainchant. The clear but intertwined rhythms of the soloists build to a crescendo of sustained harmony and balance that must have inspired awe in the congregation. The music seems to soar upward, imitating the architecture of the cathedral and elevating the faithful to new heights of belief.

The words are simple, but because each syllable is sung across a range of notes and rhythms, the music takes almost 12 minutes to perform. What follows is the Latin and translation:

Viderunt omnes fines terrae salutare Dei nostri. Jubilate Deo omnis terra.	All the ends of the earth have seen the salvation of our God. Praise God all the earth.
Notum fecit Dominus salutare suam. Ante conspectum gentium revelavit justitiam suam	The Lord has made known his salvation. Before the face of the people he has revealed his justice.

CULTURAL PARALLELS

Complex Music in Europe and Africa

While European musical forms evolved into complex compositions characterized by interweaving melodic lines and intertwining rhythms, the Benin culture in Africa, 3,000 miles away, also developed complex music. The music of Benin also focused on creating social cohesion and praising deities (rather than a single deity in Christianity). Instead of incorporating multiple melodic lines, however, the African music utilized polyrhythms.

The complexity of such rhythmic invention mirrors the growing textural complexity of the facade of Gothic cathedrals, with their spires, gables, crockets, and finials. Developing from this polyphony was an even more complex musical form, the **motet** [moh-TET], consisting of three (sometimes four) voices. The tenor—from the Latin *tenere*, "to hold"—generally maintained a traditional line based on ecclesiastical chant. The tenor line might be sung or played instrumentally, perhaps by the organ, an invention of the period, which began to replace the choir in the performance of many of these songs. In some ways, this was a practical gesture, since large choirs of the caliber needed to perform the liturgical songs were not easy to organize. But the rich tones of the organ, resonating through the nave of the cathedral, soon gained favor, and the organ became necessary to every large cathedral. In the motet, above the tenor line, two or three voices sang interweaving melodies.

By the late thirteenth century a motet might be sung in either Latin or vernacular French, and either or both parts might be hymns or troubadour love songs. All these competing lines were held together like the complex elements of the Gothic facade—balanced but competing, harmonious but at odds. They reflected, in short, the great debates—between church and state, faith and reason—that defined the age.

These debates raged at centers of higher learning, where music was part of the regular liberal arts curriculum.

Fig. 14.18 *Law Students*, relief sculpture on tomb of a law professor at the University of Bologna. ca. 1200. Marble. Masegne, Jacobello & Pier Paolo dalle (fl. 1383–1409). Giraudon, Museo Civico, Bologna, Italy. The Bridgeman Art Library. Although women were generally excluded from the professions of medicine and law, there were exceptions. In this group of law students, the central figure in the front row appears to be a woman, Novella d'Andrea (1312–66). She lectured at the university on both philosophy and law, although it is said that she was required to speak from behind a curtain so as not to distract the male students.

It was studied as a branch of the **quadrivium** [kwah-DRIV-ee-um] (the mathematical arts), alongside arithmetic, geometry, and astronomy, all fields dependent upon proportion and universal harmony. (The other liberal arts constituted the **trivium** [TRIV-ee-um], the language arts, which included grammar, rhetoric, and dialectic.) At the cathedral School of Notre-Dame in Paris, whose purpose was to train clergy, music was emphasized as an all-important liturgical tool. But by the middle of the twelfth century, cathedral schools began allowing nonclerical students to attend lectures. In 1179, a papal degree ordered the schools to provide for the teaching of the *laity* [LAY-ih-tee] (nonclerics), the decree that would eventually give rise to the university as an institution.

The Rise of the University

The first university was founded in Bologna [buh-LOHN-yuh], Italy, in 1148. Two hundred years earlier, in Spain, Islamic institutions of higher learning were generally attached to mosques since learning was considered sacred. At first, the term *university* meant simply a *union* of students and the instructors they contracted with to teach them. *Universitas* was an umbrella term for *collegia* the groups of students who shared a common interest or, as at Bologna, hailed from the same geographic area. The University of Bologna quickly established itself as a center for the study of law (Fig. **14.18**), an advanced area of study that students prepared for by mastering the seven liberal arts.

Proficiency in Latin was mandatory, and students studied Latin in all courses of their first four years of study. They read the writings of the ancient Greeks—Aristotle, Ptolemy, Euclid—in Latin translation. Augustine of Hippo's *On Christian Doctrine* was required reading, as were Boethius's writings on music and arithmetic. To obtain their bachelor of arts (BA) degree, students took oral exams after three to five years of study. Further study to acquire mastery of a special field led to the master of arts (MA) degree and might qualify a student to teach theology or practice medicine or law. Four more years of study were required to acquire the title of *doctor* (from the Latin,

doctus [DOK-tus], learned), culminating in a defense of a thesis before a board of learned examiners.

The University of Paris was chartered in 1200, and soon after came Oxford and Cambridge universities in England. These northern universities emphasized the study of theology. In Paris, a house or college system was organized, at first to provide students with housing and then to help them focus their education. The most famous of these was organized by Robert de Sorbon in 1257 for theology students. The Sorbonne, named after him, remains today the center of Parisian student life.

Heloise and Abelard The quality of its teaching most distinguished the University of Paris. Because books were available only in handwritten manuscripts, they were extremely expensive, so students relied on lectures and copious note-taking for their instruction. Peter Abelard [AB-uh-lahr] (1079–ca. 1144), a brilliant logician and author of the treatise *Sic et Non* ("Yes and No"), was one of the most popular lecturers of his day. Crowds of students routinely gathered to hear him. He taught by the **dialectical method**—that is, by presenting different points of view and seeking to reconcile them. This method of teaching originates in the Socratic method, but whereas Socratic dialogue consisted of a wise teacher who was questioned by students, or even fools, Abelard's dialectical method presumed no such hierarchical relationships. Everything, to him, was open to question. "By doubting," he famously argued, "we come to inquire, and by inquiring we arrive at truth."

Needless to say, the Church found it difficult to deal with Abelard, who demonstrated time and again that various Church Fathers—and the Bible itself—held hopelessly opposing views on many issues. Furthermore, the dialectical method itself challenged the unquestioning faith in God and the authority of the Church. Abelard was particularly opposed by Bernard of Clairvaux, who in 1140 successfully prosecuted him for heresy. By then, Abelard's reputation as a teacher had not faded, but his moral position had long been suspect. In 1119, he had pursued a love affair with his private student, Heloise [HEL-oh-eez]. Abelard not only felt that he had betrayed a trust by falling in love with her and subsequently impregnating her, but he was further humiliated by Heloise's angry uncle, in whose home he had tutored and seduced the girl. Learning of the pregnancy, the uncle hired thugs to castrate Abelard in his bed. Abelard retreated to the monastery at Saint-Denis, accepting the protection of the powerful Abbot Suger. Heloise joined a convent and later served as abbess of Paraclete [PAR-uh-kleet], a chapel and oratory founded by Abelard.

The Romance of the Rose The relationship of Heloise and Abelard would be celebrated in what is undoubtedly the most extensively illuminated and popular vernacular poem of the age, the *Roman de la Rose* (Romance of the Rose), begun by Guillaume de Lorris [ghee-OHM duh lor-EES] (d. ca. 1235) but largely written by Jean de Meung [zhun duh mun] (ca. 1240–ca. 1305). The book is the dream-vision of a 25-year-old narrator who finds himself, accompanied by Dame Oyouse, or Lady Idleness, before a walled garden full of roses and pleasure seekers (Fig. **14.19**). As he selects a rose for himself, the God of Love shoots him with several arrows, leaving him forever enamored of one particular flower. His efforts to obtain the Rose meet with little success. A stolen kiss alerts the guardians of the Rose, who then enclose it behind great fortifications. At the point where Guillaume de Lorris's poem breaks off, the narrator is left lamenting his fate. Jean de Meung concludes the narrative with a bawdy account of the plucking of the Rose,

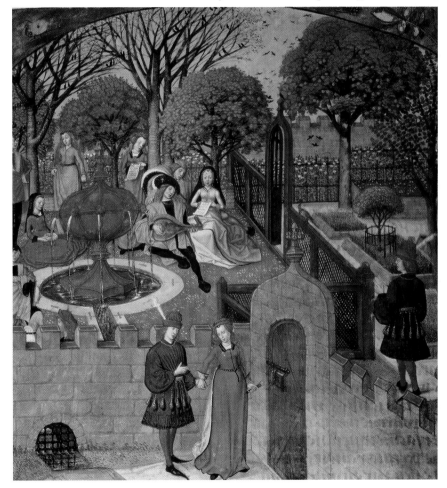

Fig. 14.19. The Master of the Prayer Books. *The Lover Being Shown the Entrance to the Garden by Lady Idleness*, *Roman de la Rose*. ca. 1500. British Library, Harley MS 4425, f. 14v. © British Library Board. All Rights Reserved, British Library, London, UK. Inside the garden, a lady, the personification of pleasure, and her companions listen to a lute player beside the fountain of Narcissus.

achieved through deception, which is very unlike Guillaume's idealized conception of the love quest. The book also included the first translations of the letters of Heloise and Abelard, originally written in about 1135–36 and rendered by Meung from Latin into the vernacular. They include Heloise's arguments to Abelard against their marriage, and her declaration of loyalty to him after she became a nun (see **Reading 14.1**, page 454).

Meung's versions of the letters are highly poeticized and bowdlerized, that is, sexual references were deleted (the term originates from the 1807 expurgated edition of William Shakespeare's works, *The Family Shakespeare*, edited by Thomas Bowdler to make the plays suitable for women and children). Heloise was a woman of considerable passion. Even during the celebration of Mass, she confesses, "lewd visions" of the pleasures she shared with Abelard "take such a hold upon my unhappy soul that my thoughts are on their wantonness instead of on prayers. I should be groaning over the sins I have committed, but I can only sigh for what I have lost." Though Meung praises Heloise for her intelligence, he especially admires her unwillingness to marry, her dedication to Abelard, and her self-sacrifice. Later medieval commentators would regard the *Roman de la Rose* as a thoroughly misogynist poem (see chapter 15).

The Education of Women Heloise's story reveals much about the education of women in the Middle Ages. Intellectually brilliant, she became Abelard's private student because women were not allowed to study at the university. There were some exceptions, particularly in Italy. At Bologna, Novella d'Andrea (1312–1366) lectured on philosophy and law. At Salerno, in southern Italy, the chair of medicine was held by Trotula (d. 1097), one of the most famous physicians of her time, although some scholars debate whether she was actually a woman, and convincing evidence suggests that her works are actually compendiums of works by three different authors. Concerned chiefly with alleviating the suffering of women, the major work attributed to her is *On the Diseases of Women*, commonly known throughout the Middle Ages as the *Trotula*. As the author says at the beginning of the treatise:

> Because women are by nature weaker than men and because they are most frequently afflicted in childbirth, diseases very often abound in them. . . . Women, from the condition of their fragility, out of shame and embarrassment do not dare reveal their anguish over their diseases (which happen in such a private place) to a physician. Therefore, their misfortune, which ought to be pitied, and especially the influence of a certain woman stirring my heart, have impelled me to give a clear explanation regarding their diseases in caring for their health.

In 63 chapters, the book addresses issues surrounding menstruation, conception, pregnancy, and childbirth, along with general ailments and diseases. The book champions good diet, warns of the dangers of emotional stress, and prescribes the use of opiates during childbirth, a practice otherwise condemned for centuries to come. It even explains how an experienced woman might pretend to be a virgin. The standard reference work in gynecology and obstetrics for midwives and physicians throughout the Middle Ages, the *Trotula* was translated from Latin into almost all vernacular languages and was widely disseminated.

Thomas Aquinas and Scholasticism

In 1245, Thomas Aquinas [uh-KWY-nus] (1225–74), a 20-year-old Dominican monk from Italy, arrived at the University of Paris to study theology, walking into a theological debate that had been raging for nearly 100 years, ever since the conflict between Abelard and Bernard: How does the believer come to know God? With the heart? With the mind? Or with both? Do we come to know the truth intuitively or rationally? Aquinas took on these questions directly and soon became the most distinguished student and lecturer at the university.

Aquinas was accompanied to Paris by another Dominican, his teacher Albertus Magnus (ca. 1200–1280), a German who taught at both Paris and Cologne and who later produced a biological classification of plants based on Aristotle. The Dominicans had been founded in 1216 by the Spanish priest Dominic (ca. 1170–1221) as an order dedicated to the study of theology. Aquinas and Magnus, and others like them, increasingly trained by Dominicans, were soon labeled *scholastics*. Their brand of theological inquiry, which was based on Abelard's dialectical method, was called **Scholasticism**.

Most theologians understood that there was a seeming conflict between faith and reason, but, they argued, since both proceeded from God, this conflict must, by definition, be a misapprehension. In the universities, rational inquiry and Aristotle's objective descriptions of physical reality were all the rage (see chapter 7), so much so that theologians worried that students were more enthralled with logical argumentation than right outcomes. Instead of studying heavenly truths and Scriptures, they were studying pagan philosophy, dating from the fourth century BCE. Scholasticism sought to reconcile the two. One of the greatest efforts in this direction is Aquinas's *Summa Theologica*, begun in 1265 when he was 40 years old. At Albertus Magnus's request, Aquinas set out to write a theology based entirely on the work of ancient philosophers, demonstrating the compatibility of classical philosophy and Christian religion. The *Summa Theologica* takes on virtually every theological issue of the age, from the place of women in society and the Church, to the cause of evil, the question of free choice, and whether it is lawful to sell a thing for more than it is worth. The medieval *summa* was an authoritative summary of all that was known

Continuity & Change

on a traditional subject, and it was the ultimate aim of every highly educated man to produce one.

In a famous passage Aquinas takes on the largest issue of all—the *summa* of *summas*—attempting to prove the existence of God once and for all. Notice particularly the Aristotelian reliance on observation and logically drawn conclusions. (**Reading 14.2**):

READING 14.2 **Thomas Aquinas, from *Summa Theologica***

Is there a God?

REPLY: There are five ways in which one can prove there is a God.

The FIRST . . . is based on change. Some things. . . are certainly in the process of change: this we plainly see. Now anything in the process of change is being changed by something else. . . . Hence one is bound to arrive at some first cause of change not itself being changed by anything, and this is what everybody understands by God.

The SECOND is based on the nature of causation. In the observable world causes are found to be ordered in series. . . . Such a series must however stop somewhere. . . . One is therefore forced to suppose some first cause, to which everyone gives the name "God."

The THIRD way is based on what need not be and on what must be. . . . Some . . . things can be, but need not be for we find them springing up and dying away. . . . Now everything cannot be like this [for then we must conclude that] once upon a time there was nothing. But if that were true there would be nothing even now, because something that does not exist can only be brought into being by something already existing. . . . One is forced therefore to suppose something which must be . . . [and] is itself the cause that other things must be.

The FOURTH way is based on the gradation observed in things. Some things are found to be more good, more true, more noble. . . and other things less [so]. But such comparative terms describe varying degrees of approximation to a superlative . . . [something that is] the truest and best and most noble of things. . . . There is something, therefore, which causes in all other things their being, their goodness, and whatever other perfection they have. And this we call "God."

The FIFTH way is based on the guidedness of nature. An orderedness of actions to an end is observed in all bodies obeying natural laws. . .; they truly tend to a goal and do not merely hit it by accident. . . . Everything in nature, therefore, is directed to its goal by someone with intelligence, and this we call "God."

Such a rational demonstration of the existence of God is, for Aquinas, what he called a "preamble of faith." What he calls the "articles of faith" necessarily follow upon and build on such rational demonstrations. So, although Christians cannot rationally know the essence of God, they can, through faith, know its divinity. Faith, in sum, begins with what Christians can know through what God has revealed to them in the Bible and through Christian tradition. Aquinas maintains, however, that some objects of faith, including the Incarnation, lie entirely beyond our capacity to understand them rationally in this life. Still, since we arrive at truth by means of both faith and reason—and, crucially, since all truths are equally valid—there should be no conflict between those arrived at through either faith or reason.

Although conservative Christians never quite accepted Aquinas's writings, arguing, for instance, that reason can never know God directly, his influence on Christian theology was profound and lasting. In the scope of its argument, the intellectual heights to which it soars, the *Summa Theologica* is at one with the Gothic cathedral. Like the cathedral, it is an architecture, built of logic rather than of stone, dedicated to the Christian God.

The Radiant Style and the Court of Louis IX

By the middle of the thirteenth century, the Gothic style in France had been elaborated into increasingly flamboyant patterns of repeated traceries and ornament that we have come to refer to as the *Rayonnant* [RAY-oh-nahnt] or **radiant style**. Similarly elaborate styles developed in both England and Germany. Although only three feet high, the Three Towers Reliquary (Fig. **14.20**), from Aachen Cathedral in Germany, gives a fair impression of this new, more complex style. It might as well be a model for a small church. Its pinnacles and spires soar upward. Rather than presenting us with a veil of stone—compare the facade of Reims Cathedral (see Fig. 14.9), which, although highly decorated, is a solid mass—the reliquary seems more like a web of gossamer. It is as if the walls themselves should dissolve into air and light, as if the building—or reliquary—should float away in a halo of golden rays.

This style was associated closely with the court of Louis IX (r. 1226–70), in Paris, which was considered throughout Europe to be the model of perfect rule. Louis was a born reformer, as much a man of the people as any medieval king could be. Under his rule the scholastics and Aquinas argued theology openly in the streets of Paris, just across the river from the royal palace. Louis believed in a certain freedom of thought, but even more in the rule of law (Fig. **14.21**). He dispatched royal commissioners into all of the provinces to check up on the Crown's representatives and ensure that they were treating the people fairly. He abolished serfdom and made private wars—which many believe to have been the

Fig. 14.20 Three Towers Reliquary. 1370–90. Chased and gilded silver, enamel, and gems, height 36¾". Cathedral Treasury, Aachen. This reliquary, probably of Flemish origin, has transparent containers just below the top of each spire, allowing light to pass over the sacred body parts contained within.

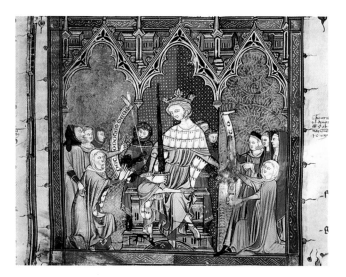

Fig. 14.21 King Louis IX rendering justice, France. 14th century. Biblioteca Real, El Escorial, Madrid, Spain. Photograph © Bridgeman-Giraudon/Art Resource, NY. Louis worked hard to make sure that legal remedies were accessible to all French people regardless of rank or wealth.

ultimate motivation for the First Crusade—illegal. He reformed the tax structure and gave his subjects the right to appeal decisions in court. He was, in short, something of a saint. Indeed, the Church later beatified him as Saint Louis.

The Church especially valued Louis's dedication to its well-being. One of his most important contributions to the Church, and to the history of Gothic architecture, is the royal chapel of Sainte-Chapelle [sant-shah-PELL] (Fig. **14.22**), constructed in the center of the royal palace on the Île de la Cité not far from

Continuity & Change
p. 386

Palatine Chapel of Charlemagne

Notre-Dame de Paris. Louis had the chapel designed so that the royal family could enter directly from the palace, at the level of the stained glass, thus symbolizing his own eminence, while others—court officials and the like—entered through a smaller, ground-level chapel below. He created for himself, in other words, a **palatine chapel**—a palace chapel—on the model of Charlemagne's at Aachen (see Fig. 12.12), thus connecting himself to his great predecessor.

The chapel was nothing short of a reliquary built large. While on Crusade, Louis purchased what was believed to be the crown of thorns that Christ wore at the Crucifixion, as well as other precious objects, from the emperor of Constantinople. These precious pieces were destined to be housed in Sainte-Chapelle. No other structure in the Gothic era so completely epitomized the Radiant style even as it embodied the original vision of the Abbot Suger:

> Thus, when—out of my delight in the beauty of the house of God—the loveliness of the many-colored gems [of stained glass] has called me away from external cares, and worthy meditation has induced me to reflect, transferring that which is material to that which is immaterial, on the diversity of the sacred virtues: then it seems to me that I see myself dwelling, as it were, in some strange region of the universe which neither exists entirely in the slime of the earth nor entirely in the purity of heaven; and that, by the grace of God, I can be transported from this interior to that higher world in an analogical manner.

Bathing the viewer in the light of its stained glass—light so bright, in fact, that the viewer can hardly distinguish the details of its biblical narrative—Sainte-Chapelle is designed to relieve the faithful of any external cares and transport them into a realm of heavenly beauty. It is spiritual space, the immateriality of its light comparable, in Suger's perspective, to the immateriality of the immortal soul. The ratio of glass to stone is higher than in any other Gothic structure, the windows separated by the slenderest of columns. The lower parts of the walls, beneath the windows, are richly decorated in red, blue, and gilt, so that stone and glass seem one and the same. Golden stars shine down from the deep blue of the delicately vaulted ceiling. Louis's greatest wish was to make Paris a New Jerusalem, a city as close to paradise as could be found on earth. For many visitors, he came as close as may be humanly possible in Sainte-Chapelle.

Fig. 14.22 Interior, upper chapel, Sainte-Chapelle, Paris. 1243–48. Although the chapel was originally surrounded by the royal castle—today it is surrounded by the Ministry of Justice—it remains more or less intact, save for a 19th-century repainting. Its acoustics were originally among the best in Paris and remain so today.

READINGS

from Jean de Meung's *The Romance of the Rose*

*The Romance of the Rose is an allegorical dream vision about love, in which a young man endeavors to pos-
sess the rosebud with which he has become enamored. In Meung's hands, it becomes a satire on contemporary
society. At the end of the poem, in an allegory of sexual intercourse, the lover finally penetrates the inner sanc-
tum of the rose. The poem ends with the narrator awakening, fulfilled, at daybreak. The following represents
the first publication of the letters of Heloise and Abelard, included in the poem as part of a jealous husband's
arguments against marriage.*

53

... Likewise did Heloise entreat
(The abbess of the Paraclete)
Her lover Peter Abelard,
That he would utterly discard
All thought of marriage from his mind.
This lady, noble and refined,
Of genius bright and learning great,
Loving, and loved with passionate
Strong love, implored him not to wed,
And many a well-wrought reason sped 10
To him in letters, where she showed
That hard and troublous is the code

54

Of marriage, howsoever true
Are those who bind themselves thereto;
For not alone had she in books
Studied, but all the closest nooks
Of woman's heart explored, and she
Love's throes had suffered bitterly.
Therefore she begged they might atwain,[1]
Though dying each for each, remain, 20
Bound by no bonds but those of love,
Whose gentle ties are strong above
All marriage laws, yet frank and free
Leave lovers—in sweet amity—
To follow learning, and she said,
Moreover, that long absence bred
'Twixt lovers unexpressed delight,
Most poignant when they're lost to sight.

But Peter, as himself hath writ
In burning letters, so was smit[2] 30
With passion, that nought else would serve
Till Heloise he drew to swerve
From her sage counsel, and thence fell
On him mischance most dire to tell;
For little more their course was run

Ere she at Argenteuil as nun
Was close immured,[3] while he was reft
Of manhood by his foes, who deft
As cruel were in his despite,
Seizing him as he lay one night 40
At Paris. After this mischance
Saint Denis, patron saint of France

55

Gave shelter to him as a monk;
And when this bitter cup he'd drunk,
Down to the dregs an abbey meet
He founded, hight[4] the Paraclete,
For Heloise, and there with good
Success she ruled the sisterhood.
Her love-lorn story hath she told
In letters which she penned with bold 50
Unshamed assurance; therein she
Declares monk Abelard to be
Her lord and master; and some say
These far-famed letters but betray
Delirious love. When first the dress
She donned of abbess, her distress
Broke forth in these wild words: If he
Who rules Rome's Empire courteously
Deigned to demand that I, as wife,
To him would dedicate my life, 60
In proud estate, I should reply
Much rather would I live and die
Thy mistress, wrapped in shame profound,
Than empress of the world be crowned.

But never since that day till now
Hath such a woman lived, I trow.[5] ■

Reading Question

**What does Jean de Meung value most in Heloise's rejection
of marriage, and why do you think a later medieval com-
mentary, written by one of the leading female writers of the
day, would reject it as misogynist?**

[1]**atwain:** separate. [2]**smit:** struck. [3]**immured:** confined. [4]**hight:** named. [5]**trow:** believe.

Summary

■ **Chartres Cathedral and the Gothic Style** The architectural style that came to be known as Gothic originated at the Abbey Church of Saint-Denis just north of Paris, which was dedicated in 1144. It was the work of Saint-Denis's abbot, Suger, who dreamed of bringing prominence to the Île-de-France by creating an architecture surpassing all others in beauty and grandeur. The most prominent feature of the new church was its stained glass. Chartres Cathedral, to the southwest, soon followed suit, after a fire destroyed the original structure in 1194, leaving only the west facade. The church was rebuilt into what many consider the most magnificent of all Gothic cathedrals, its stained glass unrivaled in Europe. Freed of load-bearing necessity by the innovative engineering that marks Gothic construction, the walls were thus also free to contain glass, which surrounds the entire cathedral. The purpose of the stained-glass programs in all Gothic cathedrals was to tell biblical stories in a compelling way to a largely illiterate audience.

As the Gothic style developed, important architectural innovations contributed to the goal of elevating the soul of worshipers to the spiritual realm. Extremely high naves were made possible by rib vaulting and flying buttresses. During the thirteenth century, architects began to embellish the exteriors of their cathedrals with increasingly elaborate decoration, including ambitious sculptural programs that culminated, during the thirteenth century, in the re-classicizing of Western art. At Reims Cathedral, particularly, the era was witness to the most fully human sculptures since Roman times.

■ **Liturgy and Music in the Gothic Cathedral** With its vast spaces and stone walls, the Gothic cathedral could easily be as animated by its acoustics as it was by its light. At the School of Notre-Dame, in Paris, the first collection of music in two parts, the *Magnus Liber Organi* (The Great Book of Polyphony), chiefly the work of the composers Léonin and Pérotin, was widely distributed in manuscript by about 1160. Among their most significant innovations is their emphasis on counterpoint and the complex musical form of the motet.

■ **Faith and Knowledge: The Cathedral and the University** In 1179, a papal decree ordered the cathedral schools to provide for the teaching of the laity (nonclerics), and the university as an institution was born. The quality of the teaching at the University of Paris distinguished it from the others. Peter Abelard, who taught by the dialectical method, was the school's most renowned lecturer. His affair with a private female student, Heloise, would cause them both great difficulty, and Heloise's fate reveals much about the prospects for educated women in the Middle Ages. But probably the most important scholar at the University of Paris was Thomas Aquinas, who adopted Abelard's dialectical method to his own Scholasticism. His *Summa Theologica* is an ambitious attempt to sum up all that was known about theology.

■ **The Radiant Style** By the middle of the thirteenth century, the Gothic style in France had been elaborated into increasingly flamboyant patterns of repeated traceries and ornament that we refer to as the Radiant style, the grandest example of which is the royal chapel of Sainte-Chapelle in Paris.

 ## Glossary

buttress A pillar or other support typically built against an exterior wall to brace it and strengthen an interior vault.

chimera A grotesque monster.

counterpoint An opposing element.

crocket A leaflike form that curves outward, with edges curling up, that was often added to pinnacles, spires, and gables of cathedrals.

dialectical method A method that juxtaposes different points of view and seeks to reconcile them.

finial A knoblike architectural form; also found on furniture.

flying buttress A stone structure that extends from a wall and employs an arch to focus the strength of the buttress's support at the top of the wall.

gargoyle A waterspout in the form of a grotesque creature.

Gothic A style of architecture and decoration prevalent in the twelfth through the fifteenth centuries in northern Europe, where, it was believed, classical traditions had been destroyed by Germanic invaders called Goths.

motet A polyphonic form consisting of three (and sometimes four) voices.

palantine chapel A palace chapel.

quadrivium In medieval universities, the mathematical arts, which included music, arithmetic, geometry, and astronomy.

radiant style A development of the French Gothic style featuring increasingly flamboyant patterns of repeated traceries and ornament.

rose window A round window with mullions (framing elements) and traceries extending outward from its center in the manner of the petals of a rose.

Scholasticism A brand of theological inquiry based on the dialectical method.

summa An authoritative summary of all that is known on a traditional subject.

trivium In medieval universities, the language arts, which included grammar, rhetoric, and dialectic.

Critical Thinking Questions

1. Explain the cult of the Virgin. How is it reflected at Chartres?

2. What, in your estimation, are the chief characteristics of Gothic architecture?

3. How does the musical style of the motet reflect the Gothic style of the architecture in which it was performed?

4. What is the dialectical method? Compare it with the Socratic method.

5. What was the purpose of the royal chapel of Sainte-Chapelle?

Among the surviving treasures of the Abbey Church of Saint-Denis is a sculpture of the Virgin and Child inscribed with the date 1339 and the name of Queen Jeanne d'Evreux [zhahn day-VRUH], wife of Charles IV of France (Fig. **14.23**). Just over two feet high, it embodies both the cult of the Virgin and the growing preference for naturalistic representation that is so evident in the jamb sculptures at Reims (see Fig. 14.17). The Virgin holds a scepter topped by a *fleur-de-lis* [flur-duh-lee], the heraldic symbol of the French monarchy, which served as a reliquary for what were said to be hairs from Mary's head. In this, she is a perfect medieval figure. But she also stands, her weight on one leg, in an exaggeration of the classical *contrapposto* pose into a pronounced S-curve, suggesting the Virgin's grace and elegance. Drapery falls around her, describing the body beneath as if it is actual flesh and bone. The softness of her face, the kindness of her expression, which the Christ child reaches out to touch, lend her a humanity that would become a characteristic of art made in the centuries to come. It is as if she is, in this sculpture, first a mother, then the mother of Christ.

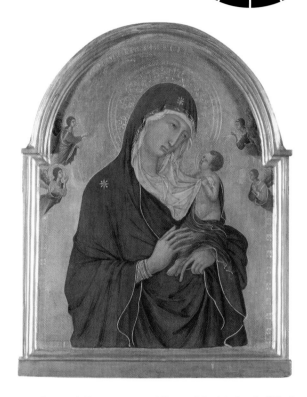

Fig. 14.24 Duccio di Buoninsegna and Simone Martini, detail of *Virgin and Child with Saint Dominic and Saint Aurea*. 1310–20. Tempera on wood, 24 1/4″ × 34 1/4″. National Gallery, London.

Painted at almost the same time, in Italy, is a depiction of the Virgin and Child by the Sienese [see-uh-NEEZ] master Duccio [DOO-chee-oh] and his assistant Simone Martini (Fig. **14.24**). Here, too, the artists emphasize the human nature of the Virgin's expression, the feeling captured in the mother's facial expression. It may have been just this humanity that made the cult of the Virgin so attractive to so many. If most of the faithful found it impossible to identify with Jesus, who was, after all, a superhuman figure, they could identify with the completely human Mary. In both images, we see a hint of what would be the driving force of intellectual pursuit in the fourteenth and fifteenth centuries: the exploration not of the meaning of the Bible, but of what it means to be human. ∎

Fig. 14.23 *Virgin and Child*, from the Abbey Church of Saint-Denis, France. ca. 1339. Inv.: MR 342; MR 419. M. Beck-Coppola/Musée du Louvre/RMN Réunion des Musées Nationaux, France. Art Resource, NY. Silver gilt and enamel, height 27 1/8″. Musée du Louvre, Paris.

15 Siena and Florence in the Fourteenth Century

Toward a New Humanism

Civic and Religious Life

Painting: A Growing Naturalism

The Spread of Vernacular Literature in Europe

The Black Death and Its Aftermath

This age of ours consequently has let fall, bit by bit, some of the richest and sweetest fruits that the tree of knowledge has yielded; has thrown away the results of the vigils and labors of the most illustrious men of genius, things of more value, I am almost tempted to say, than anything else in the whole world.

Petrarch, letter to a friend, 1351

◄ **Fig. 15.1 Leonardo da Vinci, *Landscape of the Arno River and Valley*. 1473.** Pen and two colors of brown ink, 7⅝″ × 11¼″. Gabinetto Disegna e Stampe degli Uffizi, Florence, Italy. This is Leonardo's earliest surviving dated drawing. It gives us a sense of what Tuscany looked like when Florence and Siena were rival city-states competing for political, social, and cultural dominance in Tuscany and all of Europe. As the two cities prospered, so did their painters, architects, and writers.

PRESENT-DAY TUSCANY LOOKS MUCH AS IT DID WHEN Leonardo da Vinci drew it in the fifteenth century (Fig. **15.1**). The original homeland of the Etruscans (see chapter 8), it is the area of central Italy that lies between the Apennine Mountains, the central spine of the Italian peninsula, and a

section of the Mediterranean known as the Tyrrhenian Sea (Map **15.1**). By the thirteenth century, its life and politics were dominated by two prominent city-states, Siena and Florence. Siena lies in the mountainous southern region of Tuscany, at the center of a rich agricultural zone famous for its olive oil and wine. Florence is located in the Arno river valley, the region's richest agricultural district.

The two were fierce rivals, their division dating back to the contest for supremacy between the pope and the Holy Roman Emperor during the time of Charlemagne (see chapter 12). The Guelphs sided with the pope, while the Ghibellines sided with the emperor. Siena was generally considered a Ghibelline city, and Florence a Guelph stronghold, although factions of both parties competed for leadership within each city, especially in Florence. By the end of the thirteenth century, the pope retaliated against Siena for its Ghibelline leanings by revoking the city's papal banking privileges and conferring them instead on Florence. As a result, by the fourteenth century, Florence had become the principal economic and political power in Tuscany.

In contrast to Milan and Naples, which were ruled by sovereigns, and the papal states, including Rome, which were ruled by the pope, both Siena and Florence were republics; the nobility did not rule them. This chapter traces the two cities' competition for preeminence during the thirteenth and fourteenth centuries. Out of this competition, the modern Western city as we know it—a more or less self-governing center of political, economic, and social activity, with public spaces, government buildings, and urban neighborhoods—was born. Republican Rome (see chapter 8) and Golden Age Athens (see chapter 7) were both models, but what distinguished Florence and Siena from these earlier republics was the role that the citizenry played in expressing their civic pride. The churches, monuments, and buildings of these late medieval cities were the work not of enlightened rulers but of the people themselves. Perhaps because the people were the great artistic patrons of the era, a new type of literature developed, written in Italian, not Latin, and often focusing on the more ordinary aspects of everyday life as lived by common people. The citizenry was genuinely thankful to God for its well-being and gave thanks by building, maintaining, and embellishing cathedrals. They built churches for the new monastic orders that served the cities' common folk. As in France, the cult of the Virgin inspired artists in both

cities, and both cities placed themselves under her protection. (They were, of course, practical as well, hiring mercenary armies to aid the Virgin in her work.)

Until 1348, despite the ups and downs each city experienced, the Virgin seemed to bless both with good fortune. But that year, as many as half the populations of both cities died of the plague. To many people, the Black Death represented the vengeance of an angry God punishing the people for their sins. But, in its wake, artists, writers, merchants, and scholars discovered greater personal freedom and opportunity. Perhaps inspired by the harsh realities they confronted during the plague, artists created works of ever-greater realism and candor.

Civic and Religious Life

The city halls of Florence and Siena, begun within two years of one another (1296 and 1298 respectively), and the broad plazas that fronted them, are eloquent symbols of the cities' similarities and their intense sense of competition (Figs.

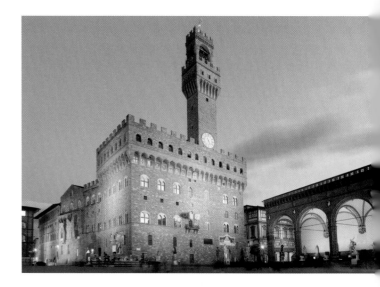

Fig. 15.2 Palazzo Vecchio, Florence. 1299–1310. To the right is the Loggia della Signoria, named for the *signori*, or "gentlemen," who governed the city. It was built between 1376 and 1382 and modeled on the Roman Basilica of Constantine (see Figs. 9.13, 9.14). In such gestures, Florence acknowledged its Roman, as opposed to Etruscan (i.e., Sienese), roots.

460

15.2, 15.3). Both buildings are more or less rectangular, decorated with crenellations meant to evoke the security and safety of the medieval fortress, and capped by tall bell towers. They dominate their urban landscapes and are reminiscent of the medieval castle's keep. Florence's Palazzo Vecchio is

Continuity & Change
p. 416

Stone Castle

heavy-looking, its massive stonework reflecting the solidity of the merchant class that erected it. In contrast, the light brickwork of the facade of Siena's Palazzo Pubblico, or "public palace," is interrupted by windows composed of thin marble columns supporting Gothic arches—as if to announce the artistic refinement of the city. Siena's bell tower purposefully dwarfs that of its Florentine rival. In front of both town halls are large public squares, places for the citizenry to gather to hear government decisions.

In both Siena and Florence, the fortunes of church and state were inextricably linked. Until the Palazzo Vecchio and the Palazzo Pubblico were built, both cities' governments met in churches. Afterward, the open squares in front of each building were used to host political events, and public sermons supported by the government brought the church into the government's very sphere. The local governments also invested heavily in building projects for the church.

Siena: A Free Commune

This marriage of church and state goes a long way toward explaining why Siena was one of the most powerful cities in Europe in the late Middle Ages. But so does its sense of its past, which lent it a feeling of historical weight. According to legend, its founders were Senius [SEN-ee-oos] and Aschius [ASS-kee-oos], the sons of Remus, who with his brother, Romulus, founded Rome. Romulus had killed their father in a quarrel, and the boys, in retribution, stole Rome's she-wolf shrine and carried it back to Siena, protected by a white cloud by day and a black cloud by night. The facade of the Palazzo Pubblico celebrates their feat: Sculptures of Romulus and Remus suckled by the she-wolf decorate it, and a heraldic crest, the *balzana*, consisting of a white field atop a black one, appears under each arch.

Siena remained a small Etruscan village for 700 years, until the Roman emperor Augustus colonized it in 13 BCE. The town was dominated first by Rome and then by local nobles, Lombard and Frankish feudal counts, who arrived in successive invasions to rule in the name of their king. By the tenth century, large numbers of serfs had migrated from the surrounding countryside to three separate hilltop villages that soon merged into one. Feudal authorities were not altogether opposed to such migration. They had trained many of the serfs to manufacture the finished goods that they desired. It seemed practical to concentrate such production by chartering Siena and other towns. The charter stipulated that the townspeople would make manufactured goods, and in return, the feudal lord would protect them. Gradually, the towns

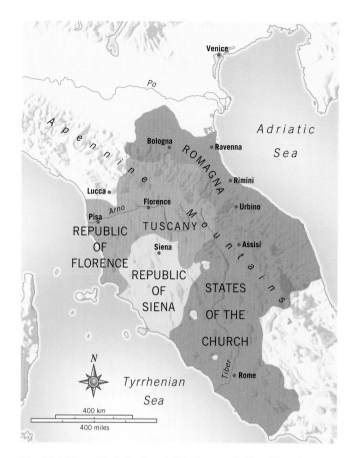

Map 15.1 Central Italy in about 1494, showing the Republics of Florence and Siena and the Papal States.

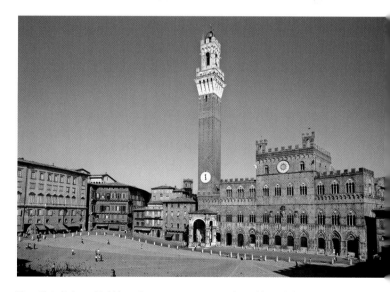

Fig. 15.3 Palazzo Pubblico, Siena. 1297–1310. The public palace faced the Campo. Townspeople rushed back and forth, trading and bartering, and although the square was surrounded by the palaces of noble families, bankers, and merchants, the Campo was considered to be the property of all Sienese citizens. On the Campo, everyone was equal.

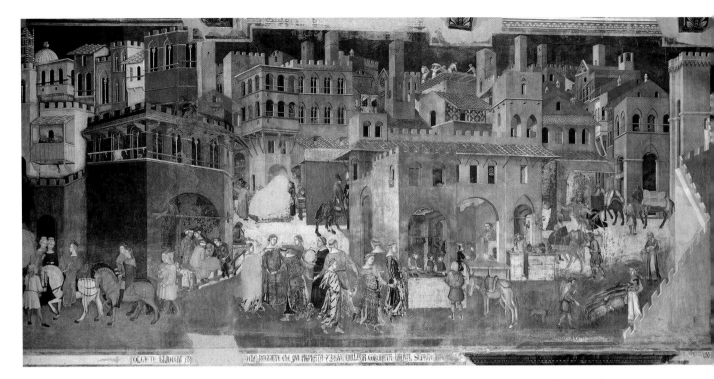

Fig. 15.4 Ambrogio Lorenzetti, *Allegory of Good Government: The Effects of Good Government in the City and Country,* fresco in the Sala della Pace, Palazzo Pubblico, Siena. 1338–39. Across from this painting Lorenzetti also painted an *Allegory of Bad Government,* in which there is no commerce, no dancing, only man killing man, destruction and darkness all around.

gained more importance and power, and their citizens began to pay allegiance not to feudal lords or papal authority but to the wealthiest citizens of the community, whose power base was founded on cooperation and the orderly conduct of affairs. When Siena established itself, in 1125, as a free **commune** (a collective of people gathered together for the common good), it achieved an immense advantage over its feudal neighbors. "Town air brings freedom" was a common saying in the late Middle Ages. As the prospect of such freedom attracted an increasing number of people to Siena, its prosperity was soon unrivaled.

Civic Life Crucial to the growing town's success was a new model of government, celebrated in 1338 by the painter Ambrogio Lorenzetti (active 1319–47) in a fresco called *Allegory of Good Government* (Fig. **15.4**), commissioned for the council chamber of Siena's Palazzo Pubblico. The fresco depicts Siena as it actually appeared. Richly dressed merchants dance in the street, one couple passing beneath the arching arms of another, followed by a chain of revelers dancing hand in hand. To the left, in an arched portico, three men play a board game. To their right is a shoe shop, behind that a schoolroom where a teacher expounds to a row of students, and beside the schoolroom, a wine shop. At the very top, masons construct a new building. Outside the city gate, to the right, the surrounding countryside is lush. Farmers bring livestock and produce to market, workers till the fields and labor in the vineyards. Above them all, floating in the sky, is

the nearly nude figure of *Securitas* [she-koo-ree-TASS] ("Security"), carrying a gallows in one hand and a scroll in the other, to remind citizens that peace depends upon justice. At the horizon, the sky is ominously dark, suggesting perhaps that Siena's citizens thought of themselves as living in a uniquely enlightened place.

Watching over the city's well-being was the Virgin Mary, uniting civic and religious life. The city called itself "ancient city of the virgin," and by 1317, a *Maestà,* or *Virgin and Child in Majesty* (see Fig. 15.11), occupied the end wall of the council chamber of the Palazzo Pubblico. Painted by Simone Martini (active 1311–44), the *Maestà* depicts the Madonna and Christ Child surrounded by a heavenly court of saints and angels. Below, two kneeling angels offer up vessels of roses and lilies. The Virgin comments in verse, written on the platform below: "The angelic little flowers, roses and lilies, Which adorn the heavenly meadow, do not please me more than good counsel." Thus the Virgin exerts her moral influence over civic life.

The demands of daily life in Siena required divine intervention. The town had long divided itself into three distinct neighborhoods, corresponding to the three ridges of the hillside on which the city stands. With the advent of the commune, the city was ruled by three consuls, one for each neighborhood. There were other divisions as well. The wealthiest Sienese nobles, called the *grandi,* or "great ones," lorded over smaller neighborhoods, or wards, in a manner not unlike their feudal forebears. The clergy, headed by a bishop,

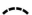

were independent, and local churches, convents, and lay organizations devoted to deeds of charity were more or less self-governing. The common people organized themselves as military companies, which could unite to form a large Sienese army, but which also guaranteed local autonomy. And competing *arti*, or **guilds**, associations or groups of people with likeminded, often occupation-based interests, exercised power over their members.

The guilds became an increasingly powerful force in the commune. Leading the way was the merchants' guild, organized as early as 1192. The richest merchant families lent money (charging interest on their loans, despite a papal ban on the practice) and dealt in wax, pepper, and spices, as well as Flemish cloth, shoes, stockings, and belts. Other guilds, such as masons, carpenters, innkeepers, barbers, butchers, and millers, quickly established themselves, but none was as powerful as the merchants' guild. By 1280, its members controlled city government, excluding the nobility and declaring that only "good popular merchants" should be eligible to serve on the city council.

Other guilds resented the merchants' control over the city's government, and in 1355, the people gathered in the Campo before the Palazzo Pubblico and forced their resignation. From then on, anyone belonging to a guild was technically eligible to serve on the council, except merchants and nobles. The exercise of power being what it is, however, control soon fell to the next great guilds below the merchants, the shopkeepers and notaries. By 1368, vying

factions caused the disintegration of the government, as four revolutions rocked the city in as many months. The commune was a thing of the past.

Florence: Arch Rival of Siena

Like Siena, Florence was extremely wealthy, and that wealth was based on trade. By the twelfth century, Florence was the center of textile production in the Western world and played a central role in European trade markets (Map **15.2**). The Arno River provided ample water for washing and rinsing sorted wool and finished cloth. The city's dyeing techniques were unsurpassed—to this day the formulas for the highly prized Florentine reds remain a mystery. Dyestuffs were imported from throughout the Mediterranean and even the Orient, and each year Florentine merchants traveled to England, Portugal, Spain, and Flanders to purchase raw wool for their manufactories.

As in Siena, it was the city's bankers and moneylenders who made Florence a vital player in world trade. Florentine bankers invented checks, credit, even life insurance. Most important, in 1252 they introduced Europe's first single currency, the gold *florin*. By 1422, over 2 million florins were in circulation throughout Europe. This was a staggering number considering that a family could live comfortably on about 150 florins a year, and the finest palace cost about 1,000 florins. Florence was Europe's bank, and its bankers were Europe's true nobility.

CULTURAL PARALLELS

Textiles in Florence and Peru

Florence was the center of textile production in the West, but 7,000 miles farther west, the Inca culture of the Peruvian highlands also produced abundant supplies of high-quality textiles. The Inca valued these woolen products even more than gold, and weavers encoded complex symbolism into the fabric (see chapter 16).

The Guilds and Florentine Politics Only two other cities in all of Italy—Lucca and Venice—could boast that they were republics like Siena and Florence, and governing a republic was no easy task. As in Siena, in Florence the guilds controlled the commune. By the end of the twelfth century there were seven major guilds and fourteen minor ones. The most prestigious was the lawyers' guild (the Arte dei Giudici), followed closely by the wool guild (the Arte della Lana), the silk guild (the Arte di Seta), and the cloth merchants' guild (the Arte di Calimala). Also among the major guilds were the bankers, the doctors, and other merchant classes. Butchers,

bakers, carpenters, and masons composed the bulk of the minor guilds.

As in Siena, too, the merchants, especially the Arte della Lana, controlled the government. They were known as the *Popolo Grasso* (literally, "the fat people"), as opposed to *Popolo Minuto*, the ordinary workers, who comprised probably 75 percent of the population and had no voice in government. Only guild members could serve in the government. Their names were written down, the writing was placed in leather bags (*borse*) in the Church of Santa Croce, and nine names were drawn every two months in a public ceremony. (The period of service was short to reduce the chance of corruption.) Those *signori* selected were known as the *Priori*, and their government was known as the *Signoria*—hence the name of the Piazza della Signoria, the plaza in front of the Palazzo Vecchio. There were generally nine Priori—six from the major guilds, two from the minor guilds, and one standard-bearer.

The Florentine republic might have resembled a true democracy except for two details: First, the guilds were very close-knit so that, in general, selecting one or the other of their membership made little or no political difference; and second, the available names in the *borse* could be easily manipulated. However, conflict inevitably arose, and throughout the thirteenth century other tensions made the problem worse, especially feuds between the Guelphs and

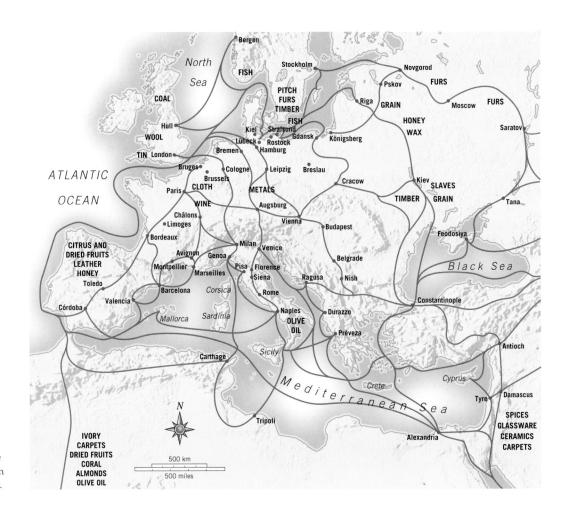

Map 15.2 Principal trade routes in medieval Europe. As commerce grew among the regions of Europe, the cities on this map grew proportionately.

Ghibellines. In Florence, the Guelphs were generally merchants and the Ghibellines were nobility. Thus, the battle lines between the two were drawn in class terms, often resulting in family feuds and street violence. In fact, the tower of the Palazzo Vecchio was built on the site of a preexisting Ghibelline tower of the palace of the noble Uberti family, and the plaza in front was created by razing the remainder of the Uberti palace complex. Thus, both city hall and the public gathering place represented the triumph of Guelph over Ghibelline, the merchant class over the aristocracy.

Tuscan Religious Life

Although the guilds exercised considerable influence over day-to-day life in fourteenth-century Tuscany, nothing influenced the people more than the Church. It is natural, therefore, that in addition to building new city halls and public plazas, civic leaders turned their attention to the cathedrals.

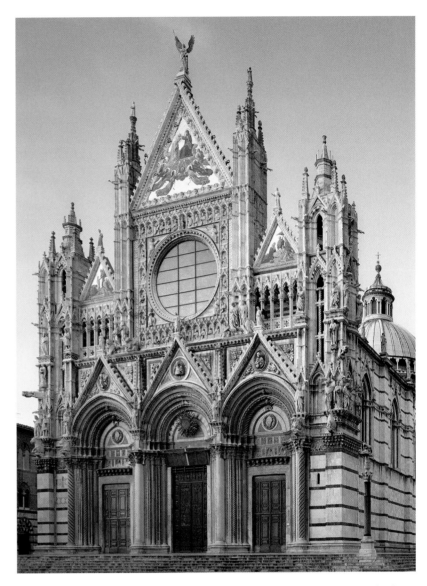

Fig. 15.5 **Giovanni Pisano, lower facade, Siena Cathedral. 1284–99.** Pisano designed only the lower half of the facade. Except for the rose window, the upper half of the facade dates from the 14th century. The mosaics in the top gables date from the 19th century.

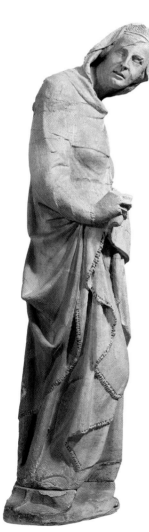

Fig. 15.6 **Giovanni Pisano, *Mary, Sister of Moses.* 1284–99.** Marble, height 74 3/4″. Museo dell'Opera del Duomo, Siena. This sculpture was once on the facade of the Siena Cathedral. The sculptures now in place on the facade are copies of the originals, which were removed to protect them from further deterioration.

Giovanni Pisano and Siena Cathedral Siena took the lead, commissioning a new facade for its magnificent cathedral in 1284 (Fig. **15.5**). The artist in charge, Giovanni Pisano, integrated features of the French Gothic style, such as the three portals and rose window, with the characteristic two-tone marble banding of the original Romanesque cathedral.

But Pisano's great innovation was his sculpture program, which incorporated freestanding sculptures of prophets and saints on the pinnacles, arches, and gables of the facade. His *Mary, Sister of Moses* (Fig. **15.6**) is an example. She leans dramatically forward, as if turning to communicate with the other figures on the facade. But her pose also is the result of Giovanni's acute sense of his public. He realized that, when seen from street level, Mary's face would be hidden behind her dress and breasts if he did not arch her neck forward. The result is a figure that stands independently of the architecture

Voices

Spilled Cherries

Even in an enlightened city-state like Florence, urban life still had its pitfalls. This account was written by Franco Sacchetti (ca. 1333–1400), the son of a merchant who gained repute as poet while a young man. He worked as an official in Florence and the surrounding regions and rose to a high rank. His best-known book, Trecentonovelle, *vividly describes the street scenes in Florence and local personalities.*

> "He had a son who was eighteen years old, and one morning when he had to go to the Bargello . . . he gave this son some of his papers . . . telling him to . . . wait for him outside the building."

In the city of Florence there was once a man called Piero Brandani who used to spend his whole time on litigation. He had a son who was eighteen years old, and one morning when he had to go to the Bargello to contest a case he gave this son some of his papers, telling him to go on ahead with them and wait for him outside the building. The boy did just as he was told, went along there and settled down to wait. . . . All this took place during the month of May and so it happened that whilst the boy was waiting it began to pour with rain. A country-woman who had come to sell fruit was passing by with a basket of cherries on her head and the basket overturned, spilling the cherries all over the street. This boy, who like the rest of the passersby, had an eye for this sort of thing, eagerly joined in the free-for-all over the cherries, and he and the others went chasing for them. . . . However, when all the cherries were finished and he had returned to his post he suddenly discovered the papers he had been holding under his arms were no longer there. For whilst his mind had been on other things they had dropped into the stream and immediately been swept way down to the Arno [river]. He began rushing hither and thither, desperately asking if anyone had seen them, but all in vain—by that time the papers were sailing towards Pisa.

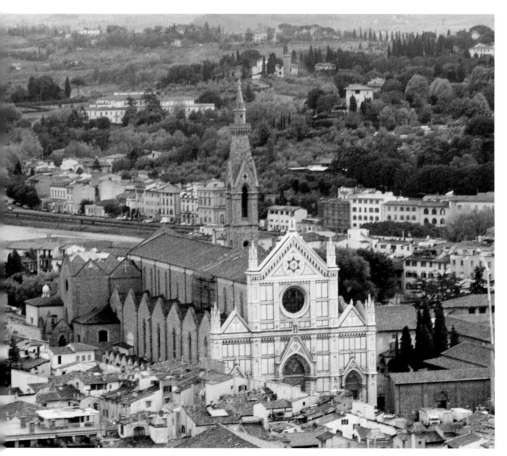

Fig. 15.7 Santa Croce, Florence. Begun 1294. Santa Croce was commissioned by the Franciscans with the support of the Florentine government and private citizens.

and, like the other figures on the facade, asserts its freedom in a manner comparable to the figures on the west portal of Reims Cathedral (see Fig. 14.17).

In 1294, Florence responded to Siena's initiative when the Arte della Lana formed the Opera del Duomo, or Department of Works of the Duomo ("duomo" comes from *domus dei*, or "house of God"), a committee in charge of building a new cathedral. Construction began in 1296, although the building would not be completed until the first half of the fifteenth century (see chapter 17). The guild claimed that the Duomo would be "the most beautiful and honorable church in Tuscany," an assertion that everyone understood to mean it would compete with Siena's cathedral.

The New Mendicant Orders Aside from cathedrals, civic leaders also engaged in building projects for the new urban religious orders: the Dominicans, founded by the Spanish monk Dominic de Guzman (ca. 1170–1221), whose most famous theologian was Thomas Aquinas (see chapter 14); and the Franciscans, founded by Francis of Assisi (ca.

1181–1226). Unlike the traditional Benedictine monastic order, which functioned apart from the world, the Dominicans and the Franciscans were reformist orders, dedicated to active service in the cities, especially among the common people. Their growing popularity reflects the growing crisis facing the mainstream Church, as isolation and apparent disregard for laypeople plagued it well into the sixteenth century.

The mainstream Church held property and engaged in business—sources, many felt, of the Church's corruption. The Dominicans and Franciscans were both **mendicant orders**: that is, they neither held property nor engaged in business, relying for their support on contributions from their communities. The Dominicans and the Franciscans were rivals, and they often established themselves on opposite sides of a city. The Dominicans' priority was preaching. The Franciscans committed themselves to a severe regimen of prayer, meditation, fasting, and mortification of the flesh, based on Francis's conviction that one could come closer to God by rejecting worldly goods. But both orders borrowed freely from one another. The Franciscans adopted the more efficient organizing principles of the Dominicans as well as their love of learning and emphasis on preaching, while the Dominicans accepted the Franciscan repudiation of worldly goods.

Franciscan and Dominican Churches

In Florence, the civic government and private citizens worked with the Franciscans to build the church of Santa Croce (Fig. **15.7**). Construction began in 1294 and continued even as the city began constructing its main cathedral. Santa Croce was on the eastern side of the city, and the Dominican church of Santa Maria Novella (Fig. **15.8**) was built on the western side, underscoring the rivalry between the two orders.

A Franciscan church and a Dominican church were also built in Sienna. Compared to Gothic churches of the period, the mendicant churches are austere in their decoration. Nothing like the dramatic gables, finials, and sculpture program that decorate Giovanni Pisano's Siena Cathedral distinguish their plain facades, and their interiors are likewise unembellished. The ceiling of Santa Croce consists of an open wooden truss, a far cry from the rising vaults of the Gothic interior. At Santa Maria Novella, the marble striping that defines the rich surfaces of Siena's cathedral is used only on the arches, leaving the rest of the interior surface bare. Families sup-

CULTURAL PARALLELS

Guilds in Siena, Florence, and Hangzhou, China

Perhaps the most important institution besides the Catholic Church in thirteenth-century Siena and Florence was the system of guilds, or associations of craftspeople, professionals, and merchants. During the same era in Hangzhou, China, guilds also played a central role in social and economic development (see chapter 16).

ported the construction of both Florentine churches by donating chapels, held as family property, and built on either side. Private family masses could be celebrated in these chapels, and, as opposed to the more public spaces in the churches, they were often richly decorated and their walls painted with frescoes. Thus, a rich family expected to guarantee its salvation by contributing to the church, and the order could accept the church and its chapels as a form of alms, consistent with its vow of poverty.

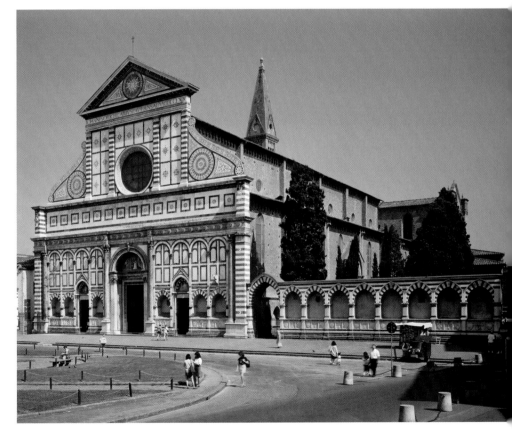

Fig. 15.8 Santa Maria Novella, Florence. Founded before 1246, nave begun after 1279. Santa Maria Novella was commissioned by the Dominicans and, like Santa Croce, its construction was supported by the Florentine government and private citizens.

The Appeal of Saint Francis Both the Dominican and Franciscan orders were sanctioned by Pope Innocent III (papacy 1198–1216). Innocent exercised papal authority as no pope had before him. He went so far as to claim that the pope was to the emperor as the sun was to the moon, a reference to the fact that the emperor received his "brilliance" (that is, his crown) from the hand of the pope. Innocent established the papacy as a self-sustaining financial and bureaucratic institution. He formalized the Church hierarchy, from pope to parish priest, and gave full sanction to the doctrine of *transubstantiation* (the belief that the bread and wine of sacrament become the true body and blood of Christ when consecrated by a priest), and made annual confession and Easter communion mandatory for all adult Christians.

Innocent was also a remarkably gifted preacher—his sermon *On the Misery of the Human Condition* was one of the most famous of its day (see Reading 13.1)—and the power of his words, if not the fierceness of his rhetoric, served as a model for both the Dominicans and the Franciscans. But, where Innocent appealed to the fear of death and damnation, mendicant orders appealed to the promise of life and salvation. Nevertheless, Innocent clearly understood the popular appeal of preaching and the influence that preaching gave to the new mendicant orders. He especially understood the attraction offered by the example of Francis of Assisi.

The son of a rich cloth merchant, Francis became disaffected with wealth and urged his followers to lead a life of poverty. A series of 28 frescoes in the Upper Church of San Francesco in his hometown of Assisi narrates his life. The works have often been attributed to Giotto di Bondone, the first great Italian painter of the fourteenth century (discussed later in this chapter). The Saint Francis paintings at Assisi are stylistically different enough from Giotto's other work, however, that many art historians believe them to be the work of an unknown Roman painter, often called the Saint Francis Master.

The faces and folds of cloth in the work of the Saint Francis Master are defined with broad white highlights applied over the background colors. Note the right leg of the figure in yellow holding Francis's clothes in a scene where the saint is depicted renouncing his patrimony (inheritance) by removing his clothing, (Fig. **15.9**). Giotto, as we will see, uses a gradual and continuous blending of dark colors to re-create the realistic appearance of shadows.

Francis's love of the natural world was profound; in his mystical poem *Canticle of the Sun*, his language suggests an intimate bond with the universe. Addressing "brother sun" and "sister moon," "brother wind" and "sister water," this poem may be the first work of literature in the vernacular, or the language spoken by the people in everyday usage., as opposed to Latin (see **Reading 15.1**, page 489). Stories detailing the deeds and miracles of Francis's life embodied the reasons that he was to be revered. In his official biography of Francis, Bonaventure of Bagnoreggio (ca. 1217–74) tells how Francis created the first crèche (**Reading 15.2**):

READING 15.2 **from Bonaventure of Bagnoreggio, *Legenda Maior***

He asked for and obtained the permission of the pope for the ceremony, so that he could not be accused of being an innovator, and then he had a crib prepared, with hay and an ox and an ass. The friars were all invited and the people came in crowds. The forest re-echoed with their voices and the night was lit up with a multitude of bright lights, while the beautiful music of God's praises added to the solemnity. The saint stood before the crib and his heart overflowed with tender compassion; he was bathed in tears but overcome with joy . . .preached to the people about the birth of the poor King, whom he called the Babe of Bethlehem. . . .
[T]he hay from the crib, which was kept by the people, afterwards cured sick animals and drove off various pestilences. Thus God wished to give glory to his servant Francis and prove the efficacy of his prayer by clear signs.

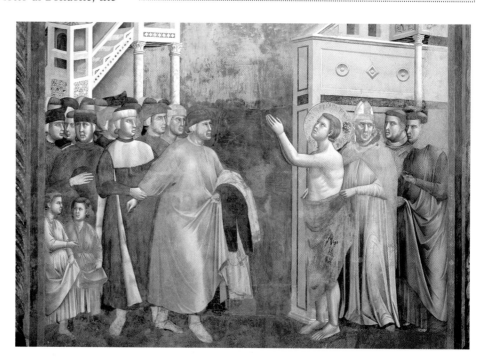

Fig. 15.9 Saint Francis Master, *Saint Francis Renounces His Patrimony,* **fresco in Upper Church of San Francesco, Assisi, Umbria, Italy. ca. 1295–1305.** A severe earthquake gravely damaged the Assisi fresco cycle on September 26, 1997, when two sections of the church's roof collapsed.

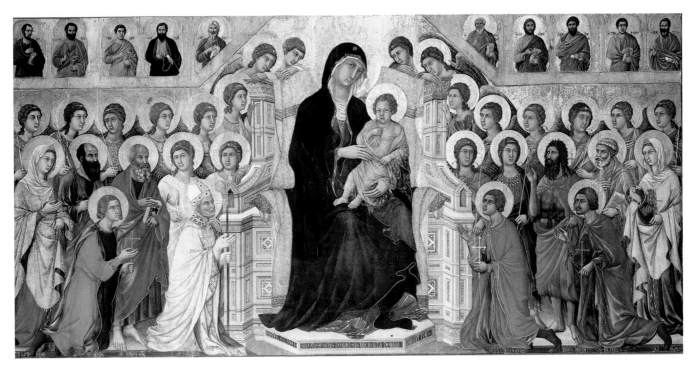

Fig. 15.10 Duccio di Buoninsegna. *Maestà*, main panel of *Maestà Altarpiece*, from Siena Cathedral. 1308–11. Tempera and gold on wood, 7′ × 13′ 6¼″. Museo dell'Opera del Duomo, Siena. The Madonna's throne imitates the stone facade of the Siena cathedral.

There were so many such stories that Pope Gregory IX (papacy 1227–41) canonized Francis two years after his death, and ordered that the Church of San Francesco be built in his honor at Assisi.

Painting: A Growing Naturalism

Even though Saint John the Baptist was the patron saint of Florence, the city, like Siena, relied on the Virgin Mary to protect it. Her image appeared frequently in the mendicant churches and elsewhere, and these images were said to perform miracles. Pilgrims from Tuscany and beyond flocked to Florence to receive the Madonna's good graces. As in Siena, whenever the city was threatened—by war, by flood, by plague—the Madonna's image was carried through the city in ceremonial procession. The two cities put themselves under the protection of the Virgin, and it was not long before they were competing to prove who could paint her the most magnificently. In the process, they began to represent her less in the stiff, abstracted manner of the Byzantine icon and more as a real person of flesh and blood.

Duccio and Simone Martini

After the Venetian rout of Constantinople in the Fourth Crusade in 1204 (see chapter 13), Byzantine imagery flooded Europe. One of the first artists to break from the Byzantine tradition was the Sienese native Duccio di Buoninsegna (active 1278–1318). In 1308, the *commune* commissioned

Duccio to paint a *Maestà*, or *Virgin and Child in Majesty* (Fig. **15.10**), to be set under the dome of Siena's cathedral. The finished work was greeted with a great celebration:

> "On the day that it was carried to the [cathedral]," a contemporary chronicler reports, "the shops were shut, and the bishop conducted a great and devout company of priests and friars in solemn procession, accompanied by . . . all the officers of the commune, and all the people, and one after another the worthiest with lighted candles in their hands took places near the picture, and behind came the women and children with great devotion . . . making the procession around the Campo, as is the custom, all the bells ringing joyously, trumpets and bagpipes playing, out of reverence for so noble a picture as is this."

Duccio was well aware of the greatness of his achievement. Along the base of the Virgin's throne he wrote these words: "Holy Mother of God, give Siena peace and Duccio life because he painted Thee thus," announcing both the artist's piety and pride in his work and the growing prominence of artists in Italian society as a whole.

Duccio's *Maestà* begins to leave the conventions of the Byzantine icon behind and incorporates the Gothic tendency to naturalism. (Compare the Byzantine Fig. 10.13.) Duccio's Christ Child seems to be an actual baby, and a slightly chubby one at that. Similarly,

Continuity & Change
p. 329

Theotokos and Child

beneath the Madonna's robes, we can sense a real body. Her knee especially asserts itself, and the drapery falling from it drops in long, gentle curves, much more natural-looking than the rigid, angular drapery of earlier, Byzantine works. Four angels peer over the top of the Madonna's throne, gazing on the child like proud relations. The saints who kneel in the front row appear to be individuals rather than types. Notice especially the aging and bearded cleric at the left. All are patron saints of the city, underscoring the fact that Duccio's painting is both an ecclesiastical and civic commission.

If Duccio's *Maestà* reflects the growing realism of Sienese art, the *Maestà* of Simone Martini, in the Hall of the Mappamondo in Siena's Palazzo Pubblico, is even more naturalistic (Fig. **15.11**). Simone had worked on the cathedral *Maestà* as Duccio's apprentice from 1308 to 1311, and he probably modeled his own work on it. Situated in a public building, overlooking the workings of civic administration, Simone's painting announces, even more dramatically than Duccio's, the blending of the sacred and secular in Tuscan culture.

One of the great innovations of Simone's fresco is the Virgin's crown, which signifies her status as Queen of Heaven. Surrounded by her celestial "court," she reveals the growing influence of French courtly poetry (see chapter 13) in Italy. She becomes a model for human behavior, an emblem in the spiritual realm for the most noble types of secular love and devotion, including devotion to the right conduct of govern-

ment. Highlighting the secular message, Jesus holds a parchment, adhered to the surface of the fresco, that reads, "Love Justice you who judge the earth." Like Duccio's painting, Simone's fresco carries a propagandistic message to the city fathers. As we have seen (see page 462), inscribed at the base of the throne are these words: "The angelic little flowers, roses and lilies, Which adorn the heavenly meadow, do not please me more than good counsel." The painting suggests that the Virgin is as interested in worldly affairs as divine ones. Because of the realistic way Simone has represented her, she is as human as she is divine.

Stylistic differences separate the two works as well. As in the Byzantine icon from which she derives (see Fig. 10.13), Duccio's Madonna wears no crown, her brows turn without interruption down into the length of her nose, she is draped in blue, with an orange undergarment, and her rounded hood echoes the halo behind her head. She is much larger than those attending her, conforming to the hierarchies of Byzantine art. In Simone's version of the theme, the Virgin and surrounding figures are depicted almost in the same scale. As opposed to Duccio's painting, with its stacked receding space, Simone's Virgin sits in a deep space of the canopy with its delicate Gothic arches behind the throne. Both of the Virgin's knees are visible, with the Christ Child standing firmly on one of them. Her head and neck, rather than being shrouded behind an all-embracing hood, are rounded and full

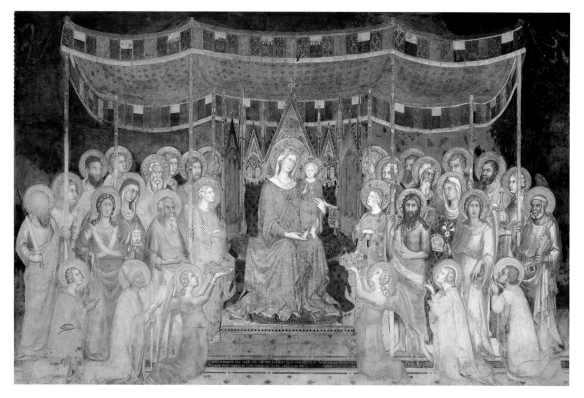

Fig. 15.11 Simone Martini, *Maestà*, Council Chamber, Palazzo Pubblico, Siena. ca. 1311–17, repaired 1321. Fresco, 25′ × 31′ 9″. Martini's fresco covers the end wall of the Council Chamber, symbolically submitting that civic body's deliberations to the Madonna's watchful gaze and care.

beneath the crown and its softly folded train, which is itself fully rounded in shadow behind her neck. Her robe, neglecting convention, is composed of rich, transparent silks, beneath which we can see her right arm. Above all, her porcelain-white skin, tinged with pink, gives her complexion a realistic tone. Blood flows through her body, rouging her cheeks, and her flesh breathes with life. She embodies, in fact, a standard of beauty absent in Western art since Classical times—the physical beauty of the flesh as opposed to the divine beauty of the spirit. In less formal pictures, Duccio, too, used a naturalistic style.

Because his altarpiece (Fig. 15.11) was free-standing under the dome of the cathedral and could be seen from all sides, Duccio decorated its back with scenes from the Passion of Christ. In *Christ Entering Jerusalem* (Fig. **15.12**), Duccio renders space in a realistic way. Jerusalem is depicted as a hill town, not unlike Siena, and Christ rides his donkey up the hill to the city gate as crowds gather to see him. Notable for the simple humanity of their behavior are the figures climbing trees behind the wall and another who peers out a second-story window inside the gate. But the remarkable achievement here is that Duccio's architecture begins to define the space of the painting, surrounding and containing the figures within it. Compare it with the architectural setting of *Hildegard's Vision* (see Fig. 12.19), where the figures occupy a space in front of what looks more like a stage set or backdrop than a real scene. Duccio's perspective, though by no means perfect, transforms the flat space of medieval painting into a deep space with three-dimensional reality.

Continuity & Change
p. 391

Hildegard's Vision

Cimabue and Giotto

Florence, too, had its master painters of the Virgin. Even before Duccio became active in Siena, a painter known as Cimabue had produced a large-scale Virgin for the altarpiece of the Church of Santa Trinità in Florence (Fig. **15.13**). Cimabue's *Madonna Enthroned with Angels and Prophets* solidified his position as the leading painter in Florence. Although its Byzantine roots are clear—following closely, for instance, a Byzantine hierarchy of figures, with the Madonna larger than the figures that surround her—the painting is remarkable on several fronts. First, it is enormous. Standing over 12 feet high, it seems to have begun a tradition of large-scale altarpieces, helping to affirm the altar as the focal point of the church. But most important are Cimabue's concern for

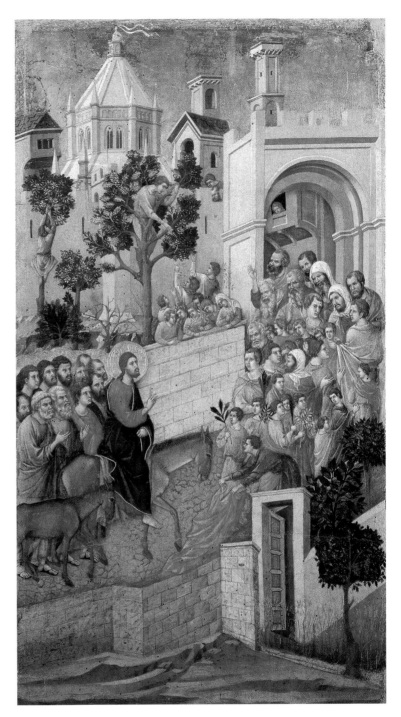

Fig. 15.12 Duccio, *Maestà*, detail of side showing the Entry into Jerusalem. 1308–11. Tempera on wood, 40″ × 22″. Various students assisted Duccio on the 25 panels on the back of the *Maestà*, which accounts for the continuation of the Sienese school of painting into the next generation.

spatial volume and his treatment of human figures with naturalistic expressions. The throne is especially interesting, creating as it does a spatial setting for the scene, and the angels seem to be standing on the architectural frame; the front two clearly are. If the Virgin and Child are stock Byzantine figures, the four prophets at the base of the throne are surprisingly

individualized, suggesting the increasing prominence of the individual personality in the era, an especially important characteristic, as we will see later in the chapter, of the literature of the period. These remarkably individual likenesses also tell us that Italian artists were becoming more skillful in painting with **tempera**, which allowed them to portray the world in ever-increasing detail (see *Materials and Techniques*, page 476). Perhaps most interesting of all is the position of the Virgin's feet, the right one propped upon the throne in an almost casual position.

According to an old story, one day Cimabue discovered a talented shepherd boy by the name of Giotto di Bondone and tutored him in the art of painting. The pupil soon surpassed the teacher. The sixteenth-century historian Giorgio Vasari would later say that Giotto set "art upon the path that may be called the true one, learned to draw accurately from life and thus put an end to the crude Greek [i.e., Byzantine] manner."

Giotto's 1310 *Madonna Enthroned with Angel and Saints* (Fig. **15.14**), painted just a quarter century after Cimabue's, is as remarkable a shift toward naturalism as Simone's *Maestà* is over Duccio's. While it retains a Byzantine hierarchy of figures—the Christ Child is almost as big as the angels and the Virgin three or four times their size—it is spatially convincing in a way that Cimabue's painting is not. Giotto apparently learned to draw accurately from life, and his figures reveal his skill. The paintings in the Chapel were done in **buon fresco**. In this technique, the artist applies pigments onto wet rather than dry plaster. (See *Materials and Techniques*, page 477.) Light plays across their forms—note the folds and pleats of the angels' gowns in the foreground—and substantial bodies seem to press outward from beneath the material. As in the paintings in the Upper Church of San Francesco in Assisi (see Fig. 15.9), Giotto's colors gradually and continuously blend from light to dark around the contours of his figures and their draperies, re-creating the realistic appearance of shadows. Giotto was also a master of the human face, capable of revealing a wide range of emotion and character. This skill is particularly evident in the frescoes of the Arena Chapel (see *Focus*, pages 474–475). (The chapel is also known as the Scrovegni Chapel, after the family that commissioned it in Padua.) The total effect is to humanize Christ, the Virgin, and the saints, to portray them as real people.

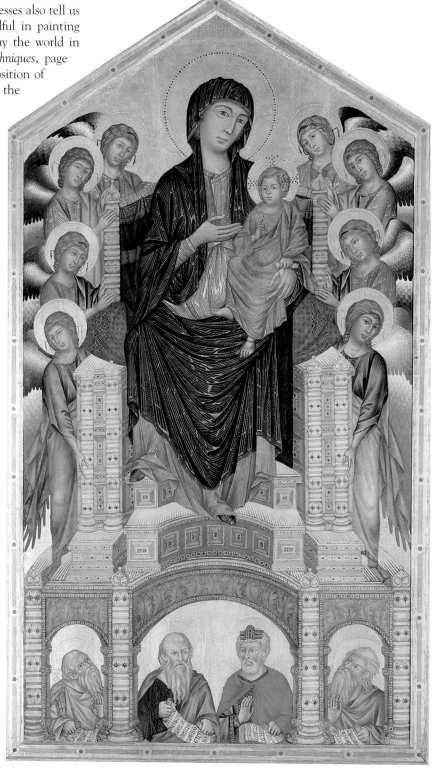

Fig. 15.13 Cimabue, *Madonna Enthroned with Angels and Prophets,* from high altar of Santa Trinità, Florence. ca. 1285. Tempera and gold on wood, 11′ 7 1/2″ × 7′ 4″. Galleria degli Uffizi, Florence. The later Renaissance historian Giorgio Vasari would claim that Cimabue had been apprenticed to a Greek painter from whom he learned the fundamentals of Byzantine icon painting.

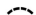

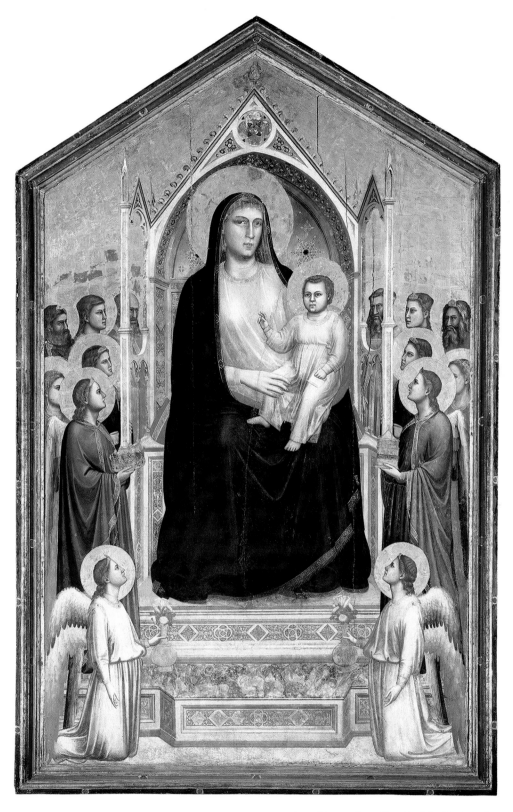

Fig. 15.14 Giotto di Bondone, *Madonna Enthroned with Angels and Saints,* **from Church of the Ognissanti, Florence. ca. 1310.** Tempera and gold on wood, 10′ 8″ × 6′ 8¼″. Galleria degli Uffizi, Florence. Giotto was a notoriously ugly but witty man. Legend has it that when the Florentine poet Dante Alighieri (discussed later in this chapter) asked him how his children could be so ugly when his paintings were so beautiful, Giotto replied that he painted by daylight but procreated in the dark.

Focus

Giotto's Arena Chapel

Giotto's greatest paintings are surely those in the Arena Chapel in Padua, painted around 1305. Giotto covered virtually every space of the barrel-vaulted family chapel of the Scrovegni family with **buon fresco** (see *Materials and Techniques*, page 477), the technique of painting on wet plaster. The top of the vault is a starry blue sky, painted with lapis lazuli. Lapis lazuli does not properly combine with wet plaster, so it was applied on a dry wall. As a result, the blues of the ceiling and other blues in the frescoes have faded far more than the other colors, most of which still look fresh. On the side walls are scenes from the life of the Virgin and the life of Christ.

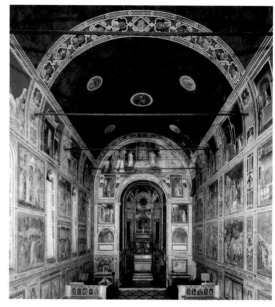

The Arena Chapel, Padua. The Life of Christ and the Virgin frescoes by Giotto. 1305–1306. A view of the Arena (Scrovegni) Chapel. In the bottom layer of images, closest to the floor, figures of the Virtues and Vices appear as painted, black-and-white simulations of sculpture, a technique known as *grisaille*. On the back wall above the door is a Last Judgment, figured as the final episode in the life of Christ.

Even the angels are wracked with grief.

John the Evangelist flings his arms back in a gesture that echoes that of the angels, almost as if his arms were wings.

The blue void at the center of the painting is a metaphor for the emptiness felt by the mourners.

The single leafless tree is a traditional symbol of death. It sits on a barren ridge that plunges in a stark diagonal toward the dead Christ.

The direction of the Virgin Mary's grief-stricken gaze continues down the diagonal line created by the barren ridge, reinforcing its emptiness.

Mary Magdalene, recognizable by her long hair, is traditionally represented at the Crucifixion kissing Christ's feet. Here, the Crucifixion over, she holds his feet in her hands, in an act of consummate tenderness and affection.

Giotto was the first artist since antiquity to depict figures from behind, contributing to the sense that we are viewing a real drama.

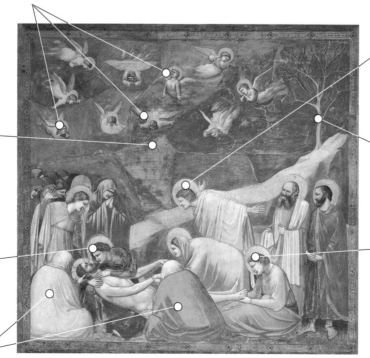

Giotto, *The Lamentation*, Arena Chapel, Padua. 1305–1306. Fresco, $78\frac{1}{2}'' \times 73''$. Among the most moving scenes in the chapel is Giotto's depiction of human suffering. The painter focused on the real pain felt by Jesus's followers upon his death, rather than the promise of salvation that it symbolized.

Halley's Comet made one of its regular appearances in 1301, just a few years before this painting was made. (We saw it depicted in the Bayeux Tapestry of 1066 [see chapter 12, Focus, page 396]). Giotto apparently modeled the star that guides the Magi on that phenomenon.

The boy looks up at the Magi's camels in astonishment. This expression of emotion is typical of Giotto's frescos. Giotto had probably never seen a camel: These have blue eyes and cows' feet.

Note Giotto's attempt to render the wooden shed in perspective. If he does not quite "get it," he is coming close.

Giotto has abandoned the Byzantine hierarchy of figures. The angels, the Magi, the Virgin, and the Child are all drawn to the same scale. (For a comparison, see Duccio's *Maestà Altarpiece*, Fig. 15.10.)

The king, Caspar, has removed his crown and placed it at the foot of the angel receiving gifts. The gesture signifies his understanding that Christ is the "King of Kings."

The blue of Mary's skirt has almost completely flaked off. Lapis lazuli, the stone used to make blue pigment, does not combine with wet plaster, so the blue had to be painted on after the plaster had dried, leaving it far more susceptible to heat and humidity, which eventually cause flaking.

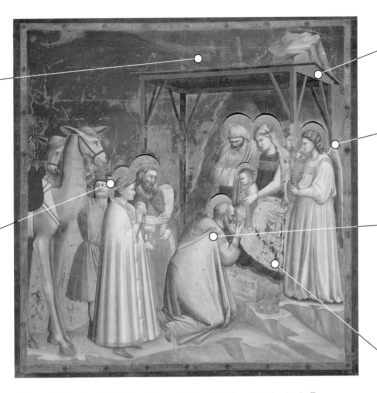

Giotto, *Adoration of the Magi*, Arena Chapel, Padua. 1305–1306. Fresco, 78 1/2″ × 73″. Boccaccio, author of the extraordinarily realistic story-cycle the *Decameron*, admired Giotto's painterly realism: "There is nothing in the whole creation he cannot depict," Boccaccio wrote.

Above the door is a depiction of the Last Judgment, in which the patron, Enrico Scrovegni, offers a model of the chapel to the Virgin. The purpose of the chapel seems clear: it was meant as penance on Enrico's part for his own and his father's sins—notably their flagrant usury.

The paintings depicting the life of Christ and the Virgin deliberately abandon the balance and symmetry that distinguish Byzantine painting (and, for that matter, the *Maestàs* of the period) in order to create a heightened sense of reality. In *The Lamentation*, for instance, Giotto places Christ in the lower left-hand corner of the work, at the bottom of a stark diagonal. Throughout the cycle, the action takes place on a narrow platform at the front of the painting. The architecture in the paintings is small in comparison to the figures, as in *The Adoration of the Magi*. Giotto may have been influenced by the stage sets made for the contemporary revival in Padua of Roman theater. Whatever the case, the drama of Giotto's paintings is undeniable. They possess a psychological intensity and emotional immediacy that involve the viewer directly in the scene.

Materials & Techniques Tempera Painting

Tempera is a painting medium made by grinding pigments to a paste and then suspending them in a mixture of water and egg yolk. Mixing tempera colors is a challenging process, since they dry almost as quickly as the artist can lay them down. To create shading, the artist adds layers of paint ranging from white to black, but especially gray and dark brown.

The technique of tempera painting was so complex that in the early fifteenth century Cennino Cennini published step-by-step instructions for making large-panel paintings in tempera in his *Il Libro dell'Arte* (The Handbook of the Crafts). He recommended using a fine-grained panel, thoroughly seasoned by slow drying. Applied to the panel were

at least nine layers of clean white linen strips soaked in **gesso**, a thick medium made of glue, gypsum, and/or chalk that creates a smooth sealed ground for painting. Each layer of gesso dried for at least two-and-a-half days. Then, the artist could outline the work in charcoal (burned willow twigs were recommended) on the gesso ground, reinforcing the outline with a **stylus**, a hard-pointed pen-shaped instrument. Finally, the tempera paint was applied with a fine squirrel-hair brush. Gold leaf was glued down with a mixture of clay and egg white, then polished with a gemstone or "the tooth of a carnivorous animal." The finished painting, Cennini wrote, should be as smooth as an eggshell.

The Spread of Vernacular Literature in Europe

Until the early twelfth century, the language of almost all educated circles in Europe, and certainly in literature, was Latin. Gradually, however, writers began to address their works to a wider lay audience and to write in the **vernacular**, the language spoken in the streets. The French led the way, in twelfth-century works such as the *Song of Roland* (see chapter 12) and Chrétien de Troyes's *Lancelot* (see chapter 13), but early in the fourteenth century vernacular works began to appear throughout Italy as well, spreading to the rest of Europe.

Dante's Divine Comedy

One of the greatest medieval Italian writers working in the vernacular was the poet Dante Alighieri (1265–1321). In Florence, in about 1308, he began one of the greatest works of the literary imagination, the *Divine Comedy* (Fig. **15.15**). This poem records the travels of the Christian soul from Hell to Purgatory and finally to Salvation in three books—the *Inferno*, *Purgatorio*, and *Paradiso*. It is by no means an easy journey. Dante, who is the leading character in his own poem, is led by the Roman poet Virgil, author of the *Aeneid* (see chapter 8). (Virgil, too, visits the underworld in the sixth book of his poem.)

Virgil cannot lead Dante into Heaven in the *Paradiso*, since he is a pagan who is barred from salvation. He is thus condemned to Limbo, the first level of Hell, a place of sorrow without torment, populated by virtuous pagans, the great philosophers and authors, unbaptized children, and others unfit to enter the kingdom of heaven. Among those who inhabit the realm with Virgil are Caesar, Homer, Socrates,

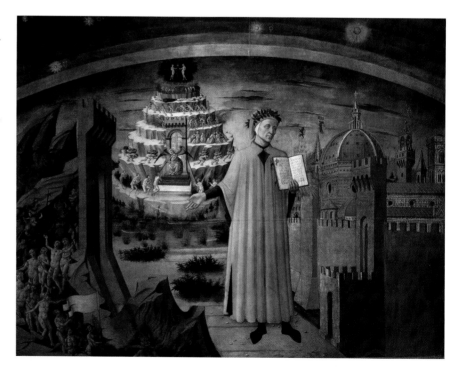

Fig. 15.15 Domenico di Michelino, *Dante and His Poem*. 1465. Fresco, 10′ 6″ × 9′ 7″. Florence Cathedral, Italy. To Dante's right is the Inferno, and behind him the seven-stepped hill of Purgatory. To his left is Paradise, imaged as Florence Cathedral, here topped by Brunelleschi's dome (discussed in chapter 17). Dante himself would never live to see or even imagine the dome.

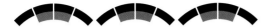

Materials & Techniques Buon Fresco

Buon fresco (literally "true fresh") is a type of wall painting that the Italians learned from Byzantine artists. Although it had been used in earlier cultures, from the Minoans to the Romans, it was perfected in Italy during the fourteenth and fifteenth centuries. Pigments are applied to a wet wall, which made the finished work far less likely to fade or flake than paintings made with the *fresco secco* ("dry" fresco) method. The buon fresco technique permanently bonds the pigment to the wall.

In *buon fresco*, a rough, thick undercoat of plaster is applied to a wall. When the wall has dried, the artist's assistants transfer a full-size drawing of the work—called a **cartoon**—to the wall. Typically, small holes were pricked in the paper cartoon, through which a dotted image of the drawing was transferred through the holes onto the plaster. The

resulting drawing on the wall, often elegantly filled out and perfected in charcoal, is known as a **sinopia**.

Assistants next applied a fresh, thin coat of plaster over a section of the sinopia, and pigments, mixed with water, were painted on just before this coat set. Since the paint had to be applied on a wet wall, only sections small enough to be completed in a single day—before the plaster dried—could be worked. The boundaries of these sections, known as **giornata**, literally a "day's work" in Italian, often conform to the contours of major figures and objects. If the area to be painted was complex—a face, for instance—the *giornata* might be no larger. Detailed work was added later, in the *fresco secco* method, as were those pigments that did not generate the chemical reaction necessary to bond the pigment to the wall. Blue was a notable example; it was made from lapis lazuli, which does not chemically combine with wet plaster.

and Aristotle. There is no punishment here, and the atmosphere is peaceful, yet sad. Virgil is, in fact, the model of human rationality, and in the *Inferno*, he and Dante study the varieties of human sin. Many of the characters who inhabit Dante's Hell are his contemporaries—the lovers Paolo and Francesca from Ravenna and Rimini, the usurer Reginaldo Scrovegni (patron of the chapel painted by Giotto; see *Focus*, pages 474–475), and so on. Dante also makes much of the Guelph/Ghibelline rivalries in his native Florence. He was himself a Guelph, but so divided were the Guelphs among themselves—into factions called the Blacks and the Whites, papal versus imperial bankers—that his efforts to heal their schism as one of the *Priori*, one of the nine leaders of the Florentine commune, resulted in a two-year exile beginning in 1302. Embittered, he never returned to Florence.

Dante's *Inferno* is composed of nine descending rings of sinners undergoing punishment, each more gruesome than the one before it (Fig. **15.16**). In the poem's first Canto the poet is lost in a Dark Wood of Error, where Virgil comes to his rescue, promising to lead him "forth to an eternal place" (see **Reading 15.3**, pages 489–491). In Hell, the two first encounter sinners whose passion has condemned them to Hell—Paolo and Francesca, whose illicit love was motivated, they tell Dante, by reading Chrétien de Troyes's *Lancelot*. The lovers are forever condemned to unreconciled love, to touch each other but never consummate their feelings. In the next ring are the gluttonous, condemned to wallow like pigs in their own excrement. Sinners, in other words, are punished not *for* their sins but *by* their sins. Dante finds intellectual dishonesty more sinful than any sin of passion, and thus flatterers, hypocrites, and liars occupy the next lower rings of hell. The violent are further down, immersed for eternity in

boiling blood. And finally, at the very bottom of the pit, imprisoned in ice "like straws in glass," are the traitors. Among the lowest of the low are Guelphs and Ghibellines from all over Tuscany who betrayed their cities' well-being. Finally, in Canto 34, Dante once again integrates the pagan and Christian worlds as Satan himself chews on the worst of all traitors—Judas (thought to have betrayed Jesus) and Brutus and Cassius (assassins of Julius Caesar) (**Reading 15.4**):

> **READING 15.4 from Dante, *Inferno*, Canto 34**
>
> . . .With what a sense of awe I saw his head
> towering above me! for it had three faces:[1]
> one was in front, and it was fiery red;
>
> the other two, as weirdly wonderful,
> merged with it from the middle of each shoulder
> to the point where all converged at the top of the skull;
>
> the right was something between white and bile;
> the left was about the color one observes
> on those who live along the banks of the Nile.
>
> Under each head two wings rose terribly,
> their span proportioned to so gross a bird:
> I never saw such sails upon the sea.
>
> They were not feathers—their texture and their form
> were like a bat's wings—and he beat them so
> that three winds blew from him in one great storm:
>
> it is these winds that freeze all Cocytus.
> He wept from his six eyes, and down three chins
> the tears ran mixed with bloody froth and pus.[2]

In every mouth he worked a broken sinner
between his rake-like teeth. Thus he kept three
in eternal pain at his eternal dinner.

For the one in front the biting seemed to play
no part at all compared to the ripping: at times
the whole skin of his back was flayed away.

"That soul that suffers most," explained my Guide,
"is Judas[3] Iscariot, he who kicks his legs
on the fiery chin and has his head inside.

Of the other two, who have their heads thrust forward,
the one who dangles down from the black face
is Brutus: note how he writhes without a word.

And there, with the huge and sinewy arms,[4] is the soul
of Cassius. But the night is coming on
and we must go, for we have seen the whole."...

Notes

[1]. **three faces:** Numerous interpretations of these three faces exist. What is essential to all explanation is that they be seen as perversions of the qualities of the Trinity.

[2]. **bloody froth and pus:** The gore of the sinners he chews which is mixed with his slaver (saliva).

[3]. **Judas:** Note how closely his punishment is patterned on that of the Simoniacs (Canto XIX).

[4]. **huge and sinewy arms:** The Cassius who betrayed Caesar was more generally described in terms of Shakespeare's "lean and hungry look." Another Cassius is described by Cicero (*Catiline* III) as huge and sinewy. Dante probably confused the two.

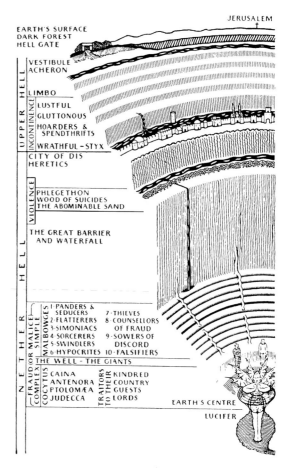

Fig. 15.16 Plan of Dante's Inferno.

The rhyme scheme of the *Divine Comedy* is **terza rima**—an interlocking three-line pattern invented by Dante that goes a/b/a, b/c/b, c/d/c, and so on. (The translator here has chosen to sacrifice the melodic harmonies of Dante's original in the interest of readability and accuracy and has foregone the interlocking rhyme, rhyming only the first and third lines of each stanza.) Just as Satan has three heads, just as there are three consummate sinners in his jaws, the three-line stanza is part of a numerological pattern in the poem. Each of the three books is composed of 33 cantos, to which Dante has added an introductory canto, for a total of 100—a number signifying perfection. There are nine circles of Hell (three squared), nine circles of penitents in Purgatory, and nine spheres of Heaven.

In the universe of the *Divine Comedy* (Fig. **15.17**), Virgil, as the embodiment of rationality, can take Dante no further than Hell and Purgatory, since in order to enter Paradise faith must triumph over reason, something impossible for the pagan Roman. Dante's guide through Paradise is Beatrice, the love of his life. Beatrice was the daughter of the Florentine nobleman Folco Potinari, and Dante first saw her when she was nine years old and he was eight. He describes meeting her in his first major work, *La Vita Nuova*: "love ruled my soul . . . and began to hold such sway over me . . . that it was necessary for me to do completely all his pleasure. He commanded me often that I should endeavor to see this youthful angel, and I saw her in

such noble and praiseworthy deportment that truly of her might be said these words of the poet Homer—*She appeared to be born not of mortal man but of God.*"

Dante wrote these words in 1293. Ten years earlier, when she was 18, Beatrice had entered into a marriage, arranged when she was eight, with Simone di Bardi. It lasted only seven years, ending in her death at age 25. Dante's love for her was, then, the classic love of the courtier for his lady, marked by an unconsummated physical desire necessarily transformed into a spiritual longing, a longing he finally imagines, at the end of the *Paradiso*, as a perfect circle (**Reading 15.5**):

READING 15.5 from Dante, *Paradiso*, Canto 33

. . . But oh how much my words miss my conception,
which is itself so far from what I saw
that to call it feeble would be rank deceptional
O Light Eternal fixed in Itself alone,
by Itself alone understood, which from Itself
loves and glows, self-knowing and self-known;
that second aureole which shone forth in Thee,
conceived as a reflection of the first—
or which appeared so to my scrutiny—

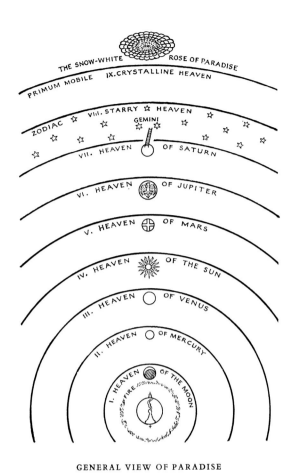

GENERAL VIEW OF PARADISE

Fig. 15.17 Plan of Dante's Universe.

seemed in Itself of Its own coloration
to be painted with man's image. I fixed my eyes
on that alone in rapturous contemplation.

Like a geometer wholly dedicated
to squaring the circle, but who cannot find,
think as he may, the principle indicated—

so did I study the supernal face.
I yearned to know just how our image merges
into that circle, and how it there finds place;

but mine were not the wings for such a flight.
Yet, as I wished, the truth I wished for came
cleaving my mind in a great flash of light.

Here my powers rest from their high fantasy,
but already I could feel my being turned—
instinct and intellect balanced equally

as in a wheel whose motion nothing jars—
by the Love that moves the Sun and the other stars.

Dante's physical desire has been transformed into a spiritual
longing that has led him to a comprehension of God's love.
So ends the *Divine Comedy*, in a vision of humankind woven
into the very substance and coloration of God, a vision so
powerful that Dante can barely find words to express it.

The Black Death and Its Aftermath

In 1316 and 1317, not long before Dante's death, crop failures
across Europe resulted in the greatest famine the continent
had ever known. For two summers, the sun rarely shone (no
one knew that huge volcanic eruptions thousands of miles
away in Indonesia had sent vast clouds of ash into the atmos-
phere). Furthermore, between 1000 and 1300, the continent's
population had doubled to a point where it probably exceed-
ed its ability to feed itself even in the best of times. In these
dark years, which were followed by a century-long cooling
period marked by too much rain to allow for good grain har-
vests, common people were lucky to eat, let alone eat well.
Then, in December 1347, rats infested with fleas carrying
bubonic plague arrived on the island of Sicily. They were car-
ried on four Genoese ships that had set sail from Kaffa, a
Genoese trading center on the Black Sea.

Since 1346, Kaffa had been under siege by Huns intent on
taking control of east–west trade routes. But the Huns had
fallen victim to the plague themselves, infected by traders
from China, where beginning in 1334 as many as 5 million
people had died. The Hun siege collapsed under the plague's
scourge, but the Huns catapulted the diseased corpses of their
dead into Kaffa. The four Genoese ships escaped, believing
they were free of infection. Unfortunately, this was not true,
and soon after the ships arrived in Sicily, the contagion
spread through the port cities of Venice, Genoa, and Pisa. An
already severely weakened population was almost pitifully
vulnerable. Within months, the disease spread northward,
through the ports of Venice, Genoa, and Pisa, across Italy,
southern France, and eastern Spain.

The disease began in the lymph glands of the groin or
armpits, which slowly filled with pus and turned black. The
inflammations were called buboes—hence the name bubon-
ic plague—and their black color lent the plague its other
name, the Black Death. Since it was carried by rodents,
which were commonplace even in wealthy homes, hardly
anyone was spared. It was an egalitarian disease—archbish-
ops, dukes, lords of the manor, merchants, laborers, and peas-
ants fell equally before it. For those who survived the
pandemic, life seemed little more than an ongoing burial ser-
vice. In many towns, traditional funeral services were aban-
doned, and the dead were buried in mass graves. By 1350, all
of Europe, with the exception of a few territories far from tra-
ditional trade routes, was devastated by the disease (Map
15.3). In Tuscany, the death rate in the cities was near 60
percent. In Florence, on June 24, 1348, the feast day of the
city's patron saint, John the Baptist, 1,800 people reportedly
died, and another 1,800 the next day—about 4 percent of the
city's population in two days' time. Severe outbreaks of the
plague erupted again in 1363, 1388–90, and 1400.

The impact of the Black Death on the popular imagina-
tion cannot be overstated. Among the most extreme reac-
tions was that of the **flagellants**, penitents who marched
from town to town beating themselves, in the belief that
such behavior might atone for the human sins they were

Map 15.3 Spread of the Black Death, 1347–50. Between 1347 and 1350, 30 to 50 percent of Europe's population—about 25 million people—died of the bubonic plague.

sure had caused the plague. But the social disruption that the flagellants created paled beside the outbreak of violent anti-Semitism across Europe. On October 30, 1348, officials at the village of Chatel, in the French Alps near Geneva, arrested and tortured a Jew named Agimet [ah-zhee-MEH], forcing a false confession that he had been sent by the local rabbi to poison the drinking water of Venice, Calabria, Apulia, and Toulouse. Soon, in Spain, France, and particularly Switzerland and Germany, the citizenry began to murder their Jewish neighbors. In early January 1349, in Basel, a number of Jews were burned. A few weeks later, on Saint Valentine's Day, in Strasbourg, 900 of the town's 1,884 Jews were burned, the rest banned from the city. In Speyer, Augsberg, Stuttgart, Regensburg, Bonn, Mainz, and town after town the persecutions continued. In July, in Frankfurt, the Jews set their own houses on fire when they were attacked, causing much of the city to burn. The need to find a scapegoat for the plague spurred on the general population, but it seems likely that officials and city leaders, well aware that the Jews were being blamed for something they had nothing to do with, allowed these **pogroms** (massacres of Jews) to

occur as a way to eliminate their own personal debts and capture Jewish wealth for themselves, much as Count Emicho of Leiningen had done during the First Crusade (see chapter 13).

More subtle than this wave of violence were the lasting psychological effects of the epidemic, including the doubt cast upon the Church's belief in divine justice. Even more pronounced was a growing social obsession with death. A good example is a Book of Hours commissioned by Bonne of Luxembourg, wife of the Dauphin of France, from her court illuminator, Jean Le Noir, at some point probably not long before her own death from the plague in 1348 (Fig. **15.18**). On the left page, three horsemen contemplate three cadavers in increasing states of decay on the right page. One horseman brings a handkerchief to his nose to fight off the stench. The cadavers address the horsemen: "What you are we were and what we are you will be!" The artist's depiction of the human body in decay is astonishingly realistic—especially in light of the Church ban on performing autopsies. It is as if, in making us confront death, the artist is determined to bring us face to face with the ultimate truth of things.

Fig. 15.18 Jean Le Noir, pages with *The Three Living* (left) and *The Three Dead* (right), from the Psalter and Book of Hours of Bonne of Luxembourg. **Before 1349.** Grisaille, color, gilt and brown ink on vellum, 5″ × 3½″. The Metropolitan Museum of Art, The Cloisters Collection. 1969 (69.86). Image © The Metropolitan Museum of Art/Art Resource, NY. Note the naturalism of the birds that decorate the margins of the manuscript.

Literature after the Black Death: Boccaccio's *Decameron*

The frank treatment of reality found in the visual arts carried over into literature, where the direct language of the vernacular proved an especially appropriate vehicle for rendering truth. The *Decameron*, or "Work of Ten Days," is a collection of framed prose tales in the manner of *The Thousand and One Nights* and Nezami's *Haft Paykar* (see chapter 11). The Florentine writer Giovanni Boccaccio (1313–75), who lived through the plague, sets the stage for the 100 prose stories of the collection with a startlingly direct description of Florence in the ravages of the disease (**Reading 15.6**):

READING 15.6 **from Boccaccio, *Decameron***

The virulence of the plague was all the greater in that it was communicated by the sick to the well by contact, not unlike fire when dry or fatty things are brought near it. But the evil was still worse. Not only did conversation and familiarity with the diseased spread the malady and even cause death, but the mere touch of the clothes or any other object the sick had touched or used, seemed to spread the pestilence. . . .

Because of such happenings and many others of a like sort, various fears and superstitions arose among the survivors, almost all of which tended toward one end—to flee from the sick and whatever had belonged to them. In this way each man thought to be safeguarding his own health. Some among them were of the opinion that by living temperately and guarding against excess of all kinds, they could do much toward avoiding the danger; and forming a band they lived away from the rest of the world. Gathering in those houses where no one had been ill and living was more comfortable, they shut themselves in. They ate moderately of the best that could be had and drank excellent wines, avoiding all luxuriousness. With music and whatever other delights they could have, they lived together in this fashion, allowing no one to speak to them and avoiding news either of death or sickness from the outer world.

Others, arriving at a contrary conclusion, held that plenty of drinking and enjoyment, singing and free living and the gratification of the appetite in every possible way, letting the devil take the hindmost, was the best preventative of such a malady; and as far as they could, they suited the action to the word. Day and night they went from one tavern to another drinking and carousing unrestrainedly. . . .

Meanwhile, in the midst of the affliction and misery that had befallen the city, even the reverend authority of divine and human law had almost crumbled and fallen into decay, for its ministers and executors, like other men, had either died or sickened, or had been left so entirely without assistants that they were unable to attend to their duties. As a result everyone had leave to do as he saw fit. . . .

It used to be common, as it is still, for women, friends and neighbors of a dead man, to gather in his house and mourn there with his people. . . . Now, as the plague gained in violence, these customs were either modified or laid aside altogether. . . . It was a rare occasion for a corpse to be followed to church by more than ten or twelve mourners—not the usual respectable citizens, but a class of vulgar grave-diggers who called themselves "sextons" and did these services for a price. . . .

More wretched still were the circumstances of the common people and, for a great part, of the middle class, for, confined to their homes either by hope of safety or by poverty, and restricted to their own sections, they fell sick daily by thousands. There, devoid of help or care, they died almost without redemption. A great many breathed their last in the public streets, day and night; a large number perished in their homes, and it was only by the stench of their decaying bodies that they proclaimed their death to their neighbors. Everywhere the city was teeming with corpses. A general course was now adopted by the people, more out of fear of contagion than of any charity they felt toward the dead. Alone, or with the assistance of whatever bearers they could muster, they would drag the corpses out of their homes and pile them in front of the doors, where often, of a morning, countless bodies might be seen. Biers were sent for. When none was to be had, the dead were laid upon ordinary boards, two or three at once. It was not infrequent to see a single bier carrying husband and wife, two or three brothers, father and son, and others besides. . . .

So many bodies were brought to the churches everyday that the consecrated ground did not suffice to hold them, particularly according to the ancient custom of giving each corpse its individual place. Huge trenches were dug in the crowded churchyards and the new dead were piled in them, layer upon layer, like merchandise in the hold of a ship. . . .

Boccaccio describes a world in virtual collapse. The social breakdown caused by the plague is especially evident in the widespread death of the ruling class and the rise of the class of men who called themselves "sextons," technically guardians of the church edifice, treasures, and vestments, but now a vile band of mercenary gravediggers. All tradition has been abandoned.

Nevertheless, a good deal of the power of Boccaccio's book is that in this atmosphere of dark matter-of-factness, he inaugurates something entirely different, suggesting that society might be ready to be reborn:

[O]n a Tuesday morning after Divine Service the venerable church of Santa Maria Novella [see Fig. 15.8] was almost deserted save for the presence of seven young ladies habited sadly[1] in keeping with the season. All were connected either by blood or at least as friends or neighbors; and fair and of good understanding were they all, as also of noble birth, gentle manners, and a modest sprightliness. In age none exceeded twenty-eight, or fell short of eighteen years. . . .

[1] **habited sadly:** dressed in mourning

One of the citizens, Pampinea [pam-pee-NEH-ee-ah], observing the dire nature of their plight, makes this suggestion:

I should deem it most wise in us, our case being what it is, if, as many others have done before us, and are still doing, we were to quit this place, and, shunning like death the evil example of others, betake ourselves to the country, and there live as honorable women on one of the estates, of which none of us has any lack, with all cheer of festal gathering and other delights, so long as in no particular we overstep the bounds of reason. There we shall hear the chant of birds, have sight of verdant hills and plains, of cornfields undulating like the sea, of trees of a thousand sorts; there also we shall have a larger view of the heavens, which, however harsh toward us, yet deny not their eternal beauty; things far fairer for eyes to rest on than the desolate walls of our city. Moreover, we shall there breathe a fresher air, find ampler store of things meet [fitting] for such as live in these times, have fewer causes of annoy[ance].

Three young men, all of whom the women know, happen to enter the church, and it is determined that they should be invited to join them, even though, as one of the young women mentions, it is well known "that they love some of us here. . . [and] if we take them with us, we may thereby give occasion for scandal and censure. . . ."

Thus, the entire enterprise takes place in an atmosphere of potential scandal—certainly an atmosphere outside the bounds of normal social behavior. They enter a new moral space, evidenced by the difference between the Florence they have left behind and their new surroundings:

The estate lay upon a little hill some distance from the nearest highway, and, embowered in shrubberies of divers hues, and other greenery, afforded the eye a pleasant prospect. On the summit of the hill was a palace with galleries, halls and chambers, disposed around a fair and spacious court, each very fair in itself, and the goodlier to see for the gladsome pictures with which it was adorned; the whole set amidst meads and gardens laid out with marvelous art, wells of the coolest water, and vaults of the finest wines, things more suited to dainty drinkers than to sober and honorable women.

The reader is aware that this idyllic island is surrounded by the terror of the Black Death, and that the sensual atmosphere of the setting offers—as arguably some of the best fiction always does—a refuge from the realities of everyday life.

The group determines that each day it will gather together and each will tell a story to entertain the others. As one of the young men, Dioneo [dee-OH-nay-oh], puts it, "I pray you, either address yourselves to make merry, to laugh and sing with me (so far, I mean, as may consist with your dignity), or give me leave to hie me back [return] to the stricken city." Of course, no sooner do they gather together on their first day than Dioneo challenges the ladies' dignity with a tale about a young monk from a monastery "once more saintly . . . than it now is" who one day spies a beautiful young woman gathering herbs in a field (see **Reading 15.7**, pages 491–492, for the tale in its entirety):

> The moment he saw her, he was passionately attacked by carnal desire. He went up to her and began a conversation. One subject led to another, and finally, they came to an understanding; he took the girl to his cell.

Dioneo's stories evoke "some qualms of shame in the minds of the ladies, as was apparent by the modest blush that tinged their faces." But the ladies are also "scarcely able to refrain their mirth." Dioneo is the embodiment of freedom, and his stories represent Boccaccio's own license to exceed the bounds of acceptable literary decorum. Not all of the other 99 tales are as ribald—that is, vulgar and indecent—as this one, but although all ten of the storytellers are aristocrats, a great many of their tales involve people of the lower, especially middle classes, and their characters, in their shrewdness and wit, ingenuity, and resourcefulness, unscrupulous behavior and bawdy desires, introduce into Western literature a kind of social realism previously unexplored. Perhaps reflecting the reality of death that surrounds them, the stories depict daily life as it is truly lived. Boccaccio's stories express the realities of life in a way that the classic tales of medieval chivalry could only intimate. His world is of flesh and blood, not knights in shining armor. If the world of the *Decameron* is a fictitious one, in its penetrating revelation of workings of human psychology, it also represents an unprecedented brand of literary realism.

Petrarch's Sonnets

One of Boccaccio's best friends was the itinerant scholar and poet Francesco Petrarca (1304–74), known as Petrarch (Fig. **15.19**). Raised near Avignon, in France, where the papacy had established itself in 1309 and where it remained through most of Petrarch's lifetime, Petrarch studied at Montpellier and Bologna and traveled throughout northern France, Germany, and Italy. He was always in search of manuscripts that preserved the priceless literary works of antiquity—copying those he could not pry loose from monastic libraries. As he wrote to a friend in 1351, these manuscripts, in a classical Latin and hard for monks to decipher, were in danger of being lost forever:

It is a state of affairs that has resulted in an incredible loss to scholarship. Books that by their nature are a little hard to understand are no longer multiplied [i.e., copied and distributed], and have ceased to be generally intelligible, and so have sunk into utter neglect, and in the end have perished. This age of ours consequently has let fall, bit by bit, some of the richest and sweetest fruits that the tree of knowledge has yielded; has thrown away the results of the vigils and labors of the most illustrious men of genius, things of more value, I am almost tempted to say, than anything else in the whole world.

It was Petrarch who rediscovered the forgotten works of the Roman orator and statesman Cicero, and his own private library consisted of over 200 classical texts. He persuaded Boccaccio to bring the Greek scholar Leo Pilatus to Venice to teach them to read Greek. Boccaccio learned the language, but, put off by Pilatus's bad manners, Petrarch did not. Both, however, benefited from Pilatus's translation of Homer into Latin prose, as well as from his genealogy of the Greek gods.

Fig. 15.19 Andrea del Castagno, *Francesco Petrarca*. ca. 1450. Fresco transferred to wood, 97¼″ × 60¼″. Galleria degli Uffizi, Florence. So great was Petrarch's zeal for the classics that he would become known as the Father of Humanism, the revival of Greco-Roman culture that would come to define the Renaissance in the two centuries to follow.

Perhaps Petrarch's greatest work was his book of over 300 poems, the *Canzoniere* (Songbook), inspired by his love for a woman named Laura, whom he first met in 1327 in Avignon, where he was working for an influential cardinal. She is generally believed to have been the 19-year-old wife of Hugues de Sade. Whether Petrarch ever revealed his love to Laura, or simply poured it into his verses, remains a matter of speculation.

The majority of Petrarch's verses to Laura take the form of the **Italian sonnet**, known also as the **Petrarchan sonnet** because he perfected the form. Petrarch had been deeply influenced by the poetry of the troubadours, written in sonnet form. (See chapter 13.) The Petrarchan sonnet is composed of 14 lines divided into two parts: an *octave* of eight lines that presents a problem, and a *sestet* of six lines that either attempts to solve the problem or accepts it as unsolvable. The octave is further divided into two four-line *quatrains*. The first presents the problem and the second develops the idea. Many of Petrarch's verses to Laura were composed after her death from the bubonic plague in 1348, and it seems likely that her death motivated Petrarch to circulate them. His devastation is clear in these three lines from Sonnet 338:

Continuity & Change
p. 421

> Earth, air, and sea should weep together,
> for the human lineage, once she's gone, becomes
> a meadow stripped of flowers, a gemless ring.

More influential, however, were the pure love poems. One of the most famous of these is Sonnet 134, in which Petrarch explores the complexities of his feelings—all the ambivalence, contradiction, and paradox—in the face of his love for Laura (**Reading 15.8**):

READING 15.8 **Petrarch, Sonnet 134**

> I find no peace, and yet I am not warlike;
> I fear and hope, I burn and turn to ice;
> I fly beyond the sky, stretch out on earth;
> my hands are empty, yet I hold the world.
>
> One holds me prisoner, not locked up, not free;
> won't keep me for her own but won't release me;
> Love does not kill me, does not loose my chains,
> he'd like me dead, he'd like me still ensnared.
>
> I see without my eyes, cry with no tongue,
> I want to die and yet I call for help,
> hating myself but loving someone else.
>
> I feed on pain, I laugh while shedding tears,
> both death and life displease me equally;
> and this state, Lady, is because of you.

Such poems would have a lasting influence, especially in the poetry of the English Elizabethan Age, because they seemed to capture all the emotional turbulence of love (see chapter 24).

Chaucer's *Canterbury Tales*

The first Englishman to translate Petrarch was Geoffrey Chaucer (ca. 1342–1400). Well-educated, able to read both Ovid and Virgil in the original Latin, Chaucer was a middle-class civil servant and diplomat. In 1368, both he and Petrarch were guests at a wedding in Milan Cathedral, and four years later he was in Florence, where he probably met Boccaccio. Chaucer's masterwork, *The Canterbury Tales*, is modeled roughly on Boccaccio's *Decameron*, but it is written in verse, not prose, and is composed in **heroic couplets**. Like the *Decameron*, it is a framed collection of stories, this time told by a group of pilgrims traveling from London to the shrine of Saint Thomas à Becket, Archbishop of Canterbury. In 1170, Becket had been murdered in Canterbury Cathedral by followers of King Henry II in a dispute over the rights and privileges of the Church.

Chaucer had planned to write 120 tales. Before his death, he completed only 22 tales and fragments of two others, but they are extraordinary in the range of characters and social types that they portray. Not only are the characters in the stories fully developed, but so are their narrators, and as a result the stories reflect perhaps the most fully developed realism of the era. Consider Chaucer's description of the Wife of Bath (Fig. **15.20**) from the Prologue to the work (**Reading 15.9**):

READING 15.9 **from Chaucer,**
The Canterbury Tales,
Prologue

> A worthy woman there was from near the city
> Of Bath, but somewhat deaf, and more's the pity.
> For weaving she possessed so great a bent
> She outdid the people of Ypres and Ghent.[1]
> No other woman dreamed of such a thing
> As to precede her at the offering.
> Or if any did, she fell in such a wrath
> She dried up all the charity in Bath.
> She wore fine kerchiefs of old-fashioned air,
> And on a Sunday morning, I could swear,
> She had ten pounds of linen on her head.
> Her stockings were the finest scarlet-red,
> Laced tightly, and her shoes were soft and new.
> Bold was her face, and fair, and red in hue.
> She had been an excellent woman all of her life.
> Five men in turn had taken her to wife,

Not counting other youthful company—
But let that pass for now! Over the sea
She'd traveled freely; many a distant stream
She crossed, and visited Jerusalem
Three times. She had been at Rome and at Boulogne,
At Compostella's shrine, and at Cologne.
She'd wandered by the way through many a scene.
Her teeth were set with little gaps between.[2]
Easily on her ambling horse she sat.
She was well wimpled, and she wore a hat
As wide in circuit as a shield or targe,[3]
A skirt swathed up her hips, and they were large.
Upon her feet she wore sharp-roweled spurs.
She was a good fellow; a ready tongue was hers.
All remedies of love she knew by name,
For she had all the tricks of that old game.

[1] **Ypres and Ghent:** Centers of the weaving industry in Flanders.
[2] **teeth . . . gaps between:** For a woman to be gap-toothed was considered a sign of being highly sexed.
[3] **targe:** A type of shield.

Fig. 15.20 Wife of Bath, from Geoffrey Chaucer's _Canterbury Tales_ ("The Ellesmere Chaucer"). ca. 1400–1405. Illumination on vellum. Victoria & Albert Museum, London. This image is from the earliest complete surviving text of Chaucer's work which contains 23 portraits of the storytellers.

Chaucer accomplishes what few writers before him had—he creates character and personality through vivid detail and description. This elaborately dressed, gap-toothed, large-hipped, easy-riding survivor of five husbands comes off as a real person. The tales themselves sometimes rival Boccaccio's in their bawdy realism, but the variety of the pilgrims and the range of their moral characters creates at least as profound a moral world as Boccaccio's, one whose scope even rivals that of Dante. The integrity of the Knight plays against the depravity of the Pardoner, just as the sanctity of the Parson plays against the questionable morals of the Wife of Bath. Chaucer's characters come from all three **estates**, or social ranks—the nobility, the clergy, and the common people—a fact that has led some to refer to his work as an "estates satire," a critique of social relations in his day.

Evolving English Chaucer wrote _The Canterbury Tales_ in the English of his day, a language we now call Middle English. After the Norman invasion in 1066, the common people spoke one language—Anglo-Saxon (or Old English), and the nobility another—French. The language of the learned continued to be Latin. In Chaucer's time, a new spoken vernacular, Middle English, had supplanted Anglo-Saxon among the common people. It combined elements of French, Anglo-Saxon, and the Scandinavian languages. Chaucer himself spoke French, and that he chose to write _The Canterbury Tales_ in the Middle English of his day (actually a London dialect, one of about five dialects used across Britain at the time) is a significant development in the history of the English language.

Before 1385, roughly the time that Chaucer began the _Tales_, English had replaced French as the language of instruction for children. By 1362, the Chief Justice opened Parliament with a speech in English. That same year, Parliament enacted the Statute of Pleading, providing that "All pleas which shall be pleaded in his [the King's] courts whatsoever, before any of his justices whatsoever . . . shall be pleaded, shewed, defended, answered, debated, and judged in the English tongue." Still, the records of the pleas were kept in Latin. By mid-century, then, even the nobility, though raised speaking French, also spoke English. Chaucer's London dialect became the dominant one thanks largely to William Caxton, the London printer of Chaucer's works, who used the London dialect—the English of Britain's intellectual, political, and commercial center—in all his publications, thus making it the standard.

To provide an idea of the history of the language, here are the opening lines of the General Prologue of _The Canterbury Tales_ in Middle English, as Chaucer wrote them, followed by a modern rendition.

Whan that Aprill with his shoures soote
> When April with its sweet-smelling showers

The droghte of March hath perced to the roote,
> Has pierced the drought of March to the root,

And bathed every veyne in swich licour
> And bathed every vein (of the plants) in such liquid

Of which vertu engendred is the flour;
> By the power of which the flower is created;

Whan Zephirus eek with his sweete breeth
> When the West Wind also with its sweet breath,

Inspired hath in every holt and heeth
> In every wood and field has breathed life into

The tendre croppes, and the yonge sonne
> The tender new leaves, and the young sun

Hath in the Ram his half cours yronne,
> Has run half its course in Aries,

And smale foweles maken melodye,
> And small fowls make melody,

That slepen al the nyght with open ye
> Those that sleep all the night with open eyes

(So priketh hem Nature in hir corages),
> (So Nature incites them in their hearts),

Thanne longen folk to goon on pilgrimages. . . .
> Then folk long to go on pilgrimages. . . .

Chaucer understood the power of this new vernacular English to evoke the reality of fourteenth-century English life, and his keen ear for the cadences and phrasings of actual speech underscores the reality of his characters and the tales they tell.

Women in Late Medieval Society

The seven women in Boccaccio's *Decameron* and characters like Chaucer's Wife of Bath represent the increasing social prominence of women in medieval society. This is no doubt at least in part, a reflection of the growing role of the Virgin in medieval religious life, and her prominence helped raise the dignity of women in general. By the thirteenth century, women were active in all trades, especially the food and clothing industries; they belonged to guilds, and increasingly had the opportunity to go to school and learn to read at least in their vernacular languages. They were, however, still generally excluded from the learned professions of medicine and law, and they performed the same work as men for wages on the average 25 percent lower.

Women in Boccaccio and Chaucer Neither Boccaccio nor Chaucer could ever be called a feminist—in fact, both depict misogynist characters—but both do recognize these new women as real forces in contemporary social life. Boccaccio's story of Filippa, told by Filostrata [fee-loh-STRAY-tah] on the sixth day, is a case in point. It recounts how Filippa is charged by her husband with the crime of adultery, punishable by death in the town of Prato where they live, a crime to which she freely admits. But in court she argues that the law represents a double standard, one for men, quite another for women, and that, further, laws should be made by the consent of the people, and no woman ever consented to the death penalty for giving "pleasure to many more people than men ever could." If, she argues, she has always satisfied her husband's every desire,

> what was I to do with what was left over? Indeed, what am I to do with it? Throw it to the dogs? Isn't it far better to give enjoyment to some gentleman who loves me more than his life, than to let it go to waste or ruin?

The court agrees, the law is overturned, and Filippa is victorious.

Boccaccio did, in fact, write a book explicitly "for the ladies," his *De Claris Mulieribus* [deh KLA-rees moo-lee-YEH-ree-bus] (Concerning Famous Women), a work of Latin prose published in 1362. The first collection of biographies in Western literature dedicated solely to

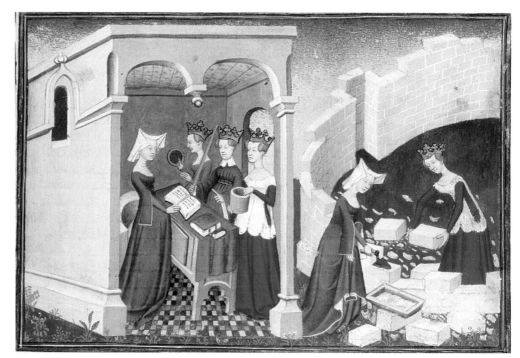

Fig. 15.21 Anonymous, *La Cité des Dames de Christine de Pizan*. ca. 1410. Illumination on parchment, page size 4³⁄₄″ × 7″. Bibliothèque Nationale, Paris. On the left stands Christine de Pizan, engaged in composition while receiving the visit of Reason, Honesty, and Justice. On the right, Christine and one of the royal ladies build the Ideal City.

women, it consists of 106 entries beginning with "Eve Our First Mother." It then moves on to both exemplary and notorious figures from history and mythology as well as from among Boccaccio's own contemporaries. The book was immensely popular across Europe and survives in over 100 manuscripts—an unusually high number. It was nevertheless an extremely misogynist text that assumes women's inferiority to men from the outset.

Christine de Pizan: An Early Feminist Women began to play an increasingly active role in the courts of Europe. In 1404, Philip the Bold, duke of Burgundy, commissioned Christine de Pizan (1364–ca. 1430) to write a biography of his deceased brother, titled *The Book of the Deeds and Good Manners of the Wise King Charles V*. Christine had been educated at the French court, apparently against her mother's wishes, by her father, a prominent Venetian physician, who had been appointed court astrologer to King Charles V. Her husband, secretary and notary to the king, further promoted her education. But when her father and husband died, she needed to support three children, a niece, and her mother. To do so she became the first female professional writer in European history.

As she gradually established her reputation as a writer, she worked as a copyist and illustrator, and her first successes were books of poems and ballads. In 1402, she made her reputation by attacking as misogynistic and demeaning to women the popular thirteenth-century poem the *Roman de la Rose* (Romance of the Rose) (see chapter 14). Two years later, in her *Book of the City of Ladies*, she again attacked male misogyny by recounting the accomplishments of women throughout the ages in an allegorical debate between herself and Lady Reason, Lady Rectitude, and Lady Justice (Fig. **15.21**). Her most immediate source was Boccaccio's *Concerning Famous Women*, but her treatment is completely different, treating only good women and freely mixing pagan and Christian examples. Her city's queen is the Virgin Mary herself, a figure whose importance confirms the centrality of women to Christianity. Thus, she opens the book by wondering why men are so inclined to demean women (**Reading 15.10**):

READING 15.10 **from Christine de Pizan, *Book of the City of Ladies***

[I wondered] how it happened that so many different men—and learned men among them—have been and are so inclined to express both in speaking and in their treatises and writings so many wicked insults about women and their behavior. Not only one or two . . . but, more generally, from the treatises of all philosophers and poets and from all the orators—it would take too long to mention their names—it seems that they all speak from one and the same

mouth. Thinking deeply about these matters, I began to examine my character and conduct as a natural woman and, similarly, I considered other women whose company I frequently kept, princesses, great ladies, women of the middle and lower classes, who had graciously told me of their most private and intimate thoughts, hoping that I could judge impartially and in good conscience whether the testimony of so many notable men could be true. To the best of my knowledge, no matter how long I confronted or dissected the problem, I could not see or realize how their claims could be true when compared to the natural behavior and character of women.

She then turns to God for guidance and is granted a dream vision in which the three allegorical ladies encourage her to build an Ideal City, peopled with a variety of women, from Sappho to her own name-saint, all of whom help her to redefine what it means to be female.

Christine de Pizan Glorifies Joan of Arc De Pizan was writing in the context of the so-called Hundred Years' War between England and France, generally dated at 1337 to 1429. The origins of the war went all the way back to 1216, when the English Normans (who had invaded England from France in 1066) finally lost control of all their possessions on the continent. In the early fourteenth century, the French throne was increasingly contested, and the English king proclaimed himself as the rightful heir. Thus the stage was set for war, driven largely by the English Normans' desire to recapture their homeland in Normandy. The war was fought entirely on French soil, and although the English were usually outnumbered by as much as three to one, they were generally victorious because of two technological innovations. First, the longbow's six-foot length allowed the English infantry to pierce the chain-mail armor of the French. Second, the introduction of gunpowder and cannon made armor altogether irrelevant. Suddenly the model of heroic hand-to-hand combat, the basis of the chivalric ideal, was obsolete, and with it, the codes of loyalty, honor, and courage upon which the entire French literary tradition since the *Song of Roland* had been based.

Even more damaging to this masculine tradition was the fact that it was a woman, Joan of Arc, who saved the French. A 17-year-old peasant girl, she approached the French king and begged him to allow her to obey the voices of the saints who ordered her to drive the English out of France. Christine de Pizan, who had retired to an abbey in 1418, after the arrival of the Burgundian troops in Paris had forced her and many others to seek protection outside the city, was overjoyed. The year before her death, de Pizan wrote a 61-stanza poem that glorified Joan's achievements (rendered in prose in **Reading 15.11**):

READING 15.11 **Christine de Pizan, *Tale of Joan of Arc***

I, Christine, who have wept for eleven years in a walled abbey . . . begin to laugh heartily for joy . . .

Oh! What honour for the female sex! It is perfectly obvious that God has special regard for it when all these wretched people who destroyed the whole Kingdom—now recovered and made safe by a woman, something that 5000 men could not have done—and the traitors [have been] exterminated. Before the event they would scarcely have believed this possible.

A little girl of sixteen (isn't this something quite supernatural?) who does not even notice the weight of the arms she bears—indeed her whole upbringing seems to have prepared her for this, so strong and resolute is she! And her enemies go fleeing before her, not one of them can stand up to her. She does all this in full view of everyone, and drives her enemies out of France, recapturing castles and towns. Never did anyone see greater strength, even in hundreds or thousands of men!

For Christine, Joan's achievement was as much a victory for women as for France. Christine, though, would not live to see her captured by the English, betrayed, probably by Burgundian French, then tried and executed as a heretic in March 1431. Joan's mysticism, like that of Hildegard of Bingen before her (see chapter 12), undermined the authority and (male) hierarchy of the Church. But the chief charge against her was cross-dressing! She dared challenge, in other words, the human-constructed gender roles that the Church fathers assumed to be the will of God. Still, probably no other figure better sums up the growing self-assurance of women in late medieval society and the sense of personal worth—both male and female—that would increasingly inform European society as the fifteenth century unfolded.

READINGS

from Saint Francis of Assisi, *Canticle of the Sun*

The Canticle of the Sun, *written just two years before Francis's death, reveals the deep reverence for nature that is fundamental to Franciscan theology. It sets out what amounts to a theology of incarnation— that is, a deep and abiding belief that God resides in the world, in his Creation, and can be understood by contemplation of that Creation.*

Most high, all-powerful, all good, Lord!
All praise is yours, all glory, all honor
And all blessing.
To you alone, Most High, do they belong.
No mortal lips are worthy
To pronounce your name.
All praise be yours, my Lord, through all that you have
 made,
And first my lord Brother Sun,
Who brings the day; and light you give to us through him. 10
How beautiful is he, how radiant in all his splendor!
Of you, Most High, he bears the likeness.
All praise be yours, my Lord, through Sister Moon and Stars;
In the heavens you have made them, bright
And precious and fair.
All praise be yours, my Lord, through Brothers Wind and
 Air,
And fair and stormy, all the weather's moods,
By which you cherish all that you have made.
All praise be yours, my Lord, through Sister Water, 20
So useful, lowly, precious, and pure.
All praise be yours, my Lord, through Brother Fire,
Through whom you brighten up the night.
How beautiful he is; how cheerful and powerful and strong.

All praise be yours, my Lord, through Sister Earth, our
 mother,
Who feeds us in her sovereignty and produces
Various fruits and colored flowers and herbs.
All praise be yours, my Lord, through those who grant
 pardon 30
For love of you; through those who endure
Sickness and trial.
Happy those who endure in peace,
By you, Most High, they will be crowned.
All praise be yours, my Lord, through Sister Death,
From whose embrace no mortal can escape.
Woe to those who die in mortal sin!
Happy those She finds doing your will!
The second death can do no harm to them.
Praise and bless my Lord, and give him thanks, 40
And serve him with great humility. ■

Reading Question

It surprises some readers that Saint Francis ends the Canticle by praising death. Why, theologically, do you think he does this, and how, structurally, could it be said to "round out" the poem?

from Dante, *Inferno*, Canto I

Dante wrote the Divine Comedy *between 1308 and 1321, completing the* Inferno *by about 1312. The whole recounts the journey of Dante (the character, as opposed to the author) into the afterlife in three books—the* Inferno, Purgatorio, *and* Paradiso—*accompanied, at least as far as he can go, by the Roman poet Virgil. In the* Inferno, *Dante visits Hell. Each book is composed of 33 cantos, with the addition of one extra canto, the first, presented in full below, which serves as a prelude to the entire work. These numbers are symbolic. The number 3 is especially important. The poem is written in tercets, three-line stanzas. There are 9 (3 × 3) circles or spheres in each realm. And the number reflects, as well, the divine Trinity.*

Midway in our life's journey, I went astray
 from the straight road and woke to find myself
 alone in a dark wood. How shall I say 3
what wood that was! I never saw so drear,
 so rank, so arduous a wilderness!

Its very memory gives a shape to fear. 6
Death could scarce be more bitter than that place!
 But since it came to good, I will recount
 all that I found revealed there by God's grace. 9
How I came to it I cannot rightly say,

so drugged and loose with sleep had I become
 when I first wandered there from the True Way. 12
But at the far end of that valley of evil
 whose maze had sapped my very heart with fear
 I found myself before a little hill 15
and lifted up my eyes. Its shoulders glowed
 already with the sweet rays of that planet
 whose virtue leads men straight on every road, 18
and the shining strengthened me against the fright
 whose agony had wracked the lake of my heart
 through all the terrors of that piteous night. 21
Just as a swimmer, who with his last breath
 flounders ashore from perilous seas, might turn
 to memorize the wide water of his death— 24
so did I turn, my soul still fugitive
 from death's surviving image, to stare down
 that pass that none had ever left alive. 27
And there I lay to rest from my heart's race
 till calm and breath returned to me. Then rose
 and pushed up that dead slope at such a pace 30
each footfall rose above the last. And lo!
 almost at the beginning of the rise
 I faced a spotted Leopard, all tremor and flow 33
and gaudy pelt. And it would not pass, but stood
 so blocking my every turn that time and again
 I was on the verge of turning back to the wood. 36
This fell at the first widening of the dawn
 as the sun was climbing Aries with those stars
 that rode with him to light the new creation. 39
Thus the holy hour and the sweet season
 of commemoration did much to arm my fear
 of that bright murderous beast with their good omen. 42
Yet not so much but what I shook with dread
 at sight of a great Lion that broke upon me
 raging with hunger, its enormous head 45
held high as if to strike a mortal terror
 into the very air. And down his track,
 a She-Wolf drove upon me, a starved horror 48
ravening and wasted beyond all belief.
 She seemed a rack for avarice, gaunt and craving.
 Oh many the souls she has brought to endless grief! 51
She brought such heaviness upon my spirit
 at sight of her savagery and desperation,
 I died from every hope of that high summit. 54
And like a miser—eager in acquisition
 but desperate in self-reproach when Fortune's wheel
 turns to the hour of his loss—all tears and attrition 57
I wavered back; and still the beast pursued,
 forcing herself against me bit by bit
 till I slid back into the sunless wood. 60
And as I fell to my soul's ruin, a presence
 gathered before me on the discolored air,
 the figure of one who seemed hoarse from long silence. 63
At sight of him in that friendless waste I cried:
 "Have pity on me, whatever thing you are,
 whether shade or living man." And it replied: 66
"Not man, though man I once was, and my blood

was Lombard, both my parents Mantuan.
 I was born, though late, *sub Julio*, and bred 69
in Rome under Augustus in the noon
 of the false and lying gods. I was a poet
 and sang of old Anchises' noble son 72
who came to Rome after the burning of Troy.
 But you—why do *you* return to these distresses
 instead of climbing that shining Mount of Joy 75
which is the seat and first cause of man's bliss?"
 "And are you then that Virgil and that fountain
 of purest speech?" My voice grew tremulous: 78
"Glory and light of poets! now may that zeal
 and love's apprenticeship that I poured out
 on your heroic verses serve me well! 81
For you are my true master and first author,
 the sole maker from whom I drew the breath
 of that sweet style whose measures have brought me honor. 84
See there, immortal sage, the beast I flee.
 For my soul's salvation, I beg you, guard me from her,
 for she has struck a mortal tremor through me." 87
And he replied, seeing my soul in tears:
 "He must go by another way who would escape
 this wilderness, for that mad beast that fleers 90
before you there, suffers no man to pass.
 She tracks down all, kills all, and knows no glut,
 but, feeding, she grows hungrier than she was. 93
She mates with any beast, and will mate with more
 before the Greyhound comes to hunt her down.
 He will not feed on lands nor loot, but honor 96
and love and wisdom will make straight his way.
 He will rise between Feltro and Feltro, and in him
 shall be the resurrection and new day 99
of that sad Italy for which Nisus died,
 and Turnus, and Euryalus, and the maid Camilla.
 He shall hunt her through every nation of sick pride 102
till she is driven back forever to Hell
 whence Envy first released her on the world.
 Therefore, for your own good, I think it well 105
you follow me and I will be your guide
 and lead you forth through an eternal place.
 There you shall see the ancient spirits tried 108
in endless pain, and hear their lamentation
 as each bemoans the second death of souls.
 Next you shall see upon a burning mountain 111
souls in fire and yet content in fire,
 knowing that whensoever it may be
 they yet will mount into the blessed choir. 114
To which, if it is still your wish to climb,
 a worthier spirit shall be sent to guide you.
 With her shall I leave you, for the King of Time, 117
who reigns on high, forbids me to come there
 since, living, I rebelled against his law.
 He rules the waters and the land and air 120
and there holds court, his city and his throne.
 Oh blessed are they he chooses!" And I to him:
 "Poet, by that God to you unknown, 123
lead me this way. Beyond this present ill

and worse to dread, lead me to Peter's gate
and be my guide through the sad halls of Hell." 126
And he then: "Follow." And he moved ahead
in silence, and I followed where he led. ■

Notes

1. **midway in our life's journey:** The Biblical life span is three-score years and ten. The action opens in Dante's thirty-fifth year, i.e., 1300 CE.

17. **that planet:** The sun. Ptolemaic astronomers considered it a planet. It is also symbolic of God as He who lights man's way.

31. **each footfall rose above the last:** The literal rendering would be: "So that the fixed foot was ever the lower." "Fixed" has often been translated "right" and an ingenious reasoning can support that reading, but a simpler explanation offers itself and seems more competent: Dante is saying that he climbed with such zeal and haste that every footfall carried him above the last despite the steepness of the climb. At a slow pace, on the other hand, the rear foot might be brought up only as far as the forward foot. This device of selecting a minute but exactly centered detail to convey the whole of a larger action is one of the central characteristics of Dante's style.

The Three Beasts: These three beasts undoubtedly are taken from *Jeremiah* 5: 6. Many additional and incidental interpretations have been advanced for them, but the central interpretation must remain as noted. They foreshadow the three divisions of Hell (incontinence, violence, and fraud) which Virgil explains at length in Canto XI, 16–111.

38–9. **Aries . . . that rode with him to light the new creation:** The medieval tradition had it that the sun was in Aries at the time of the Creation. The significance of the astronomical and religious conjunction is an important part of Dante's intended allegory. It is just before dawn of Good Friday 1300 CE when he awakens in the Dark Wood. Thus his new life begins under Aries, the sign of creation, at dawn (rebirth), and in the Easter season (resurrection). Moreover the moon is full and the sun is in the equinox, conditions that did not fall together on any Friday of 1300. Dante is obviously constructing poetically the perfect Easter as a symbol of his new awakening.

69. **sub Julio:** In the reign of Julius Caesar.

95. **The Greyhound . . . Feltro and Feltro:** Almost certainly refers to Can Grande della Scala (1290–1329), great Italian leader born in Verona, which lies between the towns of Feltre and Montefeltro.

100–101. **Nisus, Turnus, Euryalus, Camilla:** All were killed in the war between the Trojans and the Latians when, according to legend, Aeneas led the survivors of Troy into Italy. Nisus and Euryalus (*Aeneid* IX) were Trojan comrades-in-arms who died together. Camilla (*Aeneid* XI) was the daughter of the Latian king and one of the warrior women. She was killed in a horse charge against the Trojans after displaying great gallantry. Turnus (*Aeneid* XII) was killed by Aeneas in a duel.

110. **the second death:** Damnation. "This is the second death, even the lake of fire." (*Revelation* 20: 14)

118. **forbids me to come there since, living, etc.:** Salvation is only through Christ in Dante's theology. Virgil lived and died before the establishment of Christ's teachings in Rome, and cannot therefore enter Heaven.

125. **Peter's gate:** The gate of Purgatory. (See *Purgatorio* IX, 76 ff.) The gate is guarded by an angel with a gleaming sword. The angel is Peter's vicar (Peter, the first pope, symbolized all popes: i.e., Christ's vicar on earth) and is entrusted with the two great keys.

Some commentators argue that this is the gate of Paradise, but Dante mentions no gate beyond this one in his ascent to Heaven. It should be remembered, too, that those who pass the gate of Purgatory have effectively entered Heaven.

The three great gates that figure in the entire journey are: the gate of Hell (Canto III, 1–11), the gate of Dis (Canto VIII, 79–113, and Canto IX, 86–87), and the gate of Purgatory, as above.

Reading Question

This canto serves as the prelude to the whole of the *Divine Comedy*. It introduces both Dante and his guide, Virgil. How does it also introduce Dante as the reader's guide on the same journey that he and Virgil are about to undertake?

READING 15.7

from Boccaccio, *Decameron*, Dioneo's Tale

Boccaccio completed the Decameron in 1353. It is a transitional work, looking backward in many of its stories to the values and mores of medieval chivalry and mainstream Christianity even as it anticipates the individualism and ingenuity that the coming age, the Renaissance, will celebrate. A single example of its 100 tales, such as Dioneo's ribald classic below, does not do justice to the variety of subject matter and tone, the wide spectrum of human characters, and the scope of narrative structure that Boccaccio employs. But Dioneo's tale encapsulates the worldliness of the Decameron, a newfound frankness perhaps made possible only in the context of the Black Death, which has precipitated the book's storytellers to escape Florence and entertain one another in the countryside.

Loving ladies, if I have well understood the intention of you all, we are here to afford entertainment to one another by story-telling; wherefore, provided only nought is done that is repugnant to this end, I deem it lawful for each (and so said our queen a little while ago) to tell whatever story seems to him most likely to be amusing. . . . I hope to escape your censure in narrating a brief story of a monk, who by his address delivered his body from imminent peril of most severe chastisement.

In the not very remote district of Lunigiana there flour- 10 ished formerly a community of monks more numerous and holy than is there to be found to-day, among whom was a young brother, whose vigour and lustihood neither the fasts

nor the vigils availed to subdue. One afternoon, while the rest of the confraternity slept, our young monk took a stroll around the church, which lay in a very sequestered spot, and chanced to espy a young and very beautiful girl, a daughter, perhaps, of one of the husbandmen[1] of those parts, going through the fields and gathering herbs as she went. No sooner had he seen her than he was sharply assailed by carnal con- 20 cupiscence,[2] insomuch that he made up to and accosted her; and (she hearkening) little by little they came to an understanding, and unobserved by any entered his cell together.

[1]**husbandmen:** farmers.
[2]**carnal concupiscence:** sexual desire.

Now it so chanced that, while they fooled it within somewhat recklessly, he being overwrought with passion, the abbot awoke and passing slowly by the young monk's cell, heard the noise which they made within, and the better to distinguish the voices, came softly up to the door of the cell, and listening discovered that beyond all doubt there was a woman within. His first thought was to force the door open; but, changing his mind, he returned to his chamber and waited until the monk should come out.

Delightsome beyond measure though the monk found his intercourse with the girl, yet was he not altogether without anxiety. He had heard, as he thought, the sound of footsteps in the dormitory, and having applied his eye to a convenient aperture[3] had had a good view of the abbot as he stood by the door listening. He was thus fully aware that the abbot might have detected the presence of a woman in the cell. Whereat he was exceedingly distressed, knowing that he had a severe punishment to expect; but he concealed his vexation from the girl while he busily cast about in his mind for some way of escape from his embarrassment. He thus hit on a novel stratagem which was exactly suited to his purpose. With the air of one who had had enough of the girl's company he said to her: "I shall now leave you in order that I may arrange for your departure hence unobserved. Stay here quietly until I return." So out he went, locking the door of the cell, and withdrawing the key, which he carried straight to the abbot's chamber and handed to him, as was the custom when a monk was going out, saying with a composed air: "Sir, I was not able this morning to bring in all the faggots[4] which I had made ready, so with your leave I will go to the wood and bring them in." The abbot, desiring to have better cognisance of the monk's offence, and not dreaming that the monk knew that he had been detected, was pleased with the turn matters had taken, and received the key gladly, at the same time giving the monk the desired leave. So the monk withdrew, and the abbot began to consider what course it were best for him to take, whether to assemble the brotherhood and open the door in their presence, that, being witnesses of the delinquency, they might have no cause to murmur against him when he proceeded to punish the delinquent, or whether it were not better first to learn from the girl's own lips how it had come about. And reflecting that she might be the wife or daughter of some man who would take it ill that she should be shamed by being exposed to the gaze of all the monks, he determined first of all to find out who she was, and then to make up his mind. So he went softly to the cell, opened the door, and, having entered, closed it behind him. The girl, seeing that her visitor was none other than the abbot, quite lost her presence of mind, and quaking with shame began to weep. Master abbot surveyed her from head to foot, and seeing that she was fresh and comely,[5] fell a prey, old though he was, to fleshly cravings no less poignant and sudden than those which the young monk had experienced, and began thus to commune with himself: "Alas! why take I not my pleasure when I may, seeing that I never need lack for occasions of trouble and vexation of spirit? Here is a fair wench, and no one in the world to know. If I can bring her to pleasure me, I know not why I should not do so. Who will know? No one will ever know; and sin that is hidden is half forgiven; this chance may never come again; so, methinks, it were the part of wisdom to take the boon which God bestows." So musing, with an altogether different purpose from that with which he had come, he drew near the girl, and softly bade her to be comforted, and besought her not to weep; and so little by little he came at last to show her what he would be at. The girl, being made neither of iron nor of adamant,[6] was readily induced to gratify the abbot, who after bestowing upon her many an embrace and kiss, got upon the monk's bed, where, being sensible, perhaps, of the disparity between his reverend portliness and her tender youth, and fearing to injure her by his excessive weight, he refrained from lying upon her, but laid her upon him, and in that manner disported himself with her for a long time. The monk, who had only pretended to go to the wood, and had concealed himself in the dormitory, no sooner saw the abbot enter his cell than he was overjoyed to think that his plan would succeed; and when he saw that he had locked the door, he was well assured thereof. So he stole out of his hiding-place, and set his eye to an aperture through which he saw and heard all that the abbot did and said. At length the abbot, having had enough of dalliance with the girl, locked her in the cell and returned to his chamber. Catching sight of the monk soon afterwards, and supposing him to have returned from the wood, he determined to give him a sharp reprimand and have him imprisoned, that he might thus secure the prey for himself alone. He therefore caused him to be summoned, chid him very severely and with a stern countenance, and ordered him to be put in prison. The monk replied trippingly: "Sir, I have not been so long in the order of St. Benedict as to have every particular of the rule by heart; nor did you teach me before to-day in what posture it behoves the monk to have intercourse with women, but limited your instruction to such matters as fasts and vigils. As, however, you have now given me my lesson, I promise you, if you also pardon my offence, that I will never repeat it, but will always follow the example which you have set me."

The abbot, who was a shrewd man, saw at once that the monk was not only more knowing than he, but had actually seen what he had done; nor, conscience-stricken himself, could he for shame mete out to the monk a measure which he himself merited. So pardon given, with an injunction to bury what had been seen in silence, they decently conveyed the young girl out of the monastery, whither, it is to be believed, they now and again caused her to return. ■

Reading Question

The circulation of stories such as this certainly contributed to the growing crisis of trust faced by the Church throughout the Middle Ages and into the Renaissance. How does it raise broader issues than just the question of clerical celibacy?

[3]**aperture:** opening.

[4]**faggots:** firewood.

[5]**comely:** beautiful.

[6]**adamant:** diamond (i.e., a hard substance).

Summary

■ **Tuscany** Tuscany was dominated by two competing city-states, Siena and Florence. Both were republics, and central to their success was a new form of government in which church and state were closely aligned.

■ **Siena: A Free Commune** Siena established itself in 1125 as a free *commune*, a collective of people gathered together for the common good. Watching over Siena was the Virgin Mary, uniting civic and religious life. Her image oversaw the workings of the city government, exerting her moral influence over it.

■ **Florence: Archrival of Siena** By the twelfth century, Florence was the center of textile production in the Western world and played a central role in European trade markets. As in Siena, it was the city's bankers and moneylenders who made Florence such a vital player in world trade. Also as in Siena, in Florence the guilds controlled the commune. The most prestigious was the lawyers' guild, followed closely by the wool guild, the Arte della Lana, and the latter controlled the government.

■ **Tuscan Religious Life** Siena commissioned a new facade for its cathedral from Giovanni Pisano in 1284. Florence responded to Siena's initiative 10 years later when the Arte della Lana formed the Opera del Duomo, a committee in charge of building a new cathedral, for which construction began in 1296. Aside from cathedrals, civic leaders also engaged in building projects for the new urban religious mendicant orders: the Dominicans and the Franciscans. In Florence, the civic government and private citizens constructed a new church for the Franciscans, Santa Croce, on the eastern side of the city, and another for the Dominicans, Santa Maria Novella, on the city's western side. Both orders developed wide followings by preaching powerfully persuasive sermons. Legends surrounding Saint Francis of Assisi, promoted by the Church, were also appealing.

■ **Painting in Siena and Florence** In both Siena and Florence, artists began to break from the Byzantine style. One of the first was Duccio, who began to incorporate the Gothic tendency to naturalism into his *Maestá,* painted for Siena's cathedral. Even more naturalistic is Simone Martini's *Maestá,* painted for the city hall. But in less formal pictures, Duccio could realize a naturalism rivaling Simone's, especially in the scenes from the Passion of Christ decorating the back of his *Maestá.* Florence, too, had its master painters of the Virgin, Cimabue and Giotto. The latter brought an expressiveness and emotional symbolism to his work not seen in Western art since Hellenism, especially in paintings depicting the life of Christ in the Arena Chapel in Padua.

■ **The Tuscan Vernacular Tradition** In the early twelfth century, writers across Europe began to address their works to a wider lay audience and to write in the vernacular, the language spoken in the streets. One of the greatest medieval Italian vernacular writers was the poet Dante Alighieri, whose *Divine Comedy* records the travels of the Christian soul from Hell to Purgatory and finally to Salvation in three books—the *Inferno, Purgatorio,* and *Paradiso.*

■ **The Black Death** In December 1347, bubonic plague arrived in Sicily. Within months, the disease spread northward, through Europe. In Tuscany, the death rate in the cities ran somewhere near 60 percent. Many blamed the Jews, who were widely persecuted. One of the most remarkable accounts of the plague opens Boccaccio's *Decameron,* a collection of stories told by young noblemen and women who escaped Florence for the countryside. Perhaps reflecting the reality of death that surrounds them, the stories are themselves imbued with a realistic representation of life as it is truly lived.

■ **Vernacular Literature** The sonnets of Petrarch, composed in memory of the poet's beloved Laura, inaugurate one of the most important poetic forms in Western literature. Chaucer's *Canterbury Tales,* modeled on Boccaccio's *Decameron,* approach life in the Middle Ages with a realism even more profound than Boccaccio's. Many of both Boccaccio's and Chaucer's characters are women, and they represent a new, increasing independence among European women epitomized by Christine de Pizan, the first female professional writer in European history. In her *Book of the City of Ladies,* she attacked male misogyny by rehearsing the accomplishments of women throughout the ages.

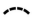

Glossary

buon fresco A type of painting applied to a wet wall.

cartoon A full-size preparatory drawing for a final artwork, especially a fresco or painting.

charnel house A building in which bones or bodies of the dead were stored.

commune A collective of people gathered together for the common good.

estate A social rank, namely, the nobility, the clergy, and the common people.

flagellant A penitent who beats himself or herself to atone for sin.

fresco secco A type of fresco painting applied to a dry wall.

gesso A thick medium made of glue, gypsum, and/or chalk that creates a smooth sealed ground for painting.

giornata The boundaries of the small sections of fresco that could be completed in a single day; often conformed to the contours of major figures and objects.

guild An association or group of people with like-minded interests or skills.

heroic couplet A rhyming pair of iambic pentameter lines.

Italian sonnet A Petrarchan sonnet.

mendicant order A religious order whose members do not hold property or engage in business.

Petrarchan sonnet A sonnet composed of 14 lines divided into two parts: an *octave* of eight lines that presents a problem, and a *sestet* of six lines that either attempts to solve the problem or accepts it as unsolvable.

pogrom A massacre of Jews.

sinopia A preliminary drawing for a fresco that is often elegantly filled out and perfected in charcoal.

stylus A hard-pointed pen-shaped instrument.

tempera A type of painting process using a water-soluble material, such as egg yolks, instead of oil paint.

terza rima An interlocking three-line pattern invented by Dante that uses the pattern a/b/a, b/c/b, c/d/c, and so on.

vernacular The language spoken in the streets.

Critical Thinking Questions

1. What does the Guelph/Ghibelline rivalry tell us about religious and civic politics in Tuscany?

2. How do the Dominicans and the Franciscans compare? What accounts for their great popularity and civic support?

3. What, in your view, accounts for Giotto's reputation as a painter?

4. How would you characterize the new vernacular literature of the fourteenth century? How does Dante's *Divine Comedy* differ from Boccaccio's *Decameron*? What does this tell us about the impact of the Black Death on European consciousness?

The Dance of Death

We do not know who, in 1424, painted a series of pictures representing a Dance of Death along the walls backing the **charnel houses**—houses where the bones of the dead were stored—that ran the length of the Cemetery of the Holy Innocents in Paris on the Rue de la Ferronnerie. These paintings were undoubtedly inspired by a clergy bent on encouraging Christian feeling and sentiment in their parishioners and on reminding them of their Christian duties in the face of certain death. Every rank and order of human society was represented in this procession, the pope and emperor at its head (Fig. **15.22**), a fool and an author pulling up the rear. Verses attributed to the Chancellor of the University of Paris, Jean de Charlier de Gerson, accompany the paintings:

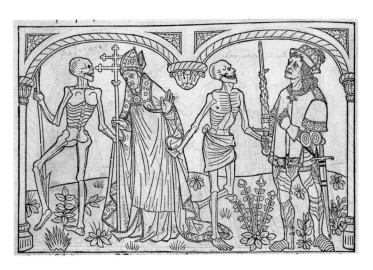

Fig. 15.22 *Dance of Death*. ca. 1490. Woodcut. Library of Congress, Washington, DC. Lessing J. Rosenwald Collection. This print is one of a series copying the images on the charnel house walls of the Cemetery of the Holy Innocents.

> By divine sentence
> No matter what your estate
> Whether good or evil, you will be
> Eaten by worms. Alas, look at us,
> Dead, stinking, and rotten.
> You will be like this, too.

The toll the Black Death wreaked on the arts was indeed devastating. In Siena, Giovanni Pisano and Ambrogio Lorenzetti were among the many victims of the Black Death. In Florence, almost all of Giotto's best students succumbed. But since the plague destroyed people and not possessions, the enormous decrease in population resulted in a corresponding increase in per capita wealth, and those who survived invested in religious art—chapels and hospitals, altarpieces and votive statues—in gratitude for being spared or in the hope of preventing future infection. Painters and sculptors turned their attention to the representation of the sufferings of Christ, the sorrows rather than the joys of the Virgin, and the miracles of the saints. The Art of Dying Well and the Triumph of Death became important themes in art

and literature. The new humanism, or belief in the value of individuals and their human potential, so evident in the realist art of Giotto and in the writings of Petrarch, Boccaccio, and Chaucer, suggests that the plague stimulated the Western imagination perhaps more than it defeated it.

Nevertheless, the specter of death, which the Black Death so thoroughly embedded in the popular imagination, haunted Western society for at least 400 years. The Cemetery of the Holy Innocents, which was the size of a large city block and occupied the area of Paris today known as Les Halles, accommodated many of the dead, but by the middle of the eighteenth century, the cemetery was almost literally exploding with corpses. Many people, who now possessed at least a rudimentary understanding of infection, argued that this cemetery was a breeding ground of disease. On December 1, 1780, a cellar wall on the Rue de la Ferronnerie burst, releasing noxious gases and fluids into the streets, and the cemetery was permanently closed. The charnel houses were demolished—along with the Dance of Death images that covered their walls. As for the dead, they were reburied in catacombs dug from ancient quarries beneath the city streets, today a tourist site.

This vast removal of the dead amounted to a banishment of the specter of death from the daily life of the city, culminating finally, in 1804, with the Emperor Napoleon's Imperial Decree on Burials. Henceforth, burial was banned within the city. Each corpse would have an individual plot, permanent if space allowed, in one of four garden environments outside the city proper—among them, the bucolic Père Lachaise Cemetery, which even today attracts Parisians to its hills and paths. All were designed to aid in absorbing what the Ministry of Interior called "cadaverous miasmata." It was envisioned that in these new Elysian Fields children would periodically scatter flowers over the tombs. Thus, the idea of the cemetery as a kind of landscape garden, as we know it today, was born. ■

16 China, India, Japan, Africa, and the Americas before 1400

Developments in China

Indian and Southeast Asian Civilizations

Japanese Civilization

The Cultures of Africa

The Cultures of Mesoamerica in the Classic Era

The Cultures of South America

❝ The houses of the citizens are well built and elaborately finished, and the delight they take in decoration, in painting and in architecture, leads them to spend in this way sums of money that would astonish you. ❞

Marco Polo, *Travels*

◄ **Fig. 16.1** *Large Seated Buddha with Standing Bodhisattva,* **from cave 20, Ungang, Shaanxi, China, Northern Wei dynasty. ca. 460–70 CE.** Stone, height 44′. By the last half of the fifth century, when this sculpture was carved, the Chinese Wei rulers, who lived near the eastern end of the Silk Road, had become acquainted with the Indian Buddhist religion. This sculpture thus embodies the spread of ideas across Asia during the period of the European Middle Ages. Buddhism would spread, through China, to Japan by 600 CE. Indian Hinduism would, in turn, spread across Southeast Asia.

BUDDHISM IS NOT A PLACE, BUT IT WAS NONETHELESS THE center of culture in Asia during the period that we call the Middle Ages in the West. Between the first and third centuries CE, Buddhist missionaries from India had carried the religion over the Silk Road (see *Continuity and Change*, page 131

chapter 4) into Southeast Asia and north into China and Korea. By 600 CE, Buddhism had reached all the way to Japan (Map **16.1**).

The first Chinese Buddhist monk to set out on the Silk Road in search of Buddhist scripture to translate into Chinese was Zhu Shixing [Joo shih-hsing] of Hunan province. His journey dates from about 260 CE. At the same time, far away on the Silk Road, a resident of Dunhuang [Doon-hwahng] began his life's work as a translator of Buddhist texts. One of the most telling manifestations of the religion's spread is the appearance everywhere of images of Buddha (Fig. **16.1**). In early Buddhist art, the Buddha was never shown in figural form. It was believed to be impossible to represent the Buddha, since he had already passed to nirvana. Instead, his presence was symbolized by such things as his footprints, the bo tree (see Chapter 4), the wheel (representing *dharma*, or the Wheel of Law), or elephants (see Fig. 4.15).

By the fourth century, during the reign of the Gupta rulers in India, the Buddha was commonly represented in human form. Typically his head is oval, framed by a halo. Atop his head is a mound, symbolizing his spiritual wisdom, and on his forehead is a "third eye," symbolizing his spiritual vision. His demeanor is gentle, reposed, and meditative. His elongated ears refer to his royal origins, and his hands are set in one of several symbolic gestures, called **mudra**. The seated Buddha in Fig. 16.1 exhibits the *Dhyana mudra* [Duh-YAH-nuh mood-rah], a gesture of meditation and balance. The lower hand represents the physical world of illusion, the upper, nirvana. Together they symbolize the path to enlightenment. The *bodhisattva*—a person of near total enlightenment who has vowed to help others achieve it—standing next to him is exhibiting the *Abhaya mudra* [Uh-BAH-yah mood-rah], a gesture of reassurance, blessing, and protection.

At Bamiyan, on the Silk Road in present-day Afghanistan, two massive Buddhas, 175 and 120 feet tall, were carved into a cliff face in the third century CE (Fig. **16.2**). These figures were completely destroyed by the fun-

damentalist Islamic Taliban in 2001. However, many surviving replicas from the Silk Road era suggest that the hands of these Buddhas, which succumbed to natural forces long ago,

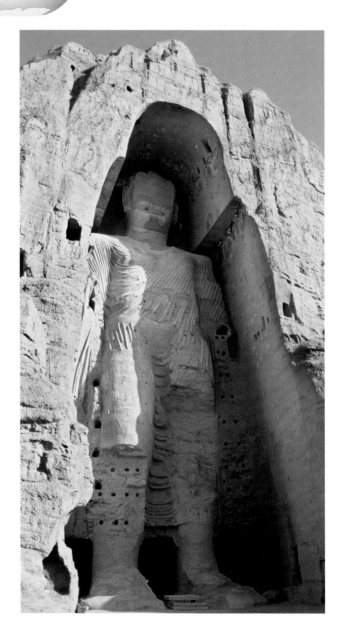

Fig. 16.2 Colossal Buddha, Bamiyan, Afghanistan. ca. 3rd century CE. Stone, height 175′. The two colossal sculptures were destroyed in February 2001 by the fundamentalist Islamic Taliban, who evidently felt that as false idols they were an affront to Mohammed.

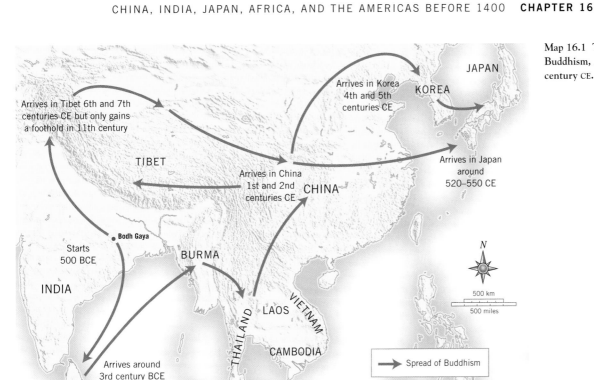

Map 16.1 The Spread of Buddhism, 500 BCE–11th century CE.

were held up in the *Dharmachakra mudra* [Dahr-mah-chahk-rah mood-rah], the teaching pose. This *mudra* symbolizes intellectual debate and is often associated with Buddhist centers of learning. Painted gold and studded with jewels, and surrounded by caves decorated with Buddhist wall paintings, these enormous images reflect the magnitude of Buddha's eternal form, at which the earthly body can barely hint.

This chapter traces the development of five great centers of culture during the period that coincides with Europe's Middle Ages: China, India, Japan, Africa, and the Americas. It was a period of great cross-fertilization in Asia, as the example of Buddhism demonstrates. Chinese technological innovation was unrivaled in the world, and Chinese art and literature flourished as well. In India, Buddhists, threatened by invading Muslims from Persia, retreated into the Himalayan Mountains, even as the Hindu religion regained prominence and spread across Southeast Asia. In Japan, a feudal, military society vied with Buddhist teaching for pre-eminence. Across the African continent, sophisticated peoples rose to dominate their regions. Similarly, in the Americas, cultures in Mesoamerica and Peru achieved similar levels of complexity and sophistication without the kind of contact with other great cultures that marked development in Asia. This chapter's overview of these cultures puts the Western Middle Ages in a broader perspective. During these years, the growing globalization of culture was just beginning to assert itself on the Silk Road. As we will see, the world's centers of culture were never again to be isolated from each other.

Developments in China

After the fall of the Han dynasty in 220 CE (see chapter 4), China entered an uneasy period. Warring factions vied for control of greater or lesser territories, governments rose to power and fell again, civil wars erupted, and tribes from Central Asia continuously invaded. During this time, Buddhism began to spread through the culture. The Confucian ethical system (see chapter 4) seemed to have resulted in civil and cultural dysfunction. In contrast, Buddhism offered an ethical system based less on social and civic duty and more on each person's duty to his or her own soul. Especially in its emphasis on meditation and enlightenment, Buddhism was compatible with Daoism (also discussed in chapter 4). By the seventh century CE, Chinese leaders had learned to take the best from all three—Confucianism, Buddhism, and Daoism—and the culture was once again unified.

The Tang Dynasty in Chang'an, "The City of Enduring Peace" (618–907 CE)

In 618, the Tang dynasty reestablished a period of peace and prosperity in China that, except for a brief period of turmoil in the tenth century, would last for 660 years. The Tang dynasty was, by far, the product of the largest and most organized government in the world in the last half of the first millennium. Its capital was the eastern end of the Silk Road, Chang'an, "City of Enduring Peace" (present-day Xi'an, which is about one-seventh the size of the Tang capital). The city had served as the capital of the Han dynasty as well, but as the Tang restored trade along the Silk Road, they created elaborate plans to restore the city too. By the

eighth century, its population was well over 1 million, living inside a walled perimeter nearly 26 miles in length and enclosing almost 42 square miles. Outside the walls lived perhaps as many as another million people. Among its inhabitants were Korean, Japanese, Jewish, and Christian communities, and its emperors maintained diplomatic relations with Persia.

Chang'an was the largest city in the world, laid out in a carefully conceived grid that dramatized the Tang commitment to social order and mirrored, they believed, the order of the cosmos (Fig. **16.3**). Each of the city's 108 blocks was itself a miniature walled city, with its own interior streets and gates that locked at night. Astronomers laid out the streets by aligning them with the shadow of the sun at noon and the position of the North Star at night, thereby orienting the city to the four cardinal directions. The imperial palace was located at the north end, facing south, thus symbolizing the emperor looking out over his city and, by extension, his empire. Traditionally, Chinese emperors turned their backs to the north, from where, it was believed, evil spirits (not to mention Huns) came. Government buildings occupied the space in front of the imperial palace. A 500-foot-wide avenue led from these directly to the southern gate.

Tang Art and Architecture Like all great Chinese dynasties, the Tang were great builders. One of their most important accomplishments was to build the Grand Canal on the Yellow River, just downstream from Chang'an, to the Hangzhou Bay, at the mouth of the Yangzi River, thus uniting northern and southern China. The Chinese had developed iron- and steel-casting during the Han dynasty in the third century BCE, and by the sixth or seventh century BCE the technique had become commonplace, used to construct not only suspension bridges but also **pagodas**. (Equally sophisticated iron- and steel-casting would not develop in the West until the eighteenth century.) The pagoda is a multistoried structure of successively smaller, repeated stories, with projecting roofs at each story. The design derives from Indian stupas (see Fig. 4.13), which had become more and more tower-like by the sixth century CE, and Han watchtowers. The pagoda was understood to offer the temple a certain protection. Of the few surviving buildings in China that predate 1400, the Great Wild Goose Pagoda at Ci'en [Tseh-ehn] Temple in Chang'an is one of the most magnificent (Fig. **16.4**). It was built—entirely of masonry, not iron or steel—in 645 for the monk Xuanzang [Shoo-ehn-tsahng], who taught and translated the materials he brought back with him from a 16-year pilgrimage to India. In its simplicity and symmetry, it represents the essence of Tang architecture.

Tang Poetry The Tang valued education above all. The imperial college at Chang'an trained all civil servants (women were excluded), and intellectual achievement was held in high esteem. Confucian and Daoist philosophy dominated the arts, particularly poetry, where two Tang poets, the Daoist Li Po (701–62) and the Confucian Du Fu (712–70), achieved special prominence. Both relied for inspiration on *The Book of Songs* (see chapter 4) but extended its range considerably. Their different temperaments are expressed in two short poems (**Reading 16.1a**):

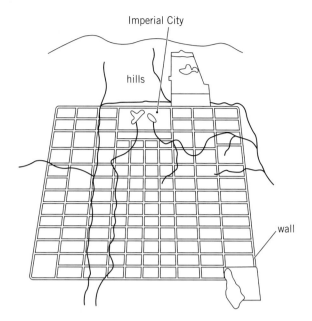

Fig. 16.3 Plan of the Tang capital of Chang'an, China. ca. 600. The location of the capital had been determined, in Han times, by the practice of *feng shui*, literally "wind and water," which assesses the primal energy that flows through a particular landscape. In this case, the hills to the north of the city and the streams running through it were understood to protect the precinct. *Feng shui* is still practiced to this day.

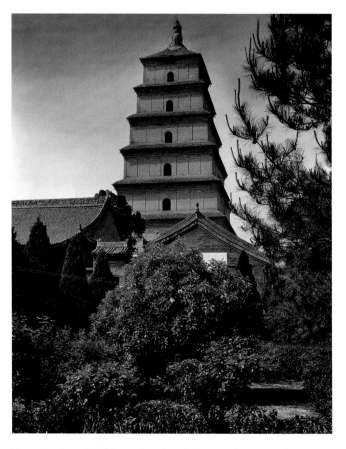

Fig. 16.4 Great Wild Goose Pagoda at Ci'en Temple, Xi'an, Shanxi. Tang dynasty, first erected 645 CE. The Temple was rebuilt in the 8th century, when two stories were added to the original five.

READING 16.1a Poems by Li Po and Du Fu

"Summer Day in the Mountains" by Li Po

Lazy today, I wave my white feather fan.
Then I strip naked in the green forest,
Untie my hatband and hang it on a stone wall.
Pine wind sprinkles my bare head.

"Broken Lines" by Du Fu

River so blue the birds seem to whiten.
Flowers almost flame on the green mountainside.
Spring is dying yet again.
Will I ever go home?

Li Po is famous for the self-examination in his poems, his colloquial speech, and his frank celebration of his own sensuality. We see these characteristics too in his poem, "Drinking Alone at Midnight," addressed to the moon (see **Reading 16.1** on page 528).

The poems of Du Fu are sometimes full of pathos. He wrote "Dreaming of Li Po," when his friend was in exile in the south. The two belonged to a group called the Eight Immortals of the Wine Cup, famous for gathering in a garden of peach and plum trees on moonlit spring nights, where they drank wine to unleash their poetic temperaments. Like all the Immortals of the Wine Cup, Li Po and Du Fu were equally expert in poetry, calligraphy, and painting—as well as statesmanship and philosophy. They present a model of what 500 years later the West would come to call the "Renaissance Man," the perfectly rounded individual, at home in any arena. They also embody the complex characteristics of Tang culture—at once strong and vigorous as well as passionate and sympathetic, simultaneously realistic and idealistic, intensely personal even while dedicated to public service.

The Song Dynasty and Hangzhou, "The City of Heaven" (960–1279 CE)

"The most splendid city in the world," so the Venetian explorer Marco Polo (1254–1324) described Hangzhou, the capital of China's Southern Song dynasty (1127–1279) when Polo first visited it in 1274. Although Hangzhou was now the world's largest city—home to about 2 million people—no other Westerner had ever seen it. Marco Polo's father and uncle had a successful trading business with the East, and Marco lived with them in China for 17 years.

He wrote at length about his journey to Hangzhou in his *Travels*, first published in 1299. He claimed that he first visited the city as the ambassador of Kublai Khan. Northern Song China was already in Kublai Khan's hands, conquered in 1271, but he would not conquer the Southern Song on the Yangzi River until 1279. So, when Marco first saw Hangzhou it was still a Song city. Its lakes and parks were so beautiful, filled with floating teahouses from which passengers could view the palaces, pagodas, and temples that dotted the shore, that the city was known as Kinsai [KEEN-sa-hee], or the "City of Heaven." The entire city, some 200 square miles, was protected by a 30-foot-high wall, with even higher watchtowers rising above it. Inside the walls, a system of canals, which must have reminded Marco of his native Venice, was crisscrossed by some 12,000 bridges. These canals were fed by the most famous and probably most beautiful lake in China, the so-called West Lake, a popular resort. Beautiful women and pleasure-seekers gathered on houseboats on its waters, and writers and artists congregated in the tranquil libraries and monasteries on its shores.

"In this city," Marco would write, "there are 12 guilds of different crafts, and each guild has 12,000 houses in the occupation of its workmen. Each of these houses contains at least 12 men, while some contain 20 and some 40, including the apprentices who work under the masters. All these craftsmen had full employment since many other cities of the kingdom are supplied by this city." In fact, each guild was formed around people from the same province. In Hangzhou, tea and cloth merchants hailed from the eastern province of Anhwui, carpenters and cabinetmakers from the city of Ningbo, and so on. All came together to enjoy the benefits of trade and commerce in the capital. Foodstuffs, silks, spices, flowers, and books filled the markets (**Reading 16.2**):

READING 16.2 **from Marco Polo,** *Travels*

Those markets make a daily display of every kind of vegetable and fruit; and among the latter there are in particular certain pears of enormous size, weighing as much as ten pounds apiece, and pulp of which is white and fragrant like a confection, besides peaches in their season both yellow and white, of every delicate flavor. . . . From the Ocean Sea also come daily supplies of fish in great quantity, brought 25 miles up river, and there is also great store of fish from the lake, which is the constant resort of fishermen, who have no other business. Their fish is of sundry kinds, changing with the season; and it is remarkably fat and tasty. Anyone who should see the supply of fish in the market would suppose it impossible that such a quantity could ever be sold; and yet in a few hours the whole shall be cleared away; so great is the number of inhabitants who are accustomed to delicate living.

These "delicate living" citizens apparently lived remarkably well: "The houses of the citizens are well built and elaborately finished," Polo claims, "and the delight they take in decoration, in painting and in architecture, leads them to spend in this way sums of money that would

astonish you." In other words, Hangzhou was a center of Asian culture that no one in the West, save Marco Polo, could even dream existed, in many ways exceeding anything the West had realized.

The Song dynasty enjoyed tremendous prosperity. It was the world's greatest producer of iron, and its flourishing merchant class traded not only along the Silk Road (see chapter 4) but also throughout the Southeast Asian seas by boat. The government was increasingly controlled by this wealthy merchant class. Crucial to their rise was the development of movable type, which allowed the Song to begin printing books on paper. The printing press revolutionized the transmission of knowledge in China. (Gutenberg's movable type printing press, which, in the West, we commonly credit with revolutionizing the transmission of knowledge, was 400 years in the future.) The children of the thriving merchant class attended public, private, and religious schools, where they could study the newly printed books—including *The Book of Songs*, required reading for all Chinese civil servants, and various encyclopedias—as they prepared for government examinations. This new class of highly educated government officials restored Confucianism to dominance and strengthened it with relevant additions from Daoism and Buddhism. Buddhism was officially rejected as foreign, but its explanation of the universe provided an invaluable metaphysical element to Confucianism. As a result, these new officials brought to government a deep belief, based on neo-Confucian teaching, that the well-run society mirrored the unchanging moral order of the cosmos. (See *Voices*, below.)

Chan Buddhism Especially important to artists and literati in the Song era was the development of Chan Buddhism. "Chan" (better known in the West as "Zen," as it is

 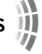

Voices

Memoirs of a Chinese Lady

Li Qingzhao was one of China's most prominent poets. She and her husband lived during the Song dynasty period and enjoyed collecting paintings and antiques as his career as an imperial official progressed. By 1126, the Song dynasty was under serious attack from nomadic groups from the North. After the couple's house was destroyed, they moved south, and Li's husband died. She spent the rest of her life writing poetry and journals, as well as publishing her husband's writing.

I n 1101 [age 18], . . . I came as a bride to the Zhao household. At that time my father was a division head in the Ministry of Rites, and my father-in-law, later a Grand Counselor, was an executive in the Ministry of Personnel. My husband was then 21 and a student in the Imperial Academy.

In those days our two families, the Zhaos and the Lis, were not well-to-do and we were always frugal. On the first and fifteenth day of every month, my husband would . . . "pawn some clothes". . . [and] buy fruit and rubbings of inscriptions. When he brought these home, we would sit facing one another, rolling them out before us, examining and munching. And we thought ourselves persons of the age of Ge-tian [an age of contentment].

When, two years later, he went to take up a post, we lived on rice and vegetables and dressed in common cloth; but he would search out the most . . . ancient writing and unusual scripts . . . I recall that . . . a man came with a painting of peonies by Xu Li [900s] and asked

> ### "I would have been glad to grow old in such a world."

twenty thousand cash for it. In those days twenty thousand was a hard sum to raise, even for children of the nobility. We kept the painting with us for a few days, and having thought of no plan by which we could purchase it, we returned it. For several days afterward my husband and I faced each other in deep depression.

Later we lived privately at home for ten years, gathering what we could here and there to have enough food and clothing. . . . When he got hold of a piece of calligraphy, a painting, a goblet, or a tripod, we would go over it at our leisure, pointing out faults and flaws, setting for our nightly limit the time it took one candle to burn down. Thus our collection came to surpass all others in fineness of paper and the perfection of the characters.

I happen to have an excellent memory, and every evening after we had finished eating, we would . . . make tea. Pointing to the heaps of books and histories, we would guess on which line of which page in which chapter of which book a certain passage could be found. Success in guessing determined who got to drink his or her tea first. Whenever I got it right, I would raise the teacup, laughing so hard that the tea would spill in my lap, and I would get up, not having been able to drink any of it at all. I would have been glad to grow old in such a world.

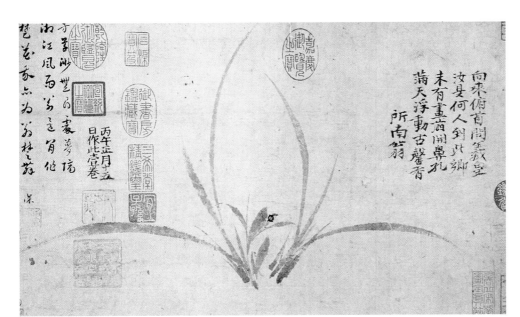

Fig. 16.5 Cheng Sixiao, *Ink Orchids*. Yuan dynasty, 1306. Ink on paper, $10\frac{1}{8}'' \times 16\frac{3}{4}''$. Municipal Museum of Fine Art, Osaka, Japan. Artists of the Yuan dynasty such as Cheng Sixiao painted for their fellow artists and friends, not for the public. Thus, Cheng Sixiao could feel comfortable describing his political intentions in the text accompanying this painting.

pronounced in Japanese) derives from the Sanskrit word *dhyana*, meaning "meditation." Like Daoism, Chan Buddhism teaches that one can find happiness by achieving harmony with nature. By using yoga techniques and sitting meditation, the Chan Buddhist strives for oneness with the Dao ("the Way") and the Confucian *li*, the principle or inner structure of nature. The Chan Buddhists thought that the traditional scriptures, rituals, and monastic rules of classical Buddhism were essentially beside the point, because Buddha's spirit was innate in everyone, waiting to be discovered through meditation. Thus, the poets and artists who practiced Chan Buddhism considered themselves instruments through which the spirit of nature expressed itself.

Song Painting This essential "rightness" of the Song world is manifested especially in Chinese painting of the Song era, when landscape painting became the principal and most esteemed means of personal and philosophic expression in the arts. The landscape was believed to embody the underlying principle behind all things, made manifest in the world through its material presence. Closely akin to the spiritual quest of the Dao, the task of the artist was to reveal the unifying principle of the natural world, the eternal essence of mountain, waterfall, pine tree, rock, reeds, clouds, and sky. Human figures are dwarfed by the landscape, insignificant in the face of nature. Over and over again, the paintings of the period rise from foreground valleys to high mountaintops, the eye following paths, cascading waterfalls, rocky crags, and tall pines pointing ever higher in imitation of "the Way," the path by which one leaves behind the human world and attains the great unifying principle (see *Focus*, pages 504–505).

The Yuan Dynasty (1279–1368)

Throughout the period known as the medieval era in the West, China was threatened from the north by nomadic tribes. The Northern Song capital of Bianjing [Beeehn-geeng] had fallen to tribes from Manchuria in 1126, forcing the Song to retreat south to Hangzhou. Finally, the Song dynasty succumbed to the Mongol leader Kublai Khan in 1279. Kublai Khan ruled from a new capital at present-day Beijing, transforming it into a walled city constructed on a grid plan and extending the Grand Canal to provision the city.

Calling themselves the Yuan dynasty, the Mongols under Kublai Khan and his descendants controlled the highest posts in the government, but they depended on Chinese officials to collect taxes and maintain order. The Chinese understood the need to cooperate with the Mongols, but they viewed the Mongols as foreigners occupying their homeland. (Remember, foreigners were banned from entering the Forbidden City.)

At the time of Marco Polo's arrival in China, the scholar-painters of the Chinese court, unwilling to serve under foreign domination, were retreating from public life. But while in exile they created an art symbolic of their resistance. Paintings of bamboo, for instance, abound, because bamboo is a plant that might bend, like the Chinese themselves, but never break. Painted in 1306, Cheng Sixiao's [Chehng-sih-she-how] *Ink Orchids* (Fig. **16.5**), according to its inscription, is meant to protest the "theft of Chinese soil by the invaders." Orchids, in fact, can live without soil, in rocks or in trees, sustained by the moisture in the air around them, even as Sixiao the painter thrives. The Mongols were finally overthrown in 1368, when Zhu Yuanzhang (r. 1368–98) drove the last Yuan emperor north into the Gobi desert and declared himself first emperor of the new Ming dynasty. China was once again ruled by the Chinese.

Focus

Guo Xi's *Early Spring*

The human presence in nature goes almost unnoticed in Guo Xi's [Gwoh hsee] hanging scroll, *Early Spring*. Nature, embodied by the mountain, is all-embracing, a powerful and imposing symbol of eternity. The composition of Guo Xi's painting is based on the Chinese written character for mountain. The fluid gestures of the calligrapher's hand are mirrored in Guo Xi's painting, both in the organization of the whole and in the individual brush-and-ink strokes that render this ideal landscape. Like the calligrapher, Guo Xi is interested in the balance, rhythm, and movement of his line.

A court painter during the reign of the Emperor Shen-zong [Shehn-tsohng] (r. 1068–85), Guo Xi was given the task of painting all the murals in the Forbidden City, the imperial compound in Beijing that foreigners were prohibited from entering. His ideas about landscape painting were recorded by his son, Guo Si [Gwoh-seh], in a book entitled *The Lofty Message of the Forests and Streams*. According to this book, the central peak here symbolizes the emperor himself; its tall pines the gentlemanly ideals of the court. Around the emperor the masses assume their natural place, as around this mountain the trees and hills fall into the order and rhythms of nature.

The central mountain is painted so that we gaze up to it in the "high distance," as we would gaze up at the emperor.

山

Chinese character for "mountain."

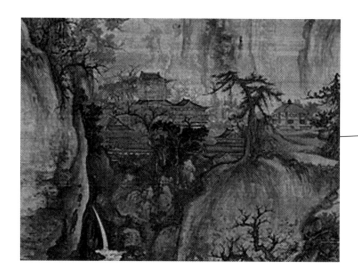

Barely noticeable, two figures get out of their boat at the bottom left, and another figure stands on the shoreline at the right. Two waterfalls cascade down the hillside behind this second figure, and a small village can be seen nestled on the mountainside above the falls.

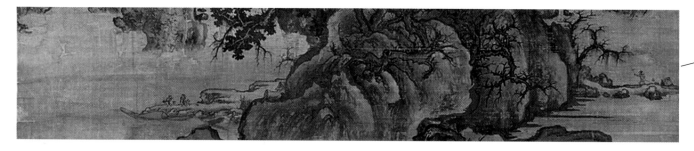

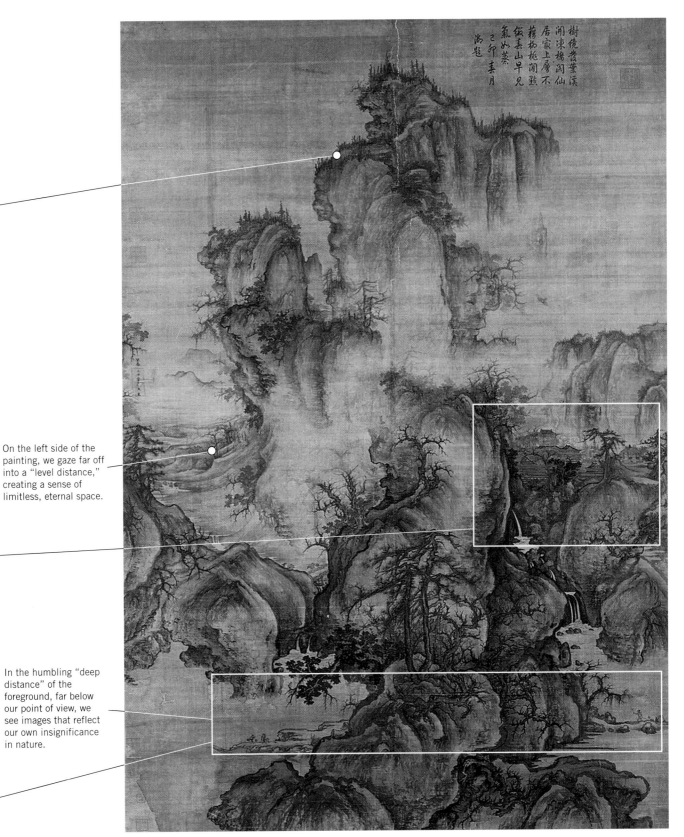

On the left side of the painting, we gaze far off into a "level distance," creating a sense of limitless, eternal space.

In the humbling "deep distance" of the foreground, far below our point of view, we see images that reflect our own insignificance in nature.

Guo Xi, *Early Spring.* **Song dynasty, 1072.** Hanging scroll, ink and slight color on silk, length 5′. Collection of the National Palace Museum, Taipei, Taiwan, Republic of China. Everything has its proper place in the Chinese universe, and thus the painting possesses multiple points of view. Accordingly, each part of this painting is constructed at the appropriate "distance."

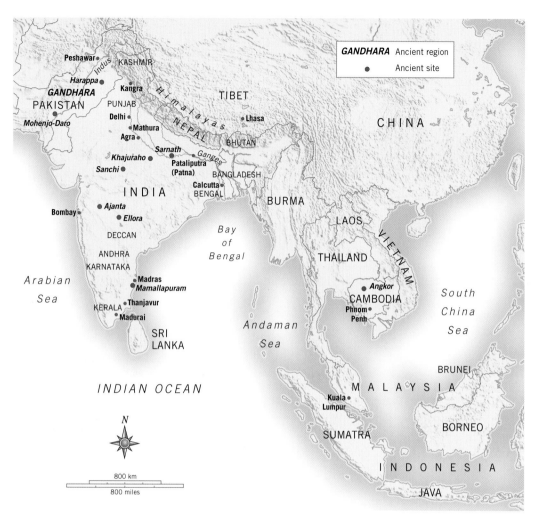

Map 16.2 India and Southeast
Asia.

Indian and Southeast Asian Civilizations

By 1200, Indian civilization was among the world's oldest, and it asserted broad influence over all of Southeast Asia (Map **16.2**). Its history during the centuries before and after 1200 was largely determined by competing religious forces, especially Buddhism, Islam, and Hinduism. Buddhism, which flourished in India from about 100 to 600 CE, had steadily waned in influence. It was further diminished when Muslim invaders entered northern India in the eleventh and twelfth centuries, destroying centers of worship in their path. Many of the Buddhist monks fled north into Nepal and across the Himalayas into Tibet. The Muslim invaders, who established their capital at Delhi, brought with them new forms of art and architecture rooted in Persian court traditions. Meanwhile, Hinduism became increasingly popular, and it gradually asserted itself as the dominant Indian religion. Well into the fifteenth and sixteenth centuries, India was ruled by Hindu dynasties, especially in the south, where the culture

was relatively isolated from the influence of the Delhi sultans. Hinduism spread throughout Southeast Asia, where Cambodian monarchs constructed magnificent temples inspired by Indian prototypes.

Buddhist Art

High in the isolated valleys of the Himalayas in Nepal and Tibet, Buddhist monks adapted Buddhism to the native Tibetan mystical religion known as Bon [BOHN]. The local religious leaders, known as *lamas* (meaning "none superior"), considered themselves the reincarnation of earlier deceased lamas and Buddhist *bodhisattvas*. The chief lama, the Dahlai (meaning "ocean"), was believed to be the reincarnation of the *bodhisattva* Avalokiteshvara [Avah-lo-kee-TESH-varah], the embodiment of compassion in Tibetan Buddhism. Among the artistic expressions of this faith were rolled-up cloth paintings, known as *thangkas* [TAHN-kas]. As monks traveled from one monastery to another, they would unroll *thangkas* as aids to instruction. Painted on the *thangkas* were images representing Buddhist figures of authority, including

lamas, *bodhisattvas*, and the Buddha himself, which, the Tibetans believed, were manifest in their images. The *thangka* reproduced here (Fig. **16.6**) represents Manjushri [MAHN-joo-shree], a *bodhisattva* associated with a great historical teacher, thus symbolizing wisdom.

Hindu Art

As we saw in chapter 4, Hindu religion and art are infused with a deep respect for sexuality, evident even in the architecture. The Kandarya [KAHN-dahr-yah] Mahadeva temple (Fig. **16.7**) at Khajurabo, the capital of the Chandella [Chan-deh-lah] dynasty, represents the epitome of northern Indian Hindu architecture. Its rising towers are meant to suggest the peaks of the Himalayas, home of the Hindu gods, and this analogy would have been even clearer when the temple was painted in its original white gesso. The plan (Fig. **16.8**) is a double crucifix, with arms extending north and south from the east–west axis. At the first crossing is the *mandapa* [MAHN-dah-pah], the columned assembly hall ("c" on the

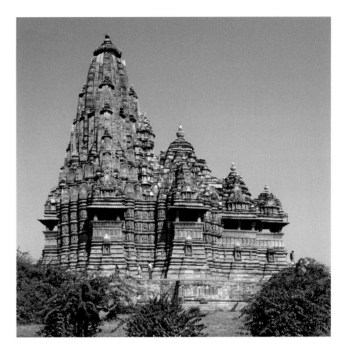

Fig. 16.7 Kandarya Mahadeva temple, Khajurabo, Madhya Pradesh, India. Chandela [Chan-deh-lah] dynasty, ca. 1025–50. The temple's formal design, like that of all Hindu temples, was prescribed in the *shastras*, a body of ancient Hindu writing that sets out the principles of poetry, music, dance, and the other arts. By the second millennium, most temples followed the *shastras* only loosely, freely elaborating on the basic plan.

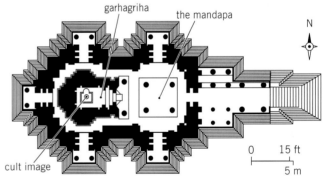

Fig. 16.8 Plan of Kandarya Mahadeva temple, Khajurabo, India. ca. 1000. The temple's main features are (a) the *garbhagriha*; (b) cult image; (c) the *mandapa*.

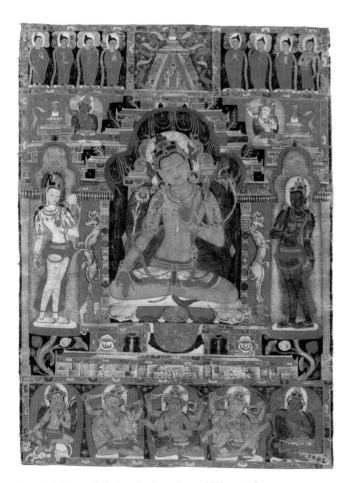

Fig. 16.6 *Manjushri,* **thangka from Central Tibet. 13th century.** Gouache on cotton, height 22″. Private collection. At the base of the *thangka* are three images of Manjushri wielding swords with four arms, representing his ability to cut through ignorance.

plan). At the second crossing is the *garbhagriha* [GARB-hah-gree-hah], or "womb chamber," the symbolic sacred cavern at the heart of the sacred mountain/temple ("a" on the plan). Here rests the cult image of the Brahman, in this case the *lingam*, or symbol of male sexuality, of Shiva, the first, or formless emanation of the Brahman. (Recall from chapter 4 that the Brahman is the creator and the universal soul.) Although it is actually almost completely dark, the *garbhagriha* is considered by Hindu worshipers to be filled with the pure light of the Brahman. The towers of the temple rise from east to west, as

CULTURAL PARALLELS

Nature in Shintoism and Christianity

A reverence for nature and the spirits that dwell in all natural elements is at the center of ancient Japanese Shintoism. Half a world away, a Christian mystic named Saint Francis of Assisi also viewed nature as a source of inspiration and as a way of manifesting a connection with God.

if gathering around the central tower, known as the *shikara* [SHEE-kah-rah], that rises to a height of over 100 feet above the *garbhigriha*. As the height increases, the temple seems to gather the energy of the Hindu religion to a single rising point, soaring with the spirit of the worshiper.

By the twelfth century, Hinduism had spread from India southeast into present-day Burma and Cambodia where, under the Khmer monarchs, its art achieved an imperial grandeur. The Khmer capital of Angkor, about 150 miles northwest of present-day Phnum Penh, covered about 70 square miles, a city crossed by broad avenues and canals and filled with royal palaces and temples.

The largest of these temples, Angkor Wat (Fig. **16.9**), was created by Suryavarman [Suhr-YAH-vahr-mahn] II (ruled 1113–ca. 1150). Five central towers, representing the five peaks of Mount Meru, the center of the Hindu cosmos, rise above a moat surrounding the complex. The approach to the galleries at the towers' base is from the west, crossing a long bridge over the moat, which symbolizes the oceans sur-rounding the known world. On June 21, the summer solstice and the beginning of the Cambodian solar year, a visitor to the temple arriving through the western gate would see the sun rise directly over the central tower. In this way, the symbolic evocation of the cosmos, so fundamental to Hindu temple architecture, is further elaborated in astrological terms.

Japanese Civilization

Of all the great Asian civilizations, the latest to develop was that of Japan. Before 300 CE, Japan was fragmented; its various regions were separated by sea and mountain and ruled by more than 100 competing and often warring states. These states did, however, share a mythology—finally collected in about 700 CE in the *Kojiki* [Koh-JEE-kee] or *"Chronicles of Ancient Events."* According to the *Kojiki*, the islands that constitute Japan (Map **16.3**) were formed by two **kami** [KAH-mee], or gods—Izanagi [izah-NAH-gee] and his consort Izanami [Izah-NAH-mee]. Among their offspring was the sun goddess, Amaterasu Omikami [AH-mah-tay-rah-soo OH-mee-kah-mee], from whom all Japanese emperors are believed to descend. In other words, the Japanese emperor was not merely put in position by the gods, as in China; he was a direct descendant of the gods, and hence divine.

Shinto: Reverence for the Natural World

When Buddhism arrived in Japan in about 600 CE, the dominant religion was Shinto, an indigenous Japanese faith whose principal goddess was Amateratsu. She was housed in a shrine complex at Ise, a sacred site from prehistoric times. The main sanctuary, or **shoden** [SHOH-dehn] (Fig. **16.10**), consists of undecorated wooden beams and a thatched roof.

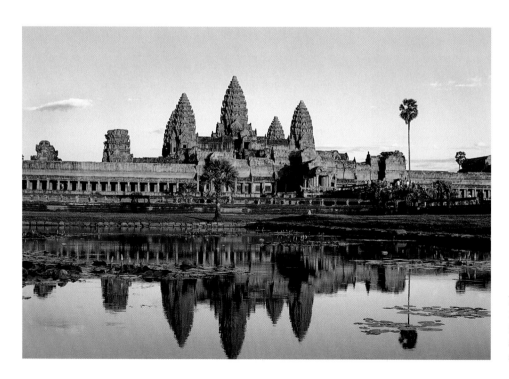

Fig. 16.9 Angkor Wat, Cambodia. Early 12th century. The entire complex, which is decorated with literally miles of relief sculptures, was constructed in the short span of about 30 years.

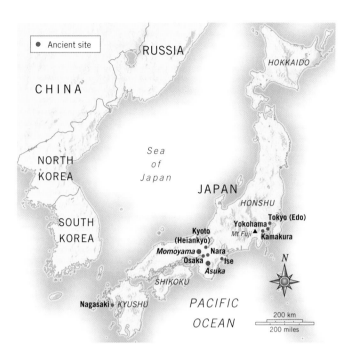

Map 16.3 **Japan** Isolated from the Asian mainland, Japan was both slow to develop and susceptible to the influence of the more advanced cultures once it became aware of them.

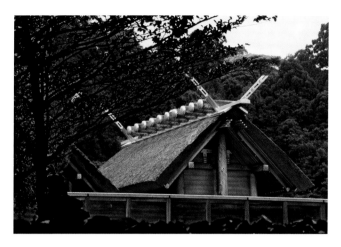

Fig. 16.10 Naiku (Inner) Shrine housing Amaterasu, Ise, Japan. Late 5th–early 6th century. Beginning in the reign of the emperor Temmu (r. 673–86), the Shinto shrine at Ise has been rebuilt by the Japanese ruling family, with some inevitable lapses, every 20 years—the natural cycle of growth and decay in nature. The most recent reconstruction occurred in 1993. Shinto is today the official state religion of Japan.

These plain and simple materials embody the basic tenet of Shinto—reverence for the natural world—and are typical of Shinto architecture. The shrine at Ise houses the three sacred symbols of Shinto: a sword, a mirror, and a jewel. Millions of Japanese pilgrims visit it each year. The shrine is ritually rebuilt at 20-year intervals in exactly the same style. Like Japanese culture, it is both traditional and continuously new.

In Shinto, trees, rocks, water, mountains—especially Mount Fuji, the volcano just outside Tokyo which is said to look over the country as its protector—are all manifestations of the *kami*, the spirits that are embodied in them. Even the natural materials with which artists work, such as clay, wood, and stone, are imbued with the *kami* and are to be treated with the respect and reverence due to a god.

Buddhism Arrives in Japan

Buddhism arrived in Japan, by way of Korea and China, in the middle of the sixth century (the first known image of Buddha arrived in Japan about 564). Chinese calligraphy was already the basis of the Japanese written language, and to some, Buddhism seemed equally amenable to Japanese adaptation. In its reverence for nature, it mirrored Shinto, but it had the advantage of codifying and organizing Shinto's diffuse set of practices into a coherent program. During the rule of Prince Shotoku [SHOH-toh-koo] (r. 593–622), whose name means "Wise and Virtuous," Buddhism became the religion of the Japanese aristocracy.

Raised in the pro-Buddhist Soga clan, Shotoku emphasized the importance of the Chinese model of civil administration, and when he built a new palace at Ikaruga [ee-KAH-roo-gah],

he constructed a Buddhist temple next to it. Others were built during his administration, and over 1,300 Buddhist monks and nuns were ordained. When Shotoku died, Shinto factions destroyed both his palace and his temple. Shinto's popularity probably stems, at least partly, from its position as a "native" religion as opposed to the "imported" Buddhism. Nevertheless, Shotoku so instilled Buddhist thought in the Japanese aristocracy that by 670 his ruined temple was rebuilt; it remains the oldest surviving Buddhist temple in Japan and the oldest wooden temple in the world.

The Heian Period: Courtly Refinement

Between 784 and 794, the capital of Japan was moved from Nara to Heiankyo—modern-day Kyoto—which quickly became the most densely populated city in the world. (According to tradition, the move occurred because the secular court needed to distance itself from the religious influence of the Buddhist monks at Nara. One of these monks had risen to power as the lover of the Empress Koken [r. 749–59, 765–70].)

Continuity & Change
p. 500

Plan of the Tang Capital of Chang'an

Heiankyo was modeled on Chang'an, the capital of the Tang dynasty (see Fig. 16.3), and the ordered grid of its streets was a conscious bow to Chinese philosophy and its reflection in the workings of government. Between the late eleventh and the middle of the twelfth century at Heiankyo, scholars estimate that the royal family dedicated a new Shinto shrine every year and founded a new Buddhist temple every five years. But distinctions between Buddhism and Shinto began to blur. The *kami* and Buddhist deities were conflated, Shinto temples were used by Buddhist priests for meditation,

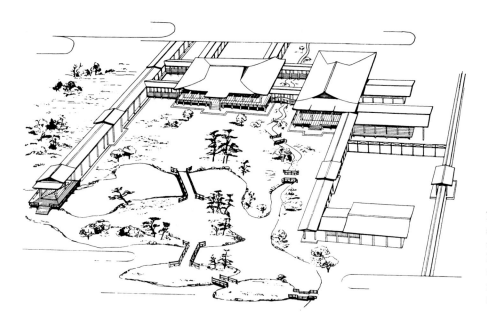

Fig. 16.11 Reconstruction drawing of a shinden-zukuri mansion. No original mansions of the nobility survive in present-day Kyoto. Drawings such as this one are based on the ample literary description of these elaborate residences, as well as their representation in illustrated scrolls.

and Shinto temples even assumed Buddhist architectural features, foregoing, to a degree, the rigorous plain style of Ise.

Life of the Nobility At Heiankyo, the arts flourished in an atmosphere of elegance and refinement. The nobility numbered around 100,000, and they lived in residential complexes that extended across several acres with multiple single-story pavilions and secondary halls tied together by covered walkways. The entire complex usually encircled a garden with a pond and small streams crossed by bridges, the whole surrounded by an earthen wall (Fig. **16.11**). The streams flowed under the complex, thus emphasizing the household's Shinto-inspired connection to nature. And, as in traditional Shinto shrines, the roofs of the complex were made of cypress bark shingles. This style of architecture is known as *shinden-zukuri* [SHEEN-dehn SOO-koo-ree], after its main hall, or *shinden*, and *zukuri*, "style." Following Chinese tradition, it was oriented to the south. It was large enough to accommodate the nobleman's several wives—polygamy was routinely practiced—and was considered a social responsibility. Behind the *shinden*, in a separate hall to the north, lived the main wife, known as the *kita no kata*, "the person to the north." Secondary wives lived in pavilions to the east and west. Each hall could open into the gardens by means of latticed shutters which could be raised to take advantage of good weather.

Wives did not necessarily communicate with one another, and, indeed, many lived their entire lives without ever seeing each other. Each of their residences opened onto a small courtyard garden, and wives rarely left the inner sanctum of their own designated space. They were, however, highly educated. Both Heian gentlemen and gentlewomen were expected to contribute to the aesthetic of the Heian court. They were judged on their looks—ideally women had round faces with small features, powdered white, with plucked eyebrows that were re-penciled in, and blackened teeth—on the arrangement of their many layers of silk robes, on their perfumes, on the beauty of their calligraphy, and on their ability to compose poetry at a moment's notice.

Literature and Calligraphy Although many court gatherings took place for the purpose of poetry competitions, poems were generally composed for a single recipient—a friend or lover—and a reply was expected. In her *Diaries*—or *Nikki* in Japanese—Murasaki Shikibu (973/8–aft. 1014), one of the most accomplished women of the Heian court, a lady-in-waiting to the Empress Shoshi [SHOH-shee] (988–1074), describes just such an exchange (**Reading 16.3**):

READING 16.3 **from Murasaki Shikibu, *Diaries***

I can see the garden from my room beside the entrance to the gallery. The air is misty, the dew is still on the leaves. The Lord Prime Minister is walking there; he orders his men to cleanse the brook. He breaks off a stalk of omenaishi[1] [Oh-MEH-nah-ee-shee] which is in full bloom by the south end of the bridge. He peeps in over my screen! His noble appearance embarrasses us, and I am ashamed of my morning face.[2] He says, "Your poem on this! If you delay so much the fun is gone!" and I seize the chance to run away to the writing-box, hiding my face:

Flower-maiden in bloom—
Even more beautiful for the bright dew,
Which is partial, and never favors me.

"So prompt!" said he, smiling, and ordered a writing-box to be brought [for himself].
His answer:

The silver dew is never partial.
From her heart
The flower-maiden's beauty.

[1] **omenaishi:** a flowering plant.
[2] **morning face:** a face without powder or makeup.

Something of the flavor of court life is captured in this brief passage, in the private space of the gentlewoman's world, her relation to the gentlemen of the court, the attention of the two poets to natural beauty, and the expression of that beauty as a means of capturing personal feeling.

Diaries, or *nikki*, comprised an important literary form that tell us much about court life in the Heian period. Murasaki's poems—indeed her entire text—are written in a new purely Japanese writing system, known as **hiragana** [HEER-ah-gah-nah]. Beginning in the early ninth century, *hiragana* gradually replaced the use of Chinese characters and enabled writers to spell out the Japanese language phonetically. The university curriculum remained based on Chinese classics and history, and the formal workings of state and government still required the use of Chinese. But women, who could not attend the university and were actively discouraged from studying the Chinese classics, were taught the *hiragana* script.

The popularity of *hiragana*, even among men, who recognized its convenience, encouraged the development of new Japanese forms of poetry, especially the **waka** [WAH-kah] (literally the "poetry of Wa," or Japan). A *waka* consists of thirty-one syllables in five lines on a theme drawn from nature and the changing of seasons. Here is a *waka* by one of the great poets of the Heian period, Ki no Tomonori [KEE noh TOH-moh-noh-ree] (act. 850–904) (**Reading 16.4**):

READING 16.4 **from Ki no Tomonori, "This Perfectly Still"**

This perfectly still
Spring day bathed in the soft light
From the spread-out sky.
Why do the cherry blossoms
So restlessly scatter down?

The tension here, between the calm of the day and the restlessness of the cherry blossoms, is meant to mirror a similar tension in the poet's mind, suggesting a certain sense of anticipation or premonition. *Waka* serves as a model for other Japanese poetic forms, particularly the famous **haiku**, the three-line, seventeen-syllable form that developed out of the first three lines of the *waka*.

Sei Shonagon's *Pillow Book* Aside from poetry and diaries, the women of the Japanese court also created a new literary form, the *zuihitsu* [ZU-EE-heet-soo] (literally, "by the line of the brush"), random notes or occasional writings. The first of these was the *Pillow Book* by Sei Shonagon [SAY SHOH-nah-gohn] (ca. 965–aft. 1000), lady-in-waiting to the imperial consort Teishi [TAY-shee] (970–1001) and head of a literary salon that openly competed against that of Murasaki Shikibu, a rivalry that helped to inspire the literary innovation of the period. The clarity of Sei Shonagon's observation

in the *Pillow Book* is captured in her short list of "Elegant Things" (**Reading 16.5a**):

READING 16.5a **from Sei Shonagon, *Pillow Book*, "Elegant Things"**

A white coat worn over a violet waistcoat.
Duck eggs.
Shaved-ice mixed with liana syrup[1] and put in a new silver bowl.
A rosary[2] of rock crystal.
Wisteria blossoms. Plum blossoms covered with snow.
A pretty child eating strawberries.

[1] **liana [LEE-ah-nah] syrup:** a light, sweet syrup made from fruit of a climbing vine.

[2] **rosary:** not the series of prayers practiced by Roman Catholics, but rather a miniature sculpture of a rose garden made of rock crystal.

Another, longer list, entitled "Hateful Things" (see **Reading 16.5** on pages 528–529), gives the reader a remarkable overview of daily life in the Heian court. Sei Shonagon looks at the entirety of her world, from its insects to the palace dog.

The First Novel: *The Tale of Genji* Murasaki Shikibu, whose *Diaries* we discussed previously is more famous as the author of a long book of prose (over 1,000 pages in English translation). Many consider it the world's first novel—certainly no fiction in the Western world matches its scope until the eighteenth century. Called *The Tale of Genji*, it tells the story of Genji, an imperial prince, born to the favorite wife of the emperor, though she is too low in rank for her son to be an heir to the throne. Much of the action takes place in the homes and gardens of Heiankyo, and besides being a moving romantic story covering 75 years of the hero's life, from his birth to his death, the novel presents us with a vivid picture of life in Japanese society at the turn of the millennium.

Soon after it was written, *The Tale of Genji* was illustrated in a handscroll attributed to Takayoshi (Fig. **16.12**). As the scroll was unwound, the viewer would have first seen the right side, the courtyard (now brown but originally silver), and then, at a sharp angle, the veranda and curtain wall of a house in which a deeply moving scene is unfolding. As a young man, Genji had fallen in love with his father's youngest wife, Fujitsubo [Foo-JEE-tsoo-boh], and fathered a son by her. Genji's own father, the emperor, acknowledged the child as his own, and the boy eventually became emperor himself. Genji came to understand the human consequences of his youthful actions only when his own youngest wife bore a son by another man and Genji was forced to acknowledge the child as his own, just as his father had accepted Genji's son. Depicted here is the moment of Genji's acceptance of his wife's son.

We look down on the scene as if through the roof at an awkward angle, underscoring the awkwardness of the scene. Genji holds the child in his arms. Beside him, bowls of food

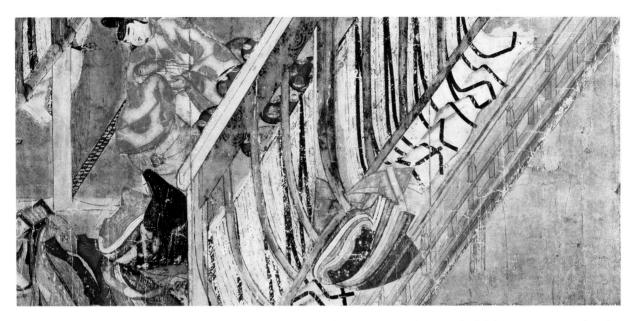

Fig. 16.12 Attributed to Takayoshi. Illustration to the Azumaya chapter of *The Tale of Genji* by Murasaki Shikibu. Late Heian period, 12th century. Handscroll, ink and color on paper, height 8½″. Tokugawa Art Museum, Nagoya, Japan. Of the original illustrations of *The Tale of Genji*, only 20 pictures survive.

are placed for the ritual celebration. A lady-in-waiting, dressed in black, sits below, and at the extreme upper left, the child's mother is indicated by a heap of fabric. Genji knows that the attendants understand that he is not the child's father, and yet he fully understands his duty. Although Genji is the hero of the book, Murasaki Shikibu gives the women of the Heian court full treatment, chief among them the telling-ly named Murasaki, whose own life, from childhood to death, is fully narrated. She is Genji's greatest love, and she receives his lavish attentions. And yet, given the polygamous nature of Japanese society, she suffers much. She is unable to bear Genji a child, and Genji must turn elsewhere for an heir. Likewise, her social status is not high enough to qualify her as his principal wife. Thus, despite her wit and intelligence, her beauty and charm, she is condemned to second-class status.

***Yamato-e* Painting** The *Genji* scroll is an example of *yamato-e* [Yah-MAH-toh ay] painting, a term coined during the Heian period to distinguish between Japanese and Chinese (*kara-e*) [KAH-rah ay] painting styles. This distinction announces a movement away from traditional Chinese styles to one characterized by Japanese literary themes, native subject matter, and landscapes evocative of traditional poetry. According to the Metropolitan Museum of Art, the *yamato-e* style "features striking compositions, flat planes of rich color, and a number of codified pictorial devices such as *fukinuki yatai* [foo-KEE-noo-kee YAH-ta-hee] ('room with roof blown away')"—that is, an aerial view into a house as if the roof has

disappeared, as in the *Genji* illustration. In the broadest sense, the rise of *yamato-e* painting, Japanese poetic forms, and *hiragana* calligraphy all left traditional Chinese styles behind.

The Kamakura Period (ca. 1185–1392): Samurai and Shogunate

During the Heian period, the emperors began to see their authority challenged by regional warrior clans from outside Heiankyo known as **samurai** (literally, "those who serve"). The absence of tax revenues from temples and nobles' valuable properties, and subsequent economic difficulties, contributed to a weak central government and a general state of unrest. While the samurai paid lip service to the sovereign, they increasingly exercised complete authority over all aspects of Japanese society.

The samurai dressed in elaborate iron armor and were master archers and swordsmen. Their essentially feudal code of conduct, the **bushido** ("way of the warrior"), was based on fidelity to one's superior, contempt for death, and total self-lessness. The code demanded ritual suicide, usually by self-disembowelment, of any samurai who was dishonored. In 1192, Minamoto no Yoritomo, the greatest samurai of the day, gave himself the title of **shogun**, general-in-chief of the samurai, inaugurating the first shogunate at Kamakura, which gives its name to the period. He established the military-based **bakufu** [BAH-koo-foo], or "tent government" (because his soldiers lived in tents), which functioned as a government separate

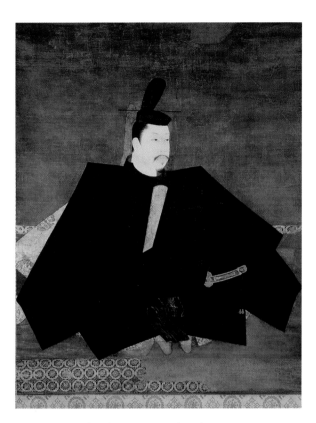

Fig. 16.13 Attributed to Fujiwara Takanobu, *Minamoto no Yoritomo*. Sentoin (Hall of the Retired Emperor). Kamakura period, second half of the 12th century. Hanging scroll, ink and color on silk, height 4′ 6½″. Jingoji Temple, Kyoto, Japan The shogun's authority is underscored by his lifesize portrait.

closed, the Nio is believed to be making the sound "un," or "om," meaning death. The two sounds are the first and last letters of the Sanskrit alphabet, and so between the two Nio mouths lie all the possible manifestations of existence. But, above all, Nio figures like *Kongorikishi* bring together in one image the political power of the samurai and the religious force of Buddhism. The Kamakura period that Yoritomo began ended in civil war in 1333. The values embodied in his own portrait and in Jokei's *Kongorikishi*, however, would persist into modern times.

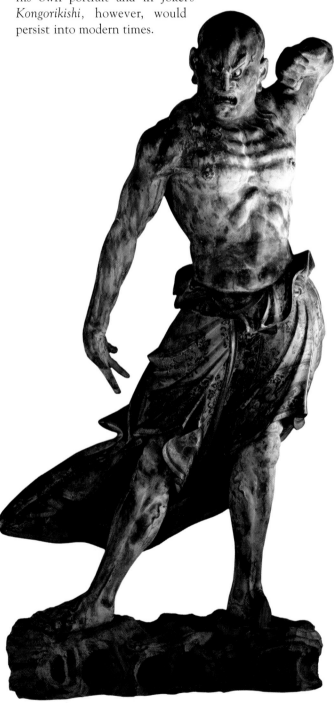

Fig. 16.14 Jokei, *Kongorikishi*, Kamakura period ca. 1288. Painted wood, height 5′ 4″. Kofukuji temple, Nara, Japan. Notice the ultra-realistic detail of the painted robe that hangs from the warrior's hips.

from the emperor's government in Kyoto. While the emperor still appointed civil governors, collected taxes, and controlled the area surrounding the titular capital of Heian, the real power of the state came to the shogunate, to whom local lords all swore allegiance.

The Arts of Military Culture Realism defined the art of the Kamakura period. Yoritomo is pictured in a masterful blend of realism and a powerful compositional abstraction (Fig. **16.13**). The painting shows his sword, the hallmark of his class, protruding from his robe. His face, with its determined eyes, is absolutely realistic, while his robe is a flat geometry of black angles without detail. Almost pyramidal in form, the figure of Yoritomo is above all a symbol of authority and self-assurance.

Especially at the new capital of Kamakura, sculptors such as Jokei [Joh-KAY] sought to achieve a new sculptural ideal based on realism and strength. His *Kongorikishi* [KOHN-gohr-ee-kee-shee] (Fig. **16.14**) is one of the Nio [Nee-OH], or Heavenly Kings, protectors who stand guard outside the gates of Buddhist temples. The samurai-like fierceness and threatening martial-arts stance of the Nio were thought to ward off evil spirits, keeping the temple grounds free of any demonic threat to Buddhist law. The mouths of Nio are either opened or closed. When open, as here, the Nio is supposed to be uttering the sound "Ah," meaning birth. When

The Cultures of Africa

Just as in Europe and Asia, all over Africa powerful kingdoms arose during this period. Several large kingdoms dominated the western African region known as the Sahel, the grasslands that serve as a transition between the Sahara desert and the more temperate zones to the west and south. Among the most important is the kingdom of Mali, discussed in chapter 11, which shows the great influence Islam had come to have on much of northern Africa long before the end of the first millennium CE. Farther south, along the western coast of central Africa, were the powerful Yoruba state of Ife [EE-fay] and the kingdom of Benin [buh-NEEN]. On the eastern side of Africa, the Zagwe dynasty continued long Christian tradi-

tions in the Horn of Africa, while the Arab-influenced Swahili culture thrived along the central east coast. Farther south, near the southeastern tip of Africa, the ancient Shona civilization produced urban centers represented today by the ruins of "Great Zimbabwe" (Map **16.4**).

Ife Culture

The Ife culture is one of the oldest in West Africa. It developed beginning around the eighth century along the Niger River, in what is now Nigeria. It was centered in the city of Ife. By 1100, it was producing highly naturalistic, sculptural, commemorative portraits in clay and stone, probably depicting its rulers, and not long after, elegant brass sculptures as well.

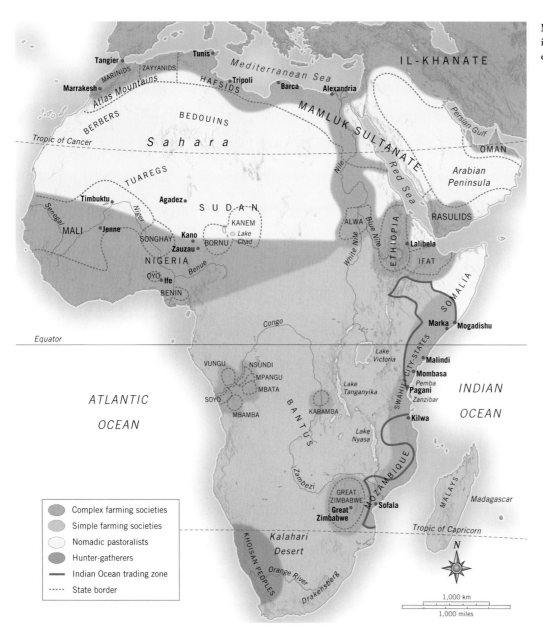

Map 16.4 Africa ca. 1350, including predominant forms of economic activity.

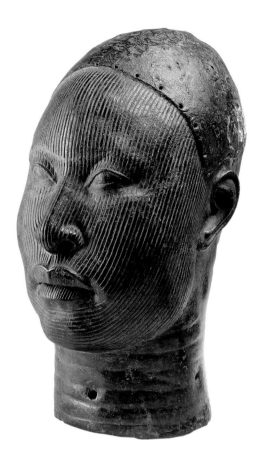

Fig. 16.15 Head of an *Oni* (King). Ife culture, Nigeria. ca. 13th century. Brass, height, 11 ⁷/₁₆″. Museum of Ife Antiquities, Ife, Nigeria. The metal used to cast this head is an alloy of copper and zinc, and therefore not technically bronze, but brass.

An example of Ife brasswork is the *Head of a King* (or *Oni* [OH-nee]) (Fig. **16.15**). The parallel lines that run down the face represent decorative effects made by scarring—**scarification**. A hole in the lower neck suggests that the head may have been attached to a wooden mannequin, and in memorial services the mannequin may have worn the royal robes of the Ife court. Small holes along the scalp line suggest that hair, or perhaps a veil of some sort, also adorned the head. But the head itself was, for the Ife, of supreme importance. It was the home of the spirit, the symbol of the king's capacity to organize the world and to prosper. Ife culture depended on its kings' heads for its own welfare. Since the Ife did not leave a written record of their cultural beliefs, we can best understand their ancient culture by looking at their contemporary ancestors.

Yoruba Origin Myths The Yoruba people, whose population today is about 11 million, trace their ancestry directly to Ife culture. The Yoruba cosmos consists of the world of the living (*aye* [Aye-yeah]) and the realm of the gods (*orun* [Oh-ROON]). The gods are themselves called *orisha* and among them are the primordial deities, who created the world, as well as forces of nature, such as thunder and lightning, and ancestral heroes who have risen to immortality. Linking these two worlds is the

king, who serves as the representative in this world of those existing in *orun*. The king's head is thus sacred, and his crown, or *ade* [ah-DEH] (Fig. **16.16**), rising high above his head, symbolizes his majesty and authority. Rows of beads fall over his face to shield viewers from the power of his gaze. Imagery on the crown varies, but often refers to Ife myths of origin, similar to myths of origin found throughout the world (see chapter 1). The first Yoruba king, Oduduwa [Oh-DOO-doo-wah], from whom all subsequent kings descend, is frequently represented. According to legend, Oduduwa was ordered to create a land mass out of the watery reaches of earth so that it might be populated by people. Oduduwa lowered himself down onto the waters, the legend continues, and emptied earth from a small snail shell onto the water. He then placed a chicken on the sand to spread it and make land. Finally he planted some palm kernels. It was at Ife that he did this, and Ife remains the most sacred of Yoruba sites.

Fig. 16.16 *Ade*, or beaded crown, Yoruba culture, Nigeria. Late 20th century. Beadwork, height, 6′ 1 ¼″. © The Trustees of the British Museum/Art Resource, NY. Today, approximately 50 Yoruba rulers wear beaded crowns and claim descent from Oduduwa.

Benin Culture

Sometime around 1170, the city-state of Benin, some 150 miles southeast of Ife, also in the Niger basin, asked the *oni* of Ife to provide a new ruler for their territory, which was, legend has it, plagued by misrule and disorder. The *oni* sent Prince Oranmiyan [Oh-RHAN-mee-yan], who founded a new dynasty and named it *ibini*, "land of vexation," from which the name Benin derives. Some two centuries later, the fourth king, or *oba*, as the Benin culture called their leader, declared the value of creating lifelike images of their ancestor rulers, as the Ife were doing. He asked the Ife if they would send a master metalworker south, and that artist, Iguegha, [Eh-GUAY-gah] whose name has come down through legend, taught the artists of Benin the method of lost-wax casting (see *Materials and Techniques*, page 49 in chapter 2).

The artists, members of the royal casters' guild, lived in their own quarters just outside the palace in Benin, where they are located to this day. Only the *oba* could order brasswork from them. These commissions were usually memorial heads, commemorating the king's royal ancestors in royal costume (Fig. **16.17**). (The head shown in figure 16.17 was made in the mid-sixteenth century, but heads like it were made in the earliest years of bronze production in the culture.) As in Ife culture, the *oba*'s head was the home of the spirit and the symbol of the *oba*'s capacity to organize the world and to prosper.

This power could be described and commemorated in an oral form known as a **praise poem**. Praise poems are a major part of West African culture. By praising something—a king, a god,

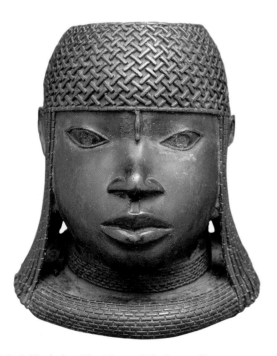

Fig. 16.17 Head of an Oba. Nigeria; Edo, Court of Benin ca. 1550.
Image © The Metropolitan Museum of Art / Art Resource, NY. Such heads were usually commissioned upon the death of an *oba* by his successor, so that the deceased leader might continue to influence his community.

a river—the poet was believed to gain influence over it. Almost everyone in West African culture has praise poems associated with them. These poems often use a poetic device known as **anaphora** [un-NAF-uh-ruh], a repetition of words and phrases at the beginning of successive sentences that, owing to the particularities of the West African languages, is almost impossible to duplicate in translation. But the poems are intended to create a powerful and insistent rhythm that rises to a crescendo.

West African Music

The rhythm-driven crescendo of the Benin praise poem shares much with African music as a whole. In fact, the poem may have been accompanied by music. African music is part of the fabric of everyday life, accompanying work, poetry, ceremony, dance, and often evoked by visual art. The Western idea that music can be isolated from everyday experience is almost incomprehensible to the African sensibility. Typically consisting of a single line of melody without harmony, African music is generally communal in nature, encouraging a sense of social cohesion by promoting group activity. As a result, one of the most universal musical forms throughout Africa is **call-and-response** music, in which a caller, or soloist, raises the song, and the community chorus responds to it.

Call-and-response music is by no means simple. The Yoruba language, for instance, is tone-based; any Yoruba syllable has three possible tones and this tone determines its meaning. The Yoruba reproduce their speech in the method of musical signaling known as **talking drums (CD-Track 16.1)**, performed with three types of batá drums, which imitate the three tones of the language. In ritual drumming, the drums are played for the Yoruba gods and are essentially praise poems to those gods. Characteristic of this music is its polyrhythmic structure. Here as many as five to ten different "voices" of interpenetrating rhythms and tones, often repeated over and over again in a call-and-response form, play off against one another. This method of playing against or "off" the main beat is typical of West African music and exists to this day in the "off-beat" practices of Western jazz.

East Africa: The Zagwe Dynasty

Ironically, one of the dynasties of greatest cultural importance in medieval East Africa was also one of the shortest lived and least revered. In the region of today's Ethiopia, the Zagwe dynasty reigned for approximately 150 years, from the early twelfth century (when the declining Aksumite Empire fell), to 1270, when the last Zagwe ruler was deposed. The new ruling family claimed descent from King Solomon, and in order to give the impression that their family had a dazzling and unbroken chain of legitimate power reaching back into biblical times, they embarked on a campaign to discredit the Zagwe dynasty as usurpers and their reign as a disgrace. Nevertheless, the Zagwe rulers had already ensured their survival as a respected part of Ethiopian history by the rock churches they left behind.

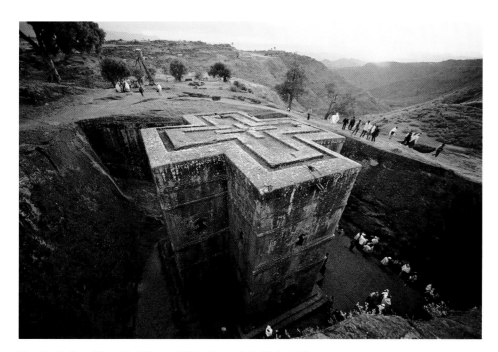

Fig. 16.18 Beta Ghiorghis (House of Saint George), Lalibela. 13th century. Saint George Church is one of more than 1,500 stone carved churches that can still be seen in Ethiopia.

The most famous of these was commissioned by the emperor Lalibela. In the town now known by his name he ordered the construction of a series of churches. Unlike most buildings, instead of being built up from the ground, the churches at Lalibela were carved downward through the soft rocks at the site (Fig. **16.18**). Engineers had to conceive of the completed building in advance, including decorative details, because subtractive techniques such as carving do not allow for repair of mistakes. Once the shell of the building was carved, the interior was hollowed out into rooms for use in Christian worship and study.

The Swahili Coast

In the medieval era, Christian places of worship were rare in Africa. In the trading centers of the north and west, Islam was the dominant non-indigenous religion. East Africans had traded with Arab sailors since before the beginning of the common era, from trade depots along a narrow coastal strip ranging from today's Somalia through Mozambique (see Map 16.4). When these traders embraced Islam, the people the Arabs called Swahili, from the Arabic word for "shore," were quick to follow. From Mogadishu in the north to Sofala in the south, a region known as the Swahili Coast, Arabs and Africans blended their customs to create one of the most vibrant cultures in Africa. They also created a new language—Swahili, an African language with many borrowings from Arabic.

Looking directly out onto the Indian Ocean, Swahili ports played a key role in trade with all of Asia from the medieval era onward. The great Chinese explorer Zheng He (see chapter 23) reached the Swahili coast, trading Chinese porcelain and other goods for African products such as spices and wild animals to take back to the Chinese emperor.

The Swahili were renowned for their architecture. Using local materials such as fossilized coral limestone, they built mosques and other buildings, carving trims and decorations directly into the stone in floral designs, arabesques, and other patterns like those in the Qur'an (see chapter 11). So beautiful were these works that, upon visiting Kilwa, medieval explorer Ibn Battuta pronounced it "the most beautiful of cities." The mosque at Kilwa (Fig. **16.19**) would have been where Ibn Battuta stopped to pray. Constructed of pieces of fossilized coral bound together by cement made from sand, the pillars, arches, and walls of the mosque were coated in a glossy plaster also made from coral, into which patterns were excised.

Great Zimbabwe

In embracing Islam, the people of the Swahili Coast transformed their society, but the influence of the new faith did

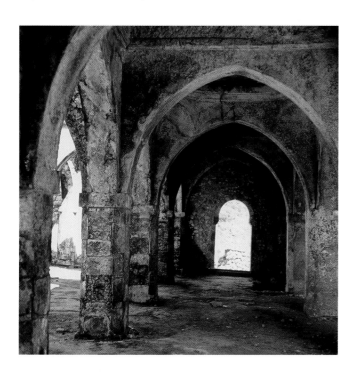

Fig. 16.19 The Great Mosque at Kilwa, interior. Built and remodeled over the centuries, it was completed with barrel vaulting and domes by the mid-15th century.

not spread far inland. West of Sofala, at a port at the southern end of the Swahili Coast, the Shona people built an entirely indigenous African civilization in the region of today's Zimbabwe. The Shona people, who still occupy the region today, are thought to have first come to the region by 1100 CE. At first the Shona relied on their advanced skills at mining, animal husbandry, and agriculture to sustain their communities in the rocky grasslands of the region, but as the Swahili Coast became more and more lucrative as a center of trade, the Shona positioned themselves as an inland hub of trade to which coastal traders could travel to procure goods for export. From surrounding regions they mined or imported copper and gold, and in return received exotic goods such as porcelain and glass from Asia and the Middle East.

Between the thirteenth and fifteenth centuries, the Shona erected the massive stone buildings and walls of a city known today as Great Zimbabwe. (The word "zimbabwe" is thought to refer to "palaces of stone.") A huge city for its time, the ruins cover one square mile and are believed to have housed a population of somewhere between 10,000 and 20,000. Great Zimbabwe has several distinct areas. The oldest of these, a hilltop enclosure known as the Hill Ruin, probably served as a lookout, but may also have been set apart for religious ceremonies or initiation rites. Built around 1250, it has a perimeter wall of smooth stone blocks that follows the contours of the hilltop. Inside this wall are several smaller enclosures with floors of clay that were hardened and polished to a shine. The enclosures also had ceremonial platforms decorated with carved geometric patterns and tall rock monoliths topped by carved birds, possibly representing messengers from the spirit world (Fig. 16.20).

Below the Hill Ruin stands the Great Enclosure, a group of structures also encircled by a tall stone wall (Fig. 16.21). This part of Great Zimbabwe was built approximately a century later, using a different style for the perimeter wall. Here, Shona craftsmen built a double wall with a space between the two walls only wide enough to allow single-file passage. They tapered the walls inward from a 17-foot-thick base for greater strength and stability, and topped the exterior wall with an alternating diagonal pattern of dark and light-colored rocks. This decoration may have been meant to represent lightning, or perhaps the zebra, an animal frequently depicted in Shona art. These decorative stripes are echoed inside the courtyard of the enclosure, where a large platform similar to those in the Hill Ruin was constructed. One other notable feature of the Great Enclosure is two conical structures that interrupt passage around the perimeter wall. These are likely to have been ancient granaries, for the Shona people today still use similar structures.

The remainder of Great Zimbabwe consists of clusters of smaller buildings known as the Valley Ruin. Historians and archeologists presume from this that most of the population lived in the valley and that the Great Enclosure was probably a royal residence. One intriguing mystery, however, is the reason for the massive walls of the Great Enclosure and Hill Ruin. Despite the turrets and lookout spots, the walls do not appear to have been meant for defense, and from this, scholars have surmised that the walls may have existed pri-

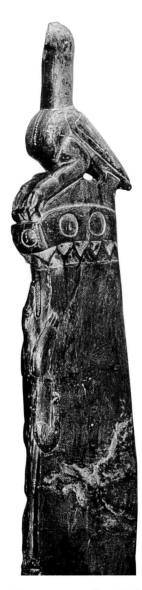

Fig. 16.20 Bird carved from soapstone, Great Zimbabwe. c. 1200–1400 CE. Height 14.5″, atop a stone monolith (total height: 64″). Great Zimbabwe Site Museum, Zimbabwe. One of eight such decorative monoliths at great Zimbabwe, the bird is not a recognizable species and includes certain human features such as toes instead of talons. This has led to speculation that the figure may represent deceased Shona rulers who were believed to have the power to move between the spirit and human worlds. A crocodile, possibly another symbol of royalty, climbs up the front of the monolith.

marily to serve as a buffer between royalty and the common people, and as a constant reminder of their power and status.

The Cultures of Mesoamerica in the Classic Era

The cultures of pre-Columbian Mesoamerica, comprising modern-day Honduras, Guatemala, Belize, and southern Mexico, possessed a great sense of their own history. They

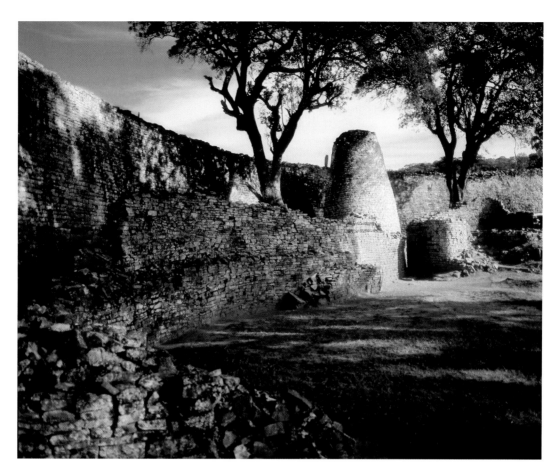

Fig. 16.21 Double perimeter wall and remains of two towers that resemble Shona granaries in the Great Enclosure, Great Zimbabwe. ca. 1200–1400 CE. The skill of the craftsmen who built these structures was extraordinary. They used no mortar, but instead fit the stones together so tightly that the walls reached 30 feet in height and were so sturdy that most of them are intact today. Only the clay smoothed over the walls, and the wooden roofs over some of the structures, have eroded away in the last eight centuries.

were fully aware that cultures at least as great as themselves—the Olmec in particular (see chapter 1)—had preceded them. But during a period of about a thousand years, roughly 250 BCE to 900 CE, which archeologists call the Classic Era, the cultures of Mesoamerica flourished. "Pre-Columbian" refers to the era before Columbus arrived in the Americas in 1492, and the title "Classic Era," borrowed from Greco-Roman culture, designates what historians consider to be the high point of pre-Columbian culture in the Americas. Three great cultures thrived in Mesoamerica during the Classic Era: the Zapotec culture in Oaxaca; the somewhat mysterious but enormously influential civilization centered at Teotihuacán, just north of Tenochtitlán (present-day Mexico City); and to the south, the Maya culture in Yucatan, Chiapas, Belize, and Guatemala (Map **16.5**). These cultures were at once highly developed and seemingly backward, astronomically sophisticated, with two separate but extraordinarily accurate calendars, yet lacking a domesticated beast of burden capable of carrying

an adult. Even more astonishing, they lacked one of the most fundamental tools of civilization—the wheel. Although they used wheels on children's toys, they never enlarged them for use on wagons or carts. These civilizations never discovered how to process bronze or iron, yet they moved and cut stones weighing in excess of 100 tons and built enormous temples, the centerpieces of cities rivaling any in Europe or Asia.

Monte Albán and Zapotec Culture

Zapotec culture, which occupied the territory later controlled by the Mixtec, was centered at Monte Albán in Oaxaca. The Zapotecs had themselves been closely tied to the Olmecs (see chapter 1), but instead of living in the alluvial lowlands of the Gulf coast, they built their capital atop a mountain overlooking the three major valleys of central Oaxaca. It seems likely that they were the first Mesoamerican people to use the 260-day calendar, and they possessed a writing system, though it remains undeciphered. Like the Olmec before

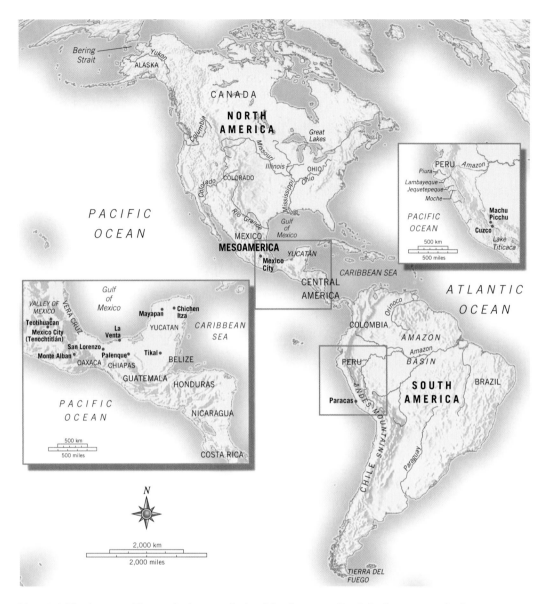

Map 16.5 The Americas The two chief centers of cultural development in Pre-Columbian times in the Americas were Mesoamerica, the semicircular land mass extending from central Mexico south and east through Guatemala and the Yucatan peninsula, and the central Andes of South America in modern-day Peru.

them, they valued jade above all other precious stones or metal—more than gold and silver. Jade would remain the most treasured material through the entire history of the cultures of Mesoamerica, from the Olmecs to the Aztecs. The translucent green color of jade symbolized water, fertility, and vegetation—in short, the life force. Large stones were very rare, and specimen pieces were passed down from generation to generation. A particularly fine example is a bat god from Monte Albán, discovered in the grave of an early Zapotec king (Fig. **16.22**). Worn as the symbol of his power, its eyes, made of shell, stare fiercely out at any who would have approached him.

Teotihuacán

By the fourth century CE, Teotihuacán was a center of culture comparable to Constantinople in the Old World. In contrast to the later Mayan cities, many of which were quickly forgotten and overgrown in the jungle, Teotihuacán remained, for the Aztecs, a thousand years after it flourished, the mythic center of Mesoamerican civilization, the site of pilgrimages by even the most important Aztec rulers.

The city is laid out in a grid system, the basic unit of which is 614 square feet, and every detail is subjected to this scheme, conveying a sense of power and mastery. A great broad

avenue, known as the Avenue of the Dead, runs through the city (Figs. **16.23**, **16.24**). It links two great pyramids, the Pyramids of the Moon and the Sun, each surrounded by about 600 smaller pyramids, 500 workshops, numerous plazas, 2,000 apartment complexes, and a giant market area. The Pyramid of the Sun is oriented to mark the passage of the sun from east to west and the rising of the stellar constellation, the Pleiades, on the days of the equinox. Each of its two staircases contains 182 steps, which, when the platform at its apex is added, together total 365. The pyramid is thus an image of time. This representation of the solar calendar is echoed in another pyramid at Teotihuacán, the Temple of Quetzalcoatl, which is decorated with 364 serpent fangs.

At its height, in about 500 CE, about 200,000 people lived in Teotihuacán, making it one of the largest cities in the world. Scholars believe that a female deity, associated with the moon, as well as cave and mountain rituals, played an important role in Teotihuacán culture. The placement of the Pyramid of the Moon, in front of the dead volcano Cerro Gordo (see Fig. 16.23), supports this theory. It is as if the mountain, seen from a vantage point looking north up the Avenue of the Dead, embraces the pyramid in its flanks. And the pyramid, in turn, seems to channel the forces of nature— the water abundant on the mountain in particular—into the heart of the city.

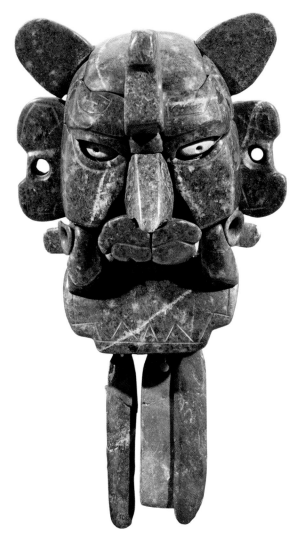

Fig. 16.22 Jade pendant, Zapotec, Monte Albán, State of Oaxaca, late Pre-Classic (200 BCE–100 CE). Jade with shell inlays, $11'' \times 6\frac{3}{4}''$. National Museum of Anthropology, Mexico. Though found at Monte Albán, where it was discovered in a tomb, this piece may well have been passed down from the Olmecs.

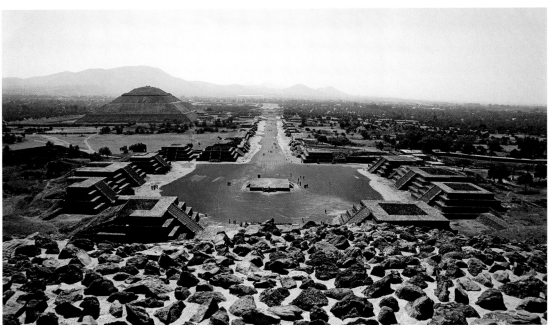

Fig. 16.23 Teotihuacán, Mexico, as seen from the Pyramid of the Moon, looking south down the Avenue of the Dead, the Pyramid of the Sun at the left. ca. 350–650 CE. One of the largest cities in the world by the middle of the first millennium, Teotihuacán covered an area of nearly nine square miles.

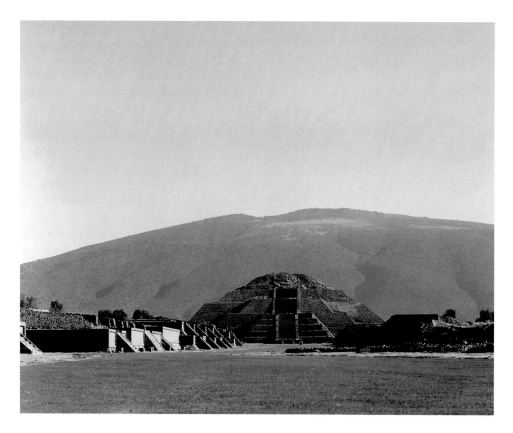

Fig. 16.24 The Pyramid of the Moon, looking north up the Avenue of the Dead. Beginning at the southern end of the city, and culminating at the Pyramid of the Moon, the Avenue of the Dead is 2 ¹/₂ miles long.

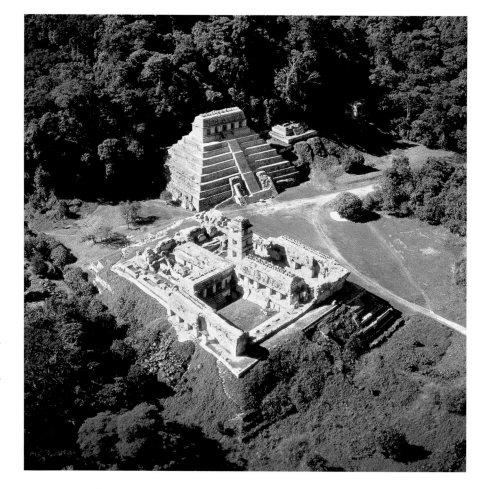

Fig. 16.25 "Palace" (foreground) and Temple of Inscriptions (tomb pyramid of Lord Pacal), Palenque, Mexico. Maya culture. 600–900 CE. The Museum of Modern Art. These two buildings, along with two other temples not seen in this view, formed the central complex of Palenque. Another complex to the north is composed of five temples and a ball court, and a third group of temples lies to the south. Palenque was the center of a territory that may have been populated by as many as 100,000 people.

Mayan Culture

To the south of Teotihuacán a competing culture, that of the Maya, was gaining strength. An elaborate calendar system enabled them to keep track of their history—and, evidence suggests, predict the future. It consisted of two interlocking ways of recording time, a 260-day calendar and a 365-day calendar. The 260-day calendar probably derives from the length of human gestation, from a pregnant woman's first missed menstrual period to birth. When both calendars were synchronized, it took exactly 52 years of 365 days for a given day to repeat itself—the so-called *calendar round*—and the end of each cycle was widely celebrated.

The City of Palenque Among the most important Mayan cities is Palenque, one of the best preserved of all Mayan sites. Lost in the jungle for centuries following its decline, which occurred around the year 850, Palenque was rediscovered in 1746 by a Spanish priest who had heard rumors of its existence. The Temple of Inscriptions, facing into the main courtyard of the so-called Palace, which may have been an administrative center rather than a royal residence, rises in nine steps, representing the nine levels of the Mayan Underworld (Fig. **16.25**). It is inscribed with the history of the Palenque kings, who were associated with the jaguar. The first recorded king is Bahlum Kuk [Bahl-um Koohk], "Jaguar Quetzal," who, so the inscriptions say, founded the city on March 11, 431. Palenque's most powerful king was Pacal (603–83), who ruled for 67 years, and the Temple of Inscriptions was erected over his grave.

In 1952, Alberto Ruz, a Mexican archeologist, discovered the entrance to the tomb of Lord Pacal, under the pyramid. It was hidden under large stone slabs in the floor of the temple at the top of the pyramid. Ruz had to clear the passage down to Pacal's tomb, at the very base of the structure, which had been back-filled with stone debris. When he reached the tomb, he found that Pacal's face was covered with a jade death mask. A small tube connected the tomb with the upper level, thus providing the dead king with an eternal source of fresh air. He was buried in a large uterus-shaped stone sarcophagus weighing over five tons and covered with jade and cinnabar. The sarcophagus lid was decorated with a relief image of Pacal falling off the Wacah Chan [Wah-kah Chahn], the Tree of Life (Figs. **16.26**, **16.27**), which connects the Upperworld, the Middleworld, and the Underworld. At the top of the tree sits the feathered serpent, Quetzalcoatl. A double-headed serpent, signifying Pacal's royal lineage, encircles the tree. The Maya believed the king embodied the Wacah Chan, and when he stood at the top of a pyramid in a ritual ceremony, he linked the three layers of the universe in his own person. During such rituals, the king would let his own blood to give sustenance to the spiritual world. Some now believe that the Wacah Chan can actually be read astronomically as the Milky Way, along which the spirits of the dead travel before being reborn into a new life.

The *Popol Vuh* The *Popol Vuh* [Po-pole Voo] is a Mayan book of creation. It was written in Quiché, a surviving Mayan dialect still spoken in the Guatemalan highlands, and produced between 1554 and 1558 by a Guatemalan Indian. Despite its late date, it probably represents Mayan belief systems that date back over a thousand years. Sometime in about 1700, a Dominican priest, Francisco Ximenez [Hee-may-nez] copied the manuscript, adding a Spanish translation in a column paralleling the Quiché original. The original has since disappeared. Over a hundred years later, the Ximenez copy was found in the archives of San Carlos University in Guatemala City by Brasseur de Bourbourg, who brought it to Paris and published a version of it in 1858. It was subsequently sold to the Newberry Library in Chicago, along with other documents from the Brasseur collection, where it remained uncatalogued and unknown until 1941. The *Popol Vuh* is in four parts, beginning with the deeds of Mayan gods in the darkness of a primeval sea (**Reading 16.6a**):

READING 16.6a from ***Popol Vuh: The Great Mythological Book of the Ancient Maya***

Before the world was created, Calm and Silence were the great kings that ruled. Nothing existed, there was nothing. Things had not yet been drawn together, the face of the earth was unseen. There was only motionless sea, and a great emptiness of sky. There were no men anywhere, or animals, no birds or fish, no crabs. Trees, stones, caves, grass, forests, none of these existed yet. There was nothing that could roar or run, nothing that could tremble or cry in the air. Flatness and emptiness, only the sea, alone and breathless. It was night; silence stood in the dark.

In this darkness the Creators waited, the Maker, Tepeu, Gucumatz, the Forefathers. They were there in this emptiness, hidden under green and blue feathers, alone and surrounded with light. They are the same as wisdom. They are the ones who can conceive and bring forth a child from nothingness. And the time had come. The Creators were bent deep around talk in the darkness. They argued, worried, sighed over what was to be. They planned the growth of the thickets, how things would crawl and jump, the birth of man. They planned the whole creation, arguing each point until their words and thoughts crystallized and became the same thing. Heart of Heaven was there, and in the darkness the creation was planned.

Then let the emptiness fill! they said. Let the water weave its way downward so the earth can show its face! Let the light break on the ridges, let the sky fill up with the yellow light of dawn! Let our glory be a man walking on a path through the trees! "Earth!" the Creators called. They called only once, and it was there, from a mist, from a cloud of dust, the mountains appeared instantly. . . .

The gods try three times to create mankind, once out of animals, a second time out of mud, and a third time out of wood.

Wood proves most successful, though the wooden men are killed off as well, and their descendants become monkeys. The rest of Part I and all of Part II deal with two sets of twins—the Hero Twins, Hunhapu [Hoon-AH-poo] and Xbalanque [Shi-bah-LEN-kay]; and their half-brothers, the Monkey Twins, Hun Batz´ [Hoon-Bahts] and Hun Chouen [Hoon-Choo-en]. Both sets of twins are ballplayers. Summoned to Xibalba [Shi-bahl-bah] (the Underworld), Hunhapu and Xbalanque undergo a series of tests, transformations, and resurrections (see **Reading 16.6**, pages 530–532).

The connection of the traditional Mesoamerican ballgame to forces of life and death, evidenced so substantially in the *Popul Vuh*, underscores its significance to the culture. Almost all major sites had ball courts. Players directed a heavy, solid rubber ball with their heads, thighs, or knees, padded to absorb the impact, through the opponent's ring high on the wall on each side of an I-shaped court. The game was closely associated with Mayan myths of origin and had deep religious significance. The ball represented the sun, and the duty of the players was to keep it from falling to earth as it passed through day and night (the games often lasted for several days). The sharply angled walls of the court itself were associated with the crack in the top of Creation Mountain described in the *Popul Vuh* (the Mayan word for crevice, *hom* [Hahm], is also the word for ball court), and play was intimately tied to the gods themselves. The losing team was believed to have betrayed both the sun and the gods. Evidence suggests that the Post-Classic Maya decapitated the losing team and displayed their heads on poles surrounding the ball court.

By 900 CE, Mayan culture had collapsed as a result of a wide variety of events, including overpopulation and accompanying

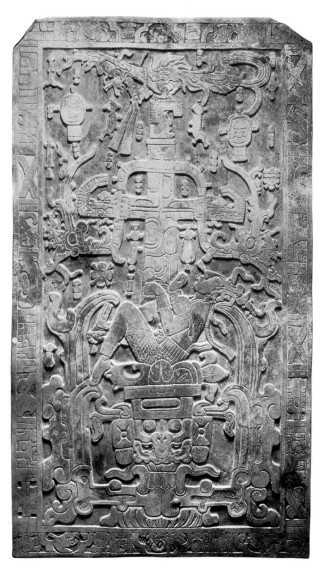

Figs. 16.26 and 16.27 Funerary lid of the sarcophagus of Pacal and reconstruction drawing. 683 CE. Limestone, 12′ 6″ × 7′. National Museum of Archeology, Mexico City. Since the sarcophagus weighs over five tons, it was surely put in place before the Pyramid of Inscriptions was built above it, though it well may not have contained the body of Pacal when it was constructed.

ecological degradation, political competition, and war. Its peoples, who survive in large numbers to this day, returned to simple farming around the ruins of their once-great cities.

The Post-Classic Era: Toltecs and Aztecs

In the north, after the decline of Teotihuacán, the warlike Toltec culture rose to power. It was centered in Tula in Hidalgo Province, but in the twelfth century its militaristic culture came to a violent end. Tula was burned, and its inhabitants scattered. One of these groups was the Mexica, later known as the Aztecs, who wandered into the Valley of Mexico in about 1325 and built a village on the shores of Lake Texcoco. There they saw an eagle perching on a prickly pear cactus (*tenochtli*) [Teh-nok-tlee], a sign that their wandering was over. They dug canals and drained the shallow areas of the lake, converting them into fertile fields, and there, as well, they built the city of Tenochtitlán on an island in the lake's center.

Blood sacrifice, a practice inherited from the Maya, was central to Aztec culture, merging perfectly with the warrior traditions inherited from the Toltecs. The Aztecs believed that the sun, moon, and earth all depended upon human blood for their sustenance. Their chief activity, as a result, was war, and the chief goal of war was to capture sacrificial victims. At puberty, boys were placed under jurisdiction of a local warrior house and trained for war, where they learned that success in life equaled the number of enemies captured alive for later ritual killing. Death itself, when realized in the pursuit of such honor, was the greatest honor an Aztec male could achieve.

Centered at Tenochtitlán, Aztec culture would survive until the arrival of the Spanish in 1519. In only a few years it was almost totally destroyed, its vast quantities of magnificent goldwork looted and returned to Europe to be melted down to support the warring ways of the European kings (see chapter 22).

The Cultures of South America

As in Mesoamerica, complex cultures developed in South America during the period corresponding to the Middle Ages in Europe, particularly in the area of present-day Peru (see Map 16.5). The region is one of dramatic contrast. The snow-capped peaks and high grasslands of the Andes mountains capture rainfall from the Pacific Ocean, creating rivers that drop quickly to the sea across one of the most arid deserts in the world.

The Moche

In these river valleys, which are essentially oases in the coastal desert, Moche culture flourished for a thousand years, from about 200 BCE to 800 CE. The Moche built large mound temples made entirely of **adobe** bricks, sun-baked blocks of clay mixed with straw. The largest, located in the Moche Valley, from which the culture takes its name, is the so-called Pyramid of the Sun. It is over 1,000 feet long and 500 feet wide and rises to a height of 59 feet. In these pyramids people buried their dead, accompanied by gold earrings, pendants, necklaces, and other ornaments, as well as elaborately decorated ceramic bowls, pots, and bottles.

The most distinctive bottles depict scenes representative of Moche culture as a whole, usually on bottles with distinctive stirrup spouts that curve elegantly away from the body of the vessel (Fig. **16.28**). The list of the subjects depicted is almost endless—animals of all kinds, from seals to owls, warriors, plants, musicians, homes, children at play, women weaving, couples engaged in sex, a man washing his hair—as if the culture was intent on representing every facet of its daily life. Recent research suggests, however, that every one of these scenes has a ritual or symbolic function. This figure, for instance, may well represent the Warrior priest who presided over Moche sacrifice ceremonies, in which prisoners captured in battle were sacrificed and their blood drunk by elaborately dressed warriors.

Fig. 16.28 *Moche Lord with a Feline,* from Moche Valley, Peru. Moche culture. ca. 100 BCE–500 CE. Painted ceramic, height 7 ½″. Buckingham Fund. 1955-2281. Photograph © 2006, The Art Institute of Chicago. All Rights Reserved. Vessels of this kind, depicting almost every aspect of Moche life, were buried in large quantities with Moche rulers.

The Inca

In about 800 CE, the Moche suddenly vanished, many believe as a result of floods brought about by a series of weather events related to El Niño. This major temperature fluctuation of the waters of the Eastern Pacific Ocean results in substantial changes in rainfall levels both regionally and worldwide. The resulting political vacuum lasted for over 400 years until, around 1300, Inca culture emerged. One of many farming cultures in the southern Peruvian highlands, the Inca took advantage of the Andean camelids—llamas, alpacas, vicuñas, and guanacos, beasts of burden unknown to the cultures of Mesoamerica—to forge trading networks that eventually united the southern highlands and northern coastal lowlands under their rule. Large irrigation projects transformed both the river valleys and the desert between them into rich agricultural regions.

The Inca were, above all, masterful masons. Working with stone tools and without mortar, they crafted adjoining granite blocks that fit so snugly together that their walls have, for centuries, withstood earthquakes that have destroyed many later structures. Few of the blocks are the same size, and some have as many as 30 faces. Still, the joints are so tight that even the thinnest knife blade cannot be forced between the stones. Cuzco (meaning "navel of the earth"), the capital of the Inca Empire, was laid out to resemble a giant puma, and its masonry, much of which still survives, is unmatched anywhere in the world. At Machu Picchu (Fig. **16.29**), stone buildings, whose thatched and gabled roofs have long since collapsed, are set on stone terraces in a setting that was a religious retreat or refuge for the Inca ruler, Pachacuti Inka Yupanqui [Pah-chah-coo-tee Ink-ah Yoo-pahn-kee], who built the complex between 1460 and 1470.

About 1,200 people lived in Machu Picchu's approximately 170 residences, most of them women, children, and priests. The Inca also created an extraordinary network of roads, ranging from as wide as 50 feet to as narrow as 3 feet, and extending from desert to Andes peaks for some 15,000 miles. Nearly a thousand lodgings were built along the routes, and relay runners could carry news across the region in less than a week.

The Inca were especially attracted to textiles, which apparently they valued even more than gold or other minerals, at least in part because of the extremely high, and cold, elevations at which they lived. The exact meaning of the design of an Inca weaving that survives from the time of the Spanish conquest is unclear, but scholars believe it is largely symbolic (Fig. **16.30**).

Llamas were the source of wool for the Inca. One was sacrificed in Cuzco each morning and evening, and a white llama was kept at Cuzco as a symbol for the Inca as a whole. According to Spanish commentators, the Cuzco llama was paraded through the streets of the city during celebrations of the coming planting season each April, dressed in a red tunic and wearing gold jewelry. These processions also included life-size gold and silver images of llamas, people, and gods.

Melted for currency by the Spanish throne, none of these large objects survive. Small objects of gold and silver, which symbolized to the Inca the sun and the moon, were once scattered through the central plaza of Cuzco. The plaza—in Incan times twice as large as it is today—was excavated to a

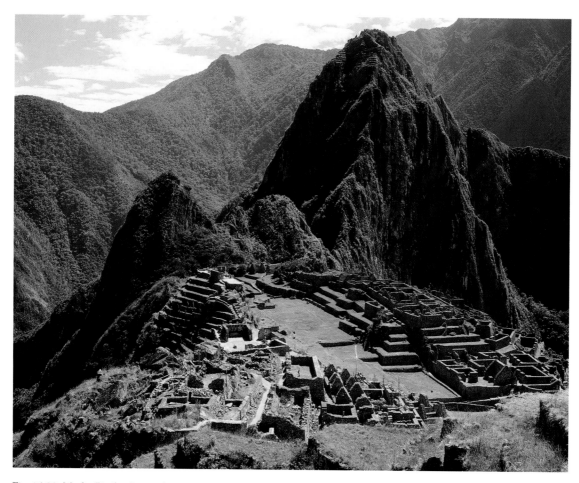

Fig. 16.29 Machu Picchu, Inca culture, Peru. ca. 1450. Machu Picchu survived destruction by the Spanish when they invaded in 1532, partly because of its remote location, high in the Andes, and partly because, compared to the Inca capital of Cuzco, it probably seemed small and comparatively insignificant. Nevertheless, by about 1537 it was abandoned as Inca civilization collapsed, victim not only of the Spanish conquistadores, but also of disease, especially smallpox.

depth of between six and twelve inches, its sacred soil carried away to each of the four quadrants of Tahuantinsuyu [Ta-WAHN-tin-SOO-yah], as the Inca called their homeland, "Land of the Four Quadrants." The plaza was then refilled with sand brought from the ocean, in which offerings of gold and silver llamas and human figures were distributed. The plaza thus symbolized a great body of water, at once the Pacific Ocean and Lake Titicaca, from which the Inca creator deity, Ticsivirachocha [TIC-see-VEER-ah-COH-cha], had emerged after the great flood to repopulate the world.

More elaborately decorated was the Coricancha [KORE-eh-KAHN-cha] (literally, "the corral of gold"), the Inca Temple of the Sun facing the plaza. Dedicated to Inti [In-tee], the sun god, the original temple was decorated with 700 sheets of gold studded with emeralds and turquoise and designed to reflect the sunlight admitted through its windows. Its courtyard was filled with golden statuary—"stalks of corn that were of gold—stalks, leaves and ears," the Spanish chronicler Pedro de Cieza de León reported in the mid-sixteenth century. "Aside from this," he continued, there were "more than twenty sheep [llamas] of gold with their lambs and the shepherds who guarded them, all of this metal."

After their conquest of Peru, the Spanish quickly adopted the foundations of the Inca temple to their own purposes, constructing a Dominican church and monastery on the original Inca foundations. The Inca traditionally gathered to worship at the curved, circular wall of the Coricancha, and thus the apse of Santo Domingo was purposefully constructed above it to emphasize Christian control of the native site. This story—of European control over former native sites and resources—would be all too common in the continuing history of the Western hemisphere, as we will discover in chapters 22 and 23.

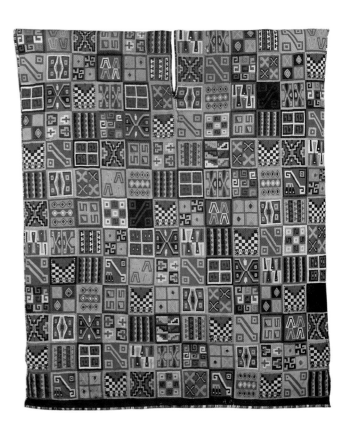

Fig. 16.30 Tapestry weave Inca tunic, south coast of Peru. ca. 1440–1540. Camelid fiber and cotton, $35\frac{1}{8}$" × 30". Dunbarton Oaks Research Library and Collections, Washington, DC. Each square represents a specific group, or an individual's identity, and functions much like a heraldic device or a logo.

READINGS

READING 16.1

Poems by Li Po and Du Fu

Li Po and Du Fu are generally considered the greatest poets of the Tang dynasty. The two became close friends after Li Po was summoned to the capital at Chang'an by the Emperor Xuanzong [Shoo-ehn-tsahng] in 742. The two wrote many poems to one another, a good example of which is the second of the two poems below. Within a few years Li Po was expelled from the court, apparently for the crime of insulting the emperor's favorite eunuch. He wandered the Yangtze valley, presenting himself as a banished and unappreciated genius, until his death in 762 at age 62. The first poem below underscores his sense of isolation and loneliness. Meanwhile, Du Fu also encountered troubles at court, not of his own making but as a result of the collapse of the Tang court in the mid-750s. Like Li Po before him, beginning in 765, Du Fu wandered down the Yangtze River, finding patrons and dreaming of his return to Chang'an, until his death in 770.

Li Po, "Drinking Alone at Midnight"

A pot of wine in the flower garden,
but no friends to drink with me.
So I raise my cup to the bright moon
and to my shadow, which makes us three,
but the moon won't drink
and my shadow just creeps about my heels.
Yet in your company, moon and shadow,
I have a wild time till spring dies out.
I sing and the moon shudders.
My shadow staggers when I dance. 10
We have our fun while I can stand
then drift apart when I fall asleep.
Let's share this empty journey often
and meet again in the milky river of stars.

Du Fu, "Dreaming of Li Po"

I've swallowed sobs from the lost dead,
but this live separation is chronic grief.

From the malarial south of the river
no news comes of the exiled traveler,
but you visit my dream, old friend,
knowing I ache for you.
Are you a ghost?
No way to tell with the long road between us.
Your spirit comes through the green maple woods
slips home past darkening border fortresses. 20
You are caught in the law's net,
so how can your spirit have wings?
The sinking moon pours onto the rafters
and your face glows in my mind.
The water is deep, the waves are wide.
Don't let the dragons snatch you! ■

Reading Question

Both poems develop the image of moonlight. Traditionally in China, the full moon is a symbol of good luck, harmony, and abundance. How does this symbol inform these two poems?

READING 16.5

from Sei Shonagon, *The Pillow Book*, "Hateful Things"

We know almost nothing about Sei Shonagon except what she writes about herself in The Pillow Book. *She became lady-in-waiting to the Empress Sadako [SAH-dah-koh] in 990 and served until the Empress's death in 1000. "Pillow books" such as Sei Shonagon's were commonplace in the Japanese court, consisting of informal collections of notes composed in their authors' sleeping chambers in the evenings and kept in drawers in their wooden pillows. "Hateful Things" is one of 164 such lists in Sei Shonagon's Pillow Book. Others include "People Who Look Pleased with Themselves," "Insects," "Things without Merit," and so on. But lists are not her only subject. She continually turns her attention to minute observations of court life, in entries such as "The Cat Who Lived in the Palace" or "The Women's Apartments along the Gallery."*

Hateful Things

One is in a hurry to leave, but one's visitor keeps chattering away. If it is someone of no importance, one can get rid of him by saying, 'You must tell me all about it next time'; but, should it be the sort of visitor whose presence commands one's best behaviour, the situation is hateful indeed.

One finds that a hair has got caught in the stone on which one is rubbing one's inkstick, or again that gravel is lodged in the inkstick, making a nasty, grating sound.

Someone has suddenly fallen ill and one summons the exorcist. Since he is not at home, one has to send messengers to look for him. After one has had a long fretful wait, the exorcist finally arrives, and with a sigh of relief one asks him to start his incantations. But perhaps he has been exorcizing too many evil spirits recently; for hardly has he installed himself and begun praying when his voice becomes drowsy. Oh, how hateful!

A man who has nothing in particular to recommend him discusses all sorts of subjects at random as though he knew everything.

An elderly person warms the palms of his hands over a brazier and stretches out the wrinkles. No young man would dream of behaving in such a fashion; old people can really be quite shameless. I have seen some dreary old creatures actually resting their feet on the brazier and rubbing them against the edge while they speak. These are the kind of people who in visiting someone's house first use their fans to wipe away the dust from the mat and, when they finally sit on it, cannot stay still but are forever spreading out the front of their hunting costume[1] or even tucking it up under their knees. One might suppose that such behaviour was restricted to people of humble station; but I have observed it in quite well-bred people, including a Senior Secretary of the Fifth Rank in the Ministry of Ceremonial and a former Governor of Suruga.

I hate the sight of men in their cups who shout, poke their fingers in their mouths, stroke their beards, and pass on the wine to their neighbours with great cries of 'Have some more! Drink up!' They tremble, shake their heads, twist their faces, and gesticulate like children who are singing, 'We're off to see the Governor.' I have seen really well-bred people behave like this and I find it most distasteful.

To envy others and to complain about one's own lot; to speak badly about people; to be inquisitive about the most trivial matters and to resent and abuse people for not telling one, or, if one does manage to worm out some facts, to inform everyone in the most detailed fashion as if one had known all from the beginning—oh, how hateful!

One is just about to be told some interesting piece of news when a baby starts crying.

A flight of crows circle about with loud caws.

An admirer has come on a clandestine visit, but a dog catches sight of him and starts barking. One feels like killing the beast.

One has been foolish enough to invite a man to spend the night in an unsuitable place—and then he starts snoring.

A gentleman has visited one secretly. Though he is wearing a tall, lacquered hat,[2] he nevertheless wants no one to see him. He is so flurried, in fact, that upon leaving he bangs into something with his hat. Most hateful! It is annoying too when he lifts up the Iyo blind[3] that hangs at the entrance of the room, then lets it fall with a great rattle. If it is a head-blind, things are still worse, for being more solid it makes a terrible noise when it is dropped. There is no excuse for such carelessness. Even a head-blind does not make any noise if one lifts it up gently on entering and leaving the room; the same applies to sliding-doors. If one's movements are rough, even a paper door will bend and resonate when opened; but, if one lifts the door a little while pushing it, there need be no sound.

One has gone to bed and is about to doze off when a mosquito appears, announcing himself in a reedy voice. One can actually feel the wind made by his wings and, slight though it is, one finds it hateful in the extreme.

A carriage passes with a nasty, creaking noise. Annoying to think that the passengers may not even be aware of this! If I am travelling in someone's carriage and I hear it creaking, I dislike not only the noise but also the owner of the carriage.

One is in the middle of a story when someone butts in and tries to show that he is the only clever person in the room. Such a person is hateful, and so, indeed, is anyone, child or adult, who tries to push himself forward.

One is telling a story about old times when someone breaks in with a little detail that he happens to know, implying that one's own version is inaccurate—disgusting behaviour!

Very hateful is a mouse that scurries all over the place.

Some children have called at one's house. One makes a great fuss of them and gives them toys to play with. The children become accustomed to this treatment and start to come regularly, forcing their way into one's inner rooms and scattering one's furnishings and possessions. Hateful!

A certain gentleman whom one does not want to see visits one at home or in the Palace, and one pretends to be asleep. But a maid comes to tell one and shakes one awake, with a look on her face that says, 'What a sleepyhead!' Very hateful.

A newcomer pushes ahead of the other members in a group; with a knowing look, this person starts laying down the law and forcing advice upon everyone—most hateful.

A man with whom one is having an affair keeps singing the praises of some woman he used to know. Even if it is a thing of the past, this can be very annoying. How much more so if he is still seeing the woman! (Yet sometimes I find that it is not as unpleasant as all that.)

A good lover will behave as elegantly at dawn as at any other time. He drags himself out of bed with a look of dismay on his face. The lady urges him on: 'Come, my friend, it's getting light. You don't want anyone to find you here.' He gives a deep sigh, as if to say that the night has not been nearly long enough and that it is agony to leave. Once up, he does

[1] **Hunting costume:** men's informal outdoor costume, originally worn for hunting.

[2] **Eboshi (tall, lacquered hat):** black, lacquered head-dress worn by men on the top of the head and secured by a mauve silk cord that was fastened under the chin; two long black pendants hung down from the back of the hat. The *eboshi* was a most conspicuous form of headgear and hardly suited for a clandestine visit.

[3] **Iyo blind:** a rough type of reed blind manufactured in the province of Iyo on the Inland Sea.

not instantly pull on his trousers. Instead he comes close to the lady and whispers whatever was left unsaid during the night. Even when he is dressed, he still lingers, vaguely pretending to be fastening his sash. 110

Presently he raises the lattice, and the two lovers stand together by the side door while he tells her how he dreads the coming day, which will keep them apart; then he slips away. The lady watches him go, and this moment of parting will remain among her most charming memories.

Indeed, one's attachment to a man depends largely on the elegance of his leave-taking. When he jumps out of bed, scur-

ries about the room, tightly fastens his trouser-sash, rolls up the sleeves of his Court cloak, over-robe, or hunting costume, stuffs his belongings into the breast of his robe and then briskly 120 secures the outer sash—one really begins to hate him. ■

Reading Question

During the Heian period, the finest writers of the day were by and large aristocratic women of middle rank like Sei Shonagon. How does "Hateful Things" reflect the prominence of women in court?

READING 16.6

from the *Popol Vuh: The Great Mythological Book of the Ancient Maya.*

The Popol Vuh (Mayan for "Council Book" or "Book of the Community") narrates the foundation and history of the Quiché Mayan civilization, containing, much like the Bible, stories and tales relating their cosmology, traditions, mythology, and history from ancient times down to the year 1550. In the excerpt below, the Hero Twins, Hunahpu and Xbalanque, are summoned to the realm of Xibalba by the Lords of the Underworld. The twins undertake the journey to avenge the death of their father and uncle, at the hands of the Xibalbans. In Xibalba they undergo a series of tests, which their father and his brother had failed. In the end, they defeat the Lords of the Underworld in a final ballgame.

"Well," they said finally, "why don't you take a rest in that house over there. Tomorrow we shall play ball."

The boys entered the House of Gloom. Where no light had ever shone, they squatted and waited until messengers entered with cigars and sticks of fat pine. "These are gifts from the Lords," the messengers said, "but they must be returned at dawn." The boys sat in the darkness. Outside, those of the Underworld rejoiced seeing the red lights of the cigars and the burning sticks of pine. They could taste victo- 10 ry! The boys sat in the dark, but they did not spend what was given to them. On their cigars fluttered the red tail feathers of a macaw, on their sticks of fat pine sat their friends the fireflies. The Lords of Death saw these fires and smiled, thinking that the boys would come empty-handed at dawn. When the boys emerged at first light, the cigars and fat pine were unburned. The Lords were baffled. Who could these two be? They all went to the playing field together, and along the way the Lords asked the boys about themselves.

The boys answered: "We ourselves do not know who we 20 are, my Lords."

At the ball-court they agreed on whose ball to use, and agreed on the terms of the game. The Lords insisted on using their ball, and on playing for the worm, not letting the head of the puma speak as the boys wanted. Starting the play, the Lords of Death threw the ball toward Hunahpu's ring. The ball was still bouncing when the Lords pulled out their sacrificial knives, and moved toward the boys. "What is this?!"

exclaimed the boys. "The first throw, and you want to kill us? We thought that you wanted to play ball. Isn't that what your 30 messenger said?"

The Lords wanted the boys' death to come quickly, and nothing else, but things couldn't happen that way. The boys moved to leave, but the Lords cried, "No, don't leave. Stay and we will use *your* ball now." The boys consented, and again they played. This time the boys moved fast, driving their ball through the Lords' ring, and that ended the game. The defeated Lords exchanged glances, and wished that they could kill the boys. Instead, they joined them in the center of the ball-court. "For the morning," the Lords said, "bring us 40 four branches of flowers."

"What kinds of flowers?" the boys asked.

"Bring us a branch of red chipilli, and a white and yellow branch as well, and a branch of carinimac." The boys agreed calmly, and the bitter hearts of the Lords were dizzy with happiness, for where could these boys get flowers? "You can go to cut them now," the Lords said. "Bring them at dawn."

The boys were put into the House of Knives for the night. As they came up the path, they could hear the harsh sound of the obsidian knives grating against one another. As they 50 entered, the knives stood watching, hard light sneering from their bodies, ready to tear the boys to shreds. But before they could move, the boys used sharp words on them. "The flesh of all animals is yours!" they said. The knives were instantly calmed; they did not move again. There among the knives, the boys called the cutting ants. When they arrived in long files

from out of the walls and under the door, the boys told them to go and bring the flowers that the Lords wanted for the dawn.

Of course the Lords of Death suspected some trick, and had warned the sentries of the flowers. "Watch our flowers tonight," they said. "Don't let them be stolen by the boys who will come. They can't see in the dark, but beware just the same." The sentries watched all night for the boys. All night they shouted up into the branches of the trees of the garden.

"Oh, owl! Oh, owl!" one shouted.

"Who? Who?" the other answered.

Down below stole the ants. The long line broke into many streams in the garden, a thousand soundless steps moved, cutting flowers that fell soundlessly. They moved silently about carrying their enormous loads in their teeth, while the guards called out into the black night, "Oh, owl! Oh, owl!" and "Who? Who?" The owls did not feel the teeth cutting even their tails and the tips of their wings. The cutting ants returned in a long line through the dark with the fragrant flowers for the House of Knives.

When the messengers arrived, the boys came out of the house each carrying two gourds of flowers, bright and dew-wet in the first light. When the Lords saw the boys approaching with flowers, their faces paled. They immediately sent for the sentries. "How is it that you let someone steal our flowers?" they yelled when the sentries arrived. "Look, aren't these ours? Our flowers that you were supposed to watch?"

"We watched," the messengers answered, "but we didn't see anything. And look, our own tails suffered too!" In their anger the Lords tore the owls' mouths to teach them to watch better. Thus the mouth of the owl was made divided, cleft.

Again that day the boys played ball with the Lords of the Underworld. After several tied games, they put away their gear until the next dawn. The boys were happy.

That night the boys went to the House of Cold. There was always a new house of torture. The coldness in that House of Hail, Mansion of Cold, paralyzes the imagination, but the boys worked quickly in the cutting wind and spent the night warmly around a fire of old logs. At the dawn the Lords found them still alive and marveled that the boys could have stood the cold. The boys spent the next night in the House of Jaguars. The ground shook with the snarling and growling of the shut-up beasts. Their red mouths welcomed anyone who came in, their ready teeth stood in greeting. At the sight of the boys, the jaguars crouched and dug in with their hind legs. "Don't bite us!" the boys called before the beasts could spring. "Here is what belongs to you," they said, throwing the jaguars bones. The cats pounced on the gift, growling and tearing flesh, cracking the bones with their powerful teeth, the way the Lords of Death had wanted them to crack and grind the bones of the two brothers. The boys came out of the House of Jaguars at dawn. The House of Fire was another place where they were sent. It was one total flame, one single smile of fire. But only coals and wood burned there, and the boys entered the heart of fire unharmed.

In the House of Bats, hundreds of death bats, vampire bats, flew around and around within locked walls. Their power for killing was like a hardened, sharp stick. The boys shrank from this quick death. They at once climbed into their blowguns to be protected. There they couldn't be bitten, and in the round house of their own blowguns they slept. All night the bats darted through the room. The air was filled with the harsh sigh of their wings and the chill of their screams. Toward dawn the boys were awakened by another bat, the Bat of Death that flew out of the sky. A hush fell on the house. The bats were still.

"Is it morning?" asked Xbalanque from his blowgun.

"I'll take a look," answered Hunahpu. The bats were still, silently pressed against the end of Hunahpu's blowgun, waiting. As Hunahpu stuck his head out of the blowgun, it was ripped from his shoulders. There was laughter, then silence. "Hunahpu, what was that? Is it morning, or not?" asked his brother. No answer. "Hunahpu, what's happened?" Xbalanque fell silent and did not move. We are finished now, he thought to himself.

The Lords of Xibalba received the head of Hunahpu with laughter and shouts. They danced and ran together as a crowd to the ball-court, and hung up the head. Victory for the Lords of Death! One of the reeds planted in the center of the grandmother's house withered and died. When Xbalanque realized that his brother was dead, he called all the animals, the wild boar, the deer and lizard, all of them. Just before dawn he inched from his blowgun, and found the animals already there. He found the headless body of his brother. "I have asked you to come," Xbalanque told the animals, "to choose your food. Come, tell me what you want." The animals came up one at a time, and chose their food. Some took rotten things, others the grasses. Some wanted stones, some wanted to gather the dark earth. Hanging behind the rest was the turtle squeezed in his shell. He came waddling up heavily alongside the body of Hunahpu to choose his food. Just as he got alongside Hunahpu's shoulders, the turtle instantly took on the form of a head. The eyes were made, but the rest had to be created. Outside the House of Bats, where the dawn was getting ready to break, suddenly there were many soothsayers soaring overhead. Heart of Heaven was there, swooping and darting above the house. It wasn't easy to make a face, to give it hair, to give it a mouth and lips so that it could speak. The work was difficult, but the face began to take shape. But it took time, and outside the horizon was becoming a red glow. "Make it dark again, Old One!" the buzzard was told. The buzzard spread his huge black wings, and it was dark again. The buzzard has darkened the sky, thus people say nowadays. How will it be? Will it look like Hunahpu? "It's fine, just like a real head," they answered. And in the cool dawn the head was finished. The two brothers talked together. Xbalanque said, "When we get to the ball-court, let me take care of everything. You just pretend to play." Xbalanque gave a rabbit instructions to hide in the grove of oaks near the ball-court. "When the ball comes to you, run!" he told the rabbit. "I'll take care of the rest."

At dawn, the boys came out of the House of Bats into the yellow light. They went down to the ball-court. As they came

close, they saw Hunahpu's head hanging over the court. "Ha!" the Lords laughed when they saw Hunahpu. "Look who's here! Maybe we should hit his head with the ball!" Hunahpu burned with anger, but said nothing. The Lords threw out the ball. It was heading straight for the ring, but Xbalanque blocked it, and the ball bounced over the walls of the ball-court and rolled toward the oak grove. As the Lords came chasing after the ball, the rabbit ran from the oaks, and down the hill. The Lords ran after him, jumping and yelling. As soon as the Lords were out of sight, Xbalanque took the turtle-head and traded it for his brother's head which hung above the court. When Hunahpu had his head back, the two boys laughed joyfully and ran to finish the ball game. They

found the ball in the oaks and called for the Lords to come back. The Lords thought that something strange was going on. Even though they played hard against the boys, they couldn't score, and the game ended in a tie. Then Xbalanque took a stone, took careful aim, and threw it at the head hanging over the ball-court. The Lords watched the head fall, and when it hit the ground, it burst apart like a ripe fruit. ■

Reading Question

What elements of this story suggest the promise of regeneration after death?

Summary

■ **Developments in China** Between the first and third centuries CE, Buddhism spread from India north into China and with it came images of the Buddha. During the Tang dynasty, trade on the Silk Road flourished. The Tang capital of Chang'an, constructed on a grid plan, dramatized the Tang commitment to social order and, according to Chinese belief, mirrored the order of the cosmos. The Tang valued the arts—they were especially gifted ceramic artists—and education. Confucian, Buddhist, and Daoist philosophy informed not only the poetry of writers like Li Po and Du Fu, but government affairs as well.

When Marco Polo visited Hangzhou in 1274, it was still the capital city of the Southern Song dynasty. It enjoyed tremendous prosperity, controlled in no small part by a thriving merchant class whose sons had benefited from the invention of the printing press at schools that prepared them for government examinations. Studying the Chinese classics, they brought to government a deep belief in the idea that a well-run society mirrored the unchanging moral order of the cosmos. Poets and artists, who practiced the neo-Confucian Chan Buddhism, believed that the spirit of nature expressed itself directly through them. Painting, then, might represent the Daoist Way or portray a mountain's dominance of the natural world as a metaphor for the emperor's rule over the court.

In 1279, the Song fell to the Mongol leader Kublai Khan, who ruled China from Beijing as founder of the Yuan dynasty. The scholar-painters of the Chinese court, unwilling to serve under foreign domination, retreated into exile, but they created an art symbolic of their resistance.

■ **Indian and Southeast Asian Civilizations** During the era known as the Middle Ages in the West, the history and art of India and Southeast Asia were dominated by the interaction of Buddhism, Islam, and Hinduism. Forced out of northern India by invading Muslims, the Buddhists retreated to Nepal and Tibet, where a new brand of the religion developed under the local religious leaders—the lamas, and the chief lama—the Dahlai. The art produced in the Himalayas reflected the sensuous style of Hinduism, which thrived especially in southern India. Distinct Hindu temple styles developed, the chief example of which is the Kandarya Mahadeva [KAHN-dahr-yah] temple at Khajurabo [KAH-dar-yah], which mirrored the Hindu cosmos. As Hinduism spread into Cambodia, enormous temple complexes were constructed, especially at Angkor Wat.

■ **Japanese Culture** When Buddhism arrived in China around 600, it encountered the indigenous religion of Shinto, which preached a reverence for the natural world that reflected the belief that all things were imbued with the spirits of nature, or *kami*. Buddhism was essentially compatible with this system of belief and effectively organized Shinto's diverse practices into a coherent program. By the time of the Heian period, the *kami* and Buddhist deities were conflated, and Buddhist priests used Shinto temples.

The Heian court was one of extreme elegance and refinement. Women led a highly protected and isolated existence, but they were expected to be educated, and many participated in the literary life of the court, where poetry was held in especially high esteem. The women wrote in a new distinctly Japanese, as opposed to Chinese, writing system, the *hiragana*, and this script, increasingly popular even among men, contributed to new forms of Japanese poetry, particularly the *waka* and the haiku. Among the most important female writers in the Heian court were the Lady Ise, the earliest female master; Sei Shonagon, author of the *Pillow Book*; and Murasaki Shikibu, whose *Diaries* are surpassed only by her monumental fictional narrative, *The Tale of Genji*.

When economic difficulties led to the downfall of the Heian dynasty, warriors known as samurai took over the country. Their code of conduct, the *bushido*, was based on fidelity to one's superior, contempt for death, and total selflessness. The most powerful samurai, Minamoto no Yoritomo, took the title of *shogun* and inaugurated the first shogunate, the Kamakura dynasty.

■ **The Cultures of Africa** By 1100, the Yoruba civilization, centered in the west African city of Ife, was producing highly naturalistic commemorative portraits in clay and stone, probably depicting their rulers, and not long after, elegant brass sculptures as well. In Benin, the art of lost-wax casting was perfected at about the same time. In East Africa, Ethiopia was developing monumental architecture in the form of stone carved churches, while farther down the coast the Swahili culture, a hybrid of indigenous African and Arab Muslim customs and languages, was developing highly cosmopolitan port cities engaged in trade across the Indian Ocean and with other parts of Africa and the Mediterranean. Inland from the southern Swahili Coast, the Shona were building Great Zimbabwe, whose stone ruins are among the most impressive in Africa.

■ **The Cultures of Mesoamerica in the Classic Era** The cultures of Mesoamerica were at once sophisticated—producing extraordinarily accurate calendars and magnificent cities, and backward—lacking beasts of burden, the wheel, and bronze or iron. Zapotec culture, centered at Monte Albán, probably helped to create the elaborate Mesoamerican calendar system, but it paled beside Teotihuacán, with its magnificent capital, and, subsequently, the Mayan cities, such as Palenque, that arose farther south and whose creation myth, the *Popul Vuh*, survives. In the Post-Classic era, these cultures were supplanted by the more warlike Toltecs and Aztecs, both of which practiced blood sacrifice.

■ **The Cultures of South America** Moche culture arose in the river valleys of the coastal plains of Peru in about 200 BCE. It produced elaborate ceramic stirrup-spouted bottles that depicted every aspect of Moche life. After the Moche disappeared in about 800 CE, the Inca gained power in about 1300 CE. The Inca lived in the high Andes, with their capital at Cuzco, but their influence extended to the coastal plains as well. They were extraordinary masons, and they were especially attracted to textiles. The llama, from which they derived the wool to make their textile wares, was sacred to them. They decorated their temples freely with gold, which they believed represented the sun, and with silver, which they believed represented the moon.

 ## Glossary

adobe A sun-baked block of clay mixed with straw.

anaphora A repetition of words and phrases at the beginning of successive sentences intended to create a powerful and insistent rhythm that rises to a crescendo.

bakufu A military-based form of government in Japan that functioned separately from the emperor's government in Kyoto.

bushido The code of conduct practiced by the samurai based on fidelity to one's superior, contempt for death, and total selflessness.

call-and-response A form of music in which a caller, or soloist, raises the song, and the community chorus responds to it.

chinoiserie Chinese designs or motifs in art.

haiku A form of Japanese poetry consisting of three lines containing usually five, seven, and five syllables.

hiragana A purely Japanese writing system that developed in the early ninth century.

kami A god or force of nature in Japanese Shintoism.

mudra A symbolic gesture.

negative space The space around or between the main objects in a composition.

overglaze A ceramic technique in which the artist paints designs onto the porcelain after firing.

pagoda A multistoried structure of successively smaller, repeated stories, with projecting roofs at each story.

praise poem A poem in praise of something designed to gain influence over it.

samurai The regional warrior clans of Japan.

scarification Decorative effects made on the face or body by means of intentional scarring.

shoden The main sanctuary of a Shinto shrine.

shogun The general-in-chief of the samurai.

talking drums In Africa, a form of musical signaling.

underglaze A ceramic technique in which the artist paints directly on an unfired surface before applying a glaze over the brushwork and firing the whole.

waka A form of Japanese poetry consisting of 31 syllables in 5 lines on a theme drawn from nature and the changing of seasons.

 ## Critical Thinking Questions

1. Why did the literati and artists of the Chinese court exile themselves during the Yuan dynasty, and what sort of art did they then create?

2. How would you characterize life in court during the Heian dynasty in Japan? How do the literary works written in the period reflect this lifestyle?

3. In what way does the indigenous Shinto belief system inform Japanese poetry?

4. Describe the symbolic function of the Wacah Chan in Mayan and Aztec culture.

5. What innovations and technological achievements distinguish these non-Western cultures from concurrent cultures in the West?

Continuity & Change

Although China began to trade with foreign countries during the Han dynasty, when Chinese merchants created the famous Silk Road through Central Asia, foreign trade was never the major economic thrust of the country. The Chinese emperors considered their country to be self-sufficient. During parts of the Ming (1368–1644) and Qing (1644–1911) dynasties, trade was even officially discouraged, just as Japanese ports were closed to all but a few Dutch and Chinese traders for two centuries until 1854.

Still, the allure of China to Westerners cannot be overstated. It was, after all, the need for a direct route to China that prompted Columbus to set sail west into the unknown waters of the Atlantic Ocean, in 1492. Westerners craved China's tea and spices, its silk, and perhaps as much as anything, its porcelain. Marco Polo is reputed to have given porcelain its name—*porcellana*, he called it, after the smooth whiteness of the cowry shell, of which it reminded him. Porcelain is made from kaolin, an extremely fine white clay, and petuntse, a rock-mineral feldspar. When mixed properly and fired at extremely high temperatures, the kaolin and petuntse fuse into an extremely hard, almost translucent ceramic.

The blue-and-white porcelain flask illustrated here (Fig. 16.31) was decorated with an **underglaze**. The artist painted directly on the unfired surface, a white glaze was painted over the brushwork, and then the whole flask was fired. The resulting design is a glowing white dragon in the **negative space** of the background. Ming porcelain such as this flask became extremely desirable in Europe after the Portuguese arrived in China in 1516 and opened a trade mission in Macau. The early Ming ceramic industry was concentrated in the remote southern town of Jingdezhen, where kaolin and petuntse were relatively abundant. But the imperial court in Beijing specified the designs to be used.

In 1684, after the Qing dynasty lifted a ban on foreign trade, Chinese design, dubbed **chinoiserie** by European designers, came to dominate European taste. In the southern port city of Guangzhou (Canton), foreign trading companies from all over Europe competed fiercely for porcelain. **Overglaze** designs began to be painted onto the porcelain after firing. These designs, directed by the trading companies, were no longer limited to the original blue and white but were fully polychromatic. The porcelain punch bowl illustrated here (Fig. 16.32), for instance, is a copy of an eighteenth-century print by the Englishman William Hogarth. The Western love of Chinese porcelain has continued to this day. ∎

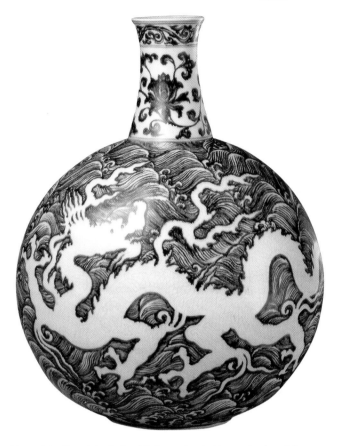

Fig. 16.31 **Porcelain flask with decoration in blue underglaze, Ming dynasty. ca. 1425–35.** Palace Museum, Beijing.

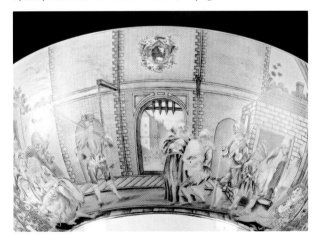

Fig. 16.32 **Porcelain punch bowl, painted in overglaze enamels in Guangzhou (Canton) with a copy of William Hogarth's print, *The Gates of Calais*. ca. 1750–1755.** Diameter 16″. Board of Trustees of the Victoria and Albert Museum, London (Basil Ionides Bequest), C. 23-1951.

Index

Photo Credits

Chapter 14

14-1 Bernard Beaujard; 14-2 Achim Bednorz, © Achim Bednorz, Koln; 14-4 Achim Bednorz, © Achim Bednorz, Koln; 14-5 Achim Bednorz, © Achim Bednorz, Koln; 14-6 Sonia Halliday Photographs; 14-7 Photo Josse; 14-8 Jean Bernard Photographe/Bordas Publication; 14-9 Achim Bednorz, © Achim Bednorz, Koln; 14-10 Peter Willi, The Bridgeman Art Library International; 14-11 John Bryson, Photo Researchers, Inc.; 14-13 Bildarchiv Monheim GmbH, Alamy Images; 14-14 Angelo Hornak, Angelo Hornak Photograph Library; 14-15 Achim Bednorz, © Achim Bednorz, Koln; 14-16 Achim Bednorz, © Achim Bednorz, Koln; 14-17 SCALA, Art Resource, NY; 14-18 Giraudon/Museo Civico, Bologna, Italy, The Bridgeman Art Library International, The Bridgeman Art Library; 14-19 The Bridgeman Art Library International, The Bridgeman Art Library; 14-20 Erich Lessing, Art Resource, NY; 14-21 Giraudon, Art Resource, NY; 14-22 Achim Bednorz, © Achim Bednorz, Koln; 14-23 M. Beck-Copolla, Art Resource/Musée du Louvre. Art Resource, NY; 14-24 The National Gallery Company Ltd., © National Gallery, London; page 440 (left), Sonia Halliday Photographs; page 440 (right), Dorling Kindersley Media Library, © Dorling Kindersley; page 441 (top), Vanni, Art Resource, NY; page 442 (right), Giraudon, Art Resource, NY

Chapter 15

15-1 SCALA, Art Resource, NY; 15-2 Guido Cozzi/© Atlantide Phototravel, CORBIS–NY, Guido Cozzi © Atlantide Phototravel / CORBIS All Rights Reserved; 15-3 Hideo Kurihara, Alamy Images; 15-4 (left) The Bridgeman Art Library International, The Bridgeman Art Library; 15-4 (right) The Bridgeman Art Library International, The Bridgeman Art Library; 15-5 Achim Bednorz, © Achim Bednorz, Koln; 15-6 Art Resource, NY; 15-7 The Bridgeman Art Library International, The Bridgeman Art Library.; 15-8 ALINARI, Art Resource, NY; 15-9 SCALA, Art Resource, NY; 15-10 Canali Photobank; 15-11 SCALA, Art Resource, NY; 15-12 Museo del'Opera del Duomo, Siena, Canali Photobank; 15-13 Cimabue (Cenni di Pepi), Index Ricerca Iconografica; 15-14 Galleria degli Uffizi; 15-15 The Art Archive/Duomo Florence/Dagli Orgi, Picture Desk, Inc./Kobal Collection; 15-16 G. W. Scott-Giles; 15-17 G. W. Scott-Giles; 15-18 Art Resource/The Metropolitan Museum of Art; 15-19 Erich Lessing, Art Resource, NY; 15-20 Eileen Tweedy, Picture Desk, Inc./Kobal Collection; 15-21 Snark/Bibliotheque Nationale, Paris, France, Art Resource, NY; 15-22 Library of Congress, Courtesy of the Library of Congress; page 474 (top), Alinari, Art Resource, NY; page 474 (bottom), Chapel, Padua, Canali Photobank; page 475, SCALA, Art Resource, NY

Chapter 16

16-1 Werner Forman, Art Resource, NY; 16-2 Ian Griffiths/Robert Harding World Imagery, CORBIS-NY, © Ian Griffiths/Robert Harding World Imagery/CORBIS. All Rights Reserved.; 16-4 Cultural Relics Publishing House; 16-5 Museum of Fine Arts, Osaka, PPS/Pacific Press Service; 16-6 Rossi & Rossi; 16-7 Neil Grant, Alamy Images; 16-9 Andrew Gunners, Getty Images - Digital Vision; 16-10 Kenneth Hamm, Photo Japan; 16-11 Japan National Tourist Organization, Courtesy of Japanese Art/Laurence King Publishing Ltd.; 16-12 The Tokugawa Reimeikai Foundation; 16-13 The ArtArchive/Laurie Platt Winfrey, Picture Desk, Inc./Kobal Collection; 16-14 Askean Company, Ltd., Askaen Co., Ltd./Kohfuku-ji Temple.; 16-15 Museum of Ife Antiquities, Nigeria, Dirk Bakker; 16-16 Art Resource/The British Museum Great Court Ltd, © The Trustees of the British Museum/Art Resource, NY; 16-17 Schecter Lee, Art Resource, NY; 16-18 Kazuyoshi Nomachi, The Image Works, © Kazuyoshi Nomachi/HAGA/ The Image Works; 16-19 Werner Forman, Art Resource, NY; 16-20 Federal Information Department of Zimbabwe, Great Zimbabwe Site Museum, Zimbabwe; 16-21 Robert Aberman/Barbara Heller, Art Resource, NY, Werner Forman / Art Resource, NY; 16-22 SCALA, Art Resource, NY; 16-23 Gina Martin, National Geographic Image Collection; 16-24 Werner Forman Archive, The Image Works; 16-25 Art Resource/The Museum of Modern Art, Licensed by Scala-Art Resource, NY; 16-26 Dr. Merle Greene Robertson; 16-27 Dr. Merle Greene Robertson; 16-28 The Art Institute of Chicago, Photograph © 2006, The Art Institute of Chicago. All Rights Reserved.; 16-29 Dagli Orti, Picture Desk, Inc./Kobal Collection; 16-30 Justin Kerr, Dumbarton Oaks Research Library & Collections, Justin Kerr/Dumbarton Oaks, Byzantine Photograph and Fieldwork Archives, Washington, DC; 16-31 ChinaStock Photo Library; 16-32 V & A Images, V & A Images/Victoria and Albert Museum; pages 504–505, National Palace Museum, Taipei, Taiwan, Republic of China.

Text Credits

Chapter 9

Reading 9.2, page 304: Josephus, The Jewish War, Book 2, "The three Sects" from "The Works of Flavius Josephus" translated by William Whiston. Copyright 2005. Used by permission of Hendrickson Publishers. Reading 9.3, page 283: from the Bible, Romans 5:1–11, "New Revised Standard Version Bible, copyright 1989, Division of Christian Education of the National Council of the Churches of Christ in the United States of America. Used by permission. All rights reserved." Reading 9.4, page 305: The Gospel of Matthew, "The Sermon on the Mount", "The New Testament", King James Version 1611. Reprinted by permission of Nelson Bibles. Reading 9.5, page 285: from the Bible, Corinthians I: 11:3–15, "New Revised Standard Version Bible, copyright 1989, Division of Christian Education of the National Council of the Churches of Christ in the United States of America. Used by permission. All rights reserved."

Chapter 11

Reading 11.1, page 364: from the Qur'an, Reprinted by permission of Koran USA. Readings 11.1a–b, pages 342–243: from the Qur'an, Reprinted by permission of Koran USA. Reading 11.4, page 356: Judah Halevi, "My Heart is in the East", MY HEART IS IN THE EAST by Judah Halevi, translated by Willis Barnstone from LITERATURES OF THE MIDDLE EAST. Reprinted with permission of Prentice Hall. Reading 11.5, page 359: from Nezami, Haft Paykar, "The Tale of the Black Princess", from MEDIEVAL PERSIAN ROMANCE (1995) by Paykar, H edited by Meisami, J.S (trans.). By permission of Oxford University Press. Reading 11.6, page 364: "Tale of the Fisherman and the Genie", "The Tale of the Fisherman and the Genie". Reprinted by permission of Emma Varesio. Readings 11.7a–b, pages 361, 362: from Jami, "Seduction of Yusuf and Zulaykha", Taken from YUSUF AND ZULAYKHA by Jami published by The Octagon Press used by permission of The Marsh Agency Ltd. Reading 11.8, page 366: from Rumi, The Divan of Shams of Tabriz, LOVE'S BODY and CARING FOR MY LOVER from LITERATURES OF THE MIDDLE EAST translated by Tony Barnstone, Willis Barnstone, and Reza Baraheni. Reprinted with permission of Prentice Hall. Reading 11.8, page 366: from Rumi, The Divan of Shams of Tabriz, THE CLEAR BEAD AT THE CENTER, From OPEN SECRET translated by John Moyne and Coleman Banks © 1984 Threshold Books. Reprinted by arrangement with Shambha Publications Inc., www.shambhala.com.

Chapter 12

Readings 12.1a–d, pages 375–377: Beowulf, From BEOWULF, translated by Seamus Heaney. Copyright © 2000 by Seamus Heaney. Used by permission of W. W. Norton & Company, Inc. Reading 12.3, page 383: Song of Roland, SONG OF ROLAND from THE SONG OF ROLAND translated by Patricia Terry. Reprinted with permission of Prentice Hall. Readings 12,5a, 12.5, pages 391, 399: from Hildegard of Bingen, Scivias, From Hildegard of Bingen: Scivias, translated by Mother Columba Hart and Jane Bishop, from The Classics of Western Spirituality. Copyright © 1990 by the Abbey of Regina Laudis: Benedictine Congregation Regina Laudis of the Strict Observance, Inc., New York/Mahwah, N.J. Used with permission of Paulist Press. www.paulistpress.com.

Chapter 13

Reading 13.3, page 421: Bernard de Ventadour, "The Skylark", Permission of the author, W.D. Snodgrass. Reading 13.4, page 422: Comtessa de Dia's "Cruel Are the Pains I've Suffered," from Lark in the morning: the verses of the troubadours, "Lark in the morning: the verses of the troubadours" edited by Robert Kehew. Copyright © 2005. Reprinted with the permission of University of Chicago Press. Reading 13.5, page 426: from Marie de France, Bisclavret (The Werewolf), BISCLAVRET from THE LAIS OF MARIE DE FRANCE translated by Hanning. Reprinted with permission of Baker Academic, a division of Baker Book House. © 1982. Reading 13.6, page 424: from Chrétien de Troyes, Lancelot, Reprinted by permission of Everyman's Library, an imprint of Alfred A. Knopf.

Chapter 14

Reading 14.1, page 454: from Jean de Meung's The Romance of the Rose, "The Story of Heloise and Abelard" from ROMANCE OF THE ROSE (1999) translated by Ellis, F.S. By permission of Oxford University Press.